Design Computing and Cognition '08

John S. Gero • Ashok K. Goel
Editors

Design Computing and Cognition '08

Proceedings of the Third International Conference on Design Computing and Cognition

 Springer

Editors
John S. Gero
Krasnow Institute for
Advanced Study
USA

Ashok K. Goel
Georgia Institute of
Technology
Georgia
USA

ISBN 978-94-017-8257-9 ISBN 978-1-4020-8728-8 (eBook)

Preface

The importance of research and education in design continues to grow. For example, government agencies are gradually increasing funding of design research, and increasing numbers of engineering schools are revising their curricula to emphasize design. This is because of an increasing realization that design is part of the wealth creation of a nation and needs to be better understood and taught. The continuing globalization of industry and trade has required nations to re-examine where their core contributions lie if not in production efficiency. Design is a precursor to manufacturing for physical objects and is the precursor to implementation for virtual objects. At the same time, the need for sustainable development is requiring design of new products and processes, and feeding a movement towards design innovations and inventions.

There are now three sources for design research: design computing, design cognition and human-centered information technology. The foundations for much of design computing remains artificial intelligence with its focus on ways of representation and on processes that support simulation and generation. Artificial intelligence continues to provide an environmentally rich paradigm within which design research based on computational constructions can be carried out. Design cognition is founded on concepts from cognitive science, an even newer area than artificial intelligence. It provides tools and methods to study human designers in both laboratory and practice settings. It is beginning to allow us to test the claims being made about the effects of the introduction of novel technologies into the design processes in addition to helping us understand the act of designing itself. Human-centered information technology, the newest of the three areas, is concerned with the use of information technologies in communities of practice. All there areas are represented in this conference.

This conference series aims at providing a bridge between the fields of design computing and design cognition. The confluence of these two fields is likely to provide the foundation for further advances in each of them.

The papers in this volume are from the *Third International Conference on Design Computing and Cognition (DCC'08)* held at Georgia Institute of Technology in Atlanta, USA. They represent the state-of-the-art of

research and development in design computing and design cognition. They are of particular interest to researchers, developers and users of advanced computation in design and those who need to gain a better understanding of designing.

In these proceedings the papers are grouped under the following nine headings, describing both advances in theory and application and demonstrating the depth and breadth of design computing and design cognition:

Shape Grammars
Design Cognition - 1
Knowledge-Based Design
Sketching, Diagrams and Design
Design Creativity
Design Cognition - 2
Design Support
Spatial Configuration
The Virtual and The Physical

While some of these themes, e.g., shape grammars, spatial configuration, knowledge-based design and design support, are well established in design research, others represent new trends in research on design computing and design cognition. For example, cognitive studies of diagrammatic representations in designing, combining virtual and physical design, and creativity in design now are receiving more attention.

There were over 125 full paper submissions to the conference. Each paper was extensively reviewed by three reviewers drawn from the international panel of over 130 active referees listed on the next pages. The reviewers' recommendations were then assessed before the final decision on each paper was taken. Thanks go to them, for the quality of these papers depends on their efforts.

Nicholas Hannon worked to turn the variegated submissions into the conference format, special thanks go to him.

John S. Gero
Krasnow Institute for Advanced Study

Ashok K. Goel
Georgia Institute of Technology

April 2008

List of Reviewers

Robin Adams, Purdue University,
USA

Saeema Ahmed, TU Denmark,
Denmark

Tom Arciszewski, George Mason
University, USA

Uday Athavankar, IIT Bombay,
India

Petra Badke-Schaub, TU Delft,
Netherlands

Stefanie Bandini,

Can Baykan, METU, Turkey

Kirsty Beilharz, University of
Sydney, Australia

Nathalie Bonnardel, University of
Provence, France

Iain Boyle, Worcester Polytechnic
Institute, USA

Dave Brown, Worcester Polytechnic
Institute, USA

Jon Cagan, Carnegie Mellon
University, USA

Luisa Caldas, Instituto Superior
Técnico, Portugal

Hernan Casakin, Ariel University
Center of Samaria, Israel

Gabriela Celani, UNICAMP, Brazil

Amaresh Chakrabarti, Indian
Institute of Science, India

Chiu-Shui Chan, Iowa State
University, USA

Scott Chase, University of
Strathclyde, UK

Per Christiansson, Aarlborg
University, Denmark

John Clarkson, University of
Cambridge, UK

Umberto Cugini, Polytecnico Milan,
Italy

Steve Culley, University of Bath,
UK

Bharat Dave, University of
Melbourne, Australia

Arnaud Dawans, University of
Liege, Belgium

Bauke De Vries, TU Eindhoven,
Netherlands

Dick Holger, University of
Colorado, USA

Ellen Do, Georgia Institute of
Technology, USA

Andy Dong, University of Sydney,
Australia

Jose Duarte, Instituto Superior
Técnico, Portugal

Alex Duffy, University of
Strathclyde, UK

Claudia Eckert, University of
Cambridge, UK

Hal Eden, University of Colorado,
USA

Catherine Elsen, University of
Liege, Belgium

Georges Fadel, Clemson University,
USA

Alexander Felfernig, University of
Klagenfurt, Austria

Gerhard Fischer, University of
Colorado, USA

Xavier Fischer, ESTIA,
France

Christian Freksa, University of
Bremen, Germany

Gerhard Friedrich, University of
 Klagenfurt, Austria
Esther Gelle. ABB, Switzerland
John Gero, George Mason
 University, USA
Pablo Gervas, Universidad
 Complutense de Madrid, Spain
Ashok Goel, Georgia Institute of
 Technology, USA
Gabirella Goldschmidt, Technion,
 Israel
Andres Gomez De Silva, ITAM,
 Mexico
Andrew Gorman, University of
 Colorado, USA
Mark Gross, Carnegie Mellon
 University, USA
Ning Gu, University of Newcastle,
 Australia
David Gunaratnam, University of
 Sydney, Australia
Balan Gurumoorthy, Indian Institute
 of Science, India
Winfried Hacker, TU Dresden,
 Germany
John Haymaker, Stanford
 University, USA
Mary Hegarty, University of
 California, Santa Barbara, USA
Michael Helms, Georgia Institute of
 Technology, USA
Mark Henderson, Arizona State
 University, USA
Ann Heylighen, KU Leuvan,
 Belgium
Koichi Hori, University of Tokyo,
 Japan
Walter Hower, Albstadt-
 Sigmaringen Universit, Germany
Taysheng Jeng, National Cheng
 Kung University, Taiwan
Leo Joskowicz, Hebrew University
 of Jerusalem, Israel
Julie Jupp, University of Cambridge,
 UK

Yehuda Kalay, University of
 California Berkeley, USA
Jeff Kan, University of Sydney,
 Australia
Udo Kannengiesser, NICTA,
 Australia
Mijeong Kim, University of
 California Berkeley, USA
Yong Se Kim, Sungkyunkwan
 University, Korea
Rüdiger Klein, TU Berlin, Germany
Terry Knight, MIT, USA
Branko Kolarevic, University of
 Calgary, Canada
Maria Kozhevnikov, George Mason
 University, USA
Gul Kremer, Pennsylvania State
 University, USA
Ramesh Krishnamurti, Carnegie
 Mellon University, USA
George Krstic, Signalife, USA
Bimal Kumar, Glasgow Caledonian
 University, UK
Pierre Leclercq, University of Liege,
 Belgium
Larry Leifer, Stanford University,
 USA
Noel Leon, ITESM, Mexico
Michael Leyton, Rutgers University,
 USA
Andrew Li, Chinese University of
 Hong Kong, China
Udo Lindemann, TU Munich,
 Germany
Hod Lipson, Cornell University,
 USA
Shaofeng Liu, University of
 Strathclyde, UK
Peter Lloyd, Open University, Uk
Sushil Louis, University of Nevada,
 USA
Mary Lou Maher, University of
 Sydney, Australia
Elene Mulet, Universitat Jaume I,
 Spain

Rivka Oxman, Technion, Israel
Rafael Perez y Perez, UNAM, Mexico
Rabee Reffat, KFUPM, Saudi Arabia
Yoram Reich, Tel Aviv University, Israel
Luis Romão, TU Lisbon, Portugal
Duska Rosenberg, RHUL, UK
Mike Rosenman, University of Sydney, Australia
Stephan Rudolph, University of Stuttgart, Germany
Pertti Saariluoma, University of Jyväskylä, Finland
Stephane Safin, University of Liege, Belgium
Somwrita Sarkar, University of Sydney, Australia
Prabir Sarkar, Indian Institute of Science, India
Larry Sass, MIT, USA
Rob Saunders, University of Sydney, Australia
Linda Schmidt, University of Maryland, USA
Gerhard Schmitt, ETH Zurich, Switzerland
Chris Schunn, University of Pittsburgh, USA
Warren Seering, MIT, USA
Kristi Shea, TU Munich, Germany
Greg Smith, University of Technology, Sydney, Australia
Steve Smith, Texas A&M University, USA
Ricardo Sosa, ITESM, Mexico
Ram Sriram, NIST, USA
Martin Stacey, de Mountford University, UK
Kostas Strathis, RHUL, UK
Louis Steinberg, Rutgers University, UK

George Stiny, MIT, USA
Markus Stumptner, University of South Australia, Australia
Joshua Summer, University of Maryland, USA
Milton Tan, NUS, Singapore
Hsien-Hui Tang, National Taiwai University of Science and Technology, Taiwan
Ming Xi Tang, Hong Kong Polytechnic University, China
Toshiharu Taura, Kobe University, Japan
Raji Tenneti, University of Strathclyde, UK
Tetsuo Tomiyama, TU Delft, Netherlands
Jan Treur, Vrije Universiteit Amsterdam, Netherlands
Jerry Tsai, University of Sydney, Australia
Barbara Tversky, Columbia University, USA
Pieter van Langen, Vrije Universiteit Amsterdam, Netherlands
Jos Van Leeuwen, University of Madeira, Portugal
Andrew Vande Moere, University of Sydney, Australia
Swaroop Vattam, Georgia Institute of Technology, USA
AV Gokula Vijaykumar, Indian Institute of Science, India
Willemien Visser, INRIA, France
Xiangyu Wang, University of Sydney, Australia
Rob Woodbury, Simon Fraser University, Canada
Huo Yuemin, Tsinghua University, China

SHAPE GRAMMARS

Automating the Creation of Shape Grammar Rules
Seth Orsborn, Jonathan Cagan and Peter Boatwright

*Ontologies and Shape Grammars: Communication between
Knowledge-Based and Generative Systems*
Francois Grobler, Ajla Aksamija, Hyunjoo Kim,
Ramesh Krishnamurti, Kui Yue and Casey Hickerson

*Categorisation of Designs According to Preference
Values for Shape Rules*
Sungwoo Lim, Miquel Prats, Scott Chase and Steve Garner

*A Technique for Implementing a Computation-Friendly
Shape Grammar Interpreter*
Kui Yue and Ramesh Krishnamurti

Approximating Shapes with Topologies
Djordje Krstic

Automating the Creation of Shape Grammar Rules

Seth Orsborn
Missouri University of Science and Technology, USA

Jonathan Cagan and Peter Boatwright
Carnegie Mellon University, USA

Shape grammars have the potential to be used in many design applications. One of the most limiting factors is that, currently, a shape grammar must be created by an expert trained in the creation and usage of shape grammars. In this paper we describe how the rules for a shape grammar can be derived automatically. A statistical analysis of the design language produces fundamental shape chunks. These chunks then form the basis for the shape grammar rules. These rules are created objectively and automatically and fewer rules are needed to create a completed design. Additionally, the form of the rules encourages divergent designs. Unique concept vehicles are given as an example.

Introduction

Vehicle designers have many tools at their disposal to help them in the creation of new vehicle concepts. Brands have established design languages that can be referenced on style sheets. Designers are trained to use their skill and intuition to bring potential designs to reality while respecting the established brand history and features for a product class. The understanding of vehicle differentiations is often based upon a general understanding of the vehicle form and established relationships between vehicle characteristics. This paper takes the results of a statistical analysis of forms as the design vocabulary for the vehicle class. This vocabulary is then used as the basis for a vehicle shape grammar.

J.S. Gero and A.K. Goel (eds.), *Design Computing and Cognition '08,*
© Springer Science + Business Media B.V. 2008

Shape grammars have been used as a computational design tool for representing design artifacts for over two decades. Shape grammars are a production system created by taking a sample of the whole for which one is trying to write a language [1]. From this sample a vocabulary of shapes can be written that represent all the basic forms of that sample. By defining the spatial relationships between those forms and how the forms are related to each other, shape rules can be written. A shape rule consists of a left and right side. If the shape in the left side matches a shape in a drawing then the rule can be applied, and the matching shape changes to match the right side of the rule. The shape rules allow the addition and subtraction of shapes, which in the end are perceived as shape modifications. These shape rules, combined with an initial shape, produce a shape grammar that represents the language of the design [1]. Shapes themselves can exist as points, lines, planes, volumes, or any combination thereof [1]. All shape generation must start with an initial shape: a point, a coordinate axis, or some foundation from which to start the shape grammar. If the grammar is going to end, it can end with a terminal rule, which prevents any other rules from being applied after it. This forces there to be closure in the rule sequence. Alternatively, a design sequence can continue indefinitely and designs could be chosen at any point in the design process.

The method discussed here fundamentally changes the method of developing the shape grammar. Mackenzie [2] demonstrates in a simplified case that if the fundamental shapes in the language are defined, the relationship between the shapes can be inferred through examples. These inferred relationships can then be mapped to trees which in turn can be used to automatically create shape grammar rules for that language. While this was shown effective in a particular use, it is more common in practice that the vocabulary of the design to be used as the foundation of a shape grammar is determined by the creator of the grammar. The creator of the grammar looks at the sample and subjectively derive the vocabulary. From that vocabulary, the rules are formed based upon the creator's experience and intention. It is quite possible that two different persons looking at the same sample of shapes would create two very different shape grammars. In this work we introduce a method that uses a statistical analysis of product characteristics to determine relevant groupings of elements. These objective groupings are then used to create rules for the shape grammar.

Orsborn, Cagan, Pawliki and Smith [3] developed a vehicle shape grammar based upon the existing vehicle classes. It was determined, in conjunction with a vehicle designer, which vehicle characteristics were most important for capturing the general form of the vehicle so that a potential consumer would recognize different vehicles. The forms for fifteen

coupes were captured using four-control-point Bezier curves. The data collected from this sample was statistically analyzed in [4]. Principal component analysis was used to determine the fundamental characteristics within the coupe vehicle class. Principal component analysis is a statistical method whereby an original set of related data is reduced in dimensionality to match the original data as closely as possible [5]. Principal component analysis finds a set of new variables that are weighted averages of the original variables. The first principal component is a vector that captures most of the variation between the original variables. Each variable is then given a weight related to the vector. The weight describes the influence of that variable on the principal component. Based upon the weights of all the variables a percentage variance explained is calculated for the first principal component. The second principal component is described using a vector orthogonal to the first principal component. The analysis is repeated, returning different weights for the variables and a smaller percentage variance explained. In many applications, like vehicles, only a few principal components account for much of the differences in the objects and identify key elements that distinguish the objects.

The fundamental characteristics found through the principal component analysis of the vehicles at times differed from the traditional and expected feature definition, resulting in a deeper understanding of what features of an existing set of designs must differentiate one form from another [6]. Orsborn, Boatwright and Cagan [7] demonstrated that these statistically derived fundamental shape relationships can be used for divergent product form exploration. In this paper, the results from the principal component analysis are used to create a new coupe shape grammar based upon these discovered shape relationships. The shape grammar is then used to create new coupe vehicles. Although the focus of this paper is on vehicle design, the methods developed here are applicable to any class of physical products based on a consistent form language. Further examples on this methodology are demonstrated in [4].

Vehicle Data Description

The coupe vehicles chosen for analysis are taken from [3]. The selection requirements were that each vehicle have an available blueprint that included the front, side and rear views. Each of the views must be isometric (or as close as possible) and the three views should complement each other parametrically, i.e. the proportions in each view of the drawing is consis-

tent with the actual vehicle. Table 1 indicates the sample vehicles for the
coupe class.

Table 1 Coupe vehicle sample

1	Acura RSX
2	Audi TT
3	BMW M3
4	Chevrolet Cavalier
5	Dodge Stratus
6	Ferrari 456M
7	Ferrari 612 Scaglietti
8	Ford Mustang
9	Honda Accord
10	Honda Civic
11	Hyundai Tiburon
12	Mercedes Benz C
13	Mercedes Benz CLK
14	Mitsubishi Eclipse
15	Toyota Celica

To maintain a reasonable degree of homogeneity within the vehicle
class, all the coupes chosen were from the 2003 model year. Unusual
forms, like the Volkswagen Beetle, were not included.

The intention of this paper is to apply our understanding of the founda-
tional forms in the coupe vehicle class through the creation and application
of a coupe shape grammar. The vehicle characteristics from [3] were used,
and will be discussed in detail in this section. Through discussion with a
vehicle designer, it was determined that the following vehicle characteris-
tics are the most relevant for sufficiently describing the form of the vehicle
(Refer to Fig. 1 for their locations on the vehicle.): (1) Front Wheels, (2)
Rear Wheels, (3) Front Wheel well, (4) Rear Wheel well, (5) Front Fender,
(6) Rear Fender, (7) Front Bumper, (8) Rear Bumper, (9) Front Wind-
shield, (10) Rear Windshield, (11) Grill, (12) Headlight, (13) Hood, (14)
Roof, (15) Trunk, (16) Taillight, (17) Rocker, (18) Door, (19) Front Side
Window, (20) Rear Side Window, (21) Door Handle, (22) Ground, and
(23) Belt line.

The belt line, which starts at the bottom of the A-pillar and runs along
the bottom of the side windows to the trunk, is an important characteristic.
There is no specific curve for the belt line, but it will be built using a com-
bination of the related characteristics: the hood, side windows, and trunk.

Each characteristic is defined by a curve or set of curves. These curves
were captured manually through the following process:

- A vehicle's blueprint was imported as an image plane into Alias DesignStudio.
- Each characteristic was traced using Bezier curves (four control points), except tires and rims, which use circles.
- The minimum number of curves were used to capture the characteristic accurately.
 This was done for each of the three views: front, side, and rear.

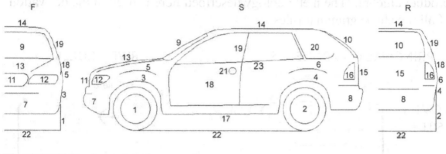

Fig. 1. Vehicle characteristics

Principal Component Analysis based Shape Grammar

This vehicle data has been analyzed using principal component analysis [6]. The coupes were separated into their views and dimensions: y- & z-coordinate for Front and Rear views (horizontal and vertical, respectively), and x- & z-coordinate for Side view (horizontal and vertical, respectively). The results produced chunks of curves that represented a percentage of the coupe vehicle class explained. For example, Fig. 2 pictorially shows the results of the coupe front y principal component analysis using darkened curves. It should be noted that the vehicles were analyzed symmetrically about the longitudinal vertical plane, but are mirrored here for the sake of visualization. The top-left Fig. is the first principal component (Comp 1) and explains 50% of the variation between the coupes in the front view and horizontal coordinate. This has been summarized as the width of the body, which means that the width of the body and track of the vehicle accounts for 50% of the variation between coupes in the front view horizontal coordinate. This chunk is inserted as the right-hand side of Rule 2F. Then, the curves shared between Comp 1 and Comp 2 become the left-hand side of Rule 3F. The right-hand side inserts the curves in Comp 2 that were not part of Comp 1. The right-hand side of Rule 3F is the entire chunk shown in Comp 2. The process is repeated for Rule 4F. The curves shared by

Comp 2 and Comp 3 compose the left-hand side of the rule and the curves chunked in Comp 3 are the right-hand side of the rule. In each instance the left-hand side of the rule is composed of curves shared with another chunk and the right-hand side is composed of the entire chunk. This just demonstrates one view of a rule. The side and rear views are also included in a single rule. These are derived in the same fashion, making this a parallel shape grammar with three component (front, side, rear) defined in a direct product algebra. The methodology described here is used in the derivation of all the shape grammar rules.

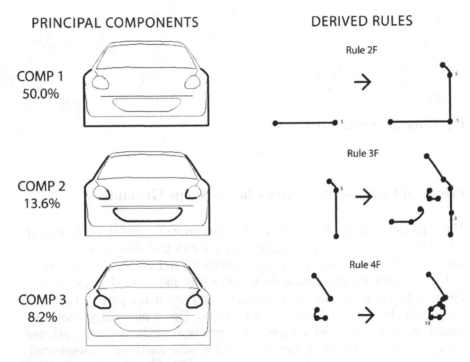

Fig. 2. Rule derivation example

Table 2 New rules from principal components

	FRONT	SIDE	REAR
Rule 1	Ground	Ground	Ground
Rule 2	Comp 1 Y	Echoes	Comp 1 Y
Rule 3	Comp 2 Y	Echoes	Comp 2 Y
Rule 4	Comp 3 Y	Echoes	Comp 3 Y
Rule 5	Comp 2 Z	Echoes	
Rule 6	Comp 1 Z	Comp 1 Z	Comp 1 Z

Rule 7	Comp 3 Z	Comp 2 Z	Comp 3 Z
Rule 8	Comp 4 Z	Comp 3 Z	
Rule 9		Comp 1 & 2 X	
Rule 10		Comp 4 Z	

The vocabulary for this shape grammar is based upon shape chunking that resulted from the principal component analysis. Because not every vehicle characteristic is contained within the principal component analysis (Table 3), additional rules will be created to fill in some of the empty spaces.

Table 3 Vehicle characteristics not completely described by principal components

FRONT	SIDE	REAR
Front Windshield, Front Wheel Well	Wheels, Ground, Fenders, Wheel Wells, Hood, Head Light, Front Windshield, Rear Windshield, Side Window, Rear Bumper, Door	Trunk, Rear Wheel Well

The shape grammar rules use labels and makers. The markers (a dot) indicate the end of a 4 control point Bezier curve. The labels (a number) guide the rule application. While the intention of many shape grammars is to be elegant, the emphasis here is to show that shape grammar rules can be objectively derived from a principal component analysis, a first step towards fully automating shape grammar creation. Table 2 lists the ten shape grammar rules and their principal component composition. It should be noted that the groupings of the principal components provided a connected progression through the rules. By selecting principal components with related curves, a sequence was automatically created that maintained the shape relationships found through the principal component analysis. In most instances, the dominant principal components came earlier in the rule progression. There are some principal components that are not used in rules. This is because the curves that are chunked together already appear in another principal component. In the instance where one principal component shares all of its curves with another, the principal component is used which simplifies the rule progression. We introduce the term echo in Table 2. An echo is when a certain shape is indicated in the front and rear views but not in the side view of the principal component analysis. The shape is "echoed" into the side view of the rule, for the sake of continuity.

The Initial Shape (Fig. 3) is a coordinate axis located on the ground at the center of the vehicle in the front and rear views and at the point where the front tire touches the ground in the side view.

Rule 1 (Fig. 4) inserts the ground, which also indicates the track width and the wheelbase. This rule is used as the starter for all vehicles. Though the ground is not an indicator in every view, it was decided to be necessary as a foundation for generation of any vehicle creation.

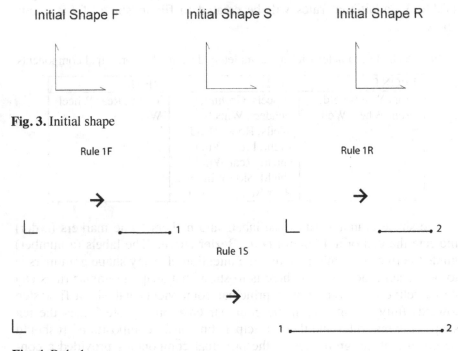

Initial Shape F Initial Shape S Initial Shape R

Fig. 3. Initial shape

Rule 1F Rule 1R

Rule 1S

Fig. 4. Rule 1

Coupe Rules

Rules 2 – 11 were derived from the principal components for coupes. If these rules are applied parametrically all the differentiating curves of a coupe will be created. The shape modification rules, generalized shape rules, are created by the user to allow for further changes to the design.

Rule 2 (Fig. 5) inserts the shoulder and width of the vehicle in the front and rear views, taken from Coupe Comp 1 Y in the front and rear. The rear fender is also inserted in the rear view and as an echo in the side view. Label 5 is added in as an echo in the side view.

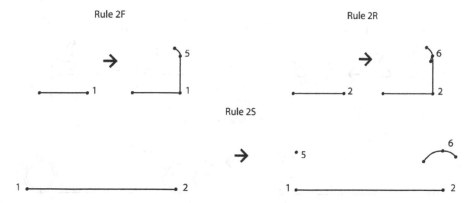

Fig. 5. Rule 2

Rule 3 (Fig. 6) inserts the chunks from Coupe Comp 2 Y in the front and rear views. The related echoes are added in the side view, along with the necessary labels. At this point it is difficult to see how a vehicle will form. But, these shape groupings are relevant in that they are taken directly from the principal component analysis.

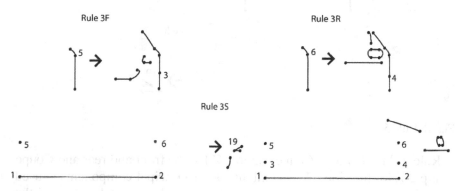

Fig. 6. Rule 3

The right-hand side of Rule 4 (Fig. 7) inserts the additional shapes found in Coupe Comp 3 Y Front and Rear, which gives the chunking according to the indicated principal components. It also inserts the echoes of the curves in the side view.

Rule 5 (Fig. 8) adds in just the horizontal front bumper line and the related Label 9. This is based off Coupe Comp 2 Z Front and echoes on the side view.

Rule 6 (Fig. 9) links together all the Coupe Comp 1 Z views. Since all of these views share curves, they can be applied in one rule. Additional markers and labels are added for continuity.

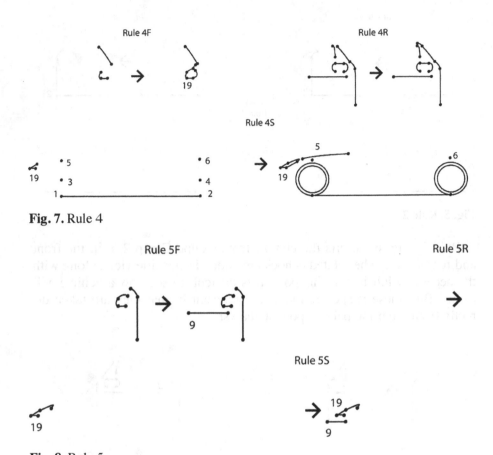

Fig. 7. Rule 4

Fig. 8. Rule 5

Rule 7 (Fig. 10) uses Coupe Comp 3 Z for the front and rear and Coupe Comp 2 Z for the side. This combination of principal components is used because of the curves that are shared between them, not because of the percentage explained by the principal components.

Rule 8 (Fig. 11) combines Coupe Comp 4 Z Front and Coupe Comp 3 Z Side. A rear principal component is not used because all the curves explained by rear principal components have been created.

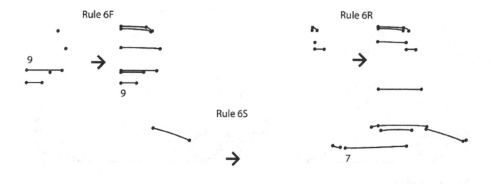

Fig. 9. Rule 6

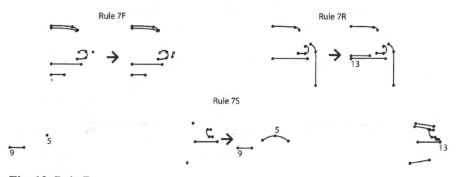

Fig. 10. Rule 7

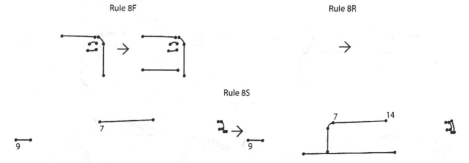

Fig. 11. Rule 8

Now that all the front and rear curves found in the principal components have been created, Rule 9 (Fig. 12) and Rule 10 (Fig. 13) add in the rest of the side chunks. Coupe Comp Side 1 & 2 X are combined in Rule 9 because they do not overlap. Then, Rule 10 inserts part of the door, handle, and lower front bumper found in Coupe Side Comp 4 Z.

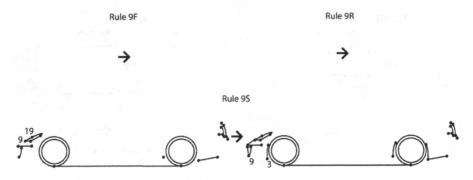

Fig. 12. Rule 9

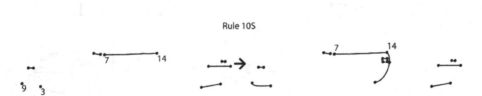

Fig. 13. Rule 10

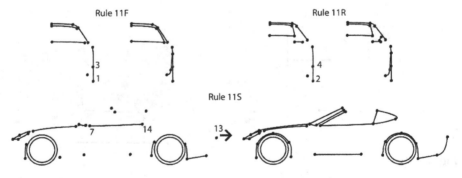

Fig. 14. Rule 11

At this point, the vehicle is not completed since not all curves are contained within the principal component analysis criteria used. So, Rule 11 (Fig. 14) was created to insert the rest of the curves, the curves not chunked together through the principal component analysis (Table 3). Af-

ter Rule 21 is applied, the shape modification rules (Fig. 15) can be applied to parametrically modify the shape of the vehicle. These will be discussed in more detail later.

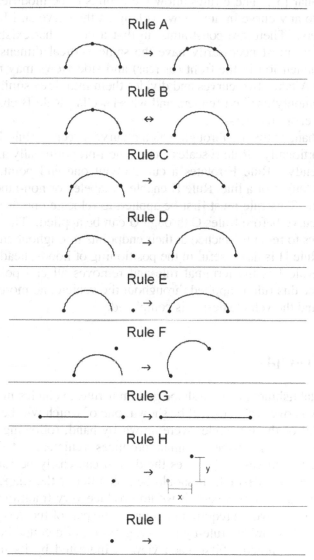

Fig. 15. Shape modification rules

Shape Modification Rules

The shape modification rules (Fig. 15) were first created for the vehicle shape grammar [3]. These rules allow the chunks to be modified and can be applied to any curve in any view, as long as the curve still has its end point markers. There are constraints, in that a curve that exists in more than one view must necessarily have the same vertical dimension. The horizontal dimension in the front (or rear) and side views may not be the same. Rule A takes two curves and divides them into three similar curves. This is commonly used on fenders and wheel wells. Rule B changes two curves to one, or vice versa.

Rule C changes the arc through which a curve sweeps. Rule D scales a curve proportionally. Rule E scales a curve non-proportionally and is used quite frequently. Rule F rotates a curve about one end point. Rule G changes the length of a line. Rule H enables a labeled or non-labeled point to be moved. This rule must first be applied to relocate one or more end-points of a curve before Rules C through G can be applied. This forces at-tached curves to remain attached at their endpoints throughout curve modi-fications. Rule H is also useful in the positioning of hoods, headlights and taillights. Rule I is the terminal rule and removes all end points of the curves. Once this rule is applied throughout the vehicle, no more rules can be applied and the vehicle design is completed.

Proof of Concept

With the establishment of new shape grammar rules, vehicles may now be created. Two novel vehicles will be shown, one of which will be discussed in detail. All of these vehicles were drawn by hand, following the shape grammar rules. The shape grammar produces vehicles, but due to the chunking of the curves in the rules the design can easily be forced in an unusual direction if desired. It should be noted that if the shape grammar were to be used conservatively, it would produce very traditional looking vehicles, though it would require intention on the part of the designer.

Figs. 16 – 29 show the rule-by-rule progression of a coupe build. Four things should be noted. First, each view is indicated by its initial (F = Front, S = Side, R = Rear), just as in the rules. Second, the front and the rear views are symmetric, so only half of the vehicle is constructed. The vehicle will be mirrored for the final design. Third, many curves are ini-tially only seen in one view, though it may finally exist in more than one view. When the curve is added to a view, it will parametrically match its related curve in another view. For example, the bottom of the front

bumper is inserted in the front view with Rule 8. It is not inserted in the side view until Rule 9 when the front wheel well is started. These will match, to keep the continuity of the design. Finally, the allowable parametric ranges for the curves are taken from [3], which were taken directly from the vehicle sample set. Not all curves fall within these ranges, but a general consistency is kept. If a designer were to completely ignore the allowable parametric ranges derived for the specific vehicle classes, the resulting designs would be much more fanciful.

Fig. 16 shows the Initial Shape, a coordinate axis in each view. Fig. 17 is the application of Rule 1, which sets the wheel base, the track width, and inserts the ground.

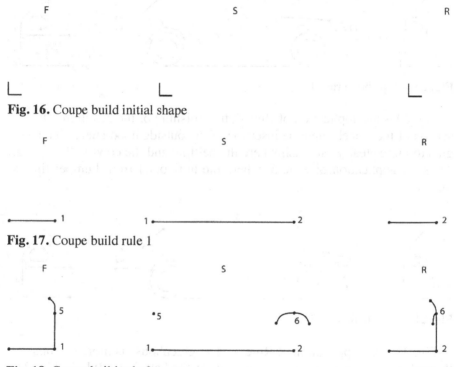

Fig. 16. Coupe build initial shape

Fig. 17. Coupe build rule 1

Fig. 18. Coupe build rule 2

Fig. 18 is the application of Rule 2. Since this is a parametric shape grammar, the curves are stretched to interesting positions. This starts a framework for the rest of the vehicle, since each rule follows linearly. Fig. 19 is the application of Rule 3. The front and rear views begin to take form, while the general dimensions of the side view are established. At any point, if the designer were not satisfied with the particular positioning

of a curve, it could be modified using the shape modification rules. This is
not done in this application.

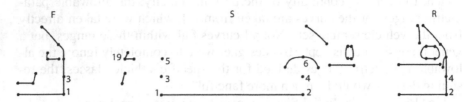

Fig. 19. Coupe build rule 3

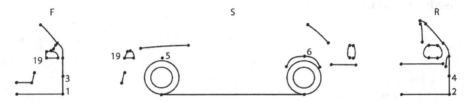

Fig. 20. Coupe build rule 4

Fig. 20 is the application of Rule 4, the finishing of the headlight, the in-
sertion of the wheels, and the insertion of the outside hood curve. This be-
gins to more clearly establish where the beltline and the cowl will be. Fig.
21 is the application of Rule 5, where the horizontal front bumper line is
inserted.

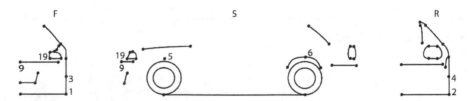

Fig. 21. Coupe build rule 5

Fig. 22 is the application of Rule 6. The greenhouse is more established
through the insertion of the roof and part of the belt line. Rule 7 (Fig. 23)
inserts the front fender and starts to establish the rear bumper in the side
view. Rule 8 (Fig. 24) puts in the front of the door, the trunk, and the
rocker, which gives a sense of the final dimensions. From this point on,
the rules are just filling in details that the principal component analysis has
found to be connected. The general form of the vehicle has been estab-
lished.

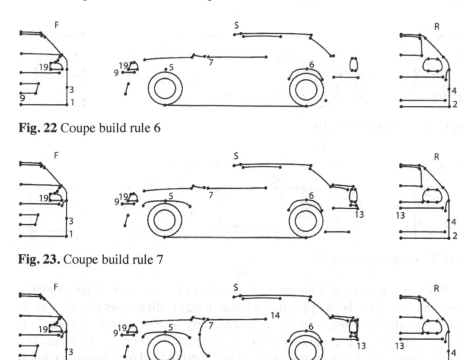

Fig. 22 Coupe build rule 6

Fig. 23. Coupe build rule 7

Fig. 24. Coupe build rule 8

Fig. 25 (Rule 9) establishes the wheel wells and closes up the nose of the vehicle. Fig. 26 is the application of Rule 10, which finishes the bottom of the front bumper and most of the door. Rule 11 is applied in Fig. 27. This is the addition of the curves noted in Table 3 that were not determined to be fundamental by the principal component analysis. There is the opportunity for a little parametric manipulation, especially with the side window. In general, the vehicle is done.

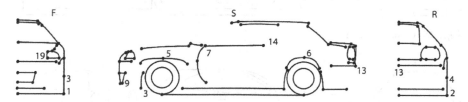

Fig. 25. Coupe build rule 9

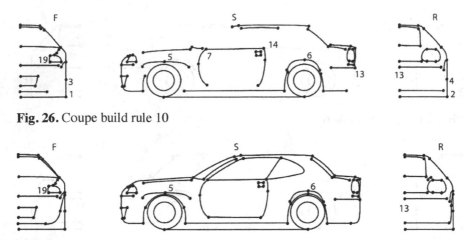

Fig. 26. Coupe build rule 10

Fig. 27. Coupe build rule 21

Now that all the rules automatically derived from the principal component analysis have been applied, the shape modification rules must be used for any further changes. In this example, only Rule I is applied (Fig. 28) which removes all the markers and remaining labels. Fig. 29 shows the final design with the front and rear views mirrored. This unique looking coupe was created not only through the purposefulness of the designer, but also through the application of rules that inserted the characteristics in a non-obvious order. By making certain choices early on in the design process, later curve insertions were forced to fill in the spaces, pushing the extents of the design language.

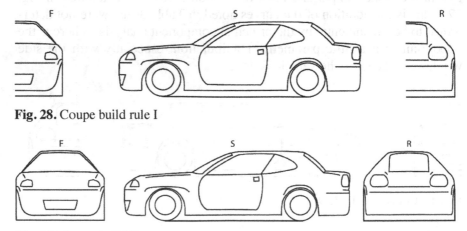

Fig. 28. Coupe build rule I

Fig. 29. Coupe build final

Fig. 30 is an additional example of a coupe created using this shape grammar. The fanciful form was obtained through the combination of ignoring the parametric constraints for the curves and the shape grammar's rules. This further demonstrates how this new coupe shape grammar based upon the results of the principal component analysis encourages divergent designs.

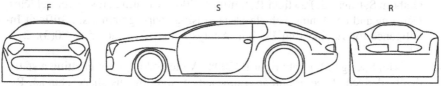

Fig. 30. Coupe concept vehicle

Conclusions

Shape grammars provide an opportunity for automated product form design and exploration. A shape grammar expert creates a shape grammar to capture a design language. The rules of this shape grammar are based upon the expert's perception of important shape relationships. This unintentionally constrains the shape grammar to generate product designs according to the expert's perspective.

A principal component analysis of a product sample objectively produces fundamental shape relationships called shape chunks. These objective chunks are then the foundation for shape grammar rules. The shape grammar rules can be created automatically based upon which shapes are, or are not, shared between the principal components. This automatically created shape grammar then facilitates the creation of divergent new product form designs.

Acknowledgments

Funding for this research was partially provided by General Motors and the National Science Foundation under grant DMI-0245218.

References

1. Stiny G (2006) Shape, talking about seeing and doing. MIT Press, Cambridge, Massachusetts
2. Mackenzie CA (1989) Inferring relational design grammars. Environment and Planning B 16(3): 253-287
3. Orsborn S, Cagan J, Pawlicki R, Smith R (2006) Creating cross-over vehicles: Defining and combining vehicle classes using shape grammars. Artificial Intelligence for Engineering Design, Analysis and Manufacturing 20(3): 217-246
4. Orsborn S, Cagan J, Boatwright P (2008) A methodology for creating a statistically derived shape grammar composed of non-obvious shape chunks. Research in Engineering Design 18(4): 181-196
5. Patel N, Shmueli G, Bruce P (2006) Data mining in Excel. Resampling Stats, Arlington, Virginia
6. Orsborn S, Boatwright P, Cagan J (2008) Identifying product shape relationships using principal component analysis. Research in Engineering Design 18(4): 163-180
7. Orsborn S, Cagan J, Boatwright P (2007) A new approach to vehicle concept generation: Statistics-based method for creating innovative product forms. Proceedings of ICED 2007

Ontologies and Shape Grammars: Communication between Knowledge-Based and Generative Systems

Francois Grobler, Ajla Aksamija and Hyunjoo Kim
US Army Corps of Engineers, ERDC Construction Engineering Research Laboratory, USA

Ramesh Krishnamurti, Kui Yue and Casey Hickerson
Carnegie Mellon University, USA

This paper discusses information flow between knowledge-based models and shape grammars for generation of building designs, explaining the interaction, system and implementation. The benefit for using the interactive system is that the complementary properties of the two schemes are used to strengthen the overall process. Shape grammar contains rules about the geometric organization, while knowledge-based model supports the contextual information.

Introduction

The nature of architectural design poses immense challenges for computing and information processing in automated or semi-automated systems. Architectural design knowledge, thinking and process are crucial components in the overall course of creating buildings; yet, computational representations of these components have been the central issue [1], [2], [3], [4]. In particular, types of information that architects seek vary depending on the nature of the problem, and the method in which information is sought is often ambiguous. For example, demographic studies are important to understand the social context of a particular site, building codes are crucial to understand the laws and regulations, and weather data is important to understand the environmental aspects. This explicit knowledge is stored in databases, is easily accessible by the designer and can be represented and

J.S. Gero and A.K. Goel (eds.), *Design Computing and Cognition '08*,
© Springer Science + Business Media B.V. 2008

analyzed computationally. The source of inspiration and implicit design knowledge are much more difficult to express. Moreover, computational analyses of sources of ideas and design require thorough understanding and comprehension of intentions, as well as contextual aspects. Designer intention and thought process are indeterminate from the system point of view. In this work, knowledge-based and generative systems are combined to construct a method for analysis of building types, in particular layout generation depending on certain parameters, such as building location and dimensions. Shape grammar contains rules about geometric manipulation and transformation, while knowledge-based model contains information about spatial use, organization, elements, and contextual information. Buildings are analyzed and layouts are generated through communication and interaction between these two systems. A case study of Baltimore rowhouses is used to illustrate the process.

Aims and Significance

Ontology contains information about building designs, location, use, orientation, and size, but does not give form to buildings with geometric meaning. It is knowledge representation about a subject, and describes individuals as basic objects, classes as collections or types of objects, properties and characteristics, and relations between objects. In this research, ontology is used to capture knowledge relating to architectural design principles, building anatomy, structure and systems. There are certain similarities between shape grammar and knowledge-based model, mainly that both contain design rules, however, the nature of the rule varies.

Shape grammars are computational rules for generation of geometric shapes, and there are two types—analytic and original. Analytical grammars are developed to describe and analyze historical styles or designs by specific architects [5], [6], [7], [8]. Analytical grammars use sets of existing designs, the corpus, to develop the language, and to infer the rules. Grammars are tested by using the rules to both generate designs in the corpus, as well as new designs. Original grammars are based on generalized rules and are intended to create instances of original styles of designs. These types of grammars have not been widely addressed as analytical, owing to the difficulty of "translation of abstract, experimental form into architectural designs that fit particular design contexts or programmes" [9].

The combinatory nature of the design rules captured by shape grammar and ontology offers the possibility that design knowledge can be explicitly represented, maintained and processed. In this respect, Baker and Fenves [10] remark:

In an engineering scenario, analysis and design are the similar processes manipulating constant knowledge. When engineers use knowledge to create new products the process is called design. The process of creating new objects will be termed generation. The checking process of objects will be called critiquing, otherwise known as analysis. Therefore, if engineering knowledge can be captured (e.g., how engineered objects fit together as well as the function of each object) and represented using a grammar, both design and analysis can be performed.

A parallel can be drawn between engineers and products, and architects and buildings. Architectural design knowledge is captured in ontology, and processed by shape grammar, thus allowing for generation and analysis. In this sense, any discrepancy between analytical and original shape grammars become diminished, as general rules can be customizable depending on context, building size, style or function.

Application

In a traditional analytical shape grammar, as found in the literature, we often come across rule descriptions of the form: "If the back or sides are wide enough, rule 2 can be used ...," which are inherently counter-computable. For shape rules to be "computation-friendly," rules need to be quantitatively specified so that they translate easily into pieces of "code," and that there is enough precision in the specification to disallow generation of ill-dimensioned configurations. A computation-friendly shape grammar interpreter would benefit from assistance of the ontology. In our efforts to quantify shape rules, originally specified in the traditional way, we frequently found that the only way to distinguish certain rules is employ threshold values statistically derived from the building sample, for example, for the area of a kitchen. The ontology can provide this dynamically as new building samples are added.

In the context of this paper, it is important to note that shape grammars are primarily used as a knowledge base for the building geometric forms, as well as a vehicle for geometric derivation for layout generation. Generating novel designs is not a concern of this particular research.

Methodology: process and communication

The starting point of the interaction focuses on requirements, including building location, dimensions, and functional type. A lightweight building

information model (BIM) is created based on the requirements, and it contains information about the building shell, general building anatomy, and components. This data is the initial input for the shape grammar rules, but additional information about the building, such as site context, environment, and cultural effects, needs to be incorporated in the process. The means of providing that information to the shape grammar rules is through the ontology of architectural design drivers. This model includes specific information according to the building type, location, culture, environment, structural system, and context, and about design factors that directly influence building layout. Once that information is received, the shape grammar system selects the rules and configures the spatial organization. During the application of shape rules, the shape grammar system may query the ontology system for certain information, in particular, statistical data and facts. The queried data will be used to decide which rule to apply among the candidates for the next step. Such queries are currently designed in a way so that no human intervention is necessary although this is not true in general. The end result is a generated layout, outlining spatial organization. The information populates the parametric BIM, and can be visualized in three dimensions. Figure 1 presents the overall process and the interaction.

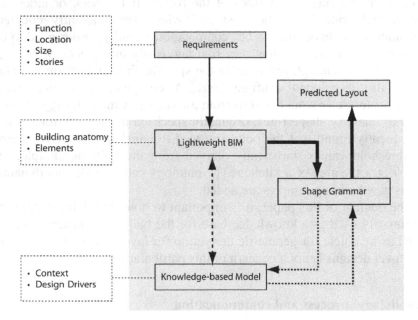

Fig. 1. The overall process and interaction between shape grammar and knowledge-based model

Lightweight building information model

The purpose of developing a lightweight BIM is to build a neutral, semantic, slimmed down representation of a building, objects in that building and relationships among them and thus to capture common building elements and anatomy [11]. Building anatomy is subdivided into gross building elements such as external features and general descriptions where each gross building element is further divided into detailed elements such as roof, walls, floors, foundation, doors and windows. This research utilized an ontological structure to represent a common behavior of a building and provide an underlying structure of objects and relationships of a building where different relations such as "bounding_Walls," "connects_Rooms," "is_Made_Of" and so on are described between elements. Figure 2 shows an ontological instance of a building with different properties and relations to represent the lightweight building elements of a Baltimore rowhouse.

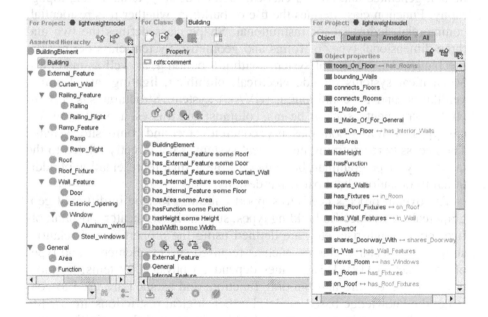

Fig. 2. Light-weight BIM contents

Knowledge-based model of architectural design drivers

The purpose of the architectural design driver ontology is to capture knowledge about the design of particular building types. The features of a building that relate to the design include size and dimensions, surrounding area, façade treatment, circulation and movement patterns, form, structure, materials, etc. The ontology is used to describe the relationships between these elements, as well as the social, cultural, and environmental factors.

The main classes include environmental, social, cultural and physical properties—the rest of the ontology follows a hierarchical model describing the main concepts. Environment class defines context, infrastructure, and site. Context includes cultural aspects, history, economy, social aspects (such as users and activities), and style. The ontology contains logical descriptions of the relationships between these aspects, thus constructing representations of these implicit drivers. Site is defined through human-generated and natural classes, such as density, climate, and topography. Function class defines the use of building, whether it is residential, commercial, industrial, or institutional. Shape class defines the two and three-dimensional types of forms and geometry. System class defines the mechanical and structural systems within a building, as well as materials. Mechanical systems include electrical, plumbing, lighting, and heating, ventilation and air-conditioning (HVAC) system. Structural systems include components, such as beams, columns, and trusses, as well as different types, such as wood, masonry, concrete, steel and composite systems. The necessity for defining mechanical system is not directly related to the queries by shape grammar, but rather for the textual representation of additional information about particular designs.

The overall process needs to support buildings located in different geographical areas. Specific building types, such as hotel, theater, hospital, office, house, high-rise, etc., are defined using the properties and relationships to the declared classes, such as required spaces, elements, and types of construction [12]. Design rules depend on physical systems, location, environment, culture and building function, and as such are used to construct the knowledge-based model. Further, logical restrictions are used to express the dependencies between building types and the activities, components, budget, circulation, location, etc., as presented in Figure 3 for manufacturing plant as a specific type.

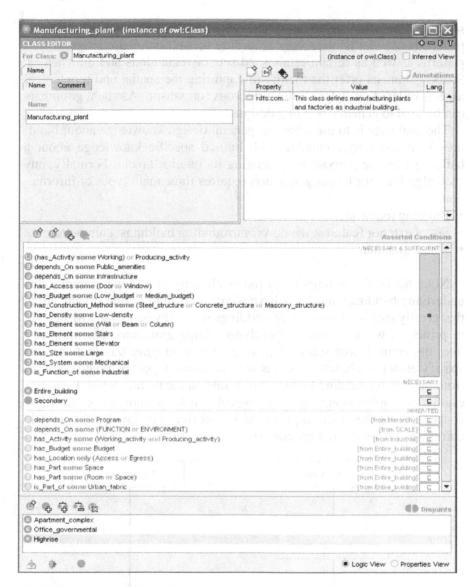

Fig. 3. Logical descriptions for manufacturing plant

Shape grammar and layout generation

In general, given present day technology, it is difficult for a machine to generate building interior layouts from a set of observable exterior features. However, by using knowledge of building styles this task (or a sub-

set) could be made significantly more tractable. Many buildings follow a pattern book; that is, they vary according to well-defined configurational patterns as well as certain established sets of regulations and dimensions. Shape grammars offer the facility of capturing the spatial and topological aspects of building styles within a rigorous formalism. As such, grammars can be used to generate building designs.

The challenge is to use a base of general design knowledge about buildings in a given style coupled with limited specific knowledge about a building with the purpose of generating its interior layout. Formally, any such algorithm for layout generation requires three main types of information:

- Building footprint
- Set of exterior features: windows, surrounding buildings, chimneys, etc.
- Shape grammar

Note that by the assumption of the availability of a shape grammar, the underlying buildings implicitly have a clear and rigid spatial organization; this greatly narrows the scope of buildings under investigation. Moreover, in principle, when applied exhaustively, shape grammars generate, as a tree, the entire layout space of a style. By leveraging this fact, we can specify an approach, which begins with an initial layout estimate obtained from employing building feature constraints on the feature input. From this estimation, further spatial and topological constraints are extracted. These constraints are then used to prune the layout tree. The layouts that remain correspond to the desired generations.

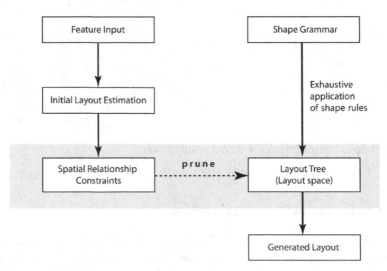

Fig. 4. Approach for layout generation

Results: case study

Queries for design rules

The Baltimore rowhouse [13] is discussed as a case study to demonstrate the process and communication between knowledge-based and generative systems. As the shape grammar rules start to execute, the system poses queries to ontology, such as the required or optional features, required spaces, dimensions, and orientation. This information is received, processed, and according to the responses the subsequent rules are implemented.

- The starting point for the interaction between shape grammar and the ontology is the list of questions that shape grammars poses for a specific building type. The questions for Baltimore rowhouse inquire about the building orientation, surrounding context, spaces, dimensions, and construction method:
- Which direction is the front?
- Which sides of the building face streets?
- Which direction is north?
- What kinds of exterior features are common to the type?
 — *Door, window, chimney, porch, dormer*
- What kinds of interior features are common to the type?
 — *Fireplace, stair*
- What kinds of spaces are common to the type?
 — *Hallway, parlor, kitchen, dining-room, air-lock*
- What kinds of wall assemblies are common to the type?
- Of the various features and spaces common to a type, which are required?
- How do interior spaces relate to building orientation?
 — *In the Queen Anne style and Baltimore rowhouse types, the parlor always faces the front side of the building.*
- How do exterior features relate to interior spaces?
 — *A front door is always on the front side of the building, though in the Baltimore rowhouse style, a front door does not always enter a hallway.*
- How do interior features relate to exterior features?
 — *The interior fireplace is offset from the chimney on the exterior.*
- What are the minimum, maximum, and average/expected dimensions for features, spaces, and wall assemblies?

— *For fireplace (depth), staircase (slope), staircase (run), parlor (width), parlor (depth), hallway (width), hallway (depth), interior-wall (thickness) and so on.*
• Do features align with stories?
• Is a group of features symmetric? If so, what is the symmetric axis?

Interaction

Baltimore rowhouses are typically quite narrow, two stories high, and facing north-south or south-west. Living rooms typically face front, and are directly accessible from the street or narrow hallway if there are two bays, and kitchen is located in the back [13]. Wood stairs are often a single run, and are oriented along one firewall. The fire walls are primarily constructed of brick, with wood framed structure for interior partitions, floors and roofs. Roofs are typically with nominal slope.

The information presented above is captured in the architectural design drivers ontology through different methods. For example, general building class contains elements, in which case an instantiation of Baltimore rowhouse presents actual elements of this particular building type. Fire wall is one of the key elements of a rowhouse, and the spatial organization is always linear and dependent on this key element. Similarly, building spaces belonging to the Baltimore rowhouse are captured. The spatial organization, general rules and typical sizes are also captured as instances, where statements such as "living room faces front" are constructed from the elements of the ontology. Minimum, maximum and average dimensions are presented for all spaces. Spatial organization is presented relative to the external and internal features. Ontology also contains information about selected existing buildings, such as footprint, material use, statistics of spatial use and organization.

Interaction between shape grammar and ontology is accomplished through XML communication by web services. Thetus Publisher[1] contains the ontology discussed in this paper. The tasks for Thetus Publisher include collecting, storing, structuring, changing and searching knowledge bases. Specific queries can be saved and stored in Thetus, as well as reused and updated as the knowledge is discovered. In the layout generation process, the queries are performed by shape grammar, where specific questions are asked from the ontology. The questions are directed to Thetus, which gathers the necessary information and sends to shape grammar rules.

[1] A knowledge modeling and discovery environment developed by Thetus, Inc. (http://www.thetus.com/)

Figure 5 presents architectural design drivers ontology for Baltimore row-house and constructed search for relationship between exterior and interior features. Once the information is received, the generation process initializes. The generated layouts are sent back to Thetus Publisher as XML-BIMs, where they are stored.

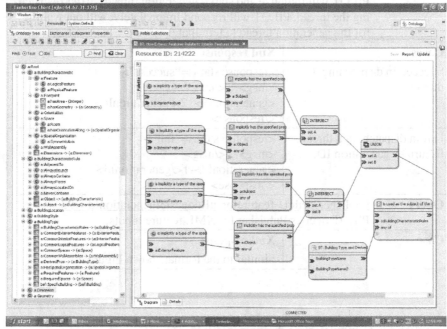

Fig. 5. Ontology capturing design knowledge for Baltimore rowhouse and constructed query for relationship rules between exterior and interior features

There are several technical issues associated with the implementation of communication through web services. Thetus Publisher is the master program of the entire building characterization system, and the generative system, named PILOT (Proposing Interior Layout Over building Types), is a sub-system. The basic model of web services is query-and-response; that is, one side starts a HTTP query of the form http://64. xx.xx.xxx/BuildingTypeServlet/?action=runSearch&search=common SpacesForABuildingType&buildingType=BaltimoreRowHouse, and the other side writes an XML response back. Due to the limitation of the query-and-response model, certain communications have to be realized by multiple query-and-responses.

Table 1 XML communication protocol

Function	Publisher's initial request to PILOT with building feature inputs.
Query	PILOT?action=generationRequest&buildingType=BaltimoreRow houses PILOT will initialize and start a generation thread. After dispatching the thread, PILOT will respond immediately, without waiting for the generation thread to terminate

Cases	Xml response
Succeed in dispatching a thread	<response status="success"> <msg>…</msg> <generationId>12</generationId> </response>
Fail in dispatching a thread. Return -1 generation ID.	<response status="fail"> <msg>…</msg> <generationId>-1</generationId> </response>

Query	Publisher?action=featureInputRequest&generationId=123 PILOT queries Publisher for XML feature inputs.

Case	Xml response
	Similar to the format shown Figure 7.

Function	Communication during generation.
Query	PILOT queries Publisher for other data. The queries are in the form of Publisher?action=runSearch&search=commonSpaces ForABuildingType &buildingType=BaltimoreRowHouse

Case	Xml response
	<results search="commonWallAssemblies"> <characteristics> <characteristic type="ExteriorWall" name="baltRowExteriorWall"> <Width> <HasMaxFeet>24</HasMaxFeet> <HasAvgFeet>18</HasAvgFeet> <HasMinFeet>12</HasMinFeet> </Width> </characteristic> </characteristics> </results>

Function	PILOT posts the generated interior layouts back to Publisher
Query	Pulisher?action=generationThreadTerminationReport&generationId=123& terminationStatus=successWithLayouts PILOT informs Publisher that a particular generation thread terminates as well as its termination status, so that Publisher can initiate query for the generated results.

Case	Xml response
	No response really needed.

Query	PILOT?action=nextLayoutResultRequest&generationId=123 Publisher queries for the next generated interior layout. (This procedure follows the enumeration model.)

Cases	Xml response
There is a next layout	`<response status="success">` `<msg>...</msg>` `<layout found="T" id="3">` `<!--xml layout here-->` `</layout>` `</response>`
There is no next layout.	`<response status="success">` `<msg>...</msg>` `<layout found="F" id="-1">` `<!--empty-->` `</layout>` `</response>`
Error	`<response status="fail">`

A generation cycle starts with a generation request from Publisher. PILOT dispatches a separate thread for each generation request so that multiple generation requests can be handled. Once a thread is dispatched, PILOT will send back status information immediately, as it may take the generation thread a while to complete the generation. Each thread is capable of conducting the standard query-and-response communications with Publisher individually until it terminates. There are three ways by which each thread possibly terminates: i) no errors with layouts generated, ii) no errors but no layout generated, and iii) errors occurred during execution. To handle possible error situations, responses are distinguished as success or failure: if success, a *found* tag is used to distinguish layouts generated or not; if fail, an *msg* tag contains the error message. Once the Publisher receives the successful termination status, it can start to retrieve the generation results by querying. It is possible that multiple layout results can be generated. Therefore, the procedure of layout result query follows an enu-

meration model; the publisher will keep query until there is no more layouts to send back. Table 1 gives a summary of the XML protocol adopted.

Generation and visualization

Generation process consists of two main steps, first being the decomposition of input footprint into a minimum set of rectangular blocks, and the second being assigning and organizing rooms. In the case of the Baltimore rowhouse, the initial layout estimation happens to be the same as the first few steps of the shape rules. This initial layout estimation can be used as the starting point for the further shape rule application without tree pruning. Shape grammar for Baltimore rowhouse consists of fifty two rules applied sequentially, where every rule is required or optional. The reason for sequential process is that rules are performed in eight phases, and the set of applied and optional rules determines the design outcome. The phases include block generation, space generation, stair generation, fireplace generation, space modification, front exterior feature generation, middle and back exterior feature generation, and interior feature generation.

The initial layout estimation is converted into graph-like data structures for further refinement by shape rules. The main manipulations are to refine the layouts from initial estimation, such as adding staircases, fireplaces, and interior doors. This requires basic functions, such as finding a shared wall of two rooms. Shape rules are further applied to add more details, such as interior doors, staircases, and openings. Figure 6 shows a screenshot of the PILOT system. There are three windows: the left is the generation window consisting of a tree of shape rule application (left panel) and a display of the layout (right panel), the middle window depicts the layout truth, and the right window shows the feature inputs.

The final step of the process is visualization of the generated layout as a three-dimensional model, which is achieved by parametric modeling. generated layout is captured in XML, as seen in Figure 8, and sent to Thetus Publisher for storing.

The modeling system uses an XML file as input to create a three-dimensional model of the building using features and parameters. Dimensions and variables are linked to geometry in such a way that when the parameter values change, the geometry updates accordingly. Based on the inter-element relationships stored in the lightweight model, the visualization modeling system determines how elements need to be created or updated. Upon creating a visual representation shown in Figure 9, the user is able to examine each part of a 3D model and rendering. The application is mainly

for conceptual design, but intended to be developed further so that it may become scalable to continue in detailed design.

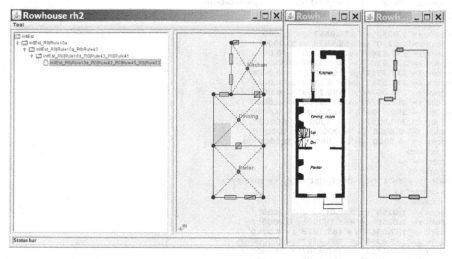

Fig. 6. Screenshot of the PILOT system
Left: generation window. Middle: layout truth. Right: Feature inputs.

Figure 7 shows results for generation of particular buildings and the original floor plan.

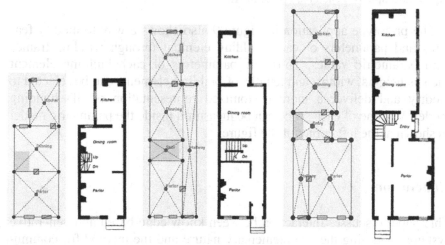

Fig. 7. Results of layout generation

```
<?xml version="1.0" encoding="UTF-8" ?>
- <building>
- <feature id="0" type="footprint" subtype="computation">
- <geometry>
- <polyline>
<point x="1.0250" y="338.0659" z="0.0000" />
<point x="1.0250" y="465.1029" z="0.0000" />
<point x="137.6360" y="465.1029" z="0.0000" />
<point x="137.6360" y="365.4787" z="0.0000" />
<point x="211.8517" y="365.4787" z="0.0000" />
<point x="211.8517" y="486.2189" z="0.0000" />
<point x="286.0674" y="486.2189" z="0.0000" />
<point x="286.0674" y="422.8709" z="0.0000" />
<point x="360.9599" y="422.8709" z="0.0000" />
<point x="360.9599" y="-6.0000" z="0.0000" />
<point x="-6.0000" y="-6.0000" z="0.0000" />
<point x="-6.0000" y="338.0659" z="0.0000" />
</polyline>
</geometry>
</feature>
- <feature id="1" type="footprint" subtype="display">
- <geometry>
- <polyline>
<point x="1.0250" y="338.0659" z="0.0000" />
<point x="1.0250" y="465.1029" z="0.0000" />
<point x="137.6360" y="465.1029" z="0.0000" />
<point x="137.6360" y="365.4787" z="0.0000" />
<point x="211.8517" y="365.4787" z="0.0000" />
<point x="211.8517" y="486.2189" z="0.0000" />
<point x="286.0674" y="486.2189" z="0.0000" />
<point x="286.0674" y="422.8709" z="0.0000" />
<point x="360.9599" y="422.8709" z="0.0000" />
<point x="360.9599" y="-6.0000" z="0.0000" />
<point x="-6.0000" y="-6.0000" z="0.0000" />
<point x="-6.0000" y="338.0659" z="0.0000" />
</polyline>
</geometry>
</feature>
```

Fig. 8. Example of generated layout in XML

The prototype application in Figure 9 also shows a way to modify features and parameters of each building element through window frames with parametric values. Thus, the parameters of each building element such as heights, widths, and lengths of building elements can be selected to modify and deliver a more customized representation of 3D building model. Volume of each space can be measured inside the parametric model as shown at the left corner of the figure.

Conclusion

This paper discusses interaction between knowledge-based and generative systems, outlining the complementary nature and the method for communication. Shape grammars contain rules for transforming geometrical entities, while knowledge-based model contains information about particular building types and context. Through exchange of information and query,

contextual aspects are explored and design knowledge is utilized to create building layouts. Baltimore rowhouse was presented as a particular case study expressing the process, knowledge acquisition, processing, characterization and visualization.

Fig. 9. 3-D Parametric Model

The discussed methodology for interaction between knowledge-based and generative systems is effective, and produces the desired results. The primary advantage of this method is that interaction is achieved by specifying the building type, so that the overall knowledge is modularized accordingly. The presented case study is a relatively simple building type, whose characteristics can be expressed relative to the major element, or firewall. The knowledge base contains information that is sufficient for shape grammar to perform selection of rules and generation of interiors. However, regional and cultural differences have not been tested yet, such as for Philadelphia or English rowhouses. Moreover, complex building types, such as multi-story mixed-use buildings or industrial facilities, are more difficult to characterize and require substantial descriptions. This process has not been performed for such intricate building types.

Currently, communication between the two systems is achieved by querying predefined searches. Constructing impromptu queries from the shape grammar side is not performed. Further research is needed to investigate methodology for dynamically accessing knowledge-base. Future plans include extending shape grammar rules to more building types, as well as knowledge-base model, and testing against regional and cultural differences.

References

1. Gero JS, Maher ML (1993) Modeling creativity and knowledge-based creative design. Lawrence Erlbaum Associates, Hillsdale
2. Kalay Y (2004) Architecture's new media: principles, theories, and methods of computer-aided design. MIT Press, Cambridge
3. McCullough M, Mitchell WJ, Purcell P (1990) The electronic design studio: architectural knowledge and media in the computer era. MIT Press, Cambridge
4. Mitchell WJ (1990) The logic of architecture: design, computation, and cognition. MIT Press, Cambridge
5. Stiny G, Mitchell WJ (1978) The Palladian grammar. Environment and Planning B: Planning and Design 5: 5-18
6. Chiou SC, Krishnamurti R (1995) The fortunate dimensions of Taiwanese traditional architecture. Environment and Planning B: Planning and Design 22: 547-562
7. Cagdas G (1996) A shape grammar: the language of traditional Turkish houses. Environment and Planning B: Planning and Design 23(4): 443-464
8. Duarte JP (2005) Towards the mass customization of housing: the grammar of Siza's houses at Malagueira. Environment and Planning B: Planning and Design 32: 347-380
9. Knight TW (1992) Designing with grammars. in Hatch (ed), Computer-Aided Architectural Design. Van Nostrand-Reinhold, New York
10. Nelson CB, Fenves SJ (1990) Manipulating shape and its function. Journal of Computing in Civil Engineering 4(3): 221-238
11. Grobler F, Kim H (2007) Ontology of a building to support reasoning in design process. Proceedings of International Workshop on Computing in Civil Engineering, ASCE, Pittsburgh
12. Grobler F, Aksamija A (2007) Architectural ontology: development of machine-readable representations for building design drivers. Proceedings of International Workshop on Computing in Civil Engineering, ASCE, Pittsburgh
13. Hayward ME, Belfoure C (2005) The Baltimore rowhouse. Princeton Architectural Press, New York

Categorisation of Designs According to Preference Values for Shape Rules

Sungwoo Lim[1], Miquel Prats[2], Scott Chase[1] and Steve Garner[2]
[1]*University of Strathclyde, UK*

[2]*The Open University, UK*

Shape grammars have been used to explore design spaces through design generation according to sets of shape rules with a recursive process. Although design space exploration is a persistent issue in computational design research, there have been few studies regarding the provision of more preferable and refined outcomes to designers. This paper presents an approach for the categorisation of design outcomes from shape grammar systems to support individual preferences via two customised viewpoints: (i) absolute preference values of shape rules and (ii) relative preference values of shape rules with shape rule classification levels with illustrative examples.

Introduction

One valuable technique to conceive designs is to generate design alternatives. Computational advancements and the evolution of modern design processes have opened new lines of research based on generative systems. The purpose of generative systems is not always to reach a unique optimal solution but instead to display a range of design alternatives. There are many different variants of generative design systems. They typically generate satisfactory designs starting from little or nothing, being guided by performance criteria within a given design space [1]. One way of obtaining sets of satisfactory designs is to define preference values for generative rules. In other words, instead of randomly generating lots of designs and

J.S. Gero and A.K. Goel (eds.), *Design Computing and Cognition '08*,
© Springer Science + Business Media B.V. 2008

then looking for meaningful solutions, it is sometimes more reasonable to define rules that generate only sequences of designs that are accord with designer preferences.

Shape grammars [2] are production systems that generate designs according to sets of shape rules. These rules are of the form $a \rightarrow b$, where a and b are both labelled shapes, and are applicable to a shape S if there is a transformation that imbeds a in S. A shape rule is applied by replacing the transformed shape a in S with the similarly transformed shape b. These allow the construction of complex shapes from simple shape elements. The potential for applying shape grammars to explore design spaces has been applied in areas such as architectural and consumer product design [3]. Despite a history going back decades [4], progress in computer implementation of shape grammar systems has been slow [5]. This is partly due to complexities in object representation used in such systems [6] but is also possibly a consequence of the characteristic of producing large, possibly an infinite number of outcomes [7]. As a result relatively few researchers have attempted to categorise outcomes from shape grammar systems. While diversity and number of outcomes may be appreciated by designers, they may wish to limit this number in order to reduce their efforts to find preferable (or appropriate) ones.

The research described here results from an ongoing project concerning design synthesis and shape generation (DSSG). The project explores how designers generate shapes and how shape computation systems might support designers without impinging upon their creativity. The aim of this paper is to present an approach to categorising design outcomes from shape grammar systems to support individual preference. It offers the possibility of providing more preferable and refined outcomes to designers based on their own ways of shape generation. Here, the categorisation of design outcomes is not intended to reflect a measure of similarity or style but instead is intended to reflect the likelihood that designs would be produced by a designer. This likelihood is based on experimental data concerned with analysing how designers specify and manipulate shapes when exploring designs [8]. This analysis led to the definition of shape rules believed to capture the manipulations typically used by designers, and to data related to the frequency that such rules were used to explore designs.

Clustering via customisable viewpoints

Shape rules can formalise the creative process that involves the generation of designs, the selection of the preferable, and the seeding of a new genera-

tion, until a competent design is found or the entire design space has been explored [9]. This process, however, may not be ideal for design exploration since design spaces tend to be immense and the probability of obtaining a satisfactory design in a reasonable length of time is very small.

One possible way to customise design outcomes is by categorisation according to the similarity of shape characteristics. Clusters of designs may be organised into a hierarchical structure where they are broken down into subclusters [10]. In this case, a hierarchical classifier is needed to divide the classes into contextual subgroups, which are then further divided to produce a tree structure defining relationships between classes [11]. A number of methods are extant for hierarchical clustering depending on the area of application, e.g. in biological taxonomy, psychology and cognitive science [12], physics [13], and artificial intelligence [14].

Some investigations have been conducted into multiple viewpoints for clustering. Researchers have found that different results can be obtained when the same data set is analysed using a different clustering strategy during computational clustering [15, 16]. For example, Howard-Jones [17] carried out an experiment in which subjects looked at a geometrical shape, generating as many interpretations of the shape as possible based on different viewpoints. Duffy and Kerr [18] suggest that designers require different viewpoints from past designs and abstractions in order to facilitate the effective utilisation of past design knowledge, and pointed out the need to support different viewpoints, termed 'Customised Viewpoints' (CV). Manfaat and Duffy [19] extended this theory to support the effective utilisation of spatial layouts for ship design by hierarchical levels of abstractions according to designers' needs. To maximise the capability of CV, the selection of criteria for clustering that are appropriate to the data being investigated is crucial [20].

Due to the characteristics of Shape Grammar systems, which potentially produce large numbers of outcomes [7], categorising design outcomes could facilitate more widespread use of this design paradigm. As the main aim of CV is to classify designs via different viewpoints, adapting the concept of CV could provide a way of categorising and refining outcomes by individual viewpoints and preferences.

Preference values and classification of shape rules

Understanding designers' preferences when interacting with shapes is needed to utilise CV with shape grammars. As a part of the DSSG project, a sketch observation experiment [8] to identify shape rules in shape trans-

formation was undertaken. Six architects and eight product designers with various ranges of professional experience were involved in the experiment. They responded to a series of conceptual design tasks and produced an output of nearly 300 sketches. Entire sketching activities and sketch strokes were recorded to analyse shape transformation using three criteria—Decomposition, Reinterpretation and Design family—which were applied to three tasks consisting of short design briefs and initial design stimuli.

Shape rules from the experiment

As a result of our preliminary experiment, 7 general shape rules (Table 1) and 14 detailed shape rules (Table 2) were identified. These can be regarded as the personal rules of the participants. The hierarchical classification was suggested due to the similarities among shape rules. Note that the *outline transformation* rule in Table 1 denotes 'changing outline shape including stretching and contour manipulation' while the *structure transformation* rule indicates 'changing shape position including rotation, translation and symmetry'.

Table 1 General shape rules identified

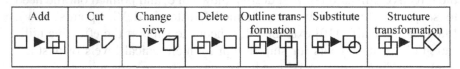

Add	Cut	Change view	Delete	Outline transformation	Substitute	Structure transformation

Table 2 Detail shape rules identified

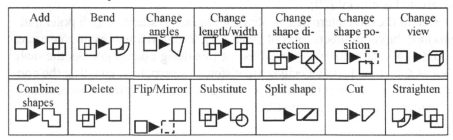

Add	Bend	Change angles	Change length/width	Change shape direction	Change shape position	Change view
Combine shapes	Delete	Flip/Mirror	Substitute	Split shape	Cut	Straighten

Shape rules in a higher (general) level could contain a number of detailed rules in their lower levels (Figure 1). From our experiment, the *outline transformation* rule comprises a number of similar shape rules i.e., *bend*, *straighten*, *change length/width* and *change angles*, while the *structure transformation* rule includes *flip/mirror*, *change shape direction*, *split*

shape, and *change shape position* rules. The *bend* rule in the detailed shape rules denotes 'giving curvature to a shape', while the *straighten* rule indicates the opposite meaning; the *change angles* rule indicates 'changing an interior angle of a shape'; and the *combine shapes* rule means 'adding and merging a new shape to an existing shape', while the *add* rule adds a new shape without merging them. Indeed, classification of these shape rules can be further refined; for example, the *bend* rule can produce different types of curvature to a shape captured in shape rules (e.g. soft radius, sharp radius, a curve with rising curvature and so on).

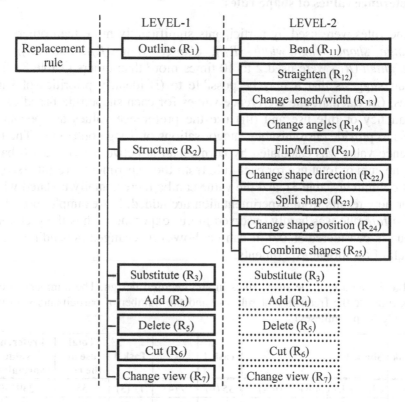

Fig. 1. Hierarchical classification of the identified shape rules

In addition to providing an objective means of analysis, these rules provide a means for formally generating design alternatives. Note that the graphical representations of these rules express shape transformations in an abstract way and are not meant to represent the exact transformation of a shape, meaning that the same rule may be applied to different shapes and transform them in different ways. For example, the first (R_{12}) and third

(R_{12}) rules for the design outcome *S01* in the Appendix are the same abstract rule—straighten—but are applied under different shape transformations. In addition, this list of rules is not by any means complete; they were, however, sufficient to capture participants' shape transformations. The identified shape rules are then hierarchically classified, and the rules R_3 to R_7 are directly applied to level-2 because they do not have child rules (Figure 1).

Preference values of shape rules

Some rules were used by participants significantly more than others, e.g. *change shape length/width* (R_{12}), *change view* (R_7), *add* (R_4), and *straighten* (R_{12}) were used 2 to 10 times more than others (Table 3). This result suggests that it may be possible to (i) identify priorities of shape rules, (ii) calculate the preference values for each shape rule based on the frequency of rule use and (iii) use the preference values as speculative tools to provide customisable categorisations of design outcomes. The preference value was calculated by normalisation between 0.0 and 1.0 based on the sum of total use for each rule from the experiment's results (see the last column in Table 3), and the value can be incrementally updated whenever new results from experimentation are added. For example, use of the *substitute* rule was hardly observed in our experiment; thus the preference value is considered as 0.0. It can be, however, changed depending on the result of additional experiments.

Table 3 The use of the shape rules in architectural design. The numbers in each task indicate the frequency of rule use and the number of participants who used the rule (in parentheses)

Rank	Shape Rules	Task 1	Task 2	Task 3	Total use of the rule	Preference value (normalised)
1	Change length/width (R_{13})	35 (6)	9 (4)	11 (3)	55	0.239130
2	Change view (R_7)	0 (0)	22 (6)	21 (5)	43	0.186957
3	Add (R_4)	18 (4)	8 (3)	7 (3)	33	0.143478
4	Straighten (R_{12})	22 (6)	0 (0)	2 (2)	24	0.104348
5	Change shape position (R_{24})	13 (5)	0 (0)	1 (1)	14	0.060870
6	Bend (R_{11})	9 (2)	0 (0)	2 (2)	11	0.047826
7	Delete (R_5)	10 (2)	1 (1)	0 (0)	11	0.047826
8	Change shape direction (R_{22})	10 (5)	0 (0)	0 (0)	10	0.043478
9	Combine shapes (R_{25})	5 (3)	4 (3)	0 (0)	9	0.039130

10	Split shape (R_{23})	0 (0)	0 (0)	8 (2)	8	0.034783
11	Change angles (R_{14})	5 (2)	1 (1)	0 (0)	6	0.026087
12	Flip/Mirror (R_{21})	3 (2)	2 (1)	0 (0)	5	0.021739
13	Cut (R_6)	0 (0)	0 (0)	1(1)	1	0.004348
14	Substitute (R_3)	0 (0)	0 (0)	0 (0)	0	0.0

Formalisation of customised viewpoints

Design outcomes can be categorised differently depending on customised viewpoints. For example, shapes S_1 and S_2, which are generated by a number of shape rules with a sequential manner, e.g. $\{S_1|R_a,R_b,R_a,R_d\}$ and $\{S_2|R_a,R_c,R_e\}$ (Figure 2), can be in the same cluster if the shape rule R_a is a most important criterion, while they could be classified in a different cluster in other cases.

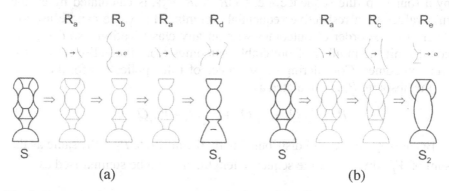

Fig. 2. Example shapes S_1 and S_2 with respective rule sequences

Here an experimental approach to categorising outcomes is presented which calculates and sorts a preference value for each outcome. The preference value P for each outcome is normalised between 0.0 and 1.0, and can be obtained via two customised viewpoints: (i) absolute P by the frequency of shape rule use; (ii) relative P by shape rule classification level. To calculate the above P for each outcome, a number of criteria need to be predefined: (i) a hierarchical (multi-level) classification of shape rules (Figure 1); (ii) a weight value Q_m for each step of a shape rule sequence; (iii) a preference value V_{R_n} for each shape rule R_n (see the last column in Table 3). For now, each Q_m is equally distributed depending on the maxi-

mum number of sequence steps from a design outcome, i.e. $Q_m = \dfrac{1}{L}$ where L is the maximum number of sequence steps. The distribution of Q_m, however, could be adjusted in future research, e.g. the first and last step of a sequence could have more weight if we consider those to be more effective for outcomes than others. The details of the formalisation of P by each viewpoint are described in the following sections.

Customised viewpoints by absolute preference values

According to our experimental data [8], designers respond positively to specific rules which can affect the types of design outcomes. In this paper, design outcomes are categorised based on the preference value of shape rules because a preference value offers one way of representing a personal design intention. An absolute P_1 for the above shape S_1, which is generated by a four step rule sequence, i.e. $\{S_1|R_a,R_b,R_a,R_d\}$, is calculated by all the rule values with respective sequential weights. This value can be used to determine the order of outcomes without any classifications, so designers could limit the number of preferable outcomes from the entire set of possible outcomes. Considering the sequence of rule application for the shape S_1, the absolute P_1 is calculated as

$$P_1 = V_{R_a}Q_1 + V_{R_b}Q_2 + V_{R_a}Q_3 + V_{R_d}Q_4 \qquad (1)$$

Because Q_m is equally distributed here, the absolute P_1 is the same as the sum of V_{R_n} divided by the sequence length, and can be summarised as

$$P_1 = (V_{R_a} + V_{R_b} + V_{R_a} + V_{R_d})Q_m \qquad (2)$$

Thus, a general shape S_1 can be calculated as below when V_i is the sum of the preference values of used shape rules for shape S_1:

$$P_i = V_i Q_m \qquad (3)$$

Customised viewpoints by relative preference values with a rule classification level

Sometimes designers may wish to limit outcomes by the generality of shapes [18, 19]. In this case, setting the outcome criteria by classification levels of shape rules would be useful because a higher classification level

of shape rules allows a broad range of shape types while a lower level allows more specific shape types. When a shape rule classification has a depth of k, there are k different relative P values, based on the depth in the hierarchy. In this viewpoint, a relative P_l for the above shape S_l is calculated by the different levels of shape rule classification rather than V_{R_n}.

Consider $V_{R_n(k)}$ is the P of the kth level of a shape rule classification that contains R_n, and is the sum of V_{R_n} in the $(k+1)$th level (Figure 3). Then the relative P_{l_k} for the above shape S_l by the kth level of shape rule classification is calculated using Equation (2) as

$$P_{1_k} = (V_{R_a(k)} + V_{R_b(k)} + V_{R_a(k)} + V_{R_d(k)})Q_m \tag{4}$$

Note that the preference value of each shape rule is the sum of its child rules, e.g. the preference value of R_{11} in the level-2 in Figure 3 is the sum of the preference values of $\{R_{111}, R_{112}, R_{113}\}$, which are the child rules of R_{11}. If R_n is located in a lowest level, V_{R_n} is applied to $V_{R_n(k)}$; thus the relative preference value by lowest level is equal to the absolute preference value.

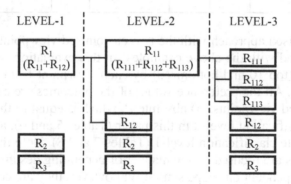

Fig. 3. Example of the hierarchical classification of preference values

Examples with customised viewpoints

The selected design outcomes used in this paper were created as a part of our experiment [8]. From the initial shape (a candle holder) we generated 115 outcomes that have a maximum of 10 rule sequences (Table 4 and Figure 4); 95 of the outcomes are derived from the subsequences of the

final 20 outcomes ($S01$ – $S20$) while omitting duplicated designs. For example, the outcome $S05$ in Figure 4 is generated by four sequential rules (see Appendix) which has four possible designs, i.e. $S05$-1 by $\{R_{11}\}$, $S05$-2 by $\{R_{11},R_{11}\}$, $S05$-3 by $\{R_{11},R_{11},R_{13}\}$, and $S05$-4 by $\{R_{11},R_{11},R_{13},R_5\}$. The rule sequences of $S05$-1 and $S05$-2, however, are already generated by $S03$; thus only two designs $S05$-3 and $S05$-4 are used and a total 115 outcomes are generated.

Table 4 The initial shape and the twenty final outcomes of the rule sequences

Initial shape	Final design outcomes									
	S01	S02	S03	S04	S05	S06	S07	S08	S09	S10
	S11	S12	S13	S14	S15	S16	S17	S18	S19	S20

The formalised approach with the two customised viewpoints is respectively evaluated with the above examples. In this evaluation, we analysed 20 outcomes (top 10 and bottom 10) by each viewpoint from the total of 115 outcomes. All the preference values of the outcomes are calculated by two customised viewpoints: (i) absolute P, which is equal to the relative P with rule classification level-2 in this paper (Tables 5 and 6), and (ii) relative P with rule classification level-1 (Tables 7 and 8). Note that since the categorisations are focused on the manner of generating designs the results may not be dependent on shape similarity; however, they are considered as the designs most likely to be produced by designers with particular preferences.

Outcomes by absolute preference values

Based on the absolute P for each rule, the outcomes were sorted as shown in Tables 5 and 6. Because the preference values are likely the design intentions of the experiment's participants, they cannot reflect general deisgn preferences. This, however, can be an alternative way to support personal preferences, as previously described.

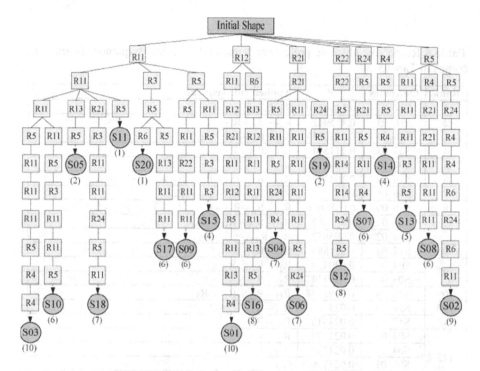

Fig. 4. Rule sequences of the design outcomes in Table 4. The numbers in parentheses indicate how many outcomes were selected from the subsequences of each final outcome (*S01 – S20*). See the Appendix for all the design outcomes.

Table 5 Top 10 and bottom 10 outcomes based on absolute preference values

Top 10 outcomes									
S14_01	S16_03	S16_04	S05_03	S01_01	S16_08	S16_05	S16_09	S05_04	S08_02
Bottom 10 outcomes									
S17_03	S04_03	S06_04	S18_04	S20_04	S17_02	S04_01	S04_02	S06_01	S06_02

Table 6 Respective absolute preference values (P) and rule sequences of the outcomes in Table 5

Rank	Outcomes	P	Applied rule sequence
1	S14_01	0.1434779	R_4
2	S16_03	0.115942	$R_{12} - R_6 - R_{13}$
3	S16_04	0.1130435	$R_{12} - R_6 - R_{13} - R_{12}$
4	S05_03	0.111594	$R_{11} - R_{11} - R_{13}$
5	S01_01	0.104348	R_{12}
6	S16_08	0.1043478	$R_{12} - R_6 - R_{13} - R_{12} - R_{11} - R_{11} - R_{11} - R_{13}$
7	S16_05	0.1	$R_{12} - R_6 - R_{13} - R_{12} - R_{11}$
8	S16_09	0.0980676	$R_{12} - R_6 - R_{13} - R_{12} - R_{11} - R_{11} - R_{11} - R_{13} - R_5$
9	S05_04	0.095652	$R_{11} - R_{11} - R_{13} - R_5$
	S08_02	0.095652	$R_5 - R_4$
106	S17_03	0.031884	$R_{11} - R_3 - R_5$
107	S04_03	0.0304347	$R_{21} - R_{21} - R_5$
	S06_04	0.0304347	$R_{21} - R_{21} - R_{11} - R_{11}$
109	S18_04	0.0293478	$R_{11} - R_{11} - R_{21} - R_3$
110	S20_04	0.025	$R_{11} - R_3 - R_5 - R_6$
111	S17_02	0.023913	$R_{11} - R_3$
112	S04_01	0.021739	R_{21}
	S04_02	0.021739	$R_{21} - R_{21}$
	S06_01	0.021739	R_{21}
	S06_02	0.021739	$R_{21} - R_{21}$

Outcomes by relative preference values

Unlike the outcomes by absolute P, the outcomes by relative P with the rule classification level-1 show a visible classification in their rule sequences (Tables 7 and 8).

Table 7 Top 10 and bottom 10 outcomes using relative preference values with rule classification level-1

For the top 10 outcomes, the first eight (where the preference value is 0.417391) are generated using the *outline* rule family R_1 ($R_{11} - R_{14}$) only, while the remaining two are generated using mixed rules, i.e. they have one *structure* rule (R_{21}) from the R_2 family as well. For the bottom 10 outcomes, the most frequently used shape rules are *delete* (R_5), *add* (R_4) and *change shape position* (R_{24}). Although the absolute P for *add* (R_4) is the third biggest value (Table 3), the R_4 rule is considered as the rules that have the lowest P in this viewpoint. This is because (i) some rules that have the lowest P such as *change angles* (R_{14}) and *flip/mirror* (R_{21}) are classified as *outline* (R_1) and *structure* (R_2) rules respectively and they are the two largest P, and (ii) *cut* (R_6) and *substitute* (R_3) rules were rarely used in the 115 outcomes. The result seems well suited to the purpose, i.e. identifying outcomes that share the same rule classifications.

Table 8 Respective relative preference values (P) and rule sequences of the outcomes in Table 7

Rank	Outcomes	P	Applied rule sequence
1	S01_03	0.417391	$R_{12} - R_{11} - R_{12}$
	S03_03	0.417391	$R_{11} - R_{11} - R_{11}$
	S05_03	0.417391	$R_{11} - R_{11} - R_{13}$
4	S01_01	0.4173909	R_{12}
	S01_02	0.4173909	$R_{12} - R_{11}$
	S03_01	0.4173909	R_{11}
	S03_02	0.4173909	$R_{11} - R_{11}$
	S10_04	0.4173909	$R_{11} - R_{11} - R_{11} - R_{11}$
9	S01_06	0.381159	$R_{12} - R_{11} - R_{12} - R_{21}\ \ R_{11} - R_{12}$
10	S01_05	0.373913	$R_{12} - R_{11} - R_{12} - R_{21} - R_{11}$
106	S02_04	0.1097825	$R_5 - R_5 - R_{24} - R_4$
107	S02_08	0.098913	$R_5 - R_5 - R_{24} - R_4 - R_4 - R_6 - R_{24} - R_6$
108	S02_03	0.0985507	$R_5 - R_5 - R_{24}$
109	S02_06	0.097826	$R_5 - R_5 - R_{24} - R_4 - R_4 - R_6$
110	S08_02	0.095652	$R_5 - R_4$
	S14_02	0.095652	$R_4 - R_5$
	S14_04	0.095652	$R_4 - R_5 - R_5 - R_4$
113	S14_03	0.07971	$R_4 - R_5 - R_5$
114	S02_01	0.047826	R_5
	S02_02	0.047826	$R_5 - R_5$

Discussion

The design examples used in this paper attempt to reflect the kind of shapes and shape transformations used in the conceptual stage of design, where designs tend to be vague and ambiguous. For this reason, shape

rules that express transformations of a shape in an abstract way without representing an exact transformation of the shape have been used as previously mentioned. As an extension of the presented approach for categorisation of designs, use in later stages of design would require more detailed shape rules. For example, *change length/width* (R_{13}) could be detailed with definitions of *length* and *width*, and with proportional rate of change. Additionally, a preference value for a single rule could be extended to certain lengths of rule sequences, e.g. a preference value for the rule sequence $\{R_1,R_2,R_3\}$ could support more in-depth personal preferences in a shape generation process.

On the other hand, we also tested another viewpoint regarding the complexity of outcomes based on multiple criteria: (i) the length of a rule sequence; (ii) the number of shape rules used; and (iii) the complexity type of a shape rule. The complexity type was determined by whether it contributes to the complexity of outcomes. For example, the *add* (R_4) rule increases complexity, the *delete* (R_5) rule decreases it, but other rules do not affect complexity. The result of the complexity viewpoint, however, was not very usable. It seems the length of a rule sequence does not affect the complexity of design outcomes. Instead, there might be more crucial criteria to determine the complexity of outcomes such as the combination of used rules, and different weightings for each step of shape rule sequence, etc.

Currently, the suggested approach is designed as a post-categorisation method after generating designs. As it seems that generating sequences of designs that are aligned with design intentions could effectively reduce design spaces [21], we may need to adapt our approach as a pre-categorisation method, which defines personal design intentions before generating designs.

Conclusion

The experimental approach that uses a hierarchical classification of shape rules with preference value of each shape rule offers multiple ways of categorising outcomes depending on designers' needs. A preference value of each design outcome, which is used as a speculative tool to identify personal preference of shape generation, has been defined via two criteria, i.e. (i) an absolute preference value based on the frequency of rule use, and (ii) a relative preference value based on shape rule classification levels. A hierarchical classification of shape rules and a preference value for each shape rule in this paper have been identified from the preliminary experi-

ment, and the examples from our experiment are used to evaluate the proposed approach.

The result of categorised outcomes with the worked examples reveals the possibility of providing more preferable and refined outcomes to designers. Therefore, this work illuminates a phenomenon that might be the subject of future research of the current project, and reveals potential diversity in the exploitation of shape grammar systems. Future work is concerned with detailing abstracted rule transformation using exact shape expression, adding a criterion regarding complexity of outcomes, applying the approach as a pre-categorisation method, and exploring how these results can inform the development of computational tools intended to support conceptual design.

Acknowledgements

This work has been carried out as a part of the project "Design Synthesis and Shape Generation" funded under the AHRC 'Designing for the 21st Century' programme. The authors would like to thank the designers and researchers who participated in the study for their cooperation.

References

1. Bentley PJ (1999) Aspects of evolutionary design by computers. in Advances in Soft Computing – Engineering Design and Manufacturing, Roy R, Furuhashi T (eds). Springer-Verlag, London, UK, pp. 99-118
2. Stiny G (2006) Shape: Talking about seeing and doing. Cambridge, Mass, MIT Press
3. Antonsson EK, Cagan J (2001) Formal engineering design synthesis. Cambridge University Press, Cambridge
4. Stiny G (1980) Introduction to shape and shape grammars. Environment and Planning B, 7: 343-351
5. Chase SC (2002) A model for user interaction in grammar-based design systems. Automation in Construction 11: 161-172
6. Piazzalunga U, Fitzhorn P (1998) Note on a three-dimensional shape grammar interpreter. Environment and Planning B: Planning and Design 25: 11-30
7. Knight TW (1996) Shape grammars: five questions. Environment and Planning B: Planning and Design 26(4): 477-501
8. Lim S, Prats M, Chase S, et al. (2008) Sketching in design: Formalising a transformational process. in Computer Aided Architectural Design and Research in Asia (CAADRIA'08), Chiang Mai, Thailand

9. Mckay A, Jowers I, Chau HH, et al. (2008) Computer aided design: an early shape synthesis system. in International Conference in Advanced Engineering Design And Manufacture (ICADAM), Sanya, China
10. Maher ML, Balachandran B, Zhang DM (1995) Case-based reasoning in design. Lawrence Erlbaum Associates, New Jersey
11. Bailey A, Harris C (1999) Using hierarchical classification to exploit context in pattern classification for information fusion. in Proceedings of the Second International Conference on Information Fusion
12. Michalski RS, Stepp RE (1983) Automated construction of classifications: Conceptual clustering versus numerical taxonomy. in IEEE Transactions on Pattern Analysis and Machine Intelligence, PAMI-5
13. Rammal R, Toulouse G, Virasoro MA (1986) Ultrametricity for physicists. Reviews of Modern Physics 58: 765-788
14. Reich Y, Fenves SJ (1991) The formation and use of abstract concepts in design. in Concept Formation: Knowledge and Experience in Unsupervised Learning, Fisher DH, Pazzani MJ (eds), Morgan Kaufmann, Los Altos, CA, pp. 323-353
15. Fisher D, Xu L, Zard N (1992) Ordering effects in clustering. in Proceedings of the Ninth International Conference on Machine Learning, San Mateo, CA, Morgan Kaufmann
16. Gordon AD (1996) Hierarchical classification, in clustering and classification. Arabie P, Hubert LJ, Soete GD (eds), World Scientific Publishing, pp. 65-121
17. Howard-Jones PA (1998) The variation of ideational productivity over short timescales and the influence of an instructional strategy to defocus attention, in Proceedings of Twentieth Annual Meeting of the Cognitive Science Society, Hillsdale, New Jersey, Lawrence Erlbaum Associates
18. Duffy AHB, Kerr SM (1993) Customised Perspectives of past designs from automated group rationalisations. International Journal of Artificial Intelligence in Engineering, Special Issue on Machine Learning in Design 8(3): 183-200
19. Manfaat D, Duffy AHB, Lee BS, (1998) SPIDA: Abstracting and generalising layout design cases. Artificial Intelligence for Engineering Design, Analysis and Manufacturing 12: 141-159
20. Lim S, Lee BS, Duffy AHB, Incremental modelling of ambiguous geometric ideas (I-MAGI). International Journal of Artificial Intelligence in Engineering, 15(2): 93-108
21. Prats M, Earl C (2006) Exploration through drawings in the conceptual stage of product design. in Design Computing and Cognition DCC'06, Gero JS (ed) Springer, Eindhoven, Netherlands, pp. 83-102

Appendix

The sequential rule processes of the design outcomes selected in the evaluation section are depicted in this appendix to help the reader's understanding.

Design Outcome – S01

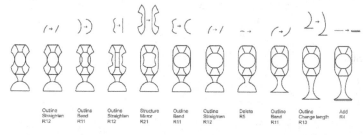

Design Outcome – S02

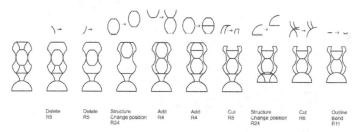

Design Outcome – S03

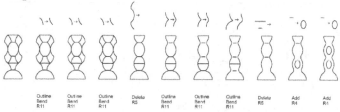

Design Outcome – S04

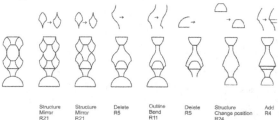

Design Outcome – S05

Design Outcome – S07

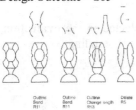

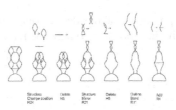

Design Outcome – S06

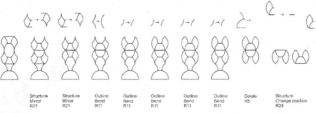

Design Outcome – S08

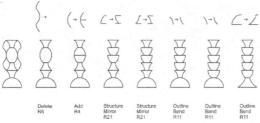

Design Outcome – S09

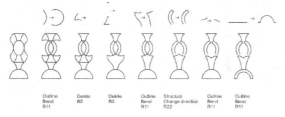

Design Outcome – S10

Design Outcome – S11

Design Outcome – S14

Design Outcome – S12

Design Outcome – S13

Design Outcome – S15

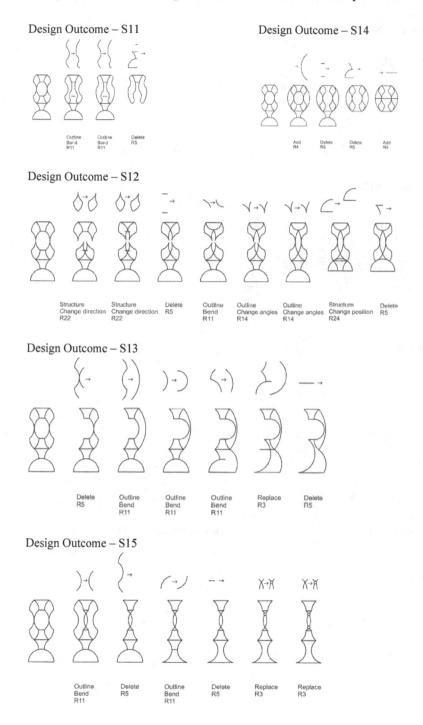

Design Outcome – S16

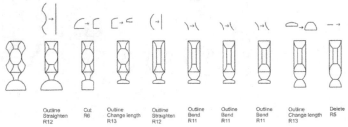

| Outline Straighten R12 | Cut R6 | Outline Change length R13 | Outline Straighten R12 | Outline Bend R11 | Outline Bend R11 | Outline Bend R11 | Outline Change length R13 | Delete R5 |

Design Outcome – S17

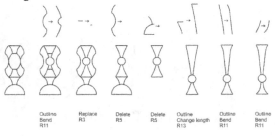

| Outline Bend R11 | Replace R3 | Delete R5 | Delete R5 | Outline Change length R13 | Outline Bend R11 | Outline Bend R11 |

Design Outcome – S18

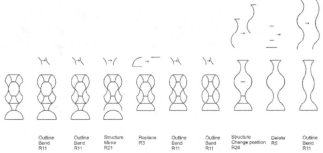

| Outline Bend R11 | Outline Bend R11 | Structure Mirror R21 | Replace R3 | Outline Bend R11 | Outline Bend R11 | Structure Change position R24 | Delete R5 | Outline Bend R11 |

Design Outcome – S19

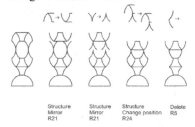

| Structure Mirror R21 | Structure Mirror R21 | Structure Change position R24 | Delete R5 |

Design Outcome – S20

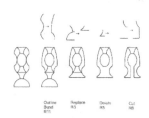

| Outline Bend R11 | Replace R3 | Delete R5 | Cut R6 |

A Technique for Implementing a Computation-Friendly Shape Grammar Interpreter

Kui Yue and Ramesh Krishnamurti
Carnegie Mellon University, USA

We discuss technical issues related to implementing a general interpreter for shape grammars directed at describing building styles, including a graph-like data structure and the concept of computation-friendly grammars.

Introduction

We are investigating how to determine the interior layout of buildings given three pieces of information: its footprint; a reasonably complete set of exterior features; and a shape grammar that describes the building style and hence, the building [1]. We have developed an approach that relies on the fact that, when applied exhaustively, a shape grammar generates, as a tree, the entire layout space of a style. The approach begins with estimating a partial layout, by resolving constraints on the input features. From this estimation, further spatial and topological constraints are extracted. These constraints are then used to prune the layout tree. The layouts that remain correspond to the desired outcomes.

Spaces (rooms) are central to buildings; whence, to shape grammars that describe building styles. Such grammars generally start with a rough layout; details, such as openings and staircases, are added at a subsequent stage. There are two main ways of generating a layout: space subdivision, e.g., as in the rowhouse grammar (see sequel), and space aggregation, e.g., as in the Queen Anne grammar [2]. Combination of the two ways is possible. Consequently, here, shape rules tend to add a room, partition a room, additionally to refine a partial layout by inserting features such as doors, staircases, etc.

Thus, pruning a layout tree, effectively, is to find a tree node with layout equal to the partial layout estimation, and continue to apply the subsequent shape rules. Such a node is typically internal, although it could be, luckily, the root node. In each case, the approach essentially requires a parametric shape grammar interpreter that caters to a variety of building types; for layout determination, it would be impractical to implement individual interpreters for each grammar.

A general parametric shape grammar interpreter is an unresolved topic of research [3]. However, shape grammars that capture corpora of conventional building types – that is, composed of rectangular spaces bounded within a rectangular form – belong to a special subset. Informally, here, shape rules are parametrically specified in such a way as to make implementation tractable. Such parametric grammars do not rely on emergent or ambiguous shapes. Markers tend to drive shape rule application. Moreover, parameterization is limited to just a few kinds of variables, for example, the height or width of a space, or the ratio of partitioning a space.

The implementation of an interpreter is non-trivial. In this paper, we describe a graph-like data structure to support a general interpreter for a particular class of shape grammars. We consider counter-computational hindrances that commonly occur in shape grammars designed in the traditional manner, leading to the concept of computation-friendly shape grammars. This is illustrated by two grammars developed for nineteenth-century rowhouses located in the Federal Hill district, Baltimore [4].

Transformations of Shape Rules

Shape rules apply under a transformation [5]. Unless stated otherwise, the allowable transformations are taken to be affine, that is, preserving parallelism. However, the more commonly used transformations are similarities, which preserve angles. These are Euclidean transformations with uniform scale The Euclidean transformations, namely, translation, rotation, reflection, and glide reflection, preserve distance. See Table 1.

For shape rule application under arbitrary non-affine transformations, shapes have to be defined parametrically [5]. For example, in Figure 1, to apply shape rule (a) to shape (b), the rule has to be considered as a parametric schema. Depending on the allowable transformations, the application of shape rule (a) to shape (c) can be considered to be either parametric or non-parametric. If the allowable transformations are similarities, the shape rule has to be parametric; if affine, then the shape rule can be applied under anamorphic (non-uniform) scale, in which case it can be con-

sidered to be non-parametric. Such distinctions are important for computational implementation. As discussed later, a computation-friendly shape grammar must specify the allowable transformations for the shape rules.

Table 1 Types of allowable transformations

	Transla-tion	Rotation	Reflec-tion	Glide re-flection	Uniform scale	Anamor-phic scale	Shear/Strain
Euclidean	Yes	Yes	Yes	Yes	No	No	No
Similarity	Yes	Yes	Yes	Yes	Yes	No	No
Affine	Yes	Yes	Yes	Yes	Yes	Yes	Yes

Fig. 1. A shape rule example

Data Structure for Layouts with Rectangular Spaces

The interpreter needs a data structure to represent layouts with rectangular spaces; that is, a data structure that contains both topological information of the spaces as well as the concrete geometry (for now, 2D) data of the layout including walls, doors, windows, staircases, etc. It needs to support viewing the layout as whole, viewing the layout from a particular room with its neighborhood, or simply focusing on a particular room itself. Moreover, the data structure needs to support Euclidean as well as both uniform and anamorphic scale transformations.

A graph-like data structure

A graph-like data structure has been designed to specify such rectangular spaces. A rectangular space (usually a room) is a space defined by a set of walls in a way that the space is considered to be rectangular by the human vision system. As shown in Figure 2, among other variations, such a space can be defined by four walls jointed to each other, four disjointed walls, three walls, or framed by four corners.

Fig. 2. Examples of rectangular spaces and graph-like data structures

There is a boundary node for each corner of the rectangular space, as well as a node for each endpoint of a wall. These nodes are connected by either a wall edge (solid line) or an empty edge (dotted line). A central node represents the room corresponding to the space, and connects to the four corners by diagonal edges (dashed lines). It is needed for manipulating boundary nodes of room units, such as dividing a wall through node insertions, creating an opening in a wall by changing the opening's edge type to *empty*, and so on. More information about a room is recorded in the room node, e.g., a staircase within the space. Windows and doors are assigned as attributes of wall edges. Further, unlike traditional graph data structures, the angle at each corner is set to be a right angle. A node has at most eight neighbors. A set of such graph units can be combined to represent complex layouts comprising rectangular spaces.

Transformations with the graph-like structure

Under the assumption that the target layout comprises only rectangular spaces, the allowable transformations are Euclidean with uniform and anamorphic scaling. As shape rule application is marker-driven, translation is automatically handled. The graph-like data structure is capable of easily handling uniform and anamorphic scaling, by firstly matching room names, then markers on corner nodes, and lastly, by comparing possible room ratio requirements.

As a result, only rotations and reflections remain to be considered. As the spaces are rectangular, rotations are limited to multiples of 90° and reflections are about either the horizontal or vertical. Moreover, a vertical reflection can be viewed as a combination of a horizontal reflection and a

rotation. Hence, any combination of reflections and rotations is equivalent to a combination of horizontal reflections and rotations. Consequently, the following transformations are all we actually need to consider:

- *R0*: default; no rotation, with possible translation and/or scale.
- *R90, R180, R270*: a rotation through 90°, 180°, and 270°, respectively, with possible translation and/or scale.
- *RR0, RR90, RR180, RR270*: (first a rotation of 0°, 90°, 180°, or 270°, followed by a horizontal reflection) horizontal reflection, vertical reflection, and their combinations.

Fig. 3. Transformation of the graph-like data structure

As shown in Figure 3, transformations can be implemented on the data structure by index manipulation. Each of the eight possible neighbors of a node is assigned an index from 0 to 7; indices are then transformed simply by modulo arithmetic. For example, index+2 (modulo 8), rotates counter-clockwise neighbor vertices through 90°. Other rotations and reflections are likewise achieved. By viewing the original neighbor relationship for each node with the transformed indices, we obtain the same transformation of the whole graph. Moreover, we need manipulate only the interior layout instead of the left side of the shape rule. This gives the same result, and is much simpler to achieve. Thus, we only need to consider how to apply shape rules with the default transformation, which is automatically applicable to the configuration under different possible transformations.

Common Functions for the Graph-like Data Structure

With the graph-like data structure, a layout is represented by an eight-way doubly linked list formed by nodes and edges. Shape rule application manipulates this structure, and a set of common functions shared by the shape rules can be identified. The functions are implemented in an object-oriented fashion.

Design of classes

LNodeCorner and *LNodeRoom* classes represent a corner node and a room node, respectively. Other nodes are represented by *LNode* class. All edges are represented by *Edge* class with an attribute representing different edge types. Theoretically, knowing the handle to a node or edge is sufficient in order to traverse the entire layout. For easy manipulation, an *InteriorLayout* class is defined to represent an interior layout configuration. There are several different ways to view an *InteriorLayout* object: i) as a layout with certain status marker, ii) as a list of rooms (room nodes), and iii) as a list of nodes and edges. Different views are useful under different contexts. For example, it is convenient to use view iii) to display the underlying layout: drawing all edges as well as the associated components first, and then drawing all nodes as well as associate components. To accommodate these different views, the *InteriorLayout* maintains the following fields:
- A status marker
- Name: for display and debugging purpose
- A hashmap of a room name to a list of room nodes: for fast retrieval of one or more room nodes with a given name
- A list of room nodes for the entire layout
- A list of all nodes for the entire layout
- A list of all edges for the entire layout
- A hashmap of attributes to values for other status values particular for a special shape grammar

Examples of common functions

Examples of common manipulations include finding a room with a given name, finding the north neighbor(s) of a given room, finding the shared wall of two given rooms, etc. The sequel describes the algorithm and pseudo code for these examples.

Finding room(s) with a given name

In the data structure, a room node represents a room. An *InteriorLayout* object maintains a hashmap of room names to lists of room nodes. Thus, finding room(s) with a given name is simply to query the hashmap with the room name as input.

findRoomNodes(*Name*)
 Query the name-to-rooms hashmap with parameter *Name*.

Finding the north neighbor(s) of a given room

Finding the north neighbor(s) of a given room is a special case of finding neighbor(s) of a given room. It turns out all that finding neighbor functions in the other three directions can be implemented as finding the north neighbor(s) under a certain transformation. For example, the east neighbor(s) of a given room is the same as the north neighbor(s) of the given room under a *R90* transformation.

a) 0 north neighbor b) 1 north neighbor c) >1 north neighbor d) missing rightmost neighbor

Fig. 4. Different cases of north neighbor(s) of a room

A room may have zero, one, or more north neighbors (Figure 4), which can be represented by a list of room nodes. Intuitively, to find the north neighbor(s) of *A*, we could start by finding *A*'s north-east corner node, *nodeNE*, and north-west corner node, *nodeNW*. Then, we traverse through each corner node from *nodeNE* (inclusive) to *nodeNW* (exclusive) along the westerly direction to find its north-west neighbors. All north-west neighbors found are the desired room nodes. For example, in Figure 4c, the north neighbors found are *B*, and *C*. However, as shown in Figure 4d, this intuitive algorithm will miss the rightmost neighbor room when the *nodeNE* is on the south edge of that neighbor room, and is not the end node. Therefore, we need to modify the intuitive algorithm to have the correct start node and end node to loop through.

It can be proven that the *nodeNW* is always the correct end node as a north neighbor *B* has to overlap with room *A*, which means room *B* must has a south-east corner node, *nodeSE*, at the right side of *nodeNW* (Figure 5a), or is *nodeNW* (Figure 4c). Otherwise, *B* is not a north neighbor of *A*.

The starting node can be either *nodeNE*, or a node to the right of *nodeNE* (Figure 5b). If *nodeNE* is not the start node, then it has neither north-west nor south-west neighbors, since having either neighbor means that *nodeNE* is the correct start point (Figure 5c), which is a contradiction. However, the reverse is not true; as shown in Figure 5d, *nodeNE* has neither a north-west nor south-west neighbor, but *nodeNE* is still the correct start node. That is, the only condition for a node, *nodeSE*, to the right of *nodeNE*, to be the correct start node, it must have a north-west neighbor.

Therefore, under the condition that *nodeNE* has no north-west and south-west neighbor, the algorithm searches for the first node, which is to the right of the *nodeNE* with a north-west neighbor. If such a node is found, it is the real start node. If a *null* neighbor is found, *nodeNE* is still the correct start node. The pseudo code is given below.

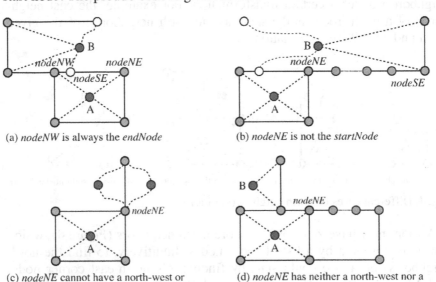

(a) *nodeNW* is always the *endNode* (b) *nodeNE* is not the *startNode*

(c) *nodeNE* cannot have a north-west or (d) *nodeNE* has neither a north-west nor a
north-east neighbor if it is not the *startNode* north-east neighbor, but it is still the *startNode*

Fig. 5. The start and end node for finding neighbor room(s)

findNorthNeighbors(*A, T*)
 (all operations related to directions are under transformation *T*)
 endNode ← north-west neighbor of *A*
 nodeNE ← north-east neighbor of *A*
 startNode ← *nodeNE*
 if *nodeNE* has neither north-west nor north-east neighbor
 search for a right neighbor, *node*, of *nodeNE*, with a north-west neighbor
 if found, *startNode* ← *node*
 go through each node in between *startNode* (inclusive) and *endNode* (exclusive), and get all north-west neighbors, *neighbors*
 return neighbors

findEastNeighbors(*A*) // Other neighbors are likewise defined
 return findNorthNeighbors(*A, R90*)

A traditional rowhouse grammar

The Baltimore rowhouse grammar, developed by Casey Hickerson, consists of 52 shape rules that generate first floor configurations with features of stairs, fireplaces, windows, exterior doors and interior doors. Rules are organized into phases, progressing from the major configurations that constrain the design process to minor configurations that follow logically from other configurations, namely: I) Block generation: rules 1~4; II) Space generation: rules 5~7; III) Stair generation: rules 8~17; IV) Fireplace generation: rules 18~22; V) Space modification: rules 23~24; VI) Front door and window generation: rules 25~29; VII) Middle and back door and window generation: rules 30~39; and VIII) Interior door generation: rules 40~52.

Rules are marked as required (*req*) or optional (*opt*). Required rules must be applied if applicable while optional rules may be applied at the interpreter's discretion. The decision whether to apply an optional rule directly impacts the overall design. In effect, the final design is determined by the set of optional rules that were applied. Whenever a rule is applied, it must be applied exhaustively; that is, the rule must be applied to every subshape that matches the rule's left-hand-shape. Finally, rules must be applied in sequence: after Rule *x* has been applied exhaustively, only Rules *x+1* and greater may be applied.

Like other shape grammars, labels are used in two ways: to control where shape rules may apply, and to ensure that mutually exclusive rules cannot be applied to the same design. Spaces and stairs are labeled with two or three characters that indicate the general location of the space or stair within the house. For instance, *Rfb* indicates a Room in the front block of the house that is oriented toward the back, a dining room. Wall labels are always of the form *x(y)* where *x* is a label for a space that the wall bounds (or *P* in the case of certain perimeter walls) and *y* is a one letter code indicating the side of the space the wall defines. For example, the front wall of the room labeled *Rfb* is labeled *Rfb(f)*. Within some rules, variables are used to match more than one label: the character * matches any string of characters while the string {*x/y*} matches the strings *x* or *y*. *Boolean* global labels are used to ensure that mutually exclusive rules are not applied with default value *false*. Due to space limitation, only the rules from phases I, II, III (all but the last) and V are shown here (Figure 7). A sample derivation is given in Figure 8.

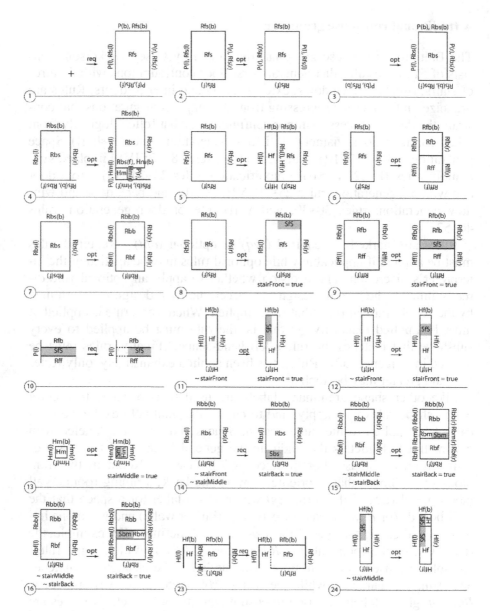

Fig. 7. Rules from four phases of the traditionally defined rowhouse grammar

Phase I: Block Generation

The four rules (1~4): i) generate the front block; ii) mirror the front block; iii) generate the back block; and iv) generate the middle block.

Phase II: Space Generation

The four rules (5~7) generate: i) a hallway in the front block; ii) two spaces within the front block; and iii) two spaces within the back block.

Phase III: Stair Generation

There are 10 rules (8~17): i) generate stair at the back wall of a single-space front block; ii) generate stair between the two spaces of a double-space front block; iii) modify the stair generated by Rule 9 if it runs the entire house width; iv) generate partial width stair in the front hallway; v) generate full-width stair in the front hallway; vi) generate stair in the middle block; vii) generate stair at the front of a single-space back block; viii) generate partial-width stair between the two spaces of a double-space back block; ix) generate full-width stair between the two spaces of a double-space back block; and x) generate accessory stair on the back wall of the back room of a back block.

Phase V: Space Modification

There are two rules, 23 and 24: i) modify the back room of a front block if the front hallway does not adjoin the middle or back block; and ii) generate a service stair behind a partial-width stair in the front hallway.

Fig. 8. Derivation of 236 East Montgomery Street

A new version of the rowhouse grammar

In many aspects, the above grammar is not computation-friendly. In particular, the conditions that apply to shape rules are not specified. In order to implement the rowhouse grammar, a new computation-friendly version of the grammar has to be developed. To focus on how to make a traditionally designed shape grammar computation-friendly, we consider only a subset of the corpus, namely, working-class rowhouses, excluding large, luxurious rowhouses, which are considered in the original grammar. Unlike their luxurious counterparts, working-class rowhouses usually have a unique set of staircases on the first floor. Table 2 is a summary of all of the cases under consideration, with the corresponding desired generated layouts obtained by the new version of the grammar. Note that the mechanism of generating fireplace is essentially identical to generating interior doors or staircases. Therefore, we omit the shape rules for generating fireplaces. Moreover, for layout determination, as the feature inputs include windows and exterior doors, rules relating to generating windows and exterior doors are not considered here. Table 3 shows the new shape rules; again, for reasons of space limitation, rules relating to interior doors have been omitted.

Table 2 Baltimore rowhouses under consideration and desired generated layouts

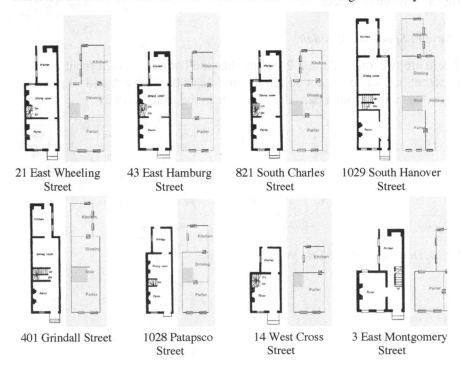

| 21 East Wheeling Street | 43 East Hamburg Street | 821 South Charles Street | 1029 South Hanover Street |

| 401 Grindall Street | 1028 Patapsco Street | 14 West Cross Street | 3 East Montgomery Street |

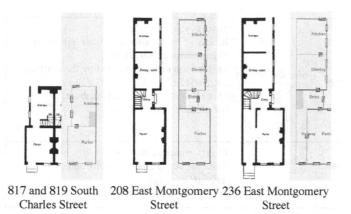

817 and 819 South Charles Street 208 East Montgomery Street 236 East Montgomery Street

Table 3 New computation-friendly rowhouse shape rules

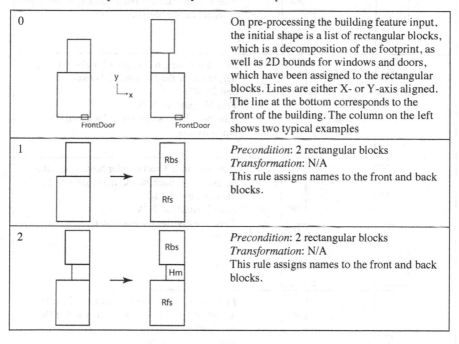

0		On pre-processing the building feature input, the initial shape is a list of rectangular blocks, which is a decomposition of the footprint, as well as 2D bounds for windows and doors, which have been assigned to the rectangular blocks. Lines are either X- or Y-axis aligned. The line at the bottom corresponds to the front of the building. The column on the left shows two typical examples
1		*Precondition*: 2 rectangular blocks *Transformation*: N/A This rule assigns names to the front and back blocks.
2		*Precondition*: 2 rectangular blocks *Transformation*: N/A This rule assigns names to the front and back blocks.

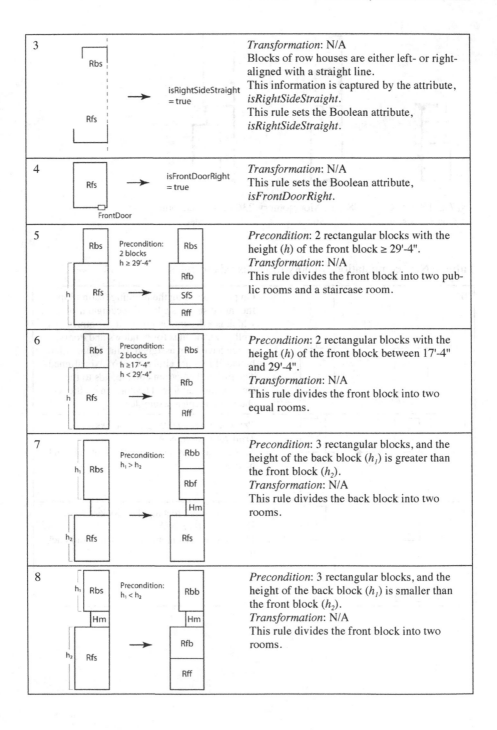

3		*Transformation*: N/A Blocks of row houses are either left- or right-aligned with a straight line. This information is captured by the attribute, *isRightSideStraight*. This rule sets the Boolean attribute, *isRightSideStraight*.
4		*Transformation*: N/A This rule sets the Boolean attribute, *isFrontDoorRight*.
5		*Precondition*: 2 rectangular blocks with the height (h) of the front block \geq 29'-4". *Transformation*: N/A This rule divides the front block into two public rooms and a staircase room.
6		*Precondition*: 2 rectangular blocks with the height (h) of the front block between 17'-4" and 29'-4". *Transformation*: N/A This rule divides the front block into two equal rooms.
7		*Precondition*: 3 rectangular blocks, and the height of the back block (h_1) is greater than the front block (h_2). *Transformation*: N/A This rule divides the back block into two rooms.
8		*Precondition*: 3 rectangular blocks, and the height of the back block (h_1) is smaller than the front block (h_2). *Transformation*: N/A This rule divides the front block into two rooms.

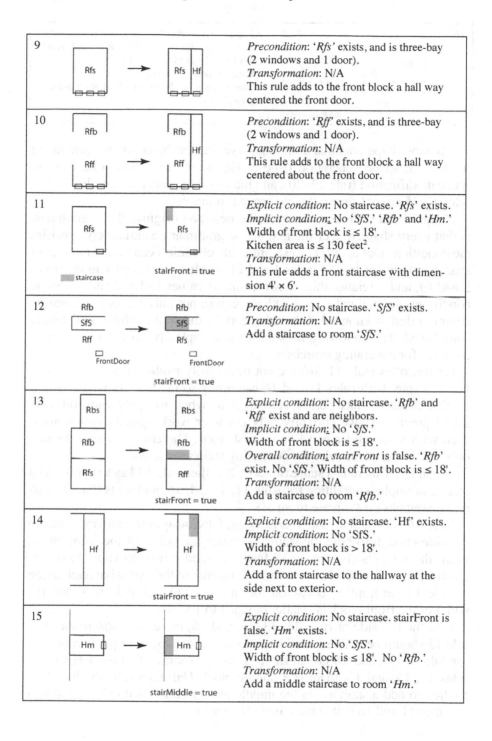

9	*Precondition*: '*Rfs*' exists, and is three-bay (2 windows and 1 door). *Transformation*: N/A This rule adds to the front block a hall way centered the front door.
10	*Precondition*: '*Rff*' exists, and is three-bay (2 windows and 1 door). *Transformation*: N/A This rule adds to the front block a hall way centered about the front door.
11	*Explicit condition*: No staircase. '*Rfs*' exists. *Implicit condition*: No '*SfS*,' '*Rfb*' and '*Hm*.' Width of front block is ≤ 18'. Kitchen area is ≤ 130 feet². *Transformation*: N/A This rule adds a front staircase with dimension 4' × 6'.
12	*Precondition*: No staircase. '*SfS*' exists. *Transformation*: N/A Add a staircase to room '*SfS*.'
13	*Explicit condition*: No staircase. '*Rfb*' and '*Rff*' exist and are neighbors. *Implicit condition*: No '*SfS*.' Width of front block is ≤ 18'. *Overall condition*: stairFront is false. '*Rfb*' exist. No '*SfS*.' Width of front block is ≤ 18'. *Transformation*: N/A Add a staircase to room '*Rfb*.'
14	*Explicit condition*: No staircase. '*Hf*' exists. *Implicit condition*: No '*SfS*.' Width of front block is > 18'. *Transformation*: N/A Add a front staircase to the hallway at the side next to exterior.
15	*Explicit condition*: No staircase. stairFront is false. '*Hm*' exists. *Implicit condition*: No '*SfS*.' Width of front block is ≤ 18'. No '*Rfb*.' *Transformation*: N/A Add a middle staircase to room '*Hm*.'

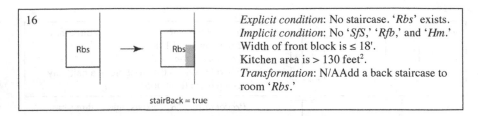

16	Explicit condition: No staircase. 'Rbs' exists.
	Implicit condition: No 'SfS,' 'Rfb,' and 'Hm.'
	Width of front block is ≤ 18'.
	Kitchen area is > 130 feet².
	Transformation: N/AAdd a back staircase to
	room 'Rbs.'

The new shape grammar comprises five phases: block (mass) generation (rule 1~4), space generation (rule 5~10), stair generation (rule 11~16), space modification (rule 17~20), and interior door generation (rule 21~25); rules 17-25 are not shown due rto space limitations.

A significant difference between the new and original shape grammars is that every shape rule of the new shape grammar quantitatively specifies the conditions that apply. For example, this condition can be the number of spaces in terms of blocks (rules 1 and 2), a value in a specific range (rules 5 and 6), and a relationship of two or more values (rules 7 and 8). Some conditions are straightforward. Others require not only reasoning based on common design knowledge, but also certain threshold values, statistically determined. The following illustrates the complexity, using as exemplar, the rules for generating staircases.

Firstly, rules (rule 11~16) are not necessarily exclusive to one another. For example, both rules 11 and 16 can apply to the layouts where no exclusive condition has been specified as to when to apply each rule. As stated previously, we currently only consider working-class row houses, each with a unique staircase on its first floor. Therefore, for each layout, only one of the shape rules for generating staircases applies.

Secondly, if there is a staircase room SfS, then rule 12 has to apply. As a result, an implicit condition for Rule 11, 13, 14, 15, and 16 is that the current layout has no staircase room SfS.

Rule 14 adds a staircase to a hallway. Obviously, the hallway needs to be wide enough to hold the staircase, hence the width of the front block. From the samples (Figure 9), 18 feet is a good threshold value to distinguish whether or not rule 14 can apply. To ensure the exclusive application of rule 14, an implicit condition for rules 11, 13, 15 and 16 is that the width of the front block is smaller or equal to 18 feet.

If in the left side of rules 11, 13, 15, and 16, there is an Rfb room, then rule 13 should be applied to add a staircase there. So, an implicit condition for rule 11, 15 and 16 is that there is no Rfb room. If in the left side of rules 11, 15, and 16, there is a middle block Hm, then rule 15 should be applied to add a staircase in the middle block. Thus, an implicit condition for rules 11 and 16 is that there is no Hm room.

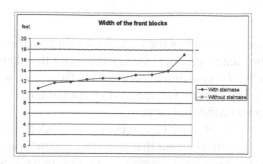

Fig. 9. Quantifying the shape rules generating staircases

It remains to distinguish between rules 11 and 16. The implicit conditions added by rules 12, 13, 14, and 15 can be summarized as: if there are only a *Rfs* room (the front block) and a *Rbs* room (the back block) in the current layout, then rules 11 and 16 can be applied. Rule 16 adds a staircase to an *Rbs* room, which is actually a kitchen. Therefore, the kitchen space has to be large enough to hold a staircase as well as function as a kitchen. From the samples, the average area of kitchens without a staircase is 127.7 feet2, and the minimum is 92.8 feet2. The area of a staircase is about 26~30 feet2. The kitchen area of the case (by using rule 11) is 94.4 feet2, and the kitchen area of the case (by using rule 16) is 165.5 feet2. The average of these two cases is about 130 feet2, which is close to the average of kitchens without staircases. So, 130 feet2 is used as the threshold value. As a result, an added condition for rule 16 is that the area of kitchen is greater than 130 feet2. An additional condition for rule 11 is that the area of the kitchen is smaller or equal to 130 feet2. Table 4 gives a summary of implicit conditions to make rules for generating staircases exclusive.

Table 4 Implicit conditions to make staircase rules exclusive

	Rule 12	Rule 14	Rule 13	Rule 15	Rule 11	Rule 16
Rule 12	With 'SfS'	No 'SfS'	No 'SfS'	No 'SfS'	No 'SfS'	No 'SfS'
Rule 14		Front block width > 18'	Front block width ≤ 18'	Front block width ≤ 18'	Front block width ≤ 18'	Front block width ≤ 18'
Rule 13			With 'Rfb'	No 'Rfb'	No 'Rfb'	No 'Rfb'
Rule 15				With 'Hm'	No 'Hm'	No 'Hm'
Rule 16					Kitchen ≤ 130 ft^2	Kitchen > 130 ft^2

Discussion

The graph-like data structure has the capacity to support the desired inter-
preter, while, at the same time, necessarily requiring the shape rules to be
computation-friendly. To ensure that shape rules from a variety of sources
are interpretable, a framework for specifying computation-friendly shape
grammars needs to be further developed.

Rule application is a process of traversing an underlying layout tree.
This requires an 'undo' mechanism that enables backtracking to a previous
partial configuration. Brute force cloning of configurations prior to apply-
ing a rule is both computationally expensive and complex, particularly as
elements of a layout may need to reference one another. One possibility is
to use dancing links [7] to realize this undo functionality; by incorporating
features such as windows, doors, and even staircases as nodes linked to the
graph units, the entire graph structure can be represented using an eight-
way doubly linked list. Another possibility is to design an 'undo' counter-
part for each shape rule, which gets applied during backtracking.

The research reported in this paper was funded in part by the US Army
Corps of Engineers/CERL, whose support is gratefully acknowledged.
The work of Casey Hickerson in developing the first Baltimore rowhouse
grammar is also acknowledged.

References

1. Yue K, Hickerson C, Krishnamurti R (2008) Determining the interior layout
 of buildings describable by shape grammars. *CAADRIA'08*, Chiang Mai,
 Thailand
2. Flemming U (1987) More than the sum of parts: the grammar of Queen Anne
 houses. Environment and Planning B 14: 323-350
3. Chau HH, Chen X, McKay A, Pennington A (2004) Evaluation of a 3D shape
 grammar implementation. in JS Gero (ed), Design Computing and Cogni-
 tion'04. Kluwer Academic Publishers, Dordrecht, pp. 357-37
4. Hayward ME (1981) Urban vernacular architecture in nineteenth-century Bal-
 timore. Winterthur Porfolio 16(1): 33-63
5. Stiny G (2006) Shape: Talking about seeing and doing. MIT Press, Cam-
 bridge
6. Fish J (1996) How sketches work: A cognitive theory for improved system
 design. PhD Thesis, Loughborough University
7. Knuth DE (2000) Dancing links. in J Davies, B Roscoe and J Woodcock
 (eds), Millennial Perspectives in Computer Science, Palgrave Macmillan,
 Basingstoke, pp. 187-214

Approximating Shapes with Topologies

Djordje Krstic
Signalife, USA

This is the second paper in the series on shape decompositions and their use as shape approximations. This time we investigate topological shape decompositions or topologies. We showed earlier that bounded decompositions behave the same way as shapes do. The same holds for topologies, which are special kinds of bounded decompositions. They are distinguished by their algebraic structure, which has many important properties to facilitate their application as shape approximations. We provide an account of their properties with an emphasis on their application.

Introduction

This is the second paper in the series on shape decompositions and their use as shape approximations. Some notions from the first paper [1] and its extended version [2] will be reiterated here for a good start.

Although shapes come unanalyzed rendering any division into parts possible this is not how we usually perceive them. An attempt to understand or explain a shape leads inevitably to its decomposition into certain parts. Only the parts that are consistent with our understanding of the shape are recognized while all the other parts are neglected. Nevertheless, the recognized parts do account for the whole shape, which is their sum. Shape decompositions are therefore sets of shapes that emphasize certain properties of their sums. Decompositions are often used in place of the shapes serving as their approximations. How good are such approximations? This is an important question given the role shapes play not only in art and design, but also in our everyday lives. We have addressed the question in [1] and [2] from the point of view of formal design theory featuring shape grammars and related shape algebras ([3] is the latest monograph on the subject).

This is an advantageous approach because shape grammars and shape algebras are both intuitive and rigorous tools. The grammars mimic the creative process of design where designers adopt and follow rules to create designs or break the rules only to create and follow new ones. The algebras support the rules by providing operations that formalize the designer's actions. The operations model what designers traditionally do when they draw or erase shapes, build or modify models or move shapes around producing different spatial relations. In contrast to their intuitive side, shape grammars and algebras are rigorous tools grounded in mathematics. The latter informs both practical computations with shapes as well as the theoretical inquiry into their nature.

We rely on the mathematics of shapes to address the problem of shapes being represented by their decompositions. The problem stems from the fact that sets of entities and entities themselves are different in nature, which becomes even more evident in computations. Shapes and related shape algebras behave (in general) differently than shape decompositions and their algebras. This renders decompositions poor substitutes for shapes. In contrast, shape decompositions of certain structure do behave like shapes. In particular, bounded decompositions behave in computations the same way shapes do. Their algebras and shape algebras are isomorphic.

Bounded decompositions recognize the shape they analyze and the empty shape and may contain other shape parts besides the two. At minimum no other parts are included. The structure of a bounded decomposition puts its elements into certain contexts.

A local context, which assures that the shape parts are always seen in relation to the whole, is established by the fact that a bounded decomposition always includes the shape it analyzes.

A global context, in which the attention is shifted from shape parts to shape surroundings, is given by the presence of the empty shape. The absence of shape parts signified by the empty shape implies the shape surroundings.

Local and global contexts are both necessary and sufficient for decompositions to be successful shape approximations. As there are no additional requirements any shape part can easily be included into a bounded decomposition if needed. Consequently, bounded decompositions may serve as the basis for other structured decompositions. They may satisfy additional conditions to become lattices, topologies and Boolean algebras. All of these structures may be used as shape approximations for different purposes.

We will explore topological decompositions and their use in design.

Background

This Symbols \varnothing, \cup, \in, and \wp will be used in their standard set-theoretic meaning, that is, as the empty set, union, an element of, and power-set, respectively. Some standard set-theoretic notions will be assumed, such as the ordered set with related maximal and minimal elements, bounds and order-preserving mappings as well as the direct product and related functions and relations.

Topologies for shapes are *lattices*. These are partially ordered sets turned algebras with two binary operations: *meet* and *join*. The operations are denoted by $+$ and \cdot and defined as the greatest lower bound and the least upper bound of the arguments. Both bounds have to be defined for every pair of elements of a set in order for it to be a lattice.

By the *duality* principle any expression valid for a lattice is also valid if $+$ and \cdot exchange places. A lattice may have two distinguished elements 0 and its dual 1. If a lattice has 0 then the meet of any of its elements with 0 is 0. Dually in lattices with 1 the join of any element with 1 is 1.

Special kinds of order preserving mappings play an important role in topologies for shapes. These are *closures* and *interiors*, which are *operators* or mappings of a set to itself. Closure $\Gamma\colon A \to A$ defined on a partially ordered set A, with x as an element, is *idempotent* and *extensive* or $\Gamma(\Gamma(x)) = \Gamma(x)$ and $x \le \Gamma(x)$, respectively. In contrast, interior $\Omega\colon A \to A$ is idempotent and *intensive* or $\Omega(x) \le x$.

If A is a lattice with 0, Γ may satisfy additional conditions to become a *topological* closure. That is, $\Gamma(x) + \Gamma(y) = \Gamma(x + y)$ and $\Gamma(0) = 0$, where x, $y \in A$. Dually, if A has 1, Ω is a topological interior if $\Omega(x) \cdot \Omega(y) = \Omega(x \cdot y)$ and $\Omega(1) = 1$.

The image of Γ is a set of closed elements of A while the image of Ω is the set of open elements of A.

We will also make use of *shape algebras* [3], [4], [5], [6], and [7]. These feature Boolean operations for shapes and are also closed under geometric transformations. Shape algebra U_{ij} computes with i-dimensional shapes occupying j-dimensional space, where $i, j = 0, 1, 2, 3$ and $i \le j$. It has a lower bound, which is the empty shape denoted by 0, but has no upper bound. Shapes from U_{ij}, together with Boolean operations of sum $+$, product \cdot, and difference $-$, form a *generalized Boolean algebra*--a relatively complemented distributive lattice with a smallest element [8].

The set of all parts of a shape \boldsymbol{a} or its *maximal structure* denoted by $\mathbf{B}(\boldsymbol{a})$ is a proper subalgebra of U_{ij} closed under the symmetry group of \boldsymbol{a}.

Finally, *shape decomposition algebras* provide the frame work for topologies for shapes. There are different families of such algebras [1], [2], but

we will use only complex algebras of decompositions $\wp(U_{ij})$. These are extensions of shape algebras U_{ij} to finite sets of shapes. Their operations are extensions of shape operations to direct products of decompositions and are defined as $A + B = +(A \times B)$, $A \cdot B = \cdot(A \times B)$, and $A - B = -(A \times B)$, where A and B are decompositions.

Structured decompositions

The structure of a decomposition may be seen on two levels: local and global. On the local level the decomposition is a set of shapes which puts emphasis on the relations among its elements. In contrast, on the global level the decomposition is seen as analyzing a shape—the sum of its elements—so that the relations between parts of the shape and elements of the decomposition are exposed. If a decomposition is to be an approximation of a shape, then its structure on a global level is of the most importance.

We should at minimum require for such a decomposition to have a representation for each part of the shape it analyzes. There are infinitely many parts, but only finitely many elements of the decomposition so that the relation between the two is many to one.

For shape a, its part x, and its decomposition A this relation is as follows. If there are elements u and v in A such that $u \le x \le v$, then A approximates x so that x is *bottomed* by u, *topped* by v, and *bounded* by both u and v. Part x has at least properties of u and at most properties of v. If neither u nor v exists, then x is not recognized by A. Elements of A are bounded by themselves, or if $x \in A$ then $u = x = v$. If x is bounded by more than one pair of elements of A and it is impossible to pick one of the pairs as the representative of x, then its representation is ambiguous.

For example, bounded decompositions satisfy the minimum requirement above because each element of a is represented (trivially) in A by the pair of shapes 0 and a. However, if A has more than two elements then representation of some parts of a may be ambiguous.

There is no ambiguity in the relation of a shape to its parts and there should be no ambiguity in how the parts are represented by a decomposition that approximates the shape. This calls for sharpening of the requirement above by making it the *unique representation requirement*--a decomposition that serves as a shape approximation should have the unique representation for each part of the shape it analyzes.

Decompositions of certain structures satisfy the unique representation requirement above chief among which are the decompositions that have structures of hierarchies and topologies.

Hierarchies

Well-known structured decompositions are hierarchies. These are widely used in arts and sciences for categorizing and organizing of large numbers of objects. Taxonomies such as biological taxonomies are hierarchies and so are many databases and file systems. Hierarchies are easy to use, but they may not be the best solution for every application.

Hierarchies are partially ordered sets with unique paths between their elements. In design, hierarchies distinguish parts and show how they are put together to assemble shapes. A shape may be decomposed in a hierarchical fashion with the aid of a simple recursive procedure, which brakes down shapes into their discrete parts. It starts by breaking the original shape and proceeds by breaking its parts and then the parts of the parts and so on. The result is a tree like structure with the original shape at the top and the minimum elements or *atoms* at the bottom. Hierarchies describe designs and their components as sums of atoms.

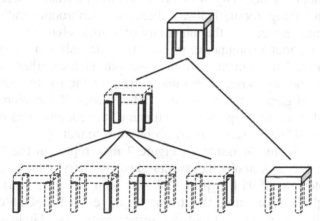

Fig. 1. Ikea coffee table: hierarchy of parts

For example, the hierarchy in Figure 1 shows how a shape, representing an Ikea coffee table, is progressively broken down into discrete parts representing the legs and the board. It also shows how this shape can be assembled from its atoms. The hierarchy satisfies the unique representation requirement by providing for each table part the smallest element that tops it. This element is the least upper bound of the part. Not all hierarchies have this property in accordance with the following result.

Let a be a shape defined in U_{ij}, $x \neq 0$ its part, and $X(a)$ a hierarchical decomposition of a. Part x has the least upper bound in $X(a)$ if the product of any two elements of $X(a)$ is either 0 or one of the elements. This is equiva-

lent to the set $X(a) \cup \{0\}$ being closed under product \square of U_{ij}, which defines a closure Γ on the set $\mathbf{B}(a)$ of all parts of a such that $\Gamma(\mathbf{B}(a)) = X(a) \cup \{0\}$. Part x is represented by its closure $\Gamma(x)$, which is an element of $X(a)$.

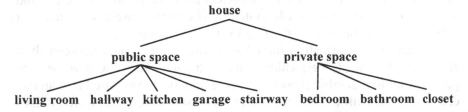

Fig. 2. A small house: hierarchy of spaces

Hierarchies may be used to order descriptions or properties of designs. Such hierarchies may not satisfy the unique representation requirement.

For example, a hierarchy in Figure 2 describes a small house consisting of kitchen, living room, hallway, bedroom, bathroom, walk-in closet, stairway, and garage. In this hierarchy of names, elements combine disjunctively without a conjunctive possibility. The bedroom has no common parts with the bathroom or walk-in closet although together they are private spaces of the house. The same is true for the living room, kitchen, stairway, and garage, which are its public spaces. If the hierarchy is altered, so that a shape represents each name, the conjunctions of elements become possible, but the hierarchy is oblivious to that.

For example, the hierarchy in Figure 2 may represent the Ohlenbusch Residence in San Antonio, Texas, designed by Darryl Ohlenbusch Design and completed in 1995 [9] (page 128). Its plan in Figure 3 (a) has spaces (b) through (i) representing the stairway, garage, kitchen, bathroom, living room, bedroom, closet, and hallway, respectively. The kitchen and living room may combine conjunctively to reveal the walls they share. The same is true for other adjacent spaces like the kitchen and bathroom or the bathroom and bedroom. In contrast, the hierarchy in Figure 2 does not recognize the conjunctive combinations above even if the names in it are replaced with shapes from Figures 3 and 4. This hierarchy does not satisfy the unique representation requirement which makes it a poor approximation of the design.

For example, the shape in Figure 6 (a) is the product of the kitchen and bathroom. It is topped by these two shapes and also by some other elements of the hierarchy that include the two as parts. Because the kitchen and bathroom are non-comparable shapes, the shape in Figure 6 (a) has two representatives, which violates the unique representation requirement.

Hierarchies are handy when conceiving the materialization of an already completed design, but may prove inadequate for the design process itself. Conjunctive combinations of entities are important in design especially in the early stages of the process. They yield new entities that have new properties not necessarily recognized by the original entities. This supports the discovery, which is an indispensable ingredient of the creative phases of the design process. Hierarchies do not support conjunction and a structure different than hierarchical is to be used in the design process. The properties of such a structure will be given first informally and then formally in the remainder of the paper.

Topologies

Consider Figure 3 as a decomposition of shape (a) defined in U_{22}. The latter is a shape algebra that manipulates planar segments in two-dimensional space. Note that figure 3 also contains lines, dashed lines, and labels. Algebras for these would be needed as well, however, for our argument U_{22}.alone will do.

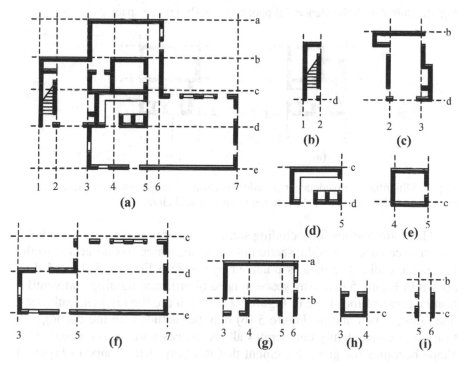

Fig. 3. Ohlenbusch Residence: (a) plan, (b) stairway, (c) garage, (d) kitchen, (e) bathroom, (f) living room, (g) bedroom, (h) closet, and (i) hallway

Shape (a), which is analyzed by the decomposition, is its member, but also is the sum of the other members, shapes (b) through (i). Therefore the decomposition represents a set of spaces of a house together with their sum, which is the plan of the house. There are other sums of interest that may be included. For example, the shapes in Figure 4 (a) and (b) that represent public and private spaces of the house may be included so that the decomposition becomes the hierarchy in Figure 2.

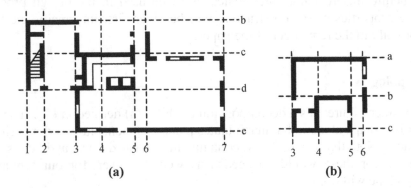

(a) (b)

Fig. 4. Ohlenbusch Residence: (a) public space, (b) private space

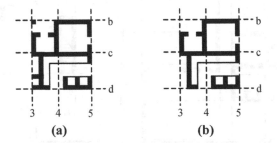

(a) (b)

Fig. 5. Ohlenbusch Residence: (a) middle section of the plan with no access to the perimeter walls, (b) sum of the kitchen bathroom and closet

There are reasons for including some other sums as well. For example, one may consider a middle section of the plan, which has no access to the perimeter walls. The area is bounded by the grid lines 3, 5, b, and d as shown in Figure 5 (a). Any space in need of artificial lighting and ventilation is a part of the shape in Figure 5 (a). Such are the kitchen, bathroom, and closet. Their sum in Figure 5 (b) may be included (in the decomposition) as it conveniently enumerates all the spaces with such a need. This shape becomes the greatest element that is a part of the shape in Figure 5 (a), or the greatest lower bound of that shape. Any part of the design may become interesting at some point in the design process. For every such

part the decomposition should contain the greatest lower bound. Consequently, all of the sums have to be included and the decomposition is closed under the sum of U_{22}. The advantages of this structure are twofold.

First, it allows for the properties of any part of the design to be assigned to the appropriate elements of the decomposition. In the above example the properties of shape in Figure 5 (a) are assigned to the kitchen, bathroom, and closet, labeling them as spaces in need of artificial ventilation and lighting.

Second, the structure comes in handy if a part of a design has to be defined in terms of properties that are recognized by the decomposition. For example, the shape in Figure 5 (a) contains or has the properties of the kitchen, bathroom and closet. This can be determined for every part of the design because there is the greatest lower bound for every such part.

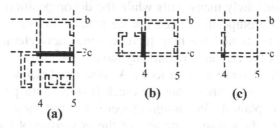

Fig. 6. Ohlenbusch Residence: partitioning walls (a) between the kitchen and bathroom, and (b) between the bathroom and closet; (c) joint of walls (a) and (b)

To explore conjunctive combinations of elements of the decomposition we rely on the product operation from U_{22} algebra. The product of shapes representing the kitchen and bathroom (in Figure 3 (d) and (e)) yields the shape in Figure 6 (a), which represents the partitioning wall between the two spaces. Likewise, the product of shapes representing the bathroom and closet yields the partitioning wall in Figure 6 (b). Taking products of adjacent spaces exhaustively enumerates such walls. The decomposition becomes a system of spaces together with partitioning walls between them. Further, products of shapes representing walls are joints between the walls.

For example, in Figure 6 the shape (c) is the product of shapes (a) and (b). It represents the joint between the walls (a) and (b). The decomposition now becomes a system of spaces, partitioning walls, and joints between the walls. Its structure is that of an algebra with respect to the sum, and a partial algebra with respect to the product. The fact that it has products rules out the possibility of the structure being a hierarchy. Further elaboration of the design may require some additional constrains on the structure of the decomposition.

Suppose that the door between the bedroom and garage is to be removed and replaced with a wall. The smallest element of the decomposition altered by this action is the wall between the two spaces. It includes the door and is the least upper bound of the door with respect to this decomposition. In order to allow for a change of an arbitrarily part of a design its decomposition should have the least upper bound for every such part. Consequently, the decomposition should be closed under products, which elevates its structure to an algebra closed under both sums and products.

Every part of the design is represented by the two distinguished elements of the decomposition. These are the least upper bound of the part and its greatest lower bound. The part is bounded by the two and has at least the properties of the latter element and at most the properties of the former one. The unique representatives are provided regardless of the fact that there are infinitely many parts while the decomposition is only finite. However, the decomposition need not be small. In our example, it has over 2000 elements and we may include some new elements like, say, complements of the elements we already have.

Complements deserve a closer look. As discussed elsewhere [1], [2] we perceive a shape as a whole, but we break it down into parts in order to understand or explain it. We assign properties to the parts and tend to see the properties of the whole as the sum of the properties of the parts. This makes finding the complement of a part an easy task: just take the shape that has all of the properties of the whole but none of the properties of the part. Unfortunately, shapes usually do not meet our Boolean expectations.

For example, the complement of the kitchen should, in a Boolean fashion, consist of all the spaces of the house but the kitchen. Algebra U_{22} has a difference operation to support the creation of complements. The shape in Figure 7 (a) is the complement of the kitchen obtained by subtracting the latter from the plan. It contains the bedroom and stairway, which are the only spaces that have no common walls with the kitchen. This shape is clearly not the complement we expected. It lacks the garage, bathroom, corridor and living room.

In another example, we may try to determine the façade walls of, say, the living room. These are partitioning the outside space from the living room and--following the logic of the construction of partitioning walls--may be determined as the product of the two spaces. The outside space should be the complement of the sum of the inside spaces. Unfortunately, this complement is the empty shape here. Our entity is not a system of inside spaces surrounded by the outside space, but a system of walls, and only in the decomposition certain combinations of walls emerge as spaces. Consequently, complement is of no help in specifying the outside space.

The latter has to be defined in the same fashion as all other spaces--as a combination of walls, Figure 7 (b). The product of the living room and the outside space is the shape in Figure 7 (c) which represents the façade walls of the living room.

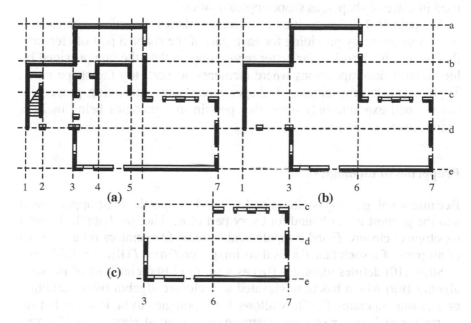

Fig. 7. Ohlenbusch Residence: (a) complement of the kitchen, (b) the outside space, (c) the living room façade walls

Although the two examples show that complements are not essential in dealing with spatial entities there may be other compelling reasons for not using them. In an early, exploratory, stage of design process designers may focus on developing certain parts of their designs while having only a vague notion of the other parts or the whole. Consequently, the complements may not be available at this stage. Without the complements we are left with an algebra which has the whole (the shape it analyzes) and zero (the empty shape) and is closed under + and · of U_{ij}. This is the same structure as that of closed (open) sets of a topological space which motivates introduction of the topologies for shapes.

Definition 1 Let *a* be a shape from U_{ij} algebra. A bounded decomposition of *a* is a *topology* on *a* or a *topological decomposition* of *a* if it is closed under + and · of U_{ij}. A topological decomposition of *a* is denoted by $T(a)$.

Topologies as shape approximations

Topologies for shapes were introduced by Stiny [10] to study the continuity of shape computations. In contrast, we examine here how they may be used in place of shapes, as shape approximations.

A topological decomposition of a shape satisfies the unique representation requirement by providing for each part of the shape a pair of elements that bounds it. This is a far better representation than the one provided by hierarchical decompositions where elements, at best, top the shape parts. Topological decompositions of shapes have many interesting properties, but we will examine only those that pertain to topologies being used as shape approximations.

Properties of topologies

Because topology $T(a)$ is closed under $+$ and \cdot it has the least upper bound and the greatest lower bound for every part of a. The two bounds define a topological closure Γ and a topological interior Ω operators on a set $\mathbf{B}(a)$ of all parts of a such that $T(a)$ is their image, or $T(a) = \Gamma(\mathbf{B}(a)) = \Omega(\mathbf{B}(a))$.

Stiny [10] defines topology $T(a)$ as a set of closed elements of Boolean algebra $\mathbf{B}(a)$ which has been elevated to a closure algebra by the addition of a closure operator Γ. Stiny allows for topologies to be infinite, but requires for each part x of a an existence of a smallest element in $T(a)$ that contains x as a part. This requirement is weaker than the standard requirement for a topology to be closed under all products--finite and infinite. Because $\mathbf{B}(a)$ is not a complete Boolean algebra there is no guaranty that all of its infinite subsets have products so the stronger requirement does not hold in infinite topologies for shapes. A topology that satisfies weaker requirement only can not be generated by a given subbase in a usual way. Because this construction plays an important role in applications, we will restrict ourselves to finite topologies only--in accordance with definition 1 above.

For example, we constructed the topology of the Ohlenbusch Residence Figure 3 (a) from a subbase consisting of spaces (b) through (i). We later modified the subbase by adding a shape representing the outside space, Figure 7 (b). This resulted in a bigger topology that included the original one.

A topology generated by a subbase is the smallest among the topologies containing the subbase: all of the topologies containing the subbase contain this topology as well.

There is a simple procedure for generating a topology from a subbase, but it may not be practical to keep all of the elements of a topology at all times. Even small designs may have big topologies like the topology in our example, which has over 2000 elements. It should be sufficient to keep the most important elements and construct the other elements as needed. In our example, the original spaces, which form the subbase should be kept and we may also keep some other shapes like the walls and joints between the walls. We need to be able to construct the relevant elements to uniquely represent an arbitrary part of the analyzed shape. These are the closure and interior of the part, which could both be constructed directly from the subbase via the following procedure.

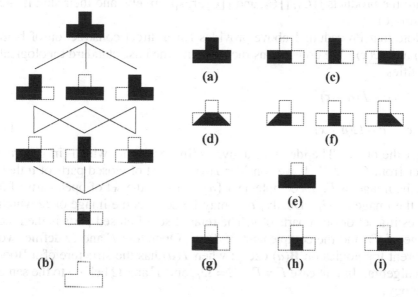

Fig. 8. Closure construction: shape (a) its topology (b) with the subbase (c), a part (d) and its closure (e), relativization (f) of (c) to (d), the sets C_1, C_2, and C_3 (g, c, i) with their products (g, h, i) which sum to the closure (e)

Procedure 1 Let a be a shape, $x \le a$ it's part and B a subbase of a topology $T(a)$ on a. Note that $\Sigma B = a$, which renders B a decomposition of a and allows for the *relativization* of B to x, or B/x, to be constructed [1], [2].

1) Construct set $B/x = \{x\} \cdot B$, which is a decomposition of x that recognizes all of the divisions of a imposed by B.

2) For every $y_i \in B/x$, where $i = 1, \dots n$ enumerates the elements of B/x, construct two sets $C_i = \{z \in B| z \cdot x \ge y_i\}$ and $I_i = \{z \in B| z \cdot x \le y_i\}$.

3) Construct a product $\prod C_i$ for each C_i and a sum $\sum I_i$ for each I_i. The product is the closure and the sum is the interior of y_i with respect to topology $T(a)$, or $\Gamma(y_i) = \prod C_i$ and $\Omega(y_i) = \sum I_i$.

4) Finally, the sum of the closures above is the closure and the sum of the interiors above is the interior of x with respect to $T(a)$, or $\Gamma(x) = \sum_{i=1...n} \Gamma(y_i)$ and $\Omega(x) = \sum_{i=1...n} \Omega(y_i)$.

For example, in Figure 8 shape (a), defined in U_{22} algebra, is analyzed via topology (b) generated by subbase (c). Shape (d) is a part of (a) and its closure is shape (e). To construct (e) we take the relativization (f) of the subbase to shape (d) and construct the sets C_1, C_2, and C_3, which are a singleton (g), a set (c), and a singleton (i), respectively. Shapes (g), (h), and (i) are the products $\prod C_1$, $\prod C_2$, and $\prod C_3$, respectively, and their sum is the closure (e).

Note that Procedure 1 above provides for a direct construction of both $\Gamma(x)$ and $\Omega(x)$. We do not construct one and then use standard topological identities

$$\Omega_\Gamma(x) = a - \Gamma(a - x) ,$$

$$\Gamma_\Omega(x) = a - \Omega(a - x) \tag{1}$$

to get the other. The identities above define operators which (in general) differ from Ω and Γ. If we consider $T(a)$ as a set of closed parts of a then it is the image of Γ. Its complement $\{a\} - T(a)$ is the set of open parts of a and the image of Ω_Γ. Dually, $T(a)$ may be seen as the image of Ω which makes it a set of open parts of a. The related set of closed parts is then the image of Γ_Ω and the complement of $T(a)$. Operators Γ and Ω define two different topologies on $\mathbf{B}(a)$ except when $T(a)$ has the structure of a Boolean algebra. In that case $\Gamma = \Gamma_\Omega$, $\Omega = \Omega_\Gamma$, and Γ and Ω belong to the same topology.

One of the reasons we dropped the complements was that they may not be available in the early stages of a design process. In contrast, complements may play a role later in the process when properties of design(s) are better understood. We may than use $T(a)$ and its complement $\{a\} - T(a)$ concurrently to represent/bound the shape parts. This is done by paring any of the two closures with any of the two interiors so that any of the four combinations (Γ, Ω), (Γ, Ω_Γ), (Γ_Ω, Ω), or $(\Gamma_\Omega, \Omega_\Gamma)$ may be chosen to best fit a particular part.

Another important use of the complements may arise in the final phases of the design process when designs are specified for production. Such a specification usually sports a kit of discrete parts from which to build a design as well as some details on how this should be done. This means that we need a discrete decomposition of a shape which can than be extended

to a hierarchical decomposition to show how the original discrete parts are put together to build the shape. There is no guaranty for topology $T(a)$ to be atomic so it may not contain a discrete decomposition of a. To get one we need to extend $T(a)$ to a Boolean algebra $T_{Bool}(a)$, which is the *Boolean extension* of $T(a)$. The latter is the smallest decomposition of a that has the structure of a Boolean algebra and contains $T(a)$. It is also a topological decomposition because it contains 0 and a and is closed under · and + of U_{ij}. In addition to this $T_{Bool}(a)$ is closed under formation of complements which is equivalent to being closed under – of U_{ij}. Because $T_{Bool}(a)$ is finite Boolean algebra, it is atomic and its set of atoms A is a discrete decomposition of a. Set A is the smallest—in terms of its cardinality— discrete decomposition of a such that all of the elements of $T(a)$ may be constructed as sums of elements of A. Finally, all the hierarchical decompositions built on the basis of A are embedded in $T_{Bool}(a)$.

As with $T(a)$ it is not practical to keep all of the elements of $T_{Bool}(a)$ when we may only need some important ones and an ability to construct the set of atoms of $T_{Bool}(a)$ as well as the closure and interior for any part of a. A procedure for constructing the set of atoms of $T_{Bool}(a)$ is as follows.

Procedure 2 Let a, $T(a)$, $T_{Bool}(a)$, and A be as above and let B be a subase of $T(a)$.

1) Construct $\wp(B)$ - Ø the set of all subsets of B with the exception of the empty set.
2) For every $S_i \in \wp(B)$ - Ø, where $i = 1, \ldots n$ enumerates the elements of $\wp(B) - Ø$, construct a set $D_i = B - S_i$.
3) For every i construct a shape $x_i = \prod S_i - \sum D_i$. This shape is either an atom of $T_{Bool}(a)$ or an empty shape.
4) Take $(\square_{i=1..n}\{x_i\}) - \{0\}$, which is the set A of atoms of $T_{Bool}(a)$.

For example, topology $T(a)$ in Figure 8 (b) is extended to a Boolean algebra $T_{Bool}(a)$ by including the shapes delineated by dashed lines. The set of atoms of the extension is given in Figure 9. Note that in this particular example the union of $T(a)$ and its complement is $T_{Bool}(a)$. Usually the latter algebra is greater then this union.

Fig. 9. The set of atoms of the Boolean extension of topology in Figure 8 (b)

Closure and interior of an arbitrary part x of shape a with respect to topology $T_{Bool}(a)$ may be obtained in accordance with the following two identities--which both make use of (1).

$$\Omega_{Bool}(x) = \Omega(x) + \Omega_\Gamma(x) = \Omega(x) + (a - \Gamma(a - x)),$$

$$\Gamma_{Bool}(x) = \Gamma(x) \cdot \Gamma_{\Omega}(x) = \Gamma(x) \cdot (a - \Omega(a - x)) \tag{2}$$

where Ω and Γ are operators from $T(a)$. Because the latter operators may be constructed from the subbase B via Procedure 1 construction of Ω_{Bool} and Γ_{Bool} is feasible.

Properties of topologies

Because shape parts are represented via elements of topologies, the relation between the parts and elements is crucial to understanding of how (well) shapes are approximated with the topologies.

For example, if some part x of shape a is examined so that the structure imposed on a by topology $T(a)$ is respected, then it is safe to say that x is $\Omega(x)$. Part x has the properties of $\Omega(x)$ and there is no other shape like this one in $T(a)$ that is greater than $\Omega(x)$. The part may have some other properties as well, but those are not recognized by $T(a)$. If, in contrast, the place of x in the structure of $T(a)$ has to be determined, then x is $\Gamma(x)$. Closure $\Gamma(x)$ accounts for all of the properties of x and is the least such element of $T(a)$. The closure may have some properties that x lacks, but $T(a)$ is oblivious to that.

Not all parts are equally well represented by a topology. Elements of the topology are the parts that are represented the best. They are represented by themselves. In contrast, parts that are both *boundary*--defined by $\Omega(x) = 0$--and *dense*—defined by $\Gamma(x) = a$--are the worse represented ones. Such parts have no recognizable properties despite the fact that only a is big enough to account for all of their properties. No matter how well a topology approximates a shape there will be infinitely many of such parts provided the shape is not made of points only. Although poorly represented, the latter parts are well analyzed by the topology.

For example, shapes in Figure 10 are both dense and boundary parts of shape in Figure 8 (a) with respect to topology (b). The shapes are, thus, poorly represented in (b). In contrast, relativization of topology (b) to any of the shapes in Figure 10 is a topology isomorphic with (b). Consequently, shape (a) and both of the shapes in Figure 10 are analyzed by (b) in the same way.

Fig. 10. Two parts of the shape in Figure 8 (a), which are both dense and boundary with respect to the topology in Figure 8 (b)

For an arbitrarily part x of shape a represented by $\Omega(x)$ and $\Gamma(x)$ in $T(a)$ there may be (infinitely) many parts of a with the same representation in

$T(a)$. This justifies introduction of an equivalence relation \equiv such that $x \equiv y$ if and only if $\Omega(x) = \Omega(y)$ and $\Gamma(x) = \Gamma(y)$, where $x, y \leq a$. If x is an element of $T(a)$, then $\Omega(x) = \Gamma(x) = x$ and equivalence class $[x]_{\equiv}$ has only one element x. In contrast, when x is not an element of $T(a)$ class $[x]_{\equiv}$ has infinitely many elements provided that x is not made of points only.

Number n_{\equiv} of equivalence classes modulo \equiv indicates how well $T(a)$ approximates a. This number in the case of the smallest (trivial) topology $\{0, a\}$ is 3. It appears that the trivial topology is not a bad shape approximation after all. It shows that a is nonempty, that it contains 0 and itself, and has proper parts as well.

For every comparable pair $x \leq y$ of elements of $T(a)$ there is a nonempty equivalence class of parts of a that are represented by x and y so that n_{\equiv} equals the number of such pairs. For a topology that is a chain with n elements $n_{\equiv} = n(n+1)/2$.

We may assume that each part x of a is, de facto, approximated by the elements of $T(a)$ that represent it. Thus, we may calculate errors that such an approximation introduces. If x is approximated by $\Omega(x)$ the error is

$$\varepsilon_{\Omega}(x) = x - \Omega(x) \tag{3}$$

while an approximation by $\Gamma(x)$ introduces the error

$$\varepsilon_{\Gamma}(x) = \Gamma(x) - x \tag{4}$$

Shapes that are elements of topologies are the most closely approximated ones—if $x \in T(a)$ then $\varepsilon_{\Omega}(x) = \varepsilon_{\Gamma}(x) = 0$. In general, if x and y are parts of a and $\varepsilon_{\Omega}(x) \leq \varepsilon_{\Omega}(y)$ then x is approximated by $\Omega(x)$ at least as well or better than y.

An interesting way of examining errors (3) and (4) is from the view point of the topology itself. Because both $\varepsilon_{\Omega}(x)$ and $\varepsilon_{\Gamma}(x)$ are parts of a we may approximate them using different closures and interiors. A simple exercise in closure/interior arithmetic yields some interesting results.

For example, the Γ closure of $\varepsilon_{\Gamma}(x)$ is

$$\Gamma(\varepsilon_{\Gamma}(x)) = \Gamma(\Gamma(x) - x) \tag{5}$$

which is the smallest element of $T(a)$ that is greater than error $\varepsilon_{\Gamma}(x)$. The error can not be greater than (5).

The Ω interior of $\varepsilon_{\Gamma}(x)$ is denoted by $\sigma(x)$ so that

$$\sigma(x) = \Omega(\varepsilon_{\Gamma}(x)) = \Gamma(x) \cdot \Omega(a - x) \tag{6}$$

The error can not be smaller than $\sigma(x)$, which is the greatest element of $T(a)$ that is a part of $\Gamma(x)$ but not of x. If $T(a)$ is a set of replaceable parts of some object and some part x breaks down, $\Gamma(x)$ will be replaced. Then again, because $\sigma(x)$ and x do not share parts the former shape may be re-

cycled. If a is a car, $\Gamma(x)$ its alternator with a bad coil x, then the repair shop uses $T(a)$ to pinpoint and replace the alternator. The old alternator goes to a remanufacturing facility as a 'core'. At the facility $\sigma(x)$ is used to find out which parts could be salvaged when rebuilding the alternator. Shape $\sigma(x)$ is the *core* of x with respect to $T(a)$ or the *reusable part* of $\Gamma(x)$.

Because closure Γ_Ω yields the complement of $T(a)$ we may take the closure of $\varepsilon_\Gamma(x)$ and then the complement of the result. This is another interesting shape and we will denote it by $\mu(x)$ so that

$$\mu(x) = a - \Gamma_\Omega(\varepsilon_\Gamma(x)) = \Omega(a - \varepsilon_\Gamma(x)) = \Omega(x) + \Omega\,(a - \Gamma(x)) \qquad (7)$$

This is the greatest element of $T(a)$ that does not have common parts with $\varepsilon_\Gamma(x)$. It has only those parts of $\Gamma(x)$ that are also parts of x. If attention is paid to $\mu(x)$ and its parts only, then it does not matter whether x or its approximation $\Gamma(x)$ is used. From the point of view of $\mu(x)$ we make no error when approximating x is with $\Gamma(x)$. This shape becomes a if x is an element of $T(a)$.

Similarly, the complement of the Γ_Ω closure of $\varepsilon_\Omega(x)$ is

$$a - \Gamma_\Omega(\varepsilon_\Omega(x)) = \Omega(a - \varepsilon_\Omega(x)) = \Omega(x) + \Omega\,(a - x) \qquad (8)$$

This is the greatest element of $T(a)$ that does not have common parts with $\varepsilon_\Omega(x)$. From the point of view of this shape there is no error if x is approximated with $\Omega(x)$. This shape becomes a if x is an element of $T(a)$.

Because $\mu(x)$ is included in shape (8) their product is $\mu(x)$. The latter is the greatest element of $T(a)$ for which it does not matter whether x or any of its approximations is used. The greater $\mu(x)$ is, the better the topology approximates the part. We may use $\mu(x)$ as a measure of that approximation. Note that $\mu(x) = a$, if x is an element of $T(a)$ and $\mu(x) = 0$, if x is both dense and boundary part of a with respect to $T(a)$.

The closure Γ of $\varepsilon_\Omega(x)$ is

$$\Gamma(\varepsilon_\Omega(x)) = \Gamma(x - \Omega(x)) \qquad (9)$$

The error can not be greater than this element of $T(a)$. In contrast, the error can not be smaller than

$$\Omega(\varepsilon_\Omega(x)) = 0 \qquad (10)$$

Identity (10) renders $\varepsilon_\Omega(x)$ a boundary element of $T(a)$. Similarly, $\Omega_\Gamma(\varepsilon_\Gamma(x)) = 0$ renders this error a boundary element, but with respect to a different topology—the one defined by Ω_Γ and Γ.

The last of the possible combinations of the errors and operators is the complement of $\Omega_\Gamma(\varepsilon_\Omega(x))$, which is $\Gamma(a - x) + \Omega(x)$. This shape although

an element of $T(a)$ is related to its complement $\{a\} - T(a)$. It is the complement of $\sigma'(a - x)$ which the core of $(a - x)$ with respect to $\{a\} - T(a)$.

Finally, the two errors are bounded by the elements (10), (9), (6) and (5) of $T(a)$, so that

$$0 \leq \varepsilon_\Omega(x) \leq \Gamma(x - \Omega(x)),$$

$$\Gamma(x) \cdot \Omega(a - x) \leq \varepsilon_\Gamma(x) \leq \Gamma(\Gamma(x) - x) \tag{11}$$

Those elements approximate (represent) errors $\varepsilon_\Gamma(x)$ and $\varepsilon_\Omega(x)$ in $T(a)$.

Conclusion

It has been shown earlier that bounded decompositions and their algebras behave the same way as shapes and shape algebras do [1], [2]. The same holds for topologies for shapes, which are special kinds of bounded decompositions. What sets them apart is their algebraic structure. The latter has many important properties to facilitate their application as shape approximations.

Topologies are expressive. Chief among their properties is their ability to uniquely represent each of the infinitely many parts of the shape they analyze.

Topologies are supportive. They provide for both conjunctive and disjunctive combinations of shapes. This yields new shapes to facilitate the discovery, which is important in the early creative stages of design.

Topologies are imprecise. Another property--beneficial at this stage--is their relaxed treatment of complements. Unlike Boolean algebras where each element calls for its complement topologies do not mandate them. This is an advantage when--early in the design process--designers do not know all the parts of their designs.

Topologies are flexible. They grow as designers add new shapes to their subbases. Every time this happens new shapes emerge in combinations with the existing ones. If new shapes are added by shape rules--in the framework of shape grammars--topologies assure that this proceeds in a continuous fashion [3], [10].

Topologies are precise. When in the later stages of the design process definitive answers are required, topologies could be extended to Boolean algebras to yield kits of parts from which to build the objects. Boolean extensions of topologies are the least upper bounds for all the hierarchies constructed with these kits of parts. The hierarchies describe all of the possible ways the parts could be put together to make the objects.

Topologies are logical. We demonstrated that one can reason about the shape parts by using interior/closure arithmetic.

Topologies are metaphysical. Their lack of complements has some philosophical implications for design. Most formal systems are grounded in Boolean logic where the principal of the exclusion of the third allows for entities to be replaced by their complements. One does not have to construct an entity to know its properties. He/she can infer that from the complement. Mathematicians have a choice of either constructing the entity or its complement—whichever is easier. Designers do not have this choice—the complement of a bridge is the running river. Designers construct they do not show. The logic of design is not Boolean but topological (Brouwerian). Interestingly enough—at the very basis of mathematics--theorems with constructive proofs are the only ones valid across different set theories. Designers have it right.

References

1. Krstic D (2004) Computing with analyzed shapes. in Gero JS (ed), Design Computing and Cognition '04. Kluwer Academic, Dordrecht, pp. 397–416
2. Krstic D (2005) Shape decompositions and their algebras. Artificial Intelligence for Engineering Design, Analysis and Manufacturing 19: 261–276
3. Stiny G (2006) Shape: talking about seeing and doing. MIT Press, Cambridge, Massachusetts
4. Stiny G (1992) Weights. Environment and Planning B: Planning and Design 19: 413–430
5. Stiny G (1991) The algebras of design. Research in Engineering Design 2: 171–181
6. Krstic D (2001) Algebras and grammars for shapes and their boundaries. Environment and Planning B: Planning and Design 28: 151–162
7. Krstic D (1999) Constructing algebras of design. Environment and Planning B: Planning and Design 26: 45–57
8. Birkhoff G (1993) Lattice theory. American Mathematical Society, Providence, Rhode Island
9. Ojeda OR (ed.) (1997) The new American house 2: innovations in residential design, 30 case studies. Witney Library of Design an imprint of Watson-Guptill Publications, New York
10. Stiny G (1994) Shape rules: closure, continuity, and emergence. Environment and Planning B: Planning and Design 21: S49–S78

DESIGN COGNITION – 1

Diagrams as Tools in the Design of Information Systems
Jeffrey V. Nickerson, James E. Corter, Barbara Tversky,
Doris Zahner and Yun Jin Rho

*Form as a Visual Encounter: Using Eye Movement Studies
for Design Reasoning*
Ameya Athavankar

The Role of Immersivity in Three-Dimensional Mental Rotation
Maria Kozhevnikov, Jodie Royan, Olesya Blazhenkova
and Andrey Gorbunov

*Comprehension of Layout Complexity: Effects of Architectural
Expertise and Mode of Presentation*
Christoph Hölscher and Ruth Conroy Dalton

Diagrams as Tools in the Design of Information Systems

Jeffrey V. Nickerson,
Stevens Institute of Technology, USA

James E. Corter, Barbara Tversky,
Columbia University, USA

Doris Zahner,
Stevens Institute of Technology, USA

and **Yun Jin Rho**
Columbia University, USA

Design typically relies on diagrams to offload memory and information processing and to promote discovery and inferences. Design of information systems, in contrast to design of buildings and products, depends on topological connectivity rather than Euclidean distance. Understanding graph topology and manipulating graphs are essential skills in the design of information systems, because graph manipulation facilitates the refinement of designs and the generation of alternative designs. Here, we found that students of systems design have difficulties interpreting diagrams, revealing two biases, a sequential bias and a reading order bias. The results have implications for teaching as well as diagram design.

Introduction

Design entails arranging and rearranging real or virtual objects and parts and evaluating the resulting configurations. Although the mind seems to have almost unlimited space to passively store information, its space for actively manipulating information is highly limited. When the mind runs out of mental space, it often turns to external space, using fingers and hands, salt and pepper shakers, the proverbial napkin, and, especially, paper. Sketches, diagrams, charts, models, and other externalizations of the workings of the mind serve many roles in thinking. They support memory, information processing, inferences, and discovery. They structure, reflect, and express ideas, for oneself and for others. They use elements and spatial relations in external space to represent the elements and relations of thought, literally or metaphorically (e. g. [1] and [2]). No wonder that they are so widely used.

One arena where diagrams and sketches have proven to be especially useful is design, particularly architectural design, documented as far back as ancient Egypt, where one of the temples in Luxor has a plan inscribed on one of its walls. For architectural design, sketches can simply reduce physical scale, demanding relatively simple and straightforward transformations for comprehension and inference. However, architectural sketches typically reduce not only scale but also detail. Ideally, they take out irrelevant detail and retain and emphasize the detail pertinent to design. Effective sketches, then, simplify the information to essentials.

Diagrams and sketches are typically richer and more complex than simple Euclidean shrinking and information reduction. In many cases, they are meant to represent more than just physical structure. Extending diagrams from representing structural information to representing functional or abstract information often requires the addition of symbolic conventions: lines, boxes, arrows, words, and more (e. g. [3]). This information can be ambiguous; arrows, for example, can indicate causation, sequence, or flow, among many other meanings (cf. [4]).

Sketches and diagrams, then, must be interpreted in order to be used. The Euclidean character and the metric properties of diagrams—distances, angles, sizes, shapes and their proximity — are difficult to ignore, even when irrelevant, and can encourage false inferences. Although diagrams and sketches present information in parallel and do not privilege any direction or location over any other, the mind does not process them in parallel; rather, they are interpreted sequentially. When there is a natural beginning, diagrams are "read" from there, but when there is not a natural beginning, diagrams tend to be scanned in reading order, in Western lan-

guages from left to right and top to bottom (e. g. [5]). The richness and complexity of diagrams render them more useful but also more problematic at the same time. Although those experienced in using and interpreting diagrams often think they are obvious because the information is "there," novices often need to learn to use and interpret the information that is "there" (cf. [6]).

Information systems infrastructure consists of physical components such as computers and routers connected together by and cables or radios. Because information systems depend on complex relations between large numbers of components, their design lends itself to sketches and diagrams. In contrast to the design of buildings and products, the design of information systems typically happens at a high level of abstraction. Buildings and products are structures visible in space. But, although an information system includes visible objects such as computers and cables, those physical objects are not the crucial components of design. At the core of an information system is a set of instructions. The set is sometimes subdivided, and sometimes copied, into multiple bundles of instructions – the programs. These programs are then installed on computers that are often distant from each other. The most important, that is, functional, aspects of the system are not visible. By looking at these instructions expressed as text, we cannot at first glance tell much about the way the system was constructed – not as clearly as we can understand a building by looking at its beams and columns.

There is structure to an information system, but it cannot be fully expressed in terms of Euclidean spatial relationships. Instead, it is about electronic connections. At the most basic level, the physical network is set of wires and computers connected together. Since electronic signals travel at the speed of light, the difference in communication performance between systems sitting next to each other and systems separated by miles is often negligible. Distance matters little. What matters more is the number of hops a message takes. The hops are the transfer points – much like the transfer points in a subway system. Because the connectivity aspects of an information network can be represented with various types of abstract graphs, we speak of *network topologies* [7].

The designer of an information system is expected to understand such network topologies. This understanding presupposes an ability to read and generate systems diagrams – diagrams that document the topology. These diagrams are conventional – there is an agreed-upon shorthand for representing networks.

Systems diagrams are used to plan the flow of information, much as city maps are used to plan the flow of people. But the constraints of physical

and information systems are different, and this is reflected in systems diagrams. For example, ordinal and interval relations in the representations of systems components are often irrelevant. What is important are the links, and they are hierarchically organized in subtle ways. For example, at the infrastructure level, network bridges and routers are used to partition networks into subnetworks so that performance or security can be controlled in a fine-grain fashion.

In order to successfully create and interpret systems diagrams, students and practitioners must learn to suppress conscious or unconscious inferences based on Euclidean properties of diagrams, such as the planar distances among nodes, and learn to rely primarily on graphs: drawings of nodes and edges. How well do novices and experts understand these conventions and the formal structure underlying them? How able are they to interpret and generate the paths that a topology implies?

Here, these questions are addressed through design problems given students in a Master's level course on systems design at the beginning and at the end of the class. This approach is inspired by Simon's path-breaking work on *science of design* [8], especially his observations that diagrams are crucial to design and that experts use diagrams differently from novices [1], [9]. For example, it has been established that experts tend to use higher-level knowledge units compared to novices [9], and that experts tend to organize problems according to their underlying structure rather than based on surface similarity [10]. Similarly, experts are better able to make functional inferences from diagrams than novices [11].

To summarize, diagrams are commonly used to expand the mind by putting some of its contents into the world where they can be more easily examined, interpreted, and manipulated. Design is one area where sketches are particularly apt and broadly used. Diagrams are essential to systems design, so studying how they are produced and understood is important in its own right. Although information systems are instantiated by physical objects, the array of physical objects does not adequately capture the structure of information flow. Flow is conveyed through conventional use of lines, rather than Euclidean properties such as proximity. Thus, students in systems design must overcome habitual spatial interpretation practices and learn new graphical ones. This is the main concern of the present paper. Because systems diagrams are representative of diagrams in other disciplines, the results should have broader implications as well. For example, topological diagrams are used in the design of electrical plants, transportation systems, supply chains, and systems biology. Therefore, ways of better explaining or teaching these diagrams may assist those who come into

contact with these fields. In addition, the analysis techniques discussed here might be used to evaluate diagram understanding of many sorts.

Related Work in Information Systems Design

There are good reasons to study the design of information systems. Recently, there has been a call to reinvigorate the science of design [12], [13]. One reason for this call is dissatisfaction with the progress of software design. While computer hardware has essentially doubled in complexity every 18 months for the past few decades, software gains have been much more modest. Many large software projects are never completed, and those that are completed are often bug-ridden [14].

In the computing disciplines, diagram use is common [15]. Practicing systems designers tend to use the diagrams that are defined as a standard in the Unified Modeling Language (UML) [16]. These diagrams are all topological – meaning they are all variations on graphs. Studies have looked at how these graphs are used (e.g. [17]). But to our knowledge, no one has looked at how well these graphs are understood.

There is reason to study this. Just as manipulating the structure of walls changes the design of a building, manipulating the structure of a network changes the design of an information system. Many of the goals of an information system – for example, reliability, performance, security, adaptability – are directly affected by the structure of the underlying network. We know that an ability to transform figures through rotation is important for architects and engineers. But information systems are built in a topological space, not a Euclidean one. Thus, it is possible that the ability to transform figures through *topological* operations is especially important for information systems designers. Moreover, it is possible that these skills, mental transformation of geometric structures and mental transformation of topological structure, are related.

Study 1: Understanding and Producing Network Topologies

In order to understand how expert and novice students produce and understand systems diagrams, we presented design problems to students in a Master's level class in the design of systems at the beginning of the semester (Study 1) and at the end of the semester (Study 2). These students represented a wide range of initial experience – some were full time students with no work experience, while others were part-time students who

worked in the information technology departments of corporations. The course asked students to engage in a series of design exercises in which they produce systems diagrams and participate in critiques of the diagrams: for example, students are asked to design a personal information system and to present diagrams representing the temporal behavior and structure of the system [18]. Students had been exposed to the commonly used diagrams of information systems during introductory courses.

The general expectation was that students' productions and comprehension of diagrams would exhibit two biases: a sequential bias and a reading order bias. Because diagrams are presented in Euclidean space, students would be biased toward Euclidean interpretations of diagrams based on proximity and thus have difficulties comprehending the topological relations in systems diagrams, indicated by lines. Specifically, they would experience difficulties making interpretations based on connectivity rather than proximity. In particular, we expected students to have difficulties comprehending and producing a logical *bus*. A bus is a sub-cluster of components that are mutually interconnected. Most local area networks are organized in such a way. By convention, busses are indicated by a line with satellite lines as in Fig. 1c. Within a bus, all nodes are interconnected to all other nodes, even though those connections are not directly shown. In contrast, Fig. 1a directly shows the connections. Fig. 1b shows a hub and spokes model, which is in how modern buildings are wired – lines run from each computer to a hub; the hub insures that everyone can easily connect to everyone else.

a) Complete Graph b) Hub and Spokes c) Logical bus

Fig. 1. Alternative LAN representations

All three of these diagrams represent the same logical topology, in that all nodes can directly connect to all other nodes.

Presented with the bus diagram (Fig. 1c), a student without knowledge of the bus diagram conventions might wrongly infer that a path between the far left node and the far right node must pass through the middle nodes. In fact, the two extreme nodes can connect directly. On the other hand, a student who misunderstands modern local area network technology may portray it using one of the diagrams shown in Fig. 2. These diagrams are inappropriate or incorrect representations.

a) Incomplete Graph b) Ring c) Chain

Fig. 2. Obsolete or incorrect LAN representations

A second expectation was that students would ordinarily inspect and interpret diagrams in reading order, which would bias them to see paths more compatible with reading order and to miss paths less compatible with reading order.

Methods, design, and predictions

Sixty-eight students from four different sections of the same course were presented with a set of four design problems to be answered in class (see Fig. 3). For problems 1 through 3, they were presented with a diagram of the configuration of a system and asked to generate all the shortest paths of information through the system. This is an important type of inference in systems design because it is a check that information flows according to system constraints. For problem 4, they were presented with a description of the configuration of a system and asked to produce a diagram of it then generate the set of shortest paths.

Problems 1, 2, and 4 had the same system configuration – the same topology - but with a different embedding on the plane. That is, the diagrams in 1 and 2 look different on the surface, but have isomorphic topologies. Thus, if students are able to ignore the spatial array of components and respond only to the connectivity relations, their answers to the two questions should be identical. Problem 4 was also isomorphic to problems 1 and 2. Problems 1, 2, and 4 describe two different networks joined by a bridging node (M, S, and B respectively). One network contains 4 nodes, and the other overlapping network contains 2 nodes (C and M, X and S, E and B). In networks, the bridging function is important, as it allows for the partitioning of networks into modular, manageable entities – indeed, the Internet can be thought of as such a hierarchical partitioning on a large scale. Students were expected to realize that all shortest paths with C as a terminal in problem 1 need to go through M – but that the shortest paths to Y from B, M, and C do not go through R. This presupposes they understand the diagramming convention, shortest paths, and bridges.

Problem 1 Problem 2

Problem 3 Problem 4

Imagine a network configuration in which Nodes A, B, C, and D are on a shared Local Area Network (LAN) and Node E is connected to node B through a different networking connection (assume machine B has two networking cards, one to connect to the shared LAN, and one to connect to node E). List all shortest paths between all pairs of nodes.

Fig. 3. The topology test questions

Students were given an example, and then asked to enumerate all shortest paths between the nodes in the graph. For problems 1, 2, and 4, there are twenty paths (Problem 1: YR, YB, YM, YMC, RY, BY, MY, CMY, RB, RM, RMC, BR, BY, CMR, BM, BMC, MB, CMB, MC, CM). For problem 3, there are sixteen paths (YT, YTJ, YW, YWJ, WY, WJ, WYT, WJT, JT, JW, JTY, JWY, TJ, TY, TYW, TJW). Students were instructed that all shortest paths should be enumerated.

For the problems requiring generation of shortest paths from pre-existing diagrams - problems 1, 2, and 3 - only two types of errors could occur. Students could list paths that were not shortest paths; these are errors of commission. Commission errors are a consequence of not understanding the topology represented by the bus convention. For example, in problem 1, listing YRBMC as a path is a commission error – the shortest path between Y and C is YMC. Thus, any commission errors are a consequence of failing to understand the essential concepts taught in the class. An error such YRBMC would suggest the students are reading the diagrams sequentially – and superficially - rather than responding to the deep structure of the diagram. This error is understandable, in that the spatial arrangement on the diagram – B is between R and M – may suggest to some that paths will include intervening nodes.

The second type of error is an omission error, failing to list one or more shortest paths. If students generate paths in reading order, starting from the upper left and proceeding left to right and top to bottom, then they should be more likely to omit backwards paths than forwards paths, where forwards means starting upper left and backwards means starting lower right. For problem 3, reading-order expectation is more counter-clockwise omissions than clock-wise.

In the case of problem 4, where students are asked to produce a diagram for a system containing a bus, and then enumerate the paths, the diagram itself should be diagnostic. The production of chains or rings suggests a sequential bias. Organizing the elements from left to right in the diagrams according to order of mention in the statement of the problem constitutes evidence for the reading order bias. For the enumeration of paths, the predictions here are the same as for the first three problems. In addition, because the diagram-generation task provides two opportunities for error, in translating the text to diagram and in interpreting the diagram, more shortest path errors (commission errors) were expected in problem 4 than in the equivalent problems 1 and 2. Specifically, for problem 4, using the appropriate diagrammatic representation, as shown in Fig. 4, should lead to better results.

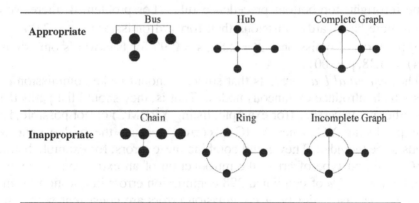

Fig. 4. Several possible diagram types for problem 4

Results

Problem solutions were coded for type of errors (omissions, commissions), and solution strategy. For problem 4 only, the type of diagram as shown in Fig. 4 was also coded.

The *reading order bias* predicts that students should list more paths starting from the upper left than starting from the lower right for problems 1 and 2; this translates into more forward paths than backwards paths. Some students, however, may have presupposed reversibility of paths; that is, they may have intentionally only listed forward paths and presupposed that each of them could be reversed to constitute a backwards path. Therefore, students who listed only forward paths for a question were eliminated from analyses of the reading order bias (this eliminated 2, 5, 4 and 1 student, respectively, for Problems 1-4). A dependent-groups t test revealed that there were more backwards omissions than forward omissions for both problem 1 (\bar{X} = 1.64, s = 2.24 for forward omissions, \bar{X} = 2.11, s = 2.71 for backwards omissions; t(65) = -2.98, p = .004), and problem 2 (\bar{X} = 1.60, s = 2.49 for forward omissions, \bar{X} = 2.02, s = 2.87 for backwards omissions; t(62) = -2.54, p = .014).

For problem 3, the reading order bias predicts the listing of more clockwise paths than counterclockwise paths. Although there were more counterclockwise omissions (\bar{X} =1.08, s=1.61) than clockwise omissions (\bar{X} = .95, s=1.73), this effect did not reach significance (t(63) = .668; p = .506). For problem 4, a reading order bias could be tested for those students who produced their own diagrams, by coding directionality of paths using the same left-right, top-bottom precedence rule. For problem 4, there were again more backwards omissions than forward omissions (\bar{X} = 2.06, s = 2.49 for forward omissions, \bar{X} = 2.84, s = 2.99 for backwards omissions; t(64) = -3.38, p = .001).

The *sequential bias* predicts that students should make commission errors which introduce extraneous nodes. That is, they should list paths that are either not necessary (for example, listing YRBMC) or not possible, for example listing YC, when YMC is correct because the bridge node M needs to be included. They could combine these errors, for example listing YRC. The first type of error, the introduction of an extraneous node, accounted for 93.7% of combined 298 commission errors in questions 1 and 2. Thus, the vast majority of commission errors are consistent with a sequential bias. The second type of error, the omission of the bridge node in a path crossing the bridge, accounted for only 2% of the errors, and omission of the bridge node combined with an extraneous node accounted for another 1.7% of the time. There were other paths that fell into no obvious category – such as the inclusion of a node from the previous diagram, or single node paths – and these occurred 2.7% of the time. Thus, bridges were only omitted 3.7% of the time. For the most part, students did understand that information had to travel through the bridge node. Students could choose nodes in any order in the commission errors. But the paths in

general proceeded either forwards or backwards, confirming a sequential bias. Of all the commission errors in questions 1 and 2, only 14, or 4.7%, involved a change of direction – for example, BMY. Fig. 5 shows the ten most common forward direction errors and their frequencies in problem 1.

Fig. 5. Commission errors. Dark lines indicate the path; RBM, YRBMC, etc.

Because problem 4 presented two opportunities for error, in translating the text to a diagram and in generating the shortest paths (presumably from the diagram), there should be more errors on problem 4 than problems 1 and 2, even though all problems are identical in structure. Indeed, more omissions were observed for problem 4 (\bar{X} = 5.45, s = 5.46) than for problem 1 (\bar{X} = 4.0, s = 5.03) and problem 2 (\bar{X} = 4.47, s = 5.94), and this difference is significant (F(1,66) = 7.58, p = .008). However, there were not significantly more commission errors in problem 4 (\bar{X} = 2.51, s = 4.15) than for problem 1 (\bar{X} = 2.26, s = 4.09) and problem 2 (\bar{X} = 2.21, s = 4.21, F(1,66) = 0.45, p = .504). Problem 4 elicited a range of diagrams from students (Fig. 6 and Table 1). Five students produced no diagram while attempting to answer problem 4.

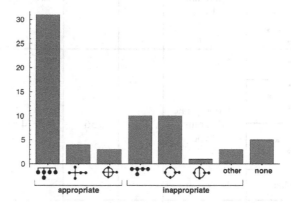

Fig. 6. Frequency of production of different diagram types for problem 4

Effectiveness of the diagram types was calculated based on number of path errors (Fig. 7). The mean number of omission errors for the use of a self-created appropriate diagram type (\bar{X} = 2.84, s= 4.30) was compared to the number of omissions for use of a self-created incorrect diagram type

(\overline{X} = 8.71, s = 4.56) and to no use of a diagram (\overline{X} = 9.60, s = 7.13). A between-subjects ANOVA showed that the use of a correct diagram resulted in significantly fewer omission errors compared to using an inappropriate diagram or no diagram (F(1, 64) = 21.47; p < .001). The two ineffective strategies - using an inappropriate diagram type and no diagram - did not differ in the number of omission errors (F(1,64) = 0.15, p = .696).

For commission errors, the mean number of errors for the use of a self-created appropriate diagram type (\overline{X} = .47, s = 1.55) was compared to the use of a self-created inappropriate diagram type (\overline{X} = 5.54, s = 5.19) and to no use of a diagram (\overline{X} = 3.40, s = 3.28). An ANOVA showed that the use of a correct diagram resulted in significantly fewer commission errors compared to using an inappropriate diagram or no diagram (F(1, 64) = 15.67; p < .001). The two ineffective strategies - using an inappropriate diagram type and using no diagram - did not differ in the number of commission errors (F(1,64) = 1.61, p = .209).

Table 1. Frequency of production of different diagram types for problem 4

freq	type of diagram	classification	Freq	% use	mean (sd) omissions	mean (sd) commissions
31						
4		appropriate diagram Type	38	57	2.8 (4.3)	0.5 (1.6)
3						
10						
10		inappropriate diagram Type	24	36	8.7 (4.6)	5.5 (5.2)
1						
3	other					
5	none	None	5	8	9.6 (7.1)	3.4 (3.3)
67	(Total)	(Total)	67	100	5.5 (5.5)	2.5 (4.1)

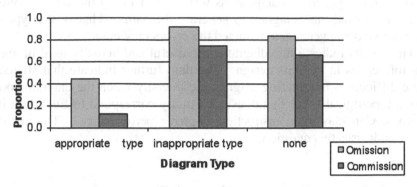

Fig. 7. Proportion of students making omission or commission errors, by appropriateness of diagram type

Discussion

Students in an introductory course in systems design were asked to solve four design problems. Three involved making inferences from a supplied diagram; a fourth entailed creating a diagram and making inferences from the created diagram. Two of the diagram problems (1 and 2) and the text-to-diagram problem (4) required understanding network buses and network bridging – that is, understanding the topological structure of the problem and the conventions used in diagrams to represent such structures. Students were expected to have difficulties interpreting and creating these kinds of diagrams. Specifically, they were expected to exhibit two biases, a sequential bias and a reading-order bias.

The sequential bias predicts the introduction of extraneous nodes in paths. Because B is between A and C on the diagram, students include B in the listed path – even though the bus convention is meant to convey that in the network topology, A connects directly to C. This bias showed up strongly in our data set. The sequential bias also predicts that only commission errors introducing extraneous nodes in their surface sequential order will occur: e.g. RBMC but not BRMC in problem 1.

What might explain these types of errors? Because we live in a Euclidean world, we may tend to make Euclidean inferences, based on the proximity of objects. More specifically, we may read the diagram imagining that we are traversing the lines of the diagrams as if they were paths.

Because diagrams are too complex to be comprehended as wholes, they must be examined in sequence. The default sequence is reading-order; this bias predicts more omissions for inferences that don't correspond to reading order. This prediction, too, was borne out by the data. When students

were asked to generate a diagram as well as generating the set of shortest paths, they used their diagram to generate the paths. That is, the type of diagram students generated predicted the errors they made.

The results indicate that diagrams are useful and actually used in making inferences in systems design. The data further indicate that students have difficulties interpreting diagrams, especially when the diagrams portray a topological space that does not exactly correspond to Euclidean intuitions. Can classroom instruction improve performance? The second study addresses this question.

Study 2: Posttest Generating Network Topologies

Methods

Late in the course, 35 Master's level students from two sections of the design course were asked to solve Problem 4 a second time (the "posttest"). Thus, the posttest data was available from two out of the four sections that participated in the pretest. The posttest was coded identically to the pretest version of problem 4, and the results were compared. The expectation was improved diagrams and improved inferences as a consequence of the classroom instruction and exercises.

Results

Although students did make fewer omission errors in the posttest ($\bar{X}=$ 3.85, s = 5.02) than in the pretest ($\bar{X}=$ 4.48, s = 4.90), indicating decreased reading order bias, this difference did not reach significance (t(32) = .73, p = .470). Subjects made fewer commission errors, indicating decreased sequential bias, in the posttest ($\bar{X}=$.97, s = 2.44) than in the pretest ($\bar{X}=$ 2.52, s = 3.80) and this difference was significant (t(32) = 2.11, p = .042). Furthermore, of the 33 students who participated in both tests, 12 students (36%) gave a fully correct answer in the pretest, while 18 (55%) gave a fully correct answer in the posttest. The reduction in commission errors demonstrates increased understanding of network topology.

Table 2 shows the frequency of producing bus, other, and no diagrams on the pretest and posttest. Those who used a bus on the pretest either used it again on the posttest or used no diagram on the posttest. Impressively, 13 of the 18 students who failed to use a bus on the pretest used a bus at post-test. This increase in use of the bus is marginally significant (χ^2 (1)= 3.02; p = 0.082).

Table 2. Diagram Type Constructed for Problem 4

		Posttest			
		bus	inappropriate	none	Total
	Bus	11	0	4	15
Pretest	other appropriate	4	1	1	6
	inappropriate	9	3	0	12
	None	0	0	0	0
	Total	24	4	5	N = 33

Do students who produce better diagrams also produce better solutions? Table 3 shows the effectiveness of the diagram types for promoting correct inferences. Fourteen out of the 26 students who drew the conventional bus diagram got the problem correct, while only one out of four students who tried to use another type of diagram did so. A chi-square test of independence for type of diagram used (bus versus other graph versus no graph) and solution correctness was conducted. The results were marginally significant ($\chi^2(2)=5.55$; p = 0.062). These results suggest that learning to choose the right diagram convention is key to solving the problem.

Table 3. Posttest Problem 4: Use of appropriate (bus) and inappropriate diagram types, with solution correctness.

Diagram type	Correct answer	Incorrect answer	Proportion Correct	N
Bus	14	12	.54	26
inappropriate	1	3	.25	4
none	5	0	1.00	5
(Total)	20	15	.57	35

In sharp contrast to the pretest, in the posttest, the five students who did not draw any diagram all got the problem correct; all five had produced correct diagrams on the pretest. This finding is intriguing, but not unprecedented. Often, it is novices who benefit or need diagrams, while experts can solve the problems without that support (e. g. [19], [20]). A chi-square test of independence for an association between the use (or no use) of a diagram and solution correctness on the post-test was significant ($\chi^2(1)=$ 4.375; p = 0.036). These students had entered the course with a high level of proficiency, and their proficiency appears to have increased to the point that they no longer needed the diagrams.

Students' diagrams provide feedback to instructors

As we have seen, diagrams can be useful to students in problem solving. Student-produced diagrams also give valuable feedback to instructors. Producing a diagram encourages extracting the essence of a problem and representing it completely. Conceptions and misconceptions may be more evident in students' diagrams than in their verbal responses.

For example, Fig. 8a shows a drawing of the network as a ring rather than as a bus. Using this configuration, the student commits commission errors – in a bus-based LAN, there is no need for a path such as DCBE.

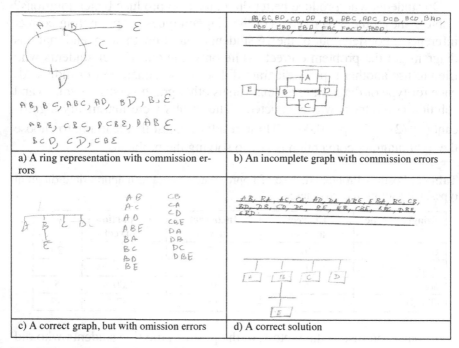

a) A ring representation with commission errors

b) An incomplete graph with commission errors

c) A correct graph, but with omission errors

d) A correct solution

Fig. 8. Examples of post-test diagrams

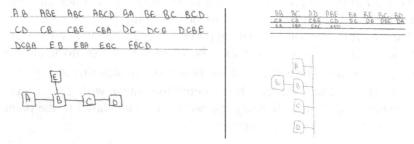

Fig. 9. A student's pretest and posttest, showing improvement

Fig. 8b would have been topologically correct if there had been a link from A to C. Because of the missing line, commission errors are made – ADC rather than AC, for example. Fig. 8c has no commission errors. However, there are omission errors – the student has forgotten links back from node E. This was the most common type of error on the posttest.

Fig. 9 shows one student's pre- and posttest solutions. The pretest had an incorrect diagram and errors; the posttest diagram was fully correct. While this degree of improvement did not happen as often as we had hoped, students got much better at drawing the diagrams. This led to fewer commission errors overall. But the omission errors persisted.

Discussion

Students in a systems design class were asked to generate diagrams to solve design problems that included a logical bus topology early in the semester and late in the semester. Compared to the pretest, in the posttest more students produced diagrams that represented a bus, and more students were able to correctly produce all shortest paths and fewer paths that were not shortest. On the whole, the students who produced more satisfactory diagrams also produced better solutions. A subset of students was able to produce the correct and only the correct paths without a diagram at post-test, though these students all produced a diagram earlier in the semester, evidence that experts often no longer need an external representation to solve a problem. Presumably, experts have mentally unitized the problem so that it requires less working memory capacity, hence less need of an external representation.

Nevertheless, even at the end of the semester, there was evidence for both biases: the sequential bias, indicated by commission errors that exhibit a lack of understanding of topological space, and the reading order bias, indicated by omission errors, especially backwards omission errors. If students fully understood the structure of the system, they would not have made either error. They would not make commission errors because they would understand that all nodes on a bus are directly accessible, and they would not make omission errors because they would know how to generate and check a complete set of paths. Commission errors decreased - suggesting that most students did master topological concepts. Omission errors remained fairly constant – suggesting that the reading order bias needs to be counteracted with a different form of instruction. In the bigger picture, overcoming commission errors is more important – topological errors may lead to a drastic misestimation of a system's performance.

Conclusions

Sketches and diagrams are an essential component of design of information systems. Systems are often large, so they overload limited capacity working memory, a problem solved by externalizing the structure (and perhaps function) of a system by committing it to paper. An external representation serves as a basis for inferences and a basis for generating new designs. Sketches and diagrams are abstractions, and the successful ones select and emphasize the correct information while omitting information that is distracting. Diagrams and sketches facilitate inferences by capitalizing on their physical features, such as proximity, angle, and connectivity. They foster creativity by enabling alternatives, expansions, reductions, revisions. Sketches and diagrams are especially appropriate for design, as they can capture complex relations among parts and wholes.

All these virtues and more depend on successful reading and interpretation of diagrams and sketches, skills that depend on expertise. Even "realistic" undoctored photographs carry information that novices may not readily detect; examples include surveillance photographs and X-rays. Because diagrams and sketches are such common artifacts, the need for expertise in their use is not always recognized. Reading and interpreting diagrams are affected by habits and biases from reading and interpreting the visual world and other common external representations, such as maps. These habitual ways of interacting can lead to failures and to errors.

Here, we studied sketches produced by students of systems design in the service of problem solving, making inferences from the sketches. The task given students, generating the set of shortest information paths from a specific configuration, is in some ways similar to finding routes on a map. It differs crucially from a map in that the systems contain a logical bus, a set of links that are mutually connected. From any node on the bus there is a direct connection to any other node on the bus. The graphic convention for the bus shows elements attached to a line, and the convention causes difficulties for students. In the present experiments, students exhibited the difficulties by generating paths that include unneeded nodes – errors of commission. Because these extra nodes are virtually always listed in the order that they appear along the path connecting the endpoints, we call this bias a *sequential* bias. The bias is a tendency to assume that all nodes passed in the scanning sequence must join the path.

The second bias exhibited by students was a *reading order* bias. Students tended to generate paths in the canonical reading order for European languages, from upper left to lower right. They often failed to generate all

the correct paths (errors of omission), and there were more backwards omissions than forward omissions.

Diagrams can be used to overcome the sequential bias; in a previous study a well-crafted diagram helped students understand that the two middle processes in a four-process system could be done in either order [21]. For the more complex problems used here, instruction over the course of a semester helped many students to master the concept of a logical bus and then to both diagram it appropriately and use it to make correct inferences.

While the logical bus is the convention used most often in industry, it causes confusion among students. In all fields, communications get abbreviated with use, and the abbreviations simplify and even distort some of the information. This can cause difficulties for the uninitiated, as it did here. Perhaps students need to work through simpler forms of connectivity and clearer forms of diagrams before they understand the current conventions in a field (the bus in this case). Indeed, physical devices corresponding to chains and rings have been used in network design and construction, but their usage has been eclipsed by fully connected topologies, which offer greater flexibility and reliability. Each of these five representations has been used in systems design in the past, and each was produced by at least one student in the present course. So the range of student performance exhibited here spans the development of design conventions, an instance of ontogeny recapitulating phylogeny, common in other domains (e. g. [2]). For these reasons, it may make sense to teach students these concepts, their instantiations, and their equivalences in roughly the order in which they have evolved, leaving the most densely coded conventions for last. Because diagrams in other domains are vulnerable to similar difficulties and misconceptions, this practice, of scaffolding changing diagrams and changing conceptual structures on each other, may have wide applicability.

Acknowledgements

The authors are grateful for the support of the National Science Foundation under grant IIS-0725223 as well as to NSF REC-0440103 and the Stanford Regional Visualization and Analysis Center.

References

1. Larkin JH, Simon H (1987) Why a diagram is (sometimes) worth ten thousand words? Cognitive Science 11: 65–99

2. Tversky B (2001) Spatial schemas in depictions. In M Gattis (ed), Spatial schemas and abstract thought, MIT Press, Cambridge, MA
3. Tversky B, Zacks J, Lee PU, Heiser J (2000) Lines, blobs, crosses, and arrows: Diagrammatic communication with schematic figures. In M Anderson, P Cheng, V Haarslev (eds), Theory and application of diagrams, Springer, Berlin
4. Nickerson JV (2005) The meaning of arrows: Diagrams and other facets in system sciences literature. 38th Hawaii Int. Conference on System Sciences
5. Taylor HA, Tversky B (1992) Descriptions and depictions of environments. Memory and Cognition 20: 483-496
6. Committee on Support for Thinking Spatially (2006) Learning to think spatially. The National Academies Press, Washington, DC
7. Peterson LL, Davie BS (2007) Computer networks: A systems approach. Morgan Kaufmann, Amsterdam
8. Simon HA (1969) The sciences of the artificial. MIT Press, Cambridge
9. Larkin JH, McDermott J, Simon DP, Simon HA (1980) Expert and novice performance in solving physics problems. Science 208: 1335-1342
10. Chi M, Feltovich P, Glaser R (1981) Categorization and representation of physics problems by experts and novices. Cognitive Science 8: 121-152
11. Suwa M, Tversky B (1997) What do architects and students perceive in their design sketches? A protocol analysis. Design Studies 18: 385-403
12. Hevner AR, March ST, Park J, Ram S (2004) Design science in information research. MIS Quarterly 28: 75-105
13. March ST, Smith GF (1995) Design and natural science research on information technology. Decision Support Systems 15: 251-266
14. Charete RN (2005) Why software fails. IEEE Spectrum 42: 42-49
15. Harel D (1988) On visual formalisms, CACM 31: 514-530
16. Fowler M (2004) UML distilled: A brief guide to the standard object modeling language. Addison-Wesley, Reading, MA
17. Lange CFJ, Chaudron MRV, Muskens J (2006) In practice: UML software architecture and design description. Software IEEE 23: 40-46
18. Nickerson JV (2006) Teaching the integration of information systems technologies. IEEE Transactions on Education 49: 1-7
19. Corter JE, Zahner DC (2007) Use of external visual representations in probability problem solving. Statistics Education Research Journal 6: 22-50
20. Heiser J, Tversky B, Silverman M (2004) Sketches for and from collaboration,. In JS Gero, B Tversky, T Knight (eds), Visual and spatial reasoning in design III, Key Centre of Design Computing and Cognition, Sydney
21. Glenberg AM, Langston WE (1992) Comprehension of illustrated text: Pictures help to build mental models. J. of Memory and Language 31: 129-151

Form as a Visual Encounter: Using Eye Movement Studies for Design Reasoning

Ameya Athavankar
CEPT University, India

In spite of the architect's interest in controlling viewer's attention, design research has not identified attributes that control attention as measurable and controllable variables. Cognitive scientists, on the other hand have studied attention and shown how variables like complexity and order can be controlled to gain and maintain attention. This paper reports an experiment using patterns created based on information theoretic principles and eye tracking to reveal various interrelated insights that explain attention, visual focus and interest. It extrapolates these findings to understand architectural forms and concludes by offering a set of design strategies or a visual rationale for creating form.

Introduction

Of the many concerns that decisively drive the making of an architectural form is its quality as a visual and perceptual experience. While architects and designers are quite conscious of the quality of their visual expression, the fact remains that this is not often acknowledged as a design problem with a rationale of its own. Architectural criticism too has lacked objectivity in dealing with the matter and so has been of little value in this respect. As a consequence, most of them turn to their intuition or experience for decisions involving judgments of visual and perceptual quality. The situation calls for investigation of the rationale influencing visual decisions about architectural form that enables architects to go beyond the intuitive approach.

In Search of a visual rationale

Design-related visual research has dealt with the 'look of the environment' or issues relating its visual form in some detail. Lynch's study was one of first to point out the visual importance of the environment and produced several generic insights such as 'imageability' and 'legibility' as attributes dealing with city form [1]. Martin Krampen reported a study conducted by Bortz, establishing the parameters that influence 'subjective impressions' describing the experience of viewing building facades [2]. Another particularly interesting study by Sanoff aimed at establishing the relation between viewers' judgment of 'visual satisfaction' with an environment and the visual attributes influencing it [3]. Sanoff's study emphasizes the importance of attributes such as complexity, novelty and ambiguity in positively influencing the judgment of visual satisfaction. The findings, Sanoff felt, supported Berlyne's experiments in complexity [4]. To Berlyne, these attributes were 'conditions leading to arousal and attention'. His study goes a step further in establishing order and organization as attributes that keep arousal within limits.

However, the studies treat visual attributes 'complexity' or 'order' as discrete and undefined adjectives. Though they are insightful, the relevance of the above studies to architectural design seems limited as they do not point out what makes a form perceivably 'complex' or 'ordered'. In other words, these studies do not suggest a method for controlling the attributes like 'complexity' or 'order'. This limitation is rooted in the inability to deal with these attributes as measurable properties of form. It underscores the need for a different framework where attributes 'complexity' or 'order' may be treated as measurable properties of form instead of discrete and undefined adjectives.

Complexity and order as measurable attributes

The information theoretic framework successfully overcomes some of the above limitations. It treats visual attributes such as complexity and order (as information content and redundancy) independent of the perceiver as measurable properties of form. This is perhaps one of the main reasons for its appeal to pattern perception. The framework also allows creating visual patterns with attributes that may be precisely described in informational terms. Such patterns have been used to measure the effect of complexity as well as order in different perceptual tasks.

Controlling complexity in visual patterns

Studies involving the use of patterns with measured complexity were pioneered by Fred Attneave [5]. He created two dimensional `patterns using matrices of three definite sizes (each twice the size of the previous). In a given pattern, each cell of the matrix represented an event with two possible outcomes: it could either contain a dot or could remain empty. Using this technique, Attneave created two sets of patterns. In the first set of patterns, the states of all cells of the matrix were determined independently using a table of random numbers while the second set contained symmetrical patterns of the same matrix sizes created simply by reflecting one half of the patterns belonging to the first set. The complexity of a pattern equaled the total number of cells in the matrix.

Complexity, order and memory for patterns

The patterns were then used to study viewers' performance in three different perceptual tasks: immediate reproduction, delayed reproduction and identification.

The results led Attneave to conclude that constraints affect the spatial relationships between elements and create 'dependency' between. This seems to build a certain amount of predictability due to which remembering a part of the pattern is enough to reconstruct the rest. So, in constructing a pattern, he concluded, any visual decision (location of a dot) that is dependent on the outcome of a previous choice or decision has an element of 'order' in it. Perceivable order thus seems to manifest as dependency among decisions while perceived visual complexity could be seen as a relation between the two variables, the *number* and *independence* of decisions (in locating dots) required to (re)construct a form.

Attneave's study offers an effective method to capture 'complexity' and 'order' as measurable and controllable attributes based on the number and independence of decisions required to (re)construct a form. Viewing 'order' as dependency among decisions is gives the concept greater universality. (see Figure 1) It is possible to account for various types of constraints (location, shape, color) as dependencies among visual events. However, it partially helps overcome the limitations of Sanoff's study. It does provide a method to measure attributes of form but not reveal their effect on attention or arousal. This understanding is of significance to architects and designers involved in the process of architectural form making.

Fig. 1. Shows examples of dependent and independent decisions. In the example on the left elements 1,2,3,4,5 share a spatial dependency while 6, 7 are spatially independent. In the example on the right 1,2,3 are dependent shape decisions while 4, 5 are independent shape decisions.

Research focus

There can be little doubt about the fact that there are aspects of attention that are of importance to architects and designers. For instance, what viewers are likely to notice or find interesting, what makes a likely foreground and what recedes to the background significantly influence visual expression and are questions of interest to architects. The aim of this study is thus to measure the effect of form on attention and explore the significance of the insights to the process of architectural form making. This study will thus try to establish:

What in a form is likely, unlikely, or more likely to (a) evoke interest or invite attention (b) sustain interest or retain attention. Further, what properties of a form are likely to arouse or capture viewers' focus and on the other hand when do viewers show a tendency to wander?

This paper, due to reasons discussed later, uses controlled experimental settings and stimuli. It then attempts to extend some of the insights to present a new understanding of architectural forms and visual strategies employed by architects to achieve some of the objectives discussed above.

Experimental approach: Attention and eye-behavior

The studies cited earlier use instruments such as semantic differential for recording descriptive responses to visual environments. This study takes a similar experimental route to seek the answers to the above questions. However, as opposed to the above studies, it ensures greater objectivity by:

- Studying eye movements instead of relying on verbal judgments
- Using forms with controlled and measurable attributes as stimuli.

Eye movements have been considered by researchers to be an 'overt behavioral manifestation' of visual attention [6]. Besides, technological developments in eye tracking have made it possible to record and precisely measure and study various characteristics of eye movements. Although its early use was restricted to fields such as psychology and human factors, in recent times eye tracking has found several other applications in many areas of visual research. These include reading, human computer interaction, advertising, visual art and films [7].

The experimental approach involves isolating visual characteristics of form and capturing them in a set of non-representational forms as controlled and measurable attributes. It proceeds to seek differences in eye movement responses to these forms so as to reveal the effect of measured changes in attributes. The insights or principles derived from the experiment are then extrapolated to understand architectural forms that are difficult to measure.

Although more direct insights could have been obtained by recording viewers' eye movements in actual settings, available eye tracking instruments did not allow for this. Also, as research has shown that eye-behavior in the real world is influenced not only by visual but also semantic characteristics and familiarity or prior knowledge of a scene [8].The interaction of visual and semantic characteristics also poses other difficulties. This became apparent in initial experiments that used photographic representations of building facades and seemed to reduce objectivity in interpreting eye movement data. As would be of interest to architects and designers in particular, it was decided to focus on studying visual (or structural) characteristics of form or its pre-meaning perception.

It is true that semantics is likely to significantly influence not only eye-behavior but also the 'look' of an architectural form. However, it may be argued that its role is restricted to providing an overall governing visual framework. It is unlikely to greatly influence architects' local visual decisions about form and the effect of this on visual attention cannot be denied. This study focuses only on establishing visual attributes and their role in influencing attention. In spite of the effect of semantics or prior knowledge, such understanding continues to hold valuable insights for architects. This, in no way implies that it underrates the influence of these factors. It merely attempts to serve as a pilot enquiry and must be seen as a starting point for studying various aspects of attention and its implications to design.

Experimental design

In order to focus on visual attributes (and eliminate semantics) nine non-representational patterns were created based on the information theoretic principles used by Attneave [1], [9]. As in Attneave's study, differential complexity and order were created through measured changes in variables *matrix size* (number of elements) and *spatial independence* of elements.

Constructing sample patterns

The visual field or display of 4:3 (1024x768) was assumed to consist of matrices of the same proportions. The sizes of matrices were fixed at three different levels: 48 (8x6), 192 (16x12) or 768 (32x24) cells. Each cell of the matrix represented an event with two possible outcomes. It could either be blank or could contain a dot. The overall probability or the total number of dots in a pattern was fixed at 1/4 (12 dots), 1/8 (24 dots) and 1/16 (48 dots) for the three levels. To begin with positions of dots were fixed in a regular or homogeneous arrangement to create three patterns (S11, S21, S31). These patterns were then reproduced with 25 percent, (S12, S22, S32) and 50 percent (S13, S23, S33) displacements in the dot-positions using a random number generator. The result was a set of nine sample patterns with three different levels of matrix size and three degrees of spatial independence of elements. (see Figure 2)

Procedure

The nine patterns were mixed with five similar patterns and shown to 8 viewers while their eye movements were recorded. All the viewers belonged to the age group 20-30 years and were found to be naïve to the purpose of the experiment. The sequence and timing of slides containing patterns was controlled by 'Presentation v11' software. Viewers were instructed to themselves control the viewing duration through a response key.

Setup

The experimental setup consisted of two computers: the subject system (a Pentium V with a 72 dpi 13" LCD monitor set to 1024x768) used for displaying the patterns and the operator system (SMI's REDIII and iViewX system) for recording eye movements. The subject's monitor was placed at 900mm from the chin support. The REDIII is a contact-free and non-intrusive device which views the subject from a distance.

Fig. 2. Shows the analytical scheme for comparing trends in values for all five measures to reveal the independent and interactive effect of the variables.

Scheme for analytical treatment of eye movement data

Eye movement data was processed and analyzed using SMI's BeGaze v1.2.76. The software was used to visualize eye movements as scanpaths and attention maps as well as to identify and log fixation and saccadic data. To systematically study the independent and interactive effect of each variable, an analytical scheme was created. The set of nine sample patterns can be arranged in a 3x3 arrangement (see Figure 2) where:

1. The rows contain patterns with the same degree of spatial independence, but show an increase in the matrix size and number of elements from left to right while the columns contain patterns with same matrix size and number of elements, but show an increase in the

degree of spatial independence from top to bottom. So, row-wise and column-wise comparisons of data reveal the *independent effects* of increase in matrix size or number of elements and spatial independence. For eg. S11, S21, S31 and S11, S12, S13.

2. Patterns located along:

a. The right diagonal (connecting the top-left to the bottom-right corner) shows an increase in number as well as spatial independence of elements. For eg. S11, S22, S33.

b. The left diagonal (connecting the bottom-left to the top-right corner) shows an increase in number but a decrease in spatial independence of elements. For eg. S13, 22, 33.

Comparison of data along the right and the left diagonal with the data along the rows and columns reveals *interactive effects* of variables.

Scope and limitations of the analysis

A search revealed no previous instances of the use of eye tracking for purposes similar to this study. As a pilot, the study had the added task of establishing measures capable of capturing relevant changes in characteristics of eye movements in response to changes in attributes. This was an effort intensive task involving a breadth-first survey of many more measures than presented here. Importantly it created two limitations:

• Eye movements of a limited sample of 8 viewers could be considered.
• Small sample of 9 patterns could be used.

A set of 9 patterns are unlikely to yield totally consistent patterns across 8 viewers. The analysis was directed to making broad categorical inferences such as relative increase or decrease rather than making detailed enquires into actual quantities or degrees of change. It was restricted to comparing and observing trends in mean values calculated from data obtained over 8 viewers consistent with the analytical scheme for a variety of measures.

The small sample size of viewers ruled out the possibility of testing the results for their statistical significance or conducting an ANOVA. The limited number of sample patterns also had its implications. It may be recalled that the patterns were created using a random number generator. This method can sometimes result in unexpected, yet strong local grouping or Gestalts. Such grouping produced some inconsistencies, visible in the data. Ideally, as in case of Attneave's study the effect of such grouping should have been eliminated by considering a large number of samples of a pattern [1]. However, increasing the number of patterns would not only have stressed viewers but also produced an enormous amount of eye

movement data. Processing data for a large number of measures would be much beyond the scope of the study.

The conclusions of the study will thus be speculative and at times tentative in tone. They must be seen as initial findings that are in need of further study. However, the results seem promising and yield interesting insights into form and visual attention. Therefore are considered worth sharing.

Interpreting eye-behavior

A discussion on concepts of eye movements has been avoided here, for reasons of economy. Those interested in deeper understanding may want to refer to Yarbus's or Duchowski's book for a fascinating account of theory as well as applications of eye tracking [10], [7]. The results have been discussed in relation to the aims of the study so as to enable an assessment of whether the study has succeeded in answering the questions that were raised earlier.

Evoking visual interest

One of the questions the study aimed to answer dealt with the 'foreground-ness' of the entire group of dots or elements as a whole and their ability to evoke visual interest. It was framed as: What in a form is likely, unlikely, or more likely to evoke interest or invite attention? This section deals with the question in detail.

Fixations: Number and locations

Ratio of on-target fixations (Preferred fixation sites): The ratio of on-target fixations compares the number of fixations received by the entire group of elements (cells with dots) to the total number of fixations received by the pattern. It captures viewers' preference for fixation sites.

Significance: In a pattern, elements (as a whole) receiving more fixations relative to the background must have greater collective ability to evoke visual interest and therefore a greater foreground-ness as compared to those receiving fewer fixations. This collective ability among elements can be captured by the ratio of on-target fixations.

In usability research, ratio of on-target fixations has been used to determine the efficiency of scanning behavior [11]. Considering the

differences in experimental task, its use and interpretation have been suitably modified in this study.

Ratio of elements-hit or hit-rate (Chance of an element being fixated): The hit-rate compares the number of elements-fixated to the total number of elements in the pattern. It captures the overall chance of an element being fixated.

Significance: An element with a higher chance of receiving a fixation must belong to a group that evokes more visual interest as compared one where fewer elements receive fixations. This individual ability among elements can be captured by the ratio of elements-hit (fixated) or the hit-rate.

Independent and interactive effects

The effects of the variables on the measures (see Figure 3) are as follows:

Independent Effects: The (a) ratio of on-target fixations (b) hit-rate seems to increase as the spatial independence of elements increases and decreases when the number of elements increases.

Insight: Increased spatial independence among elements seems to improve their collective and individual ability to evoke visual interest while addition of elements seems to marginally diminish it.

Interactive Effects: The (a) ratio of on-target fixations (b) hit-rate seems to marginally decrease along the right diagonal. The decrease is less than the independent effect of increase in number of elements.The (a) ratio of on-target fixations (b) hit-rate seems to sharply decrease along the left diagonal. The decrease is more than the independent effect of either variable.

Insight: Reduction in the collective and individual ability of elements to evoke visual interest due to a four fold increase in the number of elements may partially be balanced by a 50 percent increase in spatial independence.

Insight: Increasing the degree of spatial independence and reducing the number of elements seems to severely diminish their collective and individual ability to evoke visual interest.

Consolidated insights

Due to commonalities in content as well as to enable a better comparison, the insights presented above will be discussed in 3.3.3.

Sustaining visual interest

The 'foreground-ness' of a group of elements cannot be fully studied without establishing what influences the ability of elements to sustain visual interest. One of the questions the study aims to answer was framed as: What in a form is likely, unlikely, or more likely to sustain interest or retain attention? This section will discuss the question is detail.

Fixations: Duration and location

Relative fixation time (Share of Fixation time): Relative fixation time compares time spent by viewers fixating elements to the time spent fixating on the entire pattern. It captures the share of fixation time received by elements.

Significance: A group of elements (as a whole) receiving a larger share of fixation time must have a greater ability to sustain visual interest compared to those receiving a relatively smaller share. This collective ability among elements may be captured by relative fixation time.

Cumulative or total fixation time spent within a certain area of the image in usability studies is interpreted as the amount of interest shown by viewers [12]. However, considering the experimental design here, it was necessary to neutralize the effect of differential viewing time. The cumulative fixation time (on elements) was measured relative to the total fixation time for the pattern.

Fixation time per element-hit (Dwell time over a fixated element): The fixation time per element-hit compares the total fixation time spent over elements to the number of elements fixated. It captures how much viewers dwelt over an element.

Significance: An individual element on which fixations dwell more, arguably, sustains more visual interest compared to one on which they dwell less. This ability among individual elements may be captured by the fixation time per element-hit.

Independent and interactive effects

The effect of the variables on the measures (see Figure 4) is as follows:

Independent Effects: The (a) relative fixation time seems to increase (b) fixation time per element-hit seems to increase when the spatial independence of elements is increased. The (a) relative fixation time seems to increase (b) fixation time per element-hit seems to increase when the number of elements is increased.

Fig. 3. Shows values of ratio of on-target fixations (ot) and hit-rate (hr) for all nine patterns and typical eye-scanpaths for selected patterns. Note how elements (dots) in patterns S13 and S33 pull attention towards themselves with large saccadic movements while elements in patterns S11 or S31 cease to do so. Also note that the scanpaths shown above are typical examples and may not be consistent with actual mean data.

Insight: Increased spatial independence seems to improve the collective and individual ability of elements to sustain visual interest.

Insight: Addition of elements seems to improve the collective ability but diminishes the individual ability of elements to sustain interest.

Interactive Effects: The (a) relative fixation time seems to sharply increase (b) fixation time per element-hit seems to marginally decrease along the right diagonal. The increase in relative fixation time is greater than the independent effect of either variable. The decrease in fixation time per element-hit is less than independent effect of increase in number of elements.

The (a) relative fixation time seems to marginally decrease (b) fixation time per element-hit seems to sharply decrease along the left diagonal. The decrease in relative fixation time is lesser than the independent effect of

spatial independence. The decrease in fixation time per element-hit is greater than independent effect of either variable.

Insight: Increasing the number and the degree of spatial independence of elements seems to improve their collective ability to sustain visual interest.

Insight: Reduction in the ability of individual elements to evoke visual interest due to a four fold increase in the number of elements may partially be balanced by a 50 percent increase in spatial independence.

Insight: Reduction in the collective ability of elements to sustain visual interest due to a 50 percent increase in spatial independence may partially be balanced by four fold increase in number.

Insight: Increasing the degree of spatial independence and reducing the number of elements seems to improve their individual ability to sustain visual interest.

Consolidated insights

The ability to evoke (invite attention) and sustain visual interest (retain attention) seems to be strongly related to the spatial independence of elements. Spatial independence creates uniqueness in inter-element relationships and unpredictability the relative positions of elements. This is what possibly improves their collective as well as individual ability to evoke and sustain interest.

Addition of elements, on the other hand seems to have an interesting effect. As one would expect more elements in a pattern competing for attention diminishes the ability of an individual element to evoke or sustain visual interest. Surprisingly, addition of elements does not seem to improve the collective ability of a group of elements to evoke visual interest or invite attention but it does help them sustain interest or retain attention.

Capturing visual focus

One of the questions that the study aims to answer concerns the ability capture visual focus. It was framed as: What properties of a form are likely to arouse or capture viewers' focus and on the other hand when do viewers show a tendency to wander? This section deals with the question in detail.

Fixation time: Spatial distribution

Ratio of Fixation/ Saccadic time (Distribution of fixation time): The ratio of fixation to saccadic time compares the time spent by viewers (in fixation) acquiring information from the pattern to the time spent searching for it (through saccades). A higher fixation/saccadic time indicates that fixation time was concentrated and fixations were retained in fewer locations about the pattern, while a lower value implies that fixations were short and scattered over many locations separated by saccadic search for these locations.

Fig. 4. Shows values of ratio of relative fixation time (rf) and fixation time per element-hit (fe) for all nine patterns and typical eye-scanpaths for selected patterns. Note how elements (dots) in patterns S13 and S33 receive more as well as longer fixations (larger circles) while elements in patterns S11 or S31 receive fewer and shorter fixations (smaller circles) Also note that the scanpaths shown above are typical examples and may not be consistent with mean data presented.

Significance: It may be argued that a pattern likely to capture visual focus must produce focused or directed scanning. On the other hand, a pattern unlikely to capture focus or one that divides or distributes focus may produce a wandering tendency in scanning. This should be reflected

in the spatial distribution of fixation time (sparse or concentrated) and may best be captured by the ratio of fixation/ saccadic time.

In usability research this measure has been used to determine the search efficiency, since it compares time spent by viewers acquiring and processing information to the time spent locating it [11]. Its use and interpretation here have been modified to suit the requirements of this study.

Independent and interactive effects

The effects of variables on the measures (see Figure 5) are as follows:

Independent Effects: The ratio of fixation/ saccadic time seems to increase when spatial independence among elements is increased and decreases when their number is increased.

Insight: Increased spatial independence seems to capture visual focus while addition of elements seems to divide and distribute it resulting in a wandering tendency.

Interactive Effects: The ratio of fixation/ saccadic time seems to marginally increase along the right diagonal. The increase is less than the independent effect of spatial independence. The ratio of fixation/ saccadic time seems to sharply decrease along the left diagonal. The decrease is less than the independent effect of either variable.

Insight: Reduction in the ability to capture visual focus due to a four fold increase in number of elements may be partially balanced by a 50 percent increase in spatial independence.

Insight: Increasing the number of elements and reducing the degree of spatial independence seems to least capture focus resulting in the highest tendency to wander.

Consolidated insights

The ability (or inability) in a pattern to capture viewers' focus seems to be strongly influenced by the spatial independence of elements. Increasing the degree of spatial independence seems to break homogeneity of a pattern. It creates unique and unpredictable grouping among elements and a hierarchy among regions. This characteristic seems to be decisively influence for the ability to capture focus. Addition of elements, on the other hand seems to have quite the opposite effect. More elements seem to create more groups. This seems to taper the hierarchy, dividing and distributing it among more regions. It is however possible to counter the reduction in the ability to capture focus by proportionately increasing the degree of spatial independence of elements.

Attention vs. memory for patterns

The insights listed above are particularly interesting when seen in relation to Attneave's findings on viewers' performances in memory tasks. His study attributes learning difficulty to the independence of decisions (locating elements) required to (re)construct a pattern. The findings discussed in the previous sections also continually emphasize the decisive influence of independence of elements (or decisions), on the ability to evoke and sustain visual interest or capture visual focus. (see Figure 6) It seems that some of the characteristics of a pattern that help elicit a strong visual response, also seem to make it more difficult to memorize.

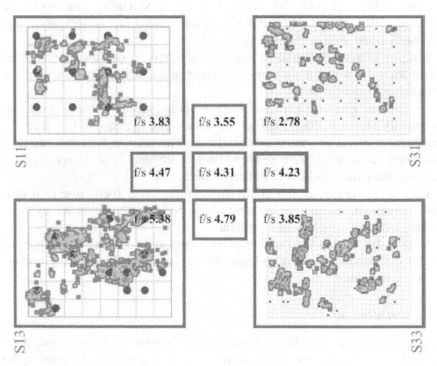

Fig. 5. Shows the values of ratio of fixation/ saccadic time (f/s) for all nine patterns and typical attention maps for selected patterns. Attention maps indicate the distribution of fixation time about a pattern. It is represented as a color gradient from violet (relatively less fixation time) to red (relatively more fixation time). Note how pattern S13 shows a dense distribution while S31 shows a scattered distribution. Also note that the attention maps shown are typical examples and do not represent mean data.

Relevance to architects and designers

This paper attempts to understand the relationship between form-attributes and visual attention through the analysis of eye-behavior. Using abstract patterns (with controlled attributes) it establishes principles that influence attention and arousal. In the sections that follow, an attempt is made to extend some of the ideas to create a different understanding of architectural form. With further research some of these ideas could also be developed as a design tool. In the near future eye trackers are likely to become increasing portable and possibly ubiquitous. This should enable direct use of eye tracking to deal with some of the issues addressed here. However, at this point of time laboratory route seems the best available option in terms of the ability to isolate and control attributes as well as objectively analyze eye movement data.

Insights as principles for architectural form-making

There is no doubt about the fact that controlling viewers' attention is one of the unstated objectives of an architect. It is not uncommon, for instance to find an architect or a designer taking special efforts to ensure that his form or its features capture the interest of viewers or so that their attention may linger on it more than what is functionally adequate. In other cases, he may wish that viewers do not notice a form or some of its features at all. He also hopes that they retain a certain memory of his form. The insights and findings presented here can be developed as visual strategies that could be employed by a designer to achieve some of these objectives.

Interestingly, the variables (number and spatial independence of elements) to some extent represent real visual situations that architects often encounter. For instance, an architect or designer may be confronted with the problem of creating entrances, displays or signage that must capture viewers' focus in settings such as commercial streets, airports, train terminals or shopping malls, where a large number of visual elements compete for viewers' attention. In other cases, he may be expected to design a showroom that not only evokes but also sustains interest. On the other hand, highway signage, advertisements or displays as instances where viewers do not have the luxury of too much viewing time. After all, influencing attention is his first essential step in establishing communication with viewers.

It must be noted that the perceived effect of form cannot be judged merely based on its ability to capture focus or invite and sustain interest. As Berlyne stated, an 'aesthetic product' is one that not only gains and

maintains the attention of the audience but also keeps arousal within limits [13]. Balancing of complexity and order in a message has always been critical in any communication. After all features which do not capture focus or interest that make time and attention available to those which do. The insights presented earlier allow a designer to carefully plan the perceived hierarchy within the features of his form influencing what is likely to capture focus and what is not.

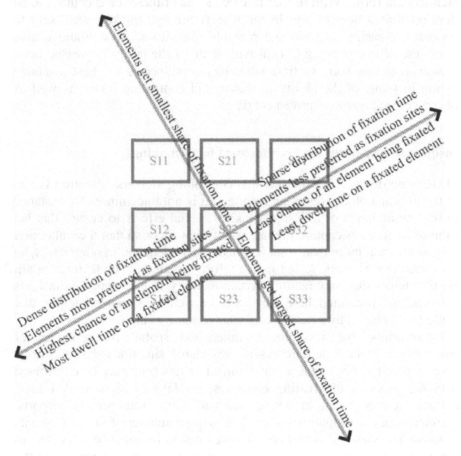

Fig. 6. Shows changes in scanpath characteristics due to the effect of measured changes in number of elements and spatial independence.

The concept of 'visual space'

The true significance of the work is in the creative use of the insights presented in the earlier sections to develop a deeper understanding of

process of creating forms going beyond the current intuitive approach. The relationships between insights can be exploited to convert them into overall visual strategies that architects can use to predictably influence visual response. To facilitate this relationships between insights, the spatial arrangement of (nine) patterns can be visualized as a continuous and limitless 'visual space' where attributes can be treated as controllable variables. (see Figure 7) The perceived effect of a form can be establishing through its position in visual space.

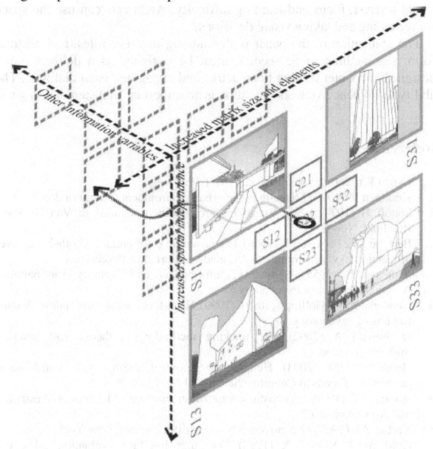

Fig. 7. Shows a representation of the 'visual space' and how built forms may take up different positions on it. The examples presented are (clockwise) German Pavillion at Barcelona, Lake Shore Drive Apartments at Chicago, Guggenheim Museum at Bilbao, Notre-Dame-du-Haut at Ronchamp.

The visual space can serve as an effective analytical tool for understanding architectural forms. Positioning carefully chosen forms in the space can reveal interesting visual strategies employed by a particular

architect or designer or during a particular time period or region etc. A preliminary attempt in this direction has been made here, by relatively placing renowned architectural forms in selected positions of the space. (see Figure 7) It seems to yield promising insights.

With further research the visual space may be developed as a design tool with that can account for many more variables and reflect the actual complexity of architectural forms. This should allow an architect to position his form (or its different features) and predict the relative effect on visual interest, focus and learning difficulty. Architects can use the space for reasoning and taking visual decisions.

The contention of the paper is that among its other roles, architectural form is something to be seen. It must be designed as a deliberate and designed encounter leading to an active and engaging visual dialogue. The ability to influence viewers' attention is an important first step in doing so.

References

1. Lynch K (1960) Image of the city. MIT Press
2. Krampen M (1979) Meaning in the urban environment. Pion, London
3. Sanoff H (1974, 1991) Visual research methods in design. Van Nostrand Reinhold, New York
4. Berlyne DE, Peckham S (1966) The semantic differential and other measures of reaction to visual complexity. Canadian Journal of Psychology
5. Attneave F (1955) Symmetry, information and memory for patterns. American Journal of Psychology 68
6. Henderson JM, Hollingworth H (1999) High-level scene perception. Annual Review of Psychology 50
7. Duchowski A (2002) Eye tracking methodology, theory and practice. Springer, London
8. Henderson JM (2003) Human gaze control during real world scene perception. Trends in Cognitive Science 11
9. Attneave F (1959) Stochastic composition processes. Journal of Aesthetics and Art Criticism 17
10. Yarbus AL (1967) Eye movements and vision. Plenum, New York
11. Goldberg J, Kotwal X (1998) Computer interface evaluation using eye movements: Methods and constructs. International Journal of Industrial Ergonomics 24
12. Josephson S (2004) A summary of eye movement methodologies. url: http://www.factone.com/article_2.html
13. Berlyne DE (1960) Conflict, arousal and curiosity. McGraw Hill, New York

The Role of Immersivity in Three-Dimensional Mental Rotation

Maria Kozhevnikov, Jodie Royan, Olesya Blazhenkova, and Andrey Gorbunov

George Mason University, USA

Recently, more realistic 3D displays have been designed as new, more ecologically valid alternatives to conventional 2D visual displays. However, research has thus far provided inconsistent evidence regarding their effectiveness in promoting learning and task performance. We are interested in the contribution of immersion to 3D image transformations and compare subjects' performance on mental rotation tasks in traditional 2D, 3D non-immersive (3DNI - anaglyphic glasses), and 3D-immersive (3DI - head mounted display with position tracking) environments. Our findings suggest that 2D and 3DNI environments might encourage the use of more "artificial" encoding strategies where the 3D images are encoded with respect to a scene-based frame of reference (i.e. computer screen). On the other hand, 3D immersive environments can provide necessary feedback for an individual to use the same strategy and egocentric frame of reference that he/she would use in a real-world situation. Overall, the results of this study suggest that immersion might be one of the most important aspects to be considered in the design of learning and training environments.

Mental imagery and spatial transformations

In order to mentally explore and travel within our environment, we need to represent three-dimensional (3D) visual-spatial images in our minds. Thus, research concerning 3D image generation and manipulation has important applications for the design of learning, training and testing environments. Recently, more realistic non-immersive 3D displays have been designed as new more ecologically valid alternatives to conventional 2D visual displays [1], [2], and [3]. Although these 3D environments are both more appealing to the user and richer in visual information, research has thus far

J.S. Gero and A.K. Goel (eds.), *Design Computing and Cognition '08*,
© Springer Science + Business Media B.V. 2008

provided inconsistent evidence regarding their effectiveness in promoting learning and task performance [4], [5]. Thus, one goal of the current research was to investigate how performance in different types of 3D environments would differ from that in a traditional 2D environment.

Another goal of this research was to shed light on an ongoing debate regarding mental imagery and to examine whether imagery preserves the same type of representation format for 2D environments as it does for 3D environments. This debate, which began in the 1970s, was initiated between Kosslyn's depictive or analogous approach to mental imagery [6] and Pylyshyn's [7] descriptionalist, anti-imagery standpoint. One of the primary ideas of Kosslyn's theory is that mental images are "quasi-pictorial" representations, in the sense that they preserve the spatial or topological properties of the physical objects being represented. According to Kosslyn's theory, mental images are generated in the visual buffer (i.e. retinotopically mapped areas V1 and V2 in the brain) and can be transformed, inspected, or manipulated, analogously to the physical manipulation of the objects they represent [8], [9].

Contrary to the preceding view, Pylyshyn and colleagues [7], [10], [11], [12], and [13], claim that spatial images are "structural descriptions", which are simply complex linguistic representations, with basic semantic parts representing object parts, properties and spatial relationships. Hinton, another descriptionalist, agrees with the basic premise of Pylyshyn's theory, but goes one step further, stating, similarly to Marr's geon theory [14], that complex images are represented as a hierarchy of parts. For example, an image of a human may be decomposed into six components, each corresponding to the head, torso, or one of the four limbs. At the second level of decomposition, the arm can be further segmented into the upper arm, forearm, and hand. According to the structural description theory, and in contrast to the analogous view of imagery, spatial transformations of images do not involve the mental rotation of images or their parts, but rather the computation of changes to some of the parameters of their intrinsic and projective relationships (i.e., relations that specify how the intrinsic frame of reference of the object is related to the viewer) [15].

One of the main behavioral experiments which lends credence to the analogue view of imagery was conducted by Shepard & Metzler [16]. In their study, participants were presented with depictions of pairs of novel 3D objects presented on a 2D screen, one of which was at a different orientation relative to the other. The task was to decide if the objects were the same or different. In each of these experiments, a positive, linear correlation was found between reaction time and the angle of displacement between the two objects. This finding was interpreted as evidence that par-

ticipants had mentally rotated one object into congruence with the other object in 3D space, which has been taken as a strong support for depictive nature of images. Moreover, the internal process of mental rotation was found to approximate physical constraints associated with rotations of actual objects.

Another aspect of mental rotation processing that has attracted much less attention, and which seems to be at odds with the analogue view of imagery, is the finding that subjects mentally rotate objects in depth as fast as (and in some cases even faster than) in the picture plane [16], [17], [18], [19], and [20]. If subjects were in fact mentally rotating 2D retina-based visual representations, the depth rotation would take longer than rotation in the picture-plane, since rotation in depth would have to carry out foreshortening and hidden line removal operations not required during picture plane rotation. Interestingly, Shepard & Metzler were the first to discover such a surprising phenomenon. They interpreted similar slopes for rotation in depth and in picture plane as indicative of latency being a function of the angle of rotation in three dimensions, not two, as in a retinal projection. To investigate this finding further, Parsons [19] conducted an extensive experimental study examining the rates of imagined rotation, not only around the three principal axes of the observer's reference frame, but also around diagonal axes lying within one of the principal planes (frontal, midsaggital, or horizontal) and around "skew" axes not lying in any of the principal planes. Consistently with Shepard & Metzler's findings, Parsons reported that the rate of rotation around the vertical axis perpendicular to the line of sight (Y-axis) was several times faster than that for the line-of-sight axis (X axis), suggesting that subjects rely largely on the "gravitational vertical" or "environmental" frame of reference. In addition, Parsons reported that the rotation rates for other axes (including rotation in depth around horizontal Z axis were as fast as or even faster than for the line-of sight-axis. Parsons concluded that this equal ease of rotation was contradictory to the analogous view on imagery but it was consistent with the hypothesis that spatial and shape information might be internally represented in three dimensions, and that observers, instead of rotating viewer-center 2D retinal images, might largely rely on representations containing "structural" information about spatial relations between the components of the object and their orientations with respect to the scene or environment in which the object lies (See the Figure 1 for the illustration of rotations around X, Y, and Z axes).

Fig. 1. Rotations around the three principle axes of rotation, X, Y, and Z.

One of the limitations of the previous experimental studies is that they have been conducted using traditional laboratory environments. In most of these environments, stimuli are presented on a 2D computer screen or another flat surface (e.g., a table-top in Hinton & Parsons' experiment, see [21]), which defines a fixed local frame of reference. The limited and fixed field of view defined by the four sides of a 2D computer screen (or table-top) may encourage the use of a more structural (propositional) encoding, during which the parts of the 3D image are encoded in relation to the sides of the computer screen or another salient object in the environment. In the above case, as Hinton & Parsons suggested, encoding in relation to the scene-based frame of reference would have a computational advantage: if the orientation of the objects were defined and computed relatively to the scene, an observer could move his/her body or head around without having to update all the representations of objects' orientations with every change of his/her perspective. In laboratory environments, subjects usually view the experimental stimuli exocentrically, "outside" of the scene in which the object lies. In real environments, however, an observer in many cases constitutes a part of the scene; being "immersed" in it and viewing it "egocentrically". Furthermore, in real world environments, objects might not be always embedded into a permanent and fixed local framework, and the perceived scene is constantly changing depending on the viewer's position while he/she is navigating and exploring the environment. In this case, the advantage of structurally encoding image parts in relation to the permanent scene-based frame of reference would be lost. Also, since the viewer becomes a part of the environment him/herself, the use of an egocentric (retina-based) encoding, in which an image is encoded as a 2D representation

on the retina and subsequently rotated mentally in a way analogous to physical rotation, might become more effective.

The goal of the current study was to investigate 3D mental rotation processes in three different environments: 3D Immersive (3DI) Virtual Environment, 3D Non-Immersive (3DNI) Virtual Environment and 2D conventional non-immersive visual display. These environments differ in terms of richness and manner of delivery of visual perceptual information, and our hypothesis is that they might encourage generation of 3D spatial images of different format, and that they could lead to different types of 3D transformation processes. A key difference between 2D/3DNI versus 3DI environments is that modern 3D immersive environments involve a head-mounted display (HMD) used in conjunction with a computer and head tracker. These 3DI environments are interactive in the sense that when the person turns his/her head, the image adjusts accordingly. This dramatically widens the "effective" visual field-of-view, giving the participant a sense of true immersion, which might encourage the participants to rely more on the egocentric spatial system which is used in many real-world navigational and locomotive tasks (see [22] for a review). Given that 2D and 3DNI displays do not provide the same level of non-visual cues for 3D image generation that would be experienced in a real-world environment, we suggest that only the 3DI environment will provide the necessary visual and non-visual cues to encode and manipulate 3D spatial images in a format that preserves perspective properties of objects in accordance with the depictive theory of imagery. In contrast, non-immersive environments might encourage encoding of abstract "structural" information about 3D spatial images in line with descriptive view of imagery.

Method

Participants

Sixteen undergraduate students (8 males and 8 females, average age = 21.5) from George Mason University participated in the study. They received either course credit or monetary compensation.

Materials

Each participant completed the Mental Rotation (MR) task, which was a computerized adaptation of Shepard & Metzler's version of the task, in three different environments: 3DI, 3DNI, and 2D. There were 72 randomly

ordered trials. For each trial, participants viewed two spatial figures, one of which was rotated relative to the position of the other. Subjects were to imagine rotating one figure to determine whether or not it was identical to the other figure and to indicate their decision by pressing the left (same) or right (different) button on a remote control device. Participants were asked to respond as quickly and as accurately as possible. The next trial began immediately, following the button press. Twelve rotation angles were used: 20, 30, 40, 60, 80, 100, 120, 140, 150, 160, and 180 degrees. In addition, the figures were rotated around 3 spatial coordinate system axes including the picture (X), vertical (Y), and depth (Z) (see Figure 2). Each test included: 12 trial groups for the 12 rotation angles, 3 trial pairs for the 3 axes, and each pair had 1 trial with matching figures and 1 trial with different figures; thus, there were 72 (12 x 3 x 2) trials in total. Vizard Virtual Reality Toolkit v. 3.0 [23] was used to create the scenes and capture dependent variables (latency and accuracy).

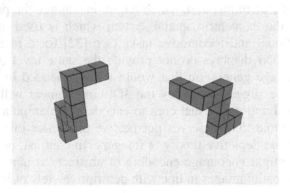

Fig. 2. Example of a MR test trial, used in the current study.

In the 3DI virtual environment, scenes are presented to the participant through a stereo head-mounted display (HMD) with a visual field of 150 degrees (see Figure 3a). The participants viewed an environment room containing only Shepard & Metzler's shapes presented in front of them. The position tracking system [24] permits full 3D optical tracking of up to 4 wireless targets over large ranges (more than 10 x 10 meters) with sub-millimeter precision. In conjunction with a gyroscopic orientation sensor, it supports the real-time picture-to-position simulation in virtual reality when any movement of subject's head immediately causes a corresponding change of the picture he/she sees in the head-mounted display. In the 3DNI environment, scenes are presented to the participant on a computer screen. Stereoscopic depth is provided by means of anaglyphic glasses (see Figure

3b). In the 2D environment, scenes are presented for monocular vision on a standard computer screen (see Figure 3c).

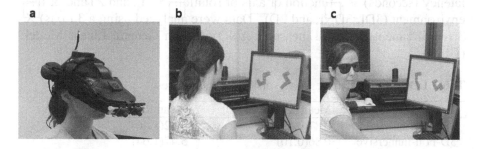

Fig. 3. Three different viewing environments: a) 3DI, which includes HMD with position tracking, b) 3DNI with anaglyphic glasses to present a stereo picture of three-dimensional spatial forms, and c) 2D monocular viewing environment.

Design and Procedure

Each participant performed the MR task in all 3 environments. Environment order was counterbalanced across participants. Before beginning the MR trials, participants listened to verbal instructions while viewing example trials (one match and one nonmatch trial) in each environment. Eight practice trials were given to ensure participants' comprehension of the instructions and use of rotation strategies. If a response to a practice trial was incorrect, the participants were asked to explain how they solved the task in order to ensure the use of a rotation strategy (i.e. rather than verbal or analytical strategy). In 3DI, to familiarize the participants with immersive virtual reality, there was also an exploratory phase, in which the participants were given general instructions about virtual reality and the use of remote control device, and they had the possibility to explore the virtual room and Shepard & Metzler's shapes from different perspectives (but they were not allowed to move around during the practice and test phases. After the experiment, participants were debriefed and received either their credit or monetary compensation.

Results

Descriptive statistics for performance in the three environments are given in Table 1. All simple main effects were examined using the Bonferroni correction procedure. Four subjects that did not demonstrate rates of rotation indicative of the classic positive linear relationship between RT and

angular deviations (c.f. [16], [19]) were not included in the analysis, so that the final analysis was performed on 12 subjects.

First, we examined accuracy (the proportion of correct responses) and latency (seconds) as a function of axis of rotation (X, Y, and Z) and of test environment (3DI, 3DNI, and 2D). Data were analyzed using a 3 (axis) X 3 (environment) repeated measures ANOVA with General Linear Model (GLM).

Table 1 Descriptive statistics for 3 versions of the MR test

Test	Mean accuracy (SD)	Mean RT (s) (SD)
3D-immersive	0.87(0.09)	5.42(1.46)
3D-non-immersive	0.86(0.10)	5.47(1.64)
2D	0.90(0.07)	5.33(1.02)

For accuracy, the patterns of subjects' response were similar for all test environments (see Figure 4a). There was a significant main effect of axis $[F(2,22) = 19.83, p < .001]$ where Y axis rotations were more accurate than X and Z axes rotations (p's < .01). The effect of environment was marginally significant $[F(2,28) = 2.9, p = .040]$ and as pairwise comparison showed, the accuracy in 3DNI environment was slightly less than in 2D (p = 0.08). The effect of interaction was not significant (p = .27). Overall, the accuracy level was high for all the environments and all the axes, ranging from 0.84 to 0.97 proportion correct. Given the high rate of accuracy, that for some rotations was reaching ceiling performance, we focused our remaining analyses on response times.

For latency (see Figure 4b), there was a significant effect of axis $[F(2, 22) = 15.40, p < .001]$ where Y axis rotations were significantly faster than X and Z (p's < .05). There was no effect of environment (F<1, p = .89), However, there was a significant interaction between axis and test environment $[F(4,44) = 6.45, p < .001]$.

Examination of simple main effects revealed that, consistently with previous studies [16], [19] in 3DNI and 2D, X latencies were greater than those for Y (p=.009 and .005) and Z latencies were greater than Y latencies (p = .047 and .029), however, X and Z latencies were similar (p = 1.00 and 0.79). Interestingly, the pattern was completely different in 3DI: Z latencies were greater than those for either X (p = .001) or Y (p = .01) latencies, while X and Y latencies were identical (p = 1.00). Thus, our central finding is that in 3DI, the RT of rotation differed between the X and Z axes (Z was slower) and that Y rotations were faster than Z but not faster than X rotations. This differs from previous findings for equivalent X and Z rotations and for faster Y rotations than both X and Z rotations [16], [19]. In

contrast, reaction time patterns for 3DNI and 2D environments were similar to those found in previous MR studies (i.e. Y rotations are faster than X and Z rotations, while X and Z rotations are conducted as similar speeds).

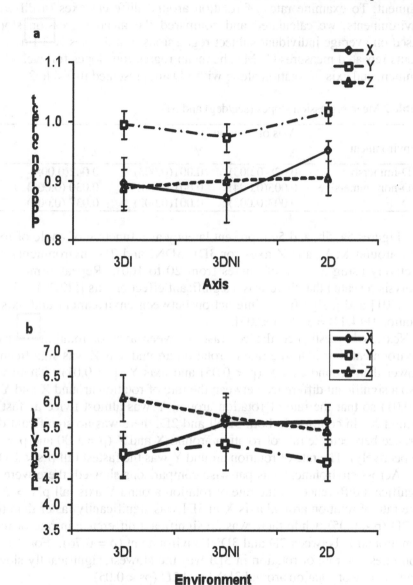

Fig. 4. a) Proportion correct as a function of axis of rotation and viewing environment. b) Latency as a function of axis of rotation and viewing environment. b) Error bars represent standard error means. Note that the Y-axis does not begin at the origin.

Given that axis of rotation interacted with test environment for latency, our next step was to investigate whether another variable, rate of rotation around three principles axes (X, Y, and Z), also interacted with test environment. To examine rates of rotation around different axes in different environments, we calculated and compared the mean regression slopes based on average individual subject regressions in a 3 Axes X 3 Environments repeated measures GLM. The mean regression slopes for each environment and axis of rotation along with SD are presented in Table 2.

Table 2 Mean regression slopes (sec/deg) and SD

Environment	Axis of rotation		
	X	Y	Z
3D-immersive	0.028(0.003)	0.001(0.003)	0.042(0.005)
3D-non-immersive	0.003(0.004)	0.001 (0.001)	0.030 (0.003)
2D	0.003(0.003)	0.001(0.002)	0.037 (0.002)

Figures 5a, 5b, and 5c represent latency as a function of angle of rotation around X, Y, and Z axes for 3DI, 3DNI and 2D environments respectively using a range of angles from 20 to 160). Repeated measures analysis revealed that there was a significant effect of axis [$F_{(2,22)} = 51.34$, $p < .001$] and a significant interaction between environment and axis of rotation [$F_{(4,44)} = 3.38$, $p < .05$].

Next, we investigated the contrasts between axes of rotation for each environment. For 3DI, the rate of rotation around axis Z was significantly slower than around axis X ($p < 0.05$) and axis Y ($p < 0.01$). There was also a significant difference between the rate of rotation around X and Y ($p = 0.01$) so that the rate of rotation around Y was almost twice as fast as around X. In contrast, in both 3DNI and 2D, there was no significant difference between the rate of rotation around X and Z ($p = 1.00$ and $p = .44$ respectively). The rate of rotation around Y was the fastest (all p's $< .01$).

Across environments, as pairwise comparisons showed, there were no significant differences in the rate of rotation around Y axis (all p's > 0.5). The rate of rotation around axis X in 3DI was significantly faster than that in 2D ($p < 0.05$), while there was no significant difference in rate of rotation around X between 2D and 3DNI environment ($p = 0.76$). For Z rotation rates, the rate of rotation in 3DI was the slowest, significantly slower than the rate of rotation around 3DNI and 2D ($ps < 0.05$).

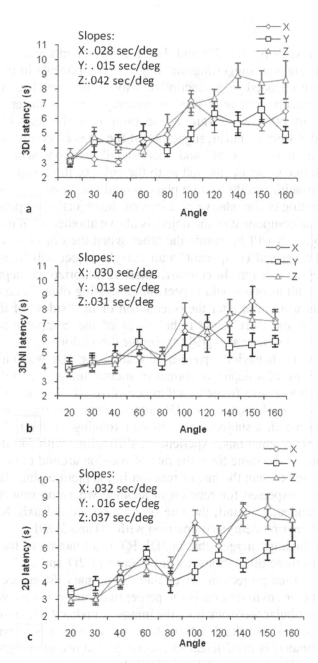

Fig. 5. a) Latency as a function of axis of rotation and angle in 3DI environment. b) Latency as a function of axis of rotation and angle in 3DNI environment. c) Latency as a function of axis of rotation and angle in 2D environment.

Discussion

Overall, the results for the 2D and 3DNI environments were consistent with previous studies, suggesting that objects' components in these environments were encoded in a descriptive way. The fact that in 2D and 3DNI environments the rate of rotation was significantly faster around Y than around any other axis, while at the same time the rates of rotation around X and Z were identical, suggests that the objects' components were encoded in terms of "vertical" and "horizontal" relations with regard to their own internal structure, as well as to the sides of the computer screen. In this case, rotations in the picture plane would not be easier since it perturbs the encoding of the relative positions of the object's components. For example, if one component of the object is above another in an upright image of an object, it will be beside the other when the object is rotated 90 degrees, and a vertical component in an upright object will be horizontal after a 90 degree rotation. In contrast, rotation in horizontal depth would not be as difficult as one would expect, since rotating object's components around Z axis would not alter the orientation of the "sides" of the object with respect to the "left" and "right" sides of the computer screen, in which the object lies (see also [19] for similar discussion).

In contrast, the behavioral pattern of results for 3DI was unique and suggested the use of a depictive format of mental imagery and the use of egocentric, retinocentric frame of reference. Overall, the rate of rotation around axis Z was slower in the 3DI environment, compared to 2D and 3DNI, suggesting that subjects were in fact rotating in depth 2D retina-based object representations, experiencing difficulties with foreshortening and occlusion. At the same time, the rate of rotation around the Z axis was significantly slower than the rate of rotation in the picture plane (around X axis), which is expected for rotation in a plane where no object components are occluded. Overall, the rate of rotation around axis X was the fastest in 3DI environment in comparison with 2D and 3DNI.

The above findings suggest that in 3DI, RT is a function of the angle of rotation not in three dimensions, as in the case of 2D and 3DNI environments, but in retinal projection. Given that the primary difference between 3DI and the other environments is the perceptual immersion as well as the addition of vestibular feedback (i.e., the image is updated while the head is turning), it appears that depth information per se, which is provided in a 3DNI environment, is insufficient to encourage the use of imagery analogous processes. Furthermore, 2D and 3DNI displays seem to encourage the use of more "artificial" encoding strategies, in which the 3D image is encoded with respect to an environmental frame of reference, in this case, the

computer screen. On the other hand, immersive environments can provide the necessary feedback for an individual to use a similar strategy and frame of reference as he/she would use in a real-world situation.

Overall, the results of this study indicate that people use a combination of menta; images encoded in a depictive format in relation to scene-based frames of reference while performing spatial transformations of the objects embedded in a permanent scene, viewed by them from the "outside." This strategy is exchanged for a combination of retina-centered frames of references when performing mental rotation of the objects in the scene in which the viewer himself/herself is immersed. These findings have implications for future studies on spatial transformations of mental images and the design of testing environments. They show that the results of the previous experiments on mental rotation, performed in laboratory conditions using a traditional 2D computer screen, might be limited and do not reflect the mental rotation patterns as if they were measured in a natural, three-dimensional environment.

In addition to its theoretical implications, this research could be of a considerable interest from an applied perspective; specifically for the design of learning environment. Although 3D environments might be more attractive to the user, the results of the current research show that 1) there will probably be no significant differences between 2D and 3DNI environments for spatial task performance, whereas a 3DI environment can provide a unique and possibly more realistic learning environment; and 2) 3DI environment is beneficial for those tasks that benefit from encoding from an egocentric frame of reference (e.g., navigation, wayfinding, etc). In addition, the findings of this research have important implications for training, and explain the results of the studies that show no transfer from training in 2D environments to immersive VR. For instance, Pausch, Proffitt & Williams [25] reported that immersive prior practice with conventional 2D displays in visual search tasks impaired performance in immersive VR. The researchers suggested that using desktop graphics to train users for real world search tasks may not be efficient. The current study explains this finding by pointing out that the encoding of spatial relations and cognitive strategies applied to perform visual/spatial transformations in these two types of environments are different.

References

1. Lee JH, Lim Y, Wiederhold BK, Graham SJ (2005) A functional magnetic resonance imaging (fMRI) study of cue-induced smoking craving in virtual environments. Appl Psychophysiol Biofeedback 30: 195-204
2. Lee JH, Ku J, Kim K, Kim B, Kim IY, Yang BH, et al (2003) Experimental application of virtual reality for nicotine craving through cue exposure. CyberPsychol Behav 6: 275-280
3. Lo Priore C, Castelnuovo G, Liccione D, Liccione D (2003) Experience with V-STORE: Considerations on presence in virtual environments for effective neuropsychological rehabilitation of executive functions. CyberPsychol Behav 6: 281-287
4. Haskell ID, Wickens CD (1993) Two- and three-dimensional displays for aviation: A theoretical and empirical comparison. Int J of Aviat Psychol 3: 87-109.
5. Van Orden KF, Broyles JW (2000) Visuospatial task performance as a function of two- and three-dimensional display presentation techniques. Displays 21: 17-24
6. Kosslyn SM (1980) Image and Mind. Harvard University Press, Cambridge
7. Pylyshyn ZW (1973) What the mind's eye tells the mind's brain: A critique of mental imagery. Psychol Bull 80: 1-24
8. Kosslyn SM, Thompson WL, Ganis G (2006) The case for mental imagery. Oxford University Press, New York
9. Kosslyn SM, Thompson WL, Wraga M, Alpert NM (2001) Imagining rotation by endogenous and exogenous forces: Distinct neural mechanisms for different strategies. Neuroreport 12: 2519-2525
10. Pylyshyn Z (2003) Return of the mental image: Are there really pictures in the brain? Trends Cogn Sci 7: 113-118
11. Pylyshyn Z, Dupoux E (2001) Is the imagery debate over? If so, what was it about? MIT Press, Cambridge
12. Pylyshyn ZW (1981) The imagery debate: Analogue media versus tacit knowledge. Psychol Rev 88: 16-45
13. Pylyshyn ZW (2002) Mental imagery: In search of a theory. Behav Brain Sci 25: 157-238
14. Marr D (1982) Vision, Freeman and Company Publishing, San Francisco
15. Hinton GE (1979) Imagery without arrays. Behav Brain Sci 2: 555-556
16. Shepard RN, Metzler J (1971) Mental rotation of three-dimensional objects. Science 171: 701-703
17. Gauthier I, Hayward WG, Tarr MJ, Anderson AW, Skudlarski P, Gore JC (2002) BOLD Activity during Mental Rotation and Viewpoint-Dependent Object Recognition. Neuron 34: 161-171
18. Kawamichi H, Kikuchi Y, Ueno S (2007) Spatio-temporal brain activity related to rotation method during a mental rotation task of three-dimensional objects: An MEG study. Neuroimage 37: 956-965

19. Parsons LM (1987) Visual discrimination of abstract mirror-reflected three-dimensional objects at many orientations. Percept Psychophys 42: 49-59
20. Parsons LM (1995). Inability to reason about an object's orientation using an axis and angle of rotation. J Exp Psychol Hum Percept Perform 21: 1259-1277
21. Hinton GE, Parsons LM (1988) Scene-based and viewer-centered representations for comparing shapes. Cognition 30: 1-35
22. Loomis JM, Blascovich JJ, Beall AC (1999) Immersive virtual environment technology as a basic research tool in psychology. Behav Res Methods Instrum Comput 31(4), 557-564
23. WorldViz (2006) Precision position tracker
24. WorldViz (2007) Vizard VR Toolkit R3: www.worldviz.com.
25. Pausch R, Proffitt D, Williams G (1997) Quantifying immersion in virtual reality, in Proceedings of SIGGRAPH, ACM

Comprehension of Layout Complexity: Effects of Architectural Expertise and Mode of Presentation

Christoph Hölscher
University of Freiburg, Germany

Ruth Conroy Dalton
University College London, United Kingdom

This paper presents an experiment on judgments of design complexity, based on two modes of stimuli: the layouts of corridor systems in buildings shown in plan view and movies of simulated walkthroughs. Randomly selected stimuli were presented to 166 subjects: 'experts' (architects or students currently enrolled on an architectural course) and 'lay people' (all others). The aims were to investigate whether there were differences between these two groups in terms of their judgments of building complexity, effects of modality of stimuli and if any environmental measures (geometric or complexity-based) correlated with the assessments. The results indicate that indeed complexity and wayfinding ratings show distinct patterns. Architects are more sensitive to differences between complexity and wayfinding ratings in the plan views, while lay-people provided more distinctive ratings for movies. Similarly, lay-people judged the same materials to be simpler and easier when seen as ego-centric movies, with architects showing the opposite pattern. The judgments of both groups correlated highly with a number of environmental measures, with architects providing greater differentiation regarding layout symmetry.

Aims

Three separate and distinct aims underpin the experiment presented in this paper. First is the investigation of the differences in how architects and non-architects view building-layout designs with respect to perceptions of complexity and judged ease of wayfinding; Montello recently suggested

(2007) that "architects will generally see greater differentiation in the built environment than non–architects".

The second aim of the experiment is to determine whether the mode of presentation of the design influences such judgments; two modes of stimuli were used in this experiment, an abstracted plan view and a 'walkthrough' movie (with ego-centric perspective, i.e., the eye-level view of a person moving through the layout). Navigating through buildings is a common regular activity for most people and they are familiar with experiencing such environments from an ego-centric movement perspective. Consequently, assessing complexity or ease-of-orientation could be more intuitive for lay-people than providing such judgments from plan views. In fact, architects are trained to rapidly switch between different perspectives and draw inferences from plan views of buildings as part of their formal education. It was initially hypothesized that differences *should* be found in the lay-people's judgments of complex environments, depending upon the mode of stimulus (the assumption being that lay-people would find the movie-mode easier to comprehend than the plan-mode, whereas architects should find both equally as easy).

The final aim is to determine whether the subject's judgements of design complexity correlate with a set of objective, environmental measures. Detecting the variables designers and non-designers – consciously or unconsciously – take into account for their judgments and especially their differences in doing so would provide a more detailed understanding of the cognitive processes involved in expert design performance.

Significance

The process of design frequently involves the continuous assessment of many aspects of the developing design solution (Cross 2006). This paper focuses on two particular types of design-criterion that *may* play a role in the process of architectural design, that of 'design complexity' and the allied judgment of 'ease of wayfinding'. These judgements are of importance, not only to the architect engaged in the process of design, but equally to the end-user of any building that is ultimately realized as the product of such a process. In fact, assessing the ease of wayfinding in a building requires the designer to anticipate the cognitive limitations of building users (lay-people) (Brösamle & Hölscher 2007), and if designers and building users differ widely in their assessment criteria such a difference might be a source of mismatch in communication between these groups (Bromme, Rambow & Nückles 2001).

Previous work on judgements of complexity have tended to fall predominantly into one of two groups: those primarily concerned with subjective assessments of design and those focussed on computational measures of complexity, an area strongly connected to the field of computational aesthetics (Sha and Bod 1993). This paper attempts to consider *both* the subjective assessments of complexity as well as objective, computational measures and to determine the relationship between them.

Measures of Design Complexity

As Montello comments, "...defining psychological complexity is difficult because humans organize information into meaningful units in a way that reduces complexity in an information-theory sense to relative simplicity in a psychological sense." (Montello 2007). This difficulty has not deterred investigation; with respect to architectural design, the key paper on subjective judgments of building layout complexity is Weisman's 1981 paper, upon which this study is based (and which will be discussed further in the Method Section). O'Neill (1991) also employed human judges to assess floor plans, but he only reports on a subset of materials and the results are mostly similar to Weisman's. Finally, Butler et al. (Butler, Acquino, Hissong and Scott 1993) use a number of different environment-variables, including some complexity-measures, to examine the route-preference for paths through a notoriously hard-to-navigate building: certain measures correlated highly with expressed preference, however, none of these were the measures of complexity.

Papers on methods of assessing complexity of abstract visual stimuli include those by Leeuwenberg (1968) and Attneave (1957) in the area of experimental psychology. The ability to compute the complexity of a building can be of great help in evaluating design decisions, in comparing and classifying plans as well as being particularly useful as a fitness function for generative design (Jackson 2001). More recently, information theoretic measures have been applied to building designs such as the interesting paper by Gero and Jupp, (2002), in which building plans are assessed using an entropy-based measure applied to string-encodings of building layouts.

Many of the calculations of design complexity focus on either linear elements (corridor segments, routes, paths, lines of sight etc.) or one-dimensional elements such as junctions, turns or decisions points.

Gestalt Forms

In a paper by Passini (1996), he suggests that two principles of building design exert most influence on wayfinding performance. The first are configurational measures: the network, spatial hierarchies and symmetries. Passini's second principle concerns the contribution to environment comprehension made by gestalt forms (Köhler 1929; Koffka 1935). Passini suggests that it is common for building layouts to be designed around gestalt, or 'good form', principles: the square, the cross, the T and L-shape etc. He suggests that these are the most easily apprehendable of layouts and that once the ordering principle has been grasped, it can be of significant assistance in understanding the complexity of the layout and then employed in navigation. This view is reinforced by Montello who suggests that, "... the overall shape or "gestalt" of a path layout can determine whether a particular element is disorienting... Layouts may be said to vary in their closeness to a 'good form'; comprehending a layout is easier when the layout has an overall pattern that can be apprehended as a single simple shape, perhaps allowing easy verbal labelling. A square has better form than a rhombus; a circle has better form than a lopsided oval. People tend to understand and remember layouts as having good form." O'Neill (1991) also reports that his subjects appeared to respond to 'good form' when rating architectural plans for their complexity. A number of the stimuli used in this study can be considered to have 'good form' (see Figure 1) and the effect of these special cases is discussed in Section *Individual Layouts with High Prägnanz*.

Method

The study by Weisman (1981) provided the first systematic assessment of floor plan complexity by human judges. He used thirty simplified building layouts that spanned a wide variety of building styles. We opted to use his original materials as the starting point for this study to allow for later comparison with the additional results of both Weisman (1981) and O'Neill (1991) about wayfinding *performance* in some of these settings.

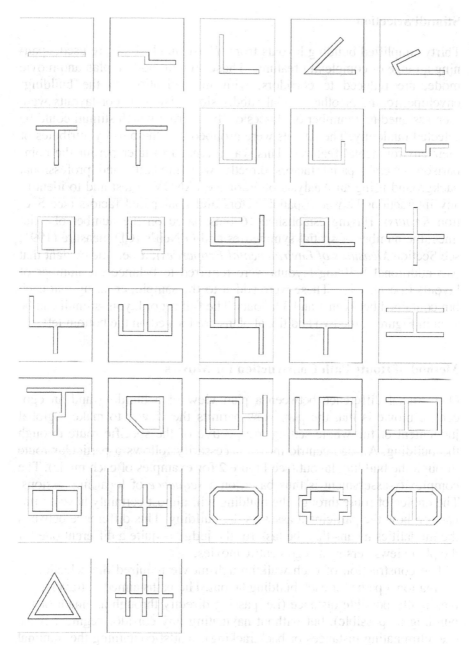

Fig. 1. Layout-stimuli as abstracted corridor systems in plan mode

Stimuli Selection

Thirty simplified building layouts from Weisman (1981) were used, spanning a range of complexity features. These stimuli, both in plan and movie mode, are reduced to corridors, with no indication of the building-envelope, rooms or other spatial subdivisions. The corridor-layouts were then assigned to a number of classes or 'bins' from which stimuli could be selected randomly. The layouts were grouped into the bins by attributes of their environmental features. This was intended to later permit the comparison several spatial factors directly with modality and professional background using an Analysis of Variance (ANOVA) test and to identify any interactions between spatial factors and non-spatial factors (see Section *Results*). Having established 16 bins based on the number of axial lines, the number of spatial symmetries and O'Neil's ICD measure (1991; see Section *Measures of Environmental Properties*), it became evident that two additional building layouts were required to balance the number of layouts in each 'bin'. These were added to the sample, ensuring that each bin contained between 1 and 3 layouts. The full set of layout-stimuli can be seen in Figure 1; the two additional plans are located on the bottom left.

Method of Route Path Construction for Movies

One crucial difference between a plan view of a building and an ego-centric movie is that the plan view permits the viewer to make a global judgement of the whole setting irrespective of the specific route through the building. An ego-centric movie necessarily follows a particular route through the building layout (see Figure 2 for examples of each mode). The complexity-assessment is thus based on a *sequence* of local impressions. The choice of route through the building will almost certainly have an impact on how the participant assesses the building. This difference between the modalities means that the task for the judge is quite a different one for the plan views versus the ego-centric movies.

The construction of each walkthrough movie required the selection of navigational paths for each building layout. The paths aimed to traverse the maximally possible distance (i.e. passing directly through as much of the building as possible), but without navigating any corridor segment twice (i.e. eliminating instances of backtracking), whilst containing the minimal number of turns. In order to ensure that all of the building was viewed, a number of stationary 'head turns', also kept to a minimum, were included at strategic junctions. In addition to these head turns, each movie commenced with a stationary 360° revolution.

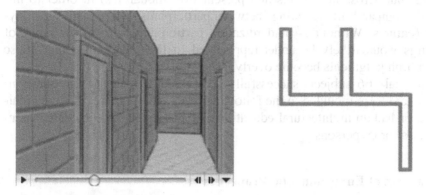

Fig. 2. Layout-stimuli as Ego-centric Movie (left) & Abstracted Plan (right)

Complexity & Wayfinding Judging Task

The complexity- and ease-of-wayfinding-judging task was administered in the form of an online questionnaire, which took approximately 20-30 minutes to complete. Each participant is presented with 16 layouts, one from each bin. Each layout is presented both as a movie and as a plan view. Presentation format and order is balanced and randomized into six blocks of 5-6 stimuli, with each block containing either movies or plans. This complex procedure ensures maximum balancing of elements, full randomisation and a minimum distance of 10 elements between the repetition of members of pairs (same element/different modality). Modality is realized as a within-subject factor. Prior to presentation of the first stimulus, participants view a page containing a set of five sample layouts, derived from the study materials and illustrating the range of layout variation in the study: this familiarizes the participants with the expected materials and minimizes the danger of any temporal *drift* in the ratings of participants over the course of the experiment.

In the main part of the study each stimulus was presented on a single page, with two questions accompanying each layout. Subjects were instructed to view each plan or movie and were asked to make two judgments: first, of the complexity of the layout (ranging from 'simple' to 'complex') and second, of the projected ease or difficulty of finding one's way around a building with such a plan configuration (ranked between 'easy' and 'difficult'). Both ratings used 9-point, bulleted scales. The rating values were used in their original state and were also submitted to a process of z-standardization (separately for each participant and rating

scale, but across all layouts and presentation modalities) in order to improve comparability of ratings between participants for the analysis of layout features. Without z-standardization participants with a low range of ratings would likely be under-represented in the correlations (and those with high judgments become overly influential).

In total 166 subjects successfully completed all parts of the questionnaire and were included in the following analyses. Of these 52 were architects or had an architectural education and 114 could be considered 'non-experts' or laypersons.

Measures of Environmental Properties

Prior to the study's inception, we identified a number of measures that could be used as objective evaluations of the stimuli. These were introduced to determine if any objective factors of the built environment correlated with people's subjective judgements of complexity as well as 'ease-of-wayfinding' and could thus be used predictively. Many of these were straightforward geometric measures such as a layout's area, perimeter or its number of walls and polygon vertices. Other measures were included due to evidence in the wayfinding literature that they may play a role in how easily people navigate (O'Neill, 1991, Passini, 1996). Measures such as the number of corridor segments and decision points were included for this reason. In particular, the number of symmetries was included as it was hypothesized that these might have a strong influence on the complexity-task: the number of lines of symmetry, rotational symmetries and their sum were evaluated. A pair of measures are included which arose from the literature on space syntax (Hillier & Hanson 1984). These are the number of axial lines and convex spaces in the layout. A convex space is a discrete spatial unit whose bounding polygon contains no reflex-angled corners and therefore all points within such a space are visible from all others. A building's decomposition into a set of discrete convex spaces is based upon a judgment of the fewest and 'fattest' spaces required to fully encompass all occupiable space. An axial line is an unimpeded line of sight and the equivalent axial description of a building consists of the fewest and longest lines of sight that pass through every convex space and complete all circulation rings.

Then, there are a number of miscellaneous measures that do not fit into any 'family' or class of measures: one of these measures is the number of 'topological loops' in a layout, i.e. a cross would contain zero 'loops', a square one 'loop' and a figure-eight two 'loops'.

Convexity is a measure developed by Batty (2001) and was originally intended for use in studying the convexity of a polygon representing a potential field of view or 'isovist'. As Batty describes, "Ψ_1 [or convexity], originates from area and perimeter, and is defined as the ratio of the radius of an idealized circle associated with the actual area of the [polygon] to the radius of an idealized perimeter from the actual perimeter in question... [Ψ_i] varies from a value of 0 for a straight line [polygon]... to 1 for a circle... This measure falls within [the range 0 to 1 and] appears to covary with the convexity of the space." Since it is derived from area to perimeter and is clearly a measure of the ratio between the two, convexity correlates well with both measures. However, it appears to outperform both in terms of correlating with the judgment tasks (see *Section Environmental Variables and Complexity*). The last measure to be included is O'Neill's measure of 'ICD' (1981) or *interconnection density*. For each location in which a change of direction must be made (a node) the number of directional choices is noted: this is 1 for a dead-end (the only choice is to turn around and go back), 2 for a 'corridor-turn' and 3 for a T-junction etc. These values are summed for the entire layout and then divided by the total number of nodes in the building. O'Neill found a strong and significant correlation between judged complexity and average ICD value ($r=0.78$, $p<0.01$). It was clear that any follow-on complexity-judging task should attempt to reproduce this result. Note that all of the environmental properties discussed in this section capture aspects of "layout complexity". Generally, any feature that increases layout complexity could at the same time also foster wayfinding difficulty, but only for a subset of measures the wayfinding literature actually points to a direct connection (namely corridor segments, decision points, axial lines and ICD).

The Interdependency of the Layout Measures

The analysis described in the previous paragraph originally included 27 variables of layout characteristics. As these variables were highly redundant a factor analysis was performed to identify a core set of features capturing a maximum variability between layouts. Note that the factor analysis was performed on the layout variables only and was thus independent of the ratings provided by the study participants. Four independent factors were identified, explaining 93% of the variance of these variables across the 32 layouts.

The seven variables listed in Table 1 formed a minimal set capturing all relevant categories identified from the literature: symmetry and decision points load uniquely in the factor structure, convex spaces and axial lines

(although having a high direct correlation) show divergent patterns of relations to the remaining factors; topological loops, convexity and ICD load highly on one common factor, yet topological loops and convexity are clearly distinct in both their correlation as features in our sample and certainly represent different levels of granularity as spatial variables.

Table 1 Correlations between measures (Pearson's r); highest loading on factor

	Axial Lines	Convex Spaces	Top. Loop	Dec. Points	Con-vexity	ICD	Symm-etry
Axial Lines	1.000	0.924	0.680	0.169	- 0.661	0.750	0.082
Convex Spaces	-	1.000	0.559	0.225	-0.652	0.674	0.184
Topologi-cal Loops	-	-	1.000	0.194	-0.532	0.857	0.294
Decision Points	-	-	-	1.000	-0.550	0.391	0.097
Convexity	-	-	-	-	-1.000	0.790	0.199
ICD	-	-	-	-	-	1.000	0.267
Symmetry	-	-	-	-	-	-	1.000
Factor No.	1	1	2	3	2	2	4

Results

First, we investigated the average rating of each participant aggregated across all layouts that the participant had experienced, as a global indicator of the impact of modality and architectural expertise as well as highlighting potential differences between assessing complexity versus wayfinding difficulty (see Table 2).

Across all layouts, the mean rating of complexity did not differ significantly between laypeople and architects (p>.65 for plans, p>.80 for movies). Yet, for the mean rating of wayfinding difficulty, laypeople and architects show clear differences: architects give higher ratings of wayfinding difficulty both for plans (t(164)= -2.23, p < .03) and for movies (t(164)= -1.74, p < .083) than laypeople.

This pattern is further reflected in differences between the average ratings of complexity versus wayfinding difficulty. The architects give significantly higher ratings for wayfinding difficulty than for complexity of *the same stimuli* (for plans: t(51)= -5.30, p < .03; for movies: t(51)= -3.93, p < .083). For laypeople this difference is numerically smaller yet, at least

for one modality, the movies it is statistically reliable (for plans: t(113)= -1.86, p < .066; for movies: t(113)= -2.84, p < .005).

Table 2 Ratings across all materials (means & standard deviations)

Rating Type	Modality	Laypeople		Architects	
		Mean	Standard Deviation	Mean	Standard Deviation
Complexity	plan	3,46	1,11	3,41	1,30
	movie	3,42	1,02	3,50	1,20
Wayfinding	plan	3,57	1,17	4,09	1,46
	movie	3,59	1,18	3,95	1,37

By contrast, we find no global difference between the modality plan versus movie: within each level of rating type (complexity; wayfinding) or architectural expertise (laypeople; architects) no statistically reliably difference was found between the average rating of plans versus movies (all t < 1.4, p < .172).

An analysis of variance (with rating type and modality as within-subject- and expertise as between-subjects-factors) identified a significant, primary effect of rating type (complexity versus wayfinding; F(1,164) = 35.15; p <.001) and a significant interaction of rating type by expertise (F(1,164) = 13.75; p < .001) as well as a three-way interaction of these factors with modality (F(1,164) = 8.85; p =.003). In order to interpret this interaction, we repeated the analysis of variance separately for laypeople and architects. This revealed a significant interaction of rating type and modality (F(1,51) = 5.64; p =.021) for architectural experts, but not for laypeople (F(1,113) = 1,43; p > .05): While experts see more extreme differences between complexity and wayfinding difficulty in plans rather than movies, the layperson's ratings of complexity versus wayfinding differ more distinctly when rating movies, with smaller differences in rating plan-view images.

To test the stability of ratings between the beginning and end of the experiment, we compared the mean ratings of layouts in the first, middle and last two blocks of the experiment, separately for each two levels of expertise and modality. We observe a main effect of presentation block within each of the four combinations of modality and expertise (all F > 4.64, all p < .01), and, more importantly, a significant interaction of presentation block and expertise for the plan-view ratings of both complexity (F(1.85; 310.77) = 5.01, p < .01) and wayfinding (F(2; 336) = 6.81, p < .01); For the ratings of plan views the architects provide stable ratings from

beginning to end of the experiment session, while the laypeople initially give lower scores that steadily increase during the session. No such interaction of presentation block and expertise is found for movies.

Environmental Variables and Complexity

To assess the impact of layout features on participants' ratings we calculated the average ratings for each of the 32 layouts, separately for the eight possible combinations of expertise (layperson, architect), modality (plan, movie) and rating type (complexity, wayfinding).

First, we observed high correlations between these eight dependent measures across layouts, ranging from $r = .825$ to $r = .982$. Some remarkable differences between experts and laypeople are also found: the median correlation between measures is $r = .896$ for architects and $r = .947$ for laypeople. This difference is clearly attributable to rating type rather than presentation modality: for non-experts the agreement between complexity and wayfinding rating is significantly higher than for experts (plans: $r = .964$ versus $r = .885$, $p < .05$; movies: $r = .982$ versus $r = .896$).

The zero-order correlations of all layout features with participants' ratings (see Table 3), except for symmetry, proved to be statistically significant for all subgroups of ratings. So each feature variable, by itself, explained a significant portion of the variance in the ratings. Two sets of multiple regressions were then conducted, either including or excluding the dominant variable 'convexity', separately for each group of ratings. Table 3 documents the resulting standardized beta-weights for these two multiple regression models. Those environmental features with a significant contribution to the prediction in each final model variant are marked with an asterisk (*).

Convexity, when included in the model, is the strongest predictor of all ratings, irrespective of expertise, modality or rating type. Removing convexity from the regression model (model 2) reveals that it picks up variance from other spatial factors, especially ICD and topological loops. Interestingly, as soon as ICD is included in the regression model, the beta-weight of topological loops turns sharply negative. Upon closer inspection of the individual materials we find that the ICD measure is extremely sensitive to the presence of topological loops. And while participants do judge layouts with such loops as more complex and difficult, they do this to a lesser extent than the ICD measure by itself would suggest.

Table 3 Correlations and multiple regression weights of environmental variables and complexity judgments

	Laypeople				Architects			
	Plan view		Movie		Plan view		Movie	
zero-order correlation	com-plexity	way-fin-ding	com-plexity	way-fin-ding	com-plexity	way-fin-ding	com-plexity	way-fin-ding
Axial Lines	.507	.541	.564	.596	.590	.650	.518	.651
Convex Spaces	.535	.568	.615	.657	.587	.686	.525	.637
Decision Points	.612	.606	.537	.509	.574	.570	.442	.538
Topological Loops	.288	.382	.379	.445	.457	.554	.331	.524
ICD	.593	.685	.640	.693	.667	.790	.606	.800
Symmetry	-.077	.065	-.054	.066	-.134	.215	-.275	-.001
Convexity	-.752	-.802	-.725	-.781	-.778	-.887	-.701	-.862
beta wt.s model 1								
Axial Lines	.106	.019	.150	.141	.108	.112	.059	-.042
Convex Spaces	.174	.079	.248	.257	.168	.187	.159	.053
Decision Points	.280 *	.237	.198	.113	.205	.118	.073	.112
Topological Loops	-.061	-.063	-.010	.040	.147	.113	.058	-.288
ICD	.103	.139	.181	.203	.236	.236	.274	.383 *
Symmetry	-.232 *	-.098	-.206	-.093	-.301 *	.040	-.432 *	-.224 *
Convexity	-.644 *	-.802 *	-.725 *	-.781 *	-.838 *	-.887 *	-.787 *	-.604 *
beta wt.s model 2								
Axial Lines	.416 *	.208	.250	-.392	.237	-.281	.086	.172
Convex Spaces	.205	.198	.316	.330	.281	.304 *	.197	.161
Decision Points	.542 *	.297 *	.255	.227	.367 *	.323 *	.152	.181
Topological Loops	-.188	-.613 *	-.639 *	-.539 *	-.170	-.298	-.601 *	-.605 *
ICD	.190	1.095*	1.187*	.932 *	.612 *	.459 *	1.235*	1.318*
Symmetry	-.165	-.083	-.201	-.094	-.333 *	.006	-.429 *	-.193

The variable *decision points* represents the number of true intersections (and not just turns in corridors) in a layout. Contrary to our expectation, the number of decision points had a significant impact beyond the other environmental variables for the plan mode, but *not* for the movies.

Although symmetry showed the lowest zero-order correlation with ratings, the multiple regression models reveal an important independent contribution of symmetry to the assessment of layout complexity and wayfinding difficulty. Again we identify a distinct difference between laypeople and experts: Laypeople respond significantly to symmetry but only for plans and this is especially true of their complexity ratings. When assessing ease of wayfinding, laypeople appear not to pick up this property. By contrast, the architects in our sample were extremely sensitive to symmetry, with significant contributions of symmetry in three out of four rating groups. This is a notable difference in the role of experts and laypersons and a clear finding of this study.

Interaction of Layout-specific and Global Factors

Next we investigate how two pre-selected layout-features (axial lines and symmetry) interact with presentation modality, rating type and architectural expertise of the participants. While the regression analysis in the previous paragraph looks at correlations of variables, we now return to comparisons of mean differences between groups of stimuli. Layouts were categorized into bins according to the number of axial lines (low / high) and symmetry (asymmetrical, 1 line of symmetry, 2 or more lines of symmetry). An analysis of variance (ANOVA) was conducted with the factors axial lines, lines of symmetry, modality and architectural expertise, separately for ratings of complexity and wayfinding difficulty (see Table 4 for the results).

As was to be expected from the literature (especially Peponis et al., 1991) and the previous regression analysis, layouts with a high number of axial lines were rated as significantly more complex ($F(1,164) = 239,30$; p <.001) and difficult for wayfinding ($F(1,164) = 256,67$; p <.001) compared to the layouts with only 1-3 axial lines.

Furthermore, we observed a fundamental effect of symmetry (complexity: $F(2,328) = 33,81$; wayfinding $F(2,328) = 63,71$; all p <.001): layouts with a low (one) level of symmetry are rated as least complex and least difficult for wayfinding. The complexity ratings of no-symmetry and high-symmetry layouts do not differ reliably, while for wayfinding assessments the highly symmetrical layouts are rated as most difficult.

To understand this rather counter-intuitive finding, we must also consider the higher-order interactions identified in the ANOVA: there is a significant two-way interaction of symmetry and modality (complexity: $F(2,328) = 5,46$; wayfinding $F(2,328) = 8,08$; all $p < .01$) and a significant three-way-interaction of modality, expertise and symmetry (wayfinding: $F(2,328) = 2,97$; $p < .53$; complexity: $F(2,328) = 2.25$; $p < .107$). While laypeople show no such interaction at all, architects react differently to symmetry depending on the presentation modality.

In addition to the effects of layout variables, this fine-grained analysis revealed another global difference between laypeople and architects: an interaction of presentation modality and expertise for complexity ratings ($F(1,164) = 4.07$; $p < .045$). Architectural experts judge the same materials as more simple in plan mode, while laypeople judge the layouts as more simple when presented as movies.

Individual Layouts with High Prägnanz

Two layouts were isolated from the above analysis, namely the cross-shaped and square-shaped layouts. This was done primarily because they are prototypical examples of shapes with high "Prägnanz" (engl.: conciseness) as described in the literature on Gestalt psychology (Köhler 1929; Koffka 1935). They represent named-shapes, most likely to be highly familiar to laypeople and architects alike and we expected that they might form their own category, potentially obscuring the interaction of other layout variables in the full sample. And indeed we observe yet another sharp contrasting interaction of architectural expertise, rating type and presentation modality for the cross-shaped layout (see Figure 3). The three-way interaction is statistically highly reliable ($F(1,164) = 6.22$; $p < .014$), statistical trends for all two-way interactions (all $F(1,164) > 2.58$; $p < .109$), main effects of rating type ($F(1,164) = 24.50$; $p < .001$) and expertise ($F(1,164) = 6.17$; $p < .014$) and a statistical trend for modality ($F(1,164) = 2.07$; $p < .087$). It is currently not clear why this distinct pattern is observed only for the cross-shape but not for the square-shaped layout.

Discussion

Previous studies by Weisman (1981) and O'Neill (1991) have only looked at zero-order correlations of judgments and have consequently interpreted the assessments of 'complexity' and 'wayfinding' to be largely equivalent, combining them in their analyses. In this study we find substantial differ-

ences between these measures when comparing movies versus plans or experts versus laypeople.

Table 4 Mean ratings for groups of layouts with varying numbers of axial lines and symmetry (z-standardized scores)

	1-3 axial lines			4-9 axial lines		
	symmetry			symmetry		
	none	medium	high	none	medium	high
Complexity						
plan_layperson	-0,153	-0,532	-0,011	0,369	0,244	0,419
movie_layperson	-0,211	-0,687	-0,294	0,303	0,220	0,417
plan_architect	-0,097	-0,502	-0,061	0,282	0,138	0,377
movie_architect	0,133	-0,499	-0,225	0,540	0,296	0,289
Wayfinding						
plan_layperson	-0,269	-0,615	0,064	0,322	0,133	0,415
movie_layperson	-0,301	-0,675	-0,246	0,281	0,135	0,424
plan_architect	-0,356	-0,585	0,150	0,238	0,038	0,583
movie_architect	-0,068	-0,707	-0,219	0,275	0,007	0,449

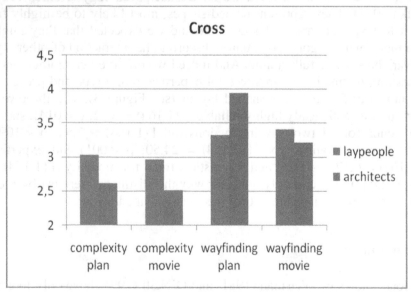

Fig. 3. Mean ratings for the cross-shaped layout

Our results show that the laypeople's ratings of complexity versus way-finding differed more distinctly when rating movies, and with smaller differences in rating plan-view images. This can be contrasted to the performance of the experts who appear to perceive greater differences between complexity and wayfinding difficulty in plans rather than movies. For the ratings of plan-views the architects provide stable ratings from beginning to end of the session, while the laypeople initially give lower scores that increase during the session. It is as if architects can immediately employ a consistent use of the rating scale, based on the 5 examples provided on the pre-test page. In contrast, the non-experts need to view a larger example-set before developing a consistent rating scale. On ratings for movies, architects and laypeople alike need time to adjust to the rating scale, possibly because such an assessment rarely forms part of their daily routine.

Architectural experts judge the same materials as being simpler in plan mode, while laypeople judge the layouts as simpler when presented as movies. A tentative interpretation of this finding is that experts are more familiar with assessing plan views, while laypeople have greater difficulties interpreting plans and thus find movies easier to comprehend. This difference does not extend to rating wayfinding difficulties per se: a further indicator that architects and laypeople interpret the two rating tasks in a different manner.

Correlation between Judgments and Environmental Factors

A number of environmental variables are shown to correlate highly with participants' judgements. Architects react differently to symmetry depending on the presentation modality. Against a general trend of judging movie versions of identical stimuli as easier to navigate, experts appear to be distinctly critical of the complete lack of symmetry in the low-symmetry group when presented in movie-mode. In plan-view, the high-symmetry, high-number-of-elements stimuli are judged as rather complex and difficult to navigate, while in movie-mode these elements receive relatively positive ratings and here the non-symmetric elements are considered complex and difficult, despite their low number of parts/axes/corridors. For complexity, the pattern is similar: highly-symmetric elements are judged as simple and easily navigable in the movie modality, but in plans, the experts rely less on symmetry and attribute high complexity to layouts with many elements, despite high symmetry. Furthermore, while participants judge layouts containing a larger number of 'topological loops' as being more complex and difficult, they do this to a lesser extent than the ICD measure, a high correlate, would suggest by itself.

In conclusion, the fact that the variables initially identified through factor analysis appear to be particularly relevant for predicting human assessments of complexity and navigability can be taken as an indication that our stimuli covered a considerable range of the potential feature space. Yet there is still considerable co-linearity between some features, especially convexity, which is correlated with all other features (except symmetry).

The Effect of High Prägnanz

The effects of 'Prägnanz' or 'good form' were considered by examining the judgments of two of the stimuli that could be considered to fit into this category: the cross- and square-shaped layouts. One of these layouts, the cross revealed a distinct pattern: The experts considered this layout as *even less complex* than the laypeople did. Interestingly, this was against their general trend not to do so across all other layouts. Furthermore, they clearly differentiated between complexity and wayfinding ratings: the architects judge the cross to be simple in complexity, yet potentially quite difficult for wayfinding and they are particularly aware of this in plan view, the mode they frequently use for assessing building-layouts. Once again, laypeople show no such differentiated pattern. One interpretation of this is that it might be because architects are sensitive to the need for 'local visual differentiation' for ease of wayfinding and, in the case of the cross, the potential for confusing one location with another, visually identical, one is quite high. This consideration simply might not be shared by laypeople.

Future Work

It is intended that work on this study will continue by including a set of 'information theoretic' measures of shape and thus layout properties (based on Leeuwenberg (1968), Shannon & Weaver (1949) etc.). Especially Leeuwenberg's approach tries to capture how difficult a stimulus is to encode for human cognition and experts and laypeople may substantially differ in their ability to deal with materials of varying complexity in this sense.

The lack of a prevalent or universal effect of symmetry was also a puzzling finding of this study, as symmetry is generally considered as a main factor of reducing visual complexity. It is intended that this be further investigated by examining the effect, if any, of Hillier's 'Symmetry Index', which provides a continuous scale of symmetry ranging from strongly

asymmetrical to highly symmetrical in contrast to the concept of symmetry as a discrete property which a layout either possesses or does not (Hillier 2007). Future work will also include a more detailed analysis of other individual layouts (focusing initially on the 'good form' layouts) to further pinpoint contributing factors of layout assessments.

The present study could also be a starting point for a new line of behavioral experiments on actual wayfinding *performance*, rather than *subjective judgments* on the matter. Such experiments would likely extend the movie stimuli into interactive Virtual Reality simulations of building layouts. The studies by O'Neill (1991) indicate that perceived complexity and performance indeed correlate substantially, but it is a fully open question whether the subjective judgments of architects or lay-people better predict the behavior of building users. One might of course suspect that architects are better trained to make such judgments properly. But it could also be the case that lay-people – when presented with materials in the egocentric modality of the movie – actually provide more accurate predictions of their fellow peer's performance in wayfinding, while architects might misjudge the spatial abilities of lay-people (see Bromme et al. 2001).

In conclusion, this study has already yielded interesting results about the design cognition of architects and lay-people, but it is anticipated that more will be forthcoming.

Acknowledgements

To the EPSRC Platform Continuation Grant (EPSRC GR/S64561/01) and to SFB/TR8 Spatial Cognition for co-funding this study. To Kinda Al_Sayed for the construction of the movie stimuli and to Gregor Wilbertz for the creation and programming of the online questionnaire. To our participants without whom this study would not have been possible.

References

1. Attneave F: (1957) Physical determinants of the judged complexity of shapes. J. Exp. Psych 53: 221-227
2. Batty M (2001) Exploring isovist fields: space and shape in architectural and urban morphology. Environment and Planning B: Planning and Design 28(1): 123 – 150
3. Bromme R, Rambow R, Nückles M (2001) Expertise and estimating what other people know: The influence of professional experience and type of knowledge. Journal of Experimental Psychology: Applied 7: 317-330

4. Brösamle M, Hölscher C (2007) Architects seeing through the eyes of build-ing users. In Barkowsky T, Bilda, Z Hölscher, C Vrachliotis, G (Eds.), Spatial cognition in architectural design. Melbourne, Australia
5. http://www.sfbtr8.spatial-cognition.de/SCAD/
6. Butler D, Acquino A, Hissong A, Scott P (1993) Wayfinding by newcomers in a complex building. Human Factors 35(1): 159-173
7. Cross N (2006) Designerly Ways of Knowing. Springer-Verlag London
8. Gärling T, Böök A, Lindberg E (1986) Spatial orientation and wayfinding in the designed environment: A conceptual analysis and some suggestions for postoccupancy evaluation. Journal of Architectural Planning Resources 3: 55-64
9. Gero JS, Jupp JR (2002) Measuring the information content of architectural plans. In Hippolyte PL & Miralles E (eds), SIGraDi Caracas 2002, Ediciones Uni. Central de Venezuela: 155-158
10. Hillier B, Hanson J (1984) The social logic of space. Cambridge University Press, Cambridge
11. Hillier B (2007) Space is the machine: A configurational theory of architec-ture. Space Syntax, London
12. Jackson H (2001) Towards a symbiotic coevolutionary approach to architec-ture. In Creative Evolutionary Systems, Bentley PJ and Corne DW (eds), Morgan Kaufmann Publishers
13. Koffka K (1935) Principles of gestalt psychology. Harcourt Brace Javanovich, New York
14. Köhler W (1929) Gestalt psychology. Liveright, New York
15. Leeuwenberg ELJ (1968) Structural information of visual patterns. Mouton & Co
16. Montello D (2007) The contribution of space syntax to a comprehensive the-ory of environmental psychology. Proceedings of 7th International Space Syn-tax Symposium, Istanbul
17. O'Neill MJ (1991) Effects of signage and floor plan configuration on wayfind-ing accuracy. Environment and Behavior 23(5): 553-574
18. Passini R (1996) Wayfinding design: logic, application and some thoughts on universality. Design Studies 17(3): 319-331
19. Peponis J, Zimring C, Choi YK (1990). Finding the building in wayfinding. Environment and Behavior 22(5): 555–590
20. Sha R, Bod R (1993) Computational esthetics (English translation of "Compu-tationele Esthetica", originally published in Dutch in Informatie en Infor-matiebeleid 11(1): 54-63l)
21. Weaver W, Shannon CE (1949) The mathematical theory of communication. Urbana, Illinois, University of Illinois
22. Weisman J (1981) Evaluating architectural legibility: Way-finding in the built environment. Environment and Behavior 13: 189-204

KNOWLEDGE-BASED DESIGN

GUITAR HERO, a Knowledge-Based System to Support Creativity in the Design and Manufacturing of Electric Guitars
Stefania Bandini, Andrea Bonomi and Fabio Sartori

Discovering Implicit Constraints in Design
Madan Mohan Dabbeeru and Amitabha Mukerjee

Capturing Decisions and Rationale from Collaborative Design
Janet E. Burge and James D. Kiper

Extending the Situated Function-Behaviour-Structure Framework for User-Centered Software Design
Matthias Uflacker and Alexander Zeier

Empirical Examination of the Functional Basis and Design Repository
Benjamin W Caldwell, Chiradeep Sen, Gregory M Mocko, Joshua D Summers and Georges M Fadel

GUITAR HERO, a Knowledge-Based System to Support Creativity in the Design and Manufacturing of Electric Guitars

Stefania Bandini, Andrea Bonomi and Fabio Sartori
University of Milan, Italy

This paper presents GUITAR HERO, a knowledge-based system to support experts of a handicraft enterprise involved in the design and manufacturing of electric guitars characterized by an aluminum body. The domain of the project is extremely innovative, because electric guitars are typically manufactured exploiting different kinds of wood rather than metals like aluminum, or other materials. To this aim, an ontological representation of the electric guitar has been implemented exploiting NavEditOW, a computational framework for the codification, navigation and querying of ontologies over Internet, based on the OWL language. This representation is the main subject of the paper together with a description of the domain and a brief state of the art.

Introduction

In this paper we present a knowledge-based approach to support the decision making process of experts involved in the design and manufacturing of electric guitars, in the context of the GUITAR HERO project.

The project is a collaboration between CSAI[1] and NOAH GUITARS[2], an Italian Small-Medium Enterprise leader in the production of high quality guitars. An electric guitar is a complex product made of the following parts: Body, Bridge, Pickups, Volume and Tone Control, Neck, Headstock,

[1] www.csai.disco.unimib.it
[2] www.noahguitars.com

Trussrod, Frets, Hardware. Each part has a precise function and some of them influence others. For example, Body is the main part of the guitar; different from an acoustic guitar, the Body of an electric one has a significant role from the sound point of view, but it is also responsible for connecting all other components.

While electric guitar bodies are traditionally made of wood, NOAH guitar body design and manufacturing are based on the adoption of aluminum. This is due to many reasons: First of all, aluminum is an inert material, thus it is less subject to deformations than wood; moreover aluminum has interesting properties from the quality of sound point of view. NOAH experts have noticed that the use of aluminum allows avoiding the generation of noises that are typical of wooden guitars, e.g. when equipped with single coil pickups.

There are also interesting advantages in the production process: an aluminum body is produced starting from a CAD model that is the input for a dedicated machine. The CAD model allows the definition of a very precise morphology of the final product, by identifying the location of pickups, controls and other components to be mounted on the body as well as the position of the neck.

The aim of the GUITAR HERO project is to build a knowledge model of the decisional process of NOAH experts. In order to do this, we have decided to follow the methodological approach exploited in the IDS project [7], with the definition of three different levels of knowledge to be acquired and represented:

- Ontological Knowledge, related to the definition of functional relationships [2] among guitar parts;
- Procedural Knowledge, related to the description of how the guitar components are manufactured starting from the CAD model, as well as which factors influence the different steps of the process (e.g. what kind of relationships exist between technical and aesthetical requirements coming from guitar players;
- Experiential Knowledge, devoted to represent into a homogeneous conceptual framework the heuristic rules adopted by the different kinds of expert involved.

In this paper, we will describe how we are building the GUITAR HERO knowledge based system following the methodological approach briefly introduced above. In particular, after an exhaustive description of the project domain, we will describe the different steps of the knowledge acquisition and representation campaign we are conducting with NOAH experts.

Moreover, details about the computational approach we are following to develop the final system will be given, focusing on the computational tool

[3] adopted for the development of ontological, procedural and experiential knowledge.

The Electric Guitar: a Complex Product

The guitar is a relatively recent kind of musical instrument: the first models of guitars where built by Antonio Torres Jurado in the 19th century. The guitar acquires importance in the 20th century and, in particular, in the period between 1930 and 1950, when American manufacturers like Fender and Gibson give very important stimulus to the development of guitar acoustics.

A real point of break is the birth of electric guitars, whose acoustic properties depend on specific electric components rather than on properties of materials and guitar morphology. These components are called *pick-ups*, and they are able to "capture the vibrations" of *strings* moved by the player conveying them to amplifiers.

An electric guitar is generally composed of the following parts (see Figure 1[3]): (1) *body* is the main part of the guitar, where the pickups and bridge are located; (2) *bridge* is an area of the guitar through which the strings are connected to the body. Very often, strings are placed on *saddles*. Saddles are configurable and can be *single* (i.e. each saddle is devoted to the connection and regulation of one and only one string) or *double* (i.e. each saddle is devoted to the connection and regulation of two strings). There exist many different kinds of bridge, some of the most used are *tremolo bridges*, (e.g. *Wilkinson* or *Bigsby*), *adjustable bridges* and *fixed bridges*; (3) *frets* are vertical metal wires that sit vertically on the guitar neck; (4) *headstock* is the area of the guitar at the end of the neck where the strings are fixed and tuned; (5) *neck* is the long narrow part of the guitar where notes are fretted. Located between the body and headstock of the guitar, the neck is usually a wooden part: to limit negative effects of deformations, an adjustable steel bar named *trussrod* is placed inside it. The trussrod can be *adjustable at the headstock* or *adjustable at the body*; The trussrod can be *adjustable at the headstock* or *adjustable at the body*; (6) *Nut* is the point on the guitar neck where the strings touch the neck and join the headstock;

[3] Picture extracted from http://www.maximummusician.com/Anatomy.htm

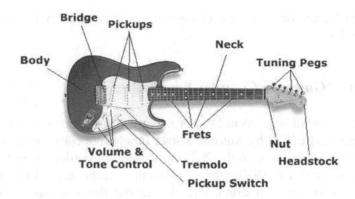

Fig. 1. The main components of an electric guitar.

(7) *pickup switch* is a switch located on the body of the guitar used to select different pickups for different tones and sounds; (8) *pickup* is a magnet wrapped in copper wires that sits on the face of an electric guitar, underneath the strings. When the strings move, they interfere with the magnetic field of the pickup, and that impulse is sent to the amplifier. There are many kinds of pickups according to the number of coils they are made up of. Typically, *single-coil* (more subject to noises) or *multi-coil (humbackers)* (less subject to noises) pickups are adopted; (9) *tremolo* (i.e. Whammy Bar) is a bar connected to the bridge of the guitar. By moving the tremolo bar up or down the bridge moves consequently, thus changing the pitch by loosening the tension of strings (10) *tuning pegs* are the pegs located at the headstock, which are used to tune the guitar. The machine heads have gears that can tighten or loosen the string when turned; (11) *volume and tone control* are Control knobs located on the body of the guitar and used to adjust guitar volume and tone.

In the next section, we'll describe the object of the Guitar Hero project, that is an aluminum guitar designed and manufactured by NOAH, an Italian Small-Medium enterprise that creates handicraft guitar used by some of the most famous players in the world.

Aluminum Guitars versus Wooden Guitars: The NOAH Case Study

Generally, electric guitars' components are made of different kinds of wood (e.g. rosewood, maple tree) according to their function. This is due to both historical reasons (in ancient time, wood was the only suitable material) and practical ones (touching wood is a pleasure for players' hands,

wood is light). The usage of wood has some drawbacks: first of all, wood is an "alive material" that modifies its characteristics. To avoid such problems, wood that is employed in the manufacturing of electric guitars is typically seasoned and expensive.

Another problem of wood is that it can be damaged very easily in case of collisions. In order to solve such problems, guitar manufacturers have experimented with other materials. In particular, metals are considered good substitutes of wood, since they are not deformable. Unfortunately, the adoption of metals leads in most case to obtain too heavy products. Moreover, metals are cold and they cause bad feelings in guitar users who touch them when playing.

For these reasons, wood is still the most suitable raw material to use in the manufacturing of electric guitars. Some exceptions can be found: NOAH Guitars is the Italian leader in the design and manufacturing of aluminum guitars. NOAH experts have devised a process to produce guitars with characteristics very similar to more traditional ones exploiting their know-how in working with aluminum.

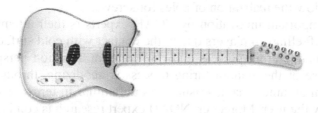

Fig. 2. A NOAH guitar with aluminum body.

It is important to notice that the NOAH method concerns the design and manufacturing of guitar bodies: other parts, like e.g. neck and headstock are still made of wood. The body is obtained from a unique piece of aluminum that is roughly processed by a Finite Element Machine according to a CAD model that defines body features. The result is a hollow body where other guitar components (pick-ups, bridge, volume and ton controls, and so on) will be located. The body is then refined in order to delete imperfections, to round off edges and make aluminum polished. An example of a typical NOAH guitar is shown in Figure 2[4].

[4] Picture extracted from http://www.noahguitars.com

NOAH experts: a community of practice

NOAH guitars have reached an excellence level form many points of view. First of all, the adoption of aluminum as the main raw material instead of wood provides NOAH guitar bodies with a natural capability to minimize noises due to the interference caused by pickups. Although these noises are less important in electric guitars, this is indeed an advantage.

Moreover, aluminum bodies can be maintained very easily: since the body is a sort of box where most of the functional parts of the guitar are placed (e.g. bridge, pick-ups, controls), the body has been designed and manufactured in order to allow an easy access to such components in case of need, for example to substitute a broken part. While this is difficult in case of wooden guitars, since wooden bodies are built-up starting form a unique piece of wood, without junctions, NOAH guitar bodies are made of two distinct parts, the *frontal container* and a *cover* that is fixed to the frontal container by means of screws. In this way, it is really simple to manage other components of the guitar by removing the cover. This kind of solution is not applicable to wooden guitars, since the body profile is too thin to allow the realization of holes for screws.

Another important innovation by NOAH experts is their attempt to reduce the bad feelings in players due to the contact with cold surfaces, both from the manufacturing process and raw material adoption perspectives. The last phase of the manufacturing process is anodizing, through which the aluminum assumes characteristics less unfamiliar in terms of touching perception by the user. Moreover, NOAH expert research is continue in the field of raw material testing, with the experimentation of new types of aluminum and their adoption in case of success.

Finally, NOAH electric guitars are appealing from the aesthetic point of view too. Aluminum is buffed by hand in order to delete imperfections and also the mounting of other components like pick-ups and bridges on it are the result of deep analysis.

Thus, we can say that the final product is the result of an intense negotiation process among NOAH experts where three distinct competencies emerge:
- *Functional competencies*, concerning the property of the guitar from the playing point of view, like e.g. the reduction of noises;
- *Procedural competencies*, concerning how to design the body exploiting CAD technologies in order to properly feed machineries that will produce them starting from pieces of aluminum and preserving its functional features;

- *Aesthetic competencies*, related to the design of guitars that can be appealing for a customer and can characterize them as artistic objects as well as good musical instruments.

Each of these competence is owned by subgroups of experts in NOAH, where it is possible to identify people skilled in playing guitars who is able to recognize benefits/drawbacks on the sound quality coming from the adoption of a specific design choice, people whose expertise is in the field of aluminum and people with deep know-how in the design of artistic objects.

The interest on NOAH from the Knowledge Management perspective derives from the nature of collaboration among these people to make possible to integrate all competencies into a unique final product and that makes possible to classify NOAH as a Community of Practice (CoP) [19].

In fact, functional, procedural and aesthetic competencies are not considered in a synchronous way during the design and manufacturing of a new product, but as different and complementary aspects of the same problem. For this reason, the task to produce a new guitar is not considered as sequence of atomic steps but as a negotiation process during which each competence is taken into account at the same time.

Thus, we can state that *creativity* in the context of NOAH is the capability of people belonging to the CoP to uniformly consider the different aspects of the knowledge involved that results into the reification of a concrete object that meets both functional and aesthetic requirements according to a manufacturing process that allows to preserve it.

The aim of the GUITAR HERO project is the development of a knowledge-based system that allows modeling the essence of this negotiation in order to support NOAH experts in the exercise of their creativity. The GUITAR HERO project aims at the acquisition, representation and codification of different kinds of knowledge involved in the design and manufacturing of electric guitar through the adoption of suitable knowledge engineering tools. In particular, this paper focuses on the representation of functional knowledge by means of ontologies, which is the subject of following sections.

Knowledge Management to Support Creativity: an Ontological Approach

State of the art

In the last years both the scientific and the industrial communities recognized the role of semantics for knowledge management, access and exchange. Semantic based approaches have been applied e.g. to information retrieval, system integration and knowledge sharing structured as semantic knowledge bases.

A lot of research has been carried out, a great number of theoretical results have been achieved (see e.g. [10][12]) and a number of applications have been developed [16].

OWL[5] has become a standard language for defining ontologies, providing a common way to automatically process and integrate information available on the Web. OWL allows defining ontologies constituted by classes, properties and instances.

Despite these efforts and enhancements, a number of open problems still prevent semantic based technologies from being effectively exploited by end users; end users in fact cannot be assumed to have formal skills that are required nowadays to interact with semantic KBs, with respect to both the contribution to the KBs growth (i.e. its update and maintenance) and the access to the KBs content on the basis of its semantics (i.e. through query and navigation).

For this reason, the development of systems that improve the access to ontological KBs, in both the updating and the retrieval and discovery of information phases, is a challenging topic in order to meet knowledge management systems users perspective.

In order to develop the user interface, many ontology editors and visualization tools have been investigated. In our opinion, these applications are critical, since the diffusion of Semantic Based Knowledge Management Systems and more generally Semantic Web applications depends on the availability of convenient and flexible tools for editing, browsing and querying ontologies.

Before developing a new system, we have analyzed the principal tools of this area. One of the most popular ontology editor is Protégé. It is a free, open source ontology editor and knowledge-based framework. A detailed description of Protégé is out of the scope of this paper and can be found in

[5] OWL Web Ontology Language – http://www.w3.org/TR/owl-features

[13]. Protégé allows editing of ontologies expressed in OWL. In our opinion, Protégé is one of the best OWL editor, but its user interface is too complex for a user with no experience of ontological languages and lacks some useful functions like the inspection of the elements (e.g via hyperlinks) and comfortable edit/visualization facilities for the individuals.

Fig. 3. NavEditOW Web Interface.

An interesting Web-based OWL ontology exploration tool is OntoXpl, which is described in [14]. In particular, an interesting feature of OntoXpl is the visualization facility for individuals that can be displayed as a tree whose nodes are individuals and arc are properties. This kind of visualization is suitable for A-Boxes with many individuals. OntoXpl also supports the inspection of the ontology elements via hyperlinks. Swoop [11] is a hypermedia inspired ontology editor that employs a web-browser metaphor for its design and usage. All ontology editing in Swoop is done inline with the HTML renderer (using color codes and font styles to emphasize changes); it also provides a querying interface for ontologies.

NavEditOW: a tool for navigating, editing and querying ontologies over the web

General Description of the Tool

NavEditOW (see Figure 3) allows exploring the concepts and their relational dependencies as well as the instances by means of hyper-links; moreover, it provides a front-end to query the repository with the SPARQL[6] query language. The main functionalities offered by NavEditOW are the navigation, editing and querying of OWL ontologies through a web-based interface.

In the following paragraphs, we present more details about each of these tree basic functionalities supported by the application. With the ontology navigation interface the users can view ontology individuals and their properties and browse their properties via hyperlinks. Browsing the ontology is essential for the user in order to explore the available information and it also helps not expert users to refine their search requirements, when they don't start from any specific requirement in mind [17].

Application to the Guitar Hero Project

The hierarchical organization of the different concepts and individuals of the ontology is graphically represented as a dynamic tree. The aim of the navigation tree is to explore the ontology, view classes and instances, discover the relation between them.

The tree does not represent only a hierarchy of classes connected by Is-A binary relations (shown in Part A of Figure 4), but also tree-like connections of individuals for domain dependent classes of properties (e.g. Part-Of, isMadeOf, and so on). Both visualizations (Is-A relations between classes and domain-dependent relations between instances) are useful for users, since they provide them with a view of the ontology from two different perspectives: The parts of a guitar can be considered as classes connected by Is-A relation (e.g. a Potentiometer is an Electronic Component, an Electronic Component is a Hardware Component, a Hardware Component is a Main Component and so on).

As an example, shown in Part B of Figure 4, the parts of a "physical" guitar can be linked to the guitar by a *Part-Of* relation. In this way, it is possible to group components under the sub-tree representing the main

[6] SPARQL is a RDF Query Language standardized by the World Wide Web Consortium – http://www.w3.org/TR/rdf-sparql-query

part they are all subparts of (e.g. starting from a *guitar* instance, it is possible to reach the *potentiometer* through the *slim body* node).

Fig. 4. Part A: the Is-A-Tree of the guitar ontology, where each componente is ideitfied by a yellow circle. Part B: The Part-Of-Tree of the guitar ontology, where each part is identified by a violet rumble.

The root of the navigation tree is the OWL class Thing, and the rest of the tree is organized as follows: Under the root node, there are the top-level classes (i.e. direct subclasses of Thing); each class can be expanded to show its subclass hierarchy and its individual members; individual-to-individual tree connections are defined according to a number of selected properties (e.g. Part-Of).

In order to distinguish between classes and individuals, they are represented with different *colors* and *markers*: a *yellow circle* for the classes, *a violet square* for the individuals. More individual properties (e.g. MadeOf, not shown in the figure) are considered by the system and *blue squares* are used to represent them. In order to simplify the adoption of the NavEditOW for the Protégé users, we selected the same colors of the Protégé user interface.

The application allows the users to create, edit and remove individuals of the ontology, their properties and, in particular, their *labels*. In fact, to ensure multi-language support, it's possible to introduce several labels in different languages for every instance. Moreover, contextual editing, that is, the editing of individuals while browsing the ontology, is supported.

Although end-users may not be familiar with query languages, the possibility to perform expressive queries is supported. From one hand, a language as much as similar to well-known query languages for relational

databases language should be preferred. On the other hand, interfaces enabling not expert users to query the ontology should be developed (e.g. *query forms*).

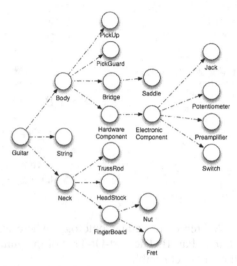

Fig. 5. A high-level view of the guitar ontology briefly introduced above. Classes are represented as circles connected by Part-of relations.

First, one kind of query interface is the SPARQL free query form, where users can write queries in the SPARQL language, display results in paginated tabular form and navigate through results via hyperlinks. This interface is very flexible because the users can write arbitrary queries but is not suitable for end users who are not expert on the ontology domain.

Another kind of query interface is based on a pre-defined set of queries: Each query is composed of a description in natural language, a SPARQL query with optional parameters. Every parameter has a *label*, a *type* and, eventually, a *restriction* on the values (e.g. a parameter can only be valued with instances of a given class). For this interface, users can select a query by its description, define the query parameters' value and execute it.

GUITAR HERO Functionalities

Through the exploitation of a tool like NavEditOW, OWL ontology could be used like a database, to store, search and retrieve information. Moreover, representing the guitar domain as OWL ontology is useful:
- To explicit the domain representation;
- To generate the *Bill Of Material* (BOM);
- To make automatic classification of guitar models.

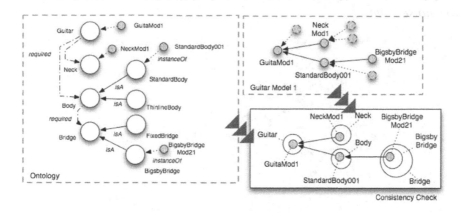

Fig. 6. An example of Consistency Check on GuitarModel1.

The explicit representation of the domain with OWL, as shown in Figure 5, allows describing every concept with a formal language and to give each term a unique an explicit definition. This definition could be shared within the enterprise, among experts, suppliers and clients.

Moreover, exploiting an OWL consistency checker it is possible to check the consistency of the ontology (see Figure 6). For example if we would assert that every guitar must have only one neck and a particular guitar has more then one neck, a problem will be detected and notified. This is a really simple example; in real cases, having to deal with larger ontologies, to find inconsistencies is a hard task for a human.

With an ontological representation of the components constituting a guitar, it is possible to automatically generate the complete set of the physical elements required to manufacture the product. The generated Bill of Material (BOM) accurately lists all parts and raw materials needed to make a unit of product, as depicted in Figure 7. An interesting aspect is the flexibility of this ontology-based BOM: For instance, if we would assert that a Guitar Body requires a Bridge, we will be able to choose either a Bigsby or a Fixed Bridge.

It will be possible to select istances of both classes because both Bigsby and Fixed Bridge are subclasses of Bridge; thus, an OWL reasoner will be able to infer that the instances of subclasses are also instances of a superclass.

Another feature provided by OWL, and inherited by NavEditOW, is the ability to automatically classify the instances of the ontology. In the guitar domain (see Figure 8), a "LowNoiseGuitar" has been defined as a guitar with an *aluminum body* or a guitar with a *multi-coil pickup*. NavEditOW is

able to discover every guitar with these features and to assert that it is a
low noise guitar.

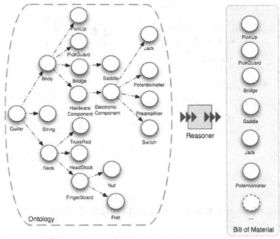

Fig. 7. Example of Bill Of Material generation.

One more example: a "FineTuningGuitar" is defined as a guitar with
single saddles or *Trussrod adjustable on the Headstock*. The first defini-
tion concerns the regulation of strings: As introduced above, single saddles
allow a more precise regulation than double ones. The second definition
regards the regulation of Neck against deformations according: Trussrod
adjustable on the Headstock is more efficient than Trussrod adjustable on
the Body. Every guitar with at least one of these features is an instance of
this class.

Since the two classes "LowNoiseGuitar" and "FineTuningGuitar" are
not disjointed, a guitar can be classified at the same time *low noise* and *fine
tuning*.

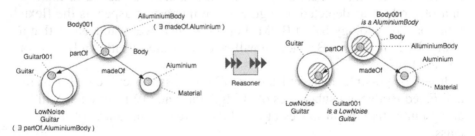

Fig. 8. Automatic Classification. The reasoner infer that Body001 is an instance of
AluminumBody and, thus, Guitar001 is an istance of LowNoiseGuitar.

A Use Case

In order to understand the improvement given by the knowledge based approach to support the decision making process in the design and manufacturing of electric guitars, it is useful to present a use case, shown in Figure 9. Let's suppose that a customer asks to NOAH a guitar with specific features: a low noise guitar. NOAH has two possibilities to meet requirements: searching for an existing guitar with such feature in the ontological repository or designing a totally new guitar.

Generally, a good choice could be to check the existing archive of products and decide to build a new one if and only if there is no product presenting the required features. NOAH can extract the list of the individuals belonging to the "LowNoiseGuitar" class. Thanks to the automatic classification provided by NaveEditOW, all the guitars that are classified as "low noise" will be inferred as a set of instances of the "LowNoiseGuitar" class. If the set would be empty, NOAH will be notified and can decide to build a totally new guitar.

Otherwise, NOAH will be able to select a guitar class from the ontology, compute the Build of Material and select all the components. Then, the system will check for the selection of all the required components, and eventually notify the user in case of omissions. The new guitar will be automatically added to the ontological repository, so that it will be chosen in the future if a new customer requires a guitar with the same features.

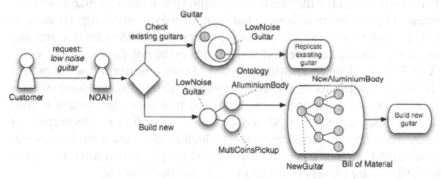

Fig. 9. Use Case.

Discussion

The GUITAR HERO project can be considered from different perspectives, as (1) knowledge based system concerning an innovative domain, (2)

a design support system, (3) a system for the preservation of cultural patrimony and creativity of handicraft and small-medium enterprises.

About the first point, it is important to highlight that guitar domain has been already explored by Computer Science (see e.g. [11]), but previous works in this field were mainly characterized by the analysis and reproduction of fingering methods for learning systems [5], classification of playing styles [4][6] or tablature generation for electronic simulation of melodies [8][15] rather than the attempt to build complete knowledge models for supporting the manufacturing of products.

With respect to the cited works, the GUITAR HERO project is devoted to the application of knowledge engineering and management techniques rather than traditional CSP and Vision-Based ones adopted in this field.

About the second point, the main interesting feature of GUITAR HERO project is the adoption of ontologies for representing complex objects from the functional point of view. In this sense, the project exploits a conceptual framework [1] already tested in the past [2][7]. This framework is very suitable to deal with design and manufacturing problems, because it allows giving a complete representation of sub-systems a complex object is composed of, describing their role in delivering functionalities.

The third issue is probably the more interesting, since it concerns the development of support systems for organizations characterized by scarce level of computer science technology.

Indeed, the real innovation of the GUITAR HERO project is the product it is focused on, that is the result of a completely handicraft manufacturing process. The challenge is how to build an effective knowledge based system for a problem where no formal representation of the decision making process is available, and creativity of experts is the key factor for success.

The functional representation adopted allows describing the properties of a complex object as they emerge from the underlying structure of relationships among functional subsystems: in this way, the system is able to classify the request of a NOAH customer according to the archive of already manufactured products, suggest which kind of raw material or semi-manufactured parts to buy and keep NOAH people in touch with collaborators, like guitar players or makers of stringed instruments.

Conclusions and Future Works

This paper has presented the GUITAR HERO project, collaboration between the Research Center on Complex System and Artificial Intelligence of the University of Milan-Bicocca and NOAH Guitars.

The project scope is the design and implementation of a Knowledge Based System for supporting creativity of NOAH experts in designing and manufacturing electric guitars with aluminum bodies.

The decision making process in this field involves different kinds of knowledge, which must be properly captured in order to understand how the different components of the guitar can be related to each other, influencing final product features. In this sense, the adoption of ontologies as conceptual framework for the representation and integration of knowledge is strategic, as well as the development of a ad-hoc tool, named NavEditOW, to guarantee their easy navigation and management.

Moreover, the adoption of NavEditOW has been made to allow an easy and quick access to the system through Internet. NavEditOW is a tool for the navigation and query of ontologies over the World Wide Web. This possibility is indeed a great benefit for NOAH, that will lead to a more efficient management of orders to suppliers, communication among people and so on. Anyway, this is object of future works at the moment, since we are still evaluating how to modify the NavEditOW interface to this aim.

It is important to notice that the functional representation of the guitar is not present in the current version of the ontology: a knowledge acquisition campaign started recently in order to cover this issue by the identification of functional systems within the guitar. Table 1 illustrates some of such functions and functional systems.

Table 1 Functions and functional systems in the Guitar Hero project

Function	Definition	Functional System Components
Precision	the guitar capability to maintain the string tuning when solicited in a hard way	Bridge, neck, strings
Usability	the guitar capability to be played comfortably	Body, neck
Timbre	the distinctive property of a guitar sound	Bridge, pickup, tone and volume controls, strings

The definition of function and functional systems is crucial to guarantee usage flexibility of the system by the user, since it allows enriching the guitar ontology with transversal relationships among parts. In this way, the user can be guided in definition of more complex properties, configuring a

new guitar not only in terms of features derived from simple aggregation or specification of parts (i.e. Part Of and IS A relations), but also of complex characteristics deriving from their combination to obtain given results (e.g. The guitar timbre must be *clear*).

At the end of the functional ontology development, we'll be able to plan the second part of the project that aims at representing procedural knowledge concerning the different steps of the manufacturing process starting from the CAD model of the body. This project phase will consist in the integration of the guitar functional model represented by ontology with constraints coming from NOAH experts in aluminum processing. The expected result of this project step is the integration of NavEditOW with tools for the management of procedural knowledge, like e.g. SA*-Nets [7] or Influence Nets [18].

Finally, we are now planning the second part of the project that aims at representing procedural knowledge concerning the different steps of the manufacturing process starting from the CAD model of the body. This project phase will consist in the integration of the guitar functional model represented by ontology with constraints coming from NOAH experts in aluminum processing. The expected result of this project step is the integration of NavEditOW with tools for the management of procedural knowledge, like e.g. SA*-Nets [7] or Influence Nets [18].

Acknowledgements

Authors wish to thank NOAH experts for their support in writing the paper, and in particular Gianni Melis, whose competencies and expertise we have tried to model in the current version of the system. Special thanks to Andrea Fulciniti for his work.

References

1. Colombo G, Mosca A, Sartori F (2007) Towards the design of intelligent CAD systems: An ontological approach. Advanced Engineering Informatics 2: 153-168
2. Colombo G, Mosca A, Palmonari M, Sartori F (2007) An upper-level functional ontology to support distributed design. Proceedings of ONTOSE 07, 2nd International Workshop on Ontology, Epistemology and Conceptualization of Software and System Engineering
3. Bonomi A, Mosca A, Palmonari M, Vizzari G (2007) NavEditOW - A system for navigating, editing and querying ontologies through the web. Proceeding

of Knowledge-Based Intelligent Information and Engineering Systems, Springer Berlin/Heidelberg 3: 686-694

4. Kerdvibulvech C, Saito H (2007) Vision-based detection of guitar players' fingertips without markers. Proceeding of Computer Graphics, Imaging and Visualisation, IEEE Computer Society: 419-428

5. Motokawa Y, Saito H (2006) Support system for guitar playing using augmented reality display. International Symposium on Mixed and Augmented Reality, IEEE/ACM: 243-244

6. Izumi T (2002) Cognitively oriented design of a multimedia system to learn guitar fingering. Proceedings of International Conference on Computers in Education 1:789-791

7. Bandini S., Sartori F (2006) Industrial mechanical design: the IDS case study. In Design Computing and Cognition'06, JS Gero (ed), Springer, Netherlands:141-160

8. Tuohy DR, Potter WD (2006) Generating guitar tablature with LHF notation via DGA and ANN. Proceedings of International Conference on Industrial, Engineering & Other Applications of Applied Intelligent Systems IEA/AIE '06, Advances in Applied Artificial Intelligence, Springer-Verlag 4031:244-253

9. Kalyanpur A, Parsia B, Hendler JA (2005) A tool for working with web ontologies. International Journal on Semantic Web and Information Systems 1: 36–49

10. Hustadt U, Motik B, Sattler U (2005) Data complexity of reasoning in very expressive description logics. Proceedings of Nineteenth International Joint Conference on Artificial Intelligence, Morgan-Kaufmann Publishers: 466–471

11. Radicioni DP, Lombardo V (2005) A CSP approach for modeling the hand gestures of a virtual guitarist. AI*IA 2005 – Advances in Artificial Intelligence: 470-473

12. Staab S, Studer R (2004) Handbook on ontologies. International Handbooks on Information Systems, Springer

13. Knublauch H, Musen MA, Rector AL (2004) Editing description logic ontologies with the Protégé OWL plugin. Description Logics, CEUR Workshop: 104

14. Haarslev V, Lu Y, Shiri N (2004) Ontoxpl - Intelligent exploration of OWL ontologies in web intelligence. Proceedings of the 2004 IEEE/WIC/ACM International Conference on Web Intelligence, IEEE Computer Society: 624–627

15. Miura M, Hirota I, Hama N, Yanagida M (2004) Constructing a system for finger-position determination and tablature generation for playing melodies on guitars. Systems and Computers in Japan 35(6):10-19

16. Broekstra J, Kampman A, van Harmelen F (2003) Sesame: An architecture for storing and querying RDF data and schema information. Spinning the Semantic Web, MIT Press: 197-222

17. Ram S, Shankaranarayanan G (1999) Modeling and navigation of large information spaces: A semantics based approach. Proceedings of the 32nd Annual Hawaii International Conference on System Sciences 6: 157-168

18. Wagenhals L, Insub S, Levis AH (1998) Creating executable models of influence nets with colored petri nets. International Journal on Software Tools for Technology 2: 168-181
19. Wenger E (1998) Community of practice: Learning, meaning and identity. Cambridge University Press

Discovering Implicit Constraints in Design

Madan Mohan Dabbeeru and Amitabha Mukerjee
Indian Institute of Technology, India

In familiar design domains, expert designers are able to quickly focus on "good designs", based on constraints they have learned while exploring the design space. This ability to learn novel constraints is a key aspect in which design differs from traditional optimization; the constraints on the search are constantly re-defined based on the search experience itself. Moreover, such constraints are often implicit, i.e. the designer may find it difficult to articulate these constraints and provide reasons for them. Here, we ask if computer-aided-design systems can discover such implicit constraints in well-understood design situations, where the function can be articulated clearly enough to be quantified in terms of *performance metrics*. By considering function across a large number of design instances, patterns of functional feasibility may be learned as a byproduct of evaluating different designs. We show how patterns of functional infeasibility result in novel constraints that rule out certain regions of the design space. We demonstrate this process using examples from the design of simple locking mechanisms, and as in human experience, we show that the nature of the constraints learned depends on the extent of exposure in the design space, and may be widely variable in early stages. We also show how the process of design change, when the design space is modified, e.g. by adding new design variables, can build on patterns learned on past designs. In conclusion, we discuss the ramifications of this process on chunking and representational change, and also on design creativity.

"The expert designer has explored extensively in previous sessions and no longer needs to try out many different alternatives. The expert is confident of immediately choosing a good one, based on experience. [16]"

Implicit Constraints in Expert Design

Repeated studies have observed how experienced designers come up immediately with designs that are superior in most respects to those produced

J.S. Gero and A.K. Goel (eds.), *Design Computing and Cognition '08*,
© Springer Science + Business Media B.V. 2008

by novice designers or CAD systems [16, 19, 5]. Clearly, this proficiency is related to some patterns learned in past experience.

This paper builds on the well-known cognitive claim that in part, the expert's ability to immediately come up with such good designs lies in her use of additional constraints, which are often implicit in the sense that the designer herself may not be able to articulate them coherently. In think-aloud sessions, designers may use terms like "looks right" without giving more detailed justifications other expressions such as "worked before". This phenomenon has been called "intuition based upon previous experience" [1], contrasting it with situations where the designer refers to past designs in a deliberate manner.

The implicit nature of such domain-specific constraints appears to be common in expert behaviour across many domains, ranging from chess, medicine, computer programming, bridge, physics, etc. [8]. In chess, grand-masters do not evaluate more positions than far weaker players, but the positions they do evaluate tend to be the better ones [15]. It has been noted that their constraints are also implicit; they are rarely revealed in direct introspection, but when the expert is questioned as to why a certain line was not considered, they will often say that it simply did not strike them [15]. Later that line almost invariably turns out to be flawed, thus validating the power of the intuitive constraint that was used. While analogies of design processes with domains such as chess have been contested since design is a much less well-defined problem [1], the implicit nature of these intuitions across so many domains cannot be ignored. Among expert human designers, similar questioning occasionally reveals domain-specific biases, but the presence of such constraints may be more widespread than appears in introspective testimony. Indeed, some researchers feel that design is essentially a process of exploring constraints [28]. Whatever be the nature of this knowledge, it is clear that somehow the expert is able to convert her experience in familiar design domains into a constraint that narrows down the design to a more fruitful region of the search space. On the other hand, the novice designer (as well as the CAD system) gives equal importance to all designs that satisfy the design specs. Clearly, the ability to learn such patterns would confer a significant search advantage for CAD systems.

The discovery of underlying patterns in the design space may be one of the earliest steps in a long process of cognitive discoveries that forms the core of design expertise. Sometimes the implicit pattern discovered may draw the designer's attention to those aspects of behaviour, which may help formulate an explicit awareness of certain interrelations, what has been called "situated invention" [33]. In the long run, this may be the first

step towards generalizing over regions in the design space, a process called chunking, that results in a restructuring of the design representation itself [36]. Differences in evaluating functions (e.g. aesthetics) or differential explorations of the design space (experience in different classes of products), may lead to differences in learned patterns, which possibly constitutes one of the primary factors behind differentiations in design style.

Design Space Exploration, Sketching, and Emergence

The human designer discovers patterns of functional effectiveness while exploring different parts of the design space, often using sketching as the mechanism of choice for this preliminary exploration. During this process, various design choices are quickly evaluated for functional feasibility, often using additional visual constructs that operate on the sketches themselves [13]. In the language of [14], "one reads off the sketch more information than was invested in its making." Thus the sketch "triggers" other images in the mind, leading to a wider exploration of the visual and spatial ramifications of the particular part of the design space, cycling between "seeing as" and "seeing that", where the former may potentially lead to a restructuring of the design space [34]. Where sketches are explicitly unavailable, the designer may conduct a similar exploration of the design space using mental imagery, often revealed through gestures or other modalities [2].

A key aspect of sketch-based exploration is the emergence of new ideas, closely related with the idea of implicit constraints. Emergence occurs when "interesting properties" arise that were not part of the initial design goals [4]. These interesting functions often arise from the complex interaction involving relatively simple low-level mechanisms. An alternate view of emergence is that aspects that were implicit in the design, are thought to be made explicit [31]. In either view, design is seen a dynamic process, where both the solution and the search space evolve dynamically in the course of the design with the evolving implicit constraints. As a result of these constraints, the process of design is far from open, and the next sketch is extremely biased by the designer's evaluation of the present sketch, so much so that design becomes more a process of *generation* rather than exploration [7]. Computational paradigms have attempted to capture this by simultaneously evolving both the solutions and also the optimization criteria [27, 30]. As part of this process, new abstractions are formed of what constitutes the feasible zone for a design in a design space. However, exactly how these specifications may be computationally reformulated in terms of function has not been worked out in detail.

Discovering Implicit Constraints in Machine Design

Since the origins of Computer-Aided design, e.g. in the very early ideas of Ivan Sutherland [32], there has been considerable emphasis on the process of discovering constraints in the design space, often through computational imagery that simulates the process of sketching [28]. Indeed, the idea of constraints on design parameters, originating in the work of Gossard [26], revolutionized CAD by introducing the notion of parametric modeling.

However, not much computational work has focused on the task of discovering implicit constraints by exploring function in the design space. Partly this is because of a difficulty of understanding function. In this work, we only consider design problems that are well understood, so that function is definable, and may be expressed in quantifiable terms. Part of the design quest is also this clarity in defining the function; but as of now, most CAD systems leave the specification of function for the human designer. Recently, Janssen [19] has proposed CAD models that incorporate designer preconceptions as similar embodiments and functions; in this paper, we use the term *Functionally Feasible Regions* FFRs to denote these "preconceived" functional constraints. While Janssen characterizes these functions, we present a mechanism for learning such FFRs within a computational framework.

One of the assumptions of this work is that function is well-characterized for the class of designs under consideration. For instance, in the case of locks, an important function may be strength, along with weight, cost, and robustness against jamming. We show how exploration in the multi-function space results in identification of different levels of feasibility in different parts of the design space. Some of the constraints learned for our second example design, the slotted wheel mechanism (rotating barrel lock), some of the constraints "discovered" by the system are quite enlightening.

In human sketching, functional evaluation uses visual mechanisms that are made available while exploring the imagery of the sketch itself [34]. In the case of computational models, such processes can be simulated using computable functions applied to various fully instantiated 3D models. In order to address this question computationally, we need a formal notion of design space.

Design Space

Following the design optimization tradition, the Design Space Ω as the space defined by a finite set of *design variables vi*, i.e. the set of independ-

ent parameters that define a design instance. These design variables are traditionally expressed as the design vector v, $v = \{v1, v2, v3...vn\}$ are elements of Rn. Fixing all the parameters results in a unique design, which may then be evaluated for different functions. Typically the design space is constrained by certain user-specified criteria, often called design specifications.

Consider the padlock shown in Fig. 1. In our model, the padlock design space consists of five design variables: *bminor*, height of the elliptical main body; *r:* Ubolt curvature; *l:* length of U-bolt; *t:* thickness of latch, and *w:* width of the slot opening in the U-bolt. A number of other structural dimensions related to shape and function are determined from these design variables alone, e.g. the width (major axis) of the elliptical body, a is specified as $2.5r$ and there are few constraints $r0 > ri$ to define valid geometry. The design vector v is the vector of these five design parameters. The Design Space () is the space of the five-dimensional design vectors.

Given a set of values for the the design variables, these uniquely define a larger set of structural variables, which are dependent parameters. For the padlock example, given the five design parameters specified above, other structural variables such as ri can be derived. Given the full set of structural variables, the final design is uniquely specified. The design space is bounded by defining a set of specification constraints $fs(v)$ which must be true (here fs is taken to be boolean; one may consider these to be algebraic functions, of the form $f() < 0$, say). These constraints typically define one or more continuous regions in the space of the design variables, and it is assumed here that the design is not over constrained (no valid designs are possible) or under constrained (design space is unbounded). Thus the set of design variables, together with these constraints, along with the mappings from the design variables to the structural variables, defines the design space Ω.

Computational Discovery of Functional Patterns

How might computational processes come up with implicit functional constraints? We describe a simple approach for learning the patterns underlying the functionally feasible regions (FFRs) based on the evaluation of candidate designs. The discovery of such new constraints may also be called Schemata or patterns in the design space that underlie expert designer knowledge [25]. Any general purpose function approximators algorithm can be used; here we use multi-layer perceptrons as our vehicle for learning the FFRs. In practical systems, the resulting constraints may be of direct value to novice designers, especially in situations involving many

choices [16]. Clearly this would constitute an important step if we are to enable computers greater access to the range of creative improvements possible for the human designer [19]. Computationally, the process of exploring design, involving computationally expensive analysis of aspects such as strength, flow, or motion, can then be limited to a much smaller range. More importantly however, it may be possible to determine a trade-off between the constraints given and the functions that are specified, a key requirement in Creative design [5].

Fig. 1. Functional Constraints: Padlock Example: (a) Padlock design vector v = {*bminor, r, l, t,w*}. (b) Design fragment U-bolt and latch moving vertically and horizontally respectively. (c) The (w, t)-slice in the design space. Here w < t is clearly infeasible, since the latch collides with the slot. If w − t is too small, ease of operation may be hindered by small misalignments; if it is too large, it may leave too much play and weaken the lock. Parts of the configuration space for design instances C, B, and A are shown in the figure (d) Configuration Space for latch-bolt design fragment – relates horizontal motion of latch (X) with vertical motion of U-bolt (Y).

In geometric design, the specification constraints *fs*(*v*) typically deal with the relationship between design variables in the form of algebraic (non-linear) equations. Some of these constraints ensure that the design is geometrically sound (e.g. the geometry has no singularities, or that the mapping functions to the structural variables are not violated). Based on the specific constraint values, a geometric object may be well constrained, under constrained and over constrained [18].

Here we are interested in an additional class of constraints, which we may term as Functional constraints that specify the relationship between elements of function. Consider for example, the function of a padlock Fig. 1, where the latch of thickness *t* has to enter the slot with a clearance *w*. Here, the constraint *w* > *t* defines a partition in the design space which may not have been explicitly specified as part of the formal design specifications *fs*(*v*). However, even novice designers will discover this constraint immediately upon exploring even a single design; thus this constraint will become explicit very soon. This may be treated as a trivial instance of an emergent constraint. On the other hand, there may be other constraints

arising from functional considerations, e.g. the strength of the lock against hammering, which impose other patterns on the design space which are far from obvious. Quite often, even with experienced designers, such patterns may be internalized in an inarticulate manner, and will thus remain as implicit constraints.

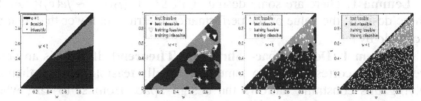

$\tau > 6$ for actual functional constraint $\tau > 6$ learning with 20 $\tau > 6$ learning with 200 $\tau > 6$ learning with 450

Fig. 2. Learning through experience for slotted-wheel. The implicit constraint on the w, t subspace of the Design Space is learned under the functional specification that the breaking-torque τ must be greater than 6k-Nm. The exact FFR is shown in the leftmost figure. The implicit constraint learned by a multi-layer perceptron based on 20, 200, and 450 samples are shown next. The decision surface learned with fewer trials are extremely variable, but it stabilizes for larger samples. By 450 instances, the learned model is quite stable.

As an example of such an implicit constraint that may be learned by our system, consider the functional specification that a lock (not the padlock, but one with a rotating barrel, say) must have a strength that can withstand a given torque. For such a specification, it turns out that the thickness t cannot be too low, for then the latch will fail too easily. Similarly, if the gap between the slot width and the latch, $w - t$, is very low, the latch may not enter deep enough into the slot, resulting also in failure. The actual and learned FFRs, or implicit constraints, for resisting a torque of 6 kilo-newton-meters is shown in Fig. 2.

Design Space Shrinking

Since the patterns for the feasible functional regions holds only over designs with a high functional performance, it results in a narrowing of the design space. Let Ω be the initial design space defined by the set of design specifications $fs(v)$. Let $fe(v)$ be an emergent constraint that is learned through exploration, based on a function characterized by a set of performance metrics $\pi(v)$. Now, whenever fe is true, fs must also be true, otherwise these designs v would not have been explored at all. This is the basis of the following simple result, which motivates this work.

Definition 1 (Specification constraints). The specification constraints $fs()$ constrain the Design Space Ω, which is defined as: $\Omega = \{v/fs(v)\}$.

Definition 2 (Emergent constraint). An emergent constraint $fe(v)$ is true for those design vectors where some functional metric π is higher than elsewhere in the design space.

Lemma 1. There are some designs v in Ω s.t. $\{fs(v)^\wedge \sim fe(v)\}$; i.e., for these designs, the value of the performance metric π is lower than that acceptable by $fe()$.

Theorem 1 (Design Space Shrinking Theorem). If $fe(v)$ is an emergent pattern corresponding to some functionally feasible regions, then applying this constraint narrows the design space from Ω to ΩE, where $\Omega E \subset \Omega$.

Proof. This follows from the fact that $(9v)\{fs(v)^\wedge \sim fe(v)\}$.

If one can obtain a measure for the cardinality of the design space, then one may also define the effectiveness of an emergent constraint in terms of the degree of shrinking $\|\Omega E\|/\|\Omega S\|$. If this shrinking factor is observed to be high, the designer's conscious attention is drawn to it, and she may explore the reasons for this behaviour. This is possibly one aspect of what [4] has called "interestingness" of the emergent relation.

Clearly, the function evaluation π is a key aspect of any computational process for discovering implicit constraints. In the next section, we develop on our model of function in terms of a quantifiable performance metric for the examples of a simple padlock and a rotating barrel padlock. Last, we show how changing a design space, e.g. by introducing an additional design variable for the rotating barrel, causes some of these implicit functions to change.

Function as Performance Metric

Modeling function and how it relates to structure is a complex question that has been addressed in many ways [37, 10, 11, 9]. Given a class of design objects, there may be a functional goal, defined in terms of user intent, associated with the design. Such a function may be analyzed in terms of Gero's Function-Behavior-Structure (FBS) framework [10], or its variations incorporating "situatedness"[12, 11], or in terms of Umeda's Function-Behavior-State framework [35]. In general, different part families (embodiments) may satisfy the desired function. In this work, we assume that we are working within a given functional part family, so that the specific function is well-understood and can be defined in terms of a *perform-*

ance metric [6] for each aspect of the intended behaviour. For the padlock example, the set of user intents may include strength of the lock, (in terms of the maximum force it is expected to sustain), ease of locking (resistance to jamming), and other aspects such as cost, ease of assembly, and also subjective aspects such as aesthetics.

In mechanical assemblies, relating functions to structure often involves relative motion of the subparts - these may be captured using Configuration Space or C-space [24, 22, 9]. However, computing the C-space for general motions remains an intractable problem [20]. Further, given a C-space, obtaining successful abstractions on it - i.e. segmenting the free-space into behaviorally significant regions - e.g., using topologically different contact types [29], remains a considerable challenge. Here, we assume that similar designs have been explored already, so that some understanding of the C-space and its abstractions are available, so that a performance metric can be defined for a given design instance. This is clearly true only for well-explored design problems, and implicit constraints can only be learned in such spaces. Design as search then involves determining the motion (behavior) as determined through kinematically constrained geometry interactions [23]. These motion constraints among the motion variables are in turn related to the design variables [21].

In the design search process, a set of structural variables γ define a specific structure in the structure space Γ. There may be several constraints between the structural variables in order to obtain a consistent design; these are reflected in the mappings that obtain the structural variables from the design variables, and the constraints on the design variables themselves. Together these variables and their constraints define the design space Ω.

In the padlock example, of Fig. 1, if we assume the width of the slot w and the thickness of the latch t to be part of the design vector v, then for the part of the design space where $w < t$, the latch cannot enter into the slot, and thus though the shape is geometrically valid it is functionally infeasible. If we define a performance metric for ease of assembly that is dependent on the clearance $w - t$, then for different minimum acceptable levels of this performance metric, different regions in the design subspace w, t will become infeasible. Similarly, strength considerations, as well as other performance issues relating to the manufacturability, assembliability, etc. may further restrict the "good" functional zones or schemata known to the expert designer. It is our purpose to construct computational algorithms for exploring such patterns in the design space.

We consider now some specific function metrics for a) the padlock example introduced in Fig. 1, (b) a Slotted wheel mechanism, and (c) Slotted wheel with latch vertical shift.

Discovering Patterns of Functional Feasibility: Multi-Layer Perceptron

In this work, we use a simple multi-layer perceptron (MLP Neural Network) as our device for discovering functionally feasible regions (FFRs) in the design space. Neural networks are general-purpose function approximators that generalize statistical models from incomplete and uncertain behaviour information, and can be designed to adapt to the designer's requirements. Artificial Neural Networks (ANN) are computing systems made up of a number of simple, highly interconnected processing elements, which processes information by their dynamic state response to external inputs [3]. These ANNs map from a set of given input patterns to an associated set of known output values.

The MLP network (also called back-propagation) map is trained using a set of given input patterns for which the associated output values are known. Weighted sums of the inputs are propagated through one or more hidden layers [17], and the errors at the output are used to adjust the weights. In our case, design vector v is the input pattern and the known output is performance metric π. During the training process, the system uses the evaluations it has made of π on some of the points in the design space to clamp the output, and this is then used to adjust the weights of the internal connections to minimize the errors between the network input and the target output. ANNs, like many other machine learning systems, can thus be thought of as general purpose function approximation tools. In the figures of the results shown, the sample designs on which evaluation was performed are shown with a "+" (infeasible) and "Δ" (feasible), and we have used different colors for feasible designs (π greater than some minimal π_0) from infeasible ones.

How the sequence of designs are selected for exploration is a critical issue in design, but this is not evaluated in this work; we use a random selection of a given number of designs as the training set for the ANN. The network architecture used has a single hidden layer and 50 neurons with single output parameter (πstr).

Example: FFRs for Padlock

To learn the FFRs for the padlock example, we sample many points v in Ω, each of which corresponds to an actual design. For each design instance, we evaluate the performance metrics. The performance metrics we consider here are $\pi str = \sigma Y \, bl \, t^2 / 6*l$ and $\pi ease = w - t$ [6] and see if the design is feasible or not. Earlier, in Fig. 2, we have presented such learned implicit constraints for a slotted wheel mechanism.

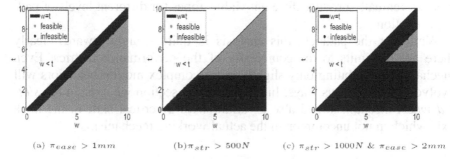

(a) $\pi_{ease} > 1mm$ (b) $\pi_{str} > 500N$ (c) $\pi_{str} > 1000N$ & $\pi_{ease} > 2mm$

Fig. 3. FFRs (Functionally Feasible Regions) in padlock design space. Even in the region $w > t$, some regions close to the boundary may be ruled out at certain levels of the Ease of Locking metric $\pi ease$ (a), while low values of latch thickness t are likely to be ruled out by strength considerations in πstr (b), Combining $\pi ease$ and πstr metrics superposes these constraints (c).

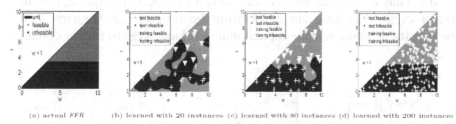

(a) actual FFR (b) learned with 20 instances (c) learned with 80 instances (d) learned with 200 instances

Fig. 4. Learning through experience for padlock. The implicit constraint on the w, t subspace of the Design Space is learned under the functional specification $\pi str > 500N$. The exact functional constraint is shown in the leftmost figure. An implicit constraint learned by the system based on exploring 20 design instances is shown next. The decision surface learned after 80 trials seems more convoluted, but this is because the sample space is an inadequate model for the actual pattern. By 200 instances, the learned model is quite good.

By applying different standards of acceptability for the performance metrics to different instantiations in the design space, one can obtain dif-

ferent bounds to the FFRs. The performance measure for ease of locking is negative for the region above the $w = t$ line, and this region thus becomes permanently infeasible. For any positive value of $\pi ease$, the line shifts more to the right. Similarly, for any given level of πstr, the material and other dimensions remaining the same, the strength rises proportionally to t^2. Combining these results in the functionally feasible space shifting to the right and up. At the same time, since high w and high t also imply higher values for other dimensions, cost and weight considerations are likely to squeeze the feasible region more to the bottom and left. This would eventually produce different viable zones for different levels of pad-lock function.

While for the padlock, this analysis is quite straightforward, clearly there are no limits to the complexity of the performance metrics. Even mechanisms exhibiting only slightly more complex motion behaviors will evolve in less obvious ways. In the following section we explain the *slotted wheel mechanism* and also a variant with a vertical shift in the latch axis which in not uncommon in the actual working mechanisms.

Slotted Wheel Mechanism

The constraints discovered in the padlock example seem extremely straightforward, of the kind that even a novice designer may discover within a few trials, along with the causal process underlying this constraint. Thus for the human therefore these FFRs become explicit, leading to a process of chunking and restructuring the design space. For a machine, the constraint would remain implicit unless it has access to further domain knowledge.

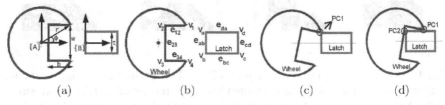

(a) (b) (c) (d)

Fig. 5. *Slotted-Wheel mechanism.* (a) Design Parameters: radius r, width w, breadth b, thickness of the latch t. (b) geometric elements' in the contact region (c) A contact formation with a single contact involving two vertices (d) a contact formation involving two principal contacts, both of vertex-edge type.

Even with this very simple methodology however, we may encounter patterns of constraints that are not very obvious at all. Let us now consider

a mechanism only a little more complex than the padlock - a lock mechanism with a rotational slotted wheel and a translational latch (Fig.5(a)). The rotation of the wheel will be locked when the latch assembles into the slot of the wheel.

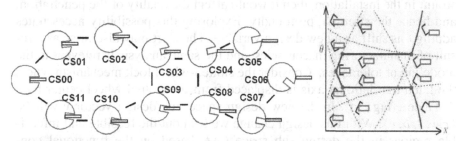

Fig. 6. *Contact State Graph*: (a) Each node represents a contact formation and the edge represents the transition of neighboring contact states (b) C-space with different contact states.

Each contact curve in Fig. 6(b) satisfies a contact equation $f(x, \theta, v) = 0$ which represents the function of each contact and it is result of solving contact constraints among the touching geometric elements. The shape of the curves depends upon the shape of the contacting geometric elements and type of contact formation. If the functional specification is to reach the contact formation CS00, (< e23, eab >) then it is a point in the contact space at $\theta = 0$.

A key aspect of design is reformulating the problem itself. Part of this process may be changing the design variables, e.g. by adding a new variable. Here, for the slotted wheel, we shall now explore how such a design change may add a variable for a shift in the latch so that it is no longer along the axis of the rotating wheel.

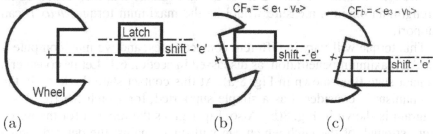

Fig. 7. Vertical Shift in Latch (a) Note that in addition to the contact formations of Fig. 6(a) two new contact formations are observed for shifts that are positive (CFa,Fig.(b)), or negative (CFb, Fig.(c)).

We next consider incorporating a new design variable as a design change. Based the designer's exploration of the behaviour of the slotted wheel lock, it becomes clear that if the latch were to be shifted so that the rotation axis of the barrel is below the latch, e.g. as a result of some constraint in the installation, then it would affect the quality of the penetration, and hence the strength, profoundly. Exploring this possibility necessitates adding this shift as a new design variable. The shift may also arise as a result of manufacturing inaccuracies, and the same analysis is relevant to the modeling of tolerances. Consider the slotted-wheel lock mechanism where the latch translational axis is displaced from the slotted wheel center by a distance e(Fig. 7a). In the new design space, the design vector v will be $\{r,w, t, b, e\}$. With this design change we find out the feasible and infeasible regions in the design sub space (w,t) based on the functional constraints. The mechanism is in the locked state when the latch is inserted into the slot of the rotating wheel. As e becomes more than $(w-t)/2$, the degree of penetration varies considerably, and this affects its function. Here, the strength of the lock may be measured in terms of the maximum torque that the barrel can withstand. The contact state graph(6)(a) also changes; two new contact nodes(7(b),(c)), emerge with the addition of vertical shift e; and this causes the mechanism to experience new set of behaviors at certain e values.

Performance Metrics

Maximum Penetration The penetration depth (PD) varies with the change in the vertical shift (e) values. The maximum penetration in the different ranges of e is shown 8(a).

Strength: Maximum Torque If we are to evaluate this lock based on its strength, an obvious measure would be the maximum torque τmax it can support.

This torque will vary in different contact states, and we may compute it for the maximum penetration, as discussed in section 6.1. Let us consider a contact state **B** as shown in Fig. 8(a). At this contact state the latch in the mechanism is considered as a simple supported, for which the free body diagram is shown in Fig. 8(b). Also, Eq. 1 gives the relation for the maximum strength of the latch which can withstand against the desired torque τ, where $w1 = w/r$, $t1 = t/r$, and $e1 = e/r$.

Here we obtain the following constraints based on Fig. 8(b). The maximum torque τmax that can be supported is determined by the contact force F and its moment arm; this contact force is in turn limited by the latch strength.

$$F = \frac{\sigma_Y b_{latch}(t_1)^2}{6l}$$

$$\tau_{max} < -F\cos\theta\, d(X,\theta) - F\sin\theta\left(e_1 + \frac{t_1}{2}\right)$$

$$d(X,\theta) = \frac{2e_1\cos\theta + t_1\cos\theta - w_1}{2\sin\theta}$$

Where $d(X, \theta)$ is the moment arm for the vertical component of the contact force F.

The performance metric πstr for the slotted wheel may be simply set to be πmax as given in the equations above. Now, asserting different levels of acceptability for πstr results in constraints involving different parts of the design space, as seen in Fig. 9. Designs with thin latches (low values of t) are clearly rejected by the requirement for strength, but owing to the penetration depth being related to theta, when e is a significant compared to t, high strength also requires higher slot width w's.

Design Experience and the Quality of Implicit Constraints

Although we are able to learn some types of constraints from the function evaluations across the design space, there are many questions that remain. For one, what is the nature of the convergence of the learning function? Are the constraints learned indeed reasonable? How do these constraints depend on the design experience? How can the next design exploration be controlled so as to maximize the effectiveness of the learning?

Human designers clearly improve in the quality of their immediate design decisions, as they gain experience. In our case we can see a similar phenomenon that can be understood in terms of learning machines. Any function generalizer that learns from a set of training data is sensitive to the size and distribution of its data. Clearly, as more samples from the design space become available as training data, the quality of the learned function will improve.

We next explore how the quality of learning changes depending on the degree of exploration in the design space. We consider a learning system that learns from a small (20), medium (200) and large (450) number of samples (Figure 10) for the slotted wheel with $v = \{b/r = 0.5, e/r = 0.3\}$. Here we attempt to learn the FFRs (feasible region constraint) for the performance constraint $\tau max > 6$.

Given that we can compute the exact FFRs that obtain in the underlying design space, we can then compute the errors in each case in terms of the

percentage of false responses in the resulting implicit constraint. We define error as the false fraction - i.e. those design instances that are actually infeasible but show up as accepted in the learned function (False Positives, FP), and those that are feasible but are rejected (False Negatives, FN). FP can be visualized as the part of the reject area in Fig 10(a) that is marked as accept by the learned function, and FN is the part of the accept area marked as reject. As expected, large swathes of the design space are marked falsely with 20 samples, and the accuracy improves or error decreases considerably with 450.

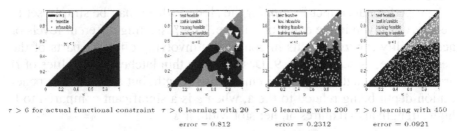

Fig. 10. Quality of Implicit Constraints learned improves with experience. The design space shows the learning after experiencing 20,200, and 450 design instances. The actual functional constraint is shown in the leftmost figure.

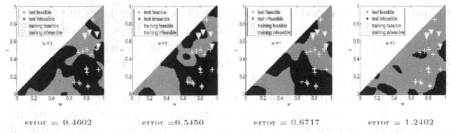

Fig. 11. Learning through different experiences for the same design instances. The design space shows the learning with 20 design instances for the torque (strength) τ > 6. Note that the Neural network sometimes fails to converge satisfactorily, so that some of the training set is mis-classified.

However, it is observed that the learning does not improve monotonically - i.e., occasionally the implicit constraint learned after evaluating 50 design instances may be poorer than the pattern with only 10 instances. This is because of the wide variability in the early stages of learning. This leads us to issues of convergence in learning the function.

Convergence: Variability of Learned Function

Since it is extremely difficult to model the convergence of neural networks, we explore the issue of convergence empirically. We consider learning from the identical training data, but with random variations in the network weights.

Fig. 11 shows the implicit constraints, learned on the w, t subspace of the design space under the same functional specification $\tau > 6$ considered for the 20 design instances with the same sample set as input. Here we report the w, t subspace, holding the other parameters as $\{b/r = 0.5, e/r = 0.3\}$. It is observed that the learned pattern varies remarkably for a sample size of 20, but is markedly less when the training set has 450 samples (Fig. 12). This indicates that a high degree of exploration in the design space is critical to learning adequate constraint functions

Table 1 Function quality with increasing exposure. The error is the percentage of false region to the total region in the design subspace w, t. The mean error of the learned constraint function, as well as its variance, decreases significantly as the number of training instances increase from 20 to 450. This data is based on 25 independent runs for each sample set, for the slotted wheel mechanism with $e = 0.3r$.

Data points	Mean	Standard Deviation
20	0.9210	0.2147
100	0.3213	0.1200
200	0.1949	0.0162
450	0.1189	0.00110

Variability is measured in terms of standard deviation on the error. Table 1 shows the mean and standard deviations of the total different 25 trials conducted on same set of design instances for different data set. With the increase in the training input data the mean error and variation is reduced. This replicates human experience; in the early stages, the designer is beginning to form a function but its quality varies considerably. Also, as the function improves, the system is itself able to measure the error rate by considering how subsequent design explorations fare with this function; thus the rate of convergence, and the sample size needed for "adequate" exposure can itself be determined empirically. Clearly, for more complex design spaces with higher dimensionality, this may be a large number, and finding ways to reduce the dimensionality and therefore the adequate sample size, would be an important challenge.

An important difference between human and machine learning of these implicit constraints is that the program requires hundreds of sample points to be explored even in this relatively simple design space, whereas design-

ers typically go through only a handful of sketches even in more complex situations. One aspect of the human experience is that each sketch represents a large-ish region in design space, and not just a single design. More importantly, the human designer is using much more domain knowledge in terms of relations between the underlying parameters and their effect on the function, whereas the computational process identified here is blind to such functional inter-relations.

Conclusion and Future Work

In this paper, we have presented a computational process based on theories of emergence to imitate an expert designer's ability to learn implicit functions that indicate regions of high feasibility in the design space. We show how computational algorithms can also identify such regions, and also present results, using the simple mechanism of a lock, on how the convergence of such algorithms may be evaluated by using the quality of the functions even as exploration proceeds.

We have also explored the nature of design change by introducing a new design variable e(shift) into the design space, and show how even this small change results in unpredictable changes in behaviour, and how these in turn affect the functional requirements. While the examples involve very simple designs, there are no theoretical limits on the complexity of the design spaces on which such functions can be built. However, in each situation, we require that the function be well understood and quantifiable in terms of performance metrics - and at this point, the human user is required to specify these. Also, learning adequately accurate functions is likely to require a much larger training data in more complex spaces, and the algorithmic complexity of this training process remains an important consideration for future

Discovering such high-feasibility regions and defining implicit constraints based on them is important for abstracting other patterns of behaviour, and in particular, for seeding the chunking process, whereby the representation of the design itself changes, typically accompanied by dimensionality reduction. Another area of exploration in the future is the possibility of starting with a simple physics knowledge-base and developing representations that capture such functional relations among the parameters based on multiple design experiences for different classes of objects. Both of these changes are key to the possibility of creative design in machines.

Acknowledgements

This research has been supported by the *Research I Foundation*, IIT Kanpur, India. We would also like to thank one of the anonymous reviewers, one of whose questions regarding convergence triggered some of the explorations.

References

1. Ahmed S, Wallace KM, Blessing LT (2003) Understanding the differences between how novice and experienced designers approach design tasks. Research in Engineering Design 14(1): 1–11
2. Athavankar UA (1996) Mental imagery as a design tool. In Thirteenth European Meeting on Cybernetics and Systems Research, EMCSR 96: 1–10
3. Caudill M (1987) Neural networks primer. AI Expert Part I: 46–52
4. Chalmers DJ (2006) Strong and weak emergence
5. Cross N (2004) Expertise in design: An overview. Design Studies 25(5): 427–441
6. Dabbeeru MM, Mukerjee A (2007) Functional design for part families of mechanical assemblies. In G Hu (ed), ISCA, ISCA: 263–268
7. Eckert C, Kelly I, Stacey M (1999) Interactive generative systems for conceptual design: An empirical perspective. Artificial Intelligence for Engineering Design, Analysis and Manufacturing 13: 303–320
8. Ericsson KA, Lehmann AC (1996) Expert and exceptional performance: evidence on maximal adaptations on task constraints. Annual Review of Psychology 47: 273–305
9. Faltings B (1992) A symbolic approach to qualitative kinematics. Artificial Intelligence 56(2-3): 139–170
10. Gero JS (1990) Design prototypes: A knowledge representation scheme for design. AI Magazine 4(11): 26–36
11. Gero JS, Kannengiesser U (2004) The situated function-behaviour-structure framework. Design Studies 4(25): 373–391
12. Gero JS, Reffat RM (2001) Multiple representations as a platform for situated learning systems in designing. Knowledge-Based Systems 14: 337–351
13. Goel V (1995) Sketches of thought. MIT Press, Cambridge
14. Goldschmidt G (2003) The backtalk of self-generated sketches. Design Issues 19(1): 72 – 88
15. Groot AD (1978) Thought and choice in chess
16. Gross MD (1986) Design as exploring constraints. PhD thesis, Massachusetts Institute of Technology
17. Haykin S (1998) Neural networks: A comprehensive foundation. Prentice Hall
18. Hoffmann CM, Joan-Arinyo RA (2005) Brief on constraint solving. Computer-Aided Design and Applications 2(5)

19. Janssen PH (2006) The role of preconceptions in design: Some implications for the development of computational design tools. In Design Computing and Cognition '06, JS Gero (ed), Springer: 365–383

20. Ji X, Xiao J (2001) Planning motion compliant to complex contact states. International Journal of Robotics Research 20(6): 446–465

21. Joskowicz L, Addanki S (1988) From kinematics to shape: An approach to innovative design. In Proceedings of the AAAI, St.Paul

22. Joskowicz L, Sacks E (1991) Computational kinematics. Artificial Intelligence 51(1-3): 381–416

23. Joskowicz L, Sacks E (1994) Configuration space computation for mechanism design. In Robotics and Automation, San Diego, CA, Proceedings vol 2: 1080–1087

24. Latombe JC (1991) Robot motion planning. Kluwer Academic Publishers, Boston

25. Lawson B (2004) Schemata, gambits and precedent: some factors in design expertise. Design Studies 25(5): 443–457

26. Lin VC, Gossard DC, Light RA (1981) Variational geometry in computer aided design. Computer Graphics 15(3)

27. Maher ML, Tang HH (2003) Co-evolution as a computational and cognitive model of design. Research in Engineering Design 14(1): 47–63

28. Gross MD, Ervin SM, JAA, Fleisher A (1988) Constraints: Knowledge representation in design. Design Studies 9(3): 133–143

29. Mukerjee A, Bhatia A (1995) qualitative discretization for two-body contacts. In Proc. of the 14th IJCAI, Montreal vol. 1: 915–921

30. Poon J, Maher ML (1996) Emergent behaviour in co-evolutionary design. In Artificial Intelligence in Design'96, JS Gero (ed), Kluwer Academic, Dordrecht: 703–722

31. Saunders R, Gero JS (2000) The importance of being emergent. In Proceedings of Artificial Intelligence in Design

32. Sutherland I (1963) Sketchpad: a graphical man-machine interface PhD thesis

33. Suwa M, Gero JS, Purcell T (2000) Unexpected discoveries and s-invention of design requirements: important vehicles for a design process. Design Studies 21(6): 539–567

34. Suwa M, Tversky B (1997) What do architects and students perceive in their design sketches ? a protocol analysis. Design Studies 18: 385–403

35. Umeda Y, Tomiyama T (1997) Functional reasoning in design. IEEE Intelligent Systems and Their Applications 12

36. Verstijnen I, van Leeuwen C, Goldschmidt G, Hamel R, Hennessey J (1998) Sketching and creative discovery. Design Studies 19(4): 519–54

37. Wolter J, Chandrasekaran P (1991) A concept for a constraint-based representation of functional and geometric design knowledge. In Proceedings of the first ACM symposium on Solid modeling foundations and CAD/CAM applications: 409–418

Capturing Decisions and Rationale from Collaborative Design

Janet E. Burge and James D. Kiper
Miami University, USA

Design is, at its heart, a decision-making process. The decisions, alternative approaches considered, and the reasons behind the final choices are known as the Design Rationale (DR). The DR is usually not explicitly captured, at least not in an easily retrievable form. One way to reduce the effort in capturing rationale is to obtain the DR from unstructured documents and import it into a Rationale Management System (RMS) that supports incremental formalization. In this paper, we describe how this capability has been added to the ORCA system and how it is used to import rationale from existing design information sources.

Introduction

Design is, at its heart, a decision-making process. This is true whether architects are designing a building, engineers are designing an automobile, or software engineers are designing the software to control a manufacturing process. Decisions are made about how to position an elevator for its greatest effectiveness; what materials to use in the fender of an automobile to appeal to the customer and yet be sufficiently strong; what software architecture to use to meet important nonfunctional requirements. Design decisions are responses to problems or opportunities faced by designers. Typically, designers have several alternatives from which to choose in solving such problems or meeting opportunities. Each of these are supported or contradicted by arguments. Navigating the labyrinth of problems, opportunities, decisions, alternatives, and arguments is what we mean by the decision-making process.

Most standard design documentation focuses on the results of the decision-making, not on the decisions themselves. The decisions, alternative approaches considered, and the reasons behind the final choices are known

J.S. Gero and A.K. Goel (eds.), *Design Computing and Cognition '08*,
© Springer Science + Business Media B.V. 2008

as the Design Rationale (DR). In its most basic sense, DR can be defined as "an explanation of why an artifact is designed the way it is" [1]. The DR is usually not explicitly captured, at least not in a way where it can be easily retrieved.

If the DR were available, it could support several strategic advantages for the organization. Such knowledge allows parts of designs to be reused; it captures important domain knowledge that otherwise resides only in the mind of designers; it facilitates design changes required to accommodate changing requirements or incorrect assumptions.

It is often the case that the result of the design process is a *point design*. By this, we mean that the design decisions have resulted in one particular design in the trade space of all possible designs; and that the relationship of this design to all others in the design space is not known. Design decisions are often made in the presence of uncertainty. Assumptions used to make decisions early in the design process may later be found to be incorrect. Technology that is the best choice at one point in time may be replaced with another due to the high velocity of technological change. Stakeholder needs commonly change with time. Without design rationale with criteria that capture the reasons for various decisions, it is not possible to easily and reliably morph the current point design to a more appropriate one. However, when we have captured the reasons that a particular technology choice was made, or what design decisions are responses to particular requirements, we have a better chance of making local modifications to parts of the design in response to these changed requirements or technology improvements, etc.

Experience in design is a vital asset for any organization. The expert knowledge of an experienced designer is invaluable. Design rationale can help to capture this expert knowledge. We do not assert that DR is a replacement for an experienced designer; only that the DR can serve as a hedge against the risk that the organization will lose this expertise because of retirement or job mobility of experienced staff. Furthermore, the DR of successfully completed projects can facilitate reuse of segments of that design for future projects when there is an overlap in requirements.

One of the fundamental barriers that we must overcome in the capture of such design rationale is that designers typically do not value this effort during the struggle to meet tight deadlines for completion of their work [2]. Capturing design rationale seems to be an "overhead" that they would prefer to avoid in the short run.

Still, while DR is not usually explicitly captured, that does not mean it is not recorded at all. Engineering design has long been a collaborative process. Long gone are the days when systems were simple enough for a sin-

gle designer to understand all that is needed. (For example, in the early 1970's, F. Baker at IBM promoted the idea of a "chief programmer team" [3] in which one extremely talented programmer wrote all of the software with the support of a small team. This method has fallen out of favor and practice due, in large part, to the scarcity of such individuals and the extreme complexity of current software systems.) Increasingly, design decisions and discussions are electronic in nature: email messages, entries in wikis [4], discussion boards, etc. Of course, there are still meetings (physical or virtual) in which designers and managers discuss issues and make decisions. However, many of these discussions and probably all of the decisions are then captured in some electronic form: meeting minutes, follow-up email messages, notes posted on a wiki, etc.

The major thesis of our work is that now, and increasingly in the future, design rationale is already present in digital form. Our major contribution is in finding ways to retrieve, structure, and mine this implicit information to produce explicit design rationale.

Related work

SEURAT and ORCA

The Software Engineering Using RATionale system (SEURAT) [5] was developed to explore uses of rationale to support software development and in particular, software maintenance. SEURAT is incremented with the Eclipse Interactive Development Environment (IDE) (www.eclipse.com) in order to integrate rationale capture and use with the tools being used to write the software. Figure 1 shows the SEURAT User Interface.

SEURAT consists of five panels, four of which are shown here (the fifth is hidden). The upper left hand panel shows the Rationale Explorer which displays the rationale captured for the software, in this example a Conference Room Scheduling System. The lower left panel shows the Java Package Explorer. The Package Explorer has been extended to include a small "rat" icon that overlays each Java file that has rationale associated with it. The lower right panel shows the Rationale Task List. The Rationale Task List displays all errors and warnings that SEURAT has detected using the rationale. The errors and warnings are also denoted by error and warning overlays on the appropriate rationale icons in the Rationale Explorer. The upper right panel shows the Eclipse Editor. The presence of rationale is shown as a "Bookmark" in the editor. If the mouse were to be moved over a Bookmark, the rationale is shown. The Bookmarks are also shown on the

Bookmark View, the fifth display that is currently hidden underneath the
Rationale Task List.

Fig. 1. SEURAT user interface

Figure 2 shows a larger view of the Rationale Explorer. SEURAT stores
rationale as argumentation where the elements consist of requirements
(that things the system/software is required to do), decisions needing to be
made, alternative solutions for the decisions, arguments for and against
each decision (which can refer to requirements, dependent alternatives,
claims, and assumptions), claims that an alternative meets or does not meet
some general criteria, and assumptions that some condition will remain
true in the future.

SEURAT also contains an Argument Ontology of reasons for making
decisions (which map to claims in the rationale) and tradeoffs and co-
occurrences giving relationships between the Argument Ontology elements
that are expected to hold true throughout the system (such as the tradeoff
between flexibility and cost).

ORCA (Ontology supported Rationale for Collaborative Argumenta-
tion) extends SEURAT to support Engineering Design[6]. ORCA includes
extensions to SEURAT to support two additional ontologies: a Design
Product Ontology that captures the design components and their relation-
ships and a Design Process Ontology, giving the stages of the design proc-
ess. ORCA's version of the Argument Ontology, the Design Criteria

Ontology, augments the SEURAT Argument Ontology with domain specific engineering criteria.

Fig. 2. SEURAT Rationale Explorer

Incremental formalization

Capturing rationale in an argumentation format, as done in systems such as ORCA, requires that the information be structured, or formalized. Formalization requires that the information be broken into pieces (chunks), the type of each piece specified, and the relationships between these pieces indicated[7]. Formalizing information as it is generated has a number of difficulties and barriers. Shipman and Marshall break these into four categories: the cognitive overhead involved when the users have to commit to categorizing information; difficulties in capturing tacit knowledge and recognizing the users' own intention; a fear of making premature commitment

to a structure; and differences among various users in how they would classify data and share structure.

One approach to these problems is to follow a process of incremental formalization where knowledge is captured informally as it is generated and then formalized later in the process with system support [8]. The Hyper-Object Substrate (HOS) [8][9] was developed to allow information from text, e-mail, and USENET articles to be imported and formalized. HOS supports the formalization process by suggesting how the information can be formalized. The suggestions are based on the text of information that the system has already formalized. When objects are added, their names and synonyms are added to a "lexicon" that is used to suggest attributes or relations based on previously entered data. The lexicon is domain specific but its use is not. Incremental formalization was also used by Phidias[10].

Rationale capture

There have been many approaches to solving the rationale capture problem. Some approaches instrument existing design tools or methods to capture the rationale as the decisions are being made. These include M-LAP, which reconstructs rationale from low-level GUI actions [11] and the Rationale Construction Framework (RCF) [12] which captures user actions from a CAD tool and extracts the rationale. M-LAP, which stands for Machine Learning Apprentice, learns design cases based on sequences of low-level user actions and uses those to predict the consequence of user actions based on those of earlier decisions stored in the case library. RCF matches user actions against event patterns that define "design metaphors", which are then used to infer designer intent.

Some approaches capture rationale as video or audio. The Software Architecture Analysis Method (SAAM) is a process that is used to analyze the impact of changing requirements on a software system [13]. SAAM is supported by SAAMPad, a prototype environment that uses an electronic whiteboard. The structure provided by the SAAM process, which uses scenarios to describe the activities involved in the new requirements and evaluates them with respect to the current system architecture, is used to organized the rationale captured in audio and video form. The rationale is not structured as argumentation. Schneider's By-Product Approach [14] captures rationale for specific tasks, where rationale is expected to occur, as audio and video. These recordings can then be analyzed to index the rationale.

There are also systems that use a design process that creates rationale as a by-product by attaching pre-defined rationale to a set of choices from which that the designer can choose. One example of this is the Active Design Documents (ADD) system [15] which supports parametric design in the HVAC domain.

One approach that uses design communication artifacts as a source of rationale is CodeLink [16]. CodeLink associates e-mail messages with the code that they describe. This requires that a message ontology be used to annotate the e-mail messages as they are written. This is different from the retrospective annotation supported by our approach where the text can be marked as rationale at any point during or after the design process.

Approach

It will be difficult to encourage designers to capture their rationale as long as it is viewed as an "extra" step they have to take to document their work. In order to reduce this difficulty, our goal is to use existing design documentation as input to an incremental formalization process where the rationale can be imported into a Rationale Management System (RMS) [17]. Our approach breaks rationale collection into several stages. See figure 3 for a diagrammatic view of this process. The stages are:
1. Identifying potential rationale in existing engineering documents
2. Tagging the "candidate rationale" within those sources (retrospectively or at the time of generation)
3. Extracting the candidate rationale
4. Importing the rationale into a structuring tool
5. Using the structuring tool to import and integrate the rationale into a "rationale repository"

Step 1, identifying rationale sources, involves understanding which documents and document types are likely to contain rationale. This can be done by any member of the project organization who is familiar with the design process and how it is documented.

Step 2, tagging candidate rationale, identifies which portions of the documents contain rationale and what types of rationale. If a design support tool is "Design Rationale Aware" this can be accomplished as the documentation is generated; otherwise it requires a more manual tagging process to mark the rationale. This can be performed retrospectively but requires that the analyst understand the domain enough to be able to identify decisions, alternatives, and arguments.

Step 3, extracting the candidate rationale, is performed using a Rationale Extraction Tool to pull the information identified as rationale out and into an XML document that adds the first level of structure to the rationale. This may require assumptions about elements that are "missing" from the argumentation.

Step 4, importing the rationale into a structuring tool, reads in the XML document into a system that can be used to perform the "incremental formalization" of the rationale. In our prototype, the structuring tool is an add-on to the ORCA (Ontology supported Rationale for Collaborative Argumentation) system[6]. If assumptions were made when the rationale was

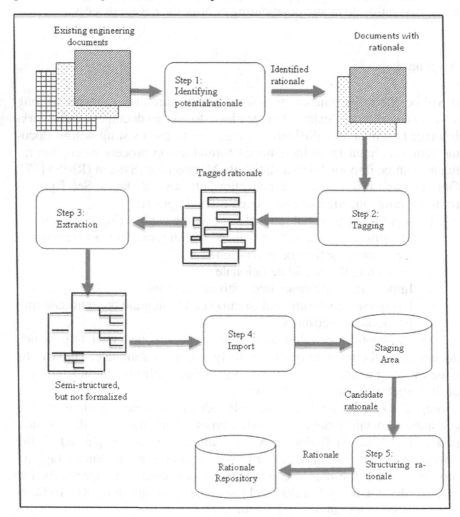

Fig. 3. Block diagram of rationale collection stages

extracted, these assumptions can be manually corrected at this time or deferred to the next step.

The final step, Step 5, completes the formalization process by supporting the integration of the candidate rationale into a more formally defined rationale base. In our prototype, this tool supports integration of the new rationale into ORCA. The structuring involves adding additional detail to the rationale required by the rationale representation used in the final rationale base.

The steps of this process that require computer support are steps 2-5, and are described in the remainder of this paper. The rationale used in the example described here [18] comes from the design of the FAIR-DART spacecraft. This design and its rationale was produced by NASA's Jet Propulsion Laboratory's (JPL) Advanced Projects Design Team ("Team X").

Tagging candidate rationale

In our vision of a collaborative design environment, all members of a design team and appropriate managers will have a set of digital tools, e.g., email, wiki, discussion boards, word processors, etc., that they use for their communication about the project design. Some of these tools are "Design Rationale Aware"—they include a built-in mechanism that the designers can use to associate text with a design rationale ontology that defines the terms used in the structured DR representation. Others are used as-is, requiring a slightly more complicated mapping process.

Word processors are typically used to capture meeting minutes, design documents, and other potential sources of rationale. Microsoft Word is often the primary mechanism for documenting this informal and unstructured design information. In our approach, the Word comment capability is used to mark sections of text as requirements, decisions, alternatives, and arguments. For the alternatives and arguments, the designer has the additional option of describing an alternative as selected, if the designer has chosen one alternative over the others, and indicating if an argument is for or against the alternative. This additional information is optional, however, in order to minimize the cognitive effort required during the tagging process. If an alternative selection has not been made, or is not described in the document, that will not preclude the information that is present from being imported as rationale. Figure 4 shows a segment of an annotated Word document with comments identifying segments of text as rationale elements.

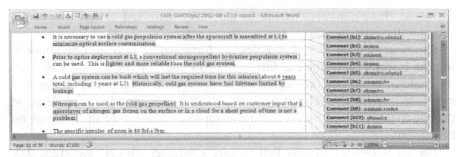

Fig. 4. Annotated Word Document

One interesting feature of this approach is that it is possible to overlay multiple comments over the same text. For example, in this example, the sentence "It is necessary to use a cold gas propulsion system after the spacecraft is assembled at L1 to minimize optical surface contamination" contains the decision "propulsion system after the spacecraft is assembled at L1" as well as the alternative "cold gas propulsion system." If there were multiple designers working with the text, they could potentially encode the same text in different ways that could then be resolved later during formalization.

To demonstrate the use of a "Design Rationale Aware" tool for collaborative design, we have begun work on a wiki-based tool that allow the designer to easily indicate the structure of the developing design and discussions about various aspects of it. The initial prototype, shown in Figure 5, allows the user to enter and export their rationale in an XML format. The next version of this prototype will allow them to add the XML tags to existing design discussions in the Wiki.

Extracting candidate rationale

Once the candidate rationale has been identified, the next step is to convert it into an intermediate format that can be imported into the ORCA RMS. The intermediate format is used because the rationale extraction application will be source-specific. The DR Aware tools can be developed to export rationale directly into this format, but other tools, such as the Word documents, will require an extraction tool specific to their representation. ORCA supports the DRXML format [19] developed as the initial RAT-Speak representation[5], but will not require that the XML be fully specified when importing candidate rationale. One extension was made to the DRXML format to support the incremental formalization process—the name of the source document is included as an attribute of the root element

of the rationale. This is important so that when the information is formalized it will be easy to review the original context of the candidate rationale. Figure 6 shows some sample rationale extracted from the Word document shown earlier.

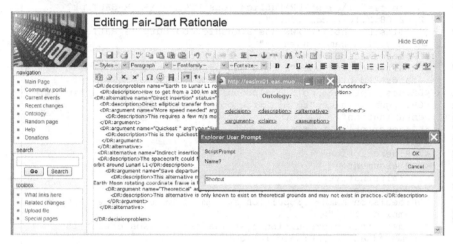

Fig. 5. DR-Aware Wiki Editor

The relationships between the decisions, alternatives, and arguments will be defined based on the order in which they appear in the text. This assumption will not be true in all cases but will serve as a plausible starting point. If the inferred relationships prove to be incorrect, they can easily be corrected later in the formalization process. The above XML shows an example of how the text ordering affects the rationale structure. The first decision is identified as "unknown" because the alternative, "a cold gas propulsion system", occurred earlier in the text earlier than the corresponding decision—"propulsion system after the spacecraft is assembled at L1." Part of the formalization process will involve making adjustments so that the rationale structure is correct.

Importing rationale into a structuring tool

Once the XML has been generated, it can be read into ORCA and stored as candidate rationale in the "Candidate Rationale Explorer." The Candidate Rationale Explorer, shown in Figure 7, is similar to the Rationale Explorer where the rationale is located after formalization has been completed. This temporary "staging area" is used so that ORCA will not report candidate rationale, which is likely to be incomplete, as having errors until it has

been moved into the Rationale Repository. Figure 7 shows the rationale imported into SEURAT from the Word document shown in Figure 4.

```
<?xml version="1.0"?>
<DR:rationale
    source="C:\Janet\DR\Publications\DCC2008\FAIR-DARTOpt2
    2002-08v2.10-nocost.docx"
    xmlns:DR="http://www.users.muohio.edu/burgeje/Rationale">
<DR:decision name="unknown">
<DR:description>unknown</DR:description>
<DR:alternative name="a cold gas propulsion system "
status="Adopted">
<DR:description>a cold gas propulsion system </DR:description>
<DR:argument name="to minimize optical surface
contamination">
<DR:description>to minimize optical surface
contamination
</DR:description>
</DR:argument>
</DR:alternative>
</DR:decision>
<DR:decision name="propulsion system after the spacecraft is
assembled at L1">
<DR:description>propulsion system after the spacecraft is
assembled at L1</DR:description>
</DR:decision>
```

Fig. 6. Sample Rationale XML

The icons shown for each candidate rationale element indicate the element type (requirement, decision, alternative, or argument) and, if that information was provided in the tagged source, the element's status. For an alternative, if the designer indicated that it was selected, a small "S" is overlaid on the icon. For arguments, if they are *for* the alternative their icon will be outlined in green and if they are *against* the alternative their icon will be outlined in red.

The Candidate Explorer will let the user edit and delete the imported rationale. It also supports the ability to "Move" rationale. This is necessary to correct any structural issues that arose from the relationship assumptions made when the rationale was exported to XML. Figure 8 shows the same rationale after the elements have been moved to represent the argumentation described in the text.

These adjustments can be made immediately after import, if the designer is confident that the information will be needed in the future and should be structured, or the structuring of the candidate rationale can wait until later in the design process. Since the source location of the rationale is stored with it, the designer can easily review the rationale in context.

Fig. 7. Imported Rationale

Rationale Integration

After the rationale has been imported into ORCA, the designer can complete the structuring and formalization process. The "Adopt" context-sensitive menu item is available for Decisions, Alternatives, and Arguments, and will move the selected item and all of its children from the Candidate Rationale Explorer to the Rationale Explorer. If the selected element is a decision, it will be added to the list of decisions displayed in the Rationale Explorer. The designer can also indicate if the decision is a sub-decision of another decision and choose that decision as a parent element. If the selected element is an alternative or argument, the designer will be prompted with a list of possible parent elements (decisions or alternatives, respectively). Once the rationale has been adopted, ORCA will inference over the new rationale and report any errors or warnings detected. This includes reporting errors for all arguments that have not been formalized by being associated with requirements, claims, assumptions, or alternatives. The error reporting will assist the designer in determining when additional information is required as part of the formalization process. Figure 9 shows the ORCA display with rationale from the Wiki imported,

adopted, and structured, and with the decision "propulsion system after the spacecraft is assembled at L1" and its sub-elements adopted but not structured further. The Rationale Task List in the lower right hand corner reports an error on the argument "to minimize optical surface contamination" because it does not have a claim, assumption, requirement, or alternative associated with it.

Fig. 8. Re-structured Rationale

When rationale is imported from Word, a source attribute in the XML indicates the name and path of the file and is used to open the document using a context menu in the Rationale Explorer. This allows the designer to view the rationale in context if they need additional information in order to structure it.

Scenario

There are many different ways that our five stage approach to incremental formalization could be utilized during design. For the purposes of this paper, and in keeping with the example we have used to illustrate our approach, we will describe a hypothetical example of how this approach could be used to support the spacecraft design example.

NASA's "Team X" performs preliminary design during design sessions where representatives of the various spacecraft sub-systems meet to discuss candidate design options for the system under development. The results of one such session were documented in a Word document [18] that provided an executive summary, the overall mission design, and the requirements, issues and concerns, assumptions, risks, and design (proposed and recommended) for each subsystem. This information provides much of the rationale behind the design but is not structured in a form that can be used computationally or, in the case of some subsystems, easily understood as rationale by non-experts in the domain.

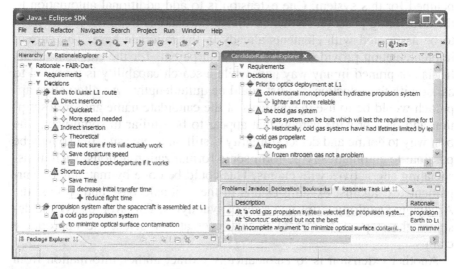

Fig. 9. ORCA with Adopted Rationale

With the incremental formalization approach available, this document can then be used to identify, extract, and formalize the rationale at a later date (the timing of which would depend on the availability of personnel to do the formalization/structuring and the need for the structured information). Interpreting the document would require some expertise in the domain but would not necessarily require involvement from someone at the same level as needed to perform the designing itself.

The formalized information would have a variety of uses. For example, the FAIR-DART document [18], dated 2002, makes a number of references to the assumption that certain technology will be available by 2011. If this assumption were to not hold true, always a distinct possibility when predicting the future, this would invalidate several design alternatives. ORCA provides the ability to disable assumptions stored in the rationale

and re-compute the support for design alternatives, alerting the user if previously selected alternatives are no longer the best supported choice for a given decision.

Conclusions and future work

The approach described above provides the first step in an approach where incremental formalization is used to capture rationale from existing documentation. There are a number of extensions and enhancements that are planned for this system. One extension is to add additional automation to the structuring process. When candidate rationale is adopted, it may need to be associated with elements already in the rationale base. The current implementation provides a list of potential parents for the candidate. This list is not pruned in any way and, while a search capability is provided to assist with the selection, the list could be quite lengthy. An alternative approach would be to use the contents of the candidate name and/or description and only provide parents that appear to be similar in some way. The best way to define and detect similarity is still an open issue. It also may be possible to automatically perform some formalization actions, such as associating alternatives with claims. This could be done by matching the argument text against existing claims in the rationale base and against the Argument Ontology terms and a set of synonyms. This would save the designer the step of having to manually create or select the appropriate claims.

Another extension is to automatically extract author information from the rationale sources. For the Wiki, author information is maintained through the user login and can be extracted into the XML schema. For the Word rationale extraction, each comment identifies the author using a name that the author can define as a MS Word option. ORCA allows a designer to be associated with each decision. This could be extended to allow all rationale elements to identify the designer who provided the data. This is particularly valuable when multiple designers supply arguments for and against a decision as part of the collaboration process.

Possible extensions to the tagging and extraction process include adding support for different rationale sources, such as e-mail messages, and providing additional automation for tagging. For example, it may be possible to identify arguments in text by looking for criteria that appear in the ORCA Argument Ontology or by looking for adjectives in the text. We also plan to integrate the rationale extraction into ORCA so that the import can be a single step process.

The future plans for this work would not be complete without evaluating the approach. There are two aspects that require evaluation. The first will be the usability and utility of the tagging, extraction, import, and structuring tools described here. Can someone familiar with the design domain use these tools to successfully generate structured rationale from unstructured documents? Is there information from the documents that should also be in the rationale whose formalization is not supported by the tools?

The next aspect requiring evaluation is the usefulness of the rationale itself—does having the rationale in a structured form provide additional utility when compared to unstructured documentation? Prior work by others has shown that DR documents can be useful in answering questions [20] and detecting design problems [2].

The largest obstacle to rationale capture and use has been concerns over the cost of capturing this information. As Grudin points out [21], there are significant disadvantages towards incurring the cost of "upstream" rationale capture to support "downstream" use. The approach described and demonstrated here shows how rationale can be extracted from existing tools and formalized incrementally on an "as-needed" basis in order to move the cost of capture closer to the point at which the rationale will be used. Adding an incremental formalization capability to an existing RMS such as ORCA allows the rationale to support uses such as impact assessment and decision evaluation.

Acknowledgements

We have been assisted in this work by several teams of Miami University students working on the Wiki tool and ORCA as their capstone projects. We would also like to thank the anonymous reviewers for their suggestions on how to improve this paper.

References

1. Lee J, Lai KY (1996) What's in design rationale? In Moran T, Carroll J (eds) Design Rationale Concepts, Techniques, and Use, Lawrence Erlbaum Associates: 21-51
2. Conklin J, Burgess-Yakemovic K (1995) A process-oriented approach to design rationale. In Design rationale concepts, techniques, and use, Moran T, Carroll J (eds), Lawrence Erlbaum Associates: 293-428
3. Baker FT (1972) Chief programmer team management of production programming. IBM Systems Journal 11(1): 56-83

4. Helmick MT, Kiper JD, Burge J, Cross V, Gannod G (2007) Incorporating Wikis into software repository mining. In Proceedings of Wiki4SE- Wikis for Software Engineering Workshop, Montreal (Canada)
5. Burge JE, Brown DC (2004) An integrated approach for software design checking using rationale. In Design Computing and Cognition'04, Gero JS (ed) Kluwer Academic: 557-576
6. Burge JE, Cross V, Kiper J, Maynard-Zhang P, Cornford S (2006) Enhanced design checking involving constraints, collaboration, and assumptions. In Gero JS (ed) Design Computing and Cognition'06, Springer: 655-674
7. Shipman FM III, Marshall CC (1999) Formality considered harmful: Experiences, emerging themes, and directions on the use of formal representations in interactive systems. Computer-Supported Cooperative Work 8(3):333-352
8. Shipman FM III, McCall R (1994) Supporting knowledge-base evolution with incremental formalization. In Proceedings of the SIGCHI Conference on Human Factors in Computing Systems, Boston, Massachusetts, United States: 285-291
9. Shipman FM, McCall RJ (1999) Supporting incremental formalization with the hyper-object substrate. ACM Trans. Inf. Syst. 17(2): 199-227
10. Shipman F, McCall R (1997) Integrating different perspectives on design rationale: Supporting the emergence of design rationale from design communication. Artificial Intelligence in Engineering Design, Analysis and Manufacturing 11(2): 141-154
11. Brandish MJ, Hague MJ, Taleb-Bendiab A (1996) M-LAP: A machine learning apprentice agent for computer supported design. In AID'96 Machine Learning in Design Workshop
12. Myers KL, Zumel NB, Garcia PE (1999) Automated capture of rationale for the detailed design process. In Proceedings of the Eleventh National Conference on Innovative Applications of Artificial Intelligence (IAAI-99), AAAI, Menlo Park, CA: 876-883
13. Richter H, Schuchhard P, Abowd G (1998) Automated capture and retrieval of architectural rationale. Georgia Tech Technical Report GIT-GVU-98-37
14. Schneider K (2006) Rationale as a by-product, In Rationale Management in Software Engineering, Dutoit A, McCall R, Mistrik I, Paech B (eds), Springer Verlag: 91-109
15. Garcia A, Howard H, Stefik M (1993) Active design documents: A new approach for supporting documentation in preliminary routine design. Stanford Univ., Tech. Report 82
16. Zaychik V, Regli WC(2003) Capturing communication and context in the software project lifecycle. Research in Engineering Design 14(2): 75-88
17. Dutoit A, McCall R, Mistrík I, Paech B (2006) Rationale management in software engineering: Concepts and techniques. In Dutoit A, McCall R, Mistrík I, Paech B (eds), Rationale Management in Software Engineering, Springer-Verlag: 1-48
18. Oberto R (2002) FAIR/DART Option #2. Advanced Projects Design Team. NASA Jet Propulsion Laboratory

19. Burge JE (2005) Software engineering using design rationale. Ph.D. thesis, Worcester Polytechnic Institute
20. Karsenty L(1996) An empirical evaluation of design rationale documents. In Proceedings of the Conference on Human Factors in Computing Systems, Vancouver, BC: 150-156
21. Grudin J (1996) Evaluating opportunities for design capture. In Moran T, Carroll J (eds), Design Rationale Concepts, Techniques, and Use, Lawrence Erlbaum Associates, Mahwah, NJ: 453-470

Extending the Situated Function-Behaviour-Structure Framework for User-Centered Software Design

Matthias Uflacker and Alexander Zeier
Hasso Plattner Institute for IT Systems Engineering, Germany

We present an ontological extension for the situated function-behaviour-structure framework to explicitly integrate the notion of user needs into the model and take it as an able platform for mapping core elements of user-centered software design to the framework. This allows us to reason about user-centered design as a conceptual and reflective conversation on interrelated design representations in a social and dynamic context. Our model points out the requirement for computational design support to assist designers in sensing design information in context, and provides a basis for understanding informational demands of design teams in user-centered software engineering projects.

Introduction

The growing observance of user-centered design principles in software development allows us to draw on a more complete and satisfying perception of design in a software engineering context. The notion of 'software design', once limited to a narrow set of pure architectural design and code development activities, is now receiving widespread appreciation as a holistic and conceptual engineering methodology. Software design starts long before structural decisions are being made and does not end after code has been generated. It encourages creativity and innovation from day one, encompassing need finding, user research and evaluation, and even implies lifecycle aspects of a software product. A design-driven software development process is capable of guiding a project team towards a usable, feasible, and viable solution that satisfies the demands on the software.

Several user-centered design processes exist to provide the required tools and methods for the activities that help in the development of useful software solutions (e.g. Beyer and Holtzblatt 1998 [2]; Nielsen 1993 [13]; Vredenburg et al. 2001 [18]). Common to all of these approaches is a strong and explicit focus on end-user needs, the specification of require-

J.S. Gero and A.K. Goel (eds.), *Design Computing and Cognition '08*, 241
© Springer Science + Business Media B.V. 2008

ments for an identified context of use, iterative prototyping, as well as repeated evaluation of the intermediary design solutions with the end-users. An abstract view on a user-focused development process for interactive systems is defined in ISO 13407 [9], which we use here to refer to these core elements of user-centered design.

During the course of design collaboration, design teams accumulate documents and generate artifacts that they use internally and externally to communicate and share knowledge, insights and ideas about the design state. This typically covers research results, contextual information, requirements, models, code, prototypes, test results, documentation, etc., which we collectively combine under the term design information, i.e. the encoded knowledge and explicit representation of facts, ideas or emotions that are relevant for the design process. There is the other world of implicit or tacit design knowledge that holds the design agent's internal representations of the design state space. This perception is strongly influenced by how the external environment is sensed, as well as by previous experiences of the designer. From this theoretical point of view, design becomes a function of the internal and external design representations as they are interpreted by the designer, and which in return affects both of these worlds through the actions the designer takes. Thus, the context of design changes continuously through the recursive activities and interactions performed in a team. This concept of situatedness in design has been described by Schön (1992) [17] as a reflective conversation with the materials of a design situation, in which he sketches design as the process of "seeing-moving-seeing": interpreting and making sense of the world (seeing), performing actions to affect a desired change (moving), and assessing the effects in the changed environment (seeing), causing further actions or the completion of the design cycle (cf. Clancey 1997 [3]; Winograd 1996 [20], pp.171–184).

This perspective on design reveals the importance for a design agent to have a precise picture of the relevant design information in a larger context. This design context is not influenced by an individual alone, but is constantly manipulated in a social, interacting and collaborative manner. Having a holistic view on such a fluctuating design situation in a team, i.e. achieving common ground among the stakeholders of a design process is a crucial, yet challenging task in engineering design (cf. Bannon and Bødker 1997 [1]; Perry, Fruchter and Rosenberg 1999 [15]). However, this is further complicated by the growing technical complexity of software systems being developed and the increasing global distribution of participants in a development process. The collective work of a design team is more and more related to information and knowledge that is distributed among different team members and geographical locations. This applies even more

to a user-centered process, where inter-disciplinary collaboration and knowledge accumulation is intensified, e.g. through repeated user research and evaluation. As Layzell, Brereton and French (2000) [12] point out, software engineering has become a social, team-based process and failure to address interaction, communication and collaboration with design information appropriately will compromise the quality of a project.

Organizing and sharing this information within a project team is therefore a requirement for design progress. Understanding the nature of design information and its relations is the goal of ongoing design research and a prerequisite for building supportive tools. In order to better understand and address the informational demands of user-centered design teams we need a model to reason about design information in software engineering. Therein, design must not be reduced to a discrete and static execution of design methods on fixed data, but must rather be understood as a social, conceptual activity that creates changes in the design environment based on the context in which the design takes place. Identifying needs and obtaining insights into the problem domain is a central part of design. Mapping the concepts of situatedness to the elements of a user-centered software engineering methodology gives us a valid starting point to improve our understanding of design information and contextual relations in the software domain.

For this reason, this work proposes an extension to Gero and Kannengiesser's (2004) [6] situated function-behaviour-structure (FBS) framework to explicitly incorporate need finding activities as a central part of a design process, and continues by mapping elements of user-centered design to it. In chapter 2, we consider situatedness in a team-based environment and give a resumé of the situated FBS framework, which provides an ontological model for design activities and representations in dynamic engineering processes. Chapter 3 builds up on this framework and extends it in order to be able to capture specific characteristics of user-centered design. We continue to show that the core activities of a user-centered process according to ISO 13407 are now consistent with the framework. In chapter 4 we take the adapted model as a basis for discussing design context awareness and the informational demands of designers in a user-centered process.

A general framework for situated design

Any attempt to model the process of conceptual designing isolated from the dynamic context in which the design interactions are grounded will provide very limited insights into the relationships between design agents

and design representations. For this reason, we base our work on an approach that is respecting the situatedness of design activities and which models design interactions in relation to the state of the design environment.

A model for situated design

Gero and Kannengiesser [6] have presented a general model for situatedness in engineering design processes that makes allowance for constant modifications of the design state, based on present knowledge and expectations of the design agent. The relationships between design representations (X) and the design agent are represented as interactions between mental and physical environments of the design process. These interactions are modeled as three recursively interacting worlds of intermediary design representations (figure 1). We adopt a social view on these worlds, to appropriately reflect the team orientation and inter-disciplinary work environments of user-centered software design [8].

The *external world* is the physical world of encoded (tangible or digital) design representations (X^e) outside the mental boundaries of a social collective. It holds the design information that has been collected and produced by the team, and which serves as input for successive design activities. The external world also provides documentation of the project state and team communication.

The *interpreted world* is the world that is constructed inside the individual minds of designers, who collaborate by direct or indirect communica-

—————▶ = action
———⇀ = interpretation / constructive memory
◀———▶ = focussing

Fig. 1. A model for situated design (after Gero and Kannengiesser [7])

tions via their external world. The interpreted world describes the knowledge the team has about the external design environment as well as the personal experience and memories (X^i). It is hence an individualized and subjective perception of the design context at hand.

The *expected world* is embedded in the interpreted world, but comprises the mental imaginations of a future design object and the predicted state of the design after the accomplishment of planned or imagined actions (Xe^i).

These three worlds of design representations stay in close relationship to each other through three classes of interactions:

1. Interpretation specifies the synthesis of design information in the external world into internal representations and concepts through sensation, perception and conception [5]. This process of making sense of the external design context directly maps to Schön's (1992) notion of "seeing".

2. Focussing describes the collaborative generation of intermediary design solutions in an expected world, which is steered by the collective state of the interpreted world.

3. Action transforms the envisioned design state from the expected world into explicit design representations, affecting change in the external world (which correlates to what Schön describes as "moving").

A situated view on a design process can now be described as follows: In a project scenario, encoded design information of the external world (X^e) is interpreted by a design team, thus forming an internal representation of the perceived design context (X^i). The model implies here the influence of *constructive memory*, i.e. the design team's knowledge and experience that has been constructed through former interactions with the external world (cf. Norman 2002 [14], pp. 54 ff.). This view on interpreting the external world is connected to Gero and Fujii's (2000) [5] concept of parallel *push* and *pull* processes: the production of an internal representation is partially pushed by the sensed data, but is also pulled by the agent's current expectations. Mental representations of the expected design state (Xe^i) are ideated by the team members individually or in a collective by focusing on the interpreted design context. Proper design actions are then carried out that aim to affect an according change in the external world, thus starting a new iteration of the situated process.

The situated FBS framework

Following Gero's (1990) [4] differentiation schema for design knowledge, design representations can be classified as descriptions of any of the three aspects function (F), behaviour (B) and structure (S).

The *function* (F) of a design object describes what the object is for. E.g. a spreadsheet application has the function "to provide a customizable set of

data tuples", "to allow entering and editing cell values", and "to run arithmetic calculations on cell values".

The *behaviour* (B) of a design object is conditioned to what the object does. It is defined as the attributes that are derived or expected to be derived from its structure (S). The behaviour of the spreadsheet application e.g. includes the "ability to handle multiple sheets", the "time required to import data", and the "expressiveness of arithmetic instructions".

The *structure* (S) of a design object is defined as "how the object is built". It describes the components of the object and their relationships. The structure of the example spreadsheet application is expressed in software models and code.

Applying the model of situatedness to these three classes of design representations yields Gero and Kannengiesser's situated framework for engineering design processes, depicted in figure 2. By instantiating the abstract notion of a design object (X), more specific representations for the aspects of function, behaviour and structure in the external (F^e, B^e, S^e), interpreted (F^i, B^i, S^i), and the expected world (Fe^i, Be^i, Se^i) are created. In addition, representations for external requirements on function (FR^e), behaviour (BR^e) and structure (SR^e) are integrated into the framework to take the influence of external demands on the design process into account [7]. E.g. a structural requirement for a spreadsheet application could be the compatibility with a specific hardware or software platform.

The different interactions between function, behaviour and structure in a situated environment are represented by 20 processes shown in figure 2. On top of these processes, the situated function-behaviour-structure framework defines eight fundamental design steps.

1. Formulation consists of interpretations of external requirements (processes 1–3), their augmentation by representations originating from previous experiences (constructive memory, processes 4–6), the ideation of an expected design state space (processes 7–9), and the formulation of expected behaviour from the set of expected functionality (process 10).

2. Synthesis transforms the expected behaviour into an internal representation of an expected structure (process 11), which is then explicitly formulated by the design agent as an external representation of that structure, making it available as input for later design activities (process 12).

3. Analysis comprises the interpretation of external representations of the structure (process 13) and the internal derivation of behaviour (process 14).

4. Evaluation (process 15) describes the comparison of the expected behaviour and the interpreted behaviour derived through analysis.

Fig. 2. The Situated FBS Framework (after Gero and Kannengicsscr 2007a)

5. Documentation is the process of affecting change in the external world by externalizing representations of the expected design state (processes 12, 17, 18) for the purpose of communication.

6. Reformulation type 1 implies changing the focus on expected structures (process 9) after re-interpreting representations of structure in the external world and constructive memory (processes 3, 6, 13).

7. Reformulation type 2 implies changing the focus on expected behaviour (process 8) after re-interpreting representations of behaviour in the external world (processes 2, 19), constructive memory (process 5), and structure (process 14).

8. Reformulation type 3 implies changing the focus on expected functions (process 7) after re-interpreting representations of function in the external world (processes 1, 20), constructive memory (process 4), and behaviour (process 16).

Setting up the FBS framework for user-centered design

With the situated function-behaviour-structure framework, Gero and Kannengiesser have provided a descriptive perspective on the nature and process of engineering design. It appropriately reflects the dynamics and recursive relationships between the design agent's internal state, activities and external information. The framework is general enough to demonstrate flexibility and applicability, meaning that it does not specifically addresses one particular engineering discipline. Casting it to a particular domain of choice can harmonize and enhance the understanding of more concrete design processes. Kruchten (2005) [10] has proven that the framework is applicable to software engineering processes by mapping elements of the Rational Unified Process (RUP) to a previous, less detailed version of the framework. Gero and Kannengiesser (2007a) [7] have shown that the principles of "emergent design", an evolutionary and agile software development cycle, are consistent with their situated model of designing. Though dealing with software design, these works do not explicitly consider user-centeredness as a guiding principle for the design iterations. Elementary activities in a user-centered design approach, like user research, need finding, or definition of a use context have not been discussed in reference to the situated FBS framework so far.

In its latest version, the FBS framework considers external demands by employing requirements (XR^e) as factors for the internal design activities of a design agent. However, regarding product requirements as given or explicitly available from external sources neglects the fact that many of those requirements are unknown at the outset of a design task. Conceptual design activities start earlier to unveil potential requirements that stem out of initially hidden insights into end-user needs and the context of use. A clear distinction between requirements and needs is therefore expedient in user-centered design. Requirements are formal descriptions of necessary attributes, capabilities or characteristics that must be provided by a future software system. They account for business, technical, and user constraints and define the goals for the to-be-designed software product (e.g. a specialized business application). Needs, on the other hand, describe the status-quo, or the present condition of the end-user and the environment. Needs represent user tasks, problems and possibilities in the context of use. They are more informal in their specification and less binding as requirements, but provide essential input for the definition of requirements (Kujala, Kauppinen and Rekola 2001 [11]).

Both, needs and requirements are relatively unexplored in the beginning of a design project. Through iterating field research and needs analysis,

the picture of the user context becomes steadily more detailed and specified. Capturing insights and knowledge about the use context is important for communication among the team and for later refinement. As a result, the external design state is not only influenced through actions that aim to transform expected function, behaviour or structure of an intermediary design object into reality. The picture of the external world also changes essentially through explicit documentation of insights, facts or decisions as a result of interpreting external demands. This encoded representation about the use context is generated, shared and communicated among the team and later incorporated into further interactions and interpretations.

From this perspective, the FBS framework is missing some important concepts in order to sufficiently provide a complete view on the activities of a user-centered design process. The applied model of situatedness only affects changes in the external world through actions that concern the realization of an expected or envisioned intermediary design state. The influence of the present conditions, constraints, targeted goals in terms of the recursive interpretation and documentation of needs and requirements is not reflected in the framework. Therefore, we motivate an extension of the situated framework to address the abovementioned principles of user-centered design.

An ontological extension for situatedness

We adapt Gero and Kannengiesser's model for situatedness to incorporate the notion of user needs by introducing an additional class of external design representations XN^e. At the beginning of a user-centered software project, needs are considered to be mostly unknown and implicit. The design team starts to increase its understanding about the context of use through incremental exposure, interpretation and documentation of contextual user information. This is supported through various methods for user research and analysis, e.g. interviews, contextual inquiries or user observations, in which the representations of needs are refined and enriched. This alternating interpretation and documentation process is considered in our extension as a direct, symmetric interaction between the interpreted and the external world. Gero and Fujii's (2000) [5] concept of a parallel *push-pull* process is hence transformed to a combination of *push, pull* and *publish*, not only causing a state change in the interpreted, but also in the external world, in the representation of needs and requirements. Note that documentation in this context does not refer to Gero's notion of a design step presented above, but describes the explicit publishing of interpretations of the external world. The extended model is shown in figure 3.

Fig. 3. An ontological extension for the model of situatedness: external needs (XNe) and documentation as a reaction of interpretation

The observance of user needs starts with the interpretation of already explicitly encoded insights XN^e or the discovery of user needs through user research (process 1). The resulting representation of this interpreting activity is influenced by the constructive memory of the designer (process 2). As an effect of this interpretation, the subjective perspective on end-user needs may be documented as a refined, possibly biased representation (XN^e) for communication with the team and successive design activities.

With the acquired interpretations of external needs, the design team can continue to define or revise requirements. This is done through the interpretation of external representations of existing requirements (XR^e, process 3), which is also a function of the other interpreted representations such as needs (XN^e, process 1), already existing design objects (X^e, process 6) and constructive memory (process 2). This updated view on the external world may yield in a reformulation of requirements and modification of their representation through documentation (process 3). The remaining interactions between the interpreted and the expected world (process 4) and between the expected and the external world (process 5) are not affected by our extension.

Mapping the FBS framework to user-centered design

As an abstract representation of a user-centered design process, we take the ISO 13407 [9] norm as reference for design processes for interactive systems. The norm defines four basic user-centered design activities that should take place during the iterative design cycle (figure 4). After having

identified the need for a user-centered design approach, the process starts with *understanding and specifying the context of use.* Essential knowledge about the users, their characteristics, tasks and goals in the working environment is collected through contextual user research. Teams continue to *specify the user and organizational requirements* in relation to the defined context of use. This implies prioritizing requirements and usability criteria and expressing them in measurable goals or terms that can be evaluated. The next task is to *produce design solutions* that are concrete and understandable enough to be presentable to the user. Those intermediary design solutions represent prototypes of the final system that are used for end-user tests and evaluation. Depending on the state of development, these prototypes range from paper sketches up to high-fidelity and functional software solutions. The *evaluation of designs against requirements* finishes a design iteration and marks the end of the process if the system satisfies the specified requirements.

We will now show how these activities of user-centered software design match into the FBS framework. With our ontological extension of situatedness, we are able to identify the core elements of a user-centered software design process.

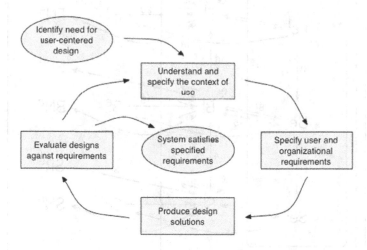

Fig. 4. User-centered design activities defined by ISO 13407 [9]

Consistent to the conceptual differentiation between representations of function, behaviour and structure, we integrate the interactions with functional needs (FNe), behavioral needs (BNe) and structural needs (SNe) as

primary elements of the design process. The final integration into the situated FBS framework is presented in figure 5.

Understand and specify the context of use

Exploration of the use context starts with a deep investigation of user needs and the interpretation/documentation of achieved findings. User needs can concern functional, behavioural or structural aspects of the design (processes 21–23). A functional need that might be relevant in the spreadsheet example could be for example that "users need to create and run daily reports based on data in an existing enterprise system". The internal perception of the context of use also depends on the previous experiences and knowledge of the designer (processes 4–6). In this case, constructive memory can implicate the risk of not diving deep enough into the world of the user, as the experience of the design agent might induce early and misleading assumptions about the use context.

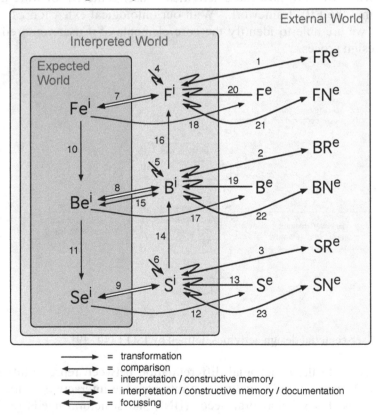

Fig. 5. Extended situated FBS framework

According to ISO 13407, the output of this activity should be an adequately documented "description of the relevant characteristics of the user, tasks and environment which identifies what aspects have an important impact on the system design". It is seen as a working document that is made available to the design team to support design activities. Consequently, this description maps directly to the union of external need representations FN^e, BN^e and SN^e.

Referring back to the design steps defined in the situated FBS framework, understanding and specifying the context of use marks the beginning of a *formulation* process to create the initial design state space (cf. 2.2).

Specify the user and organizational requirements

Continuing the formulation of the design state space, design teams specify the user and organizational requirements by interpreting requirements that have already been explicitly defined for function, behaviour and structure (processes 1–3). Taking into account user needs (processes 21–23) and constructive memory (processes 4–6), the team starts to generate expectations for the future design and populates the design state space (processes 7–9). As part of the requirements analysis, measurable behaviours to mark the fulfillment or non-fulfillment of functional expectations are formulated (process 10). Requirement specifications are defined or re-defined accordingly and published in the external world for documentation purposes (via the documentation part of processes 1–3).

The ISO norm stipulates an adequate documentation of prioritized, confirmed and measurable requirements, which are specified here as representations of FR^e, BR^e and SR^e. E.g. the functional need that has been formulated in the previous example might yield the functional requirement that the system "has to provide the possibility to create and save templates for reports" and that it "provides an easy interface for importing enterprise data". With the definition of requirements, the *formulation* of the design state space is completed.

Produce design solutions

Producing design solutions not only involves the actual encoding of a design structure in the external world. It starts with a creativity phase and ideation in the social, interpreted context of the design team. Based on internal representations of expected behaviour, the team starts to generate an expected structure for the design object (process 11). This imaginary picture is then transformed to an explicit representation of the design object's structure (process 12), making the solution concrete and presentable to the

users and team. Optionally, further external representations of intermediary or final design solutions are produced in order to document and communicate the behaviour (process 17) or function (process 18).

Thus, in terms of the design steps defined by the FBS framework, producing design solutions is composed of *synthesis* and *documentation*.

In the ISO norm, the production of design solutions is described to involve the use of existing knowledge to develop design proposals and the explicit concretization of solutions by using simulations, models or mockups, etc. The former demand is fully addressed by the situatedness of the framework and the internal representations F^i, B^i and S^i that are constructed through interpretation and constructive memory, and on which the generation of design solutions (Se^i) is grounded. The concretization of design solutions is in line with the transformation of the expected design into external representations S^e, and optionally B^e and F^e.

Evaluate designs against requirements

The evaluation of produced design solutions begins with an interpretation of the externalized prototype (S^e, process 13). This activity is governed by the feedback that has been provided by end-users or experts during the conducting of evaluation techniques. After interpretation, behaviour can be derived from that structure (process 14), which allows to make statements about the design object's overall performance. A comparison of the analyzed behaviour (B^i) and the expected behaviour (Be^i) shows whether the design solution conforms to the expectations (process 15). While these two steps correspond to the *analysis* and *evaluation* processes defined in the FBS framework, one must differentiate here between two distinct denotations of the word 'evaluation': first is an external evaluation conducted by the participants of the test procedures. Its goal is to collect feedback from the test subjects about the performance of the system in terms of measurement results, observations, surveys or user statements. After the design team has analyzed these results, a second process of evaluation applies internally in the team to compare the expected and analyzed behaviour (which corresponds to Gero's notion of evaluation in process 15).

According to ISO 13407, the aim of repeated acquisition of feedback from potential users of the software is to assess how well the system meets its goals and to select a design option that best fits the requirements. The use of evaluation results in other design activities and the reporting of feedback to the design should result in demonstrable changes in the system. The analyzed feedback can affect the structure of a design solution by re-interpreting the external structure (process 13), constructive memory of structure (process 6), the requirements on structure (process 3), or the

structural needs (process 23). Changing the focus now on the expected structures leads to the aforesaid changed state in the expected world (process 9). This structural consideration of evaluation results marks the *reformulation type 1* of the FBS framework. We abstain from a detailed description for *reformulation type 2* (behaviour) and *reformulation type 3* (function), which are analogous to the one presented for structure.

Information awareness in situated design

Taking our extended model as a formal description for situated design, we can identify basic informational demands of designers in user-centered software projects. According to the definition of Gero (1990) [4], the act of design is a "goal-oriented, constrained, decision-making, exploration, and learning activity which operates within a context which depends on the designer's perception of the context". But how can design context be characterized? Its multilateral notion is often limited to a static design factor resulting from the design problem at hand and the environment of the design object. For this work, we rather describe design context as the personal awareness of a constantly changing situation in a design process, the set of design representations, their relations, and hence the interpreted information and knowledge designers have about the state of a design process. Put into a social, team-based project scenario, having context awareness allows individuals to assess the present design information space, which is the result of and input for concerted design decisions and activities. With the situated FBS framework, we can now extract a more precise picture of what constitutes awareness in a user-centered design process. This is essential for the development of computational design support tools that aim to assist collaborating design agents in sharing and enhancing information awareness.

We describe two complementing properties of design context awareness that can be sourced from our view on the FBS framework:

1. Awareness is shaped by the interpretation of external design representations and their relationships. From a distant perspective, the goal of design is to transform a set of expected functionality (Fe^i) into an external description of a design structure (S^e) such that an artifact conforming to S^e will fulfill the functions in Fe^i (cf. Kruchten 2005 [10]). This non-linear process is driven by external needs and requirements (XN^e, XR^e), producing a growing set of intermediary and interdependent design representations (F^e, B^e, S^e). These interdependencies between representations generated by the team are first of all tacit or implicitly anchored in the

constructive memory of the designers and are rarely made available to other process participants explicitly. They are shared though through individual or social actions and communication. Having a sense about what and how representations are related with each other allows designers to get a bigger picture of the current situation, to understand and assess particular information in the design process correctly. The ability to perceive relationships between design representations improves the ability to interpret the current design situation and to evaluate the options for future design activities and decisions in a team.

2. *Awareness is shaped by the relationships between external design representations and humans.* Conceptual designing is a human process. The specification and externalization of needs (XN^e), requirements (XR^e) or representations of a design object (via processes 12, 17, 18) is a subjective act performed by one or more individuals in the design process. Thus, the information created can often directly be related to people who are involved in the design process (e.g. designers, users, etc.). Relationships between (intermediate) design representations and individuals in a design team express actions carried out by designers that led to a particular representation. Possible relations could be e.g. formulated as "contributed by" or "revised by". These relations are constructed implicitly during team-based communication and collaboration, and stimulate the perception of knowledge distribution and team structure. Being informed about the relations between team members and design representations allows designers to find answers to questions like "Who knows about ..." or "Who did ...?"

This brief characterization of information awareness indicates that the potential of individuals to comprehend the design context in a specific design situation is closely connected to the integrity of the constructive memory that is shared among the team. The constructive memory of a design team evolves through design interactions and collaboration of individuals. This is reflected in Wegner's (1986) [19] transactive memory theory, which combines constructive memory processes of individual team members in a collective 'group mind'. However, a consistent distribution of constructive memory among all process participants over the course of a project is idealistic. Distributed teams and information, changes in the team structure, individuals joining or leaving the design process, are common scenarios especially in larger software design projects, resulting in knowledge that is disconnected and unshared. This creates the demand for computational support of transactive memory processes for the provision of a common, networked design information space in social collaboration environments (cf. Bannon and Bødker 1997 [1]; Perry, Fruchter and Spinelli 2001 [16]). Relationships between design representations, information, and people should be made explicit and provided to the design

team to increase context awareness. The aforementioned factors influencing the awareness of the design context can serve as a first reference point in the design of such systems and for addressing the informational demands of designers in a user-centered process.

Conclusion

We have presented an ontological extension for the situated function-behaviour-structure framework. This was motivated by the fact that the framework in its current state does not appropriately reflect central design elements of a user-centered software design process. By introducing the notion of user needs and documentation as the externalization of an interpreted use context, we have set up the framework to address basic concepts of user-centeredness. We took ISO 13407 as a reference to identify the core activities in a user-centered development process for interactive systems and were able to map those to the process entities in the extended FBS framework. The four activities defined by the ISO norm (*"understand and specify the context of use"*, *"specify the user and organizational requirements"*, *"produce design solutions"*, and *"evaluate designs against requirements"*) were expressed as a composition of the eight design steps provided by the FBS framework: *formulation, synthesis, documentation, analysis, evaluation,* and *reformulation type 1–3*.

Based on the extended version of the design framework, we started a closer investigation into the notion of design context and design awareness in user-centered processes. Determining factors shaping information awareness have been highlighted in the framework, describing the notion of implicit relationships between design representations and designers. This emphasizes the importance of having common ground, or a shared understanding of the design situation in a team, and provides input for designing tools to support the socializing of constructive memory and sensing of design information in its context.

The added complexity that our ontological extension brings to the FBS framework can be well justified with the increased explanatory power of the model. The transfer of user-centered design principles to a situated framework creates new potential for analyzing and reasoning about design in software engineering processes. At the same time, the ontological extension is not bounded to concepts specific to the software domain. Preserving the generality of the framework, it is open for further discussions and feedback from other engineering disciplines.

References

1. Bannon L, Bødker S (1997) Constructing common information spaces. ECSCW'97: Proceedings of the Fifth Conference on European Conference on Computer-Supported Cooperative Work, Lancaster, UK: 81–96
2. Beyer H, Holtzblatt K (1998) Contextual design: defining customer-centered systems. Morgan Kaufmann Publishers Inc., San Francisco, CA
3. Clancey WJ (1997) Situated cognition: on human knowledge and computer representation. Cambridge University Press, Cambridge
4. Gero JS (1990) Design prototypes: a knowledge representation schema for design. AI Magazine 11(4): 26–36
5. Gero JS, Fujii H (2000) A computational framework for concept formation in a situated design agent. Knowledge-Based Systems 13(6): 361–368
6. Gero JS, Kannengiesser U (2004) The situated function-behaviour-structure framework. Design Studies 25(4): 373–391
7. Gero JS, Kannengiesser U (2007) An ontological model of emergent design in software engineering. ICED07. Ecole Centrale de Paris: 70:1–12
8. Gero JS, Kannengiesser U (2007) An ontology of situated design teams. AIEDAM 21(4): 379–391
9. ISO (1999) 13407 Human-centred design processes for interactive systems. ISO 13407:1999(E)
10. Kruchten P (2005) Casting software design in the function-behavior-structure framework. IEEE Software 22(2): 52–58
11. Kujala S, Kauppinen M, Rekola S (2001) Bridging the gap between user needs and user requirements. Proceedings of PC-HCI 2001 Conference, Patras, Greece
12. Layzell P, Brereton OP, French A (2000) Supporting collaboration in distributed software engineering teams. APSEC '00: Proceedings of the Seventh Asia-Pacific Software Engineering Conference, Washington, DC
13. Nielsen J (1993) Usability engineering. Morgan Kaufmann Publishers, San Francisco, CA
14. Norman DA (2002) The design of everyday things. Basic Books, New York
15. Perry MJ, Fruchter R, Rosenberg D (1999) Co-ordinating distributed knowledge: a study into the use of an organizational memory. Cognition, Technology & Work 1(3): 142–152
16. Perry MJ, Fruchter R, Spinelli G (2001) Spaces, traces and networked design. HICSS '01: Proceedings of the 34th Annual Hawaii International Conference on System Sciences, IEEE Computer Society, Washington, DC
17. Schön D (1992) Designing as reflective conversation with materials of a design situation. Research in Engineering Design 3: 131–147
18. Vredenburg K, Isensee S, Righi C (2001) User-centered design: an integrated approach. Prentice Hall PTR, Upper Saddle River
19. Wegner DM (1986) Transactive memory: A contemporary analysis of the group mind. In B Mullen and GR Goethals (eds), Theories of Group Behavior, Springer-Verlag, New York: 185–208

20. Winograd T (1996) Bringing design to software. Addison Wesley, Reading, MA

20. Winograd, T (1996) Bringing design to software. Addison-Wesley, Reading, MA.

Empirical Examination of the Functional Basis and Design Repository

Benjamin W Caldwell, Chiradeep Sen, Gregory M Mocko, Joshua D Summers and Georges M Fadel
Clemson University, USA

This paper investigates the use of functional basis within the design repository through the observation of eleven functional models. It also examines the amount of information contained in the functional model of a hair dryer at various hierarchical levels. Two experiments show that the secondary level of the functional basis hierarchy is used most often because the secondary level provides significantly more information than the primary level, and the tertiary level does not provide enough additional information to be useful.

Introduction

Functional Analysis in Design

Functional modeling is a well-accepted activity in conceptual design [1-3]. According to Pahl and Beitz, a function is *"the intended input/output relation of a system whose purpose is to perform a task"*. A function is a solution-neutral representation of the process of converting a set of inputs to a set of outputs. Input and output flows are broadly classified in early research as that of materials, energies and signals. The overall function of a product is described by linking together multiple functions via their flows, creating a function structure [1].

The use of functional analysis as a conceptual design tool is discussed in literature, particularly by European researchers [1, 4], as a means for broadening the search for solutions. Significant advances in function-based design have been made by Collins et al. [5], Hundal [6], Kirschman and Fadel [7], Szykman et al. [8], Little et al. [9], Otto and Wood [2], and

J.S. Gero and A.K. Goel (eds.), *Design Computing and Cognition '08*,
© Springer Science + Business Media B.V. 2008

Stone and colleagues at Missouri University of Science and Technology [10-12].

Functional Basis

Recent research efforts have identified the need for a finite vocabulary of terms to increase consistency in functional models [7, 8, 11]. The functional basis is one such vocabulary, which contains 54 functions and 45 flows, arranged in a three-level hierarchy that can be used to describe the function of products in a consistent manner. The functional basis seeks to support archival of design knowledge and comparison of products functionally as well as provide a standard stopping point for functional decomposition [12].

The hierarchy of functions and flows within the functional basis, shown in Table 1 and Table 2, respectively, was originally created to allow designers to describe function at various levels of detail. Hirtz and colleagues [12] explain that original design problems may use higher-level terms since the details of the product are not known. Adaptive and variant designs, however, may use more specific, lower-level terms since the details about a functional model are already known. In addition, the authors of the functional basis state that the secondary level provides the most specific function detail that is practical for engineering design [12]. However, these claims about the hierarchy are not supported by experimental evidence.

The Function-Based Design Repository

The functional basis and related research has led to the development of a function-based design repository at Missouri University of Science and Technology, hereafter referred to as *the repository* or *the design repository* (available at http://function.basiceng.umr.edu/repository/). This web-based design repository, populated through reverse engineering and disassembly of consumer products, contains a functional description of 115 products [10]. Functional models for approximately half of these products are present in graphical form in the repository, and all of the products in the repository contain customer requirements, function-component relationships, and component-assembly relationships in matrix form.

Table 1 Functional Basis Function Hierarchy

Branch	Separate	Divide
		Extract
		Remove
	Distribute	
Channel	Import	
	Export	
	Transfer	Transport
		Transmit
	Guide	Translate
		Rotate
		Allow DOF
Connect	Couple	Join
		Link
	Mix	
Control	Actuate	
Magnitude	Regulate	Increase
		Decrease
	Change	Increment
		Decrement
		Shape
		Condition
	Stop	Prevent
		Inhibit
Convert	Convert	
Provide	Store	Contain
		Collect
	Supply	Supply
Signal	Sense	Detect
		Measure
	Indicate	Track
		Display
	Process	
Support	Stabilize	
	Secure	

Table 2 Functional Basis Flow Hierarchy

Material	Human	
	Gas	
	Liquid	
	Solid	Object
		Particulate
		Composite
	Plasma	
	Mixture	Gas-Gas
		Liquid-Liquid
		Solid-Solid
		Solid-Liquid-Gas
		Colloidal
Signal	Status	Auditory
		Olfactory
		Tactile
		Taste
		Visual
	Control	Analog
		Discrete
Energy	Human	
	Acoustic	
	Biological	
	Chemical	
	Electrical	
	Electro-magnetic	Optical
		Solar
	Hydraulic	
	Magnetic	
	Mechanical	Rotational
		Translational
	Pneumatic	
	Radioactive/ Nuclear	
	Thermal	

Motivation and Research Questions

The functional basis and design repository has been continually developed for over a decade [8, 10-12], Several tools have been developed that operate on information stored in the repository, including automated concept generation [13], and functional similarity [14]. More recently, researchers have critically evaluated the role of function in product development and suggest it is not sufficient for completely describing products [15, 16].

Previous research has focused on exploring the theoretical foundations of the functional basis and the development of tools employing the

functional basis. However, there exists a gap in evaluating the practical usage of the functional basis, specifically the use of the hierarchical organization of functional terms. To address this gap, the approach taken in this research is largely empirical and is supported by experiments on functional models within the design repository. The research questions (RQ) that this paper seeks to answer are:

RQ1: To what extent has the functional basis' controlled vocabulary been used to describe the products in the design repository?

RQ2: What information value is obtained by using the hierarchy of terms defined in the functional basis?

Answering these questions will provide a deeper exploration of the claim made by Hirtz et al. [12] that the secondary level is the most frequently used level for engineering design. This is accomplished by evaluating the frequency of terms (RQ1) and further explained by computing the information content across levels of the hierarchy (RQ2).

Experimental Approach

Two experiments, which focus on the use of the functional basis within the design repository, are discussed in this paper. In the first experiment, the frequency of usage of each term of the vocabulary is evaluated for eleven functional models selected from the design repository. This experiment addresses the first research question. In the second experiment information content of a functional model is computed at different levels of the functional basis hierarchy, addressing the second research question.

The experiments completed in this research are demonstrated using a consumer hair dryer (see Figure 1).

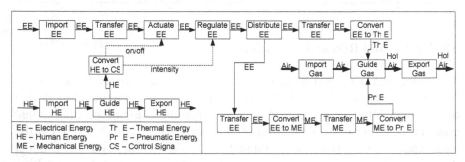

Fig. 1. Hair Dryer Functional Model

The hair dryer was selected as an example because it is an electromechanical consumer product, similar to many of the products in

the design repository. It demonstrates the use of many of the functional basis' commonly-used functions, and the hair dryer example has been used in previous research papers related to functional modeling [17].

Experiment 1: The Use of the Hierarchy within the Design Repository

Objective

The intent of this experiment is to understand how the functional basis' hierarchy is currently used by analyzing functional models in the design repository. The design repository is the largest implementation of the functional basis, so it is fitting to analyze models stored in the design repository. By exploring how the hierarchy is used, this study will give insight into the hierarchy's usefulness and each level's ability to represent the functionality of a particular product.

Experimental Protocol

In this study, ten randomly selected functional descriptions in addition to the hair dryer are analyzed. The products were limited to those with a downloadable functional model. These eleven functional models were analyzed by counting the frequency of use of each unique term in the collection of models. The terms were categorized as functions verbs, function nouns, or flows according to the guidelines in this section. A sample function block with input and output flows, taken from the hair dryer functional model, is shown in Figure 2 and used to explain the experimental procedure. Articles, prepositions, and conjunctions are ignored in this experiment, which is indicated in Figure 2 (strikethrough text).

Fig. 2. Sample Function Block from Hair Dryer

Function verbs are inside a function block and are part of the functional basis' function set (see Table 1). Function verbs were easy to identify

because they were always the first word inside a function block. In the sample, the only function verb is "Convert" (bold text).

Function nouns are inside a function block, may include an adjective describing the noun, and are usually part of the functional basis' flow set (Table 2). A function can contain more than one function noun. In the sample, the two function nouns are "Electrical Energy" and "Thermal Energy" (single underline text).

Flows are arrows that enter or exit function blocks and were usually part of the functional basis' flow set (Table 2). Any label associated with an arrow was considered a flow. In some cases, an arrow had more than one label, separated by a comma, probably for the purpose of reducing the number of arrows cluttering the functional model. In these cases each label was considered a flow. In some cases, flows were not labeled in the functional model; unlabeled flows were counted the same as their most recently labeled flow. Flows were counted each time they entered a function block; flows that exited a block but did not enter another block (outputs of the entire system) were also counted. For example, in Figure 1, the flow "Human Energy" would be counted five times because it enters four function blocks ("Import", "Guide", "Export", and "Convert") and it is an output of the system (via "Export"). The two flows in Figure 2 are "Electrical Energy" and "Thermal Energy" (double-underline text).

The eleven functional models include: *Black and Decker Jigsaw Attachment*, *Brother Sewing Machine*, *Cassette Player*, *Delta Circular Saw*, *Delta Nail Gun*, *Dryer*, *Digger Dog*, *Garage Door Opener*, *Oral B Toothbrush*, *Shopvac*, and *Supermax Hair Dryer*.

Results

The results from this experiment are shown in Tables 3, 4, and 5. The first column in each table lists the exact term used in the eleven functional models. The second column gives the total number of times that the term was used in the eleven functional models, and the third column gives this value as a percent. The shaded rows indicate terms that are not defined in the functional basis.

Observations

The following observations are made (see Table 6):

- *Approximately half of the terms available in the functional basis were used in the eleven functional models.* The first row in Table 6 shows how many terms were available and how many were used.
- *The functional models followed the functional basis well for function verbs, but not as well for function nouns and flows.* Every function verb used in these eleven models was a functional basis term; however, 15 unique function nouns terms and 32 unique flow terms were used that are not part of the functional basis. Of the 353 instances of function nouns, 90.7% were functional basis terms; of the 513 flow instances, only 75% of the flow terms were from the functional basis vocabulary.
- *There was a high frequency of use of a few terms.* The five most frequent function verbs, shown in Table 6, account for 67.7% of all function verbs. The five most frequent function nouns account for 62.6% of all function nouns (69.1% of functional basis nouns used). The five most frequent flows account for 51.9% of all flows (69.1% of functional basis flows used). Thus, excluding non-functional basis terms, about two thirds of function verbs, function nouns, and flows can be accounted for by five functional basis terms in their respective categories.
- *The secondary level of the hierarchy is used most often.* The use of the hierarchy within the eleven functional models can be seen in the last row of Table 6. Secondary terms are used 95%, 79%, and 66% of the time for function verbs, function nouns, and flows, respectively. If non-functional basis terms are ignored, then these percentages increase to 95%, 87%, and 88%, respectively. Therefore, when a functional basis term is selected, about 92% of the time it is secondary.
- *Most function verbs are a type of channel, and most function nouns and flows are a type of energy.* Table 7 and Table 8 further demonstrate how the hierarchy is used by these eleven functional models. The percentages in these tables represent the number of functions nouns, verbs, or flows that are labeled with either the corresponding term or a term hierarchically below that term. For example, in Table 8, the function noun status signal (secondary) is comprised of 0.6% auditory status signal (tertiary), 0.6% visual status signal (tertiary), and 2.8% status signal (secondary), for a total of 4.0%. Similarly, the 11.0% signal (primary) is the total of 4.0% status signal (secondary), 5.9% control signal (secondary), and 1.1% signal (primary). It can be seen from these tables that 57.3% of all function verbs used are hierarchically under channel, 57.2% of all function nouns used are hierarchically under energy, and 46.2% of all flows used are hierarchically under energy.

Table 3 Verb Results **Table 4** Noun Results **Table 5** Flow Results

Term	#	%
export	48	16
import	45	15
transfer	45	15
convert	44	14.7
guide	21	7
actuate	15	5
change	14	4.7
transmit	9	3
distribute	8	2.7
regulate	8	2.7
store	8	2.7
couple	5	1.7
supply	5	1.7
secure	4	1.3
separate	3	1
stop	3	1
process	3	1
position	3	1
indicate	2	0.7
translate	2	0.7
rotate	2	0.7
support	1	0.3
mix	1	0.3
track	1	0.3
Total	300	100

Term	#	%
electrical energy	81	22.9
mechanical energy	58	16.4
solid	40	11.3
control signal	21	5.9
human energy	21	5.9
rotational energy	15	4.2
human material	12	3.4
status signal	10	2.8
gas	9	2.5
electromagnetic	6	1.7
human force	6	1.7
acoustic energy	5	1.4
mixture	5	1.4
translational energy	5	1.4
signal	4	1.1
magnetic energy	4	1.1
torque	4	1.1
pneumatic energy	3	0.8
thermal energy	3	0.8
auditory status signal	2	0.6
solid-gas mixture	2	0.6
visual signal	2	0.6
energy	1	0.3
solid-solid	1	0.3
hand	8	2.3
garage door	5	1.4
reaction	3	0.8
(time)	2	0.6
button signal	2	0.6
garage	2	0.6
on/off	2	0.6
safety signal	2	0.6
(clothes)	1	0.3
(lint)	1	0.3
blade	1	0.3
button	1	0.3
limit signal	1	0.3
motion	1	0.3
weight	1	0.3
Total	353	100

Term	#	%
electrical energy	89	17.3
mechanical energy	75	14.6
human material	40	7.8
control signal	34	6.6
human energy	28	5.5
solid	21	4.1
human force	20	3.9
status signal	13	2.5
pneumatic energy	10	1.9
solid-solid	9	1.8
acoustic energy	8	1.6
rotational energy	8	1.6
electromagnetic	6	1.2
thermal energy	6	1.2
gas	5	1
magnetic energy	4	0.8
material	3	0.6
translational	3	0.6
auditory signal	1	0.2
visual signal	1	0.2
torque	1	0.2
hand	19	3.7
on/off	14	2.7
air	8	1.6
blade	8	1.6
ff/rew	7	1.4
play/stop	7	1.4
weight	7	1.4
thread	6	1.2
saw blade	5	1
debris	4	0.8
power pack	4	0.8
wrench	4	0.8
brads	3	0.6
debris and air	3	0.6
toothpaste	3	0.6
toothpaste/debris	3	0.6
wood	3	0.6
dirty teeth	2	0.4
heat	2	0.4
hot air	2	0.4
sewed material	2	0.4
teeth	2	0.4
alignment	1	0.2
analog video	1	0.2
feed speed	1	0.2
forward/reverse	1	0.2
intensity	1	0.2
noise	1	0.2
sewing/bobbin	1	0.2
speed	1	0.2
stereo audio	1	0.2
stitch width	1	0.2
Total	513	100

Table 6 Summary of Experiment 1 Observations

	Function Verb	Function Noun	Flow
Vocabulary terms used	24 out of the 54 available	22 out of the 45 available	19 out of the 45 available
Unique non-functional basis terms	0	15	32
Percent of terms from the functional basis	100%	90.7%	75%
High frequency terms	Export: 16.0% Import: 15.0% Transfer: 15.0% Convert: 14.7% Guide: 7.0%	Elec Energy: 22.9% Mech Energy: 16.4% Solid: 11.3% Human Energy: 5.9% Control Signal: 5.9%	Elec Energy: 17.3% Mech Energy: 14.6% Human Mat'l: 7.8% Control Signal: 6.6% Human Energy: 5.5%
Use of the hicrarchy	Primary: 0.3% Secondary: 95.0% Tertiary: 4.7%	Primary: 1.4% Secondary: 78.8% Tertiary: 7.6% Power Conj.: 2.8% Other: 9.3%	Primary: 0.6% Secondary: 66.1% Tertiary: 4.3% Power Conj.: 4.1% Other: 25.0%

Table 7 Hierarchy Distribution for Function Verb

Primary	Verb	Secondary	Verb
Branch	3.7%	Separate	1.0%
		Distribute	2.7%
Channel	57.3%	Import	15.0%
		Export	16.0%
		Transfer	18.0%
		Guide	8.3%
Connect	2.0%	Couple	1.7%
		Mix	0.3%
Control Magn	13.3%	Actuate	5.0%
		Regulate	2.7%
		Change	4.7%
		Stop	1.0%
Convert	14.7%	Convert	14.7%
Provide	4.3%	Store	2.7%
		Supply	1.7%
Signal	2.0%	Sense	
		Indicate	1.0%
		Process	1.0%
Support	2.7%	Stabilize	
		Secure	1.3%
		Position	1.0%

Table 8 Hierarchy Distribution for Function Noun and Flows

Primary	Noun	Flow	Secondary	Noun	Flow
Material	19.5%	19.3%	Human	3.4%	7.8%
			Gas	2.5%	1.0%
			Liquid		
			Solid	11.3%	4.1%
			Plasma		
			Mixture	2.3%	1.8%
Signal	11.0%	9.6%	Status	4.0%	2.9%
			Control	5.9%	6.6%
Energy	57.2%	46.2%	Human	5.9%	5.5%
			Acoustic	1.4%	1.6%
			Biological		
			Chemical		
			Electrical	22.9%	17.3%
			Electro-magnetic	1.7%	1.2%
			Hydraulic		
			Magnetic	1.1%	0.8%
			Mechanical	22.1%	16.8%
			Pneumatic	0.8%	1.9%
			Radioactive		
			Thermal	0.8%	1.2%

Experiment 1 Analysis

The lack of use of all functional basis terms does not indicate that the unused terms are not needed. The products in the design repository are limited to a specific domain of products, consumer electromechanical products, so some terms may not be used. However, if a more extensive study of products from additional domains produces similar results, then this may indicate that not all functional basis terms are needed.

The high use of additional terms in the eleven functional models demonstrates the ability of functional models to contain specific details about a product since, in most of the instances, a more-specific term was used. For example, "on/off", which was used fourteen times in seven of the functional models, contains more detail than the functional basis tertiary term *discrete control signal*. In many cases, it appears that if functional basis terms had been used, it would be nearly impossible to understand the meaning of the functional model. For example, in the hair dryer functional model (Figure 1), if both "on/off" and "intensity" were labeled as *control signal* or *discrete control signal*, an observer would have difficulty understanding that one flow referred to the on/off switch and the other to the temperature control.

The high frequency of function noun and flow terms – electrical energy, mechanical energy, solid, and human material – make sense as all of the products analyzed are consumer electromechanical products. The high frequency use of convert also seems reasonable because functions represent a transformation of energy, material, or information through a system. However, the extensive use of *channel* and its hierarchical subordinates (*import*, *export*, *transfer*, and *guide*) was not expected. Over half (57.3%) of all function verbs pertain to *channel*, which is defined as, "*To cause a flow (material, energy, signal) to move from one location to another location.*" [12]. This statistic seems to indicate that the primary means of accomplishing the overall product function is to move material, energy, or signals from one place to another. In addition, 31.0% of the function verbs are either *import* or *export*, showing the importance of moving material, energy, or signals specifically into or out of the product.

The use of primary, secondary, and tertiary terms, approximately 1%, 92%, and 6% of the time, respectively, if only functional basis terms are considered, supports the claim that the secondary level is the most practical level for engineering design. However, an explicit set of rules does not exist that tells designers which level to use when creating functional models. This suggests that designers intuitively recognize the value of the secondary level and predominantly use it for functional modeling.

Experiment 2: Information Content in Functional Models

Objective

The objective of this experiment is to further analyze the key findings from Experiment 1, which demonstrates the high use of secondary terms in the design repository and suggests that the secondary level has an inherent value that is greater than the primary or tertiary levels. To complete this experiment, first, two information content metrics are developed for quantifying the information in functional models. Second, information content is computed for a functional model described at various levels in the hierarchy. The findings of this experiment are then used to provide a plausible justification of the high frequency of secondary terms in the functional models.

Relevant basics of information theory

The information metric of functional models relies upon the basics of information theory [18]. A discrete source of information produces a message as a sequence of discrete events from a finite set of possible events, called a vocabulary. The occurrence of each event in the message is controlled by a set of probabilities. Information obtained from the occurrence of an event 'i' is defined in terms of the probability of that event, p_i, as [18, 19]:

$$I(p) = \log(1/p_i) \text{, where } b \text{ is a positive number}$$

The following properties of information (IPs) have been discussed in literature [20, 21]. These properties are summarized by Carter [22] as:

IP-1: Information is always a non-negative quantity.

$$I(p_i) \geq 0$$

IP-2: If an event has probability of 1, no information is obtained from its occurrence, meaning, since the event is fully predictable, its occurrence does not add any information.

$$I(1) = 0$$

IP-3: If two independent events occur (whose joint probability is the product of their independent probabilities), the total information obtained should be the sum of their individual information.

$$I(p_1 \cdot p_2) = I(p_1) + I(p_2)$$

IP-4: Information is a monotonic continuous function of the probabilities, which means a slight increase in the probabilities should always result into a slight increase in information.

Conceptually, when b equals 2, the magnitude of information represents the number of 'binary' questions (answered in yes/no format) that must be asked in order to determine the event exactly. Starting with 'x' choices in the vocabulary, the questions will essentially form a binary search tree through the vocabulary, each time eliminating half of the search domain (x/2, x/4, x/8... etc.) and asking if the occurred event belonged to the left branch or the right branch.

'I' is accepted as a measure of information since, conceptually, the knowledge of an event of probability p_i saves the observer asking, hence stands for answers to, 'I' number of questions. With the base of logarithm, b as 2, the unit of information is bits.

Functional models as discrete sources of information

For simplicity, consider the functional model shown in Figure 3. This model is obtained by (1) removing arrows and nouns from Figure 2, retaining only the verbs and (2) replacing non-standard terms, if any, with primary level terms of the functional basis.

Fig. 3. Hair Dryer Functional Model (Primary Verbs only)

The model in Figure 3 can be treated as a discrete source, thereby allowing the application of information theory, based on the following observations:

1. Each verb behaves as a discrete event, since it either appears fully in the model or not at all; there is no intermediate (continuous) state.
2. Each verb is chosen from a finite vocabulary (the functional basis).
3. The occurrence of each verb is controlled by a probability distribution. The distribution is assumed to be uniform in this paper.

4. The functional model as a whole behaves like a message, since a reader encounters one verb at a time when traversing through the model.

Thus, each verb carries some information with it, expressed as a function of the verb's probability. The information from the functional model can be then computed as the arithmetic sum of information obtained from individual verbs. Since the functional basis does not provide a formalism for modeling and analyzing the "connectedness" of the functional models. The connectivity between the verbs does influence the information theory-based analysis, but is not addressed in this study. Thus, flow arrows are omitted in Figure 3. However, the nouns behave in a similar manner as the verbs and add to the functional model's information.

Information metric for functional models

Based on the analogy in Section 4.3, the information in a functional model is found by adopting the definition of information from Section 4.2. For the primary functional model (Figure 3), the following is computed:

Size of available vocabulary from Table 1,

$$x = 8$$

Therefore, probability (assumed uniform) of each verb is given by

$$p_i = \frac{1}{x} = \frac{1}{8}$$

Therefore, information in each verb is given by

$$I_i = \log_2(\frac{1}{p_i}) = \log_2(8) = 3 \text{ bits}$$

Total number of verbs in the functional model, as counted from Figure 3

$$y = 18$$

Therefore, total information in the model is given by

$$I = y \log_2(\frac{1}{p_i}) = 18 \times 3 = 54 \text{ bits}$$

The results are summarized in Table 9. Conceptually, the functional model in Figure 3 represents answers to 54 binary questions, hence 54 bits of information can be said to be encoded in the functional model. Since the probability distribution of all verbs in the vocabulary is assumed uniform, $\frac{1}{p_i} = x$. Therefore, the metric of information, expressed in terms of the size of the vocabulary,

$$I = y \log_2(x)$$

is used as the expression for information of a functional model in the remainder of this paper, where y is the number of verbs and x is the size of the vocabulary in the level.

Table 9 Calculation of information in hair dryer functional model (primary)

Primary information	
Size of vocabulary	8
Probability	1/8
Unit information	3
Instances	18
Total information	54.000

Verification against requirements of information

The metric presented in Section 4.4 is verified against IR-1 through IR-4 discussed in Section 4.2. From Table 9:

1. Information in a functional model is always positive.
2. A functional model carries no information if the probability of one verb is 1. In that case, only one verb gets repeatedly used in each block (and only one noun in each arrow, if nouns are used). Such a model can be summed up as just one verb (and two nouns), irrespective of number of verbs (or nouns) in the functional model. Therefore, an additional block (same verb) does not change the functional model. Thus, each additional block carries information of zero. Therefore, the entire model carries total information of zero.
3. Information (I_1) from two independent verbs of probabilities p_i and p_j is equal to the information obtained based on their joint probability (I_2).

$$I_1 = \log_2\left(\frac{1}{p_i}\right) + \log_2\left(\frac{1}{p_j}\right) = \log_2\left(\frac{1}{p_i} \times \frac{1}{p_j}\right)$$

4. Any increase in the vocabulary size (x) results in an increase in information, since a larger vocabulary allows for a finer resolution in choosing verbs.

Therefore, the metric satisfies all conditions mentioned in Section 4.2.

Change in information with hierarchy

Secondary (Figure 4) and tertiary (Figure 5) functional models are obtained by replacing the primary level verbs of Figure 3 with verbs from

respective levels. In order to ensure that each higher level verb is represented in the lower levels, secondary verbs that have not been categorized in the tertiary level (Table 1) are propagated, as is, to the tertiary level. For example, in Table 1, the secondary verbs 'distribute', 'import' and 'export' are all propagated in the empty cells in column 3.

Fig. 4. Hair Dryer Functional Model (Secondary Verbs only)

Fig. 5. Hair Dryer Functional Model (Tertiary Verbs only)

Information based on available vocabulary

As the functional model is traversed from the primary to the secondary and tertiary levels, the size of the available vocabulary (x) increases from 8 to 21 and 35, respectively. Information based on these sizes is computed in Table 10 and Table 11 for the secondary and tertiary level, respectively.

4.6.2. Information based on hierarchically reduced vocabulary

Once a higher level verb is used in the functional model, the choice in the lower levels is limited to those verbs that are children of the higher level verb. This is defined in this paper as the *hierarchically reduced vocabulary*. In the case of the hair dryer, four of eight primary verbs are used in the primary functional model (Figure 3). These four used verbs expand into only eleven verbs in the secondary level (Table 1). Of these eleven secondary verbs, eight are used in the functional model (Figure 4). These eight used verbs expand into twelve verbs in the tertiary level.

Table 10 Calculation of information in hair dryer functional model (secondary level)

Secondary information	
Size of vocabulary	21
Probability	1/21
Unit information	4.392317
Instances	18
Total information	79.062

Table 11 Calculation of information in hair dryer functional model (tertiary level)

Tertiary information	
Size of vocabulary	35
Probability	1/35
Unit information	5.129283
Instances	18
Total information	92.327

The information content for the *hierarchically reduced vocabulary* at secondary and tertiary levels is recomputed in Table 12 and Table 13, respectively.

Table 12 Calculation of information in hair dryer functional model (secondary level, hierarchically reduced vocabulary)

Secondary information	
Size of vocabulary	11
Probability	1/11
Unit information	3.46
Instances	18
Total information	62.27

Table 13 Calculation of information in hair dryer functional model (tertiary level, hierarchically reduced vocabulary)

Tertiary information	
Size of vocabulary	12
Probability	1/12
Unit information	3.58
Instances	18
Total information	64.53

Results

Figure 6 and Figure 7 show the trend in information based on the size of available and hierarchically reduced vocabularies, respectively.

Observations

The following observations are made on the results:

- *The amount of information increases from primary to secondary to tertiary functional models.* This trend is consistent between both approaches of measurement, available and hierarchically reduced, as seen in Figure 6 and Figure 7.
- *The increase in information from primary to secondary level ($\Delta I_{1,2}$) is significantly higher than the increase from secondary to tertiary level ($\Delta I_{2,3}$).* Table 14 summarizes this observation.

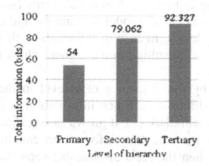

Fig. 6. Change in information with available vocabulary

Fig. 7. Change in information with hierarchically reduced vocabulary

Table 14 Increase in information across levels of hierarchy

Increase in information	Available vocabulary	Hierarchically reduced vocabulary
$\Delta I_{1.2}$	$79.062 - 54 = 25.062$	$62.270 - 54 = 8.270$
$\Delta I_{2.3}$	$92.327 - 79.062 = 13.265$	$64.529 - 62.270 = 2.259$

- *The information produced per unit size of vocabulary in any level of the functional basis reduces with increasing hierarchy levels.* For a given level, this quantity is given by

$$\frac{1}{x} = y \cdot \frac{\log_2(x)}{x}$$

This quantity reduces with increasing size of the vocabulary (x). The values for this quantity for the primary, secondary and tertiary level are 6.75 bits/verb, 3.76 bits/verb and 2.64 bits/verb, respectively.

- *Information in a functional model can be increased in two ways:*
 a. Increase the number of verbs (y)
 b. Increase the size of the vocabulary (x)

The increase in information is faster in the first case (linear with y) than the second case (logarithmically with x).

Experiment 2 Analysis

The information metric is an indicator of the degree of specificity captured in a functional model. The higher size of vocabulary at higher levels

results from increasing specificity in describing the functional terms (see Table 1 and Table 2), allowing the functional model to capture more details about the product than the lower levels. In case of information, this trend is manifested as a higher value of 'x', resulting into a higher value of information, 'I'.

The additional gain in information by introducing a new level in the functional basis, in general, gradually diminishes. Since information is a logarithmic function of the size of the vocabulary (x), it grows slower than the size (x) itself. Therefore, a larger increment in information can be obtained by adding a new level only when the ratio of sizes between the new level to the currently highest level is higher the ratio of sizes between the currently highest level and its immediate lower level.

The trend of increase of information with levels of the hierarchy (observation 1) counters the decreasing trend of information per unit size of the vocabulary (observation 3). If information per unit size of the vocabulary is accepted as the incentive of using a level, observation 3 suggests that the incentive of adding a higher level to the functional basis (or using an existing high level) is always lower than the incentive of using a lower level, even though the magnitude of information monotonically increases with levels. This analysis predicts the presence of an optimum level in the hierarchy, which produces a reasonable balance between information and incentive.

Any operation on the functional model that results into more blocks and arrows is a better means of increasing information than adding words or levels to the vocabulary. Additional words or levels not only cause an increasingly slower growth of information, they reduce the incentive of the level too. Functional decomposition, for example, is a means of breaking down a function into multiple, interacting sub-functions, the net effect of which is same as the original function. Thus, functional decomposition is identified as promising means of increasing information in a functional model.

Conclusions

The benefit of using the primary and tertiary levels in the hierarchy is minimal. This claim has been demonstrated in Experiment 1 by showing that approximately 92% of the terms used in the functional models are from the secondary level. This is further analytically supported in Experiment 2, where the presence of an optimum level in the hierarchy has been predicted. The secondary level constitutes an optimum level in the

hierarchy, because it offers significantly higher information than the primary level, yet, provides significantly higher incentive than the tertiary level. Therefore, a flat vocabulary, which combines all secondary terms with select primary and tertiary terms, is suggested.

Limitations and Future Work

The conclusions in this paper are applicable only to consumer-based electromechanical products. To address this limitation, the experiments will be conducted on a broader range of products (e.g., heavy machinery, aerospace, automobile) to determine if the conclusions hold generally for mechanical design.

Secondly, all models stored in the design repository are prepared through reverse engineering of existing products, making functional decomposition unnecessary for their creation. Functional decomposition is expected to produce more information about the product than committing to a particular level of the functional basis hierarchy.

Finally, the information content, presented in Experiment 2, is limited to function verbs. However, the information captured within a functional model is dependent on the verbs, nouns, and connectedness of the model. Current research is focused on addressing the last two information sources.

References

1. Pahl G, Beitz W (1996) Engineering design: A systematic approach. Springer-Verlag, London
2. Otto KN, Wood KL (2001) Product design techniques in reverse engineering and new product development. Prentice Hall, Upper Saddle River, NJ
3. Ullman DG (1992) The mechanical design process. McGraw-Hill, New York
4. Hubka V, Eder WE (1988) Theory of technical systems: A total concept theory for engineering design. Springer-Verlag, Berlin and New York.
5. Collins JA, Hagan BT, Bratt HM (1976) Failure-experience matrix - a useful design tool. Journal of Engineering for Industry, Series B 98(3): 1074-1079
6. Hundal MS (1990) Systematic method for developing function structures, solutions and concept variants. Mechanism & Machine Theory 25(3) pp. 243-256
7. Kirschman CF, Fadel GM (1998) Classifying functions for mechanical design. Journal of Mechanical Design 120(3): 475-482
8. Szykman S, Racz JW, Sriram RD (1999) The representation of function in computer-based design. 11th International Conference on Design Theory and Methodology, Las Vegas, Nevada

9. Little AD, Wood KL, McAdams DA (1997) Functional analysis: A fundamental empirical study for reverse engineering, benchmarking and redesign. 9th International Conference on Design Theory and Methodology, Sacramento, California

10. Bohm MR, Stone RB, Szykman S (2005) Enhancing virtual product representations for advanced design repository systems. Journal of Computing and Information Science in Engineering 5(4): 360-72

11. Stone RB, Wood KL (2000) Development of a functional basis for design. Journal of Mechanical Design 122(4): 359-370

12. Hirtz J, Stone RB, McAdams DA, Szykman S, Wood KL (2002) A functional basis for engineering design: Reconciling and evolving previous efforts. Research in Engineering Design 13(2): 65

13. Vucovich J, Bhardwaj N, Ho HH, Ramakrishna M, Thakur M, Stone R (2006) Concept generation algorithms for repository-based early design. 26th Computers and Information in Engineering Conference, Philadelphia, PA, United States

14. McAdams DA, Stone RB, Wood KL (1999) Functional interdependence and product similarity based on customer needs. Research in Engineering Design 11(1): 1-19

15. Brown DC, Blessing L (2005) The relationship between function and affordance. 25th Computers and Information in Engineering Conference, Long Beach, CA

16. Maier JRA, Fadel GM (2002) Comparing function and affordance as bases for design. 14th International Conference on Design Theory and Methodology, Montreal, Quebec, Canada

17. Mocko GM, Summers JD, Fadel GM, Teegavarapu S, Maier JRA, Ezhilan T (2007) A modelling scheme for capturing and analyzing multi-domain design information: A hair dryer design example. 16th International Conference on Engineering Design

18. Shannon CE (1948) Mathematical theory of communication. Bell System Technical Journal 27(3-4)

19. Hartley R (1928) Transmission of information. Bell Systems Technical Journal 7: 535

20. Reza F (1961) An introduction to information theory. McGraw-Hill, New York.

21. Brillouin L (1962) Science and information theory. Academic Press, New York

22. Carter T (2000) An introduction to information theory and entropy. Complex Systems Summer School

SKETCHING, DIAGRAMS AND VISUALIZATION

Is There Anything to Expect from 3D Views in Sketching Support Tools?
Françoise Darses, Anaïs Mayeur, Catherine Elsen and Pierre Leclercq

Idea Development Can Occur Using Imagery Only
Zafer Bilda and John S. Gero

Reaching Out in the Mind's Space
Uday Athavankar, P. Bokil, K. Guruprasad, R. Patsute and S. Sharma

*From Diagrams to Design: Overcoming Knowledge Acquisition
Barriers for Case Based Design*
Michael E. Helms and Ashok K. Goel

Unraveling Complexity
Athanassios Economou and Thomas Grasl

Is There Anything to Expect from 3D Views in Sketching Support Tools?

Françoise Darses
Laboratoire d'Ergonomie, France

Anaïs Mayeur
Laboratoire Central des Ponts et Chaussées & Université, France

Catherine Elsen and Pierre Leclercq
University of Liège, Belgique

This paper describes a research project which aims at studying the ergonomic and cognitive value of EsQUIsE, a freehand design environment for architects. This sketch-based modeling software is implemented on a Tablet PC. The EsQUIsE software provides architects with the possibility to generate automatically 3D views from the freehand drawings. The first part of the paper deals with the usability of such a digital environment for sketching, and especially the use of the drawing areas. The second part of the paper is dedicated to the analysis of how 3D views are generated and used for exploring alternative solutions. Although in interviews architects rate 3D highly, in fact they do not produce a large volume of 3D sketches. Issues about visual and spatial reasoning in design are thus highlighted. Finally, the benefit of such a tool for creativity is questioned.

Introduction

It is now asserted that sketches play an essential role in generating creative outcomes [1]. Researchers investigate the nature of sketching tasks with two objectives: On the one hand, understanding and modeling the cognitive processes involved in sketching [2], [3]. On the other hand, providing computer tool supports and digital environments that could better support this specific phase of the design process [4].

J.S. Gero and A.K. Goel (eds.), *Design Computing and Cognition '08,*
© Springer Science + Business Media B.V. 2008

Two different rationales can be distinguished in the attempts to support the transition from paper-based sketching to a digital environment. One is to transform selected freehand-sketched concepts to digital input. The other one is to mimic the natural sketching activity with computer-based methods. The EsQUIsE design environment which is reported in this paper belongs to the second category.

EsQUIsE is a freehand design environment for architects, which is able to capture and interpret in real time digital drawings. The architect works freely, creating his/her drawings with an electronic pen. No keyboard and no menu are needed to depict the building. The EsQUIsE interface is designed to be as close as possible to the architect's traditional and usual way of working, that is to say, a sheet of paper. Among various functions provided by EsQUIsE, the one which consists in generating automatically - from a 2D view – a volumetric view of the envisioned building is especially striking (see Figure 1, next section). Bench studies have pointed out that this function is highly-rated by practicing architects. But its added value for sketching had not been assessed yet. This is one of the goals of our study. The other goal is to conduct a systematic user-centered study of EsQUIsE's digital environment with practicing architects. As a matter of fact, previous user-centered studies have been conducted, but they were either informal design trials or experimental studies with advanced students [5], [6].

The study reported here is conducted with 7 practicing architects. The aim is to evaluate the device from an ergonomic point of view and to assess the principles adopted to build EsQUIsE's sketching digital environment on the basis of an ecological validity.

EsQUIsE, a freehand design environment for architects

EsQUIsE is a freehand design environment which captures and interprets in real time digital drawings. The architect draws with an electronic pen on a digital layout. Sketches can be drawn at any place on the layout. Suitable tools and functions for sketching (colors selection, digital eraser, sketch transformations, rooms labeling) are displayed in a menu at the left of the tracing surface. The successive layouts are indexed by the architect and stored in an easy-access area at the right of the layout. The architect can generate as many layouts as he/she wishes and can choose to superpose them or not, in any order.

Once the sketch is completed, EsQUIsE can recognize the drawn components. These are used to generate a 3D model of the building. Characteristics which were not explicitly described by the designer are then completed on the basis of an architectural knowledge base. For

example, as window heights are rarely specified in the preliminary design, EsQUIsE automatically selects relevant heights according to the type of room.

The data can be imported by all CAD tools belonging to the downstream production phase of the architectural process. The 3D model is composed of faces which can be easily translated into OBJ, DXF, DWG or VRML files. This 3D model provides the architect with a volumetric view of the artifact (see Figure 1). This view can be oriented in any direction so as to highlight a specific viewpoint. Scale options can also be changed. Other functions (e.g. evaluation of energy needs, topological representation of the building) are also provided. We do not describe them here since they are out of the scope of this paper.

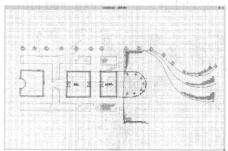 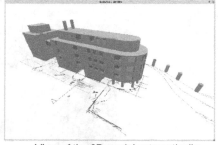

| Digital 2D sketch | View of the 3D model automatically generated by EsQUIsE |

Fig. 1. An overview is drawn on a digital layout with an electronic pen. Each layout is seen as a floor. The architect can then select those of the layout which are relevant to him and ask for an automatic generation of the 3D view (at the right).

EsQUIsE can be used either on a virtual desk (see [5] for further description) or on a Cintiq graphics tablet (see Figure 2). This latter device is the one which we used in our study. It includes a 21" LCD into the tablet (36 x 29 cm2) which can be rotated or lay flat down so that the user can work as he/she would do on a A3 slate. This choice was made because such a device is easy to install and is likely to be adopted by practicing architects.

Sketching support tools

Many CAD tools make it possible to design and manipulate digital sketches. However, most of these tools fail to help the designer in the very first design phases, when the outlines of the project have to be defined and the space of solutions must be explored. This failure is often due to the principles adopted for the user interface, which force architects to

implement data that are not relevant when sketching and compel them to choosing among a set of limited actions with the mouse.

In order to preserve the specific properties of sketching activity - especially the vagueness, incompleteness or ambiguity of sketches -, the research community in pen-computing started in the 90th with pioneers like the Electronic Cocktail Napkin [7], SILK [8] or EsQUIsE [9], [10]. More recently, many prototypes were developed for different design applications: interpretation of electrical schemas [11], sketch-based query in graphical database [12], graphic user interface design [13], generic recognition systems [14], [30] or architectural sketches interpretation [15]. The feasibility of employing multimodal input, by combining speech input, gesture input and menu-driven inputs, as a means of supporting the rapid dialogue between the designer and the sketch has also been explored [16].

Fig. 2. EsQUIsE is used on a graphic tablet

Sketching as the dialectics between internal and external representations

Sketches play a major role in the upstream phases of design, when decisive choices among design principles have to be made. During these very first phases of the design process, a sketch is not only an externalization of the design ideas, the role of which being to communicate the design principles. Ferguson [17] distinguishes these "prescriptive" sketches from the "talking" sketches. These latter enable designers to build a "conversation with the situation" [18]. In other words, the "description" of envisioned ideas goes along with a "depiction" of the design [19] cited in [20].

At the same time, since they are acting as "stakeholders" in the design process, sketches provide the designer with a basis for a "conversation with

one's self" [3]. The reasoning process is thus elaborated through the interaction between the external representation and the cognitive processes of interpreting it [1]. The cognitive strategies (such as generate solution, select and evaluate goals and constraints, generate alternative goals and solutions, build the constraints network, retrieve domain knowledge, etc.) are experienced and assessed through the sketch. This dialectics was formulated by Goldschmidt [2] as an intertwined reasoning between "seeing-as" (aimed at extracting new meaning from the sketch, on the basis of its figural properties) and "seeing that" as (aimed at using the sketch as a basis for discovering non-figural elements).

Visual Reasoning And Spatial Representations In Sketching

Thus, what do architects see in their sketches which make these drawings irreplaceable "partners" of the design cognitive processes?

Suwa and Tversky [20] claim that sketches allow architects to "read-off" non–visual functional issues from visual features. According to these authors, three explanations could be further investigated to account for the fact that sketches enable and facilitate this act of "reading-off :

• Sketches are visual; certain configurations of line drawings would visually cue the architect's background knowledge about functional issues;

• A spatial relation between things that have been drawn on the sketch irrelevantly to each other becomes emergent all of a sudden; this could suggest a certain functional issue;

• Freehand sketches afford re-interpretation of line drawings.

The way that designers manipulate graphical information in design drawings is investigated by research on visual reasoning [21], [22] [23]. But, as stressed by Bilda, Gero and Purcell [24, p.588], "there is anecdotal literature about designing with the use of imagery". Of course, designers are assumed – and feel as – they use imagery in the conceptual phase of design. The dialectics between internal and external representations is likely to be, for a large part, supported by volumetric reasoning.

Kokotovich and Purcell [22] have tried to understand the mechanisms of creative 3D mental synthesis, by contrasting 3D designers and 2D designers. They investigate whether flat two-dimensional forms would be or not of practical value to 3D-designers, such as engineers or architects. However, the experimental material was quite simple, contrary to the complexity of architectural sketches as studied in this paper.

In another research conducted by Kavakli, Scrivener and Ball [25] and Scrivener, Ball and Tseng [3] in the field of furniture design, the specific role of structural parts in mental imagery and object recognition processes are put forward. According to the authors, idea sketching is structured

along the volumetric structure of envisioned ideas. The authors focus on the role of parts in object recognition and mental imagery. They stress that sketches were predominantly drawn part by part and based on simple volumetric primitives.

Issues

Considering the previous state of the art, it can be assumed that architects would much appreciate using a CAD tool capable of generating volumetric views of their sketches. The exploration of new ideas would be made easier and their creativity would thus be enhanced. However, the expression of creativity could be impeded by a bad drawing interface.

This is the reason why the study follows two complementary goals. The first one deals with the usability of the tablet, regarding the complexity of the drawings which are to be made. The second goal investigates the use of 3D views.

We found that these scientific issues would properly be investigated on an ecological basis. So, the methods, materials and setting of the experiment had to approximate the real architectural situation. The choice of subjects was the crucial point : either recruting advanced students in architecture or recruting practising architects. The ecological validity principle implied to choose practising architects. But we could not recruit more than 7 volunteer architects, while we would have been able to recruit a great number of students. The external validity of our study is thus not ensured, since statistically reliable results cannot be adequately drawn.

The study

Three successive phases

The study was conducted into three sequential phases. The *first* one consisted of preliminary interviews (about 30 min.) during which architects were asked about their practices of sketching, and their familiarity with CAD tools. They were also asked to describe how they usually communicate their first blueprints to the customers. The *second* one was aimed at solving an architectural design problem, using the device EsQuise+Tablet. The *third* step of the study consisted in evaluating the software, on the basis of a usability questionnaire. This took about 45 minutes. This paper only reports the results of the second phase.

Participants: practicing architects

As described above, the study aimed at performing a user-centered evaluation with practicing architects. The opportunity of using an attractive freehand digital environment helped a lot in convincing seven architects to give one half day of their working time. Among them, two trial sessions could not be fully recorded. They were not included in the results. Table 1 summarizes the architect's profiles. It can be noted that two novices were recruited so as to assess the role of experience in using EsQUIsE. All of them are used to draw their first sketches by hand on tracing paper. Except for the architect *Ae1* who relies upon his/her assistant to transform the blueprints into CAD files, other architects use CAD tools (such as Autocad, Archicad, Arc+ or Architrion) for the downstream design phases.

Table 1 Architects' profiles

	Level of experience	Main job
Ae1	Expert (31 years)	Co-manager of an agency (5 people)
An2	Novice (1 month)	Unemployed yet
An3	Novice (1 year)	Assistant - architect
Ae4	Expert (40 years)	Works alone in his agency
Ae5	Expert (40 years)	Manager of an agency (2 people)

A realistic architectural problem

The problem to solve was elaborated in order to enable architects to carry out a first design cycle within two hours. The instructions given to them were: (i) to stop when they feel like having a blueprint sufficient enough to communicate the key ideas about the envisioned building; (ii) to transmit this blueprint through a sketch *and* at least one volumetric 3D view generated by EsqUIsE.

The problem was elaborated by an architect-engineer. Its feasibility was tested before the experiment. It was required to build a high school in an urban area. Other detailed requirements were given on a paper document, such as the size of the plot, the number of pupils to host, some of the functional dependencies (e.g. to have the director's office near the entrance) and functional requirements (a restaurant, a playground of a specific size, etc). Architects are asked to use the graphic tablet but they have also some sheets of paper, rulers and rubbers at their disposal.

Method

Data collection

Design sessions were audio and videotaped. Backup files were recorded. A simultaneous verbalization method was used, which benefits and limits are known [26]. We will not discuss this point here. Verbal recording was not aimed at providing data for verbal protocols but only to support further interpretation of specific sequences. Verbal records were thus not fully transcribed.

Coding scheme

The first coding scheme was elaborated to highlight the *time duration of the drawing tasks*, regarding two factors:
* *Type of drawing* (3D view, drawn perspective, 2D overview, cross-section, frontage, text). This latter modality (*Text*) is made up of annotations, calculations, rewriting or interpretation of requirements. A *"Document"* category was dedicated to the reading tasks, during which architects examine the requirements list;
* *Location of the drawing* (main area of the tablet, peripheral area, outside the tablet).

 According to this coding scheme, videotapes were cut into significant units

 (clips) using iMovie (a Macintosh application). The duration of each clip is automatically computed.

 On the basis of this coding, we have drawn graphical reports which provide a temporal view of the design session. An example is given in Figure 3 below. The type of drawing is written in the left column. The clips are numbered (in the example, from number 23 to 42). Each color is for one digital layout. Cell surrounding is for the localization (bold is on the *main area* of the layout, hatched lines are for identifying *peripheral area*). Time duration is written into each cell.

Graphical reports

Fig. 3. Graphical report (extract) elaborated on the basis of the video recordings

Assessing the Usability of the Digital Environment

Before all, it was necessary to evaluate whether the digital environment, made up of EsQUIsE and the graphic tablet, would not prevent architects from performing the design process in a satisfactory way.

Generating digital layout

We first wanted to check that the digital device, based on the layout principle, is easy to use. The system must allow the architects to generate as many layout as necessary to find out their "best" solution. As presented on Table 2, the duration of the design session varies a lot. It is comprised between 1 hour (Ae5) and more than 2 hours (An3). Because of these important disparities, the average time (1h30min) is not meaningful.

Table 2 Heterogeneous practices among architects (duration is indicated in minutes and seconds)

	Number of layouts generated during the design session	Number of alternative solutions	Duration of design session
Ae1	5	6	91'47''
An2	9	2	73'
An3	8	9	138'59''
Ae4	12	6	88'50''
Ae5	4	4	67'43''

The number of solutions which are explored can be quite low (only two solutions are explored by An2) or quite important (up to 9 for An3). Since both of these architects are novices, we explain this discrepancy by the style of designing rather than because of the level of expertise. Except for architect An2, the architects generate about 6 different solutions. It seems

that architects do not restrain themselves into a narrow exploration of the solution space when using the digital environment. However, is this exploration easy to perform or not, considering the limited size of the graphical tablet? This is answered in the next section.

Managing the drawing areas

The question is to know whether or not the various external representations needed to accomplish the design process (sketches, annotations, notes, computations) can all be handled on the tablet itself. If too many of these artifacts were to be dealt with outside the tablet, the usability of the digital environment would have to be questioned. In any case, the sketching tasks which cannot be performed on the device must be identified. It may not be relevant to support all of them, though. For instance, the manipulation of the requirements document, the re-interpretation and re-writing of the constraints may be better processed outside the main drawing space. Regarding the other tasks, additional functions could be required to expand the interface.

Figure 4 provides us with an excellent instance of the richness of sketching which is allowed by the device. Architect *Ae1* draws on a sole layout but uses both the central area (2D floor overview) *and* the peripheral area (which is itself divided into two parts: calculations on the top of the area, and a perspective on the bottom).

Results presented in table 3 stress that:
• In most cases, external representations are drawn or written *on the main area* of the tablet.
• Except for Ae1, the peripheral area is almost never used. We will report later what it is used for.

Two groups can easily be distinguished, related with the duration of the work on each area and especially, by the use of the area "*outside the tablet*" (no statistical test was done because of the small number of subjects). Contrary to our expectation, these groups do not correspond to the level of expertise, since novices are *An2* and *An3*.

Table 3 Duration of work on each area in % (in brackets, duration of the session in minutes and seconds)

Architects	Group 1			Group 2	
Area	Ae1	An2	Ae4	An3	Ae5
Main area	82	88,5	88	72,50	62,50
Peripheral area	15	4	6	0	0,5
Outside	3	7,5	6	27,50	37
Total	100 (91'47'')	100 (73')	100 (88'50'')	100 (138'59'')	100 (67'43'')

Writing and processing documents

Group 2 spent one third of the design session "outside" the tablet. We have to identify which artifacts are dealt with in this working area. As shown in Table 4 below, there are only two types of external representations which are manipulated outside the tablet: (i) Texts written on the available whitepaper sheets (such as annotations, calculations, rewriting the requirements); (ii) Documents which support the requirements list reading.

There is an important discrepancy between *Group 1* and *Group 2*. These latter architects spent much more time reading the documents and writing texts than the former. We were surprised that experience does not seem to play a role in this way of doing. From observations and interviews, it seems that *Group 2* architects were much more concerned than others to follow precisely the requirements given by the experimenter. This could explain why they spent so much time reading these documents, rewriting and interpreting them into additional texts.

Table 4 Type of external representation manipulated *outside the tablet* and duration of work on these representations (min/sec)

Type of external representation	Group 1			Group 2	
	Ae1	An2	Ae4	An3	Ae5
Text	0	0'58"	0	20'20"	9'50"
Doc	3'	4'30"	5'30"	17'51"	15'12"

This important use of *Texts* by *Group 2* architects do not mean that *Group 1* never writes down a note. But, as highlighted in Table 5, *Group 1* architects do not write so much (5 to 10 times less) and prefer to write down annotations or calculations on the *peripheral area* rather than on a whitepaper sheet.

Regarding text writing, the usability of the tablet is thus satisfactory for a classic use. Its peripheral area allows architects to write down usual annotations and calculations. As suggested by some of the architects, a computation function could be added in the interface. But it is noteworthy that the peripheral area is only dedicated to writing. Except for *Ae1* who often draws perspectives and cross-sections in the peripheral area (and a few seconds for *Ae4*, for a sole frontage sketch), this area of the tablet is never used to sketch. As a matter of fact, it is quite surprising that there are so few drawings in this peripheral area, since it is quite easy to access it. We hypothesize that it is a question of designing style. This interpretation is supported by *Ae1* preliminary interviews and post-evaluation. This architect said that he proceeds here as he usually does at his office, by drawing various viewpoints of the artifact on a sole sheet of paper. This provides him simultaneously with different abstraction levels on the same artifact. We will present in section "Results 2" which categories these external representations belong to.

Fig. 4. Diversity of sketches drawn on the different areas of the tablet

Table 5 Area where *Texts* are manipulated and duration of work on these representations (duration is indicated in minutes and seconds)

Texts areas	Group 1			Group 2	
	Ae1	An2	Ae4	An3	Ae5
Outside	0	0'58"	0	20'20"	9'50"
Peripheral	3'40"	2'53"	2'32"	0	0'29"

Use of 3D views in the sketching process

As stated before, the easy use of 3D CAAD views in EsQUIsE was highly rated by the architects in the evaluation system questionnaire. Interviews also revealed that this functionality was much appreciated as a support for designing. Accordingly, it was assumed that many 3D CAAD views were to be generated during the sketching process. We hypothesized that 3D CAAD views would be generated to evaluate partial solutions (for instance, to evaluate the location of stairs) or to evaluate a completed solution, leading on either detailing it further or exploring an alternative conjecture. This section investigates this hypothesis.

Type of artifacts representations generated with the system during design: poor use of 3d views

Table 6 shows the diversity of drawings and design actions which are performed by the architects. It is striking to note that, in both groups, the great majority of sketches are 2D *overviews*. Only two architects over the five drew perspectives, cross-sections and frontages. This result is surprising, but it is in accordance with a study conducted by Leclercq [27].

The use of 3D in general - that is to say manually sketched or automatically generated -, is very poor. There are only 2 occurrences of a sketched perspective (drawn by *Ae1* and *Ae5*). The use of 3D CAAD views is rare, as shown on Table 6, since it does not exceed 10% of the sketching activity. This is a very low result, regarding the fact that architects much appreciate this functionality, as highlighted in the post-interviews. Moreover, it has to be said that the generation of 3D CAAD views was somehow compelled for architects Ae1, An2 and Ae5, since the instructions of the experiment prescribes to generate at least one 3D CAAD view at the end of the process in order to present the project to their client (see section "The study").

How can we interpret this lack of success of 3D CAAD views generation? A first explanation could be searched for in the type of design problem given to the architects. Let us remind that the problem to cope with consists of finding the best way to superpose various floors. It could be assumed that reasoning in such a problem space would give an advantage to 2D reasoning and would not lead to handle volumetric mental representations nor 3D external representations.

Two facts come against such an interpretation. The first one is that the architectural problem to be solved was highly constrained because of the very big size of the schoolyard (960 m2) compared to the available building area (1200 m2). Such a constraint likely compels architects to cope with the combination of the various floors and their conceptual, structural and aesthetic consequences for the designed building. There is no doubt that volumetric simulation must be triggered in such a problem solving process.

The second fact to go against this interpretation is that a very different problem was given to two advanced students in architecture [6]. These latter had to design a school in a place where the relief was the highest constraint (the site was sloping steeply, with a specific recess in the relief). One of the student solved the problem using EsQUIsE on a virtual desk, the other one had only pen and paper. The former student did no generate any 3D CAAD view, while the latter drew only 2 sketches related to 3D perspectives. This single observation cannot be a basis for generalization. However, it goes along with our assumption that the poor use of 3D sketches and the poor use of 3D CAAD view is not related to the type of architectural, but rather to a specificity of the reasoning process.

Table 6 Duration of work on each external representation in % (in brackets, duration of the session in minutes and seconds)

Type of external representation		Architects				
		Ae1	An2	An3	Ae4	Ae5
3D	3D CAAD view	5	1,5	9,5	4	2
	Drawn perspective	4	0	0	0	0,5
2D	Plan	82	87	63	84	60
	Cross section	1	0	0	0	0
	Front-age	0	0	0	1	0
Other	Text	4	5,5	14,5	3	15
	Doc	4	6	13	9	22,5
Total		100 (91'47'')	100 (73')	100 (138'59)	100 (88'50'')	100 (67'43'')

Another explanation is suggested by the work of Kavakli, Scrivener and Ball [25]. These authors have studied whether sketching reflects the geometric structure of the objects represented. They have highlighted the superiority of part-to-part recognition processes over holistic objects recognition in spatial reasoning. The superposition of floors to be dealt with in our architectural problem could be seen as different parts of an artifact. 3D CAAD views available in EsQUIsE could be characterised as holistic external representations. These would thus be less relevant in spatial reasoning than superposed 2D overviews.

So, the issue which arises from these results is the question of spatial reasoning. Two lines can be investigated. First, is spatial reasoning not well supported by EsQUIsE and the digital environment? Second, what is the importance and the role of spatial reasoning at this stage of the design process? This is investigated in the next section.

Volumetric reasoning inferred through gestural and verbal cues

This part of the study stems from the results presented in the previous sections. It was highlighted that, although well-appreciated by all architects, 3D CAAD views were (almost) not generated during this sketching phase. These results lead us to investigate two hypothesis:

• Hyp.1: There is no (or poor) 3D external representations (either drawn or CAAD generated) because there is no spatial reasoning at this phase of the design process. This of course goes against the common

designers' feeling, those claiming that they "think in 3D". However, as stressed in our state of art, there are few researches investigating this issue in the domain of architectural design.

- Hyp.2: There is no (or poor) 3D external representations (either drawn or CAAD generated) because the EsQUIsE digital environment does not fit to the level of abstraction required for handling mental volumetric representations which are cognitively handled by the designers. This latter assumption seems more realistic but must be tested.

Method

To infer how spatial reasoning is conducted, we came back to the design sessions videos. The objective was to identify where volumetric reasoning is performed in the course of the design process and what it is about. This was done by two experimenters, one of them being an architect and the other one a psychologist. Since this dimension of reasoning cannot be observed but only inferred, we based our inferences on two categories of behavioral cues which likely account for spatial cognitive representations:

- *Gesture cues*: there were made with one or two hands, sometimes with the pen. To be considered as an indicator of spatial reasoning, a gesture must be "3D-shaped". That is to say that some gestures, such as underlining a shape or circling a room, are not considered as indicating a "volumetric thought" (in the rest of this paper, we will use the term "volumetric internal representation"). An example of a gestural indication of a "volumetric thought" is a stairway, described with the pen by a circular gesture finishing as an ascending loop. The mass ratio between the surrounding buildings is simulated with both hands encompassing the whole space.
- *Verbal cues*: simultaneous verbalization was used to infer the intention of the architect when performing the gesture.

These two cues point out where and what about a "Volumetric Internal Representation" (VIR). Each VIR is thus qualified as follows in Table 7.

Table 7 Volumetric Internal Representation coding scheme

VIR coding scheme	Example
Type of the gesture	Tiny and fuzzy gesture with the pen forming an ascending loop
Simultaneous verbalization	"Stairs in the frontage … it is not so great …"
Aim	Simulation of the ascending stairs
Previous action	Generation of the 3D CAAD views which presents the building mass ratio
Following action	Realizes that he did a wrong appreciation of the number of stairs of the neibouring buildings and starts correcting data.
Function in the design process	Evaluation of a form, in relation with the aesthetic perception of the solution

Data analysis

Data analysis rationale is based on the fact that time cannot be the unit for a quantitative comparison, since it is not possible to know how long a "Volumetric Internal Representation" is handled in mind. Furthermore, comparing the number of VIR to the number of other architectural units generated during design was not in accordance with our objective. Indeed, we are more interested in understanding at what level of abstraction these VIR are handled, so as to specify better what kind of 3D CAAD views should be presented to architects.

Results

Results are presented in the following tables. First (Table 7), a comparison of the two types of volumetric representations is done. It is first stressed that there are a number of volumetric thoughts which back up the design process. But there is no homogeneity among architects, nor in the ratio between the number of 3D CAAD views and the VIR. The amount of VIR is much higher that the 3D CAAD views (except for one of the architects). So, how can we explain that the VIR are not externalized into a CAAD view or a 3D drawing?

Table 8 Comparison of the number of volumetric representations: 3D CAAD views *versus* the number Volumetric Internal Representations (VIR)

Volumetric representations	Architects			
	Ae1	An2	Ae4	Ae5
3D CAAD view	1	9	2	3
Volum. Internal Rep.-VIR	27	20	30	5

To answer this question, we have characterized all these volumetric representations along an abstraction hierarchy (Table 9). There are many proposals in the literature to qualify this hierarchy (see for instance [28], [20], [1]. Here, we propose to qualify the 3D views according to how there were driven. They can be :

- *Concept-driven*, in relation with : (i) an aesthetic criteria (for instance: "with the hudge surface of this schoolyard, I would have to raise the things in such a way ..." ; (ii) an architectural choice ("I think about some stairs *à la française*") ; (iii) the evaluation of the mass or volume ratio between the surrounding buildings
- *Form-driven*, in relation with: (i) the structure of the artifact ("classrooms will be on piles") ; (ii) aesthetic criteria ("the patio is too cornered"
- *Function-driven*, in relation with: (i) the use which is foreseen ; (ii) the circulation ; (iii) the feeling or the need of space

Table 9 Number of volumetric representations, classified into categories according to their content

3D CAAD view is :	Architects			
	Ae1	An2	Ae4	Ae5
Concept-driven	1	2	1	2
Form-driven	0	6	0	1
Functional-driven	0	1	1	0
	1	9	2	3

Volumetric Internal Representation (VIR) is :	Architects			
	Ae1	An2	Ae4	Ae5
Concept-driven	11	8	15	3
Form-driven	9	5	8	1
Functional-driven	7	7	7	1
	27	20	30	5

These tables must be interpreted keeping in mind that this study is a pilot one. This is the reason why we did not try to apply any statistical treatment on the results. The 3D CAAD views cannot really be qualified, since there are too scarce, except for subject An2. This architect generated 3D CAAD views to evaluate the global shape of the conjecture rather than to externalize a concept or a function. On the contrary, VIR are often generated and, for all architects of this panel, they are more often driven by the concepts rathen than by the functions or the form. This may explain why 3D CAAD views are not so often used by the architects whose mental representations are more conceptual than the volumetric view generated by the digital environment.

Discussion and Conclusion

Usability of the digital environment

We first assessed the usability of the digital environment for sketching. The results point out that the principle on which the sketching device works is well suited to the architects' needs. The potential of simultaneously sketching on various drawing areas enable architects to keep their own style of designing. The layout principle is flexible enough and easy to use.

Our results show that architects do not restrain themselves into a narrow exploration of the solution space. Some of them do not hesitate to generate up to 9 design solutions. Beyond the electronic pen based interface, the observations show that, in terms of interaction process (layouts management and work area management) and in terms of graphical

production (sketch content : strokes, symbols, annotations), the tablet seems suitably supporting architectural design activities.The usability assessment was done in more details in the third step of this study (see section "The study"). It consisted in a questionnaire (45 minutes long) in which architects had to rate the device (sketching interface, 3D interface and navigation between each interface), according to the conventional criteria of usability [29]: effectiveness (the user can carry out its task), efficiency (it consumes a minimum of resources), and *satisfaction* (the system is pleasant to use). These detailed results are not presented in this paper, since they focus on this particular interface and are most likely useful for improving this specific system.

Use of 3D views in the sketching process

The study then investigates the use of 3D views for generating and exploring alternative solutions. Our study highlighted that, although in interviews architects rate 3D CAAD highly, in fact they do not produce a large volume of 3D sketches. Two related explanations were given:
- There are poor 3D external representations (either drawn or CAAD generated) because there is no spatial reasoning at this phase of the design process.
- There is poor 3D external representations (either drawn or CAAD generated) because the EsQUIsE digital environment does not fit to the level of abstraction required for handling mental volumetric representations which are cognitively handled by thedesigners.

Our results clearly confirm that spatial reasoning is performed during sketching,, even if not as often as we expected. If these spatial thoughts are not externalized through the interface, it is likely to be because of the level of abstraction of the 3D CAAD representation. These are mainly form-driven, since the architects' internal volumetric representations are mostly concept-driven .

Other possible explanations could be formulated. For instance, it could appear that 3D representations are more important in architectural culture than they are in fact in architectural design practice. Another explanation may also be that the use of 3D varies widely among architects, this particular group being on the low-use end of this spectrum.

As a conclusion, it appears that some exciting issues are stressed in this study. It opens towards further research regarding the creativity features of our tool. We have to measure how much (and in which ways) the application impact the design process, and especially, how creativity is enhanced thanks to such a digital environment. We cannot use the study presented in this paper to answer this issue. We propose to cope with it through an experimental comparison of digital versus manual sketching.

References

1. Purcell AT, Gero JS (1998) Drawings and the design process. Design Studies 19(4): 389–430
2. Goldschmidt G (1991) The dialectics of sketching. Design Studies 4(2): 123–143
3. Scrivener SAR, Ball LJ, Tseng W (2000) Uncertainty and sketching behaviour. Design Studies 21(5): 465-481
4. McGown A, Green G (1998) Visible ideas: information patterns of conceptual sketch activity. Design Studies 19(4): 431-453
5. Safin S, Boulanger C, Leclercq P (2005) A Virtual desktop for an augmented design process. Proceedings of Virtual Concept Conference. Biarritz, France
6. Decortis F, Safin S, Leclerq P (2005) A role for external representations in architectural design? In JS Gero & N Bonnardel (eds), Studying Designers '05, Key Centre of Design Computing and Cognition, University of Sydney: 161-177
7. Gross MD (1996) The Electronic Cocktail Napkin - computer support for working with diagrams. Design Studies 17(1): 53-70
8. Landay JA (1996) Interactive sketching for the early stages of user interface design. Ph.D. thesis, Carnegie Mellon University, Pittsburgh, PA
9. Leclercq P (1997) Programme EsQUIsE, acquisition et intepération de croquis d'architecture. Actes des 6èmes Journées Internationales Interfaces'97 Man-Machine Interaction, Montpellier, France
10. Leclercq P (1999) Interpretative tool for architectural sketches. In Gero, JS and Tversky, B (eds), Visual and Spatial Reasoning in Design , Key Centre of Design Computing and Cognition, University of Sydney, Sydney, Australia
11. Gennari L, Kara LB, Stahovich TF (2004) Combining geometry and domain knowledge to interpret hand-drawn diagrams. Proceedings of the AAAI Fall Symposium: Making Pen-Based Interaction Intelligent and Natural
12. Ferreira A, Fonseca M, Jorge J, Ramalho M (2004) Mixing images and sketches for retrieving vector drawings. Proceedings of the 7th Eurographics Workshop on Multimedia EGMM04, Nanjing, China
13. Coyette A, Faulkner S, Kolp M, Limbourg Q, Vanderdonkt J (2004) SKetchiXML: Towards a multi-agent design tool for sketching user interfaces based on USIXML. Proceedings of the 4th International Workshop on Task Models and Diagrams for User Interface Design TAMODIA 2004, Prague, Czeck Republic
14. Alvarado C, Davis R (2004) SketchREAD: a multi-domain sketch recognition engine. Proceedings of the 17th Annual ACM Symposium on User interface Software and Technology, USA, ACM Press: 23-32
15. Juchmes R, Leclercq P, Azar S (2005) A multi-agent system for the interpretation of architectural sketches. Computers and Graphics Journal 29: 5
16. Sedivy J, Johnson H (1999) Supporting creative work tasks: the potential of multimodal tools to support sketching? Proceedings of Creativity & Cognition 99, Loughborough, UK, ACM Press: 42-49
17. Ferguson ES (1992) Engineering and the mind's eye. MIT Press, Cambridge, MA
18. Schön DA (1983) The reflective practitioner. Basic Books, New York

19. Fish J, Scrivener S (1990) Amplifying the mind's eye: sketching and visual cognition. Leonardo 23(1): 117-126
20. Suwa M, Tversky T (1997) What do architects and students perceive in their design sketches? a protocol analysis. Design Studies 18(4): 385-403
21. Oxman R (1997) Design by re-representation: a model of visual reasoning in design. Design Studies 18(4): 329-347
22. Kokotovich V, Purcell T (2000) Mental synthesis and creativity in design: an experimental examination. Design Studies 21: 437-449
23. Do EY-L (2005) Design sketches and sketch design tools. Knowledge-Based Systems 18: 383-405
24. Bilda Z, Gero JS, Purcell T (2006) To sketch or not to sketch ? Design Studies 27: 587-613
25. Kavakli M, Scrivener SAR, Ball LJ (1998) Structure in idea sketching behaviour. Design Studies 19(4): 485-518
26. Ericsson KA, Simon HA (1984) Protocol analysis: verbal reports as data. MIT Press, Cambridge, MA
27. Leclercq P (1996) Environnement de conception architecturale préintégrée. Eléments d'une plate-forme d'assistance basée sur une représentation sémantique. Thèse de doctorat, Université de Liège, Belgique
28. Burns CM, Vicente KJ (2000) A participant-observer study of ergonomics in engineering design : how constraints drive design process. Applied Ergonomics 31: 73-82
29. Nielsen J (2001) Designing web usability. New Riders Publishing
30. Hammond T (2004) Automatically generating sketch interfaces from shape descriptions. MIT Student Oxygen Workshop, September

Idea Development Can Occur Using Imagery Only

Zafer Bilda
University of Technology Sydney, Australia

John S. Gero
George Mason University, USA

This paper shows that expert architects can effectively develop ideas without sketching during early conceptual designing. We analyzed design protocols of six expert architects working on two different design problems under two different conditions, one in which they were blindfolded and one in which they were sketching. Architects developed design ideas efficiently when they were blindfolded, as opposed to the common view that they would better develop ideas with sketching.

Mental Imagery in Design

Use of mental imagery is a key process in problem solving, creativity, artistic output, and many other types of human activity and interaction. What makes its use crucial is that it is an internal and fundamental mental activity that is consciously or subconsciously used during the creative process. Internal processes (such as perception, interpretation, imagination and recall) are used interactively with what occurs "outside" the mind (such as bodily movement, modeling and sketching). Internal representations refer to imagery, constructed by mental visualization and synthesis, while external representations refer to sketches, computer drawings/models, and product models.

In the early phases of the design process, architects begin with reading the design brief and understanding the problem. They usually visit the prospective site, meet clients, and negotiate the requirements of the brief [20]

21]. This initial period of conceptual designing can be lengthy, without even touching pen to paper, that is, without the need to externalize the ideas. Thus, before and after designers start to draw, the thinking process typically occurs throughout their daily routine as well; some architects' design ideas come when they are not concentrating on their project [22]. This thinking is of a visual type [1], not in the sense of "seeing", but a mechanism resembling perception [17, 24]. Thus, designing occurs not only when designers sketch, but evolves through the timeline of an internal design activity. This process can be referred to as the use of mental imagery in designing, which occurs naturally to designers, whether consciously or subconsciously, and plays an important role in designing.

Ferguson [8] described designing without drawings as the "The artisan's way":

"The product is drawn only in an artisan's mind and worked out directly in suitable materials ... First the ideas exist, where the idea could be a clear vision or a glimpse of a possibility. If the idea is in the head of an artisan, he can make the model of the idea directly... or he might make a sketch of an idea on paper in order to keep in mind the shape and the configuration of components" (p. 3–4).

This view maintains that the ideas are the basis of conceptual design activity, whether they are drawn as they come into mind or not drawn. Ferguson [8] considered design as invention and reported anecdotal evidence on how creative engineers solved technical problems by using their mental representations. In this literature, the role of the mind's eye was described in terms of the use of tacit knowledge. Tacit knowledge is referred to as the knowledge of how objects would behave in the physical world, our judgments of relative speed, dynamic relationships between objects, knowledge about the use of the right material and so on. Some anecdotes on the use of imagery in Ferguson's book refer to imagery as dynamic scenes wherein objects were animated for resolving a functional problem, while some of the anecdotes refer to a subjective experience of seeing the product or the solution. In the same vein Weisberg [32] presented anecdotes about scientists in various disciplines who had used their mental imagery for creative inventions. Other examples are often quoted of major architects, such as Frank Lloyd Wright, who could conceive of, and develop a design entirely using imagery with an external representation of the design only being produced at the end of the process [29].

Anecdotal views of engineering design, architectural design and of other creative processes put considerable emphasis on the role of imagery. In many of these imagery has been used in solving design problems or for aiding inventions. The tacit knowledge of the professionals could extend

the range of the use of their mental representations which makes it possible for these experts to design buildings or invent structures. Use of imagery alone during conceptual designing can be a tool for idea development for generating thoughts on the fly without the need to settle them on a sketch sheet. It can support a brainstorming process where one is allowed to generate ideas without worrying about constraints and their implementation. This might have the potential to improve idea development.

Related Work

In the design literature the link between visualization and engineering design drawing is well established [15] [30] [8]. The research of Bertoline et al. [3] suggests that visualization ability is central to design, and that imagery provides a bridge between design ideas and their representation in sketching and drawing. It has also been argued that the ability to draw is directly related to the ability to imagine, and that the ability to imagine will feed back into the ability to draw [19].

In design research there is a number of studies which focus on the use of imagery alone during designing. [2] conducted an experiment where an industrial designer was required to design a product in his imagery alone (with a blindfold on), without having access to sketching and the visual feedback it provides. The results of the study were qualitative, claiming that the designer was able to evolve the shape of the object, manipulate it, evaluate alternative modifications, add details and colour to it. Similar results were obtained in a study with software designers [23] where they were required to design using their mental imagery only. These studies emphasize that using imagery alone does not put a designer at a disadvantage. The further question is whether imagery might lead to a better performance than sketching in some aspects of conceptual designing. There are implications in cognitive science that this might be possible for experts.

Skilled Imagery: Blindfolded chess and designing

Researchers on expert performance agree that expertise in the form of stored knowledge becomes readily available for performing relevant tasks. Experts can process recall of knowledge interactively with the generation of images in working memory [6]. The studies with the expert chess players identified a skilled imagery [28] [25] [7] which shows evidence of the use of imagery for longer periods and with higher cognitive loads.

Blindfolded chess is played where the players do not see the pieces or the board. Research shows that it is a skill-related activity, and the more skilled a player is, the better s/he normally plays blindfolded chess [27]. Skilled imagery research indicated that the memory load can be substantial, and the experts successfully play up to 10 games simultaneously [25]. This demonstrated extensive capacity is of interest to researchers for investigating the spatial memory and skilled mental images of expert players. Earlier empirical studies showed that mental transformation plays an important role in their perceptual processes and that these experts develop specific ways for chunking visuo-spatial information that enable them to rapidly retrieve and use it in a new context [28]. This also means that experts have an extended long-term working memory to supplement their short-term working memory [6].

Saariluoma et al. [26] compared memory performance, attention and problem solving of highly experienced blindfolded chess players in a brain scanning (PET) investigation. They found that the memory task was performed spatially, such that the storage of information in LTWM involved spatial encoding. Problem solving tasks under imagery conditions involved mental transformation of the pieces, storing information in LTWM and thinking of related activities such as planning and conceptual information processing. The results maintain that skilled visuo-spatial representations are characterized by previously learned visuo-spatial chunks and automated processing habits [26]. The study concludes that experts' chess-specific images are not necessarily represented in the same way as ordinary mental images.

Experiments with blindfolded expert architects showed that they were able to design during an experimental period of 45 minutes, with complex design outcomes involving residential buildings [5] [4]. Protocol analysis of the blindfolded designing sessions showed that the expert architects constructed visuo-spatial representations through verbalizations without a perceptual interaction with their sketches. Therefore the expert architects' blindfolded performance can be related to two factors: access to and use of previously learned visuo-spatial information and skills.

Use of Linkographs to understand idea development during skethcing

Ideas are developed in the mind; they are thoughts, conceptions that serve us to reason with. Linkography is a system of notation and analysis of design processes that focuses on links among design ideas, developed by Goldschmidt [10, 11, 14] and extended by others [31] [18] [16]. Linkography has been established as a technique that can be used in protocol analy-

sis to study designers' cognitive activities and was first introduced to protocol analysis [14] to assess the design productivity of designers. In this technique the design process is decomposed by parsing the recorded design protocol into small units called "design moves". Goldschmidt defines a design move as: "a step, an act, an operation, which transforms the design situation relative to the state in which it was prior to that move" [11].

A linkograph is constructed by discerning the relationships among the moves/segments to form links. It can be seen as a graphical representation of a design session that traces the associations of every design move. The design process can then be looked at in terms of the patterns in the linkograph which display the structure of design reasoning. Goldschmidt [11] systematically analyzed and compared an individual's and a team of designers' design process using linkography. In this study Link Index (LI) and critical moves (CMs) were devised as indicators of design productivity. Link Index is the ratio between the number of links and the number of moves, and critical moves are design moves that are rich in links. Design productivity is considered to be positively related to the link index and critical moves, that is, a higher value indicates a more productive design process.

Sketching and Blindfolded Designing

In design research, sketching is considered as the medium to set out thoughts on the fly, that is to generate design ideas, concepts and further develop and elaborate them. For many designers, sketching is the medium for developing ideas because they have been trained to do this by using sketches. The benefit of externalizing ideas, concepts on paper is that they can be easily re-visited during later stages of designing. Therefore experts' sketching activity is based on producing multiple sheets and tracing previous layouts, to help them to link and navigate between the ideas.

The benefit of using mental imagery has been discussed in the context of creativity for facilitating discoveries. Designers consciously or subconsciously use their mental imagery to produce concepts and ideas [22]. Compared to sketching, use of mental imagery is considered more ambiguous in nature [9] which means ideas and thoughts remain on the fly. Therefore mental imagery has the potential to enhance idea generation, compared to sketching wherein the ideas are concretized once they are externalized.

In this paper we discuss whether it is possible to effectively develop ideas using imagery alone during conceptual designing. In the next section we describe the method, including experiment design and how idea devel-

opment was analyzed in the design protocols. Then we compare the effect of imagery and sketching on idea development by analyzing idea links in design protocols.

Method

The six architects who participated in the study (2 female and 4 male) have each been practicing for more than 15 years. Architects A1 and A2 have been awarded prizes for their designs in Australia; they have been running their own offices and also teaching part-time at the University of Sydney. Architect A3 and A4 are senior designers in two of the well-known largest architectural firms and have been leaders of many residential building projects from small to large scales. A5 and A6 are the founders and directors of two award wining architectural companies. In summary all architect participants were outstanding in the area of complex residential designs.

Design of the Experiments

The first group of three architects, called Group 1 is initially engaged in a design process where they are not allowed to sketch. This phase is called the experiment condition where they receive design brief 01. Design brief 01 requires designing a house for two artists: a painter and a dancer. At least a month after the experiment condition the same three architects were engaged in a design process where they are allowed to sketch. This phase is called the control condition where they receive design brief 02. Design brief 02 requires designing a house on the same site as design brief 01 this time for a couple with 5 children aged from 3 to 17. Both design briefs can be found in [5].

The second group of the three architects called Group 2, was initially engaged in the sketching (control condition) session, where they received design brief 02. Then after one month they were engaged in the process where they are not allowed to sketch (experiment condition) and were required to work on design brief 01.

In the experiment condition, called BF (blindfolded condition), we had the designers engage in the design process while wearing a blindfold. In the control condition, called SK (sketch condition), designers were given paper and pencil and were asked to commence designing. Each participant was given the same instruction before the BF and SK sessions and the experiments were conducted in the same room, where no visual reference

was present. The procedures for the experiment and control conditions are outlined in [5].

Group 1 architects (who were engaged in the BF condition first) were interviewed after the BF session. Group 2 architects (who were engaged in SK condition first) were also interviewed after the BF session. The interview questions were open ended, and the participants were encouraged to talk about their experience of the blindfolded design process. There was no specified duration for interviews; they varied from 15 minutes to 1 hour.

Analysis of idea Links

Ideas are the basis for conceptual designing; an idea is a conceptual entity that can be sketched or annotated. In our analysis of ideas we identified three different types; new idea, revisited/repeated idea, and an idea that is built on a previous idea. We identify an idea as new if the designer speaks about it for the first time during the design session. If we observe the repetition of the idea, then it is revisited. Third type idea occurs when a revisited idea is modified or elaborated.

"Idea generation" is generating new, revisited or third type idea, therefore it is quite frequent along the design process. On the other hand "Idea development" refers to evolution, an idea that develops into another idea, a process that eventually ends up with the third type idea.

The following scenario illustrates the idea types and what idea development is. An architect comes up with the idea of a designing a building around a courtyard garden (new idea) and later on she remembers, emphasizes this idea again (revisited idea). Maybe immediately after or a bit later, she details the idea adding on to it, by saying she likes to "build non continuous elements around the courtyard garden" (third type idea). At a later stage she revises the previous idea, by deciding to "divide the courtyard garden diagonally into two" (third type idea). She eventually designs the whole building around this idea of a courtyard garden. Other ideas come along with the initial one, and elaborate, detail or modify it. Eventually, the original idea may sound like a totally different one, and use of linkographs enables us to track the points in time where different versions of ideas occur. This is what we call idea development; the process of elaborating or detailing or revising it along the timeline of design thinking. In other words idea development is establishing a network of related ideas progressing along the timeline of the design thinking.

The linkography technique involves parsing the protocol into units, and looking at the design process in terms of relationships created by the links between those units. The process of idea development is represented in

terms of those units. Goldschmidt's [11]original notion of a unit (which is called a move) is smaller than the notion of a "segment" used in this study. The links are established on the basis of determining where the design ideas occur in the protocol and connecting the related ideas in one or more segments to each other. The process of linking the ideas and related considerations in SK and BF protocols has been discussed in [5].

During linking the ideas in the sketching protocols, idea connections were coded not only based on verbalization but also on what the architect draws on paper. In order to achieve linking of drawn ideas and keeping track of them, the video footage for each segment was visited during establishing the links in the SK protocols. When the previously drawn elements or geometries recurred, then the current segment was connected to the segment in which the related drawn elements first occurred. For example an architect may have the idea of having a courtyard garden, and s/he can sketch it in many different ways; by drawing one big rectangle which encloses a smaller one, by drawing the whole building layout, by writing "courtyard garden" on an emerging space on the sketch, or by just drawing an arrow.

Below (Table 1) is an excerpt from the verbal protocol of Architect 2 under blindfolded condition. He came up with the idea of a courtyard building (segment 51), repeated it in the next segment and decided that it should have "parts which are built and parts which are unbuilt" (segment 52). Because the idea of a courtyard house/ building is repeated in segments 51 and 52, a link is established. In segment 55, the architect refers back to the courtyard structure (parts built, parts unbuilt); therefore the idea in segments 52 and 51 is repeated, and two links are established.

Effects of sketching and imagery on idea development

We test the following hypothesis in this section:

Hypothesis: Expert architects can effectively develop ideas by using imagery alone during conceptual designing.

We have provided a conceptual description of idea development, and how this is going to be analyzed in design protocols is first via representing the ideas in linkographs, and then quantifying the density, connectedness and criticality of these ideas.

Table 1 Excerpt from a blindfolded protocol

Segments	Idea links	Content
Segment 51		(15.50) Look, the thing that I'm thinking now is that because I've got such an overwhelming desire to design a courtyard house, and I think that in this kind of situation where you've got a very large site and, umm, a semi-public space that it can borrow, in a way,
Segment 52		(16.07) that what you'd start to plumb for is a courtyard building; parts of which are built and parts of which are unbuilt.
Segment 53		(16.14) So, I'd be inclined to organise the dancer's studio and the living spaces and parts of the, the bedrooms...
Segment 54		(16.29) or no the bedroom spaces I think should go down to the east...to give them some separation...
Segment 55		(16.34) So I'm imagining now a broken form, something that's got the courtyard essentially as its organising structure, but which then has parts built, parts unbuilt.

Analysis of Linkographs

Figure 1 shows example linkographs from A1, A3 and A6's BF and SK sessions. These figures are complete representations of established links over the timeline of the design sessions. A smaller linked unit was shown in Table 1, where triangular lines and dots were connecting the segments. In Figure 1, horizontal axis (top of the triangle) shows segment numbers, and the "V" shapes illustrate the connections between the segments. The linkographs showed that the architects demonstrated different idea connection patterns in each session. In the next section we define some terms for measurements of linkographs.

Link Index and Critical Moves (CM)

Link Index is a measure of how connected the design ideas are in a design session. Link index represents connectedness because a "link" is formed

between two ideas only if they are conceptually related, i.e. connected. In order to calculate the link index (LI) in the overall session, the total number of links is divided by the total number of segments in the design ses- session.

Fig. 1. Linkographs for A1, A3 and A6's BF and SK sessions

Critical moves (CM) are the moves that generate a higher number of links (backward or forward). CMi is defined as a critical move carrying "i" number of links. Goldschmidt [12] stated "CM identifies design concepts that are deemed "successful" in the sense that the designer values them enough to devote time trying to develop the concepts or at least to promote them at various points in the protocol". Goldschmidt [12] established a threshold criterion that identified a "critical move" (CM) as a move/ segment that typically varies between three and eight links. This cri- terion is based on an estimate of the numbers of critical design ideas in a design protocol as a percentage of all ideas that occurred in moves. The threshold value is chosen arbitrarily; however a rule of thumb for setting

out a threshold is that the percentage of CMs should not exceed 10 percent of the total number of all segments in the protocol. We have identified the threshold for CMi by looking at CM percentages with five to eight links in SK sessions, since the linkographs have so far been produced with sketch protocols. CM 5 gave us an average of 9.4% for all SK sessions (Table 2). We had a higher CMi threshold compared to Goldschmidt's (2003) study where it was set at three. The reason for a higher threshold is based on the size of segments in the current study. Our segments include more information than a "move" includes, thus a segment might have a reference to more than one idea in it. Consequently a critical segment could carry more links, compared to a move. We maintained the term CM (critical move) to refer to critical segments throughout the paper.

Table 2 shows that CM5, CM6, CM7 and CM8 percentages are higher under the BF conditions for five architects. A1 is an exception to this, in that A1's SK session has relatively higher percentage of critical moves at 5–8 link levels. In BF sessions 5 out of 6 architects' CM5 percentage ranged between 12.3 and 17.2, except for A1 who demonstrated a very low CM5 percentage (1.2). In SK sessions the range of CM5 percentage was larger (4.2-14.3) producing 9.4% on average.

Table 2 Link index and critical moves

	# of links	Link Index	% CM5	% CM6	% CM7	% CM8
BF 1	201	1.2	4.8	1.2	1.2	1.2
BF 2	259	1.7	12.3	4.5	3.9	1.3
BF 3	217	1.3	16.0	8.9	4.1	1.2
BF 4	414	2.5	14.9	9.5	11.3	9.5
BF 5	319	2.2	15.8	13.7	11.6	4.8
BF 6	307	2.5	17.2	8.2	11.5	6.6
BF av	286.2	1.9	13.5	7.7	7.3	4.1
SK 1	205	1.4	11.0	4.8	0.7	2.1
SK 2	272	1.5	7.1	4.3	3.3	2.2
SK 3	171	1.2	4.2	3.5	2.1	0.7
SK 4	409	2.4	8.3	10.7	7.7	5.9
SK 5	253	1.7	14.3	7.1	4.5	3.2
SK 6	302	1.8	11.6	4.1	7	1.7
SK av	268.7	1.7	9.4	5.8	4.2	2.6

CMi: critical moves with i links

Comparing the SK and BF conditions, link index values in the BF sessions of the five architects were found to be similar or relatively higher than the link index values in their SK condition (Table 2). A1, whose SK condition link index was higher, was an exception. Average link index value for the BF sessions was 1.9; average value for the SK sessions was 1.7. Average number of links was relatively higher in BF sessions (286) than the SK sessions (269). Under the BF conditions, the percentages of CMs for five architects were higher compared to their SK sessions except for A1. On average, % CMs in BF sessions were higher than % CMs in SK sessions.

Our findings in this section can be summarized as follows:
* LI (link index) was found to be relatively higher in the BF sessions.
* BF sessions showed higher percentages of CMs (on average) compared to SK sessions, which could indicate more productivity in idea development.

Link density in clusters

A link cluster is formed by links that occur in consecutive segments. [13] says "In an ideally structured process, a suggestive move is productive if it is followed by a series of moves that explore issue(s) raised by that initial move or related subjects". This means that clusters indicate the structured units of idea development. Finding the clusters can be useful in analyzing the idea development phases; they indicate a continuous development and elaboration of ideas because the links occur in consecutive segments. Each cluster of consecutive links indicates that a designer focused on a connected set of multiple concepts to form a partial solution. Estimating the number of backward or forward clusters and their sizes in a design session would be a useful measure for efficiency of problem-solving: how well integrated the design thoughts are towards a tentative or a partial solution.

Link clusters are determined by visually inspecting the linkographs. If there are links in more than three consecutive segments, then that group is considered as a cluster. "Cluster size" refers to how many segments form a cluster. Inspecting the overall linkographs, it is possible to visually determine the starting and ending segments of a cluster. Figure 2 shows the starting portions of two clusters (marked by ellipses) inspected in a linkograph. The links that extend towards the right hand-side of the graph (that is, forward on the timeline of the design session) are marked as a forward cluster. The links that extend towards the left-hand side of the graph are marked as backward clusters (Figure 2).

A link is shown as an intersection point (shown as black dots) on the linkographs (Fig. 3) where one segment is connected to the other. Each

link in a cluster is counted. For example, the first move in the (forward) cluster has four links connecting to the latter segments 2, 3, 5 and 9 (circled in Fig. **3**), the second segment has three links connecting to 3, 4 and 9, and so on. The total number of links in each cluster is divided by the size of the cluster, which gives us the link density in each cluster (in Fig. **3**, the total number of links is 18, the size of the cluster is 5 and the link density is 18/5 = 3.6).

Fig. 2. Demonstration of link clusters

Fig. 3. Links in a forward cluster

Table 4 shows the total number of forward and backward link clusters, size of clusters, and density of links in the clusters for all participants under BF and SK conditions. The results in Table 4 indicate that the number of backward clusters is higher than the number of forward clusters in all BF sessions. In SK sessions the numbers of backward and forward clusters are closer to each other.

Table 4 shows that the fore-link density is relatively higher than back-link density under the BF conditions for all architects except for A1. Note that for A1 the fore-link density in the BF and SK conditions are very close (2.5 and 2.4). If the fore-link density is higher in forward clusters, this means that certain design ideas initiated relatively more ideas later on during the design session. Therefore higher fore-link density indicates a richer idea development, and that the design ideas in the specific cluster were potentially successful. This is one of the factors indicating an efficient idea development along with higher link index and % CMs.

Table 3 Link density in clusters

	Number of clusters in the whole session		Average size of clusters		Link Density in clusters	
	Forward	Backward	Forward	Backward	Fore-link	Back-link
BF1	6	9	5.5	4.6	2.3	1.7
BF2	5	9	6.4	5.2	2.5	2.0
BF3	2	5	5.0	5.2	3.6	2.1
BF4	11	16	5.6	5.8	3.5	2.8
BF5	11	12	5.7	5.8	3.6	2.9
BF6	7	11	8.1	6.1	3.6	3.1
BF Av	7.0	10.3	6.1	5.5	3.2	2.4
SK1	5	7	7.6	6.4	2.4	2.2
SK2	7	7	5.7	5.4	2.3	2.4
SK 3	3	6	4.7	5.8	2.0	1.6
SK 4	12	10	6.8	7.4	3.2	3.3
SK 5	7	9	7.1	6.6	2.6	2.1
SK 6	6	5	5.4	5.4	2.7	2.7
SK Av	6.7	7.3	6.2	6.2	2.5	2.4

Does imagery enhance idea development?

Our hypothesis stated that use of imagery alone does not put the expert architect to a disadvantage over sketching during idea development in conceptual designing. In order to test this hypothesis we identified and illustrated three quantitative factors contributing to the efficiency of idea development: Link indices, percentages of CMs and link densities in clusters.

The link index (LI) results supported our hypothesis; for five of the six architects, the LI under the BF conditions was higher than the LI under the SK conditions, Table 2. Hence, BF condition supported architects' idea development at least as good as sketching condition did.

Percentage CM analysis was used to demonstrate how integrated the idea development was in BF and SK sessions. Higher percentages of CM pointed to a more coherent idea development. Table 2 showed that critical segments with 5 to 8 links had higher percentages in the BF sessions of the five architects compared to their SK sessions. This indicated that previous ideas have been repeated, detailed, and developed into other ideas. In summary, architects quite efficiently developed and integrated their design ideas to develop their conceptual designs when they were blindfolded as they do when they were able to sketch.

Inspecting the clusters in the linkographs are useful because they can indicate formulation of tentative/partial solutions to the design problem. A cluster analysis of the links assisted us in finding density of the fore-links and back-links. Table 3 showed that the average back link density was same under SK and BF conditions while fore-link densities in clusters were higher under the BF conditions for all architects except A1. Higher fore-link density is one of the factors contributing to a richer idea development.

Hypothesis 1 can be accepted based on the results of five out of six architects; the use of imagery alone supported idea development as well as sketching did.

Discussion

Analysis of linkographs showed that the density of the idea links, the percentage of critical moves and link densities in clusters were almost the same or higher under BF conditions compared to SK conditions. We assume that the participant architects achieved this efficient idea development under BF conditions based on their expert knowledge. This assump-

tion is supported by the skilled imagery and long-term working memory (LTWM) studies.

LTWM studies have shown that experts with skilled imagery performance can maintain and transform associative connections between the elements in their imagery effectively over extended time periods of WM (working memory). Similarly, expert architects in the current study could have built this skilled imagery through using and learning the architectural language with the use of sketches. Design education requires an intensive learning process through drawing; students learn the design precedents through drawing and learn how to think with sketches. Thinking with sketches is also associated with the ability to develop design ideas, such as starting with one design concept and developing it into another one. Students learn how to progress their ideas through sketching. It is assumed that when novices become experts, they might have reached a state where they could progress a design via thinking only, because their repository of experience and design knowledge would allow that. Consequently, when experts are in a situation in which they have to design using their imagery alone, they might be using their experience of conceptually developing a design. This could be an important component of expertise, that is, the ability to simulate how the ideas are developed. This may be the key to our participants' abilities in blindfolded designing.

According to skilled imagery theory, architects in the current study relied on retrieving and using the visual and spatial information from their LTM. Similar to expert chess players, expert designers could have used pre-existing dynamic chunks of visual features or spatial relations encoded with their past experiences. The theory suggests that the previously learned visuo-spatial chunks would be distributed throughout the working memory subsystems which could result in a quick development of solutions through the use of imagery. Further, architects often re-represent their problem space for each sub-problem and re-interpret the related visuo-spatial information.

Conclusions

We analyzed idea links in design protocols of six expert architects working on two different design problems under two different conditions, one in which they were blindfolded and one in which they were sketching. Architects developed design ideas efficiently when they were blindfolded, and this condition did not put them to disadvantage compared to the sketching condition.

Idea development is considered to be enhanced by sketching activity only; however, the results of this study showed that it may also be enhanced by use of imagery alone. Use of imagery can be a design tool for idea development of expert designers.

Acknowledgements

This research supported by an International Postgraduate Research Scholarship and a University of Sydney International Postgraduate Award. Facilities were provided by the Key Centre of Design Computing and Cognition. Special thanks to the participating architects. We would like to thank to Gabi Goldschmidt who reviewed the first author's PhD thesis and kindly suggested ways to improve the linkograph analyses and related results.

References

1. Arnheim R (1969) Visual thinking. Faber & Faber, London
2. Athavankar UA (1997) Mental imagery as a design tool. Cybernetics and Systems 28:25-47
3. Bertoline G, Wiebe E, Miller C, Nasman L (1995) Engineering graphics communication. Irwin, Chicago
4. Bilda Z, Gero JS (2006) Reasoning with internal and external representations: A case study with expert architects. In The Annual Meeting of Cognitive Science Society CogSci'06, Lawrence Erlbaum Associates: 1020-1026
5. Bilda Z, Gero JS, Purcell T (2006) To sketch or not to sketch? That is the question. Design Studies 27(5): 587-613
6. Ericsson KA, Delaney PF (1998) Working memory and expert performance. In Logie, RH and Gilhooly, KJ (eds), Working Memory and Thinking, Psychology Press, UK
7. Ericsson KA, Kintsch W (1998) Long term working memory. Psychological Review 102: 221-245
8. Ferguson ES (1992) Engineering and the mind's eye. MIT Press, Cambridge MA
9. Fish J, Scrivener S (1990) Amplifying the mind's eye: Sketching and visual cognition. Leonardo 23: 117-126
10. Goldschmidt G (1999) The backtalk of self-generated sketches. Design Issues 19: 72-88
11. Goldschmidt G (1995) Capturing indeterminism: Representation in the design problem space. Design Studies 18: 441-445

12. Goldschmidt G (2003) Cognitive economy in design reasoning in Lindemann, U. ed. Human behaviour in design, Springer-Verlag, Berlin, 53-62.
13. Goldschmidt G (1997) The designer as a team of one. Design Issue, 16: 189-209.
14. Goldschmidt G (1990) Linkography: assessing design productivity. in Trappl, R. ed. Cyberbetics and System '90, World Scientific, Singapore, 291-298.
15. Hammond RH, Buck CP, Rogers WB, Walsh GW, Ackert HP (1971) Engineering Graphics: Design, Analysis and Communication. Ronald Press, New York.
16. Kan WT, Gero JS (2005) Can entropy indicate the richness of idea generation in team designing? in CAADRIA05 (New Delhi, India) 451-457.
17. Kosslyn SM (1980) Image and Mind Harvard University Press, Cambridge, MA.
18. Kvan T, Gao S (2005) Examining learning in multiple settings. in Martens, B and Brown, A eds. Learning from the Past - A Foundation for the Future, Springer Dordrecht, 187-196.
19. Laseau P (2000) Graphic Thinking for Architects & Designers John Wiley & Sons, Inc., New York.
20. Lawson B (1994) Design in Mind. The Architectural Press, Butterworths.
21. Lawson B (1990) How Designers Think? Butterworth Architecture, London.
22. Murty P and Purcell, AT (2003) Unexpected discovery processes in designing. in Proceedings of ANZAScA2003, (Sydney, Australia), Faculty of Architecture, University of Sydney, CD rom, no page numbers.
23. Petre EM and Blackwell, AF (1999) Mental imagery in program design and visual programming. International Journal of Human-Computer Studies, 51: 7-31.
24. Pylyshyn ZW (1984) Computation and Cognition: toward a foundation for cognitive science MIT Press Cambridge, MA.
25. Saariluoma P (1998) Adversary problem solving and working memory. in Logie, RH and Gilhooly, KJ eds. Working Memory and Thinking Psychology Press, Hove, UK, 115 -138.
26. Saariluoma P, Karlsson H, Lyytinen H, Teras M, Geisler F (2004) Visuospatial representations used by chess experts: A preliminary study. European Journal of Cognitive Psychology, 16 (5). 753-766.
27. Saariluoma P, Kalakoski V (1997) Skilled imagery and long-term working memory. American Journal of Psychology, 110: 177-202.
28. Simon HA, Chase WG (1973) Skill in chess. American Scientist, 1: 394-403.
29. Toker F (2003) Falling Water Rising: Frank Lloyd Wright, E.J. Kaufmann, and America's Most Extraordinary House Knopf New York.
30. Ullman DG, Wood S, Craig D (1990) The importance of drawing in the mechanical design process. Computers and Graphics, 14: 263-274.
31. Van-der-Lugt R (2003) Relating the quality of the idea generation process to the quality of the resulting design ideas. in International Conference on Engineering Design (ICED), (Stockholm, Sweden), 19-21.
32. Weisberg RW (1993) Creativity : Beyond the Myth of Genius W.H. Freeman New York.

Reaching Out in the Mind's Space

Uday Athavankar, P. Bokil, K. Guruprasad, R. Patsute and S. Sharma
Indian Institute of Technology-Bombay, India

Studies on blindfolded designers/architects have thrown light on their amazing abilities of creating a virtual model in their mind's eye and physically interacting and manipulating it. However, these studies suffer from the limitations that the interactions were highly restricted by the experimental settings. This paper explores the potentials of blindfolded architects using their body to interact with the virtual architectural spaces that they create in their mind's eye while designing. The results reveal two major strategies used by architects, moving the visualizations in sync with the bodies and moving within the fixed visualizations. The paper also details the nuances of how architects interacted with these visualizations.

1. Introduction

The architects and designers working with spatial creations seem to have a unique way of thinking, and much of this has been the focus of design research in the past 20 years. This paper, as well as the earlier publications on blindfolded architects and designers, is an effort to add to this knowledge. Unlike some of the other papers that deal with design logic and sometimes with the role of sketching, this paper is based on pushing architects to corner and watching them creatively use their mind's eye. In the last ten years of dealing with this area we realized that the capability of mind's eye while assisting in design is not only fascinating, but awe-inspiring. The fact that mental imagery and creativity have a synergic relationship makes these explorations significant [1]. To explore if these strategies could help improve design performances in practice, as well as its implications to design education, are seen as a long term goal.

J.S. Gero and A.K. Goel (eds.), *Design Computing and Cognition '08,*
© Springer Science + Business Media B.V. 2008

Why blindfold- the motivation: Wearing an eye mask while designing is no doubt an unusual situation. However, the aim of blindfolding the architects is not to improve design performance immediately, but to force the architects to depend completely on their internal cognitive and body capabilities and particularly ensure that they depend on the mind's eye (the focus of this paper), long term memory and precedences. The idea is to push architects to the corner and prompt them to develop visualization strategies to handle their creations in the mental imagery. (To retain consistency with the earlier publications on this topic, the spatial simulations and modeling in the mind's eye are referred as virtual models. The term is not to be confused with the 'virtual' as used in the computer world) Even though only four subjects were used in this pilot study, the analysis focuses on commonalities in visualization strategies used, rather than on the actions of individual designer. So innovative were these strategies that it was difficult to resist publishing them.

1.1 Background: Mind's eye in the design action

There are several publications that deal with use of mind's eye in design and treat it as an inseparable part of visualization process. Observing the way architects work, Sommer pointed out the flexibility and non-material character of images and their ability to allow unusual transforms as the specific advantages of imagery in design thinking [2]. In spite of most designers personally experiencing images during problem solving, the literature in design research offers limited insights into the creative use of imagery. As mental images are too elusive to catch in an experimental situation, the focus has been on externalized output, especially sketching. So the literature on designers' thinking process shows a prominent share on importance of sketching in design and its role in cognition [3], [4], [5] and [6]. Sketching has been treated as an essential medium and inseparable from the conceptual designing [7], [8], [9], [10] and [11].

In general, published material on mind's eye took quite some time to go beyond anecdotes. Pioneering work by Shepard [12] and later Kosslyn [13] helped in bringing mind's eye on the research agenda. To the design community dependent on mind's eye, this offered new research possibilities. Literature using industrial designer as a subject and blindfolding him has shown how designer effortlessly modeled 3D ideas in mind's eye, almost treating it as virtual display supporting spatial thinking [14] and [15]. The industrial designer sat in front of a table and created a virtual model in his mind's eye and using hand gestures, interacted with it fluently. Gestures substituted sketching and played various roles, from representing a surface,

its orientation and its extent, to acting as tools that shaped the model. It can be argued that the hand gestures not only assisted blindfolded designers, but may have prompted spatial thinking and the development of the images in his mind's eye.

Using architects as subjects has shown even more dramatic results. Literature shows how architects also effortlessly work in their mind's eye and 'externalization' through sketching may not be necessary for experts [16], [17] as well as for novice designers [18]. These architects were able to create, construct and alter the built form in their mind's eye as they went on taking design decisions. More recent work has shown how architects effectively handled their creations when blindfolded and that too without loss of the quality of design output [19].

However, all these experiments on architects were conducted in a set up, where the subjects were typically seated wearing an eye mask and developed their ideas across the table. For instance, Singh's subject conceived and evolved his ideas by being part of the visualized environment [16]. One striking difference is that he continued to mentally walk-through the spaces that he created in his mind, perhaps because he was restrained in his chair. This architect had to go through the additional cognitive efforts of generating mental images from the locations and viewing angles that were not consistent with his physical body orientation. The idea of extending these studies to allow designers to move in space came from these observations.

1.2 Research questions

This pilot experiment tries to explore whether the architects would use the potentials of interaction in the 3D space around them when they are let into a hall with eye mask. In testing this hypothesis, the experiment also explores if such a situation can lead to new traits of design behavior. The questions that this paper addresses are,

 • *Will Architects use of their bodies to physically explore, walk and experience the spaces that they create and alter in their Mind's Eye? If yes, would their body movements reflect or respond to the nature of their spatial creations?*
 • *Will such a situation influence the strategies they use to create the visualizations in their mind's eye?*

In exploring answers to these questions, paper also proposes a technique of externalizing the mind's eye event and thus accessing what the architects have experienced with greater details and objectivity. Even as a pilot study with a small sample size, the results are exciting enough to share.

2. Experimental procedure

The procedure shares a number of similarities with earlier experiment on blindfolding of designer. [14] Differences are mentioned here with a brief description of the five stages.

Stage 1: Detailed site drawing was shown to each subject and they were asked to remember and immediately describe it from memory.

Stage 2: Design brief was given to them and they were asked to recall all the design requirements.

Stage 3: The subjects were blindfolded and let free in an open hall. They had the opportunity to see and feel the size of the hall. This avoided their hitting the edges and obstacles. (Except A4, all lost their sense of physical orientation within the hall and could not have been influenced by the boundaries of the hall.) They were asked to think aloud while designing and when the architects forgot to include this information in their 'think aloud', two types of questions were asked without disturbing the flow of thoughts. They are,

• Where are you now?

• Can you describe details or specifications of the built form such as material, color, elevation?

Stage 4: The subjects were asked to verbally sum up the final design proposal, while they continued with the eye mask. The time taken for these stages varied from 14 minutes to 30 minutes. The sessions in stage 3 and 4 were recorded on video.

Stage 5: At the end, the eye mask was removed and the subjects were asked to quickly sketch their design. The sketches were matched with respective protocols and descriptions while designing to ensure that new ideas were not added. A4 did not sketch and so, in his case the inferences are based on his spatial demonstration of the final design while in stage 4.

Experimental set up: When the designing started, the architects were blindfolded and let into an open hall, standing. The hall was a rectangular room (size 6.6 x 8.8 meters), but smaller than the actual site (18 x 26 meters). The tile grid on the floor allowed documenting the actual physical movements that the architects covered during the session. Architects were given a cordless collar mike, so that they can move freely and their 'think aloud' audio could be recorded on video simultaneously.

Subjects: Four subjects (Two male: A2 & A4, two female: A1 & A3), all having nearly two to three years of professional experience in architectural and interior design projects participated in this experiment.

Design problem: The design task was to develop a cafeteria and an informal 'hang out' place for university students on a campus with a reason-

able tree cover. The site was surrounded on three sides by access roads and on the forth side by an open space followed by a drainage and student activity centre (SAC). The brief included detailed space requirements.

Catching the mind's eye experiences - Logging of the data: Access to the contents of the mind's eye has always been difficult. Earlier experiments have shown how protocols that logged the concurrent verbal as well as accompanying gestural movements within episodes and events allowed a reasonable access to the contents of the mind's eye [15]. The verbal data, hand gestures, head movement and the accompanying motions of the body (movements and steps) were recorded on excel sheets by a team different from those who actually conceived and implemented the experiment. Part samples can be seen table 1 and 2 in section 3 later. In doing this, the protocols were split into episodes and events.

Earlier experiments had shown that recording gestures along with protocols is critical as they are used extensively in thinking about spatial phenomena like shapes or locations. Subjects used various forms of simulations like mental walkthroughs for built environment and exploding of assembly in product design to evaluate design performance [15] and [16]. In case of namable parts, the indication of which part and where, came from words and/or sometimes from indicative gestures. These gestures were easier to interpret when seen with the accompanying verbal protocols. Information on materials, color, lighting and light quality was often included in verbal protocols. Fortunately in the current protocols, there were sufficient direct and indirect references to 'things' and their specifications. Protocols were also a rich resource to permit reconstructing designer's visualizations as series of maps. (See section 4) They neatly captured the way architects saw the site and gave clues to the contents of their mind's eye at various points in time.

3. Quick overview

The architects were taken to the hall and blindfolded. They were not specifically told to move. Responding to the new experimental condition, all the architects moved around in the hall on their own, though the nature and extent differed. Their actions after initial few minutes do not suggest that they were constrained. In general, the design behavior during these sessions seems to be a combination of following three modes.

- Speak, **Stand**, Gesture and Mental walk
- Stand, Speak, **Turn around**, Gesture, Mental walk
- **Physical walk, Turn**, Stand, Speak, Gesture, Mental walk

The spatial details of their movements and protocols suggest that architects in some virtual form were living on the virtual site, while they walked in the real world. Their actions reveal the identity of the virtual objects, their 'virtual positions' and their relationship with each other in the 'virtual' world in the mind's eye. So complete was their visualization that they were able to reply to the questions on details of the design and even simulate the activities spontaneously.

The four architects have seemingly used innovative visualization strategies and kept switching between them during the design session. On the face of it, body movement added another dimension by accounting for the subject's moving positions in the real world space, but the implications go far beyond and reveal new and surprising abilities that architects seem to have developed. The paper uses two analytical approaches to understand and reconstruct the contents and study how visualizations are handled. These are,

- **Use of direct references** in the verbal protocols. Here existing techniques are used along with asking about locations during the design action. Analysis in Section 3 is based on direct verbal references.
- **Use of mapping of the contents**, which evolved from the new experimental situation, where the architects were allowed to move in the real world room. Analysis in section 4 is based on this technique.

3.1. Experiences of virtual avatar and virtual site

Architects appeared to be 'virtually present' on the 'virtual site' in their mind's eye. There are two types of events that support this argument

- Subjects' think aloud used in words like 'I' and 'my' as well as frequent use of left, right, front, my left, with their body as reference
- Answers to the question 'Where you are now?'

3.1.1. I, my body and my design around

The direct evidence of reference to self comes from the verbal protocols that the subjects were actually experiencing the site around their body and making and reacting to their own design moves. Take for instance extensive use of the word 'I'. (Refer table 1) This was common with almost all the architects, though the frequency of use differed. Table 1 has some examples of use of word 'I'. Their real world physical movements seem to be external manifestations of what they were doing on the virtual site.

Table 1 Protocols of A3 that record speech, gestures and body movements

Time	Transcript	Gesture & Movements
00:33:16	A3: **I** want the entry for this hangout place	Hands in front
00:33:20	A3: so **I** am entering this site	Walks with small steps
00:33:30	A3: now _this will be entrance pathway_ to the.... _that_ complex.. pause Now	Both hands in front folded horizontal to ground
00:33:48	A3: on <u>both side of **me**</u> there will be the landscape areas	Hands down, slightly away from body showing sideways

Protocols are also full of words like left, right, front with expressed or implied use of 'my' in the sentences. For example in case of A3, protocols and concurrent gestures suggest that she was walking down the pathway on the site and while she did so, she proposed different parts of her design with reference to her body. She continued this further when she says, "there will be a reception in <u>front of me</u>" (A3: T 00:34:12) , or when she says, "When I go on <u>my left</u> side, I have the big sitting <u>place around me</u>." (A3: T 00:34:41). Consistently, all the architects visualized the new design ideas around their bodies. So, the features and locations were indicated by hand gestures and when necessary were accompanied by body rotations. Surprisingly, much used north point was referred only by A2 once and that too by pointing in front with his hand saying "<u>My north</u> is in this direction". (A2: T 00:20:51) Further support to the possibility of the architect's mentally experiencing being on the virtual site comes from the answers to the question ''Where are you now?''

3.1.2. Answer to "Where are you now?"

After blindfolding and letting the subject into the hall, and particularly during pauses in action, the experimenter intermittently asked the subjects 'Where are you now?' The spontaneous and quick answers clearly suggest that for most architects, being part of the virtual space was immediate. They knew where they were when they started designing and also during the act of designing.

For instance, A1 indicated her position by referring to the features around when she says, "I am standing on that curve" (A1: T 00:00:30) and moved her hand in curved fashion in space parallel to the ground to indicate her location. Later, when she started designing, she moved and con-

tinued to directly or indirectly indicated her new locations with the help of site features. (See table 2)

Table 2 Section of protocols of architect A1, showing her awareness of her location on the virtual site

Time	Transcript	Gesture & Movements
00:03:55	A1: So I am <u>actually entering from the other side</u> because its sloping like this..	uses hands to explain slope
00:04:31	A1: There is a lane in between, I am entering like that this .. is at 20mm level. ok... your site slopes like that , I am entering here...	uses hand movements to explain contour

Similar question was also asked to all the architects between the episodes, during the design session. The results are not very different. Take for example when the experimenter asked the question just after A1 had finished narrating details of the design at the location she is speaking about. She responds quickly that she is at center of the site. (A1: T 00:05:58 to 00:06:08). In a similar situation mid-way in the design act, A2 responded by saying, "right now I am imagining myself standing inside the entrance, inside that arc (that he had built) facing the tree" (A2: T 00:27:11). Similarly, A4 too declared his position using the corner of the site (A4: T 00:44:40) and referred to it with extensive hand gestures to indicate passage, SAC building, trees etc. (A4: T 00:44:35) References to the site features like trees, access road, slope and curve indicated their awareness of where they were at the beginning.

Seeing these answers together with references to self and anchoring of 'things' around their own body, it appears that almost all knew where they were throughout the session. Some actually declared their positions on their own. The answers were mostly spontaneous, often confident and only occasionally, some of them took time to answer.

Analysis so far does offer fair details of what they were thinking of, and where they were on the virtual site while taking design decisions. Though this section gives a feeling that Architects had visualized and experienced their creation in their mind's eye, it is necessary to search for a more objective proof to validate the statement. We need to establish that the 'Architects indeed saw their unfolding creations in their mind's eye and reacted to it to develop a new built form.' Using a new technique, the next

section reveals lot more details of the unfolding of innovative spatial ideas in the mind's eye.

4. Mapping the mind's eye contents

The purpose of letting the architects into a rather large hall and blindfolding them was to see how they exploit the freedom in the act of creation using their body. How the architects' actions were related to their visualization efforts? Is it possible to peep deeper into the three dimensional visual world that the architect's were experiencing? Can we reconstruct the dynamic scenarios in the architect's mind's eye?

For every major sequence of events in the episode, the concurrent and the preceding verbal and gesture information in the protocols and the accompanying motion of the body in the video (walk, move, rotate....) were analyzed. Clues in the protocols allowed plotting the contents as dynamic maps and yielded information on amazing things that architects' were able to do while visualizing in their mind's eye. Besides the usual information on physical location of the features, maps could now show how architects effortlessly handled and controlled the visualizations at all the intermediate stages of design. These maps offer a time line based sequence of reconstructions of visual events and episodes that reflected the evolving visualizations. Figure 1 shows a sample map taken from A1's summing up his design. The map shows changing orientation of site as she moved in the hall. The architectural elements described in the protocols are not shown in the map to avoid visual clutter.

These maps suggest that the Architects used two main visualization strategies to handle the developing creations in the mind's eye. These are,

1. Carrying the site on the shoulder: Architects moved in the real world space and carried the site with them in their mind's eye. The site moved and rotated with them. There were also several local variations of the strategy.

2. Pacing in the mind's eye: Architects physically moved and paced within the stationary visualization of the site which they created in their mind's eye.

It is not the case that each of the architects had a fixed strategy that s/he used throughout the act of design. Most kept shifting between these strategies, using what suited them in that particular context. These shifts between strategies seem to occur with amazing ease and suggest that they were not even aware of it. In a way this experiment does throw light on this unique thinking trait that seems to be common in architects and per-

haps in people involved in spatial problem solving. Each of the strategy is discussed in detail in the sub-sections that follow.

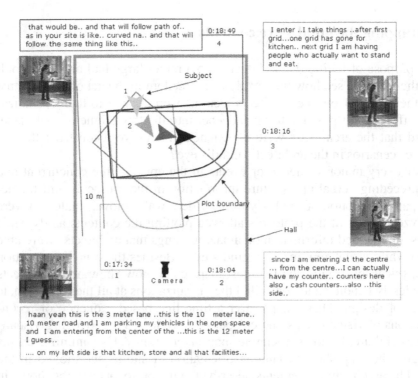

Fig. 1 Sample map captures the dynamic movements in the physical world of A1 as well as her visualization.

4.1. Strategy 1: Carrying the site on the shoulder

In all the earlier experiments where the architects were blindfolded, the architects as subjects were sitting at the table [14], [16], [17] and [20]. With the result, the issue of orientation of visualization of the site in their mind's eye did not receive attention. However these video protocols clearly show architects moving and turning while designing. A careful look at the sequence of maps shows that there is a critical relationship between the body orientation and the visualization in the mind's eye. For instance, their visualization seems to also move and rotate with them as they move and turn in the real world. It is difficult to establish, at least in the context of this experiment, if the need to move and turn was prompted by the evolving

thought process or vice versa. However, segments of protocols suggest that the architects moved in the real world physical space, but had 'anchored' their visualization of the site to their body. Maps reveal the variations in the visualizations that have occurred with greater degree of objectivity. Based on the nature of architect's movement, the variations can be broadly grouped into two categories.

- Architect **stands** at one location, but **turns** his body in the real world
- Architect physically **changes locations** as well as turns his body in the real world.

Relying on the map technique, it is planned to show how the architects took advantage of these two types of movements and how it is reflected in their visualization.

4.1.1. Architect stands at one location, but turns his body in the real world

There are segments in the design sessions where architects chose to stand at one location developing the spaces around them, later turn their bodies to face other directions, plan and locate new features and continue to develop the ideas. All along, the visualization in the mind's eye also appears to turn and further ideas evolve from this new orientation of the architect's body. There are several such examples. For instance (Figure 2) A2 at position 1 is placed as he had imagined himself initially. As session progressed, he continued to be on the same location, except that he turned slightly and the site also rotated in sync. The slow rotations continued till the end of the episode, where he found himself reoriented by 90 degrees from his initial position. He seems to be aware of this, as in reply to the experimenter's question in position 4, he said "I think.... I haven't moved too far from the tree (A2: T 00:23:11 to 00:27:10). This episode is mapped and is shown in the figure 2.

The mapped data suggests that if the body turns, the mind's eye images could also turn in sync, if the architects wish them to. Whether the visualizer is conscious of these turns or not is not clear, but on the face of it he does not seem to be aware of this. Carrying the visualization anchored to the body is indeed a unique ability that architects seem to possess. It is perhaps critical for those involved in large size spatial creations.

4.1.2. The architect physically moves as well as turns his body in the real world

Videos clearly show that sometimes the architects not only turned but also physically moved in the real world space, though the actual distances by which they moved differed. The direction and sometimes even the distances by which they moved seem to reflect intuitive logic. Most of the

movements were clearly in the direction of the design action and often simulated entering or exiting from the spaces created in the mind's eye. Thus adding a function on the left involved moving the body towards left simultaneously. In some cases, the direction and the distance traveled reflected some kind of measure of the actual (with intuitive scaling factor), while in other cases, the direction remained consistent and the actual distance traveled in the real world was notional.

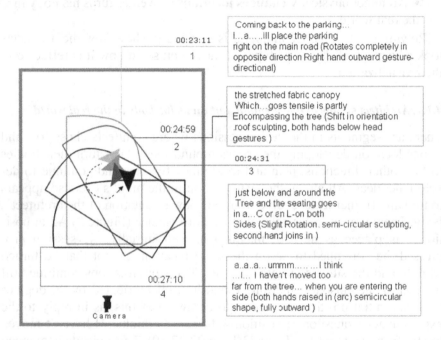

Fig. 2 Sample map to illustrate mapping of the dynamic movements of A2 and his visualization.

Protocols suggest that they were actually building and experiencing the spaces along the path. When A1 started designing, it appeared as if she was actually moving in the virtual world in her mind and changing it simultaneously. She made noticeable real world physical movements along with body rotations and the visualized site moved and rotated along with her. This is evident from the episodes from A1's protocols, shown as map of virtual site in figure 3. (A1: T 00:06:16 to 00:07:44) the site itself seems to virtually shift in sync with the A1's movements as if it was a car GPS display. But the analogy ends here. The mind's eye appears to have an immersive surround quality of a three dimensional surround display.

4.2. Strategy 2: Pacing in the mind's eye

The second and equally popular visualization strategy differed fundamentally from the first. The Architects created the visualization of their design in their mind's eye and physically moved within it as if it existed in the real world. Major difference is that, their visualization was retained in a fixed orientation, sometimes consistently for long periods of time. A4 retained the fixed orientation of the site with respect to the hall throughout (except for a short period). Others froze and held the visualized orientations of the site for shorter periods.

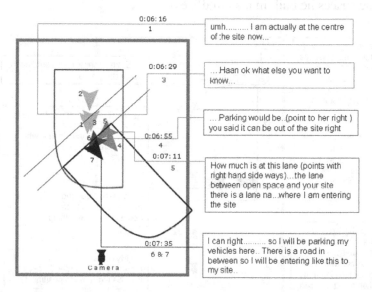

Fig. 3 Map showing the movement of the site in the mind's eye site in concurrence with A1's physical movements.

Architects paced, moved and turned in the visualized space. It was perhaps so real to them that some took physical steps to enter or come out of functional spaces that they created without losing the original orientation of the visualized site. A4's example will explain the point. He initially developed the visualization of the raw site.... "Ok, I am standing at extreme edge in it... passage starts and this is the main access to my SAC building ...alright? And there is a tree......." (A4: T 00:44.35 to 00:44:52) From then on, he physically moved several steps and indicated the area where he proposed his kitchen area and then he went ahead to propose the cafeteria. See figure 4 for details.

The event clearly shows that A4 retained this raw visualization of the site in the same orientation even when the design action started. He paced up and down in hall developing his design ideas and even turned around without losing the original orientation of the visualized site. At a later instance, when the experimenter intervened and asked his location, he replied "I think I am standing in the kitchen area". (A4: T 00:50:48) When further questioned about the location of the cafeteria his reply was "The cafeteria is ahead of kitchen". (A4: T 00:51:00) He took five steps forward and then one step backwards to tell cafeteria location. How does one explain taking a step back to adjust his position, unless he was doing it in response to the spaces he built in his mind's eye?

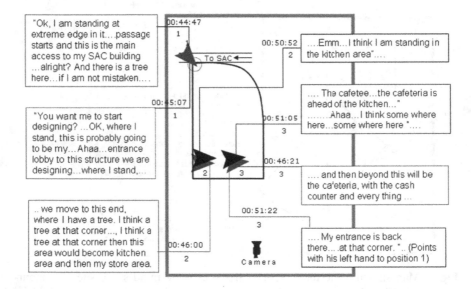

Fig. 4 Map showing the physical movement of architect A4. A steady site can be seen that he visualized in his mind's eye.

A4's visualization was definitely not carried with him on his shoulder, but was somehow anchored to the orientation of the hall in which he physically moved. In pacing up and down, he did occasionally touch edges of the furniture along the walls and that perhaps helped him to fix the orientation of the site in his mind's eye.

Not everyone anchored their visualizations to external clues like hall, but held it fixed in the mind during the episode. During designing, A3 traveled on a hard paved path through her visualized site. Instead of the normal question, when the experimenter asked A3 to go back to where she had started (A3: T 00:33:30), she was indeed able to go back exactly to the

same position, and that too using the pathway she described in the beginning. Reaching that point she said 'I am at entrance pathway'. (A3: T 36:36:00 to 37:15:00) Interestingly, later in sum up, she repeated same pattern of movements, but in a different orientation. She appears to have lost the orientation of the visualized site with respect to the hall.

It was not at all unusual to see the architects behave as if they were on the real site. When A4 was asked the usual question, "Where are you standing?", he looked up and turned his head as if he was looking around at a distance and scanning and said... "where am I standing..." and then answered that he was in the kitchen area. (A4: T 00:51:00) The search behavior and responses seem to be remarkably similar to searching and seeing with open eyes in a real world site. It is not then surprising to watch two of the designers (A1 & A4) step back a couple of steps and look up as if they were looking at something tall and wide, when the experimenter asked them to describe the elevation. (A1: T 00:09:11 and A4: T :00:49:16) So real and accurate was their presence in their own virtual creations, that some even adjusted their physical movement to the built form in the mind's eye.

4.2.1. Body orientation and the ritual of entering the plot

The strategy of moving in the visualized site appears to be more common when architects discussed the entrance. For instance, A2 said he is standing at the center of the plot with the tree behind him and pointed to the north direction by hand gesture (refer fig. 5). He referred to his idea of entrance from this position and said 'I am standing in front of the entrance'. He suddenly asked 'Can I turn around?', then took 180 degree turn and described what he saw from that position. The north had not changed, the visualized site appeared to have remained in its original state, but A2 turned and paced in a new orientation as if he was entering the site. Urge to orient the body with the mental act of entering is more than obvious.

A1 too seems to have gone through 'face the site in front' situation. She realized that her body orientation was not compatible with the direction of the entry, she physically moved to reach the edge of the site as she visualized it in her mind's eye and turned around to stand in line with the direction of the planned entry (A1: T 00:03:33 to 00:04:23).

It appears that once blindfolded, the architects seem to compensate for the loss of the real world visual inputs by depending on internal feedbacks and memory of movement. This probably explains why almost all the architects positioned themselves on the virtual site immediately after they were blindfolded. Typically all first decided on the entry to the site and po-

sitioned themselves at the entry point. Once that was done, their actions were confident and fluent.

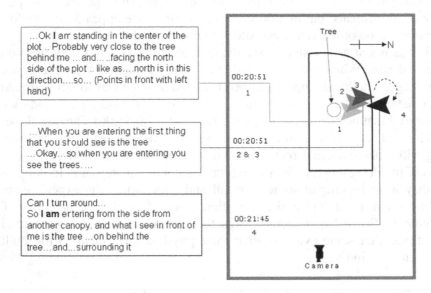

Fig. 5 Map showing A2 taking a 180 degree turn within the site with static site lacation.

4.3. Avatars and kinesthetic feedback

The positioning on the visualized site helped them orient themselves and it was almost treated as an internal reference to move around and explore spaces and still keep a tab on where they were on the virtual site. For example, A2 in the middle of the action supports this claim, when he said "I have not moved far from the tree and..., I am standing if.. right now I am imagining myself standing inside the entrance, inside the arch, facing the tree". (A2: T 00:27:00) Though he as well as the site in his mind's eye had rotated by almost 90 degrees, his judgments of directions and distances were accurate when checked with the previous records. Once he had firmly located himself on the virtual site in his mind's eye, he was able to conduct operations comfortably.

These architects were on the virtual site as 'Avatars' and moved freely around adding and modifying their creations, but also existed in the real world, gestured, turned and physically moved in it, often in measured steps! Even when answering related questions, architects continue to re-

main in the virtual avatar and so were able to reply quickly. Keeping a tab of plurality of existence suggests that it is definitely not a trivial capability. The dominance of virtual world is evident from occasional loss of orientation in the physical world. However, they seem to have compensated it by the internal feedback of body movements and gestures which they seem to memorize and used effectively. It is possible that when they were blindfolded, these architects may have been guided by their heightened kinesthetic sense and memory of movements in the real world, while they actually operated in the virtual world. This probably explains the physical adjustments of body in interaction with the virtual locations and layouts.

5. Conclusions: Return to the research question

Has the experiment been able to answer the questions this paper started with? The results clearly show that though between the architects, the degree of movement seemed to differ from the notional movement to a scaled version of the actual distances, they did move in the space. Their movements were in sync with the developing creations in their mind's eye. The fact that the interactions and the physical adjustments of the body could be consistently mapped to locations and layout in the mind's eye suggests that kinesthetic sense may have played a key role in the designers' actions. Support for this line of thinking comes from work on rehearsal loops that permit holding the material in working memory [21]. Designer's gestures may have created additional afferent channel to complete the loop. This possibility has been discussed elsewhere before [15].

The paper has also attempted a mapping method to externalize the contents of mind's eye and thus makes it available for external study. As visual maps, they appear to be far richer and more easily understandable than the protocols used earlier. The analysis of these maps reveals use of several visualization strategies and effortless switching between them. Sometimes they carry the virtual site on their shoulder and so it turns as they turn and it moves when they move. There are also instances where the virtual world has a fixed orientation and architects pace up and down and turn as if they were moving on a real world site. Interestingly, there interaction with the virtual world in their mind's eye almost mimics the behavior in the real world. They search, see and move near or away as if they are operating in the real world. The spontaneous answers to the question 'Where you are now?' further suggest that the architects had completely immersed themselves in the virtual world and almost lived in it.

5.1. Significance

This is part of the series where efforts are focused on pushing architects into an unusual situation, to force him to creatively use some of his cognitive capabilities like mind's eye and kinesthetic sense. It further confirms our belief that architects and designers have their own ways of using the mind's eye capabilities and are amazingly fluent in exploiting it. It is wonderful watching them work with remarkable dexterity in spite of artificially imposed eye mask constraint. These may be profession specific, but do not appear to be trivial abilities.

Interestingly, architects seem to develop these abilities on their own and thus the level of competence of handling mind's eye contents may vary between different architects. They seem to learn to visualize and use it in creative efforts fairly early in the education programme. Learning abstract orthographic drawings and converting them into perspective system perhaps aids the process. In spite of its implication on creative efforts, no direct attempt is made to teach this skill set and other skills like sketching continue to dominate the architectural education.

5.2. Limitations and future directions

The experiment does not deal with quality of the creative work produced by the architects, nor was that the intention. Yet we need to address some of the questions. 'Did the technique influence the thinking process?' A quick overview of the sessions show that some of the traits common to normal design process continued. For instance, taking tentative decisions, keeping alternatives open and keeping some aspects vague were clearly visible. Yet there are differences. The role of blindfolding in influencing design approach can not be ruled out. The fact that everyone started with entry and the pathway can not be a coincidence. It is even more difficult to answer 'Did moving on the site distract their thinking process? All new techniques are a cognitive load. It is only with extensive practice that you can perform in auto-pilot mode. Sketching too requires cognitive attention for those less gifted. In spite of this, it is surprising that these architects performed with relative ease with no previous experience of designing blindfolded. May be, mental imagery is easier to generate and control than other form of representations.

References

1. Finke R (1990) Creative imagery; discoveries and inventions in visualization. Lawrence Erlbaum, New Jersey
2. Sommer R (1978) The mind's eye: imagery in every day life. Delta Book, New York
3. Goldschmidt G (1992) On figural conceptualisation in architectural design. Cybernetics and System Research'92, World Scientific, Singapore: 600-606
4. Goldschmidt G (1994) On visual design thinking: the vis kids of architecture. Design Studies 15(2): 158-174
5. Suwa M and Tversky B (1997) What do architects and students perceive in their design sketches? A protocol analysis. Design Studies 18(4): 385–403
6. Suwa M, Purcell T and Gero J S (1998) Macroscopic analysis of design processes based on a scheme for coding designers' cognitive actions. Design Studies 19(4): 455–483
7. Akin O (1986) Psychology of architectural design. Pion Ltd, London
8. Lawson B (1990) How designers think? (2nd edn) Butterworth Architecture, London
9. Goldschmidt G (1991) The dialectics of sketching. Creative Research Journal (2): 123-143
10. Schon D and Wiggins G (1992) Kinds of seeing and their function in designing. Design Studies 13: 135-156
11. Goel V (1995) Sketches of thought. MIT Press, Cambridge, MA
12. Shepard R and Metzler J (1971) Mental rotation of three dimensional objects. Science 171:701-703
13. Kosslyn S (1983) Ghosts in the mind's machine: creating and using images in the brain. Norton, New York
14. Athavankar UA (1997) Mental imagery as a design tool. Cybernetics and Systems (1): 25-42
15. Athavankar UA (1999) Gestures, imagery and spatial reasoning. In Gero, JS and Tversky, B (eds), Visual and Spatial Reasoning in Design, Key Centre of Design Computing and Cognition, University of Sydney, Sydney, Australia: 103-128
16. Singh A (1999) The potential of mental imaging in architectural design process. In Proceedings of International Conference on Design and Technology Educational Research and Curriculum Development, IDATER 99, University of Loughborough, England: 230–236
17. Athavankar UA, Gill N, Deshmukh HS (2000) Imagery as a private experience and architectural team work. In Scrivener S, Ball LJ, Woodcock (eds), Collaborative Design, Springer-Verlag: 223-232
18. Athavankar U A and Mukherjee A (2003) Blindfolded classroom getting design students to use mental imagery. In U Lindemann (ed), Human behaviour in design, Springer: 111-120
19. Bilda Z, Gero J S and Purcell T (2006) To sketch or not to sketch? that is the question. Design Studies 27(5): 587-613

20. Bilda Z and Gero J S (2004) Analysis of a blindfolded architect's design session. In JS Gero, B Tversky and T Knight (eds), Visual and spatial reasoning in design III. Key Centre of Design Computing and Cognition University of Sydney, Australia: 121-136

21. Reisberg D and Logie R (1993) The ins and outs of working memory: overcoming the limits on learning from imagery. In B Roskos-Ewoldesen et al. (eds), Imagery Creativity and Discovery, North Holland,: 39-76

From Diagrams to Design: Overcoming Knowledge Acquisition Barriers for Case Based Design

Michael E. Helms and Ashok K. Goel
Georgia Institute of Technology, USA

One important and often overlooked implication of case based design systems is the acquisition of cases, which are typically hand crafted by system designers. Not only does this make case acquisition difficult and time consuming, but it may also introduce unanticipated biases and limitations into the system. In this paper we demonstrate a case based design system capable of automatically acquiring cases from diagrams, and of using those cases to solve new design challenges. Moreover, we demonstrate that our representation framework enables general teleological reasoning in design that transcends some domain borders, greatly increasing the versatility and usefulness of the cases thus acquired.

Motivation and Goals

Previous research establishes that case based design systems can synthesize new models from existing design cases to meet new functional requirements. One important and often overlooked implication of these systems, however, is the acquisition of cases. Typically, cases are hand crafted by system designers, and co-evolve with the system that will use them. Not only does this make case acquisition difficult and time consuming, but it may also introduce unanticipated biases and limitations into the system.

Perhaps the most obvious limitation is that hand crafting takes valuable time and requires skilled knowledge engineers. While a prototype system may only require a handful of cases to prove its theoretic capability, when deployed in more complex and varied domains, resource demands for large numbers of hand crafted design cases may not scale.

A second limitation is the flexibility with which design cases can be specified. Even with a syntactically well defined representational

J.S. Gero and A.K. Goel (eds.), *Design Computing and Cognition '08,*
© Springer Science + Business Media B.V. 2008

language, modelers may provide arbitrary specifications for a given model. As models and systems evolve together, specification biases emerge that both increases the difficulty of acquiring new knowledge and limits the range of the cases a system can handle.

Third, while cases crafted for a system may span different domains such as fluid dynamics and electrical circuits, designers may select domains with underlying similarities that facilitate system implementation, but that impose unintentional limitations. For example the domains just mentioned both have a concept of substance flow (electricity flow, fluid flow) with no straightforward analogy in mechanical systems. A system built using cases of electrical and fluid systems may inherently rely on substance flow for problem solving (a system bias), and will encounter difficulties with problems in mechanical system design in which substance flow may be not explicitly modeled.

One result of these limitations in design computing has been that most design systems have been small, almost toy, in their size, including some of our own earlier work (e.g., the Kritik system, [1], [2]). The question then becomes *how can we enable the construction of large scale design systems that may one day address real-world problems?*

Of course this question is not confined to design computing: the same question has arisen earlier in knowledge-based AI. In general, AI has taken two approaches to address the problem. The first approach, exemplified by CYC [3] has been to construct a large general-purpose knowledge base, which can use different inference engines to address different tasks such as understanding design drawings and generating new designs. The second approach, illustrated by KIF [4] and KQML [5], has been to first build wrappers around individual systems (e.g., for diagram understanding and design generation) and to then enable the systems to communicate with one another.

In this paper, we take the second approach toward the construction of large-scale design systems capable of automatic case acquisition. In particular, we begin with two legacy systems: the Archytas system interprets design drawings of physical systems by analogy [6], [7], and the IDeAL system generates new conceptual designs of physical devices also by analogy [8], [9], [10]. Although the underlying ontology for knowledge representation has the same origin, because of the differences in the tasks they address there are important differences between their knowledge representations. Thus, the research issue in this work is how might IDeAL and Archytas communicate with one another, with Archytas serving as a knowledge acquisition front-end for IDeAL and IDeAL serving as an evaluation mechanism for Archytas. More precisely, how might we bridge

the ontological gap between Archytas and IDeAL, where the two systems serve as exemplars of diagram understanding and design generation?

Here, we describe our work to overcome the barrier for design case acquisition by demonstrating a system for case acquisition from diagrams, supported by a very small number of "bootstrap" cases. Validation for the cases so acquired comes from integrating the cases with an existing case library and using these new cases to solve closely related but complex design problems. Our research also demonstrates the usefulness of the SBF knowledge framework to facilitate case acquisition and to generalize across arbitrary design domains.

Approach

We organized our approach into three distinct phases: 1) Bootstrap and Model Acquisition, 2) Data Extraction and Case Building, and 3) Case Evaluation. Figure 1 provides an overview of the process, as well as the systems involved. The first phase of our approach uses the Archytas system. An initial diagram and DSSBF model are used to bootstrap the system (1a), in order to acquire an SBF model from a new diagram (1b). In the second phase, we extract a limited amount of domain knowledge from the bootstrap case, which is appended to the case based reasoning system (2a), and we also make routine modifications to the newly acquired model that are required to load the model into the existing case library(2b). We will spend the majority of this paper discussing the second phase, as it highlights many of the central challenges of case acquisition. In the third phase, we use the case based reasoning system IDeAL to test the validity of the acquired model.

In subsequent sections, we provide a brief overview of the representation language used by each system, review the fundamental operations of Archytas and IDeAL, and provide additional details on the modifications required to integrate the two in the second phase. We follow with a discussion implementation details and briefly describe the successful use of a model built from a new diagram to solve a complex design problem.

SBF and DSSBF Representations

In earlier work on case-based design [1], [2] we developed Structure-Behavior-Function (SBF) models of physical devices. Both Archytas and IDeAL use the SBF language to represent design cases. The SBF language

provides conceptual primitives for representing and organizing knowledge of the structures, behaviors and functions of a device. In this representation, the **structure** of a device is constituted of *components* and *substances*. *Substances* have locations in reference to the *components* in the device, while components are related to other components through *connections*. A **function** in the SBF model is a behavioral abstraction and is represented as a schema specifying the behavioral state the function takes as input, the behavioral state it gives as output, and a pointer to the internal causal behavior of the device that achieves the function. The internal causal **behaviors** in the SBF model of a device explicitly specify and explain how the functions of structural elements in the device get composed into device functions. Annotations on the state transitions express the causal, structural and functional contexts in which the transformation of state variables, such as substance, location, properties, and parameters, can occur [11].

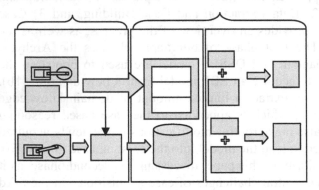

Fig. 1. A graphical depiction of the approach showing the three main phases and the scope of the systems Archytas and IDeAL.

Previous research [8], [9], and [10] establishes the capability of SBF to 1) represent systems across different domains, 2) enable systems to solve design problems, and 3) represent both case-specific models and case-independent models. However, to facilitate the mapping and transfer of diagrammatic representations to SBF models, more recent work [6], [7] extends the SBF language to include drawing and shape representations. This extended language, called the Drawing-Shape-Structure-Behavior-Function language (DSSBF) uses structure as an intermediate abstraction to relate shapes and spatial relations in a drawing to the behaviors and functions of the device depicted in that drawing. Figure 2 depicts the five tier hierarchical representation of a DSSBF model. Note that a single system may be represented by multiple drawings and multiple shapes,

which are not depicted here for clarity. We bootstrap the initial system with an initial DSSBF model, using the DSSBF specification to establish relationships between diagrams, shapes and their SBF model counterparts. Using analogical reasoning, we can then extract SBF models from new, similar diagrams.

Fig. 2. The hierarchical schema of the DSSBF language (adapted from [6]).

In this way, SBF provides a common representational language used to transform drawings to models, and to link those models into a case based reasoning system to create new designs.

Archytas

Provided with a single source diagram and DSSBF model, the Archytas system constructs an SBF model from a diagram of a physical device. Unlike other approaches that apply domain specific rules e.g. [12], Archytas uses analogical transfer of the SBF model of the device in a similar drawing to build a model from a target diagram. Archytas, however, does not implement a model retrieval task. It is assumed when a diagram is entered, that the proper diagram is assigned from which to transfer the model. The source case contains both a 2-D vector-graphics line diagram of a physical device and a teleological model of the device in the form of a DSSBF model. Given a similar diagram of the same device, the Archytas system aligns the diagrams, and transfers relevant structural, behavioral and functional elements to the new diagram. This process can be repeated for a large number of variations on the initial diagram, including variations on the device state, orientation, dimension and the number of components [6] Archytas cannot account for variations in component shape or drawing perspective. By bootstrapping Archytas with a single instance of a diagram and DSSBF model, the system is capable of

creating 1) the same model from very similar diagrams, and 2) new models for similar systems with different component configurations.

For example given the source diagram Fig 3(a), Archytas reproduces the same model given the target diagram 3(b), even with the slight differences in state, dimension, and polygon composition. Given the same source diagram, Archytas also creates a new model for diagram 3(c) that successfully accounts for the variation in the number of components, in this case two piston assemblies instead of just one.

The Archytas system requires several levels of abstraction. The structural model of the device in the source diagram specifies the components of the depicted device and their interconnections. This model is related to the diagram via an intermediate abstraction of the shape model. Archytas first gathers lines, circles and intersection points into shapes and then finds mappings between the source and the target at this level of abstraction. Then it groups these mappings and transfers shapes from the source to the target. Next it finds a mapping at the shape level, and finally transfers the structural model. Mapping and transfer thus happen iteratively in a loop, working up to each subsequent level.

IDeAL

IDeAL is a case based reasoning system that implements an analogical theory of creative design called model-based analogy (MBA). In this theory, case-specific SBF models of past designs enable abstraction of generic teleological mechanisms (GTMs), such as feedback loops and cascading, which are later recalled and adapted in a new candidate design [8],[9]. The computational process of MBA takes as input a specification of functional and structural constraints on a desired design (the target design problem) and gives as output a structure (the solution) that realizes the specified function while satisfying the constraints. The design cases in the case library are case-specific SBF models that specify the functions delivered by past designs, the structure of the design, and the causal behaviors of the design. Cases in memory are indexed by both function and the constraints they satisfy. Information requirement for IDeAL will be discussed in the next section.

Information Requirements and Integration

While our primary research goal is demonstrating a system that enables diagram-based case acquisition and use for design, neither the conversion

of diagrams into SBF models nor the use of SBF cases to solve design challenges were at issue. The Archytas and IDeAL systems addressed each problem independently. The primary challenge of our research was to integrate the two systems, shedding light on the gaps that developed between the two systems. The primary achievement of this research is in understanding the information requirements of the case-based reasoning system as a linked whole, rather than as two independent halves. In so doing, our research exposes information differences in each system, which we categorize as: 1) domain specific differences, 2) representation differences, and 3) system requirements differences.

Fig. 3. (a) and (b) illustrate a target and source diagram for the same system, with slight variations in state and dimension. The U-shaped assembly in (a) is made up of three rectangles, but is a single polygon in (b). In (c) two pistons are shown connecting to the same crankshaft, resulting in a different model from (a) and (b) (adapted from [6]).

Domain Specific Differences

Previous work on IDeAL demonstrates the ability of both SBF and the IDeAL system to operate effectively over multiple domains. Previous cases in IDeAL were taken from domains with straightforward, consistent, and explicitly represented substance flows. For instance, the substance electricity flows from one end of a battery, through a circuit, to the other end of the battery. It is by backward-chaining through the state changes in these substances (via explicitly described transitions) from one point of the system to another, that IDeAL is able to identify causally related components, and ultimately reason about design adaptations.

Archytas cases were taken from the domain of kinematic systems. In these systems, the substances are "motion-types" (e.g. piston-motion, connecting-rod-linear-motion, etc.) that are component specific and do not flow from one component to another. Fig. 4a shows this graphically. The

initial Archytas bootstrap cases have no notion of consistent substance flow.

IDeAL, therefore, cannot reason causally about the Archytas models. Instead, we have to change the point of view of the model to align with IDeAL's requirements.

We do this by thinking of the components as sharing a common flow of kinetic energy, and explicitly describing the flow of energy through points in the system. In the case of a piston-crankshaft assembly, kinetic energy flows from the piston into the connecting rod (shown in Fig 4b.), and from the connecting rod into the crankshaft. This creates a flow characterization and that meets IDeAL's backward-chaining requirements.

Additional complications occur with the assignment of important "points" in the model. Archytas' use of the symbol "points" has to do with the geometry of the diagram. The closest equivalent to IDeAL's notion of points in Archytas is the parametric description of the vectors used to describe *substances*. Within these descriptions, important points are defined as the points in a system on either side of which a component may switch states. For example a piston changes direction (a characteristic of its state) at the top and bottom of the cylinder. IDeAL, however, relies on points to represent the states between which a substance flows. For example, in the case of a piston within a cylinder, IDeAL prefers a point "point-piston" to represent the energy when it is "in" the piston. It uses the point "point- connecting-rod" to represent the place (the connecting rod), to which the energy must flow.

While the notion of energy flowing through points in a system may not be precisely (quantitatively) accurate, for qualitative reasoning about the design dynamics this representation of energy flow is useful.

We classify these problems as domain specific differences, because it is the nature of the domains that shapes the initial representations and creates the gaps. This highlights both a strength and weakness of the SBF representation language. Depending on the context (domain) for which the model will be used, many different valid representations are possible for the same system. For reproduction from diagrams, a component-centric view was adopted. For reasoning to solve a design problem, an energy-transfer view was more productive.

Representation Differences

Two key representational differences were found in the course of the research: causal loops, and substance specifications. These representation differences occur as arbitrary differences in the way the models were

created, either of which can be viewed as correct, but which we conform to IDeAL standards.

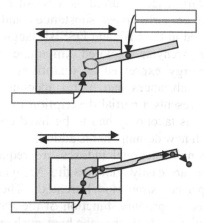

Fig. 4. In (a) The Archytas representation of a system is shown to contain substances (e.g. Piston-Linear-Motion) within the component. In (b) The IDeAL representation demonstrates the movement of a common substance throughout the system. The crankshaft was omitted for simplicity.

Causal loops occur when a component or substance begin at some time t_0 in state S_0, and at some time later, return to a state identical to S_0, but at time t_n. For Archytas, using the exact same state object to represent the state of S_0 at time t_0 and at time t_n is valid. However, because of the backward chaining of IDeAL, this would create an infinite loop during the search for changeable components. As a result, all causal loops represented in Archytas using the same beginning state require a unique state S_n representation in IDeAL. Because in all Archytas cases the state in question was the terminal state in the model, it was quite easy to automatically alter the models Archytas created as output.

Additional representational choices were made in Archytas, distinguishing an object-type *quantity* from the object-type *substance*. The only difference between the two types is that *quantities* were special *substances* that remained within a given component. Because there were no such types in IDeAL, and moreover, because substance flow between components is required in IDeAL, all such *quantities* were converted to a comparable *substance* object.

System Requirements Differences

The third kind of difference occurred as a result of the information that IDeAL required to properly index substances and functions, which is generally not included in the SBF and DSSBF language specifications. In particular, because Archytas explored kinematic systems whose main substances were energy expressed as quantities of linear and angular motion, these new substances had to be accounted added to IDeAL's memory. Fig. 5 represents a partial description of the required substance taxonomy. While this taxonomy had to be hand-crafted, it need only be crafted once for each new domain that is added.

Similarly, additional functional indexes are required, but these short, hand crafted indexes are easily added to the Archytas system at a rate no greater than once per bootstrap model created. These functional indexes describe the intended, or primary, function of the system and are common across a class of similar systems (e.g. the heat-exchange functional index is used for all systems whose primary function is to exchange heat between two substances).

Finally, IDeAL is a qualitative reasoning system. As such, it needs to have knowledge about qualitative relationships among system components and substances. While the knowledge *of* causal relationships between components and substances is provided by Archytas' representation, the knowledge of the *kind of* casual relationships is missing. For example, Archytas builds models that represent the linkage (through transitions) between a piston and crankshaft, but it does not necessarily represent their proportionality. Because the knowledge simply doesn't exist (or is at least not required to) it must be added by hand to the IDeAL model.

Therefore the information requirements for converting a diagram using Archytas to a model usable by IDeAL are: 1) successfully reworking the bootstrap DSSBF case into an IDeAL usable form, 2) modifying the indexing structures of IDeAL to successfully work in the new domain, and 3) eliminating any causal loops from Archytas output. Once this has been accomplished and a diagram converted by Archytas, we can test the system by posing a design question to the IDeAL system and analyzing the output.

This sets a different standard for building models from diagrams in that evaluation of those models should also prove application, not just correctness. It also alters the standard for building case-based reasoning systems for design in that they should be capable of not only handling the domains with which they evolved, but also of handling multiple, arbitrary domains.

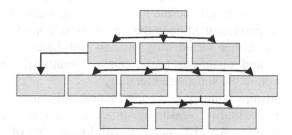

Fig. 5. New substance branches were added for abstract (energy) including kinetic energy, linear motion, friction, and angular motion. In this representation, the three main engineering substances information, energy and material are included, although information has not yet been required.

Implementation Details and Design Results

The goal of our implementation was to both create a working union of the two systems and, perhaps more importantly, to understand the key knowledge representation differences. While changing the code of Archytas or IDeAL may have created a smoother union or more elegant algorithms, it would have confounded our second goal. Therefore, we made a conscious effort not to change Archytas or IDeAL, but rather to create a bridge between the two. Aside from some minor changes and bug-fixes, nothing in the core algorithms or data structures of IDeAL or Archytas were altered.

Our technical implementation consisted of developing algorithms for converting a model from Archytas output to IDeAL input. The new model is evaluated using IDeAL to successfully solve design problems by using the new model. Here we provide a high-level description of the overall set of algorithms that we applied to an Archytas model to make it compatible with IDeAL. We follow with a discussion of design problem formulation and close with a brief description of the design solution generated by IDeAL.

Our implementation used the initial bootstrap diagram and a converted model for a piston-crankshaft device from the example provided in Figure 3a. We developed the algorithm in Table 1 for conversion of SBF models created by Archytas to IDeAL. This algorithm corresponds to Phase 2: Data Extraction and Case Building, of our system. We follow with a brief description of each step, and some examples of before and after model code.

1. IDeAL requires a separate component memory to draw from during design. We extract and add the names of components from the *(def-component* [component]*)* line in the Archytas SBF model code.
2. As discussed earlier we identify all new substances (*def-substance* [substance]) and quantities (*def-quantity* [quantity]) and handcraft their inclusion in the substance hierarchy.
3. The relationships among components and substances required by IDeAL for qualitative reasoning processes do not exist in the Archytas models. An SBF modeler with knowledge of the Archytas bootstrap system must handcraft such relationships. For example, the following code expresses the directly proportional relationship between the *linear-motion velocity* of the *piston* (*pmv2*) and the *linear-motion velocity* of the *connective-rod* (*crlv0*):

Table 1 Algorithm for Phase 2: Data Extraction and Conversion.

> *1) Add components to component memory*
> *2) Add substances to substance hierarchy*
> *3) Establish principles, principle relationships, and*
> *relative values of variables.*
> *4) Create Structural Model*
> *a) Components*
> *b) Substances*
> *c) Structural-relationships*
> *d) Quantity-relationships*
> *5) Create Behavioral Model*
> *a) Transition extraction & loop*
> *identification*
> *b) State conversion*
> *c) Behavioral conversion*
> *6) Establish substance-point correspondences for*
> *components*
> *7) Create Functional Model*
> *8) Create Design Case Index*

```
(setf principle-velocity3
(make-instance
     'principle
     :name 'principle-velocity3
     :relation 'directly-proportional-to-substance-property
     :part-1
     '(linear-motion velocity "crlv0")
     :part-2
'(linear-motion velocity "pmv2")))
```

The handcrafting of these relationships is the largest bottleneck in the process, largely because the system must be well understood before they can be encoded. There is no reason in principle that the Archytas bootstrap model could not encode these relationships and transfer them with the new model.

In addition at this stage we establish the relative values of variables, so we can know $crlv0 > crlv1$, for example.

1. With the exception of point assignment, discussed below, creation of the structural model is straightforward, as correspondences are generally one-to-one. Table 2 demonstrates this.

Table 2 Code level comparison of Archytas and IDeAL structural elements for the same piston-crankshaft system.

	Archytas Model Code	IDeAL Converted Model Code
a) Components	(def-component piston (piston-crankshaft) :primitive-functions ((allow piston-motion)))	(setf piston (make-instance 'component :name 'piston :points '() :set-of-functions (list allow-piston-motion)))
b) Substances	(def-quantity piston-motion (piston-crankshaft) :parameters ((piston-velocity vector (downward upward)) (piston-position vector (cyl-bot cyl-top))))	(setf linear-motion (make-instance 'substance :name 'linear-motion))
c) Component Relationships	(def-connection piston-crankshaft (cylindrical-joint piston cylinder))	(setf piston-cylinder-reln (make-instance 'structural-relation :relation 'cylindrical-joint :component1 piston :component2 cylinder))
d) Substance Relationships	(def-quantity-relation piston-crankshaft (contains piston piston-motion))	(setf piston-linear-motion-reln (make-instance 'structural-relation :relation 'contains :component1 piston :component2 linear-motion))

There are several of items worth noting. First, in the component model, there is no "point" equivalent between Archytas and IDeAL, so we leave the list of points associated with piston empty (we will address this later).

Second, *piston-motion* has been transformed to *linear-motion* a non-component-centric view of substance. We use our substance hierarchy, created in 2, above, to accomplish this mapping. Third, the parameterization of substances that is seen in the Archytas code is used in establishing substance parameters when building the substance hierarchy.

2. Behavioral model conversion is slightly more complicated, as the data structures are different between Archytas and IDeAL. Archytas combines into a single behavior object what in IDeAL are separate objects for state, transition and behavior. We show the differences in Table 3, leaving out the trivial conversion to IDeAL behavior, for brevity.

Close inspection of the code reveals the transition loop in the Archytas piston motion behavior *trans (p-s1 p-s2)* and *trans (p-s2 ps1)*. The causal chain is perpetuated outside of the piston-motion behavior through *under-condition-transition* slot, providing a pointer into the *rod-linear-motion* behavior. Notice, our converted code for IDeAL uses the *next-transition* slot in the state-schema to hand control to the *rod-linear-motion* behavior, and in so doing, breaks the causal loop. Unfortunately the cost is the loss of the notion of the piston returning back to its original state, which is disconcerting.

Table 3 Code level comparison of Archytas behavior object and converted IDeAL state and transition objects for the same piston-crankshaft system.

Archytas Model Code	IDeAL Converted Model Code
(def-quantity-behavior piston-crankshaft	(setf ps2
(piston-motion piston-velocity piston-position)	(make-instance
:state	'state-substance-schema
(p-s1 (piston-position cyl-top)	:location "piston"
(piston-velocity downward))	:next-state rls1
:transition	:next-transition trans-ps2-rls1
(trans (p-s1 p-s2)	:prev-transition trans-ps1-ps2
:using-function	:main-substance
((allow piston piston-motion))	(make-instance 'substance
:under-condition-structure	:name 'linear-motion
((cylindrical-joint piston cylinder))	:concept-schema
:due-to-stimulus	kinetic-energy
(piston-downforce pf))	:property-list
:state	'((velocity
(p-s2 (piston-position cyl-bot)	"downward")
(piston-velocity upward))	(position "cyl-top")))))

:transition *(trans (p-s2 p-s1)* *:using-function* *((allow piston piston-motion))* *:under-condition-structure* *((cylindrical-joint piston cylinder)* *(revolute-joint piston connecting-rod))* *:under-condition-transition* *((rod-linear-motion rl-s2 rl-s1))))*	*(setf trans-ps1-ps2* *(make-instance* *'transition* *:using-function* *(list* *(make-instance* *'using-function* *:component piston* *:function allow-piston* *-motion))* *:under-condition-structure* *(list piston-cylinder-reln)* *:due-to-stimulus* *(list (make-instance* *'due-to-stimulus* *:name 'piston-downforce* *:stimulus 'piston-downforce* *:magnitude 'pf))*

3. We already discussed the differences between point representations in the Archytas model and the IDeAL model. In step 4d We establish the correspondence between the quantity *piston-motion (linear-motion)* and the component to which it belongs, *piston*. Additionally, because the substance will flow in and out of the *piston*, we must establish one "inflow" point, and one "outflow" point. Structure points are first class objects in IDeAL, so we must first establish both points, along with its relationship with the substance *piston-motion*

(setf piston-point-in
 (make-instance 'structure-point
 :name "piston-point-in"
 :substance-name 'linear-motion
 :input-end '(piston end1)))
(setf piston-point-out
 (make-instance 'structure-point
 :name "piston-point-out"
 :substance-name 'linear-motion
 :output-end '(piston end2)))

We then append the points to *piston* object construct.
4. The creation of the high level functional model is trivial, as seen from the side by side code below.
5. The design case index is used by IDeAL to access design cases. It is defined in the IDeAL SBF model, including indexes into structures, behaviors and functions.

We converted an original bootstrap model as outlined in the previous section. Substance taxonomies were added to IDeAL per the representation in Figure 7. We loaded the converted model directly to IDeAL's case library.

For our test, the target design problem posed to IDeAL was to design a piston-crankshaft device that delivered twice as much energy to the crankshaft as the original design (from Archytas) provided. IDeAL was limited, in this case, to using only parts and substances available to it in that design domain (e.g. an alternative part, for instance a larger piston that delivered the required amount of energy, was not available). Our aim was to test whether or not IDeAL was now capable of retrieving a GTM from a different domain and successfully applying it in the new domain, to a model acquired from Archytas.

Prior to asking the design question, IDeAL was asked to solve a similar problem for an electrical system. In this case, IDeAL used the cascade GTM (learned previously from cases involving heat exchangers) to design a system with two batteries in series so that the light bulb in the circuit would produce twice as much light. These are cases that IDeAL is already capable of solving, demonstrating both cross-domain transfer and the ability to solve the amplification problem using the cascade mechanism.

IDeAL's output for the complex design question we posed is represented graphically in Figure 3c, which demonstrates the use of two pistons to deliver twice the energy to the crankshaft. IDeAL was successfully able to identify the nature of the problem, understand that the cascade mechanism was applicable, find the part capable of delivering the additional power, and arrange an SBF model that correctly delivers that additional power to the crankshaft. This test provides a single positive example of how a diagram can be used to automatically produce a model, populate a case-based reasoning tool, and successfully apply cross-domain principles to solve a complex design problem.

Issues and Future Research

The research is limited to the acquisition and testing of a single model from one diagram. This provided a promising proof-of-concept, and exposed a number of deeper issues concerning differences between extracting a model from a diagram and model use in design. Application of the proof-of-concept system to additional diagrams and domains will enable greater generalization of these differences.

The creation and reuse of new designs is a fundamental and necessary strategy for building a scaleable, real-world system. While IDeAL is capable of learning from the new designs it creates, this capability was not validated for the model created by IDeAL in this test case. That is, although a new design solution was created by IDeAL, no effort was made to solve further problems using that new solution.

This research raises more questions than it answers about context-specific model creation. Both Archytas and IDeAL created different models for the same system, despite the common underlying representation framework. Do human designers have multiple versions of the same system represented in their own mental models? In the extreme, do they require a model for each complex task they wish to undertake with a system? Or instead, is there some universal framework with which we represent a system, limited aspects of which we access depending on the context? These questions have important implications as we begin building larger, scalable, multi-functional design systems.

Related Work

We have already discussed in previous sections the preceding work on Archytas and IDeAL. The origin of Ideal's SBF models lies in Chandrasekaran's Functional Representation (FR) scheme for representing the functioning of devices [13], [14]. More recent work by Chandrasekaran has posited multimodal internal representations as a central element to cognitive architecture, for which DSSBF might be viewed as an example. In cognitive engineering, Rasmussen [15] developed similar SBF models for aiding humans in trouble shooting complex physical systems. In computer-aided engineering, Tomiyama developed similar FBS models [16] for aiding humans in designing mechanical systems. In design cognition, Gero [17] developed similar FBS models for understanding the mental information processing of designers in general. In their analysis of verbal protocols of designers working in a variety of domains, [18] found that while (1) novice designers spend most of their time on the structure of the design solutions, spending relatively little time on the design functions or behaviors, (2) expert designers spend significant amounts of time on all three major elements of FBS models: function, behavior, and structure.

The SketchIT systems [19] takes as input a 2D sketch of a physical device, and gives as output multiple designs, augmented with state-transition diagrams. In contrast to SketchIT, which use model construction for diagram understanding, our systems relies on analogical reasoning.

GeoRep [12] is a diagrammatic reasoning system that gives as output a symbolic description of the physical processes represented in a 2D vector-graphics line drawing. Geo-Rep uses a high-level domain-specific domain describer to apply domain-specific rules to produce a final description.

The Structure-Mapping Engine (SME) is a powerful, but content-free analogical mapping system. JUXTA uses SME to compare two nearly identical drawings of a physical process. JUXTA first uses GeoRep for deriving structure from shape, then uses SME to compare the two structures looking for differences in associated attributes, and based on these differences, draw candidate inferences. In contrast, our system constructs a model by analogical transfer from a bootstrap case, and further reasons over that model using model-based analogy.

Conclusions

End-to-end knowledge acquisition and design is a long-term goal of the DCC community. Here we demonstrate a complete design system capable of both rapid case acquisition by analogy, and design problem solving using those same cases. By working on the end-to-end process, rather than on fragmented processes in small domains, our exploration exposes a number of interesting research issues that will need to be addressed if we are to realize our long-term goals of scalable, multi-functional complex design systems.

A necessary condition for large, scalable case-based design systems is the rapid acquisition of initial cases that minimizes reliance on human engineered cases. Two general frameworks have been developed for development of such large-scale applications: 1) large, general knowledge frameworks disassociated from specific functions, and 2) smaller, functionally dependent representations that can be shared across applications by a knowledge interface framework. In demonstrating a successful deployment of the second approach, we highlight three aspects of a knowledge interface framework that must be addressed for design systems: 1) domain specific differences, 2) system representation differences, and 3) function dependent differences.

In the case of domain specific differences, we believe that crafting new bootstrap cases can account for domain-specific biases that occur in the original development of a system. By relying on bootstrapping and analogical transfer, minimal domain specific hand crafting of a few systems can be leveraged across all diagrams within that domain. The same approach can be applied to system representation differences,

redeploying changes in the bootstrap case throughout the analogically derived cases. While functional dependent differences cannot be analogically transferred from bootstrap cases, we observed that such differences are limited to small, simple extensions of taxonomies, which once developed for a domain, need not be readdressed. In effect, we've shown that once a single bootstrap case is developed and deployed for a system, rapid case acquisition becomes possible for many instances and variations of that system.

Furthermore, while we show that SBF is valid for representing models of systems for both diagrammatic case acquisition and design problem solving, the flexibility of the SBF language allows for many valid representations for the same system. Because each model develops with a bias to meet specific functional requirements, this raises the question of how might we build a representation that meets the needs of large, multi-functional systems?

Because of this representational ambiguity, while a model can be constructed from a diagram, and that model can be shown to be syntactically accurate in that language, that does not guarantee usefulness of the model in an end-to-end system. By demonstrating a more complete system, that is, a system that acquires cases or models from diagrams, and solves problems with those same models, we provide the community with a new standard of evaluation for diagrammatic model acquisition.

Acknowledgements

This research has been supported by a NSF IIS grant (award number 0534266) on Multimodal Case-Based Reasoning in Modeling and Design.

References

1. Goel AK, Chandrasekaran B (1989) Functional representation of designs and redesign problem solving. In Proc. 11th International Joint Conf. on Artificial Intelligence (IJCAI-89) , Morgan Kaufmann: 1388-1394
2. Goel AK, Bhatta S, Stroulia E Kritik (1997) An Early Case-Based Design System. In *Issues and Applications of Case-Based Reasoning in Design*, M. Maher and P. Pu (editors), Mahwah, NJ: Erlbaum, pp. 87-132.
3. Lenat DB, Guha RV, Pittman K, Pratt D, Shepherd M (1990) CYC: Toward programs with common sense. Communications of the ACM 33(8): 30-49.

4. Genesereth MR, Fikes RE (1992) Knowledge interchange format, version 3.0 Reference Manual. Technical Report Logic-92-1, Computer Science Department, Stanford University
5. Finin T, Weber J, Wiederhold G, Genesereth M, Fritzson R, McKay D, McGuire J, Pelavin P, Shapiro S, Beck C (1992) Specification of the KQML agent-communication language. Technical Report EIT TR 92-04, Enterprise IntegrationTechnologies, Palo Alto, CA
6. Yaner PW, Goel AK (2006) (a) From diagrams to models by analogical transfer. In D Barker-Plummer et al (eds), Diagrams 2006, LNAI 4045: 55-69
7. Yaner PW, Goel AK (2006) (b) From form to function: from SBF to DSSBF. In JS Gero (ed), Design Computing and Cognition'06, Springer, Netherlands: 423-441
8. Bhatta S, Goel AK (1996) (a) From design cases to generic mechanisms. *Artificial Intelligence in Engineering Design, Analysis and Manufacturing*, Special Issue on Machine Learning 10:131-136
9. Bhatta S, Goel AK (1996) (b) Model-based indexing and index learning in engineering design. *International Journal of Engineering Applications of Artificial Intelligence*, Special issue on Machine Learning in Engineering 9(6):601-610
10. Goel AK, Bhatta S (2004) Design patterns: a unit of analogical transfer in creative design. *Advanced Engineering Informatics* 18(2):85-94
11. Bhatta S, Goel AK (1997) A functional theory of design patterns. In Proceedings of the 15th International Joint Conference on Artificial Intelligence (IJCAI-97), Morgan Kaufmann: 294–300
12. Ferguson RW, Forbus KD (2000) GeoRep: a flexible tool for spatial representation of line drawing. In Proc 17th National Conf. on Artificial Intelligence (AAAI-2000), Austin, Texas. AAAI Press
13. Sembugamoorthy V, Chandrasakaran B (1986) Functional representation of devices and compilation of diagnostic problem-solving systems. In J. Kolodner and C. Riesbeck (eds), Experience, Memory and Reasoning, Lawrence Erlbaum, Hillsdale, NJ: 47-73
14. Chandrasekaran B, Goel AK, Iwasaki (1993) Functional representation as design rationale. In Euro. Workshop on Case Based Reasoning: 58-75
15. Rasmussen J (1985) The role of hierarchical knowledge representation in decision making and system management. IEEE Trans. Systems, Man and Cybernetics 15: 234–243
16. Umeda Y, Takeda H, Tomiyama T, Yoshikawa H (1990) Function, behavior, and structure. In Gero, JS (ed), Applications of Artificial Intelligence in Engineering V, Vol. 1, Springer-Verlag, Berlin: 177-193
17. Gero JS, McNeill T (1998) An approach to the analysis of design protocols. Design Studies 19(1): 21–61
18. Gero JS, Tham KW, Lee HS (1992) Behavior: A link between function and structure. In Brown, DC, Waldron, MB, and Yoshikawa, H (eds), Intelligent Computer Aided Design, North-Holland, Amsterdam: 193–225
19. Stahovich TR, Davis R, Shrobe H (2001) Generating multiple new designs from a sketch. *Artificial Intelligence* 104(1–2): 211–264

Unraveling Complexity

A Computational Approach for the Generation of All Underlying Structures of Three-Dimensional Shapes with an n-Fold Symmetry Axis

Athanassios Economou and Thomas Grasl
Georgia Institute of Technology, USA

A computational approach for the generation of all underlying structures of three-dimensional shapes with an *n*-fold symmetry axis is briefly discussed and an automated environment for the complete generation of all partial lattices of three-dimensional shapes with an *n*-fold symmetry axis is presented in the end.

Introduction

Contemporary architecture discourse is driven by extensive research on issues of three-dimensional patterns, space packing, non-periodic three-dimensional tilings, parametric space modules, three-dimensional Voronoi tessellations and so on. This is not an accident; three-dimensional spatial vocabularies and transformations have already been in the center of design inquiry in twentieth century architectural discourse and the recent emphasis on CAAD related three-dimensional descriptions of architectural form could only foreground this trajectory even more. Still, an inherent difficulty in the systematic exploration of all these classes of designs and configurations lies in the fact that the representations that the architects use to explore these spaces have the same dimensionality of the space they intend to explore; in other words, there is a lack of a vantage point from which an architect can see and control the whole spatial composition. What exacerbates the problem even more is the lack of a body of formal knowledge that could effectively help architects to explore systematically the possibilities afforded in a given setting and specifically within the three-dimensional design space.

J.S. Gero and A.K. Goel (eds.), *Design Computing and Cognition '08,*
© Springer Science + Business Media B.V. 2008

Among various competing formal methods that are typically employed to address these problems, group theory plays a prominent role. Classic expositions of group theory and their application in visual arts can be found in the work by Weyl [1], and Shubnikov and Kotpsik [2] and various applications in architecture especially for two-dimensional designs can be found in March and Steadman [3]. Extensions of these methods for point and linear designs in three-dimensional space have been given by Economou [4]. Some first steps towards the extension of the tools of group theory to explore asymmetry –or in fact complexity, if complexity can be associated with the lack of symmetry– have been taken by March [5] and Park [6]. A computational environment for the complete enumeration of all nested symmetries in planar designs has been given by Economou and Grasl [7].

The work here looks at a specific class of designs in three-dimensional space, namely the three-dimensional designs with an n-fold symmetry axis, and provides a computational approach to a) enumerate all their repeated parts; b) depict their relationships in a graph theoretical manner; and c) illustrate all shape correspondences with pictorial visualizations for each distinct class of designs. The specific sets of symmetry groups that are examined here are the four infinite types of the point space groups, namely, the cyclic groups, the dihedral groups and their direct product groups with a cyclic group of order two. These four types of groups can capture the symmetry of any three-dimensional shape or design with an axis of symmetry of an order n. The complexity of these structures can be staggering and it is suggested here that their graph theoretical representation and pictorial representation can contribute to a better understanding of problems of spatial complexity in architectural design. The paper outlines the computational approach for the generation of all partial order lattices of these shapes and illustrates some of these ideas with consistent mappings of these lattices to a language of diagrams to visualize their part to whole relationships.

Parts and wholes

In three-dimensional space the symmetries of any finite three-dimensional shape can be captured by any of the fourteen possible types of symmetry groups [8]. These fourteen types of symmetry groups split into two types: seven finite types and seven infinite types. The symmetries of the seven finite classes of symmetry are described by the seven polyhedral groups that provide the symmetries of the platonic solids and their variations. The

symmetries of the seven infinite classes of symmetry are described by the seven infinite types prismatic groups that provide the symmetries of any solid that has a primary axis of n-fold rotation and does not have a greater than a two-fold rotation axis perpendicular to this major axis. Both types of these geometric symmetries, the finite and the infinite types, can be succinctly described algebraically by abstract groups whose elements are not described in some concrete way [9]. More specifically, the seven finite geometric types can be captured by six abstract groups, and the seven infinite geometric types can be captured by four infinite abstract groups [10]. These last four structures, namely, the abstract cyclic group C_n of order n, the abstract dihedral group D_n of order $2n$, and their direct products with the abstract cyclic group C_2, that is, the group C_nC_2 of order $2n$ and the group D_nC_2 of order $4n$, comprise the object of study here and provide the corpus of configurations to be systematically explored.

The key idea explored in this work is the part relation (\leq) as it is manifested in group theory and exemplified in spatial composition. Briefly a set G together with a rule on G becomes a group when it satisfies three axioms: a) The composition of the elements in G is associative, that is to say, $(xy)z = x(yz)$ for any three, not necessarily distinct elements in G; b) There is an element e in G, called an identity element, such that $xe = x = ex$ for every $x \in G$; and c) Each element in G has an inverse x^{-1} which belongs to the set G and satisfies $x^{-1}x = e = x^{x-1}$. Formally, for any group G with an operation (.), a subset H of G is a subgroup if H forms a group under the operation (.). Not every subset of G is a subgroup; for example any subset of G that does not contain the identity element is bound not to be a group because it does not satisfy the group identity axiom. Still, subgroups are extraordinarily common; every group G is a subgroup of itself, and the identity element e is also a subgroup because it satisfies all group axioms. The enumeration of all possible subgroups for a given group is a very difficult task and has been carried through only for selected few finite groups. The corresponding task of enumeration and illustration of all cyclic and dihedral groups for a given group n is straightforward but the computation is not trivial.

The set of the symmetry subgroups of a particular symmetry group can be further sorted by a relation that orders all the subgroups in the set. If this relation can be established for all pairs of elements in the set then this relation is called total or strict order and the set is called chain. For instance, the relation "less than or equal to" is a total order on integers, that is, for any two integers, one of them is less than or equal to the other. If this relation is defined for some, but not necessarily all, pairs of items, then the order is called partial order and the set is called a partial ordered set. For

instance, the sets $\{a, b\}$ and $\{a, c, d\}$ are subsets of $\{a, b, c, d\}$, but neither is a subset of the other. In other words, the relation "subset" is a partial order on sets. Typically graphs are used to represent such order and show the nested relations of the subgroups diagrammatically in lattice diagrams. The graph representation of all symmetry subgroups of a configuration suggests a complex but rewarding insight in the symmetry structure of a spatial configuration.

Sieve

Sieve is a computational tool that has been developed to address the inquiry discussed above and to enumerate and illustrate all possible subgroups of a given three-dimensional finite shape. The tool has been built upon an earlier version designed to compute and illustrate all possible subgroup relationships of two-dimensional shapes [7]. This earlier version of the software, code-named, *Sieve 1.0*, produces all dihedral groups D_n of order $2n$ and all cyclic groups C_n of order n are found embedded within each corresponding graph. The new version of the software, code-named here *Sieve 2.0*, produces analogously all possible direct product groups D_nC_2 of order $4n$ consisting of a dihedral group D_n of order $2n$ with a cyclic group C_2 of order 2, and all four types of three-dimensional groups with an axis of symmetry n, namely, a) the cyclic groups C_n of order n; b) the dihedral groups D_n of order $2n$; c) the direct product groups C_nC_2 of order $2n$, consisting of the cyclic group C_n of order n and a cyclic group C_2 of order 2; and d) the direct product group D_nC_2 of order $4n$ itself, consisting of the dihedral group D_n of order $2n$ and a cyclic group C_2 of order 2, are found embedded with the computed graph.

The theory for the computation here relies on a sorting based on two theorems proved by Lagrange and Sylow respectively: Lagrange theorem identifies a very precise numerical relationship between subgroups and groups, namely that the order of a subgroup always divides the order of a group. Sylow's theorem proposes that if a number m is a power of a prime k and divides the order of a group n, then the group has a subgroup of order m. Here the automation relies on a routine to generate the complete list of all prime factors for a given number n. The simplest, albeit not most efficient, algorithm to generate the primes is the sieve of Eratosthenes. Since computing time is not a key feature for the relatively small magnitudes dealt with in this project, algorithmic simplicity has been chosen over efficiency. Once the primes are extracted all possible distinct products are

computed and tested to produce the possible lists of factors and the corresponding cyclic and dihedral subgroups.

The graph representation of the symmetry groups and subgroups is a straightforward task of iterating through the factors and generating the nodes noting each time which set of operations the node represents. The completion of the illustration of the structure of the graph is done with the pictorial representation of the edges of the graph deduced from each label iterating over the nodes and arranging the nodes and the edges in a hierarchical manner for different orders of symmetry. The application was created using the Java Universal Network/Graph Framework (JUNG) [11]. All complete subgroup graphs of the direct product groups $D_n C_2$ consisting of dihedral groups D_n with a cyclic group C_2 of order 2 for order $n \leq 12$, are shown in Figure 1.

The stunning complexity found even in the simplest of structures is overwhelming. The series is illustrated here for an order up to 12 to compare this rising complexity with that of the five polyhedral shapes – the infamous platonic solids and their derivatives. For example, the last shape in Figure 1 has an order of symmetry 48, that is, an order of symmetry equal with that of the cube. Still, their respective structures are quite different; the lattice of the 48-gon prism here has 125 subgroups and the lattice of the cube has 98 nested subgroups [12].

Sieve 2.0 produces all possible symmetry structures of three-dimensional space as embedded graphs within a super graph of order $4n$ for an n-fold symmetry axis. For example, a graph depicting an order of 12 in the $D_n C_2$ type will have embedded subgroups within it to exemplify all possible four types of three-dimensional symmetry with a three-fold axis of symmetry, namely, a) C_3; D_3; $C_3 C_2$; and $D_3 C_2$ with orders of symmetry 3, 6, 6, and 12 respectively. These nested graphs are shown in Figure 2.

The numeric relation of all four types of n-fold prismatic symmetry to the group $D_n C_2$ is clearly defined. Any specified order of symmetry n is represented at least by one symmetry group which has this order n and every order of $4n$ is represented by all four types of symmetry structures.

Interface

The interface of Sieve 2.0 is straightforward and combines typical conventions found in graphical applications as well as specific characteristics and functions unique for the computation of the lattices of symmetry groups. The key characteristic of the application is that it combines two interfaces, one for the computation of the lattice representation of the structure in-

quired, and a second one for a pictorial representation of all the nested symmetries corresponding to each node of the lattice. Some of the characteristics of these two interfaces are described below.

Graph output

The default output of the program has been designed to provide a consistent layout for all graphs. This layout allows for a visual inspection and comparison and of the rising complexity of all nested subgroups. All lattices are ordered from top to bottom from higher to lesser degrees of symmetry; the top node has the maximum symmetry and the last node in the bottom shows the identity element with a symmetry of 1. All in-between rows pick up the different orders of symmetry for a specific shape. For example, the lattice of the symmetry of a shape with symmetry 12 will consist of nodes arranged in six horizontal lines, each picking up in a descending order the symmetries of 12, 6, 4, 3, 2, 1. Furthermore, this distribution of all horizontal lines along the y axis of the graph shows spatially the metric difference of the nested symmetry classes found in a shape. The visual arrangement of the graph in this way show especially nicely the relationship of odd and even factors in the graph picking up polyrhythmic relationships in the arrangement of the nodes. For example, in the lattice of the symmetry of a shape with symmetry 12, the horizontal line that hosts the nodes that represent the symmetry equal to 6, is 6 units below the horizontal line of 12, 2 units above 4, 3 units above 3, 4 units above 2 and 5 units above 1. Figure 3 shows diagrammatically the distribution of horizontal orders in the symmetry lattice of the triangular prism D_3C_2.

The distribution of all vertical lines along the x axis shows spatially the qualitative difference of different types of symmetry classes found in a shape. These groupings pick up all the rotational, reflectional, screw rotational and rotor reflectional types and their combinations and show their interrelationships. Still subgroup relationships between the nodes cut across these initial visual groupings. One of the most exciting characteristics of the design of the interface of the application is that the complete partial order lattice for any node of the graph can be computed and illustrated automatically in a set of weighted lines and nodes. Any node in the graph once triggered by a mouse-over function show visually the complete set of subgroup below the node as a set of subgraphs that are linked from the node to the identity element itself. Figure 4 shows diagrammatically the distribution of subgroups within the symmetry lattice of the triangular prism D_3C_2; each subgraph unfolding from any node can be highlighted.

Fig. 1. The lattices of the D_nC_2 symmetry groups for $n \leq 12$.
a) 4; b) 8; c) 12; d) 16; e) 20; f) 24; g) 28; h) 32; i) 36; k) 40; l) 44; m) 48

a. b.

c. d.

Fig. 2. The four types of prismatic symmetry found within the structure of the triangular prism D_3C_2. a) C_3; b) D_3; c) C_3C_2; and d) D_3C_2

Fig. 3. Vertical arrangement of nodes in the graph

Fig. 4. Horizontal arrangement of nodes in the graph

A second characteristic of the design of the interface of the application is that it allows for repositioning of the nodes while keeping the topology of the graph invariant. All structures computed by the system can be repositioned and reshuffled in any setting and degree desired and all transformations of the graph retain the number of the nodes and links between the nodes. A typical application of this functionality is that the graph can be transformed in meaningful ways to foreground specific relations that are possibly hidden in the complexity of the original output. Figure 5 shows

the same subgraph unfolding from the node in Figure 2(d) repositioned to clarify visually the given subgroup relation within the structure of the triangular prism D_3C_2.

Fig. 5. A part of the structure of the triangular prism repositioned

A nice by-product of this functionality of reshuffling is that the application allows for an immediate appreciation of topology and the aesthetic possibilities of graph rearrangement. It is characteristic of all these lattices that there is no known algorithm to distribute the nodes and their connections in some common aesthetic mode. Drafting graphs can be as aesthetic and complex as design itself! Figure 6 shows a different repositioning of the structure of the triangular prism D_3C_2. The repositioning here considers the identity element in the center and all subgroups are unfolded from this central point.

Fig. 6. The structure of the triangular prism repositioned

All structures can be inspected at any desired degree of closeness. Each time the user zooms in or out of the graph, all spatial relationships are scaled to simulate the closeness, but the nodes, the width of line, and the discursive notation of the nodes are all remaining constant to allow a common framework for illustration. The zoom is most effective when it is performed on a node; everything around it scales to de-clutter the drawing and show the computed part. Figure 7 shows a scaled version of a part of the structure of the triangular prism, D_3C_2.

Diagram output

The diagram interface of Sieve 2.0 provides the most immediate visual output to the structure of any finite three-dimensional shape with one axis of symmetry. This interface provides a pictorial representation of the symmetry of the shape in terms of labels in the form of an open, closed and a dashed circle that are all associated with the faces of the shapes to break down their symmetry. The set of conventions for this representation includes: a) a set of closed, open and grey labels; b) a set of lines representing the symmetry axes of the shape; and c) a set of lines representing

Fig. 7. The structure of the triangular prism scaled

the outline of a regular *n*-prismatic shape. More specifically, in this notation labels associated with the front face of a shape towards the viewer are represented as closed and labels associated with the back face of a shape are open. A grey label is used only as a placeholder to show the comparative disposition of all possible symmetries in a configuration. All labels are combined here with the lines of the outline of the shape to break down the symmetry of the shape; the labels themselves being circular would be ambiguous to break down the symmetry because any axis of the whole configuration traversing through their center would render the shape as at least possessing one reflectional symmetry. Moreover the positions of the labels are asymmetric with respect to the length of the line – edge of the regular polygon. Finally the symmetry axes in the notation are primarily used for clarity of presentation and visual foreground of the reflectional parts in all computed configurations and they are not needed for the reduction of symmetry. Figure 8 shows the three rules of combination of lines of the outline of the shape with the three different labels to reduce the symmetry.

Fig. 8. Three rules of combining lines of the outline of the diagram with labels to reduce the symmetry of the configuration

The complete diagrams of all subgroups found in the structure of the triangular prism D_3C_2 are shown in Figure 9. The first diagram in the upper left corner has the complete symmetry of the triangular prism and it is composed by twelve labels, six closed and six open, and the final diagram to the lower right has the identity element and it consists of a single closed label. All the other fourteen diagrams represent the total number of possible subsymmetries of the rectangular prism and they can be all automatically retrieved in Sieve 2.0 by mouse-over functions over the nodes of the graph. Significantly, the visual computation of all diagrams nicely illustrates the equivalent classes of symmetry within each symmetry class and shows spatially some of the groupings in the output of the graph. For example, the diagrams in Figure 9(b) and (d) are equivalent because they are produced by a single generator and they are both described by one algebraic group, the C_6. The diagrams in Figure 9(e)-(g) are all equivalent because they are all produced by two generators, rotations and reflections through the vertices of the triangle, and are all described by the group D_2. Less intuitively, the diagrams in Figure 9(i)-(p), are all produced by two generators and are all described by the group D_1 but these generators are different in kind here; three include reflections and rotations, three include rotations along different axis and one includes rotor reflections and rotations.

Discussion

A major motivation behind this work is the hypothesis that any asymmetric shape or configuration can be understood as a sum or subtraction of configurations that have discerned orders of symmetry. The key idea that underlies this work is that asymmetry –and uniqueness and complexity and so forth– can be understood as a sum or subtraction of several parts that in themselves may have some symmetry but their products or spatial relations, render the design asymmetric. Needless to say, any superimposition or any subtraction of spaces nonesoever will not immediately render inter-

esting a space nor will say an interesting story – most probably not. What most probably will say an interesting story is the ability to reasonably discuss the possibilities that each system allows. The compositional and organizational processes that are immediately available to the designer during any design inquiry can be determined; whether all these will be used is irrelevant; whether they all known and are readily available is significant. The answers to all that can be taken from group theory and particularly from its construct of the part relation that structures the whole hierarchy of algebraic subgroups and supergroups and its spatial counterpart in configurational possibilities.

Fig. 9. Diagrammatic representation of all subgroups embedded within the structure of the triangular prism

Here a computational approach for the generation of all partial lattices of three-dimensional shapes with an *n*-fold symmetry axis has been presented to provide an interactive catalogue with the architecture of form of all possible structures with a center of symmetry. Future work will explore

a) the automatic generation of all possible graphs for all finite shapes in three-dimensional space including those of the seven polyhedral shapes; b) a design refinement of the interface to include the automatic generation of all geometric structures in terms of any algebraic structure; and c) the design of a new interface to correlate the diagrammatic language of the existing subgroups with shape grammars rules [13] [14] to generate designs that will be described by the given symmetry configurations.

References

1. Weyl H (1954) Symmetry. Princeton University Press, New Jersey
2. Shubnikov A, Koptsik V (1974) Symmetry in science and art. Plenum Press, NY
3. March L, Steadman P (1974) The geometry of environment: an introduction to spatial organization in design. MIT Press, Cambridge, MA
4. Economou A (2006) Tracing axes of growth. In L Albertazzi (ed), Visual thought: The depictive space of perception: Advances in consciousness research 67, John Benjamins, Amsterdam: 351-365
5. March L (1998) Architectonics of humanism. Academy Editions, London
6. Park J (2000) Subsymmetry analysis of architectural design: some examples. Planning and Design B: Planning and Design 27(1): 121-136
7. Economou A, Grasl T (2007) Sieve_n,. In J Kieferle et al, (eds), Predicting the future, ECAADE 25, Frankurt Am Main, Germany: 947-953
8. Yale P (1968) Geometry and symmetry. Dover, New York
9. Budden FJ (1972) The fascination of groups. Cambridge University Press, London
10. Armstrong A (1988) Groups and symmetry. Springer-Verlag, New York
11. O'Madadhain J, Fisher D, Smyth P, White S, Boey Y (2005) Analysis and visualization of network data using JUNG.
http://jung.sourceforge.net/doc/index.html
12 Economou A (1999) The symmetry lessons from Froebel's building gifts. Environment and planning B: Planning and Design 26: 75–90
13. Stiny G (2006) Shape: talking about seeing and doing. MIT Press, Cambridge, MA
14. Knight T (1994) Transformations in design: a formal approach to stylistic change and innovation in the visual arts. Cambridge University Press, Cambridge

DESIGN CREATIVITY

Compound Analogical Design: Interaction between Problem Decomposition and Analogical Transfer in Biologically Inspired Design
Swaroop S. Vattam, Michael E. Helms and Ashok K. Goel

A Model of Creative Design Using Collaborative Interactive Genetic Algorithms
Amit Banerjee, Juan C. Quiroz and Sushil J. Louis

An Evolutionary Process Model for Design Style Imitation
Andrés Gómez de Silva Garza and Arám Zamora Lores

Compound Analogical Design: Interaction between Problem Decomposition and Analogical Transfer in Biologically Inspired Design

Swaroop S. Vattam, Michael E. Helms and Ashok K. Goel
Georgia Institute of Technology, USA

Biologically inspired design (BID) can be viewed as an example of analogy-based design. Existing models of analogy-based design do not fully account for the generation of complex solutions in BID, especially those which contain compound solutions. In this paper we develop a conceptual framework of *compound analogical design* that explains the generation of compound solutions in design through opportunistic interaction of two related processes: analogical transfer and problem decomposition. We apply this framework to analyze three sample biologically inspired designs that contain compound solutions.

Introduction

Biologically inspired design (BID) [1], [2] uses analogous biological systems to develop novel solutions for engineering problems. BID can be viewed as an instance of analogy-based design where novel design representations in one domain (engineering) get created by drawing upon existing designs in a different domain (biology). In design literature, a number of models of analogy-based design have been proposed, all of which employ the generic cognitive process of analogical reasoning (e.g., [3], [4], [5], [6] [7], [8]). Existing models of analogy-based design explain the generation of solution for a target problem by reminding and transfer of elements from a known design (source design). Here we argue that the explanatory adequacy of existing models has to be enhanced to account for the complexity of some of the design solutions that emerge in BID. Specifically, the traditional accounts of analogy-based design do not fully explain the generation of *compound solutions*. We define compound solution

as one that contains compound analogies, i.e., the overall solution is obtained by combining solutions to different parts of the problem where solution to each part is derived from a different (biological) source. We describe a high-level conceptual framework of *compound analogical design* for understanding the generation of compound solutions in the context of BID and for analyzing the designs that we encounter in our studies. This framework extends the traditional accounts of analogy-based design by incorporating the interaction between two related processes, *analogical transfer* and *problem decomposition*.

In this paper, we first give an overview of BID. In the study presented here, we observed designers engaged in BID in the context of an interdisciplinary introductory course on BID offered at Georgia Tech in the Fall of 2006. Our presentation of this study will mostly focus on sample designs which contain compound solutions. Next we present our conceptual framework of compound analogical design. Finally, we analyze three sample designs using our framework, and present our conclusions.

Biologically inspired design

Biologically inspired design (BID) is an important recent movement in design that espouses the adaptation of functions and mechanisms in biological sciences to solve human problems. BID is usually associated with engineering (although not necessary) where the target design problems are typical of the problems faced by designers in different engineering disciplines like mechanical and aerospace engineering, electrical and computer engineering, chemical engineering, biomedical engineering, etc. The potential for BID has been documented by Vincent and Mann ([9]) with a number of examples including drag reduction based on dermal riblets on shark skin, deployable structures based on flowers and leaves, tough ceramics based on mollusk shells, underwater glues based on mussel adhesive, self-cleaning paint based on the lotus leaf, etc. "Products" of BID are usually intended to be interesting to engineers, and are sometimes a radical departure from the past engineering designs.

One of the approaches to promoting BID has been through education – training engineers in seeking biological analogues. The other approach is to form interdisciplinary design teams of engineers and biologists where the complementary skills of both engineers and biologists can be taken advantage of. We believe understanding the cognitive processes of BID may help us develop a theoretical basis for BID, and thus also help better promote BID through education and development of interactive design tools.

The context of our study

Our study was conducted in the in the context of an interdisciplinary introductory course on BID offered at Georgia Tech in the Fall of 2006. This is a project-based learning course in which about 40 students work in small teams of 4-5 students on assigned projects. The projects involve identification of a design problem of interest to the team and conceptualization of a biologically-inspired solution to the identified problem. Each team writes a 15-20 page report and makes an oral presentation near the end of the semester. This course was primarily structured into lectures, found object exercises, journal entries, and a final Design Project.

Lectures: A large percentage of lectures focused on exposing the students to existing BID case-studies. A small percentage of lectures were devoted to the "cognitive practices" involved in BID work (e.g., reframing engineering problems in biological terms, functional decomposition of a problem, adopting design processes, optimization, and the use of analogy in design). Some lectures posed problems for the students to solve in small group as within-class exercises.

Found object exercises: These exercises required students to bring in biological samples and analyze the "natural" solutions employed by these samples. The intention was to expand the awareness of biological solutions, provide hands on experience with biological systems, and encourage the students to dig progressively deeper into the functions of biological systems. Students formed small groups during these in-class exercises, with each group discussing the merits of their found objects' solutions.

Journal entries: Students were required to write about their classroom experiences and document their own design thinking in a journal that each student maintained.

Final design project: Term projects grouped an interdisciplinary team of 4-5 students together based on interest in similar problems or solutions. Each team typically had one student from biology and a few from different engineering disciplines. After each student submitted two problems of personal interest, the instructors created groups based on (1) similarity of interests, and (2) balance of disciplines. This grouping provided each team with a constrained space of problems to explore. Each team was responsible for identifying a problem, exploring a number of solution alternatives, and developing a final design based on one or more biological solutions. Towards the end of the course, teams presented their final designs.

As observers, we attended all the classroom sessions, collected all course materials, documented lecture content, and observed teacher-student and student-student interactions in the classroom. We also did *in*

situ observations of a few of the student teams engaged in their design projects. Our observations paid special attention to (i) classroom instruction and dialogue, (ii) student group discussions in the classroom, (iii) student and instructor examples and exercises, (iv) student group discussions outside the classroom, and (v) student interim and final presentations. We minimized our intervention, only occasionally asking clarifying questions.

Our observations focused on the cognitive practices and products of the designers. In terms of the practices, we observed and documented the frequently occurring problem-solving and representational activities of designers as part of the design process. Some of these activities were part of the standard design process taught by the instructors. Others emerged during practice. In terms of the design products, we observed and documented the "design trajectory" – the evolution of the conceptual design over time.

Although this study was conducted in the context of a classroom setting, we approached the study from the design cognition perspective as opposed to the learning sciences perspective. That is, we were less concerned about the pedagogical approach and the learning outcomes of the course itself. Although we believe that our research will have long term implications on the design and the conduct of this course, we were not directly involved in the decision-making regarding the design of this course. From our perspective the classroom merely provided a setting where we could observe designers engaged in BID.

Instructors had many years of practical biologically inspired design experience and focused classroom lectures on sharing their biologically inspired design experience through specific case studies. Most students, although new to biologically inspired design, had some previous design experience. Out of the 45 students, at least 32 had taken a course in design and/or participated in design projects as part of their undergraduate education. Throughout this paper, we will refer to the students in the class as designers.

Study Findings

Here we provide a short summary of our findings relevant to the subject matter of this paper. Additional details of this study are documented in [10]. First, we noted the existence of two high-level processes for biologically inspired design based on two different starting points – *problem-driven* and *solution-driven* process. In a problem-driven approach, designers identified a problem which formed the starting point for subsequent problem-solving. They usually formulated their problem in functional

terms (e.g., stopping a bullet). In order to find biological sources for inspiration, designers "biologized" the given problem, i.e., they abstracted and reframed the function in more broadly applicable biological terms (e.g., what characteristics do organisms have that enable them to prevent, withstand and heal damage due to impact?). They used a number of strategies for finding biological sources relevant to the design problem at hand based on the biologized question. They then researched the biological sources in greater detail. Important principles and mechanisms that are applicable to the target problem were extracted to a solution-neutral abstraction, and then applied to arrive at a trial design solution. In the solution-driven approach, designers began with a biological source of interest. They understood (or researched) this source to a sufficient depth to support extraction of deep principles from the source. This was followed by finding human problems to which the principle could be applied. Finally they applied the principle to find a design solution to the identified problem.

Interesting trends were noted in the above processes. First, we noted how the problem-driven process was "given" to the designers by the experts as a normative methodology for BID, while the solution-driven process emerged in practice. Second, we noted that once a biological solution is selected, that solution constrained the rest of the design process in many ways. For instance, when the process was solution-driven, the initial source fundamentally drove the design process, from problem definition through final design. On the other hand, in the problem-driven process, a particular biological solution became a source of design fixation, limiting the range of possible designs. Third, throughout the process designers consistently fell prey to a common set of mistakes (judged by experts/instructors) like vaguely defining problems, over-simplification of complex functions, using "off-the-shelf" biological solutions, misapplied analogy, improper analogical transfer, etc. Finally, we noted that a substantial number of design solutions generated were compound solutions (about two out of every three), which are the focus of this paper.

Sample biologically inspired design projects

Table 1 provides samples of design problems and solutions that we documented in our study. Details about each project are available in [10].

Table 1 Sample BID projects from our study

Project	Design	Type	Inspiration
Abalone armor	A self-healing bullet-proof vest that combines the qualities of strength and toughness	non-compound	Material of abalone shell (nacre)
Traffic control	A traffic system that reduces congestion on urban roads	non-compound	Traffic load-balancing in ant colonies
Shell phone	Cell phone case that is tough and resistant to everyday wear and tear	non-compound	Material of abalone shell (nacre)
BioFilter	Portable, stand-alone, home air filtration system	compound	Adhesive properties of spider silk + porous properties of diatoms
Brite-View	Electronic display that is resistant to drowned illumination in bright sunlight	compound	Hummingbird feathers + Morpho butterfly wings
Eye in the sea	Underwater micro-bot with stealthy motion	compound	Copepod locomotion + squid locomotion
Invisi-Board	Surfboard that does not produce silhouette when seen from underwater to prevent shark attacks	compound	Counter-illumination mechanism in pony fish + photo-capture mechanism in Brittle star
iFabric	A thermally responsive and adaptive fabric for clothing that provides thermoregulation for the wearer	compound	Bee hive material + blood circulation system of arctic wolves
Robo-Hawk	Aerial bomb detection device	compound	Chemical sensing in dogs + scent tracking movement of sea gulls

Six of the above nine projects yielded compound solutions. These solutions are of interest to us in this paper. Out of those six, we choose three projects (highlighted in Table1) for our analysis presented in later sections.

Compound Analogical Design: A conceptual framework

Recent research on design, especially creative design, has explored the use of analogies in proposing solutions to design problems in the conceptual

phase of the design process. Analogy-based design involves reminding and transfer of elements of solution for one design problem to the solution for another design problem. To date, a number of models of analogy-based design have been proposed. An important distinguishing feature among them has been the domain of application. Different researchers in different design domains have arrived at their own accounts of how analogy-based design happens in their respective domains. For instance, [8] and [5] provide examples of analogy-based design in architecture; [11], and [3] provide an account of analogy-based design in electro-mechanical device design; [12] provides an account analogy-based design in the domain of software design; etc.

Another crucial distinguishing feature among the existing models has been the capability to handle cross-domain analogies. A majority of existing models are examples of with-in domain analogical design. That is, if the problem is to design an electronic display screen, for instance, they can explain how a solution to this problem can be generated by retrieving and adapting existing (or previously encountered) designs of electronic displays. They do not, however, explain how the knowledge about the structure of butterfly wings can be retrieved and adapted to generate a new design for an electronic display. One fundamental requirement for a model that is applicable to BID is this capability to carryout cross-domain analogical retrieval and transfer. Some models of analogy-based design do address the issue of cross-domain retrieval and transfer of knowledge. In [3], for example, when a new design problem is encountered, the function to be achieved in the new design (or some abstraction or transformation of that function) is used as a cue to retrieve an analogous design, which can originate in another domain. The retrieved design is then modified or adapted to generate a solution to the target problem.

Although some of the existing models are capable of handling cross-domain analogies, they do not account for the following aspects of design problem-solving documented in our study. Firstly, the existing models only model problem-driven generation of solution. They do not adequately explain how, starting with some existing design solution, a relevant problem can be found to which this solution is applicable. Rather than starting with a problem and searching for solutions, in a solution-driven approach one starts with a solution and searches for problems in the human domain.

Secondly, and more importantly, most existing models of analogy-based design are *single source-based* solution generation models. That is, given a target design problem, the process proceeds to retrieve a suitable analogue (within-domain or cross-domain) and modifies or adapts the retrieved design to generate a solution to the target problem. From the cases of BID

presented here, it is apparent that this form of one-shot analogical design from a single source is not adequate for generating complex designs. In complex design tasks, multiple sources are often needed to solve different parts of a complex problem. This immediately suggests interplay between two related processes, analogy and problem decomposition.

Interplay between Analogy and Problem Decomposition

Solving complex problems by decomposition is a common strategy. There are just as many models of design problem-solving based on decomposition as there are based on analogy. The strategy of decomposition, where designers break large, complex problems into small, less complex, manageable one is not new. But when we make the decompositions explicit in the context of analogy-based design, it becomes apparent how the processes of decomposition and analogy influence each other. We will characterize their interplay here, leading to the development of our high-level conceptual framework of *compound analogical design*. We will use this framework to analyze our sample bio-inspired designs in the next section.

In the simplest case of compound analogical design, when a target design problem is presented, designer iteratively decomposes the problem into sub-problems to get a problem abstraction hierarchy (based on his/her background domain knowledge). Assuming that the problem is decomposed along functional lines, each node in this hierarchy is a function to be achieved. Each function (node) can be used as cue to retrieve known designs that achieve that function. Solutions from known designs are transferred to the current problem. Solutions to different functions are aggregated to generate the overall solution. Complications can arise during the reintegration of solution parts if the problem cannot be cleanly decomposed into independent sub-problems. Complications can also arise due to constraint propagation. Figure 1(a) shows this simple case of compound analogical design. An example of this case can be found in the RoboHawk project (see Table 1) where the problem of designing an aerial bomb detection device immediately suggested two sub-functions: sensing certain chemicals, and navigating towards the chemical source. These sub-functions, however, were not independent of each other (the method of sensing affected the method of navigating and vice versa). This decomposition was based on designers' background knowledge.

In many cases, it may not be obvious to the designer how to decompose a problem into manageable subparts or the designer may not be happy with a known decomposition. The designer might then search for an analogous design based on the high-level problem itself. Finding one will allow the

designer to adapt the known design to solve the current problem. This retrieved source design will not only provide a potential solution, but a deeper understanding of it will allow the user to infer the problem decomposition in the source design. This decomposition in the source design (along with solutions to the sub-problems) can be "brought into" the current design space as shown in Figure 1(b).

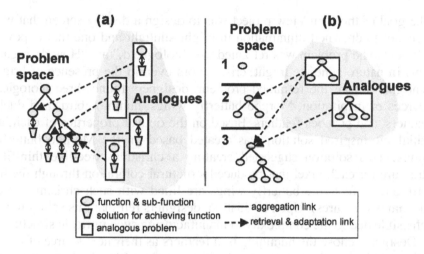

Fig. 1. (a) a simple case, and (b) a more realistic case of compound solution generation in design

Each new node from the source design decomposition can further act as cues for retrieving another set of design analogues. This process can continue iteratively leading to the incremental development of the solution. At every stage of this iterative process, the designer can evaluate the partial solution generated and can decide to take further actions (decompose based on background knowledge, or analogize and find solution, or analogize and grow the problem decomposition, etc.). This is a more flexible case of compound analogical design where the process of problem decomposition and analogical reasoning interact opportunistically, dynamically and in a more context-dependent fashion, accounting for the incremental nature of the evolution of complex design solutions. Examples of this complex case of compound analogical design follow in the next section.

Analysis of three designs using the conceptual framework of Compound analogical design

Project 1: BriteView

The goal of the BriteView project was to design a display screen that was resistant to drowned illumination in bright sunlight and one that is power efficient. The problem was reframed, or "biologized," as: "How do organisms in nature generate bright, crisp colors even in the presence of bright sunlight?" From the reframed problem, designers found three biological sources of inspiration, Morpho butterfly wings, hummingbird (and duck) feathers, and peacock feathers. Based on the optical properties of each, an initial bio-inspired solution was created based on the Morpho butterfly wings. This solution suggested creating a christmas tree-like thin-film structure for each pixel that produced structural coloration through the interference effect (the butterfly wings are lined with such christmas tree-like nano structures). Upon evaluation, designers felt that this solution was infeasible due to the complexity in manufacturing such intricate structures.

Designers chose the humming bird feathers as their next source of inspiration. Although the structural coloration produced by the humming bird feathers is based on the same optical principle as that of the butterfly wings, the hummingbird feathers contain a series of alternating layers of thin-films with different thickness instead of the intricate christmas tree-like structure. Since simple layering of thin-films is more feasible to implement, this source was selected. At the same time this solution was being developed, designers also considered the structure of peacock feathers (the third source of inspiration). Any solution based on peacock feathers was quickly rejected because they had to contain multi-dimensional structure (as opposed to single-dimensional structure in both butterfly wings and humming bird feathers), which was considered even harder to implement.

Based on the humming bird feathers, the initial solution suggested that each pixel contain a two-layered thin-film structure, each layer having a different thickness. When they initially evaluated this solution, they realized that this solution did not give them the control to dynamically vary the color produced by the pixel, which was crucial for the design of the display. Then they revisited their earlier source of inspiration, the butterfly wing, because they knew that the color that the wing produced was determined by the length of the air-gap between the layers in the christmas tree-like structures. Varying the length of this air-gap would vary the output color. Using this principle they modified their initial solution to include a

gap between the two layers filled with air. Now they could move the bottom layer up and down mechanically changing the length of the air-gap between the two-layers, which in turn effected the color change in the pixel.

Figure 2 shows the generation of this solution using the framework of the compound analogical design. Step 1 depicts the problem space early in the design. The overall function "design a display" has been decomposed based on the background knowledge and one of the sub-functions "generate bright color" has become the focus. Step 2 shows the initial solution generated based on the Morpho butterfly wings. This solution was evaluated and rejected. In Step 3 another trial design is generated based on the humming bird feathers. This is evaluated and a new function "control the reflected color" is added to the problem space. Step 4 shows the addition of this new function and an improved solution that integrated the idea of air gap (inspired by the Morpho butterfly wing design) into the trial design generated in Step 3.

Project 2: Eye in the Sea

The goal of this project was to design an underwater micro-bot with locomotion modality that would ensure stealth. The problem was "biologized" as: "how do marine animals stalk their prey or avoid predators without being detected?" Two marine biological systems were considered as sources of inspiration, copepod and squid.

The initial research for the underwater micro-bot focused on the copepod as a source for understanding stealthy locomotion. In exploring this concept, designers became aware that the copepod used two rhythms (of leg-like appendage movement) for achieving motion underwater. A slow and stealthy rhythm was used during foraging for food, and a quick but non-stealthy rhythm was used during escaping from predators. This understanding led the designers to decompose their original problem into two separate functions, one for slow and stealthy movement, and one for rapid, yet stealthy movement.

Copepod acted as a source for generating a solution to the former part of the problem (slow and stealthy motion). While foraging for food, a copepod is not noticeable to its prey because it moves its appendages rhythmically in a way such as to minimize the wake produced in water. The knowledge of this mechanism, known as "metachronal beating pattern," was transferred from the copepod source to create a partial solution.

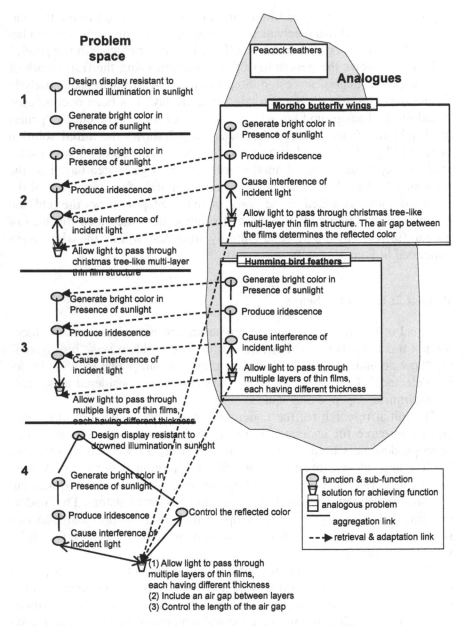

Fig. 2. Design trajectory of the BriteView project

Next, the designers had to address the second sub-function (stealthy fast motion). They used the squid locomotion as an inspiration for achieving this function. Some squids implement a single orifice, interrupted, jet pro-

pulsion for forward motion. This mechanism simultaneously addresses two constraints. First, this kind of locomotion is much faster compared to the copepod's locomotion. Second, this kind of locomotion is stealthy because its wake matches the external disturbances that naturally occur in the surrounding water. The stealth achieved here (wake matching) is significantly different from the way stealth is achieved in copepod motion (wake minimizing). Figure 3 develops a model of the generation of this solution using the framework of the compound analogical design.

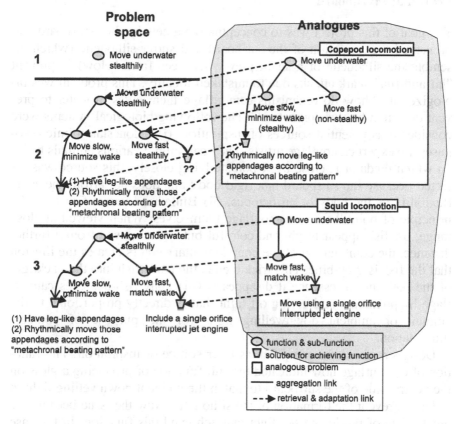

Fig. 3. Design trajectory of Eye in the Sea project

Step 1 depicts the nature of the problem space early in the design. The main function is to move underwater stealthily. In Step 2, the function of moving underwater is decomposed into sub-functions: moving slowly and moving fast, based on the decomposition that exists in the source design of a copepod. The solution to the function of moving slowly by minimizing wake (using "metachronal beating pattern" of legs) is adapted to generate a

partial solution as shown in Step 2. But the function of moving fast, yet stealthily remains unresolved in Step 2. In step 3, the analogue of squid is retrieved to address this function. Its solution of using a single orifice, interrupted, jet engine for movement is transferred to the current problem to generate the other partial solution. These two partial solutions are aggregated to achieve the trial design.

Project 3: Invisiboard

The goal of this project was to conceptualize a new kind of surfboard that prevented the formation of the surfboard and surfer silhouette (which resemble the silhouette of a shark prey when seen from below) to prevent "hit-and-run" shark attacks due to mistaken identity. This problem was biologized as: "how do organisms camouflage themselves in water to prevent detection by their predators?" The following biological systems were considered as potential sources of inspiration. (i) Indonesian mimic octopuses are expert camouflage artists. They can mimic various animals based on which predator is close by. Upon studying closely, this source was rejected because the surfboard is a rigid body and does not afford the same flexibility as the body of an octopus. (ii) Bullethead parrot fish uses the principle of pointillism to camouflage themselves. When viewed at close range, the fish appear bright and colorful but when viewed from a further distance, the combination of the complementary colors creates the illusion that the fish is grey-blue. This trick blends the parrotfish into the backlight of the reef, and in essence it disappears. (iii) Pony fish achieves camouflage by producing and giving off light that is directly proportional to the amount of ambient downwelling light for the purpose of counter-illumination.

Designers chose the pony fish as their source of inspiration. The function of camouflage now indicated the sub-function of producing a glow on the ventral side of the surfboard to match the ambient downwelling light in order to prevent the formation of the silhouette. Now the issue became the mechanism of producing the light that achieved this function. In the case of pony fish, designers understood that the light is produced by bioluminescence – the light-producing organ of the fish houses luminescent bacteria Photobacterium leiognathi. This light is channeled from the light-producing organ to the ventral side and dispersed by creating rectangular light spots on the ventral side. Therefore, the function of producing ventral glow was decomposed in other sub-functions: produce light, channel and disperse light.

In order to produce light for the surfboard, the traditional means of having an onboard light source and a power source was considered an inferior solution. The search for alternate means of producing light sparked another round of search for biological sources of inspiration, which led them to an organism called Brittle star (a kind of a star fish). This organism implements the mechanism of photo-reception. The dorsal side of the Brittle star is covered with thousands of tiny eyes, or microscopic lenses, making the entire back of the creature into a compound eye. This mechanism can be used to collect surrounding light rather than having to produce luminescence as in Pony fish. This suggested a design in which the top of the surfboard would be covered with (suitably distributed) tiny lenses to collect the sunlight incident upon the surfboard.

In order to channel and disperse the light collected to the bottom, their design incorporated embedding optic fibers within the surfboard. One end of these cables would be connected to the lenses on the top side and the other end would be positioned on the bottom side. Although this would channel and disperse light, it would lead to spots of brighter and dimmer light when seen from below the surfboard. This would still produce a silhouette, albeit of a different kind compared to the normal surfboard. To counter this, they had to think of another sub-function: disperse light to mimic the wavy pattern of the ocean surface. In order to achieve this function, their final design included adding a layer of "pattern light diffusers" on the bottom of the surfboard which disrupts the pattern of light (coming from the optical fibers) in controlled ways. This layer could be structured to mimic the wavy pattern of the ocean surface.

Figure 4 shows the generation of this solution using the framework of the compound analogical design. Step 1 depicts the nature of the problem space early in the design. The main function is the prevention of silhouette. Step 2 shows the retrieval of the pony fish analogue and the creation of two sub-functions: produce light, and channel and disperse light. For the first sub-function (produce light), Step 2 depicts the following: (i) solution in the source design (bio-luminescence) is not transferred, and (ii) the simple solution of mounting a light and power source is rejected. For the second sub-function (channel and disperse light), a fiber optic-based solution is proposed in Step 2.

In Step 3, the search for a solution to the function of producing light has been transformed into "harness ambient light." A search based on this transformed function has led to the retrieval of the Brittle star analogue and the transfer of the photo-reception solution. Step 3 also depicts how the evaluation of partial solution of Step 2 has indicated that using fiber optic cables alone for both channeling and dispersing light does not elimi-

nate the silhouette (but merely creates a different kind of silhouette). This
has led to further decomposition of the original "channel and disperse
light" function into two individual sub-functions. The channel light sub-
function is still done through fiber-optic cables, but the dispersion is done
through specialized "pattern light diffuser" devices. Knowledge about the
diffuser devices was based on background domain knowledge and not
gained by analogy as far as we can tell.

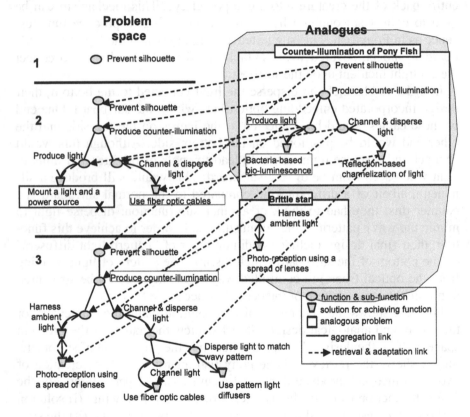

Fig. 4. Design trajectory of Eye in the Sea project

Related research

There are few cognitive accounts of biologically inspired design available
in the literature. The available studies focus mostly on the effect of exter-
nal representations on the number and quality of generated designs. For
example, Linsey *et al.* ([13]) found that when compared with using only

diagrammatic representations of biological systems, combining diagrams with functional descriptions increases the chances of successful analogies. In contrast, our work provides a more descriptive account of biologically inspired design, with a focus in the use of compound analogies.

In a different context, viz., software design, Smyth *et al.* ([12]) have described Déjà Vu, a system that uses hierarchical case-based reasoning for generating design solutions. Their model of design does combine problem decomposition and analogy (specifically, case-based reasoning). One important difference between our work and theirs is that, unlike case-based reasoning, biologically-inspired design uses cross-domain analogies. An even more important difference is that while in Déjà Vu, the problem decomposition is already compiled into the cases. But in our model, the problem decomposition is generated dynamically and incrementally, and is interleaved with the process of analogy.

Recently there have been a few attempts to build computational tools for supporting biologically inspired design. The Biomimicry Institute provides an online library of research articles on biological systems. Chakrabarti *et al.*'s ([14]) Sapphire tool represents the structure, behaviors and functions of biological and engineering systems in a uniform representational scheme. It retrieves biological and engineering designs based on matches between functional abstractions of the systems and functional abstractions used in a problem description. Chiu and Shu ([15]) use latent semantic indexing to find a match between functional abstractions. Insofar as we know, none of these efforts addresses the issue of compound analogies in biologically inspired design.

Conclusion

Our overall goal is to understand the cognitive processes of BID and propose design methods and tools based on this understanding. To develop such an understanding we first conducted a study of designers engaged in BID and identified some of the salient aspects of BID [10]. A closer look at the design products and processes in BID revealed a complex interplay between knowledge of biological systems and knowledge of engineering problems, leading to the incremental, iterative development of compound solutions. In this paper, having noted that existing models of analogy-based design do not account for the generation of compound solutions, we have developed a high-level conceptual framework of *compound analogical design* to address this gap. This framework extends the traditional accounts of analogy-based design by incorporating the interaction between

two related processes, analogy and problem decomposition. We have applied this framework to analyze three sample designs from our study that contained compound solutions.

We draw two main conclusions from our analysis. First, successful BID requires that designers carry rich representations of the systems (both biological and engineered) they bring to bear during design. Further, these rich representations are organized at different levels of abstraction and aggregation that facilitate the decomposition of the target problem and allow retrieval of biological (and engineering) analogues with cues taken from each level. Second, knowledge about functions and mechanisms that achieve those functions are likely to be explicitly captured at each level. Once a mapping is established between an engineering function and a biological function, it leads to the transfer of the associated biological mechanism to the engineering domain, along with any inferences about the functional decomposition in the biological solution. This opportunistic interplay between the decomposition and the analogy-making process is the key to achieving successful compound solution in the context of BID.

Our framework has primarily concentrated on the issues related to the interaction between the analogy-making and problem decomposition processes in the service of generating compound solutions. There is no principled reason to limit the framework to just these processes. Design, especially complex creative design such as BID, involves a variety of other processes such as interpretation and elaboration of the design problem, evaluation and refinement of candidate solutions, reinterpretation and reformulation of the problem, problem abstraction, etc. Our framework can only gain in richness as we go forward by accounting for some of these processes. In future we also intend to develop a computational model of compound analogical design based on the conceptual framework presented here.

One of the conundrums in research on creativity is that any solution to any problem has to start from what one already knows: so, how is it possible to create novel solutions? For example, if a solution to a new design problem starts from a known design solution to a similar problem, then it is not clear in what sense the design solution to the new problem can be called novel, or the design process called creative. One way of getting around this conundrum is to study design situations in which the solution to the new design problem is a composition of known design solutions to multiple problems. In such a situation, it becomes possible to argue that the design is novel, with the creativity lying in the process of composition. Our conceptual framework of compound analogical design which embod-

ies this intuition will, we hope, encourage discussion into this conundrum of creativity.

Acknowledgements

We thank the instructors of ME/ISyE/MSE/PTFe/BIOL 4803 in Fall 2006: Profs. Jeannette Yen, Marc Weissburg, Bert Bras, Nils Kroger, Mohan Srinivasarao, Craig Tovey, and others. We also thank the student designers for their input in this study. This research was supported by NSF grants #534622 (Multimodal Case-based Reasoning in Modeling and Design) and #0733363 (Towards a Computational Model of Biological Analogies in Innovative and Engineering Design).

References

1. Bar-Cohen Y (2006) Biomimetics: biologically inspired technologies, CRC/Taylor & Francis, Boca Raton, FL
2. Benyus J (1997) Biomimicry: innovation inspired by nature. William Morrow, New York
3. Goel AK, Bhatta S (2004) Design patterns: a unit of analogical transfer in creative design. Advanced Engineering Informatics 18(2): 85-94
4. Goel AK, Bhatta SR, Stroulia E (1997) KRITIK: an early case-based design system,. In Maher, ML and Perl, P (eds), Issues and Applications of Case-Based Design, Erlbaum, Hillsdale, NJ: 87-132
5. Maher ML, Balachandran B, Zhang DM (1995) Case-based reasoning in design. Lawrence Erlbaum, Mahwah, NJ
6. Qian L, Gero JS (1996) Function-behaviour-structure paths and their role in analogy-based design. AIEDAM 10: 289-312
7. Wills LM, Kolodner JL (1994) Towards more creative case-based design systems. In Proceedings of the 12th National Conference on Artificial Intelligence, AAAI Press/The MIT Press, Menlo Park, CA: 50-55
8. Zhao F, Maher ML (1988) Using analogical reasoning to design buildings. Engineering with Computers 4(1): 107-119.
9. Vincent J, Mann D (2002) Systematic technology transfer from biology to engineering. Philosophical Trans. of the Royal Society: Physical Sciences 360: 159-173
10. Vattam S, Helms M, Goel AK (2007) Biologically inspired innovation in engineering design: a cognitive study. Technical Report GIT-GVU-07-07, Graphics, Visualization and Usability Center, Georgia Institute of Technology
11. Goel AK (1997) Design, analogy, and creativity. IEEE Expert 12(3): 62-70

12. Smyth B, Keane MT, Cunningham P (2001) Hierarchical Case-Based Reasoning Integrating Case-Based and Decompositional Problem-Solving Techniques for Plant-Control Software Design. Transactions on Knowledge and Data Engineering 13(5):793–812
13. Linsey JS, Murphy JT, Wood KL, Markman AB, Kurtoglu T (2006) Representing analogies: Increasing the probability of success. Proceedings of ASME Design Theory and Methodology Conference, Philadelphia, PA
14. Chakrabarti A, Sarkar P, Leelavathamma B, Nataraju B (2005) A functional representation for aiding biomimetic and artificial inspiration of new ideas. Artificial Intelligence for Engineering Design, Analysis and Manufacturing, 19:113-132
15. Chiu I, Shu L (2007) Using Language as Related Stimuli for Concept Generation. Artificial Intelligence for Engineering Design, Analysis and Manufacturing 21(2):103–121

A Model of Creative Design Using Collaborative Interactive Genetic Algorithms

Amit Banerjee, Juan C. Quiroz and Sushil J. Louis
University of Nevada, Reno, USA

We propose a computational model for creative design based on collaborative interactive genetic algorithms, and present an implementation for evolving creative floorplans and widget layout/colors for individual UI panels. We map our model and its implementation to earlier models of creative design from literature. We also address critical research issues with respect to the model and its implementation – issues relating to creative design spaces, design space exploration, design representation, design evaluation (competition), design collaboration, and design visualization (for interactivity). Results comparing collaborative evolution of floorplans to non-collaborative evolution are also presented, and pre-tests using surveys indicate that floorplans developed via collaboration are more *original* than those produced by individual non-collaborative evolution.

Introduction

Design is a fundamental, purposeful, pervasive and ubiquitous activity and can be defined as the process of creating new structures characterized by new parameters, aimed at satisfying predefined technical requirements. It consists of several phases, which differ in details such as the depth of design, kind of input data, design strategy, procedures, methodology and results [1]. Usually the first stage of any design process is the preliminary or the conceptual design phase, followed by detailed design, evaluation and iterative redesign [2]. Computers have been used extensively for all these stages of design except the creative conceptual design phase. According to Goldberg [3], this phase of design has been regarded as a *black art locked up in a time warp of platitudes, vague design procedures and problem-specific design rules*.

J.S. Gero and A.K. Goel (eds.), *Design Computing and Cognition '08*,
© Springer Science + Business Media B.V. 2008

Creative evolutionary computational systems have been defined by Bentley and Corne, as evolutionary systems that either aid human creativity or solve problems that only creative people could solve [4]. Goldberg presents an idealized framework for conceptual design in four components: problem, designer, alternative designs and design competition, and shows how evolutionary techniques (specifically genetic algorithms) can be thought of as 'a lower bound on the performance of a designer that uses recombinative and selective processes' [3]. Rosenman has explored evolutionary models for non-routine design [5] and has investigated the generation of creative house plans (later referred to as floorplans in this paper) using genetic algorithms [6]. Creation of floorplans has also been investigated by Gero and Schnier as an evolving representation problem that restructures the search space in [7], by co-evolution of design and solution-spaces in [8], and using case-based reasoning by De Silva Garza and Maher in [9].

Unlike detailed design where optimization criteria are readily quantifiable, alternative design concepts during the preliminary design phase may need to be subjectively evaluated, especially when requirements include aesthetic and other subjective criteria. It is difficult, often impossible to construct matrices and explicit functions that can mimic the way designers evaluate subjective criteria. Interactive Genetic Algorithms (IGAs) are genetic algorithms whose fitness function is replaced by interactive user evaluations. IGAs in particular and interactive evolutionary computation (IEC) in general have been used in a wide range of applications, ranging from engineering to arts and social sciences, to design user-centric optimization systems [10].

At the same time, collaborative systems have been the focus of studies into creativity and computer supported cooperative work [11] since the early 90s. There has been a paradigm shift from computer-aided design systems to computer supported collaborative design systems [12]. It has been argued that much of our intelligence and creativity results from interaction and collaboration with other individuals [13]. In this paper, we propose a computational model of the creative design process using a collaborative interactive human-centered approach to exploration of design spaces. We present a collaborative interactive genetic algorithm implementation for our model to evolve floorplans and widget layout/style design, as a user-interface development tool. We compare designs evolved by a collaborative peer group, against those evolved individually by designers, and find that the former designs consistently rated higher on the "originality" scale, thereby lending credence to our computational model.

Motivation

The purpose of the research presented in this paper is to build a collaborative, interactive, genetic algorithm based design tool to test the hypothesis that collaborative, interactive, evolutionary exploration of design space is a viable computational model of creative design. One of the distinctions made between different types of creativity include Boden's [14] two types of creativity: *H*-creativity and *P*-creativity. *H*-creativity or historic creativity occurs when the design falls outside the range of designs created by anyone in the society, whereas *P*-creativity or personal creativity occurs when the design is novel to the designer (but may not be novel to the world). *S*-creativity or situated creativity [15], a more recently identified type, occurs when the design contains ideas that were not expected to be in the design when the design was commenced. Thus the design may not be novel in the *P* or the *H* sense but is novel in that particular design situation. In the absence of cohesive collaboration, artists or creative people exhibit *P*-creativity. We are interested in investigating the social aspects of creativity by facilitating and encouraging group interaction and cooperation, which we hypothesize, will lead to individual *P*-creativity and a group *S*-creativity. Our model maps to a system of creative design through social acts and social influence [13,16], where individual designers interact with an evolutionary system to guide the *P*-creative design process while at the same time cooperating within themselves by introducing new state variables, thereby guiding the *S*-creative design process.

Our collaborative interactive evolutionary exploration model also relates to the *blind variation and selection retention* model based on the Darwinian theory of creativity [17]. The *blind variation and selection retention* model of creativity states that the creative process is characterized in the first stage by production of a myriad of ideas and thoughts while lacking the foresight in the production of variations, followed by subjective selection and retention of the most meaningful ideas and thoughts. Since 1960, a body of research has been dedicated to furthering the evolutionary model of creativity [18]. This Darwinian framework for modeling creativity has found use in a connectionist approach to create a computer-based model of the creative process [19] and connects well with our model. In the next section we present the discussion on the proposed computational model and issues related to its implementation.

The Computational Model of Creativity

A computational approach to investigate design spaces (or solution spaces) to support a human designer's exploration is presented in Woodbury and Burrow [20]. A design space is defined as a networked structure of related descriptions of partial and intentional designs encountered in an exploration process. Woodbury and Burrow also claim that robust reuse of paths of exploration is of critical importance in design space exploration. We continue this line of thought with a collaborative approach to the exploration of a solution space using an interactive genetic algorithm. The designer-centric aspect due to the interactivity with the genetic algorithm helps in assigning a utility to a particular solution in the space, while collaboration between various designers helps the genetic algorithm to diversify and explore an extended search space. We hypothesize that the collaboration brings about concurrent exploration of design subspaces, and elements of the final design are a creative (unforeseen) collection of individual elements of various subspaces.

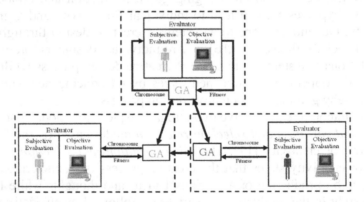

Fig. 1. Schematic showing implementation of the proposed collaborative interactive evolutionary model for creative design

Figure 1 represents an implementation of our computational model of creative design. Each dotted box represents a running instance of the interactive design tool – each instance is guided by a designer and searches a particular subspace in accordance with designer preferences. The genetic algorithm in each instance combines the designer's subjective picks with a computable fitness function to drive genetic search through a design subspace. The user-interface to our design tool allows the designer to zoom in on a particular displayed design and pick aspects of the design for exploration. In addition to guiding his or her own search through a subspace, each

designer also can see a small subset of the other designers' evolving designs. The designer can then choose to expand his or her search space or move to another space by incorporating one or more of the peer-evolved designs into his or her genetic population. Incorporating peer-evolved designs tends to influence the subjective and objective utility functions associated with the genetic search. The proposed model and its implementation raise several research issues. We divide these issues into five broad categories.

Design Space Exploration

The most important research issue is the collaborative versus individual exploration of the design space. Having investigated both collaborative and individual interactive genetic algorithms for evolving floorplans and widget layouts/styles for UI, we have empirical evidence that the creative content of the collaboratively evolved designs are superior to those of the individually evolved designs. We present evidence of our claim in the results section later in this paper.

Creative Design Spaces

According to Gero [21], creative designing can be defined in computational terms as the activity that occurs when one or more new variables are introduced into the design. This leads to the distinction between product and process creativity – creative design processes (processes based on addition and deletion of design variables) have the potential to aid in the design of creative artifacts, but as such they do not guarantee that the artifact produced is creative by itself. In other words, the creative design process is characterized by an extension or movement of the state space of potential design to new regions in the infinitely large state space of all possible designs. This is shown as a pictorial in Figure 2 (left).

Collaboration provides an effective framework for extending an existing state space or moving to a new state space. By injecting peer-designs into his or her genetic population, the designer is in a way modifying his or her own "effective" state space. This is shown as a schematic in Figure 2 (right) with designer 1 moving from his initial state, 1S_0 to S_n by collaborating with two other designers, both of whom also converge to the creative space. This feature can be implemented in two possible ways within our collaborative interactive evolutionary exploration framework: (1) different designers have different underlying representation schemes to start with, and the representation of the designer who is injecting peer-designs

is influenced drastically so that he or she can now search a previously un-
known solution space; or (2) the underlying representation is the same
across all users, but design parameters are either switched off or on and in-
jecting peer-designs will switch off (and on) a different set of design pa-
rameters, thereby extending or moving the state space of solutions. This
can be implemented by an efficient masking scheme in the representation.
In summary, collaboration in evolutionary search has the potential to be a
creative designing process.

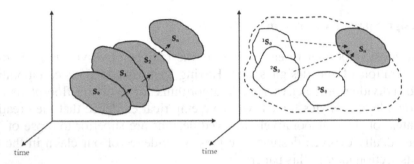

Fig. 2. Left: Creative designing involves changing state spaces of possible designs
with time [21]; Right: Collaborative creative exploration

Fitness Function

Evaluation of alternative designs is central to the conceptual design proc-
ess. In addition to objective guidelines (which usually are derived from de-
sign requirements analysis), designers use their domain expertise and
knowledge, preferences, emotions and biases to root out bad designs from
the good ones. We incorporate evaluation based on subjective biases by
letting the designer interact with the evolving population at either every
generation of the evolution process or after every n generations ($n > 1$).
However, since not every design criterion is subjective, we are faced with
the problem of either combining the metrics obtained from the subjective
and objective evaluation criteria or treating them separately. In the former
case, how does one create a weighted linear combination of such metrics,
and decide how to assign weights to signify relative importance of the dif-
ferent criteria? In the latter case, one might be tempted to treat the criteria
separately by analyzing Pareto-optimal fronts (if any) produced by the set
of criteria under consideration. We have investigated both approaches;
however, there is no conclusive evidence for one approach being better
than the other, and hence remains an open research question.

Representation

The issue of what constitutes a good representation is vital to the efficacy of any evolutionary search technique. Evolutionary optimization techniques, including genetic algorithms, require that designs (or solutions) be encoded in a manner suitable for genetic operators, such as crossover and mutation, to work on. For the floorplanning problem, we have used a binary tree with much initial success as the genotypic representation that encode for the floorplans. We have also used the integer and bit-string representations to evolve widget layout/style.

In the next section, we present the collaborative interactive genetic algorithm implementation of our proposed model, which we call IGAP – Interactive Genetic Algorithm Peer to Peer.

IGAP: Interactive Genetic Algorithm Peer to Peer

We present an implementation of our collaborative model for creative design for evolving floorplans and widget layout/style schemes. Although, we have implemented them as two distinct modules, they can be seamlessly put together as a coherent two-phase user-interface design tool. In addition to being used as an archetype for UI panel layout, floorplanning is of importance to Architecture and Civil Engineering. The implementation is shown in Figure 3. We first present details of the IGA framework and discuss the collaborative framework later.

IGA Framework

IGAP is part of a GA/IGA framework we have built to support evolutionary design of user interface elements. For a problem requiring interaction with a user, the designer is required to implement the fitness function - which takes the user input and evaluates each individual in the population based on the user provided feedback, and a drawing function - which draws to the screen the subset of individuals from the population to be evaluated by the user.

Representation

For evolving floorplans we have used a binary tree representation, coded as a nested list. At every node of the tree, the parameters specify how the rectangular panel at that level is subdivided (either left/right or top/bottom)

and what percentage of panel area at that level is contained in either the left or the top subdivision. Figure 4 shows how the rectangular panel is subdivided into *rooms* and *spaces*. A *room* is represented by the list [0, 1] and a *space* by [0, 0]. An arbitrary list [0, 0.75] represents division in top/bottom configuration with top sub-panel containing 75% of the parent panel. Another list [1, 0.80] represents division in left/right configuration with left sub-panel containing 80% of the parent panel.

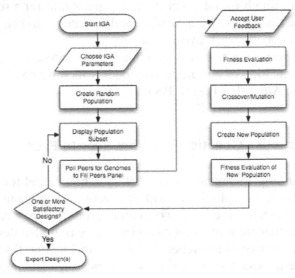

Fig. 3. The collaborative interactive genetic algorithm implementation for creative designing

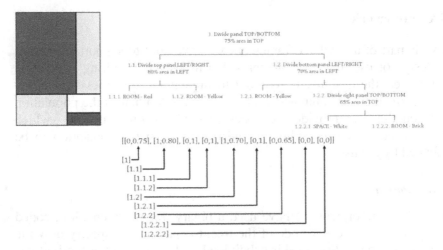

Fig. 4. Binary tree representation of floorplans encoded as a nested list

For widget layout and style design, we use two chromosomes to specify the user-interface panel. On the panel, the widgets are laid out on a grid and different widgets are identified by a widget identification number (1 onwards, 0 for spaces on the panel grid). A sample layout and its encoding are shown in Figure 5. This is an example of an integer representation. The second chromosome encodes for various style characteristics, including background and foreground color, vertical and horizontal spacing between widgets in the layout grid, and font type. All of these attributes are encoded in a bit string – string of 0s and 1s. For color we use the RGB representation, where each color consists of three components: red, green, and blue. The RGB components vary from 0 (black) to 255 (white).

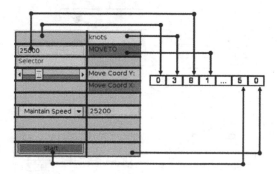

Fig. 5. Encoding of the widget layout: Widgets are identified by integer IDs (>0) and empty cells in the grid are identified with 0s

Genetic Operators

The binary tree representation for floorplans necessitates the need for a specialized tree-crossover operator. The nested list is parsed as a binary tree and two such parent trees are crossed at randomly chosen nodes, such that entire sub-trees following those nodes are swapped. The tree representation is used in genetic programming (Koza 1992) and hence, our crossover operator maps to the crossover operator used in genetic programming. The operator is shown schematically in Figure 6.

Depending on the probability of mutation, the mutation operator works on the two parameters of the nodes (or leaves) differently. It performs a binary swap on the first parameter thereby changing the subdivision configuration. Depending on the value of the second parameter, the operator either performs a binary swap (if the value is either 0 or 1), thereby changing a *room* to a *space* and vice versa, or if the second parameter is a real number between 0 and 1, the operator replaces it by another random real

number in the same interval, thereby altering the dimensions of the *room* (or the *space*).

The widget layout chromosome is an integer sequential encoding, and in order to preserve this permutation representation, we use the Partial Mapped Crossover (PMX) operator. PMX keeps crossover from creating individuals with duplicate genes, which would violate the permutation property. We also use swap mutation, which randomly picks two alleles from the chromosome and swaps them. For the widget style chromosome, we use single point crossover and bit-flip mutation operators.

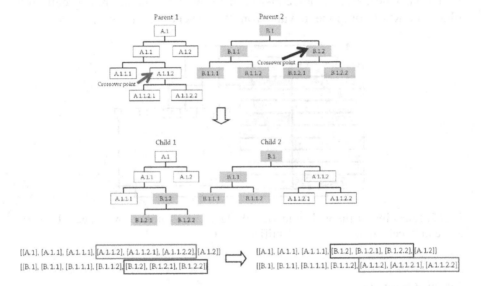

Fig. 6. Tree crossover operator

Fitness

There are times when it is difficult if not impossible to determine the fitness function for a problem domain when using evolutionary computation. An IGA replaces the fitness evaluation with the user. IGAs are useful when there is no better fitness measure than the one in the human mind. IGAs have been applied to various domains, ranging from artistic and highly creative applications to engineering [10].

A typical IGA session consists of a user evaluating a set of individuals from the IGA population. The individuals of the population are then assigned a fitness value (or values), based on subjective and objective criteria of evaluation. In the floorplanning problem, we separate objective

criteria from subjective criteria as, (1) the only measurable objective in floor-plans is their compliance with the Architect data guidelines [22]. The guidelines for single-storey house plans relate to minimum room dimensions and areas. Every individual floorplan is assigned a fitness value based on its compliance with the minimum dimension and minimum area guidelines. (2) The IGA lets the designer pick a particular floorplan as being the "best". This subjective pick (based on preferences) is translated into his or her preference for the number of rooms, total built area (area occupied by *rooms*), and room adjacencies. An individual plan is compared with the "best" plan and assigned high fitness values if the plan is similar to the "best" plan in each of the three subjective criteria.

The objective component of fitness for evolving widget layout and style comes from UI style guidelines. The main guideline currently incorporated in the objective evaluation is the use of highly contrasting background and foreground colors. The grid positioning of the widgets in the layout automatically enforces a widget alignment guideline. The objective fitness is the Euclidean distance between the color vectors of the foreground and background colors. The subjective evaluation consists of finding the similarity between the currently evaluated individual with the user selected best by using the longest common subsequence (LCS). We find the length of the LCS of the layout chromosome (length1) and of the style chromosome (length2). We add these two lengths and use the sum as the subjective fitness score.

Genetic Algorithm

We use the Non-dominated Sorted multi-objective Genetic Algorithm, abbreviated as NSGA-II [23]. The NSGA-II creates fronts of non-dominated individuals, where within a front none of the individuals are any worse than any other individual across all optimization criteria. All individuals within a front are said to have the same rank. We select parents by using the crowded distance tournament operator. We pick two individuals to participate in the tournament, and we select the individual with the higher rank to be part of the mating pool. In case the two individuals have the same rank, and consequently belong to the same front, then the crowded distance of both individuals is computed, and we select the individual with the highest crowded distance to be part of the mating pool. This translates to the individual being in a less crowded region of the front and hence, the crowded distance selection favors the most diverse individuals within a front.

We implement both the floorplans design and widget layout/style evolution with the NSGA-II. For floorplans design we use a four-criterion

multi-objective minimization function. With the widget layout/style implementation we keep the objective and subjective criteria separate and use a two-criterion minimization function for NSGA-II. We have also used the standard canonical GA where we combine the subjective and objective fitness into a single weighted linear sum [24].

Visualization of Solution Space

We display a subset of nine individuals, from a large population size, to be evaluated by the designer. We chose nine because it allows us to display a visually appealing grid of 3x3 individuals, which also does not overwhelm the designer. What to display from the population to be evaluated by the user is a critical step, since displaying useful information to the user makes for a productive session, while displaying a poor subset can inhibit the progress of the interactive evolutionary process.

Various methods of selecting a small subset from a large population have been previously explored [24-26]. In the work presented in this paper we select individuals from the fronts created by the NSGA-II. We pick three individuals from the first front, three individuals from the second front, and so on until we have obtained nine individuals. If there are less than three fronts, or if one of the fronts has less than three individuals, then we obtain the next three individuals from the next front in a round robin fashion. We also enforce that all individuals in the displayed subset are unique, given that the population contains enough diversity, since displaying a small subset consisting of numerous repeats is not useful to the user and does not give the user a sense of the current state of the population.

By displaying a small subset and through fitness interpolation we can reduce the amount of user interaction, and thereby, user fatigue. However, if the case arises that the user does not like any of the individuals in the displayed subset, then the user has the option to scroll down the current panel, and view the rest of the population, which remains hidden from view unless the user scrolls down. For users with little patience or that fatigue quickly (which is often the case), they can adhere to the use of the displayed subset. For the adventurous users, who are not intimidated by viewing hundreds of individuals to find the individual they like the best, they can scroll to view every single individual in the population. The ability to view the entire population also proves useful to users who early in a session explore the entire population, when there is a high degree of diversity, and later on only use the subset after the population has been biased to custom-evolved individuals. A snapshot of the interactive screen for non-collaborative floorplanning is shown below in Figure 7.

Fig. 7. The non-collaborative interactive interface for floorplanning

The user input consists of selecting the individual the user likes the best from either the subset, or from one of the individuals from the rest of the population (viewed by scrolling). We use the user selected best to interpolate the fitness of every other individual in the population. On the top of each individual displayed, we add a button with the label "Best". By clicking on the "Best" button of a design displayed to the user, he or she provides input to the IGA regarding the fitness criteria. Currently, we only support for only one individual to be selected as the best. Through the interface we also support the ability to provide input every n^{th} generation, where the value of n stands for the number of generations skipped before asking for user input, and which can be changed during a session. We also allow the user to go back to a previous generation if the population diverged into an undesired direction. The user also controls the crossover and mutation rates through the interface.

Collaborative Framework

The collaborative module is wrapped over the interactive module and is what binds the individual IGA sessions together. Collaborative evolution is implemented by networking with a peer to peer network. We treat each user participating in evolution as a node, handling incoming requests from other nodes (peers) and requesting information from peers. By using a peer to peer network, control is decentralized and each node is free to chose

who to connect to and if necessary who to exclude from its set of peers. Note that connections between peers must be direct, we do not support for spidering connections, where node-A can connect to node-C through node-B. Since each node consists of a server to handle request from any peer, each node can broadcast its signal to any peer that connects to it.

Collaborative Interface

During collaborative evolution, a subset of peer-evolved designs is displayed to the right of the user's population. We limit the number of peer individuals to nine, organized in a 3x3 grid, similar to how we present the user's own population, in order to be consistent. For more than one peer, we cannot display all the individuals belonging to the subset of each peer, since we only display nine. We do make sure that the user selected best individuals from each peer are displayed on the peers subset. We save the user selected best from generation to generation, and we always make it part of the subset displayed the next time the IGA requires user input. The reason for making sure that a peer can see the user selected best from other peers is that if a user selects an individual as the best, then it was because the user found the selected individual to be the most interesting/intriguing/creative and to be the best candidate to bias the evolution of his or her own population, as well as those of other users. We select the rest of the individuals that make up the peers subset by taking a random subset from a collective pool of all individuals that make up peers' subsets. By selecting a random subset, we believe that over many generations, all of the participants will get approximately the same amount of their designs displayed on the screens of collaborators.

The benefit of viewing the best individuals from peers is limited, unless the user is able to take promising individuals from peers and mold them to their liking. We support this by allowing the user to inject individuals from the subset of peers into the user's own population. The user can select an individual from a peer to be added to the user's own gene pool by clicking on the "Add to Genome" button. The user can also select a best individual from the subset of individuals from peers, in which case the user selected best is automatically injected into the population, and used for fitness interpolation. We require the user to select a best individual, but it does not have to be from the user's own population – the user selected best can come from peers. The collaborative interface is shown in Figure 8.

Fig. 8. The collaborative interactive interface for the floorplanning problem

Fitness Bias

We use fitness biasing to ensure that injected individuals survive long enough to leave a mark on the host population by using the concept of bloodline. Injected individuals are considered to be *full blood*, while those individuals already in the population are treated as individuals with *no blood*. The bloodline consists of a number between 0 (no blood) and 1 (full blood), and this value is added as another criteria to be maximized by the NSGA-II with Pareto optimality. Thus injected individuals will all be non-dominated (in the topmost front) and will not die off immediately. The injected individuals replace the bottom 10% of the population [27]. When a full-blooded individual crosses over with a no-blooded individual, then the offspring will inherit a bloodline value equal to a weighted sum of the bloodline of the parents, where the weight values depend on the percentage of the genetic material inherited from each parent.

Computational Results

We present some preliminary results for the floorplanning and widget layout/style design problem. Floorplans were evolved based on a simulated design brief that stated the problem as a minimally constrained one. The

brief was to design a floorplan for a two-bedroom, one-bathroom apartment with the following constraints: (1) one of the corners of the living area is also the north-west corner of the plan, (2) the two bedrooms should not have a common wall, and (3) at least one of the bedrooms has a direct access to the bathroom. The problem stated above was solved both individually and collaboratively by the authors and two of their colleagues. During the collaborative evolution, only nine representative designs were made visible to every designer in the peer-group. Every designer also had access to a subset of nine evolving designs from the populations of the four other peers. However, during individual evolution of floorplans for the same problem, the designer had visual access to all the evolving designs in his own population to ensure some sort of parity in the visualization space vis-à-vis the collaborative evolution. In other words, for a standard population size of 100, the designer participating in the collaborative evolution effort had visual access to 18 designs at a time, while the same designer involved in the individual pursuit of evolution had visual access to all 100 designs.

We also used a design template to aid us with the first fitness computation. For a population size of 100, the initial population has 99 floorplans that are created randomly and the design template constituted the 100th floorplan. The template serves as the assumed "best" for the first generation, and the randomly created floorplans are compared to the template and assigned the three subjective fitness values discussed in section 4.1.3. All floorplans are also evaluated based on their compliance with the Architectural data guidelines. Based on the four criteria, the Pareto-optimal fronts are calculated and three members selected at random from the first fronts each are displayed to the designer. The designer then interacts with the interface and brings the evolution to a stop when he or she feels that there are one (or more) *interesting* designs in the current population.

Solutions to the two-bedroom one-bathroom problem described earlier were evolved over multiple runs both individually and collaboratively. Interestingly, we used as a design template a one-bedroom one-bathroom plan, which goes on to show that the choice of template is not an issue (the template itself was lost in 5-6 generations). We achieved satisfactory results (floorplans meeting all or most of the constraints) in most cases within 15-20 generations. In Figure 9 a set of six floorplans the designers considered interesting while individually evolving floorplans is shown, and in Figure 10 we show a set of six floorplans that the same designers considered interesting when they collaborated on the same problem. The rooms are color coded as red (living area), yellow (bedrooms), green (eat-

ing areas – kitchen and/or dining rooms), firebrick (bathrooms) and white (empty spaces in the plan).

Fig. 9. Six representative floorplans for the design problem evolved non-collaboratively

Fig. 10. Six representative floorplans for the design problem evolved collaboratively

The plans were evaluated for creative content based on practicality and originality on a five-point scale [28]. We conducted this as an initial pre-test that would eventually help us devise a more effective methodology for design concept evaluation. We sought the participation of ten graduate students, five from our lab and five outside of our lab. In addition to the two viewpoints of practicality and originality, we also asked survey participants to rate how close a design comes in meeting the minimum design requirements and the set of constraints. Based on this, it was unanimously felt that #5 (Figure 9) and # 9 (Figure 10) did not meet the north-west living room constraint and hence, it was decided to omit them from the evaluation. The results of the evaluation are presented in Table 1.

The collaboratively designed floorplans were consistently rated higher on the originality scale, while the individually (non-collaborative) designed floorplans were found to be more practical. Many survey participants ranked #12 (Figure 10) as being the most original and the least practical floorplan. Because of the limited size of the survey population, it would be premature to conclude that collaboratively developed floorplans do not address resolution aspects as well as the individually developed floorplans do. We also feel that a designer-centric viewpoint of creativity

should hold as much weight as peer-evaluation based on practicality and originality. Design #7 (Figure 10) came about when one designer evolving designs with "two-bedrooms one-bathroom with no eating areas" (similar to #2) injected his population with a peer's design, one who was evolving plans with a kitchen area (similar to #3). Neither designer was likely to come up with #7 on their own, which also happens to score highly on the originality scale. In fact, all the collaboratively designed floorplans were rated in the top-5 on the originality scale.

Table 1 Creativity evaluation of the ten representative design concepts

DESIGN #	PRACTICALITY	ORIGINALITY	RANK
1	2.7	3.1	6
2	2.9	2.7	8
3	2.4	3.3	7
4	**4.4**	3.3	2
6	4.0	3.2	3
7	2.2	3.4	8
8	2.8	3.4	5
10	3.2	3.5	4
11	4.2	3.6	**1**
12	1.6	**3.8**	10

The UI panel evolution shows promise, but further experiments and data analysis are required. Figure 11 (left) shows three UI panels evolved individually and Figure 11 (right) shows three panels evolved collaboratively. Although the preliminary results are inconclusive, we did find that collaboratively evolved panels, showed overall visually appealing softer color tones, while individually evolved panels show a high degree of contrast between background and foreground color (at times uncomfortable combinations).

Fig. 11. Left: Three representative UI panels evolved individually (notice the high contrast between foreground widget colors and background panel color); Right: Three representative UI panels evolved collaboratively

Conclusions

In this paper, we propose a collaborative model for creative designing based on interactive genetic algorithms. We implement our proposed model to collaboratively evolve floorplans and widget layout designs – two applications that may have potential use in interactive development of user-interfaces. We have addressed several issues relating to implementation and issues relating to genetic search, interaction and collaboration. We also compare results of collaborative evolution with similar results obtained with individual (non-collaborative) evolution, by evaluating created designs on a five-point scale for practicality and originality. The pre-test indicates that while individually created floorplans were rated highly for practicality, the collaboratively generated floorplans were considered more original. Based on these preliminary findings, we believe that there is enough empirical evidence to support our hypothesis that collaborative interactive evolutionary search of design spaces is indeed a viable computational model of creative design.

Acknowledgements

We thank the survey participants for their time. This work was supported in part by contract number N00014-0301-0104 from the Office of Naval Research and the National Science Foundation under Grant no. 0447416.

References

1. Renner G, Ekrárt A (2003) Genetic algorithms in computer aided design. Computer-Aided Design 35: 709-726
2. Bentley PJ, Wakefield JP (1997) Conceptual evolutionary design by genetic algorithms. Engineering Design and Automation Journal 3: 119-131
3. Goldberg DE, Rzevski G (1991) Genetic algorithms as a computational theory of conceptual design. Applications of Artificial Intelligence in Engineering VI: 3-16
4. Bentley PJ, Corne, DW (2002) An introduction to creative evolutionary systems. In Creative Evolutionary Systems. New York: Academic Press
5. Rosenman MA (1997) An exploration into evolutionary models for non-routine design. Artificial Intelligence in Engineering 11: 287-293
6. Rosenman MA (1997) The generation of form using an evolutionary approach. In Evolutionary Algorithms in Engineering Applications. Berlin Heidelberg: Springer-Verlag

7. Gero JS, Schnier T (1995) Evolving representation of design cases and their use in creative design. In Proc 3rd Int Conf Comput Models Creative Design
8. Poon J, Maher ML (1997) Co-evolution and emergence in design. Artificial Intelligence in Engineering 11: 319-327
9. De Silva Garza AG, Maher ML (2000) Characterising evolutionary design case adaption. In Artificial Intelligence in Design. Dordrecht: Kluwer Acad
10. Takagi H (2001) Interactive evolutionary computation: fusion of the capabilities of EC optimization and human evaluation. Proc IEEE 89: 1275-1296
11. Wilson P (1991) Computer supported cooperative work: an introduction. Kluwer Academic, Dordrecht
12. Peng C (2001) Design through digital interaction: Computing communications and collaboration on design. Intellect Books
13. Csikszentmihalyi M (1997) Creativity: flow and the psychology of discovery and invention. Harper Perennial
14. Boden M (1999) Computer models of creativity. In Handbook of Creativity, Cambridge Univ Press, Cambridge
15. Suwa M, Gero J, Purcell T (2000) Unexpected discoveries and S-invention of design requirements: important vehicles for a design process. Design Studies 21: 539-567
16. Csikszentmihalyi M (1988) Society, culture and person: a systems view of creativity. In The Nature of Creativity, Cambridge Univ Press, Cambridge
17. Campbell DT (1960) Blind variation and selective retention in creative thought as in other thought processes. Psych Rev 67: 380-400
18. Simonton DK (1999) Creativity as blind variation and selective retention: Is the creative process Darwinian. Psych Inquiry 10: 309-328
19. Martindale C (1995) Creativity and connectionism. In The Creative Cognition Approach, MIT Press, Cambridge, MA
20. Woodbury RF, Burrow AL (2006) Whither design space. Artificial Intelligence for Engineering Design, Analysis and Manufacturing 20: 63-82
21. Gero JS (2002) Computational models of creative designing based on situated cognition. In Proc 4th Conf Creativity Cognition: 3-10
22. Neufert E, Neufert P, Baiche B, Walliman N (2002), Architects' data. Wiley
23. Deb K (2001) Multi-objective optimization using evolutionary algorithms. John Wiley, New York
24. Quiroz JC, Dascalu SM, Louis, SJ (2007) Human guided evolution of XUL user interfaces. In Computer Human Interaction, ACM Press, San Jose, CA
25. Lee JY, Cho SB (1999) Sparse fitness evaluation for reducing user burden in interactive genetic algorithm. In Proc Int Fuzzy Syst Conf 2: 998-1003
26. Quiroz JC, Dascalu SM, Louis, SJ (2007) Interactive evolution of XUL user interfaces. In Proc Conf Genetic and Evolutionary Comput: 2151-2158
27. Louis SJ, Miles C (2005) Playing to learn: case-injected genetic algorithms for learning to play computer games. IEEE Trans Evol Comput. 9: 669-681.
28. Finke R, Ward T, Smith S (1992) Creative cognition: theory, research and applications. MIT Press, Cambridge, MA

An Evolutionary Process Model for Design Style Imitation

Andrés Gómez de Silva Garza and Arám Zamora Lores
Instituto Tecnológico Autónomo de México (ITAM), México

In this paper we propose a process model for producing novel constructs that fall within an existing design or artistic style. The process model is based on evolutionary algorithms. We then present an implementation of the process model that we used in order to imitate the style of the Dutch painter Mondrian. Finally we explain and give the results of a cognitive experiment designed to determine the effectiveness of the process model, and provide a discussion of these results.

Introduction

Using computers to generate artwork is not a new idea, and neither is using ideas from evolutionary algorithms [1] for this task. Some examples of design systems that are inspired in evolution are presented and discussed, for example, in [2] and [3]. Most of the systems that generate artwork that are described in these two books (e.g., [4], [5], [6], [7], [8], [9], and [10]) do so by using the evolutionary operators of crossover and mutation to propose new paintings. However, they leave it to the user(s) to decide, during the evaluation phase of the evolutionary algorithm, which of the new paintings, or which of the features of the new paintings, to keep for future evolutionary cycles, and/or how to rank the new paintings according to whatever the user's subjective, and probably unconscious, aesthetic criteria might be. Thus, the decisions on what is aesthetic or interesting are not made by the systems.

This approach assumes that one is interested in producing new artwork, with the aid of the computer, that is deemed by people to be pleasing, and that there are enough people available to provide feedback to the evolutionary process in order to generate such artwork. On the other hand, we are more interested in the computational and algorithmic aspects of art-

J.S. Gero and A.K. Goel (eds.), *Design Computing and Cognition '08*,
© Springer Science + Business Media B.V. 2008

work generation rather than the artistic value of the final product. We would like to create fully autonomous systems that require no user feedback as their evolutionary or other algorithms proceed. The point of our approach is to explore, and perhaps push, the limits of what computers are capable of doing by themselves.

To provide additional focus, what we are interested in is to have computer systems that can imitate an artistic style given examples of that style. This contrasts with systems that are programmed with their own, completely new, artistic style, for instance by generating paintings that follow the patterns defined by some pre-programmed mathematical equations, or that, because of the way they are programmed, emulate the artistic style of their users or programmers, such as Harold Cohen's AARON [11]. Imitating a style involves achieving a trade-off between making sure that the new designs or paintings that are created are indeed novel, rather than simply copying previously-existing ones, but at the same time making sure that the new products do not differ in significant ways from the original ones in order not to go beyond the limits of the style that is being imitated.

We believe, for various reasons given below, that evolutionary algorithms provide us with a computational framework that allows us to achieve our goal. Work into capturing the style of particular artists or designers in the computer has often focused on shape grammars (*e.g.*, [12]) or semantic networks (*e.g.*, [13]), though some work has also used evolutionary algorithms to explore style. For instance, a system is described in [14] that generates traditional Chinese architectural facades after it infers a representation of their style. The inference and subsequent learning is done with an evolutionary algorithm which in the end obtains a hierarchical genotype that represents a particular style (according to the exemplars which have been shown to it). Recognizing whether a new design matches a particular style involves matching its features with the style representation embodied in the hierarchical genotype. However, generating these new designs is not done with evolutionary algorithms by the system.

In contrast, in our framework we believe that the power of the evolutionary algorithm is in the generation of new artwork. In Section 2 we describe our process model for generating imitations of style based on an evolutionary algorithm, and explain our reasoning behind this choice. In Section 3 we present a particular artistic style, Mondrian's, that we tried to imitate by implementing our process model. In Section 4 we explain a set of experiments we performed for evaluating our implementation and give the results of these experiments. Finally, in Section 5 we discuss our findings and future work to be done.

Evolutionary process model

Figure 1 shows the flow of tasks in our evolutionary process model of style imitation.

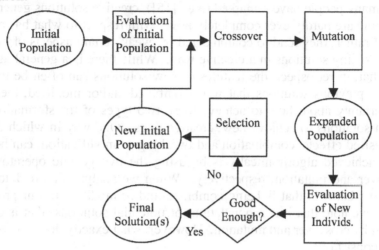

Fig. 1. Evolutionary process model of style imitation

Briefly, a population of potential solutions (*e.g.*, paintings, in case we want to imitate an artistic style) is kept throughout the process. The makeup of the population changes due to the evolutionary process. New potential solutions are generated by the genetic operators of crossover and mutation, which at random combine and modify the features of old potential solutions that are already in the population, respectively. This is in contrast with the use of shape grammars or other approaches that generate new potential solutions based on rules that embody expert knowledge on a particular design domain.

Returning to our process model, a temporarily expanded population is created by adding the new potential solutions to the original population. Each new potential solution is evaluated and a fitness value assigned to it. The fitness value is a measure of how close or how far each potential solution is from the style that we are trying to imitate. If one or more (as desired) of the new potential solutions is already perfect (i.e., already fits the desired style) according to the evaluation procedure, the evolutionary process stops (or, alternatively, if the search has gone on for too long without successfully producing any imitations). Otherwise, a selection procedure sorts the potential solutions in the temporarily expanded population according to fitness value, keeps the best of them, and discards the rest.

The individuals that are kept become the initial population for the next evolutionary cycle. This new population may include both old and new potential solutions (*i.e.*, some carried over from previous generations and some newly-generated ones), and the process repeats itself.

As many people have remarked (*e.g.*, [15]), creative solutions generated by people are hardly ever completely novel with respect to what has come before; rather, they tend to combine and/or tweak certain aspects of previously-existing solutions in a creative way. While there is a general agreement that, in retrospect, the features of new solutions can often be traced back to previous solutions that were combined and/or modified, there is less certainty about how to achieve these two types of transformation of known solutions to achieve new, creative ones. One way in which these two desired effects, combination and tweaking or modification, can be directly achieved algorithmically is by using the two genetic operators of crossover and mutation, respectively. When we analyze Figure 1 to determine what it is that is being combined and/or modified in our process model, we note that it is a population (of potential solutions) that is operated on by crossover and mutation. However, what exactly does this population consist of?

Eventually, over time, the population that is processed by the evolutionary algorithm consists at least partly of potential designs or paintings that were generated by the evolutionary algorithm in previous generations. But initially what is the contents of the population? If we want to combine and modify aspects of previously-existing solutions, this would seem to indicate that the initial population should consist of known solutions. Fortunately, to achieve our task of style imitation we already have known solutions to draw from: exemplars of the style that we would like to imitate. For other design-related tasks, depending on how creative one wants to be, it might not always be so easy to have access to previously-known solutions as for style imitation. On the other hand, if the initial population consists exclusively of exemplars, then producing any new solutions that do not consist solely (and boringly) of some combination of the features of the already-existing solutions would take a very long time, and would depend on the efficiency and effectiveness of the mutation operator. Thus, in addition to exemplars we recommend placing some randomly-generated solutions into the initial population to add some variety into the population, a popular trait used in most evolutionary algorithms. This raises the question: how much of each (exemplars and random "solutions")? In the following section we discuss this issue with respect to our implementation domain.

The other aspect that needs to be discussed is evaluation. Our process model involves the evaluation of the solutions in the initial population and of each new potential solution generated and placed into the population during the evolutionary algorithm. There is also the matter of selecting the best individuals in the population before starting each new evolutionary cycle, which depends on the results of the aforementioned evaluation. Some points that have to be taken into account with respect to evaluation are: 1) in the initial population those individuals that are real exemplars (as opposed to randomly-generated "solutions") of the style to be imitated should be awarded a fitness of 100% by the evaluation procedure, 2) the randomly-generated initial individuals and the potential solutions that are newly generated during each evolutionary cycle should be awarded a degree of fitness that depends on how closely they fit within the style that is being imitated, and 3) the evolutionary process has successfully imitated the style when an individual in the population that was not there initially gets awarded a fitness of 100%. Because of this there are some major, though perhaps subtle, differences between our process model and standard evolutionary algorithms, which generally begin with a completely random initial population, none of whose individuals have a 100% fitness, or anywhere close to that, and where convergence usually takes place the first time that any individual's fitness reaches or approaches 100%.

How to determine the degree of fit of a given design to a given style is the key factor in the evaluation procedure. We propose that the same exemplars that are used to seed the initial population of the evolutionary algorithm can be used to generate a generic description of the style that is being imitated, which can then be used during the evaluation phase of the evolutionary algorithm. Whether this generic description is obtained through a process of knowledge engineering, data mining, training a neural network to recognize the style, or some other means, depends on the appropriateness of each of these possible methods for each domain. In the following section we also discuss this issue with respect to our implementation domain.

Mondrian

The Dutch painter Piet Mondrian, who was active mainly in the first half of the 20th century, like many other modern painters, started his career painting landscapes, human figures, and other realistic subjects. Eventually, however, he developed his own distinctive and abstract style, which came to be called simply *de stijl*, which is Dutch for "the style." Paintings

in Mondrian's style typically include vertical and horizontal black lines painted over a white background, with some or all of the primary colors (blue, red, and yellow), plus black, filling in some of the square or rectangular regions (or parts of the regions) that are separated out from the background by the black lines. It is in order to imitate this style that we implemented a system that follows our process model.

In the MONICA (MONdrian-Imitating Computer Artist) system we have 55 paintings by Mondrian that we use as exemplars of his style. These 55 paintings do not include his early, non-abstract work, his lozenges (following the style described above but painted on diamond-, rather than rectangle-shaped canvases), or his later work (in which he started to use colored lines, sometimes multi-colored lines, rather than just black lines, to separate out the white or colored regions in his paintings). In Figure 2 we show the 55 exemplars we used in MONICA, which were obtained from several Internet websites or scanned from one of two books, [16] and [17].

Through a series of experiments whose details are beyond the scope of this paper, we determined that, for our domain and representation, the optimal mixture of individuals in the initial population of the evolutionary algorithm to ensure quicker convergence is to use 60% exemplars and 40% randomly-generated individuals. Therefore our evolutionary algorithm operates on populations of 92 individuals which consist initially of 55 exemplars and 37 randomly-generated ones. The details of the experiments and the representation scheme we used for the exemplars are presented in [18].

For the Mondrian domain we figured it would be relatively simple to come up with a series of evaluation rules based on our own observations of the patterns present in the 55 exemplars we were able to find. The series of evaluation rules we implemented pay attention to such factors as the total number of vertical or horizontal lines present in a painting, the total number of colored regions present in a painting, the locations of the colored regions with respect to the black lines and/or the edge of the canvas, and the thickness of the black lines. Judging from the 55 exemplars, it seems to us that Mondrian was also taking into account these constraints while producing new paintings in *de stijl*, at least subconsciously. The implemented rules can be consulted in [18] or in [19], where we also show the high degree of agreement that occurs between the ranking of a preselected set of potential solutions evaluated using the system's rules and the ranking of the same potential solutions when evaluated by human subjects in an experiment.

The series of evaluation rules we implemented take into account what seem to us, after a careful analysis of the exemplars, to be the general

characteristics and limits of Mondrian's style. For other implementation domains perhaps it would have been necessary to use neural networks or data mining techniques, rather than doing the necessary knowledge engineering manually. It is also not necessary for rules to be used as the generic representation scheme for the style to be imitated; design prototypes [20], genotypes as in [14], or other knowledge representation schemes can be used instead.

Fig. 2 (part a). Exemplars of Mondrian's paintings

Fig. 2 (part b). Exemplars of Mondrian's paintings

Fig. 2 (part c). Exemplars of Mondrian's paintings

Experimental setup and results

In order to test the effectiveness of MONICA we designed an experiment in which we would be able to determine whether people in general are able to distinguish between paintings produced by MONICA and original paint-

ings produced by Mondrian. The experiment was performed in two phases for reasons which will be explained below. In both phases we used the five Mondrian-style paintings produced by MONICA that are shown in Figure 3.

Fig. 3. Five Mondrian-style paintings produced by MONICA

In both phases we tried two experimental setups. In the first setup we put each one of the five MONICA-produced paintings shown in Figure 3 next to the nine Mondrian paintings that seemed to us to be closest to the set of five MONICA paintings. These Mondrian paintings were probably the direct genetic predecessors which produced the MONICA paintings from Figure 3 after a small number of evolutionary cycles, and are shown in Figure 4. The idea in this setup was to make it as difficult as possible for the experimental subjects to identify each MONICA-produced painting by putting it next to some very similar Mondrian paintings.

Fig. 4. Nine Mondrian paintings that are very similar to the MONICA paintings from Figure 3

In the second setup we put each one of the five MONICA-produced paintings shown in Figure 3 next to the nine Mondrian paintings that

seemed to us furthest from the five MONICA paintings. These Mondrian paintings are shown in Figure 5. The idea behind this setup was to serve as a control for the first setup by making it easier for the subjects to identify the MONICA-produced painting, as it would be as different as possible to the Mondrian paintings shown to them, while in theory still fitting within the same style.

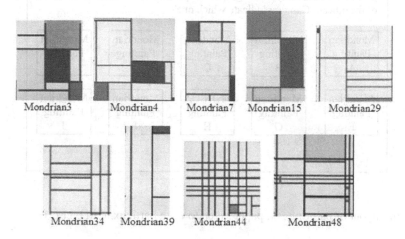

Fig. 5. Nine Mondrian paintings that are relatively dissimilar to the MONICA paintings from Figure 3

In all the experiments we performed, our subjects were given a sheet of paper on which we presented ten paintings, nine painted by Mondrian and one produced by MONICA, in two rows of five, the layout of which was different for each phase. In the sheet of paper was the following text: "One of the following paintings was not painted by the same artist as all of the others. Can you indicate which one?" The experimental subjects all participated voluntarily, were undergraduate students, mainly of engineering, mathematics, actuarial science, economics, and accounting degrees, and were told that they could take as much time as they would like to answer the survey. If the MONICA-produced paintings are virtually indistinguishable from the Mondrian paintings, and if none of the Mondrian paintings stand out compared to the others, we would expect each painting on the sheet of paper that was handed out to each participant to be chosen approximately 10% of the time.

Phase 1

The layout of the paintings that we presented to our experimental subjects during phase 1 is shown in Figure 6.

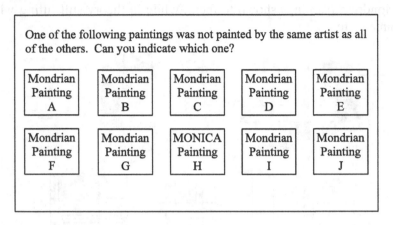

Fig. 6. Layout of paintings on paper given to each participant in phase 1

Phase 1 was split into two experiments. In the first experiment, the nine Mondrian paintings in positions A-G, I, and J from Figure 6 were the ones shown in Figure 4, the ones that are very similar ones to the MONICA paintings, using an ordering that we chose at random but that remained fixed across the experiments. In the second experiment, the nine paintings in positions A-G, I, and J from Figure 6 were the ones shown in Figure 5, the ones that are relatively dissimilar to the MONICA paintings, again choosing a random ordering for the Mondrian paintings that then remained fixed.

Each of the two experiments had five variants, one for each of the MONICA paintings. These MONICA paintings were always shown in position H, the middle position of the lower row of paintings on the paper handed out to the participants, in order to avoid having the results of the experiments vary according to the physical locations of the paintings on the page. Thus, we numbered the experiments 1-1, 1-2, ..., 1-5 and 2-1, 2-2, ..., 2-5. In total we had 282 respondents whose answers were not cancelled, spread equally among the different variants of the experiments, so there were nearly 30 volunteers that performed each variant of the experiments.

Figure 7 shows the results (the percentage of time each of the ten paintings shown on the handout was chosen) for experiment 1, Figure 8 the re-

sults for experiment 2, and Figure 9 the results for both experiments combined.

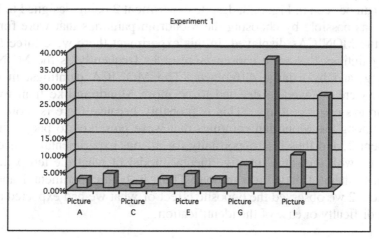

Fig. 7. Results of experiment 1

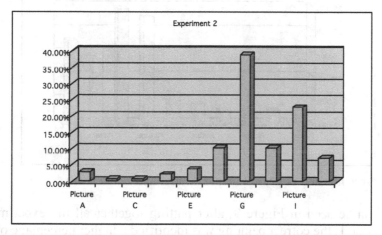

Fig. 8. Results of experiment 2

As can be seen in Figure 7, despite the fact that experiment 1 was designed purposefully to be as difficult as possible for the participants, since the Mondrian paintings that were chosen to be shown next to the MONICA ones were as close as possible to the MONICAs, the correct answer was chosen 37% of the time, at least 10% more frequently than any other painting shown. However, there was also one Mondrian painting (in position J, corresponding in this experiment to the painting labeled Mondrian37 in

Figure 4) chosen with very high frequency (26%), and therefore deemed by many people to not fit Mondrian's style.

As can be seen in Figure 8, despite experiment 2 being designed to be as "easy" as possible by choosing the Mondrian paintings that were furthest from the MONICAs displayed, in this experiment there were three Mondrian paintings that were chosen more or as frequently as the MONICA painting, and by a large difference. The MONICA paintings, in other words, were on average deemed to be more Mondrian-like than two of Mondrian's own paintings. This is probably because there is more variance among the Mondrian paintings that were presented to people in experiment 2, and thus less opportunity for all our experimental subjects to come up with the same intuitive mental model of what the ten paintings shown to them all have in common. Thus, in both experiment 1 and experiment 2 we observed the opposite effect of what we had expected as far as the difficulty or ease of the identification.

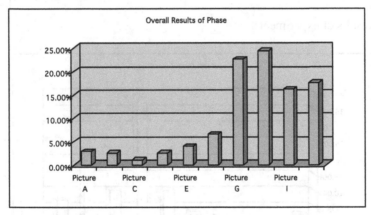

Fig. 9. Overall results of phase 1 (experiments 1 and 2 combined)

As can be seen in Figure 9, after putting together all the experiments from phase 1, the correct painting was identified a higher percentage of the time (23%) than any other. We can also see from the figure that each of the five paintings on the bottom row of the paper handed out to the participants was chosen more frequently than any of the paintings from the top row. This led us to believe there to be a bias towards choosing a painting on the bottom row, on which people were perhaps focusing their eyes more for some reason. This is the reason we decided to perform a phase 2 of the experiment.

Phase 2

In phase 2 we decided to flip the top and bottom rows of paintings in the papers handed out to the experimental subjects to eliminate the bias towards choosing one of the bottom-row paintings. In addition, though it was not printed on the handout, we also asked the subjects to explain their reasons for choosing a given painting over the others, if they could, in order to have additional information. The layout of the paintings that we presented to our experimental subjects during phase 2 is thus shown in Figure 10.

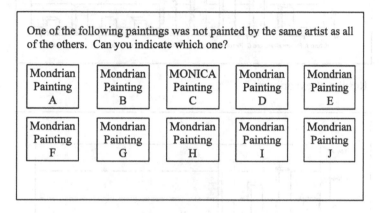

Fig. 10. Layout of paintings on paper given to each participant in phase 2

Like phase 1, and for the same reasons, phase 2 was divided into two experiments, each of which had five variants, labeled experiments 3-1, 3-2, ..., 3-5 and 4-1, 4-2, ..., 4-5. In phase 2 we had a total of 145 respondents whose answers were not cancelled (i.e., just under 15 for each variant of the experiment), perhaps a low number, but these experiments were complementary to the ones from phase 1, giving us further information on the same things, rather than designed to substitute them.

Figure 11 shows the results (the percentage of time each of the ten paintings shown on the handout was chosen) for experiment 3, Figure 12 the results for experiment 4, and Figure 13 the results for both experiments combined.

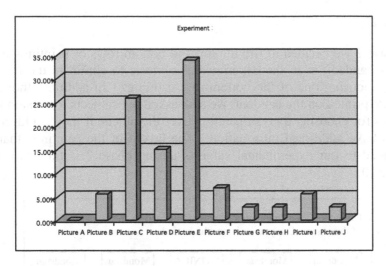

Fig. 11. Results of experiment 3

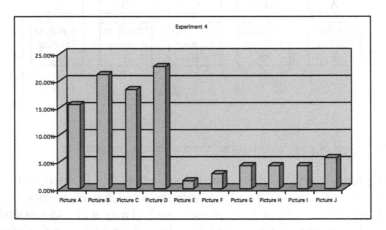

Fig. 12. Results of experiment 4

As can be seen in Figure 11, picture E, produced by Mondrian, was chosen more frequently (33% of the time) than picture C, produced by MONICA (which was chosen 25% of the time) as not fitting into the same style as the rest (picture E in this experiment corresponds to the picture labeled Mondrian37 in Figure 4, just as in experiment 1). However, the MONICA painting was still identified more than the 10% of the time that would be expected if it were completely indistinguishable from the others.

As can be seen in Figure 12, pictures D and B, produced by Mondrian (labeled Mondrian44 and Mondrian39, respectively, in Figure 5), were chosen more frequently (22% and 20% of the time, respectively) than pic-

ture C, produced by MONICA (which was chosen 18% of the time) as not fitting into the same style as the rest. However, the MONICA painting was still identified more than the 10% of the time that would be expected if it were completely indistinguishable from the others.

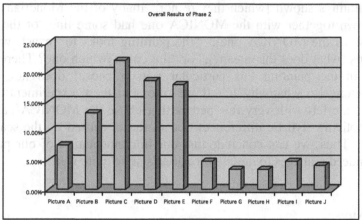

Fig. 13. Overall results of phase 2 (experiments 3 and 4 combined)

What we can observe from the overall results of phase 2 shown in Figure 13 is that the bias we observed in phase 1 towards choosing one of the paintings from the bottom row is not present anymore. In fact, just the opposite: people were now choosing paintings from the top row most of the time. Therefore, it appears that that "bias" was not due to the positions of the paintings on the handout, but rather must be due to something more inherent to that particular set of five paintings (actually ten paintings, five used in experiments 1 and 3, and a different five used in experiments 2 and 4) which were on the bottom row in phase 1 and on the top row in phase 2, which keep being chosen more frequently no matter their position on the page with respect to the others.

Of the 32 respondents (22%) in phase 2 who chose the MONICA-produced painting, most of them (17) gave reasons that were caused by them picking up on unfortunate and unintended visual cues whose existence we did not realize until after the experiment was performed. These visual cues were artifacts of the scanning process we used to obtain most Mondrian paintings before printing the handout that was given to the experimental subjects, such as the fact that the "white" background of most paintings scanned from books came out looking slightly grayish in the digitized image. This contrasts quite clearly with the pure white background of all the paintings produced by MONICA. Thus, these 17 respondents gave reasons such as "different colors and clarity," "sharper image," "more

brilliant colors," "different tones," "different shade of blue/violet" for choosing the MONICA painting. A further 10 respondents gave what we would call nonsense reasons, or at least non-understandable reasons, for choosing the MONICA painting, such as "the lines are thicker than in the other paintings shown [which they're not...many of the Mondrian paintings shown together with the MONICA one had some lines of the same thickness as the MONICA one]," "the painting looks too exact, without variations [what does this mean?]," or "the color [which one? There were several in the painting this particular person chose] does not correspond/belong [to what/why?]." If we filter out these experimental subjects, we are left with very few people that chose the MONICA painting due to noticing stylistic differences that were not caused by the scanning process. Thus, we can conclude that our implementation of our process model indeed manages to imitate Mondrian's style quite well.

Discussion

In this paper we presented a process model, which is based on evolutionary algorithms, whose task is to imitate an existing design style. A key aspect of the process model is the existence of exemplars of the style, which serve both as a key component of the initial population of the algorithm and as a key aspect of being able to perform the evaluation phase of the algorithm effectively. We then described a particular style that we wanted to imitate, the Dutch painter Mondrian's, and a system called MONICA which implements the process model for the Mondrian domain.

After, we discussed and presented the results of a series of experiments that were designed to test the effectiveness of MONICA. Our final conclusion is that MONICA indeed manages to imitate Mondrian's style quite well. In addition to this conclusion, the results of the experiments also permit us to make several observations with respect to the notion of style in general and the attempt to imitate it computationally in particular.

First, the fact that in some experiments Mondrian paintings were chosen by people as being less Mondrian-like than the MONICA-produced paintings, despite them being specifically chosen to be as close as possible to the MONICA paintings, leads us to comment on the fact that the concept of style in general, and any given style in particular, seems to be a radial category, as defined in [21]. These are categories which are easier to describe to others by showing one or more prototypical examples than by explicitly articulating a generic linguistic definition of the concept. Implicit in this kind of category is the fact that different objects will have different

degrees of pertaining to the category depending on their distance from the prototypical exemplar(s). Also implicit is the fact that the boundaries of the category are in general undefined or fuzzy. Hence, people's impressions on the differing degrees of Mondrianness of even the Mondrian-produced paintings, not to mention the MONICA paintings, as shown by the results of the experiments.

This observation about style being a radial category is also reinforced by the fact that in phase 2 of the survey there was a relatively large percentage of the people who could not coherently articulate their reasons for choosing one painting over another. It also confirms the appropriateness of several aspects of the design of our process model, for instance the fact that it's based on using exemplars as starting points for coming up with new potential solutions, the fact that it's functioning is based on assigning a fitness value according to the degree of Mondrianness of the individuals in the evolutionary algorithm population, and the fact that this value is calculated based on measuring the distance of each individual to the exemplars. In the future we want to continue using this process model to explore its effectiveness in imitating more styles, both visual (other painters) and non-visual (e.g., musical). For styles that are more complex than Mondrian's, it may not be feasible to come up with a set of rules that describe and constrain the style (which can be seen as an explicit linguistic definition of the style, as the rules make reference to certain types of descriptive features and their values), and some other form of knowledge representation that instead embodies prototypical examples of the style may have to be used.

References

1. Mitchell M (1998) An introduction to genetic algorithms. MIT Press, Cambridge, MA
2. Bentley P (ed) (1999) Evolutionary design by computers. Morgan Kaufmann Publishers, San Francisco, CA
3. Bentley P, Corne DW (eds) (2002) Creative evolutionary systems. Morgan Kaufmann Publishers, San Francisco, CA
4. Todd S, Latham W (1999) The mutation and growth of art by computers. In Bentley P (ed), Evolutionary Design by Computers, Morgan Kaufmann Publishers, San Francisco, CA: 221-250
5. Witbrock T, Neil-Reilly S (1999) Evolving genetic art. In Bentley P (ed), Evolutionary Design by Computers, Morgan Kaufmann Publishers, San Francisco, CA: 251-259
6. Rowbottom A (1999) Evolutionary art and form. In Bentley P (ed), Evolutionary Design by Computers. Morgan Kaufmann Publishers, San Francisco, CA: 261-277

7. Rooke S (2002) Eons of genetically evolved algorithmic images. In Bentley P, Corne DW (eds), Creative Evolutionary Systems, Morgan Kaufmann Publishers, San Francisco, CA: 339-365
8. Pagliarini L, Lund HH (2002) Art, robots, and evolution as a tool for creativity. In Bentley P, Corne DW (eds), Creative Evolutionary Systems, Morgan Kaufmann Publishers, San Francisco, CA: 367-385
9. Hancock PJB, Frowd CD (2002) Evolutionary generation of faces. In Bentley P, Corne DW (eds), Creative Evolutionary Systems, Morgan Kaufmann Publishers, San Francisco, CA: 409-424
10. Eiben AE, Nabuurs R, Booij I (2002), The Escher evolver: evolution to the people. In Bentley P, Corne DW (eds), Creative Evolutionary Systems, Morgan Kaufmann Publishers, San Francisco, CA: 425-439
11. McCorduck P (1991) Aaron's code. Freeman
12. Cha M-Y, Gero JS (1999) Style learning: inductive generalisation of architectural shape patterns. In Brown A, Knight M, Berridge P (eds), Architectural Computing from Turing to 2000, eCAADe, University of Liverpool, UK: 629-644.
13. Gero JS, Jupp JR (2003) Feature based qualitative representation of architectural plans. In A Choutgrajank, E Charoenslip, K Keatruangkamala and W Nakapan (eds), CAADRIA03, Rangsit University, Bangkok: 117-128
14. Ding L, Gero JS (2001) The emergence of the representation of style in design. Environment and Planning B: Planning and Design 28(5): 707-731
15. Boden M (2003) The creative mind: myths and mechanisms. Routledge
16. Deicher S (1999) Mondrian. Benedikt Taschen Verlag GmbH, Cologne, Germany
17. Bax M (2001) Complete Mondrian. Lund Humphries (Ashgate Publishing), Aldershot, UK
18. Gómez de Silva Garza A, Zamora Lores A (2005) Case-based art. In Muñoz-Ávila H, Ricci F (eds), Case-Based Reasoning Research and Development (ICCBR '05), Springer Verlag, Berlin/Heidelberg, Germany: 237-251
19. Gómez de Silva Garza A, Zamora Lores A (2004) A cognitive evaluation of a computer system for generating Mondrian-like artwork. In Gero JS (ed), Design Computing and Cognition '04, Kluwer Academic Publishers, Dordrecht, Netherlands: 79-96
20. Gero JS (1990) Design prototypes: a knowledge representation schema for design. AI Magazine 11(4): 26-36
21. Rosch E (1988) Principles of categorization. In Collins AC, Smith EE (eds), Readings in Cognitive Science, Morgan Kaufmann Publishers, San Mateo, CA: 312-322

DESIGN COGNITION – 2

Using Design Paradigms to Evaluate the Collaborative Design Process of Traditional and Digital Media
Hsien-Hui Tang and Yung-Ying Lee

An Empirical Investigation of Affordances and Conventions
Jeremiah D. Still and Veronica J. Dark

Novices' Satisfactory Design, Some Implications for Performance and Satisficing in Character Design
Tsai-Yun Mou and Chun-Heng Ho

Roles of Negotiation Protocol and Strategy in Collaborative Design
Yan Jin and Mathieu Geslin

Using Design Paradigms to Evaluate the Collaborative Design Process of Traditional and Digital Media

Hsien-Hui Tang and Yung-Ying Lee
Chang Gung University, Taiwan

This paper provides a quantitative examination of the collaborative design process of traditional and digital media in terms of design paradigms. The representative coding schemes are design prototype and reflection-in-action. 20 sets of protocols are analyzed as the statistical basis. The major result is that the averaged position of Function-Behavior-Structure and the number of mature framing could be used as measurement for the quality of the collaborative design process, opening a new direction for protocol research.

Introduction

The last three decades have seen growing importance placed on protocol analysis in design research society since the first design research using protocol [1].

There has been a rapid growth of protocol studies in a wide range of design disciplines, such as architectural design, industrial design, engineering design, commercial design, and electronic design. A number of research topics have appeared to address different aspects of designing, such as sketching, perceiving, design media, design process. Most of these papers are qualitative research. The reasons are firstly it is hard to recruit a great number of good design subjects, and secondly, it is very time-consuming to conduct protocol analysis. With the increase of the complexity of coding scheme, the second problem worsens. Therefore, very little protocol analysis has been re-examined, and very few coding scheme has been re-applied. These establish the beginning of this paper.

Applying previous important protocol analyses, we are interested in examining the quality of the collaborative design process in an attempt to produce quantitative evaluation criteria. They could provide a bridge

connecting design research and design practice. Hopefully, the results of protocol analysis could guide the application of collaborative designing in design practice.

The research problem of this paper is how we could quantitatively measure the quality of the collaborative design process using protocol data. The aim of this paper is utilizing design paradigms to measure the quality of the collaborative design process using traditional and digital media.

The objectives are three. First, we conduct 20 sets of collaborative design experiments, so we have enough number of data sets to run quantitative tests. Second, we re-applied previous successful coding scheme to form a solid foundation. It forms the theoretical base to compare the differences of these design processes. Two design paradigms were applied using design prototype and reflection-in-action coding scheme as representatives. Third, we use the quantitative results of encoded protocol to generate the criteria. They can measure the quality of the collaborative design process.

The reason of focusing on collaborative design process is that we could apply concurrent protocol without further labors on reminding subjects to think aloud, avoiding the possible deficiency of think-alod.

Literature Review

After the first design protocol study, protocol analysis has been widely applied in design community [2]. The delft design conference further established its methodological position [3]. Currently, protocol analysis has become the standard experimental technique for exploring the process and the cognitive activities of designing [4][5]. Two types of protocol approaches have been developed: concurrent and retrospective [6]. In concurrent protocols, the subjects are required to design and verbalize thoughts simultaneously. In contrast, in retrospective protocols, subjects are asked to design first and then retrospectively report the design processes with or without visual aids.

In general, concurrent protocols have been utilized in the process-oriented aspect of designing, which is largely based on the information processing view proposed by Simon [7]. Comparatively, retrospective protocols have been utilized in the cognitive content aspect, which is largely based on the notion of reflection-in-action proposed by Schön [8]. Normally, design researchers choose one or the other methodology according to their research purposes.

In terms of collaborative design, think aloud is the common technique in design studies because members of collaborative design have to communicate verbally to carry on the design process. The think-aloud occurs naturally in the process.

Design Paradigms

In design studies, there have been two design paradigms: information-processing [7] and reflection-in-action [8]. Studies based on information tend to explore the issues of the design process, such as the content of design process or the foci of design reasoning. Studies based on reflection-in-action tend to explore the cognitive behaviors of designers, such as drawing, perceiving, and related cognitive activities.

The representative coding scheme of information-processing is design prototype [9]. It has been applied in several process-oriented protocol studies [10][11]. This coding scheme provides a simple but solid analysis for the reasoning of the design process, including function, behavior, and structure. The term, design prototype, is given in the original paper, and its content is actually an ontology of the design process.

Comparatively, the representative coding scheme of reflection-in-action is produced by Valkenburg and Dorst [12]. It similarly provides a simple descriptive method for understanding the reflective aspects of the design process, consisting of naming, reflection, framing, and moving. The microscopic coding scheme of Suwa, Purcell and Gero [13] is also based on reflection-in-action, but its structure and details focus more on designers' cognitive activities. Since our research topic is the collaborative design process, we apply the coding schemes of design prototype and reflection-in-action by Valkenburg and Dorst [12].

Method

This is a typical protocol studies. Data were collected using think-aloud procedures of protocol analysis in which subjects conducted collaborative design. The experimental procedure is first announcing the instruction and design brief, warming-up, running main experiment, presenting design results by subjects for 5 minutes, and an interview in the end. The 5 minutes presentation and corresponding drawings were used as materials for expert judgment of the design results.

A design competition devised for this research was held to recruit subjects from the third year industrial design students in Taiwan. A group

of two students were qualified to join the competition, and they are free to select their partners from their classmates. 10 groups of students, two third of the class, participated in the design competition, and each team has to finish two design tasks respectively using traditional and digital media in about 60 minutes. Two design tasks were design a USB flash drive that can protect you and a USB flash drive that can wake you up. The levels of difficulties were regarded as similar by two design experts. Marketing and supportive information about current USB drives were provided. It should be noticed that twenty subjects in total along with 20 design processes is a large number in design studies using protocol analysis.

Environmental settings of experiments are shown in the follows. Figure 1 illustrates the collaborative design using traditional media where two subjects, marked (1), face to face. The experiment instruction and design briefs, marked (3), were provided. Two cameras, marked (5), and a digital camera, marked (4), were utilized to record the design process with the experimenter, marked (2), taking memos for observational findings.

Figure 2 illustrates the collaborative design using digital media where two subjects, marked (1), were located separately in two rooms. The experiment instruction and design briefs, marked (3), were provided. Four cameras, marked (5), and two digital cameras, marked (4), were utilized to record the design process with two experimenters, marked (2), taking memos for observational findings respectively in two rooms. The digital media included WACOM digitizer and ALIAS sketchbook pro, to establish a digital sketching environment. A LCD monitor and web cam with MSN software in each room provided face to face video image, namely being virtually co-located.

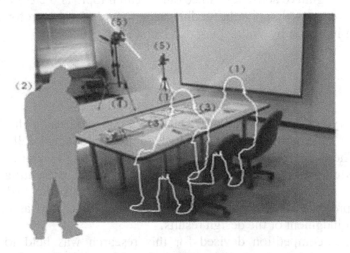

Fig. 1. The experimental setting using traditional media

The settings for digital media were devised in an attempt to provide a digital sketching environment that is almost no differences to the traditional sketching environment. That is pens and papers. With the help of the digitizer and the sketching software, subjects can easily adapt to the system with their own habits of using pens and papers. Most of design studies on media, however, utilized either too complicated CAD packages, such as Alias, or low-resolution software, such as MS Paint, to produce a fair comparison.

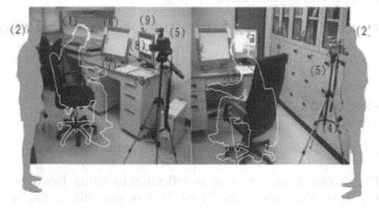

Fig. 2. The

After conducting experiments, we began the analysis, including transcribing protocol, segmentation, encoding protocols, and producing qualitative descriptions and quantitative results to verify our hypotheses. The protocol was parsed by the intention of the subjects. The coding schemes were reflection-in-action and design prototype, respectively being the representatives of two design paradigms. Details of the coding schemes are described in the follow.

CODING SCHEMES

The verbal conversations between members during the collaborative design process were transcribed into protocols. They were then parsed by subjects' intention. Namely, if finding a coherent idea in the protocols, researchers separated it from the rest to form a single segment. It therefore consisted of several words or sentences, representing a single intention of the design team. Each design process produced different numbers of segment. The **segment number** is not necessarily related to the length of time but to indicate the amount of design intention shift. Each segment was categorized into one type of the coding scheme.

Two coding systems were selected from previous studies of protocol analysis. The first one is design prototype based on information processing theory. It consists of three categories: function, behavior, structure. Function corresponds to the users' need, the service the system will provide, the purpose of the artifact. Behavior corresponds to the system's documented and actual requirements, how the system and its sub-systems work. Structure corresponds to the design of the system and its physical form. Details of the system are shown at Figure 3, including the separation of behavior and documentation [14].

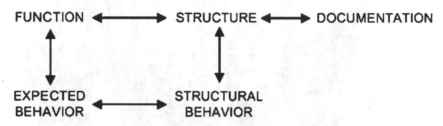

Fig. 3. The full structure of design prototype (Gero 1990)

The second coding scheme is reflection-in-action based on Schön's theory [15]. Valkenburg and Dorst [12] devise this coding scheme to describe the nature of team design, and their findings have them won the best paper of the year. The coding scheme consists of four activities: naming, framing, moving, and reflection. During the naming-activity the team is explicitly pointing to parts of the design as being important or is looking for relevant issues needed to focus on. During the framing–activity, the team is setting the context for the next activities or is framing a (sub) problem or (partial) solution to explore further. During the moving-activity, the team is trying to solve the problem, for example generating ideas, drawing, and comparing concepts. During the reflection-activity the team is evaluating earlier activities to know what to do next.

The four activities could visualize the design process, as shown in Figure 4. Valkenburg and Dorst [12] visualized two design teams attending The Philips Design Competition, and concluded that reflection-activity was the core for successful collaborative design process.

Results

The final results of each team with its 5-minutes presentation was used as material for expert judgment. 6 expert judges, 2 from industry and 4 from

education, evaluated the participants' design results. Judges gave scores from 9 to 1 in terms of seven aspects: design concept, function, material, scenario, creativity, aesthetics, and completeness. The scores of each team using both media were listed in Table 1. Each team has two scores, one for design using digital media and one for traditional. The design teams were listed by the rank of the sum of both scores. If these two media do not cause the differences in the design results, the rank could represent the quality of the end products produced by a design team.

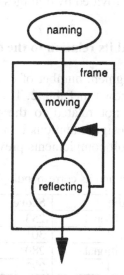

Fig. 4. Visualizing the design process using Reflection-in-action

Table 1 The score of expert judgment and ranks for each design team

Design Team	Digital Media	Traditional Media	Sum	Rank
A	301	253	554	1
D	272	280	552	2
C	305	235	540	3
F	245	275	520	4
G	219	294	511	5
H	221	290	494	6

E	248	246	494	7
I	213	251	464	8
B	222	201	423	9
J	216	196	412	10

The scores across different judges were examined for their reliability. Cronbach's alpha value, being 0.833, indicated that the external consistency of the scores provided by 6 judges was reliable.

The segment number and its relation to the design results

The results showed the segment number of design process was not related to the design results, as shown in Table 2. This implies that the number of design intention shift is not related to the performance of the design process. The number of design intentions in a design team does not affect its design results. This result complements previous study.

Table 2 The segment number and its corresponding rank in each team

Rank	Team	Media	Score	Segment Number
1	A	Traditional	253	779
		Digital	301	702
2	D	Traditional	280	216
		Digital	272	178
3	C	Traditional	235	525
		Digital	305	530
4	F	Traditional	275	445
		Digital	245	416
5	G	Traditional	294	359
		Digital	219	372
6	H	Traditional	290	335
		Digital	221	334
7	E	Traditional	246	397
		Digital	248	403
8	I	Traditional	251	534
		Digital	213	501
9	B	Traditional	201	516
		Digital	222	506
10	J	Traditional	196	375
		Digital	216	381

Tang [16] demonstrated the experienced designers have more segment number than a novice, meaning that a design expert handles more design issues than a student due to a bigger chunk of knowledge. However, we demonstrate that this phenomenon is not significant amongst students, even though they perform differently. The differences between students do not exceed that between experts and novices.

The encoded protocol using design prototype

The raw protocol was encoded by two coders. The proportion of encoded protocol using design prototype is shown in Table 3. The results of design process using traditional (T) and digital (D) media was presented separately in terms of function, behavior, and structure.

The results showed the distribution of function-behavior-structure was not related to the rank of design results. This implies that the proportion of design prototype is not related to the performance of the design process. This idea is not examined in previous studies using design prototype [10][11].

Table 3 Proportion of encoded protocol using design prototype for each team

Team	Rank	Media	Function	Behavior	Structure
A	1	T	5%	92%	3%
		D	5%	93%	2%
D	2	T	9%	86%	5%
		D	7%	90%	3%
C	3	T	7%	90%	3%
		D	5%	91%	4%
F	4	T	4%	93%	3%
		D	3%	94%	3%
G	5	T	3%	93%	4%
		D	4%	92%	4%
H	6	T	3%	95%	2%
		D	4%	92%	4%
E	7	T	8%	88%	4%
		D	7%	91%	2%
I	8	T	4%	93%	3%
		D	3%	92%	5%
B	9	T	2%	92%	6%
		D	4%	95%	1%
J	10	T	5%	92%	3%
		D	5%	92%	3%

In terms of Function-Behavior-Structure, the difference of design process between media in one team was measured using Chi-Square. If the difference between media is significant, our following discussion should be divided into two parts, presenting the findings of collaborative design using traditional and digital media separately.

Table 4 The Chi-Square value of different media in terms of design prototype

Team	Rank	Media	Observation Value	Chi-Square Value	d.f
A	1	Traditional	0.91	$\chi^2 =1.92<5.99$	2
		Digital	1.01		
D	2	Traditional	0.33	$\chi^2 =0.73< 5.99$	2
		Digital	0.40		
C	3	Traditional	1.34	$\chi^2 =2.67<5.99$	2
		Digital	1.33		
F	4	Traditional	0.42	$\chi^2 =0.87<5.99$	2
		Digital	0.45		
G	5	Traditional	0.38	$\chi^2 =0.75< 5.99$	2
		Digital	0.37		
H	6	Traditional	1.49	$\chi^2=2.98< 5.99$	2
		Digital	1.49		
E	7	Traditional	1.49	$\chi^2 =2.97< 5.99$	2
		Digital	1.47		
I	8	Traditional	1.42	$\chi^2 =2.93< 5.99$	2
		Digital	1.52		
B	9	Traditional	1.89	$\chi^2 =3.82<5.99$	2
		Digital	1.93		
J	10	Traditional	0.7	$\chi^2=0.14< 5.99$	2
		Digital	0.6		

As shown in Table 4, the differences between media in each team are not statistically significant. The environments of different media did not cause differences in the encoded protocol of the design process. We can assume that the two design processes of each team are the same in terms of design prototype.

The encoded protocol using reflection-in-action

The raw protocol was encoded by two coders again using reflection-in-action. The proportion of encoded protocol using reflection-in-action is

shown in Table 5. The results of design process using traditional (T) and digital (D) media was presented separately in terms of naming, framing, moving, and reflection.

The results showed the distribution of naming-framing-moving-reflection. was not related to the rank of design results. This implies that the proportion of reflection-in-action is not related to the performance of the design process. This is actually inconsistent with the results of Valkenburg and Dorst [12] in which the number of reflection was related to the design performance.

Table 5 Proportion of encoded protocol using reflection-in-action for each team

Team	Rank	Media	Naming	Moving	Framing	Reflection
A	1	T	5%	81%	2%	12%
		D	5%	78%	3%	14%
D	2	T	9%	74%	3%	14%
		D	7%	71%	5%	17%
C	3	T	7%	82%	2%	9%
		D	5%	85%	2%	8%
F	4	T	4%	77%	3%	16%
		D	3%	80%	3%	14%
G	5	T	4%	79%	4%	13%
		D	4%	79%	4%	13%
H	6	T	3%	80%	4%	13%
		D	3%	80%	4%	13%
E	7	T	8%	76%	3%	13%
		D	7%	77%	5%	11%
I	8	T	3%	84%	3%	10%
		D	3%	87%	2%	8%
B	9	T	6%	76%	3%	15%
		D	4%	80%	2%	14%
J	10	T	5%	78%	6%	11%
		D	3%	86%	3%	8%

In terms of reflection-in-action, the difference of design process between media in one team was measured using Chi-Square. If the difference between media is significant, our following discussion should be divided into two parts, presenting the findings of collaborative design using traditional and digital media separately.

As shown in Table 6, the differences between media in each team are not statistically significant. The environments of different media did not cause differences in the encoded protocol of the design process. We can

assume that the two design processes of each team are the same in terms of reflection-in-action.

Table 6 The Chi-Square value of different media in terms of reflection-in-action

Team	Rank	Media	Observation Value	Chi-Square Value x^2	d.f
A	1	T	1.66	(x^2 =3.49< 7.82)	3
		D	1.84		
D	2	T	0.62	(x^2 =1.36< 7.82)	3
		D	0.75		
C	3	T	1.75	(x^2 =3.48< 7.82)	3
		D	1.73		
F	4	T	0.75	(x^2 =1.55< 7.82)	3
		D	0.80		
G	5	T	0.73	(x^2 =1.43< 7.82)	3
		D	0.70		
H	6	T	0.13	(x^2=0.25< 7.82)	3
		D	0.13		
E	7	T	1.19	(x^2 =2.36< 7.82)	3
		D	1.17		
I	8	T	0.49	(x^2 =0.96< 7.82)	3
		D	0.46		
B	9	T	1.97	(x^2 =3.97< 7.82)	3
		D	2.00		
J	10	T	3.01	(x^2=5.98< 7.82)	3
		D	2.97		

To summarize, we find that the number of segment, proportion of design prototype and reflection-in-action, as the measurement of performance of the design process, are not related to the design results in terms of the rank of their scores. Next section, we look into the encoded protocol using the essential meaning of design prototype and reflection-in-action in an attempt to relate rank of the design results to the encoded protocol of the design process.

Discussion

The segment number, the proportion of design prototype, and the proportion of reflection-in-action establish a macroscopic view toward the quality of the collaborative design process. However, there is no

relationship between these factors and the rank of the design results. This research continues to explore this issue from a microscopic view consisting of the essential ideas of design prototype and reflection-in-action.

The position of design prototype

McNeill, Gero and Warren [11] generalizes that a designer begins a conceptual design session by analyzing the functional aspects of the problem, continues by focusing on the three aspects of function, behavior, structure, and ends by focusing on synthesizing structure and evaluating the structure's behavior. This implies a standard of sequential order of time as shown in Figure 5. In the theoretical situation, we assume that the averaged position of function is located in the 25th percentile, the averaged position of behavior is located in the 50th percentile, and the averaged position of structure is located in the 75th percentile. They are the hypothetically ideal location of function-behavior-structure.

Fig. 5. The hypothetically ideal location of function-behavior-structure

We calculated the deviation of the function-behavior-structure from their hypothetically ideal location in terms of averaged segment number. The Δ equals to the sum of D1, D2, and D3. The hypothesis is that a better design process produces a smaller Δ value.

Fig. 6. The calculation of deviation from the idea location

For example, the location of function-behavior-structure of the first team using traditional media is the 17th, the 51st, and the 73rd percentiles, and the total segment number is 779. The Δ value is about 85, and the calculation is $((0.25 - 0.17) + (0.51 - 0.5) + (0.75 - 0.73))*779$.

Table 7 The sum of deviation values of 10 design teams

Team	Rank	Media	Deviation	Sum of D
A	1	T	85.17	99.95
		D	14.78	
D	2	T	10.51	43.91
		D	33.40	
C	3	T	134.09	319.49
		D	185.40	
F	4	T	231.62	439.20
		D	207.58	
G	5	T	15.68	53.09
		D	37.41	
H	6	T	29.06	132.59
		D	103.53	
E	7	T	64.12	166.03
		D	101.91	
I	8	T	70.09	241.13
		D	171.04	
B	9	T	41.29	127.61
		D	86.31	
J	10	T	58.11	179.20
		D	121.09	

We sum up the Δ values of both media of each team, correlating the sum of Δ to the corresponding rank of the team, as shown in Table 7. Findings were the top five teams had smaller Δ values than the last 5, except C and F. The reason why team C and team F had larger Δ values was their spending more time on drawing than other top 5 teams. Therefore, their averaged S positions moved toward the center of time line, increasing the Δ values.

This finding is consistent with McNeill, Gero and Warren [11]. They conclude there is no significant negative slop for the structure category, but the center of gravity for function is significantly before the center of gravity for structure. Although the trend is conceivable, the Δ value is not significantly related to the rank of the design performance.

The number of mature framing activities

Valkenburg and Dorst [12] demonstrated that the number of reflection is related to the design performance, but this phenomenon is not obvious in our data sets. We examined the reflection in our data, finding that the activities triggered by reflection did not always contribute to the design process. Some reflections were not followed properly to form a new direction for the design process. It would be beneficial for the design process that a reflection triggers a series of actions to form a partial solution or a sub-goal. This is named framing in the coding scheme of reflection-in-action. However, the number of framing is not related to the rank of the design results.

This study further examined the framing activity that contains at least 10 segments, and had it named **mature framing**. This kind of reflection really changes the design process in terms of solutions or problems. The proportion of mature framing to the total number of framing in each design process is calculated, shown in Table 8.

Table 8 The proportion of mature framing to the total number of framing for each team

Team	Rank	Media	The number of mature framing
A	1	T	87.5%
		D	82.6%
D	2	T	71.4%
		D	87.5%
C	3	T	90.0%
		D	87.5%
F	4	T	71.4%
		D	71.4%
G	5	T	75.0%
		D	73.3%
H	6	T	58.3%
		D	53.9%
E	7	T	66.7%
		D	50.0%
I	8	T	57.1%
		D	60.0%
B	9	T	33.3%
		D	53.3%
J	10	T	40.9%
		D	45.4%

The results demonstrated a clear separation between the top 5 teams and the last 5. In our cases, a design process consisting of more than 70% of mature framing was among the top 5 ranking teams. The more the number of mature framing the better the final rank. This result is consistent with the visualization of the results in Valkenburg and Dorst [12]. The winner, Team Tecc, had 3 mature framing, while the loser, The Delft Pitchbulls, had only one mature framing. Their research divided the protocol into episodes in which the same activity occurs, and this research distinguished episodes by the objects the teams attend to. Therefore, the number of segments needed to form a mature framing is different.

Conclusions

We can conclude with certainty that this paper provides a beginning for quantitative protocol studies. Our goal is not only to generate statistical results, but also to provide different angels for exploring the collaborative design process. Four of these findings are worth summarizing: first, the segment number, the segment proportion of design prototype, the segment proportion of design reflection-in-action are not related to the rank of the design results. Second, the averaged position of function-behavior-structure is related to the rank of the design results. Third, the number of mature framing is related to the design results. Fourth, the digital environment for conceptual design in this study is no different to the traditional environment of pens and papers in terms of segment number and proportion of our coding schemes.

The results fulfill our purpose of using design paradigms to evaluate the collaborative design process of traditional and digital media, but more issues remains to be resolved in the future research. First, this study should complete all the statistical examination of the results, for example, the relation between the segment number and the rank. Another important issue is re-examining the differences between two media using the averaged position of function-behavior-structure and the number of mature framing. Second, the original score of expert judgment could be utilized instead of the rank of the result. Third and most importantly, we would explore the reason why the relationship of the second and the third findings exist to have better understanding of the quality of the collaborative design process.

This work has potential contributions to design computing and cognition. For design computing, this paper demonstrates that it is possible

to produce an almost identical digital environment compared to traditional pens and papers. Therefore, the trend for CAD development should be connecting this environment to the current CAD/CAM system to form a holistic supplementary environment for designers from concept design to manufacture. Moreover, some excellent works on computational sketching software systems [17] could further incorporate our digital sketching environment to their proof-of-concept software to have better design cognition support. For design cognition, we can start to verify our findings in previous studies of design cognition to form a better scientific base for design computing to continue. Hopefully, the results of this paper can contribute to the connections between design cognition and design computing.

Acknowledgements

We would like to thank Prof. Wen-Ko Chiou for his assistance in statistical examination.

References

1. Eastman CM (1970) On the analysis of intuitive design process. In G Moore (ed), Emerging Methods in Environmental Design and Planning, MIT Press, Cambridge, MA: 21-37
2. Cross N (2001) Design cognition: results from protocol and other empirical studies of design activity. In WC Newstetter, CM Eastman and WM McCracken (eds), Design Knowing and Learning: Cognition in Design Education, Elsevier, New York
3. Cross N, Christiaans H, Dorst K (eds.) (1996) Analysing design activity. John Wiley, Chichester
4. Ericsson KA , Simon HA (1993) Protocol analysis: verbal reports as data. MIT Press, Cambridge, MA
5. Van Someren MW, Barnard YF, Sandberg JA (1994) The think aloud method: a practical guide to modelling cognitive processes. Academic Press, London
6. Dorst K, Dijkhuis J (1995) Comparing paradigms for describing design activity. Design Studies 16: 261-274
7. Simon HA (1992) Sciences of the artificial. MIT Press, Cambridge, MA
8. Schön DA (1995) The refelctive practitioner. Arena, London
9. Gero JS (1990) Design prototypes: a knowledge representation schema for design. AI Magazine 11: 16-36

10. Gero JS, McNeill T (1997) An approach to the analysis of design protocols. Design Studies 19: 21-61
11. McNeill T, Gero JS, Warren J (1998) Understanding conceptual electronic design using protocol analysis. Research in Engineering Design 10: 129-140
12. Valkenburg R, Dorst K (1998) The reflective practice of design teams. Design Studies 19: 249-271
13. Suwa M, Purcell T, Gero J (1998) Macroscopic analysis of design processes based on a scheme for coding designers' cognitive actions. Design Studies 19: 455-483
14. Kruchten P (2005) Casting software design in the function-behavior-structure framework. Software, IEEE 22(2): 52-58
15. Schön DA, Wiggins G (1992) Kind of seeing and their functions in designing. Design Studies 13(2): 135-156
16. Tang HH (2002) Exploring the roles of sketches and knowledge in the interlinked and multimode design process. PhD Thesis, The University of Sydney, Australia
17. Gross M, Do E (2004) The three Rs of drawing and design computation. In JS Gero (ed), Design Computing and Cognition '04, Kluwer, Dordrecht,: 613-632

An Empirical Investigation of Affordances and Conventions

Jeremiah D. Still and Veronica J. Dark
Iowa State University, USA

There is a debate in the literature concerning whether a distinction between affordances and cultural conventions ought to be drawn. It is possible that in the absence of affordances users develop conventions to resolve interaction ambiguity. We explored whether a difference between affordances and conventions existed through a button pressing task. Our results show that affordances exist when the spatial button configuration is congruent with directional cues. When affordances were not available, most participants demonstrated consistent button-to-action mapping that sometimes represented a convention. Additionally, there was no difference in response time in the affordance and convention conditions.

Introduction

A question of concern to designers is why some designs cause repeated failure while others facilitate error free use. That is, what aspects of a design lead the user to more easily comprehend the design's functions? In his book the Psychology of Everyday Things (POET), Norman (1988) suggested that good designs provide implicit visual instructions that constrain how an object should be used [1]. The constraints can be physical, logical, and/or cultural in nature. Because these implicit visual instructions are simply understood and do not demand much cognitive effort (limited working memory resources) to figure out the proper interaction to meet the user's task goals, Norman referred to them as *perceived affordances* in order to distinguish the concept from the more narrow concept of affordances as developed by J. J. Gibson (1970). Gibson coined the term to capture the idea that the physical structure of some object allows observers to directly perceive potential interactions [2].

J.S. Gero and A.K. Goel (eds.), *Design Computing and Cognition '08*,
© Springer Science + Business Media B.V. 2008

In commenting on the many different uses of the term affordance in the design literature, Norman (1999) distinguished between perceived affordances in general and a subclass of culturally constrained perceived affordances that he called conventions [3]. Users cannot ignore affordances because they physically constrain interactions. However, conventions can be ignored because the constraint is learned, rather than physical. Thus, Norman suggested that there is a qualitative difference between conventions, or situations in which the mapping of visual cues to actions is an arbitrary choice of the designer, and affordances, or situations in which the mapping is a natural consequence of the physical world. He suggested that most computer systems are limited to a small number of built-in affordances (e.g., keyboard, pointing device, mouse buttons, etc.), and that these affordances are of little use for facilitating software application interactions. For example, because the user is not physically constrained to click on a specific icon, Norman cautioned that designers should not conclude that an icon within a desktop metaphor affords clicking. To do so would be an incorrect use of Gibson's affordance.

Although the desktop user is physically unconstrained to click on an icon or anywhere else within the visible screen, past experiences of the user will make the clicking on the icon a likely behavior. It is this type of culturally constrained interface interaction (i.e., one that depends on learning) that defines a convention. Another example of a convention is having learned that moving a scroll bar up moves the page up while viewing the document. The relationship between the scroll bar and the page movement is not transparent until the user moves the bar and receives visual feedback [3]. According to Norman, "This is what the interface designer should care about: Does the user perceive that clicking on that object is a meaningful, useful action, with a known outcome?"(p.40).

Implied by Norman's distinction between affordance and convention is that they should be treated differently by the designer. Others, however, disagree with Norman's conceptualization of conventions as distinct from affordances. According to McGrenere and Ho (2000), software application interfaces may afford specific interactions [4]. "The functions that are invokable by the user are the affordances in software... Norman claims that a scrollbar is a learned convention and implies that it is not an affordance. We disagree. The fact that the object affords scrolling is an affordance that is built into the software. The information that specifies this affordance is in fact a learned convention... [Acting on the bar will either move the page up or down]" (p. 6). Additionally, McGrenere and Ho described how users often customize their interfaces making affordances more efficient to undertake. They suggested that affordances are efficient when the execution

of it is rapid, comfortable, and reduces exertion (e.g., hot keys or short-cuts).

Oshlyansky, Thimbleby and Cairns (2004) noted the lack of empirical work associated with perceived affordances in relationship with design [5]. They were interested in how perceived affordances (conventions) vary across similar cultures. To empirically examine a potential cultural differ-ence, Oshlyansky et al. surveyed US and UK students. The participants were asked to determine the current state of a bulb ("ON" or "OFF") based on an image of a light switch. The participants were not told if their re-sponses were correct. The results showed that most participants from the UK reported a light switch in the down position as indicating that a light bulb was "ON" while most of the US participants reported a light switch in the down position as indicating that a light bulb was "OFF". The study provided strong evidence that students from different cultures interpreted the same very simple interaction (i.e., move a switch up or down) in oppo-site ways. Thus, Oshlyansky et al. stressed that designers need to consider previous knowledge when designing interfaces.

The light switch study assessed participant *knowledge* without providing feedback. The results suggested the existence of a different convention in the US and the UK regarding how to interact with a light switch. Our in-vestigation focuses on how users *act* in a very simple situation that some-times offers an affordance and sometimes does not. Our question is whether, when no affordance is available, there will be evidence of a con-vention. We could find no formal definition of a convention in the litera-ture. Therefore, we defined a convention as 80% or more of the users re-sponding in the same way, suggesting that they have learned a meaningful action based on past experience.

We empirically examined conventions (arbitrary button-to-action map-pings) and affordances (natural button-to-action mappings) associated with the spatial configuration of two buttons (or keys) on when the user was acting on directional cues. We asked whether users would adopt consistent button-to-action mappings that might be the result of similar interface in-teractions within their everyday environments. Basically, the task for the user was an analog of a person being asked to navigate a menu with two buttons on a controller. The questions concerned: 1) whether performance would reflect affordances when they were available, 2) whether conven-tions exist when affordances are not available, and 3) whether affordances and conventions would differ in their impact on users.

We explored the possibility that conventions exist within the context of a button pressing task. In this task two buttons were available and the par-ticipant was instructed to try to "move" in one of four specific directions

(i.e., up, down, left, and right). We used the numeric keypad of a standard keyboard in which the buttons closest to the user's body were slightly lower than buttons farther from the user. The spatial configuration of the buttons was manipulated; participants were presented with two buttons arranged vertically, horizontally, or diagonally. The configurations are shown in Figure 1. We assumed that an affordance would be present when the spatial button configuration was congruent with the directional cue (affordance condition). Thus, the vertical buttons (panel A) afforded two directions (up, down) because one button was slightly higher than the other on the keyboard, the horizontal buttons (panel B) afforded two directions (left, right), and the diagonal buttons (panel C) afforded all four directions because the buttons were both above/below and to the side of each other.

We predicted that participants would make the afforded response when it was possible. Of interest was the nature of responses when affordances were not available (i.e., for left/right cues with a vertical orientation of buttons and for up/down cues with a horizontal orientation). In these instances, individual participants could respond in one of two ways. The participant could use a consistent button-to-action mapping (e.g., a participant might consistently choose the right button when given the up cue and the left button when given the down cue) or the participant could select buttons so that there is no consistent pattern. If participants individually show consistency in their responses, then one can ask if there is consistency between participants in the nature of the button-to-action mapping. If a convention exists, then most participants should use the same consistent button-to-action mapping.

A. **B.** **C.**

Fig. 1. Each panel represents one of the two-button configurations used in the current research.

Method

Participants

The university institutional review board approved all experimental procedures. Thirty undergraduate volunteers (28 right handed, 14 females) were recruited to participate in exchange for course research credit in an introductory psychology course. Each participant had normal or corrected to normal vision.

Stimuli and Apparatus

The trials were presented on an HP Pentium 4 Windows XP machine with a 17 inch monitor. On each trial, one of four directional cue words (Up, Down, Left, or Right) was presented centrally in size 48 Arial font. Responses were collected through a PS/2 keyboard's numeric keypad. Only three pairs of keys (six buttons) were used and those keys were covered with the appropriately colored stickers as is shown in Figure 2. Red stickers represented the diagonal configuration by covering keys 5 and 9. Blue stickers represented the horizontal configuration by covering keys 1 and 2. Yellow stickers represented the vertical configuration by covering key 3 and 6. This study was created and executed within E-prime experimental presentation software (Psychology Software Tools, Inc., www.pstnet. com).

Fig. 2. Photograph of the three configurations of two-button pairs as implemented on the keyboard.

Participants were run at individual computer stations in groups of up to four. They wore sound deadening earmuffs and there were dividers between computer stations so that participants could not see each other.

Procedure

Participants faced an ambiguous situation in which they were not instructed *how to act* on the given button configuration, nor was any feedback given. Participants were told, "You will be instructed to place your fingers onto the specified color. Then you will be given a directional cue to either move up, down, left or right. You should move in the direction indicated to the best of your ability given the available button configuration. Your response times are going to be recorded. Please, respond as accurately and as quickly as possible!" At the beginning of each color block they were also given these instructions, "Please place your fingers on the [Red, Yellow, or Blue] buttons. Respond as accurately and as quickly as possible. Press one of the [Red, Yellow, or Blue] buttons to continue." These instructions were intended to encourage participants to make speeded responses and to indicate that one button press was in fact correct for each directional cue. The instructions also ensured that participants' fingers were on the correct buttons before the onset of a block of trials.

Spatial configuration of buttons was manipulated across blocks in a within-subject factorial design with three spatial configurations of the buttons (vertical, horizontal, diagonal) and four directional cues (up, down, left, right). Only two buttons were available for response within each block. There were three blocks: vertical (yellow buttons), horizontal (blue buttons), and diagonal (red buttons). Block order was counterbalanced across participants such that there were three possible block orders (yellow, blue, red; blue, red, yellow; red, yellow, blue) and each participant was assigned to one order. Each block contained 80 trials, 20 with each directional cue. The order of cues within a block was randomized for each participant.

After the instructions for a block were presented, the participant would view a 'Get Ready' slide for 2000 msec which was directly followed by the presentation of a randomly selected directional cue (Up, Down, Left, or Right). Upon seeing the directional cue, the participant would press one of the possible buttons and the next trial would begin. The procedure is illustrated in Figure 3. Participants completed the experiment in approximately 20 minutes and were fully debriefed at the end.

Results

All statistical tests used an alpha level of .05. Error bars in the figures represent the mean standard error. In addition to recording which button was pressed, response times were recorded. Responses on specific trials were

excluded from the analysis if reaction times were less than 200 msec or greater than 2000 msec. This filtering only removed 2% (150 outliers) of the total data. Three dependent variables were examined: response choice, consistency of choice, and response time.

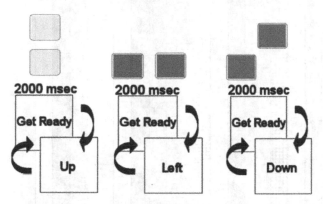

Fig. 3. Schematic representation of the experimental procedure. The arrows indicate the change of displays. The three colors and button configurations represent the three blocks of trials. For each button configuration, a participant was presented 20 trials, each of which began with 'Get Ready' for 2000 msec and then a directional cue (up, down, left, or right) would appear until the participant responded with a button press. The 'Get Ready' slide then appeared, indicating the onset of the next trial.

Response Choice

Participants were faced with a binary response decision on every trial. There were three different sets of binary responses (i.e., three spatial configuration of buttons) and four different cues. For each combination of spatial configuration and cue, we calculated the proportion of times that each response was chosen. Because of the binary nature of the response, a complete picture of the results can be derived from consideration of the proportion of trials of which one of the two responses is made. We had predicted that affordances were present for all cues in the diagonal condition and that an affordance was present only for the up/down cues with the vertical configuration and only for the left/right cues with the horizontal configuration. The proportions of trials on which the afforded response was made in these conditions are presented in solid bars in Figure 4. For the nonaffordance conditions (i.e., left/right cue with the vertical orientation and up/down cues with the horizontal orientation), the response yield-

ing the highest group proportion is displayed in a patterned bar. The associated response is indicated below the bars.

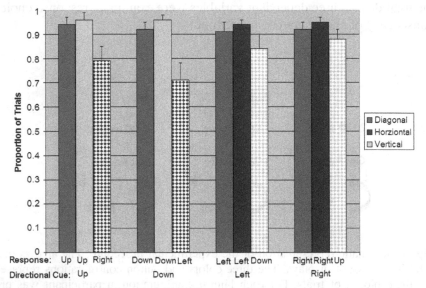

Fig. 4. Proportion of trials on which the group dominant response was made as a function of each combination of button configuration and directional cue. The response under each bar is the dominant choice for that combination. The solid bars represent affordance conditions and the patterned bars represent the nonaffordance conditions.

The first thing to notice is that the proportion of what we had assumed were afforded responses (solid bars) is above 0.90 for all button configurations, suggesting that we were correct in our assumption that affordances were present. The second thing to notice is that although the proportions in the nonaffordance conditions (patterned bars) were well above 0.50 (chance), suggesting regularity in how participants were responding in these situations, the proportions appeared to be lower than in the affordance conditions. The third thing to notice is that the difference in proportions between the affordance and nonaffordance conditions appears to be stronger for the up/down cues than the left/right cues.

A 4 (cue) x 3 (type of affordance: diagonal affordance, horizontal/vertical affordance, no affordance) within-subjects Analysis of Variance (ANOVA) confirmed that the apparent patterns were real. There was a main effect of type of affordance, $F(2,58) = 9.175$, $MSE = .079$, $p < .001$, reflecting lower proportions in the no affordance conditions, however, the Type of affordance x Cue interaction also was significant, $F(6, 174) = 2.27$, $MSE = 0.026$, $p = .039$. A separate ANOVA on just the up/down cues

showed a main effect of type of affordance, $F(2, 58) = 8.64$, $MSE = 0.086$, $p = .001$. Comparisons among the means showed that performance was lower in the no affordance conditions ($M = 0.746$) than in the diagonal affordance ($M = 0.925$) or vertical affordance conditions ($M = 0.952$), which did not differ. A separate ANOVA on just the left/right cues showed only a marginally significant main effect of type of affordance, $F(2, 58) = 2.64$, $MSE = 0.045$, $p = .08$, indicating only a trend for lower performance in the nonaffordance condition.

Consistency of Choice

As expected, participants were influenced by the affordances when they were available. They also appeared to be responding in a consistent manner in the nonaffordance conditions. As noted earlier, the observed consistency could reflect either a general tendency within each individual to make one particular response to each cue or it could reflect a difference in the number of individuals consistently choosing one response with some individuals consistently choosing the other response. In order to determine which might be going on in our data, participants were placed into one of three categories for each combination of cue and configuration. We arbitrarily defined "consistent" responding as making the same response to a given cue 80-100% of the time. Thus, participants could be consistent in making the group dominant response (which is labeled > 79% in the figure), or consistent in making the opposite response (which is labeled < 21%), or they could be not consistent (which is labeled NC). The number of individuals falling into each category for each cue and configuration combination is shown in Figure 5. These categorization data show that even in nonaffordance conditions, individuals are performing in a consistent fashion.

The data presented in Figure 5 confirm the interpretation offered for the response choice data. Affordances exist in the spatial configuration of the buttons. In an ambiguous situation in which individuals are told to make a response indicating a movement, a button that matches the direction of the movement affords a response. We believe that the data also support the existence of conventions. A convention is present when the majority of participants consistently choose the same response when no affordance is present. We operationally defined 80% agreement over participants as indicating the existence of a convention. By this definition, there is a convention in place for mapping right to an up response and left to a down response. The trend for mapping up to a right response and down to a left response is weaker and does not constitute a convention by our definition.

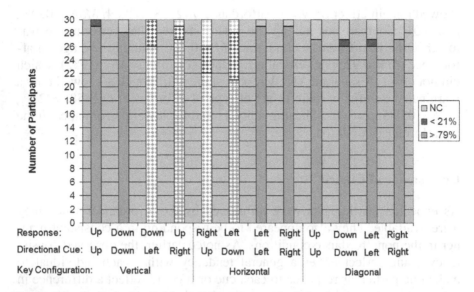

Fig. 5. Distribution of individuals falling into each of the three consistency categories as a function of each combination of button configuration, cue, and response. Solid bars represent affordance conditions and patterned bars represent nonaffordance conditions.

Response Time

Affordances reflect physical information and, therefore, responses to affordances might be faster than responses reflecting a convention (right/left responses in the vertical configuration) or a nonaffordance based consistent response (up/down responses in the horizontal configuration). A difference in response time would support Norman's (1999) suggestion that designers treat affordances and conventions differently. Our final analysis compared the response times in the different cue and configuration combinations for those individuals who consistently gave the most frequent group response in the nonaffordance conditions. Seven participants were excluded from the analysis of response time to the up/down cues and four were excluded from the analysis of the right/left cues because their responses were inconsistent or did not follow the pattern shown by the group as a whole. The mean response times are shown in Figure 6. Although for both the up/down cues and the right/left cues, the responses were numerically faster in the affordance conditions than the nonaffordance conditions, the differences were not statistically reliable. A within-subjects ANOVA on the response times to the up/down cues with cue direction and type of

affordance as variables showed a significant main effect of cue direction, F $(1, 22) = 8.28$, $MSE = 10,626$, $p < .001$, in which responses to the up cue were faster ($M = 560$ msec) than responses to the down cue ($M = 580$ msec). Neither the main effect of type of affordance nor the interaction effect were significant.

A similar ANOVA on the response times to the right/left cues showed no significant differences. We defined the responses to right/left cues in the vertical configuration as reflecting a convention. Although one must be cautious in drawing conclusions from null effects, the similar response times in the convention and affordance conditions in conjunction with the fact that the response times were rather quick, suggests that the choices in both cases were made quickly without much conscious effort.

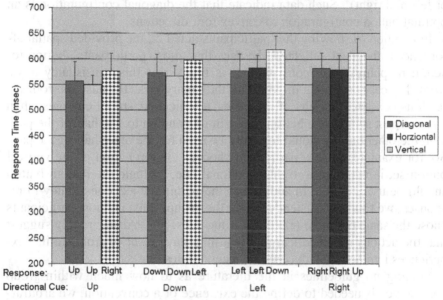

Fig. 6. Response time for participants making the group dominant response as a function of each combination of type of affordance and directional cue. The response under each bar is the dominant choice for that combination. The solid bars represent affordance conditions and the patterned bars represents the nonaffordance conditions. Seven participants were omitted from the analysis of the up/down cues and four participants were omitted from the analysis of the left/right cues.

Discussion

We explored the influence of affordances and conventions, which reflect previous knowledge, on a task in which participants made a speeded response to "move" in a specific direction using two buttons at different spatial configurations. The experiment was designed to answer several questions. One question was whether participants would use an affordance when it was available. The answer is yes. Each button configuration had at least one pair of affordances and in each case, the afforded response was the one made most consistently by participants. We note that performance with the diagonal configuration was just as high for *all* four directional cues as it was when the buttons only afforded two directions (up and down or left and right). Such data indicate that the diagonal configuration is an optimal button configuration to convey four directions.

In addition to showing that participants acted on the provided spatial affordances, the data reflected the fact that most participants' button-to-action mappings were consistent. It is likely that this consistency arose from logical constraints imposed by the binary task. Because the four directions consisted of pairs of opposites, a logical constraint emerges when a participant selects one button to use in responding to one half of the pair, then the other button should logically be used for the other half of the pair. So, for example, when a participant chooses the top button of the vertical button set in response to right directional cue, by logic the bottom button should be used for left. In addition to the within-subject consistency in responses, we found consistency within the group. That is, most participants chose the same button to reflect the same cues. These data strongly suggest that the actions reflected learning that may have resulted from similar experiences interacting with common technologies.

Finding no guidelines in the literature as to how much within-group consistency is needed to define the existence of a convention, we arbitrarily used an 80% criterion. Response to only one of two spatial configurations of buttons satisfied this criterion for the existence of a convention in the nonaffordance conditions – the vertical button configuration. Given the directional cue to move right, the conventional response was to press the top button when using the vertical button configuration. We conjecture that this conventional mapping may be a reflection of common usage. For example, in US automobiles, the turn signal is typically to the left of the steering wheel and is designed so that an up action signals a right turn and a down action signals a left turn. Experience driving leads to an association in long-term memory between the directions and the actions. Figure 7 illustrates another instance of this strong nonaffordance mapping (i.e., this

convention) within a remote control interface design (see Figure 7). Thus, previous experience with button-to-action mappings like this could explain the existence of our convention.

Fig. 7. Example of a remote control device using a two-button configuration for four directions. Notice that the mapping of direction to the button configurations is congruent with our results.

Basically, the idea is that based on such experiences, when faced with the ambiguous situation of pressing one of two vertically arranged buttons to indicate left, the participant "knows" that the appropriate answer is to press the down button. The nonaffordance conditions associated with the horizontal button configuration reflected high within-group agreement, but the agreement was not sufficiently strong for us to conclude that a convention was in place. The lower within group agreement may reflect either that competing mappings exist in daily activities or that the mapping is not common.

The message for designers from our data is that users are far from being blank slates. As noted by Vyas, Chisalita, and Van der Veer (2006), "During the technology use, users continuously interpret and reconstruct the meanings related to the technology, ..." (p. 93) [6]. In even simple actions like button pressing, they are biased to prefer one of two binary responses. In some situations, the bias may be widespread, indicating the presence of a convention. Designers need to know the nature of conventions that might have an impact on their designs. In other situations, the bias may be less pervasive, but even then each individual may have a bias; even if users are not following a convention, they may still be acting consistently. In other words, if users are performing poorly on a design that uses popular conventions it could be a result of their following a minority consistent strategy. Regardless, when users act according to a consistent strategy, that

strategy may have been previously learned and could therefore be very difficult to retrain. In addition, violating the users' previous knowledge could cause accidents [7]. Finally, we note that if conventions are not stable across device interactions, it could result in a continuous battle between interface designs leading to negative transfer for both designs (reflected by numerous errors for both designs). Therefore, it is important to know the users' current understanding of any conventions in place for there to be successful design outcomes.

As already noted, our prediction that diagonally offsetting the buttons would produce a situation in which there was an affordance for all four directions was supported. No difference was found between the diagonal configuration and any of the other affordances conditions. Thus, according to Fitt's Law, the diagonal button configuration is the best design choice for moving in the direction of up, down, left, and right. In spite of this, we do recognize that this is only optimal when only one of the directions is possible at a time (i.e., down/up or left/right). Another unique action would have to be included in order to discriminate between user's wanting to move up rather than right or vice versa.

In summary, we have demonstrated in a simple interaction that conventions may exist. We would like to stress the importance of understanding the users' previous experiences when there is the possibility of a convention based interaction. Ignoring the users' previous knowledge may result in repeated errors. Further, the previous experience may have developed into a convention. Research has shown that such highly practiced consistent mapping situations are difficult to retain because they are no longer under conscious control [8].

Our results do not provide evidence that affordances allow faster responses, at least in the simple task we examined. Prior learning of a button-to-response mapping removes ambiguity from the interaction. The learned mapping is stored in long-term memory, so when a similar instance of interaction arises again, relevant information in long-term memory becomes active and this leads to more efficient processing of the situation and the response. Neisser (1976) referred to this as the perceptual cycle in which past experience drives current perception [9]. Our data suggest that even though the designer may not see a visually constrained interface, the user may. When an affordance is present, the designer is likely to view the situation just as the user does. When an affordance is absent, the extent to which the designer and user view the situation in a similar fashion will depend on the extent to which they have had similar past interactions that lead to a similar perceptual cycle. In these situations, the designer needs to

consider the possibility that a convention exists, a point also made by Oshlyansky, Thimbleby and Cairns (2004).

From a user-centered design perspective, there are two major reasons for recognizing the concurrent conventions in play. First, requiring the user to repeatedly learn new interface conventions consumes the users' working memory which, in return, slows their information processing system. Good interface design rapidly becomes pervasive in supporting the users' task goals (i.e., success in the interaction does not need to itself become a goal). Second, there may be operating conditions (e.g., non-optimal arousal, working memory is filled with primary task calculations, etc.) in which a user does not have full access to working memory. Under such conditions, an interaction may be slow or fail. Thus, a good interface design should take advantage of knowledge stored in long-term memory so that the user's interaction with the interface is more effortless and more successful. In short, considering users' conventions during the design process will lead to increased usability by minimizing interference with existing applications.

Acknowledgments

We would to thank Matthew Fee for running participants and Mary L. Still for suggestions on earlier drafts.

References

1. Norman DA (1988) The psychology of everyday things. Basic Books, New York
2. Gibson JJ (1979) The ecological approach to visual perception. Houghton Mifflin, Boston
3. Norman DA (1999) Affordance, conventions, and design. Interactions (May): 38-42
4. McGrenere J, Ho W (2000) Affordances: clarifying and evolving a concept. Conference Proceedings of Graphics Interface: 1-8
5. Oshlyansky L, Thimbleby H, Cairns P (2004) Breaking affordance: culture as context. Conference Proceedings of the third Nordic conference on Human-Computer Interaction: 81-84
6. Vyas D, Chisalita CM, Van der Veer GC (2006) Affordance in interaction. ACM Proceeding of the 13th European conference on Cognitive ergonomics: Trust and Control in Complex Socio-technical Systems 250: 92-99

7. Besnard D, Cacitti L (2005) Interface changes causing accidents: an empirical study of negative transfer. International J of Human-Computer Studies 62(1): 105-125
8. Shiffrin RN, Schneider W (1977) Controlled and automatic human information processing: II perceptual learning, automatic, attending, and a general theory. Psychological Review 84: 127-190
9. Neisser U (1976) Cognition and reality. WH Freeman, San Francisco

Novices' Satisfactory Design, Some implications for Performance and Satisficing in Character Design

Tsai-Yun Mou
Kun Shan University, Taiwan

Chun-Heng Ho
National Cheng-Kung University Taiwan

Researches indicate that problem decomposition strategy and visual analogy are helpful for novices to improve their design quality. However, whether novices could attain satisficing level or evaluate designs critically basing on these strategies are unknown. Hence, we try to uncover this through a character design task. Comparing novices' self-assessment with the experts' judgement, the results suggest novices achieve better performance with analogy and explicit index requirements in design solution. Nevertheless, index requirements are not effective for novices to self-evaluate critically. Although there is satisficing level gap between novices and experts, their evaluations of the design still maintain a positive correlation.

Introduction

The pre-production stage of animation in visual and aesthetic aspect, which includes storyboarding, character design and layout, is what demonstrates the designers' performance and attracts the audiences' attention. In animation education, character design is one of the key essentials in building up a good animated film. However, even though students are trained to analyze the features of a desired character before they start to design, most of the outcomes still reveal poor design performances. This may because design problems are generally ill-structured [1]. Lacking the abilities in decomposing a design problem often results in unsatisfactory solution.

J.S. Gero and A.K. Goel (eds.), *Design Computing and Cognition '08,* 473
© Springer Science + Business Media B.V. 2008

Similar findings that novice does not have a good problem decomposing strategy which results in poor design performance are discussed in a protocol study in industrial design [2].

Studies of the differences between experts and novices are well-discussed in later researches, in which all point out novices common defects in solving problems [3], [4], and [5]. If decomposition of problems is one critical stage of migrating from novices to experts, then assigning explicitly pre-decomposed problem may lead novices into good enough and satisfactory solutions. Surely, besides problem decomposition, there are also other factors that affect and inhabit in novices' design cognition [6]. Among these factors, information over-gathering [7] and problem-focused instead of solution-focused [8] are two critical problems existing in character design. These phenomena actually root in the inability of problem decomposition. Without forming up the problem scope and dividing them, novices collect unnecessary information and thus result in low quality works. Also, novices tend to spend too much time on defining the problem, instead of seeing the design problem through relevant solutions from problem structure perspective. Therefore, in this study, problem decomposition ability in novices is the critical part which we will look into.

In addition to problem decomposition, previous studies indicated that even though visual analogy is an integrated design cognition in experts, novices can improve their design quality if they are explicitly required to use this approach [9]. Related researches also suggested that in ill-structured design problem, novice designers perform better if analogy, as a high-level problem solving strategy, is utilized [10]. Heylighen [11] studied architecture students' performance in using case-based reasoning also confirmed positive impact of analogy. Similar approach is actually applied in animation production, including character design and keyframe animation, in which observations of real life are the sources of new creation for designers [12]. Therefore, we would use analogy as the supportive method in achieving better design solutions of the novices.

While visual analogy is a good guideline for novices, their design solutions may not be *satisficing*, as defined by Simon [13]. In solving a design problem, in which there are lots of complexity and interacting variables, searching for an optimal solution is not a wise decision in terms of time, resources, and returns. Rather than achieving an optimal design, designers search for a satisfactory solution that is better than current situation by improving incrementally.

However, while with novice designers, their inexperience in problem solving might lead to low satisfactory solutions and performances. Nevertheless, satisficing could be interpreted from two perspectives⊡the de-

signer and the evaluator, that this research will focus on the differences. Novices' low satisfactory solutions lie in the fact that they usually settle down on early and instinctive designs without exploring new possibilities [14], and [15]. Previous research on design misconceptions indicates that 'fixation' is novice designers' common defect [16] and [17]. Therefore, in our study, we are interested in seeing whether requiring novice designers to use visual analogy, without reminding certain decomposed design elements, could also help novice designers to overcome the fixation problem and achieve satisfactory solutions from experts' points of view.

Objectives and Hypotheses

Based on related literature review in previous section, more fundamentally speaking, here we would like to investigate if novices have good self-assessment abilities and/or if we can improve their self-assessment abilities by reminding them some important design criteria such as problem decomposition and visual analogy. In sum, there are two hypotheses in this study. First, if we explicitly require certain criteria, i.e. problem decomposition and analogy, in design solution, novice designers will have higher satisficing levels and better performances. Second, novices' satisficing levels will be corresponding with the experts' evaluations in ratio aspect.

Method

Participants

Eight character design students (3 male, 5 female) regarded as novices participated in this experiment. They were third year undergraduate students and had same training background in sketch and graphic design. Because drawing skill is influential in the representation of design which directly affects the score judgement [18], the selection of participants were refined to meet similar drawing skill level. Thus there were only eight participants in the experiment. Their drawing skills were considered as same level based on their prior assignments' performance. The participants took this experiment as their final exam and earned credits for their participation.

Design

There were two experimental conditions within each including four participants. In the test condition, 4 participants were given a character design problem, i.e. a girl character with personality, reference pictures and a task sheet containing general instructions. The index requirements for character design were pose, face, and costume. Participants were requested to achieve these requirements to a satisficing level in their designs. In the control condition, the same problem and instructions were given to the other 4 participants. They were asked to use visual analogy to design a character to a satisficing level without explicitly indicated to meet the index requirements.

The reference pictures contained thirty images, which were divided equally in amount into three categories: figure pose, human/animal face, and costume. The visual references were arranged randomly in order to confound the category similarity in display. Individual copy of image references was given to each participant. In order to achieve satisfactory solution, there was no time limit for solving the problem. Nevertheless, the task duration time of each participant was recorded so as to reveal the correlation between satisfactory solution and problem solving time.

Procedure

The experiment was carried out in one design session with each condition group in different room. After finishing the design problem, each participant met with the experimenter individually to score his or her own design according to the index requirements and the overall design on a given evaluation sheet. The participant was explained that the evaluation would not affect his or her grades in the course. Interview with each participant regarding the design solution and the score was conducted after self-evaluation. The one-on-one session was video-taped to obtain qualitative research data to examine the rational decision and the score points. Besides self-evaluation, three instructors, as experts, were invited to judge the participants' character designs as well.

Scale of Measurement

An ordinal scale was used to evaluate the character design solution. The scale was from 1 to 9 to establish the satisficing levels of the participants' designs. A score of 1 stood for least satisficing and 9 for most satisficing. A score of 5 points was given if participant regarded the design as moderate and acceptable. Each aspect of the requirements, i.e. pose, face, and

costume, was scored independently and the overall design was scored as well.

Judges

As we mentioned previously, three judges reviewed the designs independently. Likewise, each aspect of the requirements and the overall design performance were evaluated. The works of the two groups were mixed in a random order but consistent among the experts to score. Nevertheless, during the evaluation, experts tended to spread out all designs to judge these works.

Results

Quantitative Results

Design performance differences between test group and control group

Figure 1 shows the experts' evaluation of design performance of the two groups and their task duration time. The level is based on the sum of the three indexes, i.e. pose, face, and costume. While previous studies suggest visual analogy can improve design quality for novices, yet here control group met much lower level than test group. We find a significant difference between the two conditions ($t(6) = 2.999$, $p = 0.024$). This result could infer that novice designers performed better if they were given visual references with explicit index requirements. However, with the small number of design students, the result is simply suggestive.

Another noticeable result is the design duration time of the two groups. The average time of the test group was 97.5 minutes while for the control group was 195 minutes, which was exactly twice the time of test group. This may due to the index requirements were only given to the test group. Novices without index requirements spent more time in solving the problem but acquired lower performance level evaluated by the experts. While in the test group, novices spent less time and performed better.

Self-evaluation differences between test group and control group

To verify if novices with explicit index requirements can have higher satisficing levels than those without index requirements, we compare these two groups as shown in Figure 2. Here we couldn't find a reliable significant

difference between the two conditions ($t(6) = 0.594$, $p = 0.574$). The test group did not have higher satisficing level as we have expected.

Fig. 1. Satisficing level (design performance) and task duration time of test group and control group

Fig. 2. Test group's and control group's self-evaluation of satisficing levels

The results of the two groups were contrary to our hypothesis: novices with analogy and index requirements in design solutions will have higher satisficing levels. We could examine this opposing result from two perspectives. If the hypothesis was wrong, this means that index requirements: pose, face, and costume, cannot raise novices' satisficing levels. Even though the criteria are critical in good character design, it seemed that novices in the test group did not regard the indexes as hints of a pre-decomposed problem for them. Therefore, when we look at test group's

self-evaluation, although their actual performances were higher than the control group's (Figure 1), their satisficing levels were not raised. Another reason to interpret this insignificant difference may because without index requirements, visual analogy alone had already increased novices' satisficing levels in their character design. Thus, whether or not the index requirements are requested, the satisficing levels in test group would not change. Yet this explanation need to be verified through a within subject experiment in future researches.

On the other hand, if our hypothesis is correct, then there are several explanations for this result. First, since there was no time limit for them to solve the problem, novices in both groups were believed to have achieved satisfactory character design before they turned in their works since this was their final exam. As we can see that the task duration time for control group was twice of the test group, which implies novices without index requirements needed more time to achieve satisfactory design. Therefore, this can explain why there was no significant difference in the satisficing levels. Second, because assessment is subjective, thus novices' self-evaluation could be biased. Without enough independent and rational thinking, which could be attained through proper consulting and learning [19], novices may lack the abilities to evaluate design quality. Hence, from the results we could not see much satisficing level differences between test group and control group. Third, it could be possible that test group's assessment truly reflected their satisficing levels which had been enhanced through index requirements and analogy; but due to control group's inability of assessment that causes over-contented judgement, we could not see much difference. Other possible reasons may come from participants' different personalities and assessment standards, which were unavoidable in many between subject experimental designs.

In spite of the participant variable and several possible explanations, the result of similar satisficing levels, as we estimate, mainly derived from novices' inability of assessment. First, based on the concept of rational choice [20], a satisfactory design was chosen and evaluated by the participant himself/herself. It is undoubted that novices had chosen the most satisficing outcome from the characters they drew. However, their assessment is *incommensurable* [21]. This can imply that novices seemed to lack the abilities to consider their own designs in a broader scope. Therefore, participants in both groups would judge their own designs as meeting a satisficing level, which lacked a rational evaluation. Thus we could not see a significant difference from the result. Second, while test group was requested to meet the criteria using analogy in the experiment, their post-evaluation should have reinforced their satisficing levels. As for the con-

trol group, the participants only considered these indexes in evaluation, thus this should result in lower satisficing levels. However, the satisficing levels of two groups were similar. This confirms that the indexes in evaluation are not effective for novices to judge their design critically. Therefore, the three indexes of character design cannot improve novices' abilities in self-assessment.

Evaluation differences between experts and novices

The other hypothesis that we want to test is whether novices' self-assessment of satisficing design would be corresponding with experts' evaluation of their design performance. Besides using *t-test* to see the correlation, a *paired t-test* is used to examine whether there would be correspondence between each self-evaluation and experts' evaluation. The results of test group and control group are discussed individually. Figure 3 shows test group's self-evaluation of satisficing design and experts' evaluation of design performance. The result shows that there is a significant difference between test group's and experts' evaluation ($t(6) = 3.413$, $p = 0.014$). In paired t-test, it also reveals a significant difference between each self-evaluation in test group and experts' evaluation ($t(3) = 3.916, p = 0.029$). This suggests that even though novices were asked to use visual analogy with index requirements in their design solution, their satisficing levels still fell behind experts' standard.

Fig. 3. Test group's evaluation of satisficing levels and experts' evaluation of design performance

Figure 4 shows the control group's self-evaluation and experts' evaluation of the design. There exists much more significant difference than test

group in this comparison: t-test ($t(6) = 4.213$, $p = 0.005$) and paired t-test ($t(3) = 11.66$, $p = 0.001$). The result indicates that the evaluation gap of control group was wider than test group's. Novices who were required to use analogy only, met much less standard of the experts. Therefore, from the results of Figure 3 and Figure 4, we can confirm that a gap existed between novices' self-evaluation of satisficing design and experts' evaluation of design performance. Nevertheless, there is a positive correlation between experts' and novices' evaluation of the design. Since test group's higher satisficing level was corresponding with experts' higher evaluation, although there was a level gap. While with control group's over-satisficing assessment, the correspondence did not seem to be obvious.

Fig. 4. Control group's evaluation of satisficing levels and experts' evaluation of design performance

Qualitative Results

Novice design with visual analogy and index requirements

Figure 5 shows a novice's design with the requirement to use visual analogy and meet the three indexes: figure pose, face, and costume. In the interview with the participant, she mentioned the images shown in Figure 6 contributed to her design solution:

She looks like a bad woman who probably seduces the leading character by her beauty and good figure. She is a mysterious woman with the outfit. She is quiet but with a wide mouth shape like a frog, which makes her different and charming.

Fig. 5. Sketch by novice in test group

(a (b (c)
))

Fig. 6. Selection of images by novice in test group

Source: (a) http://www.gettyimages.com
 (b) http://www.art.com
 (c) http://news.nationalgeographic.com

It is noticeable to know that she not only followed the analogy rule in her design, but also modified the references, i.e. imagistic transformation [10] and inputted of her knowledge into the character which is a crucial component in design process [22]. Thus, this character was judged by the experts as good design performance and scored 18.67 based on the average of three index requirements.

The aim of the task is to design a girl character with personality. In character design for animation, the personality can be revealed through

proper plan of pose, face and costume [23] and [24], which are our index requirements for test group. Thus when the participant was asked whether visual analogy with index requirements would enhance her character design, she believed that the three explicit indexes helped her to think of the criteria constantly during the design process. In addition to the indexes, our intention is to uncover whether the character's personality is conveyed and meets the criteria. So when the participant was asked what kind of personality her character has, she described:

She looks like a bad woman who probably seduces the leading character by her beauty and good figure. She is a mysterious woman with the outfit. She is quiet but with a wide mouth shape like a frog, which makes her different and charming.

As we can see from her description, personality of the character was literally revealed through the index requirements. The 'figure' (pose) of the character makes her attractive; the frog 'outfit' (costume) makes her mysterious; and the 'wide mouth shape' (face) makes her charming. With careful deliberation of these aspects during the design process, the personality stood out naturally. Experts' evaluation for this participant's design was the highest among the four novices in the test group. She got 18, 17, and 21 respectively for the three indexes. This suggests that visual analogy with index requirements can help novices to achieve higher performance, which is corresponding with the result shown in Figure 1.

Another critical phenomenon is that three out of four participants in the test group believed that visual analogy with index requirements actually increased their satisficing levels, which was indistinct in the result (Figure 2). In the interviews with them, we can understand how novice designers considered their character designs:

(Novice A) My character (Figure 5) seems to have some personality from the index requirements. I like the way you remind us to fulfill these criteria. This helped shape up my character.
(Novice B) I choose this little girl (Figure 7a) as my final. Her hair style resembles this picture (Figure 7b). And the idea for her costume comes from this (Figure 7c). I like this style.
(Novice C) The face of this character (Figure 7d) is from this picture (Figure 7e). I like this character because she doesn't look like a female and that's cool.

(a) (b) (c) (d) (e)

Fig. 7. Novices' satisfactory design

Source: (b) http://www.gettyimages.com
 (c) http:// www.my.musicazoo.com
 (e) http://www.gettyimages.com

As we can see, the way novices thought their characters as satisficing depending on if he/she 'likes' some aspects of the designs. Their self-assessment was thus biased and subjective. Hence novices in the test group, although in their belief the level was raised, did not seem to have different satisficing level than the control group (Figure 2).

Novice design with visual analogy only

Figure 8 shows one design from the control group which was judged as poor performance by the experts. In the retrospective interview with the participant, he pointed out the images of his selection, as shown in Figure 9.

Without pre-decomposed the task for the control group, visual analogy strategy for the novice did not seem to be a good method to achieve satisfactory design. He described his usage of the pictures:

The hair and facial expression idea came from this little girl (Figure 9a). I like the Marilyn Monroe pose (Figure 9b), so I made my character stand like her. For her sharp face shape I used this picture (Figure 9c).

It is interesting to know that the novice chose two pictures (Figure 9b and 9c) in pose category to form up his design. Nevertheless, the pose was not correct because human's pelvis and shoulder bones counterbalance each other when the weight is placed on one side. Moreover, in his description of the character, the costume was not considered. We can obvi-

ously see that this character did not have an outfit well-designed. Looking at the small detail of face shape in Figure 9c, the novice decided to apply it with the girl's expression onto his design. One expert commented on this character as too 'dull' and 'usual'.

Fig. 8. Sketch by novice in control group

Fig. 9. Selection of images by novice in control group

Source: (a) http://www.gettyimages.com
 (b) http://www.bookitentertainment.com
 (c) http://www.gettyimages.com

As we can see, with the use of visual analogy only, novice designer seems to lack the ability to analyze the design problem in sub-problems level, which here in character design contains pose, face, and costume.

When the novice was asked whether visual analogy with index require-
ments would increase his design performance, he said:

*Well, I think these reference pictures give me a direction for design. It is enough. I
would like to not having the index requirements for me. They would limit my inspi-
ration. This (visual analogy only) is better.*

However, the judged performance of this design was 13.67 (the lowest
score) based on the three indexes. It is also noteworthy that among the four
novices in the control group, two participants who believed that with vis-
ual analogy only was enough to achieve satisfactory design, actually got
lower scores than the other two in the group. Control group's overall per-
formance judged by the experts were lower than test group's (Figure 1),
and received critiques as 'simply drawing without design' and 'illustra-
tion'.

Regarding the self-evaluation of this participant, he explained his
thoughts:

*It took me longer to solve this design task with visual analogy only. But as I said
before, index requirements would not help me do better design. Even if I have the
guild line, my satisficing level would not change. I have my own style of drawing.*

The participant did not regard the three indexes as important criteria of
satisfactory design in character. His self-assessment level was close to oth-
ers' in control group as well as test group. From his opinion and the results
(Figure 2), we can verify that novice designers in both groups indeed
lacked the abilities to self-evaluate fairly, whether this phenomenon might
due to limited scope (incommensurability) or inability to utilize the in-
dexes critically.

His other character designs are shown in Figure 10 (not evaluated), in
which the designs seemed to lack of 'characters' and personalities. Nov-
ices' design without index requirements appears to be of 'surface' simi-
larity [9] and [25]. As we can see that these characters were merely 'imita-
tion' of reference pictures (Figure 9a and 9c) without notable modification
as Figure 5 had in test group. Although this design flaw is common among
novices, previous research in architecture design believed that analogy did
not increase the danger of fixation [11]. Instead, it helped novices' creativ-
ity and quality of work. However, on the contrary, here we could not find
much creativity and modification in control group's work. This result fur-
ther confirms that though analogy alone is helpful in improving perform-
ance of novices, fixation problem is still inevitable especially in novice
designers with visual analogy only. On the other hand, index requirements as

pre-decomposed problems offer novices a constructive approach to achieve better performance and satisfactory design.

Fig. 10. Other sketches by novice in control group

Conclusions

This study examines novices' performance and self-assessment abilities through visual analogy and index requirements. The results suggest that analogy alone might have positive effect to improve design performances, which confirms the result found in Heylighen's study [11]. However, this study further suggests that visual analogy with index requirements - pose, face, and costume, are constructive for novices to achieve better performance and satisfactory design. Even though this method is helpful for improving design solutions, the results also imply that index requirements are not effective for novices as criteria to self-evaluate designs critically. Novices' similar satisficing level comes from their inabilities of self-assessment, which may due to incommensurability of design and inability of utilizing indexes. Although the choice is their satisfactory design, novices' evaluation heavily depends on their preference with some aspects of the character. By judging their own designs from a limited scope, novices can not evaluate critically; thus the assessment is biased and incommensurable. Also, novices' inabilities of utilizing indexes can be revealed from similar self-assessment level of both groups and their overlook of index requirements in assisting critical evaluation. In addition to novices' self-assessment, from the evaluation comparison between experts and novices, we can see that novices' performance still falls behind experts' standard. This phenomenon is particularly obvious in novices' design with visual analogy only, in which the characters seem to be constrained by the refer-

ence pictures. Similarly, Akin and Akin [26] find being unable to go be-
yond restrictions, novice designers cannot have creative solutions for the
task, thus this makes novices in this study only achieve limited perform-
ance level. In spite of the level gap, as we can see, there still remains a
positive correlation between experts' and novices' evaluation of the de-
sign; since test group's higher satisficing level is corresponding with ex-
perts' higher evaluation.

In the design process, problem decomposing strategy is an integrated
cognition in experts. In this study, problem decomposition is verified to be
the key factor in better performance as found in a previous study [2]. In
addition, it also affects novices to utilize analogy to achieve satisfactory
design. With the joins of analogy and explicit index requirements, this is a
better guideline in improving novice designers' performance. Hence, this
method could be practicable in design education. Nevertheless, whether
training with problem decomposition strategy would assist novices to inte-
grate this ability in design process needs further research.

This study reveals there is a satisficing level gap between experts and
novices. Understanding this phenomenon is crucial for inexperienced de-
signers. Thus inexperienced designers should bear in mind that their satis-
ficing design solutions are not truly satisficing. Higher but not optimum
[13] standard, should be set for design goal state in order to attain experts'
satisficing level. Additionally, here different standards are represented
through evaluation score for the designs. Yet quantitative method only
captures the external phenomenon. For both experts and novices, to what
extents of certain criteria are met and what aspects of design problem are
solved, these cognitive decisions are not explored deeply in this research.
Thus future studies on experts' and novices' cognition of satisfactory de-
sign can be conducted more qualitatively and profoundly.

Novices' self-assessment abilities as disclosed here (similar satisficing
level) are undeveloped. Although index requirements as pre-decomposed
problem can improve novices' performance, they cannot enhance novices
to judge design critically. This might indicate that criteria as decomposed
sub-problems are not necessary for self-assessment or there could be a bet-
ter means to keep novices aware of their evaluation standard. In addition to
these inferences, as we have discussed previously the probable reasons of
assessment inability, further researches can focus on how novices regard
their works in design entirety, or how novices analyze designs by the in-
dexes. More broadly speaking, to cultivate novices' assessment abilities is
an important aspect in design education and more researches are needed.

References

1. Simon HA (1973) The structure of ill structured problems. Artificial Intelligence 4(3-4):181-201
2. Ho C-H (2001) Some phenomena of problem decomposition strategy for design thinking: differences between novices and experts. Design Studies 22(1): 27-45
3. Ball LJ, Ormerod TC, Morley NJ (2004) Spontaneous analogising in engineering design: a comparative analysis of experts and novices. Design Studies 25(5): 495-508
4. Brand-Gruwel S, Wopereis I, Vermetten Y (2005) Information problem solving by experts and novices: analysis of a complex cognitive skill. Computers in Human Behavior 21(3): 487-508
5. Chen S-C (2001) Analysis of the use of computer media by expert and novice designers. International Journal of Design Computing 2000-2001(3): 1-10
6. Cross N (2004) Expertise in design: an overview. Design Studies 25(5): 427-441
7. Christiaans H, Dorst C (1992) Cognitive models in industrial design engineering: a protocol study. Paper presented at the International Conference on Design Theory and Methodology
8. Lloyd P, Scott P (1994) Discovering the design problem. Design Studies 15(2): 125-140
9. Casakin H, Goldschmidt G (1999) Expertise and the use of visual analogy: implications for design education. Design Studies 20(2): 153-175
10. Goldschmidt G (2001) Visual analogy--a strategy for design reasoning and learning. In C. Eastman, M. McCracken & W. Newstetter (eds), Design Knowing and Learning: Cognition in Design Education, Elsevier Science, Oxford: 199-219
11. Heylighen A, Verstijnen IM (2003) Close encounters of the architectural kind. Design Studies 24(4): 313-326
12. Beiman N (2007) Prepare to board! Creating story and characters for animation features and shorts. Focal Press, St. Louis
13. Simon HA (1996) The sciences of the artificial, 3rd ed. MIT Press, MA
14. Jansson DG, Smith SM (1991) Design fixation. Design Studies 12(1): 3-11
15. Purcell AT, Gero JS (1996) Design and other types of fixation. Design Studies 17(4): 363-383
16. Guindon R (1990) Knowledge exploited by experts during software system design. International Journal of Man-Machine Studies 33(3): 279-304
17. McCracken M, Newstetter W, Chastine J (1999) Misconceptions of designing: a descriptive study. Paper presented at the ACM SIGCSE Bulletin
18. Verstijnen IM, van Leeuwen C, Goldschmidt G, Hamel R, Hennessey JM (1998) Creative discovery in imagery and perception: combining is relatively easy, restructuring takes a sketch. Acta Psychologica 99(2): 177-200
19. Güth W (2007) Satisficing in portfolio selection--Theoretical aspects and experimental tests. Journal of Socio-Economics 36(4): 505-522

20. Simon HA (1955) A behavioral model of rational choice. Quarterly Journal of Economics 69: 99-118
21. Byron M (2005) Simon's revenge: or, incommensurability and satisficing. Analysis 65(4): 311-315
22. Christiaans H, Venselaar K (2005) Creativity in design engineering and the role of knowledge: modelling the expert. International Journal of Technology and Design Education 15(3): 217-236
23. Bancroft T (2006) Creating characters with personality. Watson-Guptill, New York
24. Hamm J (1986) Cartooning the head and figure. Perigee Trade, New York
25. Gentner D (1983) Structure-mapping: A theoretical framework for analogy. Cognitive Science 7(2): 155-170
26. Akin O, Akin C (1996) Frames of reference in architectural design: analysing the hyperacclamation (A-h-a-!). Design Studies 17(4): 341-361

Roles of Negotiation Protocol and Strategy in Collaborative Design

Yan Jin
University of Southern California, USA

Mathieu Geslin
Honda R & D Americas, Inc, USA

In collaborative design, designers work together to identify requirements, explore design spaces, generate design alternatives, and make agreements. Due to information latency and disciplinary differences, it is often a difficult task for designers to reach agreements when needed. Negotiation has been a method for facilitating information exchange, mutual understanding, and joint decision-making. Our research attempts to understand how negotiation protocols and strategies may influence collaborative design behavior. In this paper, an experimental study is presented that indicates the roles of an argumentative negotiation protocol and a multi-level negotiation strategy in collaborative design. The results of the experiment have shown both positive effects and limitations of the protocol and strategy.

Introduction

Engineering design is a multi-faceted activity of which a key component is to achieve tradeoffs between competing criteria in order to deliver quality products to a demanding market. Designers must constantly explore new avenues to keep their products up to date with the expectations of the fast-paced market. To do so, the effective teamwork is essential. Designers from different technical areas work together to identify requirements, generate design alternatives, make both interactive and joint design decisions, and eventually arrive at a final design. Such a process requires not only

flawless communications but also proper means to facilitate mutual understanding, agreement making, and generation of new ideas.

Most collaborative design support systems are developed with the primary goal of achieving seamless information flows among designers and engineering systems. Database systems, various communication and workflow tools have been developed to support information sharing, design change propagation, and process management. Few systems help designers negotiate decisions for the benefit of the overall design, and little work has been done to quantitatively assess how negotiation protocols and strategies may influence collaborative behaviors and design results.

In our research, we take an argumentation-based negotiation approach [1] to supporting collaborative design. Our goal is to develop a negotiation framework that links designers and engineering systems together at the decision-level, facilitates understandings among them, and helps designers expand their search space and subsequently generate better alternatives. In our previous work [2][3], we developed an Argumentative Negotiation framework for Engineering Design, called ANED. ANED is composed of an argumentation model, a negotiation protocol, and a number of multi-level negotiation strategies. It has been implemented as a computer tool to support engineering negotiation. As the second step of this research, we conducted an experiment study to assess the roles of ANED negotiation protocol and strategy on the process and results of collaborative design.

Negotiation is a process in which a joint decision is made by two or more parties [4]. The parties first verbalize contradictory demands and then move towards an agreement through tradeoffs and/or searching for new alternatives. For collaborative design, negotiation can be a way for designers to exchange information, learn about others' perspectives and intents, and identify new opportunities based on the learned information and knowledge. Therefore, negotiation in collaborative design should not be merely a way for designers to reach agreements through simple give-and-take interactions. It should facilitate designers' exploration of a wider range of solution space through influencing each others' understanding of the problem, knowledge, perspective and judgments.

Negotiation processes can be analyzed from two different perspectives. The *value analysis* views negotiation as a multi-party joint decision making process [5] and attempts to comprehend the negotiation situation in more numerical terms such as buyer's/seller's true and revealed prices, preferences, and zone of possible agreements (ZOPA). In this analysis, it is often the case that the "propose-reject/accept" negotiation structure is assumed and the choice space for each party is relatively clear. By translating the contents of negotiation into numerical values, the analysis can un-

cover potential win-win directions, the efficient frontier (or Pareto frontier) and how compromising or modifying one's preference can lead to more desirable agreements.

Another way to understand the negotiation process is *linguistic analysis*. This analysis focuses on the structure and process, and attempts to reveal how the use of the different *communication language* and *domain language* may vary the process and outcome of negotiation. The communication language can be modeled as locutions or speech-acts [6] that the parties use for their negotiation. It defines the structure of interaction and determines what intentions and information can or cannot be communicated. For example, if only the locutions of *propose*, *reject*, and *accept* are used for negotiation, then one will not be able to *request* the other party to provide justification for a given proposal. The domain language for negotiation determines what concepts and information of the domain can be communicated and negotiated. In case of design, the domain language may cover only the *design parameters* and their *values*, or it may further include *constraints* and *functional requirements*.

In order to support collaborative design through negotiation, we need to understand what negotiation structures and processes are most effective in encouraging designers explore their design spaces and generating good design alternatives. In this research, we follow the *linguistic analysis* and attempt to clarify the roles that our argumentation-based negotiation framework may play in supporting collaborative design. Our research question hence is: *What are the roles of the ANED protocol & strategy (enforced by ANED tool) in influencing collaborative design processes and outcomes?*

To address this question, we conducted a design experiment study in which human subjects were engaged in solving collaborative design problems with and without using our ANED tool. In the following sections, we first review the related work in Section 2 and then provide a brief overview of the protocol, strategy, and other key concepts of the ANED framework in Section 3. After that the method of experiment study and the performance measures are described in Section 4. The experiment results are presented and discussed in Section 5 & 6, and conclusion remarks drawn in Section 7.

Related Work

Extensive research on negotiation has been done in diverse areas from social psychology and social sciences where the focus is on human interaction [4][7][8][9], to distributed artificial intelligence whose goal is to achieve collaborative work between computer systems [10][11][1][12].

Decision theorists proposed normative models of negotiation based on decision and game theories [5].

Gulliver [7] proposed an eight-phase model of negotiation process that describes the progress of negotiation from the initial recognition of the dispute to some kind of outcome. The eight phases are: search for arena, agenda setting, exploring the field, narrowing the difference, preliminaries to final bargaining, final bargaining, ritual affirmation, and execution. Pruitt [4] proposed a strategic choice model of negotiation, stating that parties involved in negotiation must make strategic choices at every point in time. The choices include conceding unilaterally, standing firm, or collaborating with other parties in search of a mutually acceptable solution. Toulmin [8] introduced a simple model of argument structure for negotiation based on the exchange of "claims", "data" and "warrant" amongst the participants to assert and justify their negotiation stance.

Researchers in the distributed artificial intelligence community have investigated the issue of negotiation by creating agent-based support system that collect data from the participants and reconcile their disparities to achieve optimal decisions. Sycara [11] proposed a negotiation process that uses case-based reasoning mechanism together with a restricted protocol to support agents resolving their goal conflicts. Jennings et al [13] proposed argumentation-based negotiation to support negotiation among distributed agents. Through argumentation, the parties can exchange various information pertaining to the negotiation situation, explore mutual option spaces and eventual arrive at an acceptable solution.

Raiffa et al [5] proposed taxonomy of group decision-making and suggested negotiation as a way to make joint decisions. Extending the multi-objective decision theory and game theory, he examined the dynamics of win-lose, win-win and multi-party negotiations and proposed novel approaches for successful negotiation.

While the advances of the above-mentioned negotiation research have been applied in business management activities and networked computer systems, few have been introduced to the field of engineering design. Some researchers treated the problem of negotiation in design as an issue of information imprecision and developed formal mathematical models to incorporate the imprecision into design computations [14][15]. Others formulated collaborative design problems as games and treated negotiation as a process of conflict resolution [16] or playing various types of games [17][18]. One common feature of the existing approaches to negotiation in engineering is that they treat negotiation as a process of single level information exchange and conflict resolution and attempt to *reduce* the negotiation problem into a multi-objective optimization problem so that a conver-

gent solution can be found. Because these approaches usually require prior knowledge of evaluation criteria and available alternatives, they have only limited use for the early stage of engineering design where defining problems and exploring alternative spaces are part of the negotiation process.

There have been experiment studies of negotiation in the literature but few of them are specific to the engineering design field. Some experiments conducted in the fields of social and management sciences study the impact of personality on the negotiation outcome [19] and others explore the difference between individual vs. group negotiators [20]. Kirshmann et al [21] tested the influence of groupware on a design project.

Overview of ANED

ANED was developed based on the argumentation-based approach to negotiation [13]. It is composed of three key components: 1) an *argumentation model*, 2) a *communication language* composed of specific speech-acts, and 3) a number of multi-level *negotiation strategies*.

Argumentation Model

Following Toulmin [8] we model argument as a structure depicted in Fig. 1. In this model, negotiation starts when a designer makes a "Claim", e.g., "Hinge position h_g should be 20cm $< h_g <$ 25cm." If the claim is challenged by another designer, then the designer is required to provide "Data", e.g., "Door size D_s=60cm", to defend it. If the challenger is still not satisfied with the data, then a "Warrant", e.g., "If sports car, then $h_g < 0.5\ D_s$", can be supplied by the designer, either voluntarily or at the request of the challenger. A "Warrant" can be a rule that states the relation between a "claim" and "data", as shown in Figure 1, or a related higher-level concept, such as a function requirement. In the latter case, if the challenger starts to challenge the "warrant", the negotiation moves to a higher-level in which the "warrant" becomes a "claim" and negotiation continues.

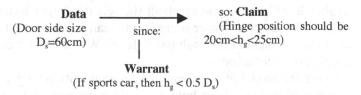

Fig. 1. ANED Argumentation Model (Adapted from Toulmin [8])

Communication Language

Communication language determines the structure of negotiation in terms of what actions can be taken in the process. The speech-acts of ANED, shown below, were chosen from Ballmer and Brennenstuhl's speech-act dictionary [22] based on our analysis of engineering negotiation needs [3].

* *Propose <claim>*: introduce *<claim>* and initiate negotiation process.
* *Counter-Propose <claim>*: introduce a new *<claim>* going against another *claim* proposed by the other party earlier.
* *Compromise <claim>*: proposed *<claim>* that is a compromised version of the previous one.
* *Critique NOT <claim>AS <data> (or SINCE <warrant>)*: introduce a negated *<claim>* followed by *<data>* and possibly a *<warrant>* to justify the negation.
* *Defend <claim> AS <data> (or SINCE <warrant>)*: introduce *<data>* and/or *<warrant>* to defend the *<claim>* challenged by the other party.
* *Agree <claim>*: declare that an agreement is reached on the *<claim>* and the party is committed to the agreement.
* *Refine <claim1> WITH <claim2>*: introduce a new *<claim2>* whose contents build upon the last *<claim1>* passed on to the other party.

Multi-Level Issues and Negotiation Strategies

In collaborative design, negotiation usually starts from identification of conflicts. The conflicts can be task related, such as entity conflicts and constraint conflicts, or they can be value judgment related, such as objective conflicts and preference conflicts. Conventional negotiation begins from identifying ZOPA (Zone Of Possible Agreements). If there is no ZOPA between the two participants, then the negotiation can be deadlocked. In our research, we propose a *multi-level argumentation* approach, as shown in Figure 2. The basic idea is that, most issues being negotiated belong to a hierarchy of related issues. Usually, a "super issue" governs the "range" and "behavior" of its "sub issues". If two participants cannot agree at the level of certain "sub issues", then they should be able to move to a "higher level" and negotiate about the related "super issues". The agreement at the level of "super issues" may lead to an innovative and unforeseeable agreement at the "sub issue" level. We call this process multi-level integrative negotiation.

Given the model of argument and communication language, the efficacy of negotiation depends on how the participants decide on strategic actions, proposals and arguments. The question is related to negotiation strategy:

whether to explore the solution space of the current issue, or identify new issues at the same level, or to move to a higher level of relevant issues. In ANED, four generic strategies are devised based (Figure 2).

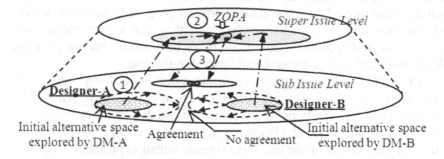

Fig. 2. A Model of Multi-Level Issues & Negotiation

- *Solution exploration*: Try to stick to the current issue and explore its solution space extensively.
- *Issue exploration*: Try to move to, or create, new issues at the same level in order to avoid conflicts.
- *Hierarchy exploration*: Try to move to a higher level of the design entity hierarchy in order to resolve conflicts. The hierarchy includes (from lower to higher level): *parameter-value → parameter → parameter constraints → functional requirements → design objectives (evaluation criteria)*.

Method

The objective of this experiment study is to investigate how ANED protocol and strategy influence the collaborative design process and results. In this section, we describe the experiment design, the test problem, and the measures devised to evaluate the outcome of design results and processes.

Experiment Design

The experiment involved 24 subjects who were divided into 3 treatment groups: a control group (CG), a protocol group (PG), and a protocol plus strategy group (PSG). Each group had 4 teams, and each team had 2 participants working together to solve a common design problem. All 12

teams worked on the same design problem and were given the same information.

To make sure that all communications between the two subjects of a team are correctly monitored and there is no unmonitored communication, such as those through voice volume, body language and gestures, we divide the two subjects into two rooms, and they can communicate only through a keyboard-and-text based computer connection that we provide. All communication logs are saved and used for analysis.

The CG, PG and PSG groups were different in the following ways.

- *Control Group (CG)*: The CG teams are given an ordinary *chat tool* so that they can chat freely using any language and design information.
- *Protocol Group (PG)*: The PG teams are asked to use the ANED tool so that they are forced to use the ANED communication protocol.
- *Protocol and Strategy Group (PSG)*: The PSG teams use the ANED tool and apply the *"Hierarchy Exploration"* strategy described above.

The 24 subjects who participated in this study were recruited amongst the students attending a senior level design class AME410 (*Engineering design theory and methodology*) offered at the University of Southern California. Participation was strictly on a voluntary basis. The twelve 2-person teams were created randomly, and the different treatments administered to each of them were also the product of a random process. The students were all undergraduates in their senior year, majoring either in mechanical or aerospace engineering.

Each experiment sample lasted about an hour and proceeded as follows:

- **t = 0–15 min:** Subjects sit through an automated PowerPoint slideshow of the design exercise that explains the their tasks and responsibilities.
- **t = 15–25 min:** Brief practice time for the subjects to familiarize with the problem, data, use of ANED tool for design and communication.
- **t = 25 min – 1h:** The subjects collaborate to solve the design problem.

Design Problem

The design problem for the experiment should be simple enough so that the subjects can comprehend and solve it within the allowed time frame. On the other hand, the problem should also be rich or complex enough so that the effect of applying the ANED protocol is observable. We created a problem of designing a *manufacturing line* for the production of a *water filter* composed of a *grid* and a *filter body*., Each subject is responsible for a part of the process: Designer 1 is in charge of the fabrication of the filter body, while Designer 2 is in charge of the grid production and assembly processes.

The task of each subject is to select (1) the required operations for fabricating the water filter and (2) the needed machines to carry out the selected operations. All possible operations for producing and assembling Part1 and Part2 are predefined. Each operation has 3 alternative corresponding machines. Each machine as two attributes: the *cost ($)* of using the machine and the *space (m^2)* the machine occupies. Table 1 summarizes the design objectives, tasks, and the design information for each designer.

Table 1 Design Tasks, Objectives and Information

	Design Objectives	Design Tasks	Information Provided
Designer 1	> Ensure full compatibility of machines selected > Minimize the cost of use of machines > Minimize the space occupied by machines	> Select operations and machines to produce Part 1 > Lay out machines according to the rules	> Drawing of Part 1 > Table of operations for Part 1 > Partial table operations for Part 2 (no cost & space info) > Compatibility, issue, option list > A list of rules
Designer 2		> Select machines to produce Part 2 & assemble it w/ Part 1 > Lay out machines according to the rules	> Drawing of the Part 2 > A table of operations for Part 2 > A partial table of operations for Part 1 (no cost & space info) > Compatibility, issue, option list > A list of rules

To add needed complexity to the manufacturing line design problem, we framed the following concepts as part of the problem definition.

- *Local incompatibility:* Two machines may be locally incompatible so that they cannot be applied simultaneously by one designer in one manufacturing process. For example, M_{32} and M_{41} *are locally incompatible, so Designer 1 cannot select both in his solution set.*
- *Global incompatibility:* Two machines may be globally incompatible so that they cannot be applied by the two designers in a team simultaneously in the overall process. For example, M_{11} and M_{61} *are globally incompatible; Designer 1 cannot select M_{11} in his solution set if Designer 2 selects M_{61}, and vice-versa*
- *Issue:* Two machines may have a shared *issue*. In this case, they can be simultaneously applied only if the issue is addressed by selecting an op-

tion. For example, M_{22} and M_{61} have an issue (#2): "Cut grid must be checked dimensionally to match NC high quality"

• **Option:** An option is an item that can be selected from the option list to resolve an issue encountered by the subjects during their machine selection task. For example, Option #11 in Designer 2's options list "Dimensional Control Station", which costs $3 and takes up two blocks of space addresses the aforementioned issue #2.

The incompatibilities and issues were arbitrarily chosen to prevent the subjects from selecting the cheapest or the most compact set of machines. This way, the subjects are forced to make decisions over local and global tradeoffs. Each of the two team members had different list of options. The lists were designed to provide the subject with some of the solutions to his/her own issues and some of the solutions to the issues of his/her teammate. Therefore, the only way to properly resolve some of the issues was to discuss them, and collaboratively search for suitable solutions.

A machine layout tool is given to each of the subjects during the design session. Besides the computer based communication tool, each subject can also see the other team member's machine layout screen. The following guidelines were given to the subject:

• The space is shared between the two sets of machines selected by each designer and machines cannot overlap.
• Machines must be laid out left to right following order of operations.
• Designer 1 must position machines in the top half of the factory, and Designer 2 in the bottom half.

These guidelines were enforced to give the subjects another opportunity to collaborate about the layout, explore possibilities and possibly create some win-win situations.

Performance Measures

One task of this research is to develop meaningful performance measures to assess the effectiveness and efficiency of the collaborative design process. Following indices are introduced as performance measures.

Score-based Design Performance Index (SDP): This index is computed using two metrics: cost performance S_c and space performance S_s. The maximal score $S_c=100\%$ was assigned to the cheapest design observed (m_c), while the score of $S_c=0\%$ was assigned to the design with the highest possible cost (M_c). A linear grading scheme was used. We have cost score:

$$S_C = 1 - \frac{A_C - m_C}{M_C - m_C} \tag{1}$$

where A_c is the cost of the machine set selected by the team.

Similarly, the space score is computed as:

$$S_S = 1 - \frac{A_S - m_S}{M_S - m_S}$$

(2)

where M_S: maximum number of cells used; m_S: minimum number of cells used; A_S: number of cells used in the experiment evaluated.

The SDP index is computed using weighting factors:

$$SDP = 0.8 \times S_C + 0.2 \times S_S$$

(3)

Design Space Exploration Index (DSE): When there is an issue associated with an incompatibility, resolving the issue may need new solutions or options. DSE index measures the "exploration" quality of the design process and is computed by counting the number of *issues* discussed (A_I) and the number of *options* considered (A_O) to resolve these issues. For each of these two measures the highest number recorded throughout the experiment (M_I and M_O, respectively) are considered as full scores and scaled to 100%. The lowest values for each were both 0. We have:

$$DSE = \frac{(I + O)}{2} \; ; \textbf{where} \quad I = \frac{A_I}{M_I} \; \textbf{and} \; O = \frac{A_O}{M_O}$$

(4)

Negotiation Content Distribution (NCD): This term refers to the occurrence of each *speech-act* (Figure 2) in a given experiment. For each team, the numbers of occurrence of the following utterances are collected: (1) plan proposals (propose/counter-propose), (2) solution proposals (propose/counter-propose), (3) arguments (critique, defend, dissent) and (4) information requests (acquire-info).

Tracking the speech-acts used provides an overview of the negotiation contents that can be used to assess dominant communication activities.

Negotiation Process Distribution (NPD): In this study, a collaborative design process is divided into 3 consecutive phases. They are:

• ***Planning***: During the strategic planning phase the subjects strategize about how to address the design problem.

• ***Resolution***: During the design resolution phase the subjects generate solutions for the common design problem.

• ***Optimization***: During the design optimization phase, the subjects try to improve their design.

For each team sample, NPD index measures the ratio of utterances devoted to each of the phases. For example, for the planning phase, we have:

$$NPD_{Planning} = \frac{\sum\limits_{Planning} Utterances}{\sum\limits_{Experiment} Utterances}$$

(5)

Similarly, we can calculate $NPD_{Resolution}$ and $NPD_{Optimization}$.

Roles of Argumentative Negotiation Protocol

In the course of this research we developed the following hypotheses regarding how our argumentative negotiation protocol may influence collaborative design results and processes.

- *Hypothesis #1: ANED protocol can help designers generate more design alternatives,* because better understanding of others through argumentation and insisting on one's own stance may lead to searching for more alternatives.
- Hypothesis #2: ANED protocol can improve design results, since more design alternatives lead to better design.
- Hypothesis #3: ANED protocol can increase the efficiency of collaboration, since the communication is more focused and targeted.

One-way analysis of variance (ANOVA), equivalent to a t-test in this case, was performed with the negotiation type (two levels: ad-hoc (-1) and ANED-protocol (+1)) as the independent variable and performance measures as dependent variables. Level of significance was set to $p = 0.05$. Pearson's correlation coefficient was also used to support a number of observations. Table 2 summarizes the experiment results

Protocol and Design Performance

From the data shown in Table 2, the average SDP of the Control Group is 81.38% versus 85.66% for the Protocol Group. While the difference is subtle, the tendency of improvement from using Protocol can be seen. Because the standard deviation is relatively large in both groups, the analysis did not yield a significant result ($F_{1,6} = 1.05$, $p = 0.344$), hence could not conclusively validate our *Hypothesis #2*.

The insignificance might be due to the definition of the design problem. Further analysis of the design problem revealed that the problem was created such that the score differences between the good solutions and the bad ones are small comparing with the total scores. Therefore the chance for

the subjects to achieve significantly better scores by uncovering win-win situations was relatively low.

Table 2 Summary of Experiment Results (CG vs. PG)

	Control Group (CG)				Protocol Group (PG)			
	T1	T2	T2	T4	T1	T2	T3	T4
SDP (%):	73.9	83.4	79.3	89.0	87.6	86.6	90.4	78.0
Score-cost (%)	77.9	79.3	77.6	86.2	84.5	100	96.5	81.0
Score-space(%)	66	100	66	100	100	33	66	66
DSE (%):	37.5	0	0	0	87.5	87.5	75	62.5
Issue-discussed	1	0	0	0	4	3	4	3
Option-discussed	2	0	0	0	3	4	2	2
NCD:								
Proposals-plan	8	4	15	11	6	0	0	2
Proposals-other	6	2	10	9	14	12	21	12
Agreements	14	3	15	13	25	14	19	9
Info-request	21	5	37	29	6	5	9	5
Issue-discussed	1	0	0	0	4	3	4	3
NPD:								
Planning	0.56	0.20	0.09	0.09	0.02	0.0	0.0	0.0
Resolution	0.21	0.20	0.64	0.62	0.91	0.83	0.86	0.88
Optimization	0.23	0.60	0.27	0.29	0.07	0.17	0.14	0.12

Protocol and Design Space Exploration

Using DSE as the response and the CG/PG as the factor, the ANOVA result shows that the ANED protocol *has a significant effect on design space exploration* ($F_{1,6}$ = 38.21, p = 0.001), supporting our *Hypothesis #1*. Another interesting analysis can be done by looking at the correlation between the experiment type (with or without protocol) and the number of issues discussed. Pearson's coefficient value computed is r = 0.961 (p = 0.000), indicating a very strong correlation.

When ANED was developed, one of the initial postulates was that negotiation is not merely a communicative process but also a stimulating and hence creative one, during which the parties not only exchange information but also argue with, and attempt to influence, each other. Conflicts

between two parties are not only problems to deal with but opportunities of finding new solutions. This principle is adopted by TRIZ [23]. Our results indicate the potential to apply the principle to collaborative design.

Protocol and Negotiation Content Distribution

By analyzing the *negotiation content distribution* (NCD) data shown in Table 2, we notice a significant difference between the two treatment groups in the type of activities dominating the negotiation process.

The one-way ANOVA for the total number of non-planning proposals ("Proposal-other" in Table 2) shows that the protocol *has a significant impact on subjects' proposal making behavior* ($F_{1,6}$ = 8.21, p = 0.029). Using ANED protocol leads the subjects to generating more *resolution* and *optimization* related proposals. This result was expected because proposals and counter-proposals are the locutions introducing possible agreement points: generating more proposals expands the range of the possible agreements. This supports our *Hypothesis #1*.

The analysis of the number of information request utterances indicates that the protocol *reduces the need for information request* ($F_{1,6}$ = 5.90, p = 0.051). This can be explained as the result of two combined effects. First, higher number of proposals is balanced by a lower number of information request/passing loops since proposing and arguing assume the information passing function in the form of *data* and *warrants* (see Section 3.2). Second, the efficiency of argumentative negotiation enhances mutual understanding of their stances and reduces the need for information requests.

The analysis of the number of *planning* related proposals shows a conclusive result ($F_{1,6}$ = 7.58, p = 0.033): the *ad-hoc group* does more planning related exchanges than the *protocol supported group*. We will discuss this interesting result in the following subsection.

The average amount of utterances used by each group validates our *Hypothesis #3*, i.e., the protocol improves collaboration efficiency, as the teams in Protocol Group used an average of only 69 utterances to complete the design task whereas Control Group teams needed an average of 118.

Protocol and Negotiation Process Distribution

Besides negotiation content distribution, we assessed the impact of the protocol on negotiation process distribution (NPD) by counting the numbers of utterances used in each of the three phases, *planning*, *resolution*, and *optimization*. The experiment results are shown in Table 2.

The statistical analysis supports the observation from Table 2. Although the significance is not as strong for the resolution phase ($F_{1,6}$ = 4.25, p = 0.085), the data leads to significant results for planning ($F_{1,6}$ = 13.33, p = 0.011) and optimization ($F_{1,6}$ = 6.45, p = 0.044).

The data analysis revealed two interesting results. First, the teams in the PG teams spent little effort of their communication on *planning*, while the CG teams devoted almost a quarter of their effort in *planning*. Planning related communications are needed when two designers try to decide on their strategy and process to solve a problem. The ANED protocol was designed with a focus on the argument exchange, and the exchange process is predefined. This restriction to some extent relegates the need for planning: the subjects first identify their stances and then go directly into the argumentation process. In the ad-hoc CG teams, however, after the subjects get together, they spend a long time on deciding what needs to be done and how to do it. In other words, they try to "optimize" the way to solve the problem. This planning "optimization" often leads to an "easy way out" to solve the problem. As a result, the solutions found from the "easy ways" are considered *the* solutions. Few more explorations are pursued. The discussion in the following paragraph further supports this observation.

The second interesting result is that the Protocol Group had twice the *resolution* related communications than the Control Group. Without the guidance and restriction of the protocol, the ad-hoc teams tend to find solutions and then stick to the found solutions, rather than try to argue for and maintain their own stances. As a result *any* solution is a *good* solution, leading to less effort in resolution phase.

Roles of Multi-Level Negotiation Strategy

The PSG treatment group was exposed to the "hierarchical exploration strategy" described in Section 3.3. Prior to the test, the subjects were given a number of case examples of how to apply the strategy. Our intent was to assess how effective this exposure to the strategy can be. Two hypotheses are postulated:

- Hypothesis #4: Following the "hierarchical exploration strategy" can improve the thoroughness of design space exploration, since moving to a higher level provides a better view of sub-issues in the lower level.
- *Hypothesis #5: The strategy support leads to more proposals and agreements*, since having the options of moving into higher levels provides more opportunities to find proposals

The experiment results of PG vs. PSG teams are shown in Table 3.

Strategy and Score-based design performance

We can draw a number of conclusions based on the raw costs and space re-
sults from Table 3. First, the average cost scores vary (PG-90.52% vs.
PSG-97.03%) between the two treatment groups. Furthermore, the teams
from the PSG did not get as high space scores (average 49.5%) as the
teams of the PSG (average 66.25%) which reveals a more thought-out
process focusing on high cost score and compromising on the space score
(consistent with *Hypothesis #4*). The strategic support has thus been in-
strumental in keeping the design effort in line with the design requirement
shown in Eq (3).

Table 3 Summary of Experiment Results (PG vs. PSG)

	Control Group (PG)				Protocol & Strategy Group (PSG)			
	T1	*T2*	*T2*	*T4*	*T1*	*T2*	*T3*	*T4*
SDP (%):	87.6	86.6	90.4	78.0	83.8	90.4	83.8	91.8
Score-cost (%)	84.5	100	96.6	81.0	96.6	96.6	96.6	98.3
Score-space (%)	100	33	66	66	33	66	33	66
DSE (%):	46.4	47.3	39.3	33.0	52.7	19.6	80.4	100
Issue-discussed	4	3	4	3	5	2	6	8
Option-discussed	3	4	2	2	3	1	6	7
NCD:								
Proposals-plan	6	0	0	2	6	5	5	10
Proposals-other	14	12	21	12	32	16	27	29
Agreements	9	10	16	8	17	11	18	17
Info-request	6	5	9	5	16	8	17	43
Issue-discussed	4	3	4	3	5	2	6	8
NPD:								
Planning	0.02	0.00	0.00	0.00	0.00	0.00	0.00	0.00
Resolution	0.91	0.83	0.86	0.88	0.51	0.77	0.66	0.70
Optimization	0.07	0.17	0.14	0.12	0.49	0.23	0.34	0.30

The analysis indicates, however, that the cost difference shown in Table
3 is not statistically significant ($F=1.97$, $p=0.21$), fending off any conclu-

sion. Nevertheless, the standard deviation drops from σ_2 =2.66 to σ_3 = 0.25, denoting a higher consistency of the design results among the PSG teams. This observation corroborates the average number of issues selected by teams of each group in their final design (2.25 for PSG vs 0.75 for PG).

The SDP values follow comparable trends, as they are based on the scores along the cost and space performance measures. The average SDP shows a progression from PG to PSG. However, the statistical significance is not clearly established. Therefore, the contribution of the strategy on the design outcome quality is important but not as far-reaching as expected according to this experiment. The reasons can be the limited exposure to the strategy received by the subjects of PSG. It can also be the limitation of the problem definition. Further research is needed.

Strategy and Design space exploration performance

For design space exploration, Table 3 shows a progression in the average numbers of issues and options discussed from PG to PSG teams (consistent with *Hypothesis #4*), even though the statistical significance is not reached due to large standard deviation values ($F_{1,6}$ =1.49, p = 0.269).

A careful examination of the date indicates that although T2 of PSG did not exhibit significant efforts to explore the design space thoroughly, they achieved a high scoring design. This "singularity" may be due to the design problem's insufficient intricacy to require extensive and thorough design space exploration to achieve a good design. In a real-world design task, the complexity stems from the fact that the solution space is continuous and not discrete as in the problem used in this experiment. There are virtually thousands of solutions for each task leading towards a design solution, and the likelihood of achieving a good design by chance is essentially annihilated. Further study is needed to include more real and complex design problems.

Strategy and Negotiation content distribution

The analysis of the negotiation content distribution data of the PG and PSG teams in Table 3 reveals conclusive results of the impact of the negotiation strategy. PSG teams generated a significantly higher number of strategic proposals ($F_{1,6}$ = 5.93, p = 0.051) and the total number of other proposals ($F_{1,6}$ = 8.40, p = 0.027). In addition, the increased number of proposals is echoed by a direct increase in the number of agreements reached as visible in Table 3 ($F_{1,6}$= 6.79, p = 0.040).

The results are consistent with our *Hypothesis #5*. The implication can be drawn that the hierarchical exploration strategy has a distinct effect on the types of utterances employed by the subjects. The density of the total argumentative content does not change; however, more proposals are exchanged. The subjects are conscious that the discussion should not be limited to the machine selection and machine layout, but should spread over the higher levels of machine issues and incompatibilities. This way, they can generate proposals over a larger scope, leading to more proposals and agreements.

Strategy and Negotiation Process Distribution

The NPD data in Table 3 indicate that PSG teams share the same behavior in strategic planning with those in the PG teams: the *planning* phase is totally missing for the same reasons described in Section 5.4. Nonetheless, the distribution over the other two phases, i.e., *resolution* and *optimization* is appreciably different. One-way ANOVAs over the ratio of utterances used for *resolution* and *optimization* yield both $F_{1,6} = 13.37$ and $p = 0.011$. The PSG teams spent an average of 66% of their communication efforts over the design problem *resolution* phase and the remainder 34% *optimizing* the design solution. This redistribution of the two activities is synonymous of a more effective problem resolution phase, since the total amount of utterances used is comparable in the two groups. This observation agrees with the higher efficiency of collaboration for PSG teams observed through the number of agreements reached. The team members, who adhere to the same strategy, achieved better understanding of each other's intentions and negotiation stances.

Concluding Remarks

This experiment study yielded several results backing up our initial hypotheses and showed that negotiation outcomes in a collaborative design process can be significantly affected by the ANED negotiation protocol and strategies. The findings can be summarized as follows:

- The use of ANED's *argumentative negotiation protocol* and *hierarchy exploration strategy* affects the dynamics of the negotiation/collaboration process positively and has the potential of improving the results of collaborative design. Future research is needed to link the process benefits to the improvement of the design results.

- By imposing argumentative interaction, the protocol leads the subjects to making more efforts on design space exploration and alternative generation, avoiding general human tendency of "plan, quick solution, and finish."
- Furthermore, the restrictive exchange of information of the argumentative negotiation protocol makes the overall collaboration process more efficient because the communication is more focused and well guided.
- Little planning occurred in protocol- & strategy-supported teams implies that the designers should have a good understanding about the design problem and the design process when they come to work together. Future research is needed to verify if adding more speech-acts may help planning interactions.
- The *hierarchical exploration strategy* propels the designer to explore a wider range of design space more thoroughly, both vertically over different issue levels and horizontally across each issue level.
- The *hierarchical exploration strategy* provides a larger space and more opportunities for designers to generate more proposals and thus more agreements. As a result, the number of arguments exchanged being equal, the strategy-supported teams are able to reach a final design faster and spend more time optimizing their results.

The experiment study described above has two major limitations. First, the experiment study was not set up to address the issue of multi-disciplinary collaboration. Although it can be speculated that being able to enhance design space exploration can be positively linked to being able to facilitate better understanding between the designers of different disciplines, further study is needed to verify this link. Second, the results obtained thus far are limited to the type of the design problem tested. Future experiment research is needed to test various types of design problems and to include professional designers as subjects.

References

1. Parsons S, C Sierra, Jennings NR (1998) Agents that reason and negotiate by arguing. J. of Logic and Computation 8(3): 261-292
2. Jin Y, S Lu (2004) Agent-based negotiation for collaborative design decision making. Annals of the CIRP 53(1): 122-125
3. Geslin M, Y Jin (2005) A context based approach to engineering design negotiation. Proc. of 17th ASME Intl Conf. on Design Theory and Methodology, DETC2005/DTM-85183 Long Beach, CA, September 24-28
4. Pruitt DG (1981) Negotiation behaviour - organizational and occupational psychology. Academic Press, New York

5. Raiffa H, J Richardson, D Metcalfe (2002) Negotiation analysis: the science and art of collaborative decision making. The Belknap Press of Harvard University Press
6. Searle J (1969) Speech acts: an essay in the philosophy of language. Cambridge University Press, Cambridge
7. Gulliver PH (1979) Disputes and negotiations: a cross-cultural perspective. Academic Press, New York
8. Toulmin SE (1969) The uses of argument. Cambridge University Press, Cambridge
9. Rahim MA (1986) Managing conflict in organizations. Praeger, New York
10. Bond AH, L Gasser (1988) An analysis of problems and research in DAI. In AH Bond and L Gasser (eds), Readings in Distributed Artificial Intelligence, Morgan Kaufmann, San Mateo, CA: 3-35
11. Sycara KP (1989) Multiagent compromise via negotiation. In Gasser, L and Huhns M (eds), Distributed Artificial Intelligence Vol 2, Pitman Publishing, London: 119-137
12. Ronsenschein J, G Zlotkin (1994) Rules of encounter: designing conventions for automated negotiation among computers. MIT Press, Cambridge, MA
13. Jennings NR, S Parsons, P Noriega, C Sierra (1998) On argumentation-based negotiation. Proc. of the Intl Workshop on Multi-Agent Systems: 1-7
14. Antonsson E, KN Otto (1995) Imprecision in engineering design. ASME Journal of Mechanical Design 117(B): 25-32
15. Scott M (1997) Formalizing negotiation in engineering design. Ph.D. Thesis, California Institute of Technology
16. Klein M (2000) Towards a systematic repository of knowledge about managing collaborative design conflicts. In Gero, JS (ed), Artificial Intelligence in Design'00, Kluwer, Dordrecht
17. Lewis K, F Mistree (1998) Collaborative, sequential and isolated decisions in design. ASME Journal of Mechanical Design 120: 643-652
18. Peña-Mora F, Wang CY (1998) Computer-supported collaborative negotiation methodology. Journal of Computing in Civil Engineering 12(2): 64-81
19. Evan WM, McDougall JA (1967) Inter-organizational conflict: a labor-management bargaining experiment. Journal of Conflict Resolution 6(4): 398-413
20. Polzer JT (1996) Intergroup negotiations the effects of negotiating teams J. of Conflict Resolution 40(4): 678-698
21. Kirschman JS, Greenstein JS (2002) The use of groupware for collaboration in distributed student engineering design teams. Journal of Engineering Education 91(4): 403-407
22. Ballmer T, Brennenstuhl W (1981) Speech act classification: a study in the lexical analysis of English speech activity verbs. Springer-Verlag, Berlin
23. Altshuller GS (1998) 40 principles: TRIZ keys to technical innovation. Technical Innovation Center, Inc, Worcester, MA

DESIGN SUPPORT

Ontology-Based Process Modelling for Design Optimisation Support
Franz Maier, Wolfgang Mayer, Markus Stumptner
and Arndt Muehlenfeld

Learning Symbolic Formulations in Design Optimization
Somwrita Sarkar, Andy Dong and John S. Gero

*Automating the Conceptual Design Process: From Black-box to
Component Selection*
Tolga Kurtoglu, Albert Swantner and Matthew I. Campbell

A Case Study of Computing Appraisals in Design Text
Xiong Wang and Andy Dong

TRENDS: A Content-Based Information Retrieval System for Designers
Carole Bouchard, Jean-francois Omhover, Celine Mougenot,
Ameziane Aoussat and Stephen J. Westerman

Ontology-Based Process Modelling for Design Optimisation Support[1]

Franz Maier, Wolfgang Mayer, Markus Stumptner and Arndt Muehlenfeld
University of South Australia, Australia

The integration and reuse of simulation and process information is not well-integrated into current development practices. We introduce a framework to integrate Multidisciplinary Design Optimisation (MDO) processes using ontological engineering. Based on a multi-disciplinary design scenario drawn from the automotive industry, we illustrate how semantic integration of process, artifact and simulation models can contribute to more effective optimisation-driven development. Ontology standards are evaluated to assess where existing work may be applicable and which aspects of MDO processes require further extensions.

Introduction

In the design and engineering context, ontologies provide an explicit formalisation of design knowledge that is otherwise distributed among several design teams [12]. Ontologies also aid in semantic interoperability between design disciplines due to the introduction of meta-models that serve as a linking element between disciplines [18], providing means to reason about process-, simulation- and domain-specific aspects [5]. The work described in this paper extends the emphasis from artifact-centric approaches to *process-oriented* ontologies to provide a comprehensive unified framework.

As designs become more complex, designers and engineers increasingly rely on tool support to manage not only design artifacts, but also the design processes themselves. In order to store, manipulate, connect and validate

[1] This work was funded by the Cooperative Research Centre for Advanced Automotive Technology (AutoCRC), *Project 10: Integrated Design Environment*.

J.S. Gero and A.K. Goel (eds.), *Design Computing and Cognition '08*,
© Springer Science + Business Media B.V. 2008

513

processes, semantic representations of processes are desired that are able to convey not only the structure, but also the semantics of process parameters and activities unambiguously. This has become an even more pressing issue since many global manufacturers increasingly rely on distributed supply chains where consumer-specified manufacturing and machining processes may be imposed on suppliers. Similar issues arise where design activities are carried out in a distributed scenario [4].

Enacting, monitoring and predicting the execution of complex collaborative processes is crucial to react timely to changes and delays in subprocesses. This may span the entire process hierarchy from top-level business processes down to the execution of simulation tasks on cluster computers. Adequate process models allow to formalise and record the negotiation processes between design teams, as well as assessing their implications across organisational boundaries. Furthermore, process driven upper-level activities can be linked to data-centric optimisation tasks to automatically compose, enact and monitor the actual execution of optimisation tasks.

In this paper we outline an ontological representation of typical multidisciplinary optimisation (MDO) processes within analysis-driven design processes. Our ontological models comprise semantic descriptions of process constraints, design variables and further parameters originating from different design disciplines. We show how ontologies may serve as a reusable framework for MDO processes and how integrated reasoning about artifacts, related processes and optimisation tasks and their results may lead to more effective product development processes. We are not primarily concerned with the interoperability between engineering applications, but focus on how existing analysis tool chains can be employed more effectively.

In Section *Design Process Overview*, we present a general note on a framework for representation of optimisation processes and optimisation tasks at a domain-independent level. In Section *MDO Process Meta-model Development*, vital aspects of design process models are discussed and a meta-model of optimisation-driven design processes is introduced. In Section *Evaluation of Languages and Ontologies*, ontology languages are evaluated w.r.t. our modelling framework with focus on representation of and reasoning about processes. The architecture of our ontological framework for design optimisation processes is presented in Section *Task and Domain Representation*. Finally, related work is discussed, and our contributions and future work are summarised.

Design Process Overview

The design of complex products and systems is rarely carried out in a single monolithic step, but is broken down into a number of stages. The design cycle is structured in different activities, where initial tasks are concerned with exploration of design goals and alternatives at a conceptual level; detailed exploration of selected design alternatives and design artifacts is done only later in the product development cycle.

Tasks allocated to each state are typically distributed among a number of teams, each concerned with a particular aspect of the design under consideration (see Fig.1). Stages of the design process are synchronised by milestones, where the outcomes of the previous design activities obtained from different teams are assessed, integrated and approved as input for the subsequent stage. If a design does not satisfy certain required constraints, negotiation between design teams takes place in order to revise the specifications.

For example, the initial design activities in the automotive industry are concerned with market analysis, styling and overall architectural decisions; detailed manufacturing assessment and construction, integration and testing of physical prototypes are done only later in the process. Since the design of a car's underbody and its engine block may be carried out by different teams in parallel, teams must ensure that the interfaces of engine block and underbody remain compatible (dimensions, mount points, etc).

While widely employed, the approach is not free of drawbacks in practice:

- Infrequent information interchange only at milestones may lead to inefficient development, where different teams aim at meeting specifications that have become obsolete due to changes made elsewhere.
- Semantic integration of results stemming from different disciplines may be challenging due to varying level of detail, data representation and terminological mismatches. Incompatible data formats and tools may also contribute to poor data quality.
- Assessment and integration of information at a milestone may be difficult, since design activities may be carried out at different levels of detail or may not reach the same level of maturity at a synchronisation point.

Multidisciplinary Design Optimisation (MDO)

Multidisciplinary Design Optimisation (MDO) is a form of virtual development where rigorous modelling and optimisation techniques are applied

starting early in the design process, to obtain a coarse understanding of different aspects of a design across a number of heterogeneous domains. Rather than optimising each discipline separately, all disciplines are analysed in parallel and the results are merged with the intent to obtain the best design alternative as a compromise of all included disciplines.

The virtual design artifact is abstracted into a number of design variables that represent relevant properties for each domain under consideration. Relationships, such as trends and correlations, between design variables derived from domain-specific models and simulations express properties of the design and guide designers in selecting and refining design alternatives. Typically, these relationships are not explicitly known and must be obtained by simulation.

The Design of Experiment (DoE), that is, selecting appropriate parameters for simulation, is a challenging problem given the increased number of design variables and interactions between different domains. Since a single experiment may run for many days even on high-performance computing environments, careful choice of parameter values is critical.

A related problem is the representation of the *Design Interfaces* that specify the design variables. All solutions of sub-designs connected to the interface must assign compatible values. *Design Constraints* specify partial value assignments to variables of design interfaces and determine the design space that remains for investigation. Through this representation, both goals and (partial) design solutions are communicated between otherwise independent design teams in the optimisation processes. For example, a design interface between engine block and car body could specify that both components must agree on the location, shape and strength of joints. A particular design solution would assign concrete values to the interface variables.

Since the representation of goals, design constraints and design solutions may vary, semantic-preserving translation is critical to ensure a consistent overall design: (i) Multiple interfaces that represent a design artifact at different granularity can coexist in a design problem. For example, there could be an abstract interface representing an engine block and lower level interfaces representing the individual components comprising the aggregate component. Since the representation and level of abstraction may differ, semantic-preserving translations between the two representations must be performed. Design goals for the aggregate component are mapped to sub-goals, while detailed simulation results obtained for each component must be aggregated into a consistent result at the more abstract level. (ii) Similarly, the analysis granularity may vary among components. To ensure a consistent model, abstract and detailed representations of design constraints and simulation results must be mapped onto each other.

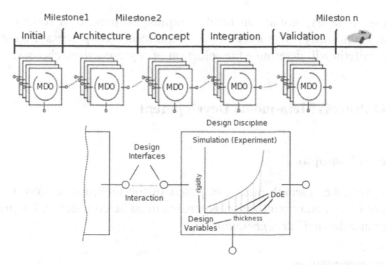

Fig. 1. MDO-driven design process

A design optimum obtained from an MDO process execution may affect other DoEs or their optimal solution, which may require negotiation between teams to reach acceptable tradeoffs, subject to the list of issues from the previous section. A prerequisite for this is the representation of MDO processes and information flow in a way that permits semantic analysis. For this we have to focus on two views: the traditional product/design modelling view, and the explicit modelling of the process view.

To combine theses two aspects, we use what we call an Ontology-based approach, where "ontology" (a term used in many meanings in the literature) is used in the interpretation of [16] as meaning a set of concepts plus logical axioms that describe their interrelations. The requirements of the domain drive the requirements for the axioms and the language in which they are expressed.

Ontology development for MDO

Provided with above understanding of MDO processes, a number of issues can be addressed by introducing an appropriate level of formalisation, in particular, the ability to merge, reuse, and locate past MDO runs; provision of interoperability between different MDO domains and abstraction levels; design and execution tracking; specification of processes, products, and design objectives; visualisation of MDO results; support of the negotiation process; data translation (from and to CAD and solver systems); administration of constraints; representation of design interfaces, constraints,

process elements, simulation results (inputs, outputs, data formats); and (most ambitiously) synthesising and monitoring of process executions. These criteria will determine the selection of representation choices.

MDO Process Meta-model Development

System Philosophy

To address the research questions posed in the previous section, two aspects of design and optimization processes must be considered: the *process aspect* and the *artifact representation*.

Process representation

The process representation is concerned with the representation and execution of design and engineering processes within and across organisational boundaries. A consistent formal process model allows to connect design decisions and artifacts to the processes that induced them. This is important in particular for process analysis to detect and resolve inefficiencies, as well as to track the evolution of processes over time. This can be considered an extension to the well-known "Corporate Memory" idea advocated, for example in [10], where design artifacts are stored to be retrieved by designers for later reuse. Having process information attached allows to extend this idea to the entire product development and deployment life cycle, such that it becomes possible to query process-related properties.

Common to all scenarios mentioned here is the requirement for a process model to represent not only the flow between process activities, but also the preconditions, effects and inter-dependencies between sub-processes at different levels of the hierarchy. While flow-models for processes have been extensively researched [1], the formalisation of semantic representations of activities in design and engineering processes has not been fully addressed so far.

Artifact representation

Adequate representations of structure, function and semantic annotation of design artifacts are essential requirements for reasoning about design artifacts as well as design processes, their prerequisites and their results. Ontologies provide the means to represent the relationships between artifacts and sub-artifacts, as well as (material and domain-specific) properties and

annotations made by designers/engineers, in a way that is amenable to semantic analysis and translation. This aspect is not new; in fact there is much work in this area that we incorporate into our approach. Ontologies designed to express hierarchical and functional rather than flow information are required to express complex artifacts and related constraints. Standards like STEP [14] and ontologies to represent function [17] serve as a starting point for the specific purpose of artifact modelling.

Example Application

The optimisation problem outlined in Figure 2 and Table 1 serve as a running example in this paper. The problem consists of a prismatic sheet metal structure that serves as a stub for a model of a real vehicle [23]. The model is parametric such that different combinations of artifact properties like material or number and location of structural elements may be investigated. Aspects of the MDO process itself, for example analysis granularity, are also configurable.

Table 1 Configuration of the Benchmark Example

Parameters	Values	Parameters	Values
Nodes (crash model)	ca. 6000	Design concepts	1
Volume elements (crash model)	ca. 20	Objectives	1
Independent design variables	16	Simulations	200
Design disciplines	1	Duration of optimisation	ca. 72h

The analysis problem under consideration is a crash simulation where the prism is equipped with a mass element and is driven into a fixed wall. The energy absorption of the model at different points in response to changes to structural and material properties is obtained as output. Crashworthiness is considered a good test bed for MDO processes since a considerable number of design variables are involved and the problem is one of the central tasks in virtually every vehicle design process.

The workflow shown in Figure 2 describes part of the basic structure of the problem. It consists of four steps: *configuration*, *gambit*, *mesh* and *lsdyna*. The four sub-processes represent the setup process, the geometry generation process, the meshing process (that is, creating the finite element mesh from a geometric model), and the solving process (simulation of finite-element model), respectively. To allow engineers to experiment with parameters, sub-processes may be configured to reuse a previous result rather than recompute an analysis.

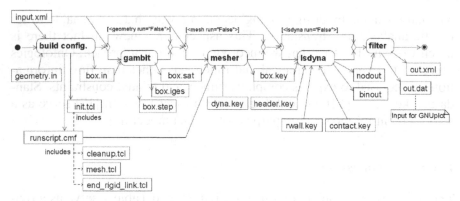

Fig. 2. Sample MDO Workflow

A Process Meta-Model for MDO

As the basis for the joint semantic representation a generic meta-model for optimization-driven design processes has been created (see Figure 3). We use the Unified Modeling Language (UML) due to its widespread usage.

The central model component of the model is *Process*, which represents generic activities in a process. Specialisations for trivial tasks, *Simple-Process*, and for hierarchically structured sub-processes, *CompoundProcess*, exist. Each process has *Ports* that represent inputs required and results generated by each process. While ports of *SimpleProcess*es are determined by the represented activity, *CompoundProcess*es aggregate the inputs and outputs of its constituents.

Each *Port* is associated with a *ParameterDescription* that acts as a placeholder for the semantic specification of the data that is obtained from/generated at a port. Through references to *ModelVariable*s, a parameter description may refer to aspects of a particular MDO problem. Similar to [22], the separation of *ParameterDescription* from *Port* allows to encapsulate language and implementation of ontologies within a separate entity and avoids duplication. Most closely related to our notion of *ParameterDescription* is the concept of typed input and output channels that are integral part of well-known Web service and workflow models [21].

Processes are connected through source and a target *Transitions*, where each transition is guarded by a *Constraint*. Constraints are an abstraction of logical expressions over instances of *Port* and *ParameterDescription*s. Control flow between processes along transitions is guarded by constraints that determine whether a transition may be followed or if the transition is blocked. This model is generic in that it subsumes other well-known process languages such as BPEL and UML Activity Diagrams. Constraints also

express preconditions and effects of a particular process step, represented as expression over ports and parameters.

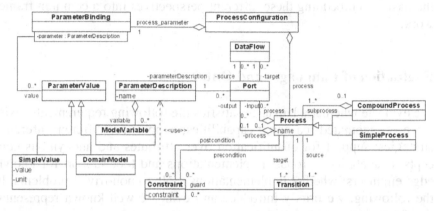

Fig. 3. MDO Meta-Model

Entity DataFlow represents an abstraction of "data channels" that determine the flow of values, design artifacts and other MDO-related data between ports.

Entity *ParameterValue* represents data that is passed into or generated by process activities. This includes complex structures such as entire geometry models or response surfaces generated from domain-specific analyses. Again, this entity serves to separate domain-specific and process-specific ontologies and representations.

The meta-model described here is an abstraction of concrete process models used in a particular domain, which in turn are specifications of possible execution scenarios that may occur. As such, the meta-model must be instantiated for a particular domain to obtain domain-specific process models. As discussed in Section *Evaluation of Languages and Ontologies*, we have investigated the translation of the generic UML model into more formal representation languages to allow automated reasoning and synthesis of instantiated models. The model as depicted omits environment specific implementation details, such as particular workflow enactment engines, which must be added in the course of refinement. We have equipped our meta-model with mechanisms to represent different versions, configurations and implementation platforms, similar to what is commonly referred to *grounding* in Web service specification formalisms. Similarly, ontologies and languages used to represent *ParameterDescription*s and *Constraint*s have been deliberately left unspecified in our meta-model to allow different (domain-specific) ontology languages to interface with our process model. This way, different formalisms may be used to

describe processes and design artifacts. As shown in the following section, no single formalism is perfectly suitable for the purpose and we work on the basis of embedding these different perspectives into a common framework.

Evaluation of Languages and Ontologies

We evaluate whether a language satisfies the following requirements: existence of automated reasoning capabilities; support for different inference strategies; support for quantification over attributes and anonymous concepts; availability of robust implementations and tool support for knowledge engineers; whether implementations scale to non-trivial problems. In the following, we briefly introduce and evaluate well-known representation formalisms and ontologies.

Representation Formalisms

Table 2 summarises our analysis of representation languages. For space reasons, only the most promising formalisms are considered.

Table 2 Characteristics of Representation Languages ('-' not available, '+/-' available to some degree, '+' available)

Requirement	PSL	F-Logic	KIF+CL	STEP	OWL	RDF(S)	XML
Concepts	+	+	+	+	+	-	+
Attributes	+	+	+	+	+	+	+
n-ary Relations	+	+/-	+	+	+	+	+
Functions	+	+/-	+	+	-	-	-
Instances	+	+	+	+	+	+	+
Rules	+	+	+	+	-	-	-
Formal Semantics	+	+	+	-	+	+	-
Inferences							
Subsumpt. checking	+	+	+	+	+	+	-
Constraint checking	+	+	+	+	+	-	-
Concept hierarchies	+	+	+	+	+	+	-
Subtyping	+	+	+	+	+	+	-
Subsumption	+	+	+	-	+	-	-
Complex Constr.	+	+	+	+	-	-	-
Domain-spec. prop.	+	+	+	+	+	+	-
Modularity	+/-	+	+	-	-	+/-	+

UML lacks standardised semantics and is thus unsuitable for reasoning. The Object Constraint Language (OCL) provides means to express constraints over sets of objects that cannot be expressed by a diagrammatic notation.

KIF and CL represent an interchange format for logic languages and enable translation between ontologies. F-Logic, which has similar characteristics, has been used in design environments [18].

Constraint satisfaction techniques are an efficient mechanism to search for solutions to logic theories and have successfully been applied to industrial problems including design environments, serving as the standard representation form for configuration and process modelling tasks [7], [24].

Description Logics (DL) and related Semantic Web standards OWL and DAML+OIL are less expressive than full First Order Logic. They have strong reasoning and tool support but lack core features for the modelling of product entities as, e. g., the representation of resources [7]. OWL does not provide support for modularity and complex constraints, two pivotal criteria in design environments. XML lacks formal semantics and axioms; hence, reasoning capabilities are not available.

Ontologies

Table 3 summarises our analysis of ontologies. The Standard for the Exchange of Product Model Data (STEP) [14] tailored for a comprehensive representation of product data and therefore can be employed in a manufacturing environment to capture artifact-specific, geometric and domain-specific data. On a meta-model layer STEP can serve as a representation of an artifact ontology. STEP tools, such as translators between different CAD-applications, exist and are deployed in design environments.

Table 3 Characteristics of Ontologies ('n.e.' not evaluated)

Requirement	PSL	STEP	CPM	OAM	FBS
Processes	+	-	-	-	+
timed	+	-	-	-	-
concurrent	+	-	-	-	-
exceptions	-	-	-	-	+
asynchronous	+	-	-	-	-
events	+	-	-	-	+
Intention Recording	+	-	+/-	+	+
Robustness	+/-	+	n.e.	n.e.	n.e.
Scalability	+	+	n.e.	n.e.	n.e.
Industry Acceptance	+/-	+	-	-	n.e.
Execution engine	+/-	+	-	-	n.e.
Tool support	+/-	+	-	+/-	n.e.

The Core Product Model (CPM) covers engineering information shared in product development [22]. The model intends to capture generic product information and structure. The Open Assembly Model (OAM) extends

CPM and represents a model and exchange protocol for assembly. Both do not support process modelling.

The function-behaviour-structure (FBS) ontology [11] represents a framework to classify processes that supports the situated design of processes. It has been used in a number of design-support tools, but must be complemented by a more detailed representation to capture detailed process-related information. The Process Specification Language (PSL) was designed to describe process entities using a formal approach based on first-order logic [1] to describe and reason about manufacturing processes. PSL meets most of the evaluation criteria, but has no procedures and limited support for modular reasoning.

Kitamura et al. [17] provide an ontological modelling framework of functional knowledge including a controlled vocabulary and an ontology of device and function. The framework, further discussed in section *Related Work* is able to represent design rationale and provides a hierarchic decomposition of functions.

Analysis and Recommendation for MDO

The analysis in previous sections shows that PSL, F-Logic, KIF and CL fulfil most evaluation criteria. We utilise PSL as a formal basis to reason about task ontologies and execution traces, but specialise the ontology to aspects specific to MDO.

While PSL is well-suited for representing processes, detailed artifact- and analysis-related knowledge cannot be captured. To bridge the gap, complementary ontologies must be applied. Here, STEP is a suitable candidate, since standardised data formats as well as mappings to formal frameworks are available. STEP/EXPRESS allow to capture and analyse structural properties of artifact models and concrete instances. The absence of formal semantics can be resolved by mapping to a FOL-based formalism. This approach has already been used for the optimisation of diagnostic processes in an industrial environment [25].

Task and Domain Representation

Task and Domain Ontologies for MDO

The meta-model described in Section *A Process Meta-Model for MDO* represents a generic framework that describes model-driven design proc-

esses at an abstract level. While at this level generic concepts such as design variables, control flow, tracing and grounding of executions are introduced, the model must be specialised to a particular domain and organisational structure to be applied in practice.

This specialisation may be interpreted as ontology engineering problem, where a generic ontology is adapted to suit particular domain- or task-specific aspects [20]. The adaption can be approached in two separate dimensions to yield a *task ontology* and a *domain ontology*. Task ontologies represent knowledge that is particular to performing individual tasks (from the process point of view) at a domain-independent level, while domain ontologies capture the conceptual primitives necessary to describe a particular domain. This separation of concerns allows to represent knowledge about individual domains separately from knowledge about how domain knowledge is manipulated [2].

Task ontologies specialise the generic meta-model to express ways to approach a design or optimisation problem and their relationships. Hence, task ontologies provide the means to reason about and link a given set of *goals* to processes that achieve these goals.

Domain ontologies on the other hand focus on the representation of design artifact and domain-specific information. Established standardised representations such as STEP [14], the Core Product Model (CPM) and the Open Assembly Model (OAM) [22] may be applied and extended to serve as formal representations or meta-models for domain ontologies. Ontologies developed to describe the structure and function [17] may also be utilised within our framework to represent the function of artifact parts and elements that may be used as replacements.

The explicit use of *adaptors* [2] has been advocated to bridge gaps between ontologies, including for parametric configuration problems [8]. Although not based on adaptors, in [17] it is shown that domain-specific ontologies representing the function of devices can be related via a common model to extend reasoning about roles and functions beyond a single domain.

Framework Architecture

Our framework relies on domain experts and knowledge engineers to identify and represent relevant interactions between domain ontologies and formalise mappings (our manifestation of ``adaptors") between ontologies. Hence, it becomes possible to support designers and engineers in planning, revising, and executing and analysing MDO related processes and their results. The proposed approach is illustrated in Figure 4.

We pursue a layered approach where our meta-model is located at the
top, task and artifact ontologies comprise the intermediate layer, and do-
main-specific ontologies form the bottom layer in the ontology hierarchy.
Concrete executable systems, such as CAD environments, MDO optimisa-
tion tools, data bases and workflow orchestration engines, are located in
lower layers.

From analysis of individual domains, ontologies of domain-specific
concepts, properties and relations are created, as well as specifications of
domain-specific analysis primitives. Process execution environments, for
example workflow enactment systems, are treated in the same way. As a
result, a set of domain ontologies is obtained.

Fig. 4. Ontology Architecture

Domain-independent aspects and processes are found by generalisation
of domain-specific ontologies to form the intermediate layer. By defining
suitable ontology mappings, specific knowledge is mapped into the unified
ontologies at the intermediate level. Established engineering practices and
processes may also be incorporated into the MDO task ontology. Simi-
larly, a generalised artifact ontology is constructed from the artifact do-
main ontologies.

Task and artifact ontologies at the intermediate layer must conform to
the meta-models in the upper layer. This is desirable for two reasons: first,
a common meta-model allows to describe and reason about domain-
independent and task-independent concepts, such as execution traces and
execution histories. The meta-model defined in Section *A Process Meta-
Model for MDO* defines the necessary framework and concepts. Second,
task and artifact ontologies need not be expressed in the same formal

framework and may need to be reconciled to obtain an inference framework that can handle mixed expressions (see the following section).

Hence, ontologies and inference systems that comprise the intermediate layer serve as a platform to integrate information and processes obtained from different domains and expressed in languages defined by different ontologies. Common task and artifact ontologies allow to *design, trace, reason about* and *execute* analysis-driven processes in a language that is suitable for designers and engineers. Support environments developed for the design and execution of distributed scientific experiments have demonstrated that this is feasible without exposing the underlying formal knowledge representation mechanisms to designers and engineers [21]. Translation between the intermediate layer and the ontologies below is accomplished by adaptors that map between domain-independent and domain-specific representations.

The Benefits of Formal Ontologies for MDO

Compliance to the meta-models in the top layer allows use of automated reasoning systems to integrate ontologies and artifact ontology in a uniform framework [6].

We use PSL to formalise the task ontology, while the STEP/EXPRESS [13] framework is applied to define the artifact ontology. For space reasons we will briefly depict some representative examples of the automated process manipulation.

Process execution

Using automated reasoning technology, process models can automatically be translated into workflow enactment models that are executed. This allows to automatically track, store, and reason about process outcomes that are handled by the MDO environment. Through common task and artifact ontologies and adaptors, simulation inputs and results can be compared and possible changes to the process may be suggested and validated.

Simulation reuse

For example, an MDO optimisation task can be adapted and streamlined if suitable results are available from previous similar analysis. To re-use the result of a past simulation rather than performing redundant analysis becomes possible if it can be shown that the candidate result is an acceptable replacement in context of the current simulation. This requires reasoning

about the execution history of past and current processes and to compare assumptions, results, constraints and goals of execution traces.

In our framework, abstract process specifications, optimisation tasks and traces of process executions are represented using the PSL ontology. For example, Figure 5 expresses that activity *lsdyna* is a subactivity of crashworthiness analysis that requires as input a finite-element model. Similarly, execution traces of process instances are encoded as PSL statements (Figure 6). Each trace represents the actual execution of a process, where each node is associated with information about its execution (for example, machine node identifier and time stamps). Figure 6 represents a fragment of an execution of the workflow in Figure 2, where an execution of task *HMBatch* is immediately followed by an execution of *LsDyna*, and no other activity immediately follows *HMBatch*. Also given are execution-specific data, in this case time stamps and software version.

```
(activity Crashworthiness)
(exists (?mesh ?result)
  (and (activity LsDyna(?mesh,?result))
    (subactivity LsDyna(?mesh,?result) Crashworthiness)
    (forall (?occLD)
        (=> (occurrence_of ?occLD LsDyna(?mesh,?result))
            (and (occurrence-input ?mesh ?occLD)
                (occurrence-output ?result ?occLD))))))))
```

Fig. 5. Task Specification in PSL

```
(and (occurrence_of occHMB HMBatch(geom1,mesh1))
    (occurrence_of occLD  LsDyna(mesh1,result1))
    (occurrence_of occC   Crashworthiness)
    (= occLD (successor LsDyna(mesh1,result1) occHMB))
    (= (begin_of occHMB) '23/11/07 12:00')
    (= (end_of occHMB) '23/11/07 18:00')
    (holds (version 1.1) occHMB)
    (forall (?occ ?m ?r)
        (=> (= ?occ (successor LsDyna(?m,?r) occHMB))
            (= ?occ occLD))))
```

Fig. 6. Process Execution in PSL

```
ENTITY Mesh;
  model_of: Part;
  points : SET of Point;
  granularity : NUMBER;
END_ENTITY;
FUNCTION compatible(m1,m2:Mesh):Boolean;
  RETURN m1.granularity = m2.granularity;
END_FUNCTION;
```

Fig. 7. Mesh Compatibility Constraints

Assume that an analysis is to be conducted to compare the crash behaviour of two alternative designs. For two crash simulations of the same artifact part to be comparable, it is required that the finite element models used in both simulations are of equivalent granularity. Furthermore, due to algorithmic differences between software versions, it is required that both meshes were computed using equivalent software (version number). Figure 7 formalises this aspect of compatibility between mesh models in our artifact ontology.

The formal representation of compatibility requirements and execution traces allows to query and retrieve from the repository simulation results that are compatible with the requirements of the current experiment. In our example, requirements imposed on the input mesh model can first be transformed using the artifact ontologies to obtain constraints on mesh models restricting software version numbers. These requirements can then be injected into the models of each candidate execution trace to assess whether all process activities manipulating the model satisfy the constraints. Conforming traces can be presented as candidates, while a constraint violation would lead to the rejection of a candidate.

Simulation Selection

Given that processes and process executions are represented in the same framework, similar reasoning may be applied in the experiment preparation stage *before* optimisation processes are executed. For example, PSL process descriptions can be used to ensure that a suite of experiments leads to compatible results that can subsequently be aggregated into a global view.

Error Handling

Simulations may also benefit from improved robustness of models and execution through semi-automated error recovery. If a simulation aborts due to modelling errors or invalid input values, formal ontologies and a repository of models and execution traces support determining whether a different model is available that does not exhibit the same problem and has been applied using parameter values matching the current situation.

Related Work

Ontologies to exchange product data are discussed in [5], focusing mostly on the interoperability aspect. However, translation and mediation remains

an issue, as standards are often not fully implemented in practice. In [15] a framework is introduced where mediation is negotiated *dynamically*, based on a knowledge model rooted in the function-behaviour-structure ontology [11]. We assume that the engineering processes are already in place and the focus is therefore on supporting engineers in *using* the available resources more effectively.

In [19], extensions of STEP to represent analysis-driven design activities are investigated. Here, we extend the approach to integrate artifact and process models into a unified framework.

An ontology of device and function and a vocabulary has been implemented by [17]. The framework partially formalises the functionality of an artifact and covers parts of the intended artifact ontology and the functional model of a design artifact in our architecture.

In [9] Constraint-based mechanisms have been applied to validate a given design but process modeling and manipulation are not addressed.

Grid services are recently becoming a factor in design and scientific environments due to their ability of providing resources that substantially accelerate the processing of simulation tasks [21]. In [3] ontology engineering is applied to support the design and execution of scientific simulations. Different from our work, ontologies are used to compose workflows rather than to relate different processes and their executions to each other.

Conclusion

Analysis and optimisation-driven design processes have become prevalent in many disciplines. However, support for designers and engineers to effectively *use* the results of simulation processes has not been addressed satisfactorily. Our work on integrating representations of design artifacts, design processes, and process execution aims to address these challenges.

Based on formal ontologies representing design processes, simulation and optimisation tasks and abstractions of design artifacts, we provide a framework where prerequisites and results of different simulation tasks are related through common ontologies and synergies between analysis tasks may be exploited. Separation of task-related and artifact-specific representations allows to employ different standards to represent each. Mappings between common and domain-specific ontologies allow to interpret and reason about process executions and domain-specific simulation results on a meta-level.

We evaluated different ontologies and standards to assess their suitability to represent aspects relevant to design optimisation processes and de-

sign artifacts, respectively. As a result, PSL, STEP and OAM were identified as the ontologies that best fit into our generic framework, with [13,21] remaining candidates for future integration.

Further work includes extension to formal mappings between common and domain-specific ontologies, as well as to investigate the application of different inference systems. We investigate adapting constraint technologies to our ontological framework and contrast that approach with FOL-based theorem provers. Currently, we exploit these technologies for consistency assessment of processes and their instances. Integration of one of the publicly available workflow execution engines for Grid environments into our framework and detailed evaluation of possible inferences, impact on engineering practices and system scalability also remain for further investigation.

Acknowledgements

Domain knowledge and processes are developed jointly with the Victorian Partnership for Advanced Computing and General Motors/Holden Innovation. We thank Chris Seeling (VPAC) and Daniel Belton (GM/H) for the reference problem design and insights into the MDO process.

References

1. Bock C, Grueninger M (2005) PSL: A semantic domain for flow models. Software Systems Modeling: 209-231
2. Chandrasekaran B, Josephson J, Benjamins R (1998) The ontology of tasks and methods. Proc. of KAW'98
3. Chen L, Shadbolt R, Tao F (2005) Semantics-assisted problem solving on the semantic grid. Computational Intelligence 21(2): 157-176
4. Chira C, Roche T, Tormey D, Brennan A (2004) An ontological and agent-based approach to knowledge management within a distributed design environment. In JS Gero (ed), Design Computing and Cogition'04, Kluwer,: 459-478
5. Dartigues C, Ghodous P (2002) Product data exchange using ontologies. In JS Gero (ed.), Artificial Intelligence in Design'02, Kluwer, Dordrecht: 617-636
6. Deshayes L, Foufou S, Grueninger M (2006) An ontology architecture for standards integration and conformance in manufacturing. Proc. of IDMME
7. Felfernig A, Friedrich G, Jannach D, Stumptner M, Zanker M (2003) Configuration knowledge representations for semantic web applications. AI EDAM 17(1): 31-50.
8. Fensel D, Motta E, Decker S, Zdráhal Z (1997) Using ontologies for defining tasks, problem-solving methods and their mappings. Proc. EKAW: 113-128

9. Fowler D et al. (2004) The designers' workbench: Using ontologies and constraints for configuration. Proc. AI2004/SGAI'04
10. Fruchter R, Demian P (2002) CoMem: designing an interaction experience for reuse of rich contextual knowledge from a corporate memory. AI EDAM 16(3): 127-147
11. Gero JS, Kannengiesser U (2007) A function-behaviour-structure ontology of processes. AI EDAM 21(4): 379-391
12. Gómez-Pérez et al. (2004) Ontological engineering. Springer
13. Haymaker J, Kunz JC, Suter B, Fischer MA (2004) Perspectors. Advanced Engineering Informatics 18(1): 49-67
14. ISO 10303-11 (1994) Ind. automation systems and integration-Product data representation and exchange-Part 11:The EXPRESS language ref. manual.
15. Kannengiesser U, Gero JS (2006) Towards mass customized interoperability. Computer Aided Design 38(8): 920-936
16. Kifer M, Lausen G, Wu J (1995) Logical Foundations of Object-Oriented and Frame-Based Languages. Journal of the ACM 42(4): 741-843
17. Kitamura Y, Koji Y, Mizoguchi R (2006) An ontological model of device function: industrial deployment and lessons learned. Applied Ontology 1(3-4): 237-262
18. Maier A, Schnurr HP, Sure Y (2003) Ontology-based information integration in the automotive industry. Proc. Intl. Sem. Web Conf., LNCS 2870: 897-912
19. Maier F, Stumptner M (2007) Enhancements and ontological use of ISO-10303 (STEP) to support the exchange of parameterised product data models. Proc. ISDA'07: 433-440
20. Mizoguchi R, Vanwelkenhuysen J, Ikeda M (1995) Task ontology for reuse of problem solving knowledge. KB&KS: 46-59
21. Oinn T et al. (2006) Taverna: lessons in creating a workflow environment for the life sciences. Concurrency and Computation: Practice and Experience 18(10): 1067-1100
22. Rachuri S et al. (2005) Information models for product representation: core and assembly models. Int. Journal of Product Development 2(3): 207-235
23. Seeling C (2007) User Manual for the Crash-box MDO reference problem
24. Thiagarajan R, Stumptner M, Mayer W (2007) Semantic web service composition by consistency-based model refinement. Proc. 2nd IEEE Asia-Pacific Service Computing Conference (ASPSCC'07): 336-343
25. Wilmering T, Sheppard J (2007) Ontologies for data mining and knowledge discovery to support diagnostic maturation. Proc. 19th Intl. Workshop on Principles of Diagnosis (DX'07): 210-217

Learning Symbolic Formulations in Design Optimization

Somwrita Sarkar and Andy Dong
University of Sydney, Australia

John S. Gero
George Mason University, USA

This paper presents a learning and inference mechanism for unsupervised learning of semantic concepts from purely syntactical examples of design optimization formulation data. Symbolic design formulation is a tough problem from computational and cognitive perspectives, requiring domain and mathematical expertise. By conceptualizing the learning problem as a statistical pattern extraction problem, the algorithm uses previous design experiences to learn design concepts. It then extracts this learnt knowledge for use with new problems. The algorithm is knowledge-lean, needing only the mathematical syntax of the problem as input, and generalizes quickly over a very small training data set. We demonstrate and evaluate the method on a class of hydraulic cylinder design problems.

Motivation

Design formulation and reformulation significantly affect the results of any automated optimization exercise, and is a difficult problem from both computational and cognitive perspectives. It is a difficult problem for many reasons – there is no known formal process that takes an abstract set of design requirements as input and produces a symbolic mathematical design model as output [1]; It is knowledge intensive and requires both domain and mathematical expertise from designers; the numbers of variables, parameters, objectives and constraints in a problem often exceed

J.S. Gero and A.K. Goel (eds.), *Design Computing and Cognition '08*,
© Springer Science + Business Media B.V. 2008

human short term memory, with the number of dimensions exceeding human visualization capacities; the problem definition and the design model both change dynamically as the designer's understanding of the problem develops, i.e. the learning and doing of the problem develop together [2]; the solutions produced by the symbolic design model are only as valid as the modeling assumptions that are built into the model, making "reasonable and good" modeling assumptions essential for a valid solution [3]; the adopted modeling formalism is fundamentally related to the kind of algorithms that the designer intends to use to solve the problem. Problem formulation and solution method selection co-evolve [1].

Designers rely upon experience, subjective decision making, and trial and error to produce a final design optimization model that guarantees both the existence of a solution and the finding of an optimal solution through the application of optimization algorithms. Also, designers produce different formulations, given the same design requirements. The process of designing is also a process of discovery and invention, causing the re-definition of the problem along with the construction of the solution [4].

Any learning algorithm assisting the designer in problem formulation would typically be characterized by its ability to learn characteristics of both the designed product and designing process, including both engineering design and representational domain knowledge. As the complexity of engineering design and products increases, computational systems provide support for tasks that were previously considered purely cognition-based human tasks. (Re)-formulation of design problems is one such task. Human designers typically become better at formulating and solving problems as their expertise in a design domain increases with experience. Previous design experiences become the basis of learning; learnt knowledge is applied to future problems, with human designers doing this over much lesser number of experiences as compared to a machine learning system [5]. Computational systems designed for supporting cognitive design tasks must also develop this capacity of learning, generalizing and applying design knowledge using fewer number of design cases as providing a large training database of design cases becomes impractical in real situations.

Aim

This paper presents a knowledge-lean learning and inference mechanism for unsupervised learning of semantic design concepts and relationships from purely syntactical examples of design formulation data in

optimization. It models design optimization problem formulation as a statistical pattern extraction learning problem. Design formulation examples expressed in standard mathematical form, make up the training set. The learning mechanism operates on each sample individually; each sample is defined as one "design experience" for the system. A new experience becomes part of the existing training set. The system then acts as a "design formulation assistant" by extracting the learnt knowledge for new, but similar problems (problems from a common design domain, e.g. the design of hydraulic cylinders, or sharing a common mathematical form, e.g. linearly formulated design optimization problems). The assistance is provided in the form of the designer querying the system for advice. The designer can choose a class or family of optimization problems, define a new problem in this family and then query the system for formulation choices on variables, parameters, constraints and objectives. The algorithm operates as an incremental learning system such that, over time, the same query is able to return different and "richer" answers as the number of "design experiences" provided to the system increases.

The mechanism is based on employing the Singular Value Decomposition (SVD) algorithm from linear algebra [6] [7]. Because the system operates only on syntactical design formulation training data with no other inbuilt knowledge, providing "faulty" data (wrongly or badly formulated examples) can cause the system to learn wrong concepts. However, it may be conjectured that because of the statistical nature of the algorithm, the mechanism should eventually even out "noisy" effects (results from wrongly formulated examples) if enough correctly formulated examples are provided.

The next section presents other related research approaches in the field of machine learning applied to design optimization formulation and reformulation, with comparisons to the method described in this paper.

Related prior work

Many recent approaches in design automation and optimization are based on combining artificial intelligence, machine learning and cognitive science approaches. Balachandran and Gero developed an expert system for rule-based problem formulation [8]. Mackenzie and Gero developed a tool that allows interaction between problem formulations and results [9]. But, in these, the knowledge is not persistent beyond the current design experience, and no new knowledge may be created that can influence

future design tasks. Schwabacher et al. developed a decision-tree inductive learning based optimization tool, where characteristics of the designed product and the optimization process are learnt [10]. Ellman et al. developed a tool allowing the user to formulate, test, reformulate and visualize a tree of optimization strategies constructed by the user that may be applied onto test problems in order to identify relevant optimization strategies for particular design domains [11]. Nath and Gero developed a machine learning tool that acquires strategies as mappings between past design contexts and design decisions that led to useful results [2]. Campbell et al. developed an automated synthesis tool called A-Design. A multi-agent based system combines genetic algorithms, asynchronous teams and functional reasoning to get a team of agents with given roles to evolve conceptual design objects [12]. Moss et al. have further explored learning in such a system, wherein useful "chunks" of design knowledge are learnt and used in future design tasks [5].

Most of the above approaches either require a high level of knowledge engineering (e.g. rules, heuristics, grammars, pre-designed inbuilt algorithms), or a large training database solved of design cases. In this research, we approach the problem from an altogether different perspective – statistical machine learning – inspired in part by research in the statistical natural language processing (SNLP) and digital image processing (DIP) domains. In both these domains, SVD (singular value decomposition) is used as a tool for pattern extraction and dimensionality reduction. In SNLP, SVD based Latent Semantic Analysis (LSA) [13] reveals semantic patterns in textual data. In DIP, SVD [7] is used for identifying pattern redundancy in image data for compression of images. The main insight provided by these methods is that the syntax of representation (words, pixels) embeds the semantics of the knowledge being represented (contextual meaning – sentences, graphic objects), either latently or explicitly. SVD as a dimensionality reduction mechanism, applied in these diverse domains, reveals the hidden or explicit semantic patterns contained in the syntax. We develop a parallel approach, where we use SVD on symbolic-mathematical design formulation data to automate the extraction and learning of semantic design concepts.

Design optimization formulation is a knowledge-intensive task requiring expertise in many domains. To develop learning mechanisms that require high-levels of knowledge engineering or a large training database of cases can be impractical. The main feature of our method is that it is knowledge-lean, and no data or knowledge beyond the mathematical syntax of a problem need be provided as input for learning. Instead of taking a knowledge-based approach, we develop a statistical machine learning

based approach, and conceive the design formulation problem as a pattern extraction problem.

Cognitive-Computational characteristics of design optimization problem formulation

This section presents a discussion on the cognitive-computational characteristics of the problem, its modeling as a statistical pattern extraction problem, the mathematics of SVD, and how the method captures the cognitive-computational characteristics of the problem.

Knowledge representation

For this work, we assume that an optimization problem is formulated in its general canonical form by the designer:

$$\text{Min} f(x, P)$$

$$\text{Sub to } g(x, P) \le 0, h(x, P) = 0, x, P \in X \subseteq \mathbf{R}^n$$

Here, x is the vector of design variables and P is the vector of design parameters. Design or decision variables are what the designer can vary in the search for a solution. Parameters are kept fixed for a particular design model, symbolically or numerically. g is a vector of inequality constraints and h is a vector of equality constraints that the design must satisfy to be feasible. Both x and P belong to some subset X of the real space \mathbf{R}^n, where n defines the total number of dimensions in terms of the numbers of variables and parameters. The functions f are objectives to be minimized; for a single objective case, this becomes a single function f.

In general, there are many subjective decisions that the designer makes in formulating this model [1]. Examples are choices on which elements are to be decision (design) variables and parameters, whether the design constraints to be incorporated in the model are natural ones, described by the physics of the system, or pragmatic ones, guided by engineering and design guidelines and "rules of thumb", or ones that are imposed externally (manufacturing limitations, material availability, interdisciplinary constraints), which algorithm is chosen to solve the model, how formulation decisions change based on the choice of algorithm, any mathematical features in the problem (e.g. linearity) that require special formulations, and solution algorithms (e.g. linear programming) etc. As is evident, not only do the designers' personal experience based choices form the basis of this decision-

making, many external factors beyond the direct control of the designer come into play as well. This makes the formulation problem a dynamic one. As the understanding of a problem grows after initial formulations, many reformulations are normally required to finally reach a design model that produces a satisfactory result. The mathematical model contains and represents, either implicitly or explicitly, many of these subjective decisions along with the characteristics of the object being modeled.

Cognitive hypothesis as basis of the learning and inference mechanism

Modeling design formulation and reformulation as a statistical pattern extraction problem is based on our hypothesis that the mathematical representation of optimization problems contains, in hidden and explicit ways, many semantic design concepts and relationships. Many of the choices available to the designer as discussed above are embedded in the syntactic structure of the formulation – the compact notation of mathematics. The syntax can be "expanded out" to reveal these embedded semantic relations.

Designers often formulate and reformulate problems because they discover hidden semantic or mathematical relationships between variables, parameters, objectives and constraints – ones that were not directly observable before, or new ones that appear as designing progresses. This helps them to redefine the design problem, re-representing it in a form that becomes easier to solve or captures new design semantics. The main insight is that the problem representation itself captures design semantics in a latent manner, i.e. the variables, parameters and constraints as design concepts occur in "context" of each other, capturing designer intentions and choices and the functional-behavioral-structural relationships of the design object being modeled.

There are close parallels between this hypothesis and work done using natural language processing applied to design. Dong and Agogino use information retrieval methods to explore construction of design representations from textual documentation [14]. Hill et al. apply the Latent Semantic Indexing method for document analysis to show how designers develop a "shared understanding" of a design object that is inherently captured in textual design documentation [15]. According to Moss et al. internal and external knowledge representation mechanisms and changes in them capture the structure and content of a domain, as well as internal cognitive processes [16]. In all these studies, the implicit assumption is that the textual-syntactic representation of a design captures not only the semantic concepts and choices the designer employs, but also

the structural-behavioral-functional characteristics of the design object itself.

Since mathematics is a formal language, it has characteristics very different from natural language. The syntactic-semantic relationships are much more strict and precise with little of the ambiguity that characterizes natural language. However, it is the primary symbolic language employed by designers for constructing representations in design optimization [1]. It, therefore, seems reasonable to draw a parallel and hypothesize that the mathematical representation of a problem, implicitly or explicitly, captures the design object semantics as well as the semantic choices exercised by the designer in producing that representation. Changes in this representation as the optimization process passes through reformulations will reflect how the modeling of the design object changes, as well as how the designer changes his/ her choices and decisions on the design.

In addition to this hypothesis, another important observation from the cognitive viewpoint is that designers typically become better at solving problems based on their experiences [5]. Their performance improves with their experiences in solving problems in a particular domain. Each engineering and design domain tends to develop "favorites" and "best practices" – preferred formulations and preferred algorithms for solving these models. Over time, the discipline, as a whole, discovers what works well and what does not for a particular family of problems [1] [11]. What works is usually based on many factors – the design-based and mathematical characteristics of the problem being modeled, pragmatic engineering and design considerations, or, very often, a designers' developed understanding of a formulation or algorithm developing into a preferred choice.

From the cognition perspective, this provides two lessons for the design of a learning and inference mechanism: (a) Look for patterns of design semantics, concepts, relationships and decisions in the syntactical (mathematical-symbolic) structure of a design formulation, and (b) Base the design of a learning and inference mechanism on statistics, i.e. use examples of different types of formulations of the same problem to learn how these semantic "patterns" evolve for a particular family or class of problems.

Computational basis for the design of the learning and inference mechanism

We use the Singular Value Decomposition (SVD) algorithm from linear algebra in order to perform semantic pattern extraction from syntactic examples of design formulation. SVD is an attractive choice because,

mathematically, it manages to bring out many of the characteristics discussed in the above section in a relatively simple way. In general, SVD takes any general rectangular matrix A with m rows and n columns and decomposes it into a product of three matrices, $A = USV^T$, where U ($m \times m$) and V ($n \times n$) are the orthogonal matrices with columns that are left and the right singular vectors and S ($m \times n$) is a rectangular matrix with singular values on the diagonal that can be arranged to be non-negative and in order of decreasing magnitude. The number of singular values is r, where r is the rank of A. The implicit mathematical idea [6] is as follows. A is an $m \times n$ matrix, whose row space is r-dimensional and inside \mathbf{R}^n and whose column space is also r-dimensional and inside \mathbf{R}^m. For this decomposition, we have to choose orthonormal bases $V = (v_1, v_2, \ldots v_r)$ for the row space, and $U = (u_1, u_2, \ldots u_r)$ for the column space. Av_i should be in the direction of u_i, with s_i providing the scaling factor, i.e. we want to choose v_i and u_i such that $Av_i = s_i u_i$. In matrix form, this becomes $AV = US$ or $A = USV^T$. A is the linear transformation that carries orthonormal basis v_i from space \mathbf{R}^n to orthonormal basis u_i in space \mathbf{R}^m. The singular values expand or contract – scale the vectors that are being carried from one space to the other.

Any general matrix A where the rows stand for design concepts and elements (variables, parameters) and the columns stand for the "context" of the occurrence of these concepts and elements (mathematical functions) can be decomposed into independent principal components (columns of U and V) represented by a set of new, abstract variables that represent correlations between the variables of the original data set. SVD analysis on the matrix produces a distributed re-representation of the original data (that can be combined again to generate the original data perfectly), where the new abstract variables produced contain within themselves information with regard to all correlations between the original matrix entries. If one entry in the matrix is changed, then this is enough to produce changes in all of the components. The same decomposition can also be used to provide an approximation of the matrix A in a linear least squares sense. If in the decomposition $A = USV^T$ only the first k singular values are retained, a new matrix $A\square$is returned that is an approximation of the original matrix A. This approximation is a dimensionally reduced approximation of the original matrix A that preserves latent and explicit relationships between design elements and functions. SVD is, therefore, a method for producing distributed re-representations of original data, as well as a method for performing dimensionality reduction. This dimensionally reduced re-represented data is queried by the designer by measuring the semantic "closeness" or "distance" between design concepts through cosine

calculations. This information is useful for use with new problems. Doing this for different formulations of the same problem captures characteristics from different representations of similar classes of optimization problems.

Detailed methodology, demonstration and results on a hydraulic cylinder design problem

Representation

The data representation used draws an analogy with natural and formal languages. It assumes that variables and parameters are elements (symbols) that occur in and come together by rules (syntax) of mathematics to form functions as constraints and objectives (clauses). We take formal optimization problem statements and convert them into occurrence matrices that measure whether each element (variable, parameter) occurs in each function (objective, constraint). The rows of the matrix A represent design elements (variables and parameters), while the columns represent the syntactic "context" in which design elements occur (mathematical functions – objectives and constraints). Each entry A_{ij} is a number specifying whether or not the particular variable or parameter i occurs in a particular constraint or objective j. This provides the raw data for each case on which SVD analysis is carried out. One such matrix is generated for each "design experience" or one example of a design formulation. The basis for this data matrix is that variables and parameters that share high semantic correlations will tend to co-occur together in the same objectives and constraints (for example, length l and breadth b will always co-occur in an area function $a = l \times b$).

Data generation

Identify a particular design problem domain

The method developed is general and may be applied to any other problem domain, provided the design problem is stated as a formal optimization model. The design of hydraulic cylinders was chosen as a demonstration example primarily because it has been solved in various ways, allowing us to compare approaches. There is nothing special in this example that affects the results.

Select formal optimization models from books and journal papers

Although design optimization models have a general mathematical form, the specifics of the forms differ. The same problem may be modeled as a single or multi objective problem, with different sets of variables, parameters and constraint functions. We take example problems from various sources and use the authors' formal models to provide the basis for our data. Different symbolic models capture different design intentions. The learning and inference mechanism uses these as training experiences to make predictions on which sets of variables, parameters and functions have high (or low) semantic correlations. This information is helpful in formulating new problems. The new problems when formulated join the existing database, thereby enlarging the experience database with each example. Figure 1 shows an example problem formulation of the single objective hydraulic cylinder design problem [1].

Hydraulic/ Explosive Cylinder Design Problem
FORMULATION EXAMPLE 1

DESIGN VARIABLES:	DESIGN PARAMTERS:	FORMULATION:
i: Internal diameter	T: Minimum Wall Thickness	Min f = i + 2t
o: External diameter	F: Minimum Output Force	Sub to:
t: Wall thickness	P: Maximum Pressure	g1: t - T >= 0
f: Output force	S: Maximum Hoop Stress	g2: f - F >= 0
p: Pressure		g3: p - P <= 0
s: Hoop stress		g4: s - S <= 0
		h1: f - (pi/4)i²p = 0
		h2: s - ip/2t = 0

	f	g1	g2	g3	g4	h1	h2
i	1	0	0	0	0	1	1
t	1	1	0	0	0	0	1
f	0	0	1	0	0	1	0
p	0	0	0	1	0	1	1
s	0	0	0	0	1	0	1
T	0	1	0	0	0	0	0
F	0	0	1	0	0	0	0
P	0	0	0	1	0	0	0
S	0	0	0	0	1	0	0

Fig. 1. The hydraulic cylinder design problem [1] and related occurrence matrix

Generate the variable-parameter-constraint-objective matrix

The variable-parameter by objective-constraint matrix A is comprised of m variables and parameters $x_1, x_2, \dots x_m$ occurring in n objectives and constraint functions $y_1, y_2, \dots y_n$, where the entries A_{ij} indicate whether or not a variable or parameter x_i occurs in objective or constraint y_j. Figure 1 shows the matrix generated for the example problem.

Singular Value Decomposition Analysis

Perform Singular Value Decomposition on the matrix

SVD is performed on the matrix A, producing a distributed re-representation of the data in terms of a new abstract space, the components of which space are independent of each other, but are created by mutual

correlation information contained in the original data matrix. The underlying assumption is that patterns of high and low correlation between variables and parameters will emerge, as highly correlated variables have a tendency to appear together in some constraints and objectives, while negatively correlated variables have a tendency not to. Figure 2(a) shows the SVD decomposition for the data matrix shown in Figure 1.

(a) $A = U\Sigma V'$, SVD decomposition for data matrix in Figure 1
U

-0.58432	-0.027303	-0.15931	-9.4601e-0...	0.54433	0.031583	0.3231	0.47184	-0.090179
-0.47993	0.53769	-0.37041	9.4601e-0...	-0.19799	-0.26214	0.06829	-0.47184	0.090179
-0.21423	-0.58922	-0.28424	-0.40825	-0.11171	0.27223	0.06038	-0.3912	-0.34087
-0.52143	-0.35962	0.28296	0.40825	-0.16509	0.14877	-0.3322	-0.080644	0.43105
-0.30721	0.22961	0.5672	-0.40825	-0.053386	-0.12346	-0.39258	0.080644	-0.43105
-0.07594	0.25281	-0.28027	5.9136e-0...	-0.54599	0.55879	-0.10319	0.47184	-0.090179
-0.033897	-0.27704	-0.21507	-0.40825	-0.30804	-0.58029	-0.091236	0.3912	0.34087
-0.082507	-0.16908	0.2141	0.40825	-0.45525	-0.31712	0.50196	0.080644	-0.43105
-0.04861	0.10796	0.42917	-0.40825	-0.14722	0.26317	0.5932	-0.080644	0.43105

Σ

2.7055	0	0	0	0	0	0	0	0
0	1.7683	0	0	0	0	0	0	0
0	0	1.5237	0	0	0	0	0	0
0	0	0	1.4142	0	0	0	0	0
0	0	0	0	1.1673	0	0	0	0
0	0	0	0	0	0	0.72861	0	0
0	0	0	0	0	0	0	0.58155	0
0	0	0	0	0	0	0	0	0
0	0	0	0	0	0	0	0	0

V

-0.39336	0.28864	-0.34766	0	0.29669	-0.31644	0.673
-0.20546	0.44705	-0.42704	7.4555e-0...	-0.63734	0.40714	-0.06001
-0.09171	-0.48989	-0.3277	-0.57735	-0.35958	-0.4228	-0.053058
-0.22322	-0.29899	0.32623	0.57735	-0.53143	-0.23106	0.29192
-0.13151	0.1909	0.65393	-0.57735	-0.17185	0.19175	0.34498
-0.48788	-0.55203	-0.10539	2.4763e-0...	0.22918	0.62115	0.088172
0.69964	0.21511	0.21031	-4.9659e-0...	0.10953	-0.2817	-0.57328

(b) k-Reduced approximation: k = 2, retained k values = 2.7055 and 1.7683

0.60792	0.30322	0.16863	0.36733	0.19869	0.79793	1.0957
0.78519	0.69183	-0.3467	0.0055679	0.35227	0.10863	1.113
-0.072747	-0.3467	0.56358	0.4409	-0.12268	0.85794	0.18137
0.37139	0.0055679	0.4409	0.50504	0.064139	1.0393	0.85022
0.44413	0.35227	-0.12268	0.064139	0.18682	0.18137	0.66884
0.20985	0.24206	-0.20016	-0.0878	0.11236	-0.14654	0.23991
-0.10532	-0.20016	0.2484	0.16694	-0.081459	0.31518	-0.041219
0.0015083	-0.0878	0.16694	0.13922	-0.02772	0.27396	0.091859
0.10683	0.11236	-0.081459	-0.02772	0.053739	-0.041219	0.13308

Fig. 2. (a) SVD decomposition for data matrix in Figure 1 (b) k-Reduced approximation for original data matrix A, k = 2, retained k values = 2.7055 and 1.7683

Retain the first k important singular values and produce a dimensionally reduced truncated SVD

From this computed SVD, retain the first k important singular values and compute a truncated SVD, which is a least squares approximation of the original one. For the purposes of visualization and the relatively small dimensional sizes of the original problems used for demonstration in this paper, we fix $k = 2$ and 3, i.e. the first 2 or 3 singular values are used to compute a truncated matrix. For larger problems, one may experiment with

more number of dimensions. Deciding the correct number of dimensions to retain for different families of problems is important. It can be answered through experimentation, though from a heuristic point of view the original problem size is a good indicator of the value of k. Generally, the smaller the problem size, the smaller the required k value, and the larger the problem size, the higher the value of the required k. Figure 2(b) shows the k-reduced approximation matrix for k = 2. Note how the original 0s and 1s have changed to higher or lower values – this is the main claim, that a reduced dimensionality re-representation will capture the hidden semantic patterns between design elements and functions, and that these patterns may not be directly observed from the original syntactic formulation.

Use this data to generate distributed graph representations:

It is helpful to use the k-reduced approximation (for $k = 2$ or 3) to visualize the patterns between the elements and functions. For higher k, the computational mechanism stays the same, although we cannot visualize it. For example, in the 2 dimensional case, the first column of is U multiplied by the first singular value and the second column of U multiplied by the second singular value to produce the x and y coordinates of the design elements (variables and parameters) in 2D space. Do the same with V for obtaining the x and y coordinates for visualizing the design functions (objectives and constraints) in the same 2D space. Plot this data as a 2D graph. For a 3D graph, retain the first 3 values for each. In this dimension reduction and feature extraction process, one obtains a distributed context sensitive representation of the all the original variables, parameters, objectives and constraint functions in a semantic lower dimensional space. This is used to retrieve data for new experiences, as this representation captures semantic patterns existing in the formal syntactic representation. Figure 3 shows the graph for the 2D case.

Querying the data for information retrieval

For new problems, use the old problem graphs to make new predictions. Each experience is stored as one SVD matrix and graph. The following queries are possible:

Fig. 3. Distributed graph representation of elements and functions, 2 dimensions; variables, parameters, constraints and objective projected into the same 2D space

Variable-variable or variable-parameter correlations and query retrieval:

This query extracts information on what other variables or parameters should one consider in formulating the problem, given that a variable x has been chosen by the designer. This query is answered calculating the cosine of the angle θ between the query variables and the $U*S$ vectors. The closer the value of $\cos(\theta)$ is to 1, the higher the semantic similarity between two variables or parameters. The closer the value of $\cos(\theta)$ is to 0, the lower the semantic similarity between the two variables or parameters. A threshold value of $\cos(\theta)$ may be decided upon, such that all variables and parameters having a $\cos(\theta)$ value higher than this threshold measured with the query variable is returned as the answer of the query for the new problem. Setting the cosine threshold higher or lower will return fewer or more numbers of variables – this is purely a matter of trial and error and there is no set threshold that may be considered as a benchmark.

For example, in the hydraulic cylinder design example problem, setting the query variable as internal diameter i with a cosine threshold of 0.7 returns variable set $\{t, p, s\}$ as other relevant variables. Figure 4 demonstrates this.

Fig. 4. The element-function set returned for query variable i; Cosine threshold = 0.7; Variable-parameter set returned = {t, p, s}; Function set returned = {i+2t, p-P<=0, s-S<=0; f-(pi/4)i²p=0, s-ip/2t=0}; (the middle arrow shows the query variable, the side arrows show the limits set by the cosine threshold of 0.7

Variable-function correlations and query retrieval:

A similar cosine similarity measurement is also possible between a variable and a constraint or objective function – i.e. if the designer is considering a particular variable or parameter, which constraints and objectives may be relevant in modeling? A similar cosine analysis, but now between the variable and constraints and variable and objective, will return the relevant constraints and objectives as answer to the query. Figure 4 shows the relevant function set returned by setting the query variable as *i* with the cosine threshold set to 0.7. It is evident from the results that the method returns even those variables and constraints as an answer that do not directly co-occur with the query variable in individual functions. For example, *i* co-occurs with *p* and *s* in the two equality constraints, but does not occur anywhere in the two pressure and stress inequality constraints ($p - P <= 0$ and $s - S <= 0$), but these two are still returned as relevant to variable *i*. This is an interesting result. The SVD method, because it captures all direct and indirect syntactic correlations in a distributed way, reveals even indirect, "hidden" relationships between variables that may or may not occur together in functions explicitly.

Design "cases", constraint activity and inactivity identification:

Consider solving this example problem using monotonicity analysis [1]. This method is well documented on this problem in not only [1], but also other sources [17]. Monotonicity analysis is a problem-solving-by-reformulation method, where constraint activity information is used to reformulate the problem to a simpler form. The method discovers design cases – sets of constraints that can be active or inactive, in order to reach upon simpler forms that may then be easily solved by traditional means (unconstrained optimization etc.). A significant charcateristic to note here is that this process of reformulation is actually similar to discovering previously unobserved "hidden" relationships between variables, parameters and constraints, that when made explicit, make solving the problem easier.

In the case of this example problem, there are 5 design variables, and 6 design constraints. The mathematical theorem for monotonicity analysis states that the number of non-redundant, active constraints cannot exceed the number of design variables for a consistent solution to be found, revealing that there will be design "cases". All the constraints cannot be active at the same time. There will be sets of active constraints, leading to different solution cases. Papalambros and Wilde develop a monotonicity analysis based solution procedure, identifying 3 design cases – stress-bound, pressure-bound, and thickness-bound [1]. Their results show that for design variable i (internal diameter) either constraints $(g3, (g2, h1))$ or $((g4, h2), (g2, h1))$ will be active, and for variable t (wall thickness) either constraints $((g4, h2), (g2, h1))$ or $(g1)$ will be conditionally critical. Figure 5 shows that the SVD analysis followed by cosine measurements shows similar conclusions by purely a syntactic analysis of design formulation. Observe that constraints $(g2, h1)$ and $(g4, h2)$ form distinct visual groups, with constraints $g3$ and $g1$ falling close to these two groups, a fact numerically confirmed by the cosine measurements.

Results over many design experiences

We applied the method on a family of hydraulic cylinder design problems. There are multiple ways in which the same problem has been formulated by different designers. For example, in [1] it is formulated as a single objective problem (Figure 1) while in [17] it is formulated as a multi-objective problem with conflicting objectives and a slightly different set of constraints and parameters. The SVD based algorithm was applied to these problems. The main conclusion to report is that the algorithm generalizes

very quickly over a very few number of training examples. This is interesting because, in general, machine learning systems for design support require either a very high level of knowledge engineering, or they require a large database of training examples. This method requires only 2 to 3 training examples for it to generalize, while all further examples are "real" design experiences that either reinforce or change the learning gained from these first examples. For example, we used the querying techniques on these 2 experiences [1] [11], we found that the algorithm returns "correct" answers for query variables that exist in the first two examples (for example $\{t, p, s\}$ for i using a cosine threshold of 0.7, with k = 2 or 3). Because the algorithm is based on pure statistical extraction of patterns, it does not discriminate between "wrongly formulated" and "correctly formulated" examples. However, it can be conjectured that over many numbers of design experiences, a statistical effect will ensure that the algorithm generalizes "correctly", assuming that most of the examples provided to the algorithm are "correct" from the design point of view.

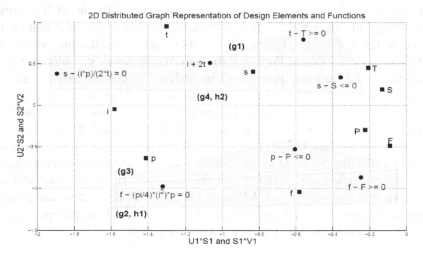

Fig. 5. Design "case" identification using SVD based mechanism for hydraulic cylinder design problem 2D representation

Specifically, we report the effects of changing two parameters in the algorithm, the size of the design problem with variances in formulation, and the number of dimensions k that are retained while performing the dimensionality reduction as compared to the number of "correct" answers the algorithm returns. The relevance or "correctness" of the answers returned by the queries was measured by observations on how each of the answers matches up with those provided by any other relevant and

documented design solution method that actually solves the problem. For example, in the previous section we present a comparison of the answers returned by the queries from our method with the well-known and documented monotonicity analysis applied to the same problem. Since monotonicity analysis is mathematically proven and guaranteed to find the optimal solution in this case, and our results match those provided by the monotonicity analysis, it may be safely claimed that the answers returned by this algorithm are correct.

Effect of problem size

Keeping the number of dimensions k fixed, the algorithm pulls more variables, parameters, objectives and functions as the size of the problem increases. For example, the multi-objective version of the problem contains more number of variables and constraints than the single-objective version. If we keep the number of dimensions fixed for both design experiences, the number of answers returned to the query variables in the multi-objective case is higher than in the single objective case. Figure 6 shows this result, as over two examples of the same problem with different formulations, we see that the algorithm manages to capture the variances in the formulations. The single objective formulation has an original matrix size of 9 X 7 (Figure 1). The multi-objective formulation of the same problem has an original matrix size of 17 X 10 as the multi-objective problem has an increased number of variables, parameters and objective function and weight identifiers [17]. The algorithm returns a higher number of design concepts as answers in the multi-objective case. This is an interesting result as a designer wishing to formulate a new problem from the same family would be able to retrieve different answers to the same query using different examples from the database. They would be able to see how different designers have conceptually "grouped" variables and functions as semantically related to each other. For example, the multi-objective formulation of the problem also uses monotonicity analysis as the design solution method, but because of the differences in formulation, groupings of variables and functions in design "cases" appear different from the single objective formulation. The SVD method captures this, and our results show similar groupings of design cases as reported in the two original sources.

Effect of the number of retained dimensions

Increasing the number of dimensions k shows that the number of variables, parameters, objectives and functions returned reduces, until the final number of dimensions k becomes equal to the original matrix dimensions,

when it returns exactly the same answers as directly available in the original problem formulation. A reduced dimensionality captures hidden design patterns in the problem statement. For different families of designs, experimentation on varied problem sizes will lead to the "correct" number

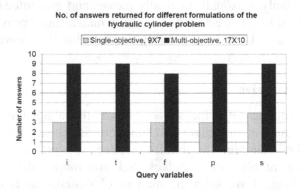

Fig. 6. Answers returned from different formulations of the cylinder problem

of dimensions that give the best results. Heuristically, the size of the original problem is a good rough indicator of the best value for k. A small problem size indicates a low value of k and a larger problem sizes imply larger values. For example, in the cylinder design family, due to the relatively small size of the problem, the best dimensions came out to be 2 and 3. Comparing the two formulations, we can see in Figure 6, that in fixing k = 2, the multi-objective version (larger problem size) returns more number of answers (8 or 9) as compared to the answers from the single-objective version (4 or 5). This is an indication that, sometimes, for very large problems, fixing k to very low values (say 2) can mean that the algorithm is unable to discriminate between finer pattern groups, and it would need more dimensions to bring out the patterns more clearly. Figure 7 shows that for the multi-objective formulation, the number of answers returned reduces (and becomes more relevant as "correct" answers) as we increase k from 2 to 3. Beyond k = 4, the performance deteriorates, and the answers returned are not semantically relevant. Again, the "correctness" of answers is measured by the match on results to a published method for solution to the same problem. In the multi-objective case, the documented method was [17]. In conclusion, the correct dimensionality is best left as a parameter that the user can tweak for various problem classes and sizes. The problem domain and the problem size affects the correct value of k.

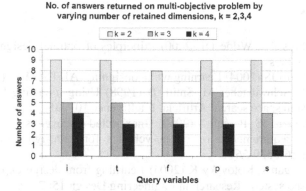

Fig. 7. Answers for different k values for the multi-objective cylinder problem

Discussion and conclusions

This paper presents the methodology for a learning and inference mechanism for design optimization problem formulation. The method is based on a statistical pattern extraction view of machine learning, where syntactic patterns of previous formulations are hypothesized to be the foundation for representing semantic design concepts, relationships and patterns. The main contribution of the method is in its ability to extract hidden and explicit design concepts, relationships and patterns expressed mathematically in the problem formulation, using a small number of training examples for a family of design problems. A possible contribution of the method lies in its potential application to large scale problems, where the design patterns to be extracted are not made apparent by simple human observation of the problem statement. We are currently in the process of applying and testing the method to large-scale problems, where the size of the problems is significantly larger in terms of the number of design variables, parameters and constraints, and the method is being used for symbolic problem model decomposition. It is a known fact that SVD calculation algorithms scale well. The main aim of the application to large scale problems is to test whether the method scales well for design optimization. The preliminary results appear promising and a full "design formulation assistance" system is being developed in MATLAB. With this tool, the designer will be able to state problems symbolically, define experiences and experience databases, and query the experience database for problem (re)-formulation advice.

References

1. Papalambros PY, Wilde DJ (2000) Principles of optimal design. Cambridge University Press
2. Nath G, Gero JS (2004) Learning while designing. AIEDAM 18 (4): 315-341
3. Gelsey A, Schwabacher M, Smith D (1998) Using modeling knowledge to guide design space search. Artificial Intelligence 101: 35-62
4. Suwa M, Gero JS, Purcell T (2000) Unexpected discoveries and s-inventions of design requirements: important vehicles for a design process. Design Studies 21(6): 539-567
5. Moss J, Cagan J, Kotovsky K (2004) Learning from design experience in an agent-based system. Research in Engineering Design 15: 77-92
6. Strang G (2003) Introduction to linear algebra. Wellesley-Cambridge Press
7. Kalman D (1996) A singularly valuable decomposition: the SVD of a matrix. The College Mathematics Journal 27 (1): 2-23
8. Balachandran M, Gero JS (1987) A knowledge based approach to mathematical design modeling and optimization. Engineering Optimization 12(2): 91-115
9. Mackenzie CA, Gero JS (1987) Learning design rules from decisions and performances. Artificial Intelligence in Engineering 2(1): 2-10
10. Schwabacher M, Ellman T, Hirsh H (1998) Learning to set up numerical optimizations of engineering designs. AIEDAM 12: 173-192
11. Ellman T, Keane J, Banerjee A, Armhold G (1998) A transformation system for interactive reformulation of design optimization strategies. Research in Engineering Design 10(1): 30-61
12. Campbell MI, Cagan J, Kotovsky K (2003) The A-design approach to managing automated design synthesis. Research in Engineering Design 14: 12-24
13. Landauer T K, Dumais S T (1997) A solution to Plato's problem: The latent semantic snalysis theory of acquisition, induction and representation of knowledge. Psychological Review, 104(2): 211 – 240
14. Dong A, Agogino AM: (1997) Text analysis for constructing design representations. Artificial Intelligence in Engineering, 11 (2): 65-75
15. Hill A, Song S, Dong A, Agogino A (2001) Identifying shared understanding in design teams using document analysis. 13th International Conference on Design Theory and Methodology, DETC2001/ DTM-21713, ASME Press, Chicago, IL
16. Moss J, Kotovsky K, Cagan J (2004) Cognitive investigations into knowledge representation in engineering design. In JS Gero (ed), Design Computing and Cognition '04, Kluwer: 97-116
17. Michelena N, Agogino A (1988) Multiobjective hydraulic cylinder design, Journal of Mechanisms. Transmissions and Automation in Design 110: 81-87

Automating the Conceptual Design Process: From Black-box to Component Selection

Tolga Kurtoglu
NASA Ames Research Center, USA

Albert Swantner and Matthew I. Campbell
University of Texas at Austin, USA

Conceptual design is a vital part of the design process during which designers first envision new ideas and then synthesize them into physical configurations that meet certain design specifications. In this research, a suite of computational tools is developed that assists the designers perform this non-trivial task of navigating the design space for creating conceptual design solutions. The methodology is based on automating the function-based synthesis paradigm by combining various computational methods. Accordingly, three nested search algorithms are developed and integrated that mimic a designer's decision-making at various stages of conceptual design. The implemented system provides a method for automatically generating novel alternative solutions to real design problems. The application of the approach to the design of an electromechanical device shows the method's range of capabilities, and how it serves as a comparison to human conceptual design generation and as a tool suite to complement the skills of a designer.

Introduction

Conceptual design plays the central role in ensuring the overall design quality and the level of innovation. It is at this phase, where the architecture of the final design is established, the technologies are chosen to fulfill the customer needs, and when most of the cost of a product is committed. Because of these characteristics, conceptual design is often considered as the most important phase of the product development cycle.

J.S. Gero and A.K. Goel (eds.), *Design Computing and Cognition '08,*
© Springer Science + Business Media B.V. 2008

Yet, the conceptual design process has seen few attempts at automation. The concept of "automating design" has often been leveraged in later stages of the design process where a to-be-designed artifact accrues numerous parameters but lack specific dimensions. Automated methods such as optimization provide a useful framework for managing and determining details of the final designed artifact. These methods make the design process less tedious and time-consuming and are used in a wide variety of industries to support or optimize current design efforts. However, one of the pervasive bottlenecks in design is the lack of continuity between computational design tools and conceptual design methods.

The difficulty may hinge on the very nature of conceptual design, which is often viewed as a highly complex decision-making process that does not lend itself easily to "automation". This decision-making process begins with the specification of the product to be designed and involves the continual cycle of concept generation and evaluation until a design opportunity is transformed into an embodied solution that satisfies a set of design requirements.

This systematic view of conceptual design starts with the formulation of the overall function of the product to be designed. This high level product function is then decomposed recursively into lower level functions - a process that produces a function structure, which is a representation that defines function as transformation between energy, material, and information [1]. The function structure is then used to generate solutions to each of the product sub-functions. Here, the designer seeks solutions, i.e. a component or a set of components that perform a particular function. Next, solutions to the sub-functions are synthesized together to arrive to the final architecture or configuration of a product. Finally, the design is embodied by the selection of designed components. Using this approach, a broad number of concepts can be generated by making decisions about the decomposition of the overall product function, and the selection and integration of different design solutions to elemental sub-functions.

In this research, we automate the aforementioned conceptual design process starting from a black-box level product specification to the physical embodiment of design components. Accordingly, we have developed a suite of automation tools that combine and formalize the function-based synthesis paradigm [1] with various computational methods in order to describe the comprehensive space of conceptual solutions and search it for feasible candidates. The implemented system consists of three nested search algorithms that mimic a designer's decision making at various stages of conceptual design and serves as a comparison to human conceptual design generation.

Related Work

Researchers have employed different methods in order to computationally support the conceptual phase of design. Among these, one of the most historically significant is the expert system formulation described in the PRIDE system established by Mittal, et al. [2], which is specifically developed for creating paper roller systems. A subset of expert systems, case-based reasoning techniques apply past knowledge stored in a computational database towards solving problems in similar contexts. Examples include Gero et al. who presented a system called FBS [3] that uses relations among function, behavior, structure to retrieve design information to conduct analogy-based design. Similarly, the Structure-Behavior-Function modeling scheme [4] and its computational application KRITIK is a system relying on a design-case memory to conduct computational synthesis.

Apart from expert system formulations, typical examples of computational synthesis applications start with a set of fundamental building blocks and some composition rules that govern the combination of these building blocks into complete design solutions. Hundal [5] designed a program for automated conceptual design that associates a database of solutions for each function in a function database. Ward and Seering [6] developed a mechanical design "compiler" to support catalog-based design. Bracewell and Sharpe [7] developed "Schemebuilder," a software tool using bond graph methodology to support the functional design of dynamic systems with different energy domains. Chakrabarti and Bligh [8] model the design problem as a set of input–output transformations. Structural solutions to each of the instantaneous transformation are found, and infeasible solutions are filtered according to a set of temporal reasoning rules. Bryant, et al. (2005) developed a concept generation technique that utilizes a function-component matrix and a filter matrix to generate a morphological matrix of solutions during conceptual design. The A-Design research [9] is an agent-based system that synthesizes components based on the physical interactions between them.

Function structure research, on the other hand, has found its way into a number of educational texts since the presentation provided by Pahl and Beitz [1]. Computational approaches have also been explored that further expand the value of function structures [10]. One of the interesting implementations of automating the function-based design is the work of Sridharan and Campbell [11] that uses graph-grammars.

Graph grammars are comprised of rules for manipulating nodes and arcs within a graph. The rules create a formal language for generating and updating complex designs from an initial graph-based specification. The de-

velopment of the rules encapsulate a set a valid operations that can occur in the development of a design. Through the application of each grammar rule the design is transformed into a new state, incrementally evolving towards a desired solution. The rules are established prior to the design process and capture a certain type of design knowledge that is inherent to the problem. The knowledge captured in the rules offer the option of exploring different design decisions and thus different design alternatives.

Using this formalism, Sridharan and Campbell [11] defined a set of 69 grammar rules that are developed to guide the design process from an initial functional goal to a detailed function structure. Elsewhere, graph-grammars are widely used in various engineering applications. Agarwal and Cagan's coffee maker grammar [12] was one of first examples of using grammars for product design. Their grammar described a language that generates a large class of coffee makers. Shea et al. [13] presented a parametric shape grammar for the design of truss structures that uses recursive annealing techniques for topology optimization. Other engineering applications include Brown, et al. [14], who presented a lathe grammar, Schmidt and Cagan's grammar for machine design [15], Starling and Shea's grammars for mechanical clocks [16] and gear trains [17].

While these methods are primarily concerned with generation aspects of conceptual design, there are various techniques developed to automate the selection of components for an already generated design configuration. These techniques include using genetic algorithms, simulated annealing, and integer programming. Weilinga, et al. [18] classify the component selection problem as category one within their work, where the set of components as well their assembly is fixed. Carlson, et al. [19] use a genetic algorithm for component selection given a user-defined system layout, a database of components and a set of design specifications. They apply a genetic algorithm for solving the problem of catalog design and create an initial set of components types followed by component selection from the component database.

In summary, our background research shows that a number of attempts have been made to automate various key elements of the design process such as creation of function structures, configuration design, and component selection. However, most of these methods have been developed for specific applications. The method presented here is a generalized technique that follows the grammar formalism and integrates it with fundamentals of function based synthesis paradigm to automate the design decision-making that govern the entire concept generation process starting at a black-box level product specification and finalized by the selection of components that physically embody the design.

Research Approach

This research aims to automate the systematic design process (presented in Pahl and Beitz [1]). Accordingly, it extends the previous automated design research by developing a suite of computational design tools that transform a high-level, functional description of a non-existent product into a set of embodied concept variants by following the systematic design process.

By automating this process, a design is changed from an abstract set of customer needs to an embodied conceptual configuration. The customer need analysis and the formulation of the initial "black-box" steps are performed by the designer. The computational design synthesis is initiated at the level of a black-box. The output of the automated design process is a set of conceptual designs where specific electromechanical components are first associated with individual or sets of sub-functions from the function structure, then composed into a design configuration based on their interactions, and finally physically instantiated from a catalog of design components. Feasibility and consistency is maintained throughout the design process while transitioning between these domains.

In the end, the design method manifests itself as a suite of computational design tools. The first design tool (i.e. the function structure grammar) converts an initial functional goal of a to-be-designed device into a set of detailed function structures by using functional decomposition rules. Based on this functional input, the second design tool (i.e. the configuration grammar) synthesizes individual or sets of components into a set of conceptual design configurations. Finally, the third design tool (i.e the tree search algorithm for component selection) instantiates specific components in a design configuration guided by specific design constraints and objectives. In the following paragraphs, each of the three design tools and their specific search algorithms are explained in detail.

Research Effort I: Function Structure Grammar

A common technique in phrasing the problem as a black-box is useful in engineering design to clarify the goals of the project. By removing all unnecessary information, the black-box defines only the flows entering and leaving the product. The black-box is often labeled with a primary function, which is typically a verb-noun pair. The first automated design tool [11] acts on this black-box input to automatically create the necessary functions for translating the input flows into the output flows. In order to accomplish this, a series of 52 rules have been created based on the data of thirty black-boxes and their corresponding function structures. These rules

are carefully created to capture common chains of functions used in a variety of artifacts. For example, an automobile jack has a functional module where mechanical energy from the human is required, but instead of being applied directly, it is first converted to pneumatic energy, amplified, and then converted back to mechanical energy. This module is also seen in a toy gun, the Nerf Ball Blaster. This inference of common modules can help make better function structures, as it is not always easy for a designer to make a connection between such different products.

Starting with the black-box, the grammar rules enumerate all possible valid function structures. This can be viewed as a search tree, where the black-box is the seed or start node, and the rules provide the transition operators that lead to the many leaves of the tree. It is interesting to note that the black-box is a rather detailed start state for the tree, and the existence (or absence) of input and output flows limits the size of the search tree significantly. This is shown clearly in the results of this paper. In the future, the rules may be revisited so as to create or modify specified input and output flows of the black-box, but it is unclear how these will be regulated.

The original function structure grammar [11] was modeled like all grammar rules, as independent if-then statements. This is often shown graphically with a left-hand and right-hand sides (Fig.1a). In terms of implementation, this work was done ad hoc resulting in a large and unwieldy set of java files. Recently, these rules have been rewritten in a new graphical environment known as GraphSynth [20] which allows one to graphically create the rules and manages the resulting data as a series of portable XML files (Fig. 1b). Notice in Fig. 1a, the gray and black circles which are referred to as "active centers" serve as markers to ease the implementation. This concept is borrowed chemical polymerization and indicates the potential areas where incoming molecules can attach. Similarly, during the creation of a function structure, there are many 'active centers' where incoming flows and functions can attach themselves. These active centers are the points where grammar rules can be applied and where new functions and/or flows are added if certain criteria are met at a specific open connection. In recreating these rules (**Error! Reference source not found.**b), the concept is maintained, but no longer required as GraphSynth includes a more general and powerful sub-graph recognition procedure. In either case, the rule provides guidance in developing the connecting flows to a "remove" function. This rule captures the principle that whenever we cut or grind a solid, we need to supply some mechanical energy and this results in two or more pieces of the solid. It should also be noted that this rule cannot be applied again since the active center necessary for rule rec-

ognition has been eliminated. Care must be taken to define rules that prevent the same rule from being applied over and over again.

The rule shown in Fig. 3a captures another common principle. Usually, when mechanical energy is being supplied, the energy is amplified using gears and this is represented by the function 'Change ME'. This rule looks for a flow of type mechanical energy that is open at the tail and is pointing to the function, 'Remove Solid'. If applied, this rule adds the function 'Change ME' to the tail and adds another flow open at its tail to the back of the 'Change ME' function. Fig. 3b shows a rule where an electric energy flow that is pointing from 'Import' is recognized and the functions 'Transmit EE' and 'Actuate EE' are added to it. This rule is observed in many products, which use electrical energy, as electrical energy is always transmitted and actuated before being converted to the required form. Whenever two flows are recognized such that we have an open electrical energy flow and energy of any other kind (represented as XE) that needs to be supplied, we convert the electrical energy to the required form and transmit it. Termination rules are vital in obtaining a valid function structure.

Research Effort II: Configuration Design Grammar

For decisions at the conceptual phase of design, the interconnectivity of design elements is more important than parametric details. In such conceptual design problems, it becomes essential to determine an optimal configuration of components prior to tuning individual component parameters. Creating such configurations is the objective of the second design tool – i.e. the configuration design grammar.

The starting point for the configuration design grammar is a function structure. The synthesis process is aimed to perform a graph transformation of an initial function structure into a set of configuration-based graphs called the Configuration Flow Graphs [21]. In a configuration flow graph, nodes represent design components, and arcs represent energy, material or signal flows between them. The graph is also similar to an exploded view in that components are shown connected to one another through arcs or assembly paths. Using a CFG, designers can capture components that are present in a design, their connectivity, and physical interfaces between a design's components.

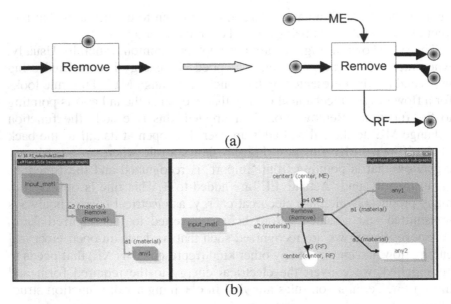

(a)

(b)

Fig. 1. An example rule shows the use and propagation of active centers. (a) as shown in the original publication (Sridharan and Campbell 2005), (b) as recreated in GraphSynth

The grammar rules for the configuration design are defined through a knowledge acquisition process that is based on the dissection of existing electromechanical devices. Accordingly, for each device that is dissected, a function structure and a configuration flow graph is generated. Then, the mapping between the two graphs is captured where each mapping represents a potential grammar rule [21]. Some of the rules derived from this analysis are shown in Fig. 4. In reality, each rule represents a design decision that shows how a functional requirement was transformed into an embodied solution in an actual design. Currently, the rule database contains 161 grammar rules derived from the dissection of 23 electromechanical products.

The grammar provides an effective method for automatically generating design configurations through a search-based execution of rules. This computational synthesis approach is to perform a graph transformation of the initial function structure of the to-be-designed product into a set of configuration flow graphs. Each execution of a rule adds more components to the design configuration which incrementally builds to a final concept. At the end, the computational search process returns different concepts with potentially varying degrees of complexity as candidate configurations to the same functional specifications.

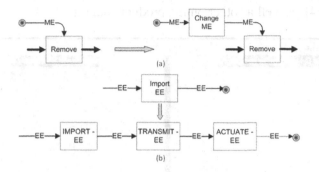

Fig. 2. Two additional examples of function structure grammar rules

In detail, the transformation from the function structure to CFG is part of a recognize-choose-apply cycle. The recognize step identifies all possible locations in the function structure where a grammar rule can be applied. These locations define a set of possible graph transformations that can be applied at that design stage. This step is followed by choosing one of the valid grammar rule options. In the final apply step, the CFG is updated as per the instructions provided by the selected rule. This process is repeated until there are no more rules that can be applied.

The final configurations obtained at the end of this generation process depend on the selection of the rules applied. To fully automate the generation process, this selection is made by the computer. The basis and the guidelines to select the rules are embedded in the search algorithm. In the current implementation, each applicable grammar rule is systematically selected by the computer with equal likelihood as the configuration space is traversed using a breadth-first search approach.

At the end, the search process generates a variety of configurations that are developed from a functional description of a product by synthesizing component solutions together that have been successfully used in the design of past products.

Research Effort III: Tree Search Algorithm for Component Selection

The objective of the third design tool is to determine the optimal choice of components for a specified CFG [22]. To accomplish this, the components are chosen from a database, which contains a compilation of real component information for each component abstraction (such as electric motor, bearing, shaft, gear, etc.) that can be present in a CFG. This data for each component, or artifact, has been collected from an online repository cre-

ated and maintained by the University of Missouri, Rolla [23], McMaster and Carr [24], as well as other online product catalogs.

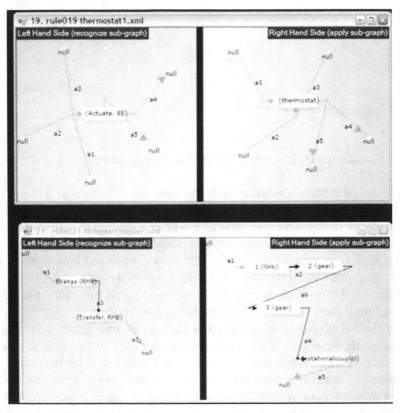

Fig. 3. Two grammar rules of the configuration grammar in GraphSynth. The left-hand-side of the rules capture the functional requirement and the right-hand-side depict how the functional requirement can be address by the use of specific component concepts

The approach is an iterative process that replaces each component in the CFG with an artifact that is stored in the database. Each component in a CFG represents a different level of the search tree, and the number of options at each level is equivalent to the number of artifacts in the database for that particular component. Each transition down the tree replaces the generalized CFG component (e.g. gear) with an artifact (e.g. steel plain bore 14.5° pressure angle spur gear with 24 teeth, a pitch of 32 and a face

width of 3/16 in.). The branching factor[1] thus, depends on the number of choices for a component while the number of levels in the tree is the number of selections to be made, as determined by the CFG. Currently there are, on average, six artifacts per component (there is only one electrical cord but twenty gears). As the search process unfolds, more components are instantiated by replacing abstract components in the CFG with actual artifacts from the database.

The space of solutions found in the tree is searched using a Uniform Cost Search (UCS) algorithm. The search begins at the root node (a complete CFG) and the traversal of the tree is employed by instantiating one component at a time. During the search, it is possible to evaluate the design decisions governing the instantiation of components. Accordingly, an objective function is constructed that combines criteria measuring how well various customer needs (such as minimize cost, and maximize power) are met with compatibility metrics for neighboring components (e.g. how different is the shaft diameter from the mating gear's bore diameter). At each node of the tree, the node expansion is performed after calculating transition costs based on this objective function formulation. These transition costs are additive in nature, and at each step only the child with the minimum transition cost is generated. This search process continues until the CFG is fully instantiated and hence an optimum solution is reached.

Case Study: Design of A Coffee Grinder

The proposed methodology is demonstrated in this section by solving a test problem – the design of a coffee grinder. In this problem, we start off by creating a simple black-box, and illustrate how the computer can generate associated function structures, and configuration flow graphs.

Fig. 6 shows this black-box, the primary function of which is "change solid". The input flows of the black-box are also determined by the designer. Accordingly, the designer decides on the required inputs for the design. These decisions govern the energy domains, materials, and signals, which the product would operate on. For the selected problem, it is envisioned that the designed artifact would primarily utilize human and electrical energy. Moreover, it is assumed that a user would actuate the device operation. These design decisions are captured by the specification of human material, and human and electrical energy input flows as shown in Fig. 6. Similar decisions are made for the output flows. Accordingly, it is

[1] In computing and tree data structures the branching factor is the average number of children from each node in the tree.

specified that the machine would use mechanical energy to perform the separation function and that the human material would be returned and not used in the product. The specification of input and output flows poses constraints to the design problem and keeps the artifact choices in certain domains. By specifying electrical energy as input and mechanical energy as output, we limit the functions that can be called and consequently the variety of components that can be selected. The specification of the primary function and the input and output flows ensures that the customer needs are captured before the design process starts and that the computer will not end up with solutions that the user did not intend or is not interested in.

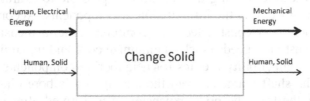

Fig. 4. The black-box for a coffee grinder. Note the flows and primary function are simplified so that it is understandable to the computer

The complete search process is run using the GraphSynth environment [20]. The process starts with the user drawing the black-box of the to-be-designed artifact. The function structures and configuration flow graphs (CFGs) are then created automatically using their respective sets of grammar rules. The results for the selection of the components are yet to be implemented for the presented design example as we continue working on formulating an objective function to evaluate the performance of the coffee grinder.

Results and Discussion

For the implementation of this case study, the algorithms are run on a Windows PC with 3.25 GB ram and 2.2 GHz processor. After the input is specified as shown in Fig. 6, the computational synthesis of the coffee grinder begins, initially with the creation of potential function structures for the design.

Recall that the function structure grammar makes use of three rule sets. The first rule set encompasses initiation rules and inserts 'active centers' to the graph for each of the input and output flows as described in Sridharan and Campbell [11]. The second rule set of the grammar, called propagation rule set, generates all of the functions in the functional model. This model

is built utilizing two directions starting from both the input and the output (left and right as seen in Fig. 6) flows. After the propagation rules are executed some functions may not be fully connected. The final termination rule set ensures that these loose ends are stitched up and that the generated function structure is complete.

For the coffee grinder problem, the function structure grammar ran for 4 hours and creates two unique function structures. These are shown in Fig. 7 and Fig. 8. The generated function structures are similar in nature and only differ in their use of mechanical energy. One of them uses translational mechanical energy to perform the grinding operation while the other one uses rotational mechanical energy.

These two unique function structures are then posed as inputs into the second design tool which takes the function structure as a starting point and generates conceptual configurations from it. Specifically, the computer

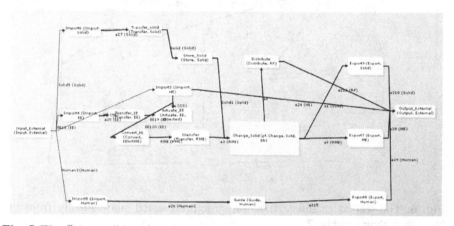

Fig. 5. The first candidate function structure created automatically from the black-box shown in Fig. 4

employs a modified bread-first search (BFS) algorithm that includes a filtering mechanism which removes duplications of previously visited nodes from the search space. This filtering is based on a property in graph grammar theory known as "confluence" which means that the order in which a subset of rules is invoked does not affect the final outcome. To better illustrate this concept, let us consider three rule choices, A, B, and C, that must be called to complete a candidate design. After making the first choice it appears as if one may have three unique solutions, A__, B__, and C__. After the second choice, the number of possible unique solutions stays at three, AB_, AC_, BC_, but these solutions are interpreted by the computer using six possible branches since the computer cannot differentiate be-

tween the designs AB and BA. Finally, it is not until the last iteration, that
one can conclude that there is only one unique solution. This is shown
more clearly in the bar graph of Fig.9, where the number of candidates is
shown on the y-axis and the number of rules called is depicted on the x-
axis. As the rules are invoked the number of candidates quickly expands
only to be followed by a decrease. The reason for this is similar to the sim-
ple example given above where one cannot tell that there are three identi-
cal copies of the design in the search tree until later in the process. As the
plot shows, the number of unique candidates needs to reach a critical point
after which the filtering takes effect. This filtering cuts the amount of time
that the process took by a factor of twenty and greatly reduces the number
of candidates at each level.

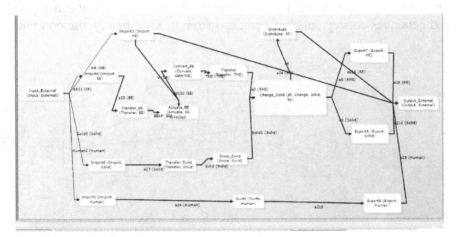

Fig. 6. The second candidate function structure created automatically from the
black-box shown in Fig. 2

The fourth set of grammar rules (i.e. the configuration grammar) ran for
about five days and generated 1536 unique solutions. Two of the unique
solutions are shown in Fig. 10 and Fig. 11. The CFG in Fig. 10 was de-
rived from the function structure in Fig. 7 and the CFG in Fig. 11 was de-
rived from the function structure in Fig. 8. These CFG's are different from
each other in many ways, but strictly speaking, for a CFG to be unique,
only one component needs to be different. For example, if the 'transfer
electrical energy' function is accomplished by a wire in one CFG and by a
conductor in another, those two CFG's are considered to be unique. In the
two CFG's shown here, there are many differences. The first of the CFG's
takes the mechanical energy from the motor and goes straight to the shaft
to the blade. In the second CFG, this mechanical energy goes from the
motor to a gripper then to a support, a sprocket, and then the blade. This

second chain of energy may spark an interesting idea by the designer on a way to get rid of the costly shaft, or it may be deemed too complicated for this application and disregarded. The purpose of this part of the research is to present the designer with as many different ways to solve the problem as possible.

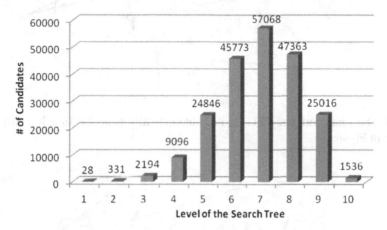

Fig. 7. The bar graph showing the number of candidates on each level

The next step in the automated process is to invoke the automated component selection discussed above as Research Effort III (see Section 3.3). Current efforts are in place to accomplish this, but a detailed evaluation of component choices is not completed at this time. Fortunately, we are able to approximate the size of the search tree. The average number of components to instantiate is thirteen (note: Fig. 10 has thirteen components while Fig. 11 has fourteen). This determines the depth of the tree. The breadth of the tree is six (the average number of instantiated components). As a result, the number of possible instantiations is 6^{13} or 13 billion. This enforces the need for some evaluation to eliminate many of these branches since many of these include incompatible components. Taken with the previous search trees, the total number of embodied configurations that result from the single black-box is estimated at 40 trillion. ($2 * 1536 * 6^{13} \approx 40*10^{12}$).

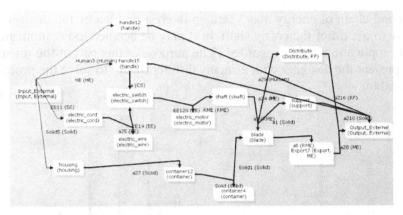

Fig. 8. The first candidate CFG created automatically from the function structure shown in Figure 2

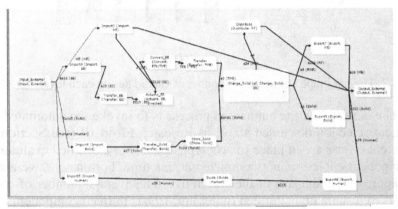

Fig. 9. The second candidate function structure created automatically from the black-box shown in Fig. 5

Conclusions

In this paper, three previous research projects are combined to automate the conceptual design process from black-box to a configuration of specific components. The results are incomplete due to the lack of evaluation necessary to narrow down the 40 trillion possible candidate solutions. This large space is not captured explicitly, but rather implicitly in the grammar rules (213 rules total) and the database of real components (300 in all). The grammar affords a representation of the design space as a tree of solutions built from an initial specification. Each transition in the tree corresponds to an application of a rule, thus incrementally building a final design which is

represented as one of the leaves of the tree. This process is illustrated in Fig. 12. As is evident from the tree, the result of rule applications generates a design space that requires navigation techniques to enable search for a desired or optimal solution. The issue of implementation of the grammar then becomes one of controlled searches through this space of solutions.

The visualization in Fig. 12 shows cascading search trees as is created by this knowledge base. At each node in the process, a recognition process first retrieves the valid options. The illustration only shows two or three options per node, but realistically this varies throughout this design process from one to 33. Some have claimed that design is essentially a decision making process and this is captured by this illustration. With each decision – each commitment to follow a particular branch of the tree – the design process diverges. One can undo decisions to follow other branches or maintain a small diverse set of candidate concept scattered about the search tree. The abandonment of all decisions would return one to the top of the tree as if to fulfill the proverbial "back to the drawing board" struggle.

Computationally, no single decision is made in the current research; rather we have taken advantage of the large computational memory stores to follow every path in the search tree to simply enumerate all possible candidates. This rote approach, known as Breadth First Search is complete but unmanageable for the final tree in which components are instantiated. Fortunately, this search tree is the first opportunity for us to numerically evaluate the quality of each decision, since real components are being compared and such components have data available about their cost, weight, performance, etc. The lack of evaluation limits the computer's ability to decide between which option at each stage of the tree is better. Eperienced designers can make judgments about which paths to follow in these early stages based on intuition or previous experiences. It is unclear how a computational process can mimic this yet. Essentially, storing what changes can be made is one knowledge-base, but comparing and deciding between various options may require another knowledge-base. Previous work has been accomplished by this research group to capture some of this decision-making knowledge. This is shown for the function structure to CFG rules in [25].

Furthermore, the early search trees are complicated by confluence in the rules. Confluence clearly happens and essentially reduces the search tree thus making it easy to manage, but it is not clear by examining the rules a priori how much confluence exists or how to manage it. The tree search algorithms used in this paper include a check for common configurations at each level of the tree in order to reduce the memory burden; however,

this check is time consuming and account for the 80% of the nearly 5 day span of time required to reach the 1536 candidates at the bottom of the fourth search tree.

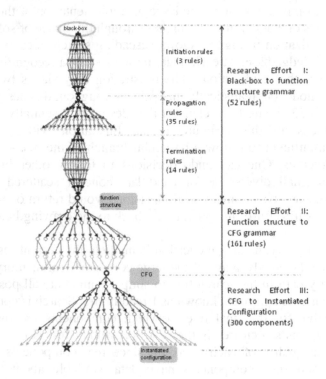

Fig. 10. An illustration of the cascading search trees

The results of this study provide some interesting insight when compared to the human activities in accomplishing the design process. First, the stages of the design process can help to reduce the search space by committing to a best candidate at each level and using that as the seed for the next. These key decision points provide a moment of evaluation and limit the number of solutions needed to be searched in the future. Second, human designers are capable of comparing only a small number of concepts. The current implementation contains many heuristics as stored in the 213 grammar rules, but it is likely that humans collectively know many more, and each likely contains many caveats, exceptions, and useful minutiae. And yet, if all the heuristics about this electromechanical design domain were captured, the number of alternatives at each stage would be even larger. Perhaps then human and computer can help each other, since the computer can store many alternatives it can help keep the designer(s)

on track; and since the human may know of countless more heuristics (and is loath or incapable of articulating them) they can direct the computer to new and unforeseen options. Third, the design process is vague. Approaches to systemize it like design tools such as creating a black-box or a function structure clarify the design process and make it more scientific. Our work has attempted to transition these design tools into an even more rigorous language. The results are promising as the computer is capable of creating a configuration of real components – a coffee grinder in this paper – into a real set of connected components. With more rules and a thorough evaluation of concepts, it now seems possible that the conceptual design process can be solved wholly computationally.

Acknowledgments

This material is based upon work supported by the National Science Foundation under grants CMMI-0448806 and IIS-0307665. Any opinions, findings, and conclusions or recommendations presented in this paper are those of the authors and do not necessarily reflect the views of the National Science Foundation.

References

1. Pahl G, W Beitz (1996) "Engineering Design: A Systematic Approach," Springer Verlag.
2. Mittal S, Dym C, Morjara M (1985) "PRIDE: An Expert System for the Design of Paper Handling Systems", IEEE Computer, Vol.19:7, pp. 102-114. 22.
3. Qian L., Gero JS, (1996) "Function-behavior-structure paths and their role in analogy-based design", AIEDAM Vol. 10, pp. 289-312.
4. Bhatta S, Goel A, Prabhakar S (1994) "Innovation in Analogical Design: A Model-Based Approach," Proceedings of the AI in Design, Kluwer Academic, Dordrecht, The Netherlands, pp. 57–74.
5. Hundal M (1990) "A Systematic Method for Developing Function Structures, Solutions and Concept Variants," Mechanism and Machine Theory, 25:3, pp.243-256.
6. Ward AC, WP Seering, (1989) "The performance of a mechanical design compiler", ASME, Design Engineering Vol 17, pp. 89–97.
7. Bracewell RH, Sharpe JEE (1996) "Functional Description Used in Computer Support for Qualitative Scheme Generation- "Schemebuilder□", Artificial Intelligence for Engineering Design, Analysis and Manufacturing, Vol. 10:4, pp. 333-345.

8. Chakrabarti A, Bligh T (1996) "An Approach to Functional Synthesis of Mechanical Design Concepts: Theory, Applications and Emerging Research Issues," AIEDAM, 10, pp.313-331.

9. Campbell M, Cagan J, Kotovsky K (2000) "Agent-based Synthesis of Electro-Mechanical Design Configurations", Journal of Mechanical Design, Vol. 122:1, pp. 61-69.

10. Wang K, Yan J, (2002) "An Analytical Approach to Functional Design," Proceedings of ASME 2002 DETC, Montreal, CA.

11. Sridharan P, MI Campbell (2005) *A Study on the Grammatical Construction of Function Structures*. Artificial Intelligence for Engineering Design, Analysis and Manufacturing,. 19(3): p. 139-160.

12. Agarwal M, J Cagan (1998) "A Blend of Different Tastes: The Language of Coffee Makers", Environment and Planning B: Planning and Design, Vol. 25, No. 2, pp. 205-226.

13. Shea, K., J. Cagan, and S.J. Fenves, 1997, "A Shape Annealing Approach to Optimal Truss Design with Dynamic Grouping of Members", ASME Journal of Mechanical Design, Vol 119, No. 3, pp. 388-394.

14. Brown, K.N., and J. Cagan, 1997, "Optimized Process Planning by Generative Simulated Annealing", Artificial Intelligence in Engineering Design, Analysis and Manufacturing, Vol. 11, pp.219-235.

15. Schmidt L, Cagan J (1995) "Recursive Annealing: A Computational Model for Machine Design", Research in Engineering Design, 7:2, pp. 102-125.

16. Starling AC, K Shea (2003) "A Grammatical Approach to Computational Generation of Mechanical Clock Designs", Proceedings of ICED□03 International Conference on Engineering Design. Stockholm, Sweden.

17. Starling AC, K. Shea (2005) "Virtual Synthesizers for Mechanical Gear Systems," Proceedings of ICED□05 International Conference on Engineering Design, Melbourne, Australia.

18. Wielinga BJ, Schreiber AT (1997) "Configuration Design Problem Solving" Technical Report University of Amsterdam, Department of Social Science Informatics.

19. Carlson-Skalak S, White MD, Teng Y (1998) "Using an Evolutionary Algorithm for Catalog Design", Research in Engineering Design

20. Campbell MI, (2007) The official GraphSynth Site, http://www.graphsynth. com, University of Texas at Austin

21. Carlson SE (1996) "Genetic Algorithm Attributes for Component Selection", Research in Engineering Design

22. Kurtoglu T, MI Campbell (2008) "Automated Synthesis of Electromechanical Design Configurations from Empirical Analysis of Function to Form Mapping," Journal of Engineering Design, vol. 19, available online.

23. Tamhankar MS, MI Campbell (2007) "An Intelligent and Efficient Tree Search Algorithm for Computer-Aided Component Selection". ASME DETC07/DAC-34587, Las Vegas.

24. Design Repository, Design Engineering Lab, University of Missouri Rolla

25. McMaster-Carr®, McMaster-Carr Supply Company, www.mcmaster.com

A Case Study of Computing Appraisals in Design Text

Xiong Wang and Andy Dong
University of Sydney, Australia

This paper presents case studies of the calculation of appraisals, the linguistic construal of emotions and attitudinal positions, in natural language design text. Using two data sets, one a standard set of movic review text and one a set of a natural language design text, we compare the performance of support vector machines for the classification of design documents by overall semantic orientation based on two different numerical representations of the design text. For the natural language design text data set, we additionally compare the performance of the support vector machine for the categorization of the text into three categories, Product, Process and People. We find that the sparse yet high dimensional representation of the design text allows the support vector machine to perform best. Further, we find modest benefit in encoding statistically derived data about the semantic orientation and lexical data about the semantic category into the representation beyond frequency counts on the occurrence of unigrams in the text.

Computing sentiments in design text

In recent years, the computational linguistics community has turned its attention toward the modeling of the subjectivity and sentiment of language. The aim of understanding the sentiment of a text is to distinguish the subject of the text from the subjective stance taken by the author towards the topic. At the moment, a primary task of sentiment analysis is to determine the semantic orientation, positive or negative, of the sentiment. Determining the semantic orientation of design documents may have useful outcomes such as determining the level of risk and uncertainty in product specifications, assessing the temperament of a design team, or managing the progress of the design process. For example, by mapping semantic orientation in design text to a model of design as reflective practice, we have been able to elicit the co-existence of affective

processing and rational cognitive processing [4] and the effect of attitudes toward the formation of shared understanding [5]. Building a general purpose sentiment classifier for design text is, however, not *a priori* obvious. Some of the challenges in building such a classifier are studied in this paper.

One of the principal challenges of developing sentiment analysis systems has been the lack of a precise computational language model of sentiment. Within the theory of systemic-functional linguistics, the APPRAISAL system [7] provides a rigorous, network-based model for sentiment, which linguists characterize as the construal of emotions and interpersonal relations in language. The model has been partially implemented [14].

Yet, what is intriguing is that one of the most accurate supervised machine learning sentiment classifiers to date relies on a standard bag-of-words representation of the text using unigrams found in the text [8] rather than feature sets from the semantic resources in the APPRAISAL system. The semantic resources for the APPRAISAL system are all the linguistic means available to a speaker to express subjective content, such as affect ("I *like* this book") and engagement ("*You know*, this is a *really good* book"). Pang's method is based on characterizing a document as a bag-of-words. The bag-of-words ignores knowledge about the words, such as part-of-speech and semantic meaning, and the grammar, treating the text as an unordered collection of words. Each document in the corpus is numerically represented as a high-dimension vector of frequency counts of unigrams matching a pre-determined list. For any unigram in the candidate list of content-bearing words, if the unigram appears in both the target document and the list, the corresponding position in the vector will be labeled as 1; else it will be marked as 0. This method attained around 80% accuracy in semantic orientation classification. Only by combining the semantic resources for Attitude and Orientation from the APPRAISAL system with bag-of-words features does the performance of sentiment classification improve [14], though not by much. Another method which employed cognitive and commonsense knowledge as rules also does not perform as well as the bag-of-words classification [9].

There are two challenges in adapting the bag-of-words and appraisal features methods to the analysis of design text. The first challenge has to do with re-using the existing bag-of-words sentiment classifier. The standard test corpus for sentiment analysis in the computational linguistics community is movie reviews (http://www.cs.cornell.edu/people/pabo/movie-review-data/). All of the sentiment classifiers described previously were trained,

tested, and compared based on this movie review data set. Whilst it is not altogether explainable, at least theoretically, why the bag-of-words method works so well compared to a method rigorously grounded in linguistic theory, it is tempting to apply the bag-of-words classifier immediately to design text nonetheless. After all, the performance of the APPRAISAL theory based classifier is not so markedly better to justify the additional computational expense of generating the lexicon for the appraisal groups. However, it is important to note that the bag-of-words classifier was trained on a data set consisting of text about movie reviews. It is not *a priori* obvious whether a supervised machine learning system trained on a linguistic data set from a specific domain, movie reviews, could perform equally well on the target data set, design text. The lexicon of the two domains is different. It is not known if this difference will result in a significant degradation in performance in accuracy of sentiment classification when the classifier is trained on one data set but deployed on another. This drop in performance has been claimed [9] but not tested. Yet, there is the potential that it might be possible to transfer the sentiment classifier across domains. There is evidence from research by Wiebe [15] that a sentence is 55.8% likely to have subjective content if there is an adjective within; thus, the appearance of a broad range of adjectives in the training data set might be sufficient for sentiment analysis, and it would not be necessary to utilize all the words that appear in the target domain to train the classifier. It would be highly attractive to re-use a sentiment classifier trained on existing data sets due to the expense of producing tagged data to train machine learning classifiers.

Second, the bag-of-words method relies on a very high-dimension representation that hinges on training a system on a text domain which contains a high coverage of words that are likely to appear in the target corpora. The fewer words that the two corpora share, the less likely it is that the bag-of-words sentiment classifier would perform well. This is not altogether attractive since this makes such systems difficult to transport across linguistic domains or even within a linguistic domain within which the training set does not have as many unique words as found in the target domain. Also, if such a system were deployed on a very large corpus, such as the corpus associated with the design of very large engineering systems, such as aircraft, it is very possible that there will be millions of features (unigrams). This very high dimensionality reduces the computational efficiency of the machine learning system and introduces other pragmatic implementation challenges. Finally, the more unique words which exist in the text, the more training cases are needed, which is, from a practical

standpoint, difficult to obtain. It would, instead, be desirable to have a lexicon-independent representation.

In our prior work [13], we presented an initial feasibility study of a method to calculate the semantic orientation of design text using a compact representation of text wherein the possible semantic orientation of individual words in clauses was calculated using a statistical measure of co-occurrence with known positively and negatively oriented words. That study confirmed the feasibility of the approach, but revealed two key limitations. First, the calculation of a word's semantic orientation is computationally expensive and requires a real-time lookup to a very large online database. For that research, we used Google, although other "off-line" data sets are available such as the Google/Linguistic Data Consortium Web 1T 5-gram data set. We found that the calculated values from the Google queries fluctuated depending upon which Google servers were "hit" during a particular query. Second, the evidence from the recent research comparing computational sentiment analysis based on appraisal theory against the bag-of-words approach, showing that the bag-of-words approach is superior, leads us to question the utility of embedding statistically derived data about semantic orientation into the representation of text. Thus, in this project, we tested the claim that embedding statistically derived data of a word's semantic orientation into the text representation could improve the sentiment classification of text by setting the value of the sentiment of individual words to 1 (neutral).

In this paper, we set out to investigate these related issues. That is, this paper investigates:

- The accuracy of a bag-of-words sentiment classifier trained on the movie review data set applied to a design text data set (same algorithm, same text representation, different training and target data sets)
- The accuracy of a bag-of-words sentiment classifier compared to a sentiment classifier operating on a highly compact representation of design text (same algorithm, different text representation, same training and target data sets)
- The accuracy of the compact representation when knowledge of the semantic orientation of individual words is included in the representation and when it is absent

To address these research questions, we:

- Produced a tagged corpus of design text rated for semantic orientation (positive or negative)
- Developed a compact document representation for text that includes features for word category and semantic orientation

- Trained a bag-of-words sentiment classifier on the design text
- Executed various comparative tests

What is it about design documents?

There are characteristics which distinguish design documents from other types of documents such as newspaper stories or political policy platforms. The language of design is a special kind of language owing to the performity of the language. That is, the reality producing effect of the language of design, where the reality is both the design work and the design process, is itself an enactment of design, a praxis about materialising realities [3]. From this point of view, the suggestion is that there is a connection between the practice of design and the linguistic properties of the language of design. Design texts constitute the materiality of the design work through language, and it is the sentiment in text which sanctions one work from another. Thus, understanding this process of privileging one work over another, which we believe is realised through the linguistic process of appraisal, is a key step in understanding how the language of design produces design. Secondly, designers write down their thoughts about a project as they are working on it. Design documents can be considered a recording of a design process over time. Ascertaining the ebbs and flows of attitudes toward the design work and design process could illustrate a more nuanced picture of how well design happened.

In sentiment classification of design text, it is also important to consider the subject matter. We categorize three high-level subject matters. Appraisals of *Product* are directed towards the design work, including its requirements and goals and the data informing the construal of the design brief. Appraisals of *Product* can justify (provide rationale) decisions taken during the design process. That is, appraisals of *Product* can explain how the designers' *feelings* toward the design work influenced the designing of the work. In the appraisal of *Product*, the designer may rely on semantic resources that apply an external, normative *judgment* or a personal, subjective *appreciation*. For example, *"Uniqlo is a comparatively reserved design"* which is a positive appraisal by 'Tokyo Style' of the style of the Uniqlo clothing line.

Taking stances towards tangible tasks and actions performed during designing identifies the appraisal of *Process*. Appraisal of *Process* is generally associated with concrete actions. In all of the process-oriented appraisal clauses, a tangible action is being evaluated. The evaluation associates a position toward the state of being of the action. An example is,

"That's a risky strategy here," which displays a negative attitude towards a way of doing a design task.

Appraisals of *People* express evaluations of a person's (a stakeholder in the design process) cognitive and physical states of being. Appraisals of *People* tend to take on an air of normative evaluation about how people should and should not be or behave. *"Uniqlo hired the country's hottest retail designer"* is a positive appraisal of the people doing design for Uniqlo by *Tokyo Style*, here employing a normative evaluation where a norm for a "hot" designer is assumed to be known by the reader.

System Development and Experiment Setup

Labeled Design Text

To understand the difference in performance of the bag-of-words sentiment classifier when trained on a movie review data set and deployed on design text, we needed to create labeled design text. That is, we needed to create a new data set consisting of text about design works, the process of designing, and designers, which were labeled for semantic orientation. A cohort of three native English speakers with a background in a design-related discipline (e.g., engineering, architecture, and computer-science) was tasked with reading and categorizing various design texts. The texts included formal and informal design text from various online sources and across various design-related disciplines. All design texts were collected by the authors. Each coder was paid to classify the texts. The rating cohorts were trained to identify the proper category and its semantic orientation according to the context. Training lasted for one hour. During coding, 2 of the 3 coders had to agree on the semantic meaning (category), semantic orientation (orientation), and the value of the orientation, that is, positive or negative. Working in two hour time blocks, the coders read various design texts, including formal design reports, reviews of designed works, reviews of designers, and transcripts of conversations of designers working together.

Every thirty minutes, the coders took a "fatigue check" test to assess their performance. The fatigue test consisted of six appraisals that the second author had previous labeled. These constituted a set of "known" appraisals with correct content categorization and semantic orientation. The appraisals were randomized so that the group would not receive two tests containing the same set of appraisals in the same order. The fatigue

test usefully provides us a baseline for the "best" performance we could expect from the machine learning classifier as well as an assessment of the internal validity of the collected data. One-third of the data set was cross-categorized by the second author and a colleague coding per standard practice in protocol analysis to ensure agreement upon a reliable categorization and sentiment classification. Finally, the second author reviewed the cohorts' work to ensure that they were correctly following the rules for coding the categories and orientation according to the framework for the language of appraisal in design. Following the review, the coders were required to make one last pass through the data to re-code text the author thought might be incorrectly labeled. In the practice of human labeling of data for training computational linguistic classifiers, the guideline of more than five votes per paragraph is used a baseline for confirming "correct" labeling of a text. This coding system satisfies this requirement and is reliable because at least five people, three people from the student cohort and two researchers, agreed on the rating.

The accuracy of the coders for semantic orientation was about 90% accuracy over most of the sessions [13]. Pang [8] found that human-based classifiers were accurate only 58% to 64%; thus, the performance of our coders is consistent (actually better since the coders discussed their interpretations) with other studies and is likely to be the "best" that could be expected from a computational system.

Methods of Representation of Design Text

Bag-of-Words Representation

The bag-of-words sentiment classifier operates on a simple word occurrence representation format. In this representation format, one (a full-text text analysis software program) counts the frequency of occurrence of a single word (unigram) or word group (bigram, trigram … n-gram). This word-by-document matrix F (see Table 1) is comprised of n words w_1, w_2, …, w_n in m documents d_1, d_2, … d_m , where the weights indicate the total frequency of occurrence of term w_p in document d_q.

Let us take the sentence "It is a great masterpiece" to show how to compose the bag-of-words (BoW) representation. First, the "bag" consists of a list of 12,111 words which appear in the design documents. The list of words is generated from a full-text parse of the design text to extract key words and phrases, but not stop words such as "a" and "the." Because the representation vector is sparse, we only show the columns which are non-zero. In the following equation, the right side is the BoW vector for the

sample sentence. For each vector component, the first number is the column, and the appearance of the word (indicated by a 1) follows the colon: BoW("It is a great masterpiece.") = [3:1 6:1 10:1 176:1 3077:1]

Table 1 Sample Word by Document Matrix

	d_1	d_2	...	d_m
w_1	0	1		2
w_2	1	0		0
...				
w_n	0	1		1

Compact Representation

To compare the accuracy of the bag-of-words sentiment classifier compared to a sentiment classifier operating on a highly compact representation of design text, we propose a compact representation of design text that could overcome problems with lack of lexicon coverage between the training data set and the target data set. That is, the aim of the representation is to be lexicon independent and train the classifier only on the appearance of a set of numerical values relating to the potential sentiment of the text and the semantic category of the text.

The basic requirement for the representation is that it must encode which categories words might belong to and whether the individual words express a positive or negative sentiment. Thus, for each clause, we need to encode the category – Product, Process, or People – and the sentiment of the clause's constituents in the numerical value. The content-bearing constituents in a clause are nouns, verbs, and adjective or adverb modifiers. To encode this information requires $3 \times 3 = 9$ combinations, 3 dimensions for each category and 3 dimensions for each constituent in a clause. The insight here is that each triplet of vector dimensions encodes the category of the clause and the length of each vector dimension encodes the sentiment. In total, we have a 9–dimensional vector of the following form (Fig. 1):

$$\begin{bmatrix} Pd_N & Pd_V & Pd_A & Pr_N & Pr_V & Pr_A & Pp_N & Pp_V & Pp_A \end{bmatrix}$$

Fig. 1. 9-dimensional vector representation of text

where Pd = Product, Pr = Process, Pp = People, N = Noun, V = verb, and A = adjective/adverb.

The value of each of the vector dimensions is determined in the following way. First, all the content-bearing words are automatically extracted from the text, and their grammatical relationships are identified. Then, each word is looked up (queried) in the WordNet lexicographer database to ascertain the logical grouping that might indicate the appropriate category (Product, Process, People) for the word. The WordNet lexicographer database and their syntactic category and logical groupings were used to categorize words (nouns) as being about Product, Process or People. Verbs, adjectives and adverbs are categorized according to the category(ies) of the noun they related to grammatically. These clusters of syntactically related words are called word groups.

For the noun in each word group, rules were applied to identify which of the WordNet logical groupings would contain nouns in the categories [13]. Two correction factors are multiplied with the count of the frequency of occurrence of a word in the target clause applied: κ_1, which is inversely proportional to the number of possible Product-Process-People categories a WordNet logical grouping can belong to; and, κ_2, which takes into account the uncertainty of a word's category. Since the correction factor κ_2 for a word may have up to three values, it is normally expressed as a vector of the form $\kappa_2(word) = [\kappa_{2,Pd}, \kappa_{2,Pr}, \kappa_{2,Pp}]$.

The semantic orientation (SO) of the words in each word group is calculated using the SO-PMI measure, which is in turn based on their pointwise mutual information (PMI) [12]. The strategy for calculating the SO-PMI is to calculate the log-odds (Equation 1) of a canonical basket of positive (Pwords) or negative (Nwords) words appearing with the target word on the assumption that if the canonical good or bad word appears frequently with the target word then the target word has a similar semantic orientation.

Equation 1 The log odds that two words co-occur

$$PMI - IR(word_1, word_2) = \log_2\left(\frac{p(word_1 \& word_2)}{p(word_1)p(word_2)}\right)$$

As reported in our prior research [13], we used a Google query with the *NEAR* operator to look up the co-occurrence of the target word with the canonical basket of positive and negative words. The SO-PMI based on the *NEAR* operator is described by Equation 2.

Equation 2 The semantic orientation of word based on mutual co-occurrence with a canonical basket of positive and negative words

$$SO - PMI(word) = \log_2 \left(\frac{\Pi_{pword \in Pwords} hits(wordNEARpword) \cdot \Pi_{nword \in Nwords} hits(nword)}{\Pi_{nword \in Nwords} hits(pword) \cdot \Pi_{nword \in Nwords} hits(wordNEARnword)} \right)$$

SO-PMI values generally follow intuitive notions of positive and negative words. The SO-PMI values for a strongly negative word such as "unlikely" is –8.1 whereas it is 1.7 for "unintended" and 17.9 for "unified", a positive word. However, this is not always true as many positive words could be used ironically or sarcastically such as "This is a *masterpiece?*". SO-PMI values can be "close" and negative-valued even when, qualitatively, it is intuitively known that the two words differ in positive/negative orientation. For example, SO-PMI("masterpiece") = –5.7 whereas SO-PMI("depressed") = –6.7. No structural relation to the sentiment of a text can necessarily be imputed from the SO-PMI values of individual words alone. It is for this reason that it is necessary to use a machine learning system trained over aggregations of SO-PMI values for word groups in the text than individual words.

The distribution of SO-PMI values for the data sets is shown in Fig. 2. From this figure, we can see that the SO-PMI values are fairly evenly-distributed. This implies that the words in the training and validation set are not inherently biased negative or positive.

Fig. 2. Frequency Distribution over SO-PMI

We selected a basket of 12 canonical positive and negative words. Adjectives and adverbs were selected based on most frequent occurrence in written and spoken English according to the British National Corpus [6, pp. 286-293]. Because this list is published separately, we joined both lists and ordered them by frequency per million words. We selected only those adjectives and adverbs which were judged positive or negative modifiers according to the General Inquirer corpus [http://www.wjh.harvard.edu/~inquirer/]. The basis for the selection of these frequently occurring words as the canonical words is the increased likelihood of finding documents which contain both the canonical word and the word for which the PMI–IR is being calculated. This increases the accuracy of the SO-PMI measurement. Table 2 lists the canonical Pwords and Nwords and their frequency per million words.

Table 2 Canonical positive and negative words

Positive Words	Negative Words
good (1276)	bad (264)
well (1119)	difficult (220)
great (635)	dark (104)
important (392)	cold (103)
able (304)	cheap (68)
clear (239)	dangerous (58)

The SO-PMI of all unigrams (noun, verb, modifiers) in the target lexicon are pre-calculated and saved in a database to speed up the analysis.

In previously reported research, the assignment of the modifiers into a specific category did not take into account which noun or verb a modifier is complementing; rather, the category for a modifier was assigned by lexical distance from a noun or verb. In this paper, we correct this gross assumption by making use of a more rigorous grammatical parse of the clauses. Second, we previously ignored the verb *to be*. There is the possibility of its contribution to the semantic orientation in spoken English when the verb is emphasized through a prosodic effect as in "It is!."

In order to determine which noun or verb a modifier is associated with, we generated a part-of-speech (POS) parse [11] for each clause. The POS tagger provides a way to analyze grammatical relationship between words within a sentence and outputs with various analysis formats including part-of-speech, phrase structure trees (how the words are assembled into the clause), and typed dependency (which words modify another word in the clause). We applied the latter two formats to analyze labeled design

documents to correctly associate the modifiers with the respective noun or verb as described in Fig. 3.

We will use the simple clause "It is a great masterpiece" to demonstrate how to assign modifiers to the correct noun or verb. In Phrase Structure Tree format, the clause is parsed as:

```
It/PRP is/VBZ a/DT great/JJ masterpiece/NN ./.
```

In Typed Dependency Format:
```
nsubj(masterpiece-5, It-1)
cop(masterpiece-5, is-2)
det(masterpiece-5, a-3)
amod(masterpiece-5, great-4)
```

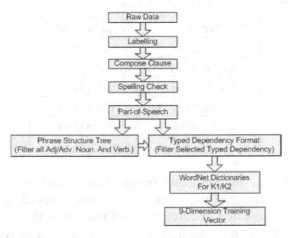

Fig. 3. Interaction between phrase structure trees and typed dependency parse

All modifiers (adjectives and adverbs) and their complements (nouns and verbs) are picked up according to the Phrase Structure Tree Format.

"*is*" (VBZ)
"*great*" (JJ)
"*masterpiece*" (NN)

The amod dependency (adjectival modifier) amod(masterpiece-5, great-4) is the most relevant relation and identifies that "*great*" modifies "*masterpiece*."

For each noun in a sentence, all verbs and modifiers related to it will be clustered with the noun and saved into a queue with the other clausal participants. In this example, the queue for the sentence is [5 4 2]. For all verbs and modifiers which do not belong to any noun, they will be attached to the end of the queue. Stop words and anaphoric references are ignored.

Let w_1, w_2 and w_3 be the SO-PMI values for each of these words, respectively. The correction factor \varkappa_2 for the word *masterpiece* is (based on the WordNet 2.1 dictionary) is $\varkappa_2(masterpiece) = [0.5\ 0.5\ 0]$. The initial 9-dimension vector should be:

$$\begin{bmatrix} w_3 \times 0.5 & 0 & w_2 \times 0.5 & w_3 \times 0.5 & 0 & w_2 \times 0.5 & 0 & 0 & 0 \end{bmatrix}$$

Because there is no relevant modifier relation for the word *"is,"* the algorithm just:

1. looks up its SO-PMI value
2. divides the value by 3 since it could belong to any category
3. inserts the value into the vector

The final 9-dimension for this clause is *"It is a great masterpiece"*:

$$\begin{bmatrix} w_3 \times 0.5 & \dfrac{w_1}{3} & w_2 \times 0.5 & w_3 \times 0.5 & \dfrac{w_1}{3} & w_2 \times 0.5 & 0 & 0 & \dfrac{w_1}{3} \end{bmatrix}$$

Supervised Machine Learning With Support Vector Machines

The supervised machine learning algorithm used in this research is based on support vector machines. For a two-class pattern classification problem, a support vector machine seeks to determine a separating hyperplane that maximizes the margin of separation between the two classes of patterns. Here, the two classes of patterns are documents of positive sentiment and documents of negative sentiment.

For a set of patterns x_i 2 $<^n$ with labels y_i 2 $\{\pm1\}$ that are linearly separable in input space, the separating hyperplane $\mathbf{w} \cdot \mathbf{x} + b = 0$ must satisfy, for each training data sample (\mathbf{x}_i, y_i) a set of constraints that are usually written in the form $y_i [\mathbf{w} \cdot \mathbf{x} + b] \geq 1$ $i = 1, 2, \dots, m$ for a training set of m data points. The distance between these two sets of points is 2 / $\|\mathbf{w}\|$. Thus, the margin of separation of the two classes in this linearly separable case can be maximized by minimizing $\frac{1}{2}\|\mathbf{w}\|^2$. This minimization problem can be solved by forming the Lagrangian function in the usual way. The solution then lies at the saddle point of the Lagrangian given by minimizing with respect \mathbf{w} and b, and maximizing with respect to the Lagrange multipliers. Conditions on \mathbf{w} and b at the

saddle point can be found by differentiating the Lagrangian and setting it to zero. These conditions on ⬚ and b allow them to be eliminated from the Lagrangian and all that remains then is to maximize with respect to the Lagrange multipliers. This step takes the form:

$$\text{maximize } W(\alpha) = \sum_{i=1}^{m} \alpha_i - \tfrac{1}{2} \sum_{i=1}^{m} \sum_{j=1}^{m} \alpha_i \alpha_j y_i y_j (x_i \cdot x_j)$$

such that $\sum_{i=1}^{m} y_i \alpha_i = 0$. The αi are the Lagrange multipliers which are constrained to be non-negative. Optimum values of ⬚ and b (i.e., those that define the hyperplane that provides the maximum margin of separation) can then be obtained by substituting the values of the α_i that maximize $W(\alpha)$ into the conditions on ⬚ and b that hold at the saddle point.

To format the training data for SVM, the bag-of-words or the compact representation, respectively, is defined as the \mathbf{x}_i and the sentiment orientation the \mathbf{y}.

Data Processing

After the rated text data was collected, spell-checked, grammar-checked, and saved in a sentence pool, additional pre-processing steps were taken due to the following issues:

- Imbalance of text data distribution. In the 10131 rated sentences/ paragraphs, the distribution of Process/Product/People categories text is 3915:4484:1732. If we keep this ratio in the training to validation set, that would lead to the imbalance of the training and validation set.
- Shortage of data. The machine learning system should be trained on 900 vectors and validated on 600 vectors (fixed length paragraphs) respectively. In total, 1500 (900+600) paragraphs are needed. If each of the paragraphs is composed by 7-8 rated sentences, then about 10500-12000 rated sentences are required, and this amount exceeds the 10131 rated sentences/paragraphs mentioned above.

To obtain sufficient data points for this study, we must "reuse" the rated sentences to generate data points.

We modified the data pre-processing step we have mentioned in our previous paper [13] to produce more data for training. The difference between the old method and the new one is that we use a *sentence* rather than a *paragraph* as a textual unit. For each sentence in the sentence pool,

part-of-speech tagging will provide the phrase structure trees and typed dependency in order to obtain the grammatical relationships. A noun-based clustering algorithm is then applied. The basic idea is to identify every noun in a sentence and put all verbs and modifiers (adjectives and adverbs) connected to the noun together with it. The average value of the SO-PMI of all words in a word-cluster will be distributed into the corresponding categories in the 9-dimension vector. When all word-clusters in a sentence are processed, a complete 9-dimension vector is generated.

The advantage to this approach is that we can generate enough training data for training and validation by selecting paragraphs with the same semantic orientation and semantic meaning, separate the sentences from the paragraphs, and re-combine the sentences into synthetic paragraphs to compose the training and validation vectors. That is, one sentence could be used by more than one training or validation vector. As shown in Table 3, after applying the sentence-reused data produced method, we have enough data points for training and validation. If each paragraph is composed with n sentences, then for a corpus with m sentences, theoretically, there are $C_m^n = \dfrac{m!}{(m-n)n!}$ possible paragraphs.

For example, there are 1732 rated sentences about People. If we applied the pre-processing method in [13], then only about 220 paragraphs will be composed. That is insufficient for training and validation purpose. By re-using the rated sentences, we can have more than 2.47×10^{20} paragraphs for the same purpose.

Table 3 Statistics about collected design text data

Category	Process	Product	People
Rated Text Data (Paragraphs / Sentences)	500/3915	550/4484	220/1732
Proposed Training/Validation	300/200	300/200	300/200
Re-used Sentences ($\times 10^{20}$)	1698	5035	2.47

Results and Discussion of Results

In the first set of results, we compared the accuracy of sentiment classification for the movie review data set and the design text using unigrams (Table 4). We conducted the test of the movie review data set to ensure the accuracy of the software implementation. The results obtained

are consistent with that obtained by Pang. The bag-of-words text representation achieved almost 88% accuracy in sentiment orientation for the design text. The overall, average accuracy of sentiment classification that we achieved in the previous method for sentiment classification of design text using the compact representation and SO-PMI values for individual words was 70.0% [13]. When we set the SO-PMI value for individual words to be 1, that is neutral (Strictly, 1 is not neutral, as there is no *neutral* word. As long as all the words have the same SO-PMI value, and it is nonzero, then there is no difference between words in semantic orientation. In other words, they are neutral relative to each other.), the overall accuracy of sentiment classification was still 70.0%. There is no significant improvement or degradation in performance even when correcting for the correct noun modifiers in the 9-dimensional vector representation.

Table 4 Accuracy of sentiment classification for bag-of-words and compact representation

Data Set	Bag-of-Words	Compact Representation
Movie Review	80.2%	N/A
Design Text	87.6%	70%

The accuracy of categorization was also compared. Again, the bag-of-words approach beats the compact representation. There is an improvement in semantic categorization over our prior results [13] when the SO-PMI value is *not* included in the representation (i.e., set to 1). Turney [12] reported that it is not clear whether SO-PMI would help (or hinder) semantic categorization. These results indicate that SO-PMI may hinder semantic categorization when training over limited feature sets.

Table 5 Accuracy of categorization for bag-of-words and compact representation

Data Set	Bag-of-Words	Compact Representation
Product	87.05%	79.7%
Process	84.52%	77.0%
People	89.82%	78.3%

Table 6 reports on the accuracy of the sentiment classification when trained on the movie review database using the unigram word list from the movie review data set (A) and when using the unigram word list from the design text data set (B). Here, we find that the results are worse than merely guessing. What this finding confirms is that it is not possible to

train the sentiment classifier on one text domain and then deploy the classifier on another domain since the classifier is highly sensitive to the words which appear in both the training and target domains.

Table 6 Accuracy of sentiment classification when trained on design data

Data Set	A	B
Movie Review	33.02%	33.67%

We conjectured that the results might improve if we used a word list consisting of words that appear in both the movie review data set and a word list consisting of words that appear in either the movie review or the design text data sets. To examine the effect of the word list on the sentiment classification, we ran tests of the sentiment classifier when trained on the movie review data set using words (unigrams) which appear in both the movie and design text data sets (M & D) and using words (unigrams) which appear in the movie or design text data sets (M ‖ D). The results are reported in Table 7. There was essentially no improvement. It would appear that there are specific patterns of co-occurrence of words in specific texts which are related to semantic orientation. This result suggests that the accuracy of the sentiment classifier is not necessarily improved merely by adding more words (evidence) into the training set, particular if the added words do not necessarily appear in the training set.

Table 7 Accuracy of sentiment classification when trained on movie review

Data Set	Bag-of-Words (M && D)	Bag-of-Words (M ‖ D)
Design Text	33.58%	32.56%

Despite the limitation of the bag-of-words approach in training the sentiment classifier on a corpus which differs from the target set, the results point to a more intriguing hypothesis. When Claude Shannon published A Mathematical Theory of Communication [10], he showed that it was possible to model the generation of communication as a probabilistic system based on relatively simple rules on the statistical co-occurrence of letters in English words. In prior research, it has been demonstrated that latent semantic analysis exploits the statistical co-occurrence of words in discourse to model the underlying knowledge representation of the communicator and that meaning emerges from the statistical co-occurrence of semantics [1]. An application of lexical chain analysis showed the statistical co-occurrence of semantic links in discourse reveals the way that ideas are connected by language and that concept

formation is driven by the accumulation of knowledge represented as lexicalized concepts [2]. Finally, the success of the bag-of-words approach for sentiment analysis shows that a relevant set of semantic features is sufficient to recognize the semantic orientation. This new result adds evidence that it might be possible to generate a computationally-derived view of the language of design [3] purely on statistical patterns of co-occurrence of linguistic features rather than based on a rigorous linguistic model.

Conclusions

This paper presented empirical studies of the calculation of semantic orientation (sentiment analysis) of design texts using the same supervised machine learning algorithm on two different representations of the text, one which is knowledge lean (bag-of-words) and one which requires more linguistic knowledge. In all cases, the knowledge lean representation outperformed the other representation. The compact representation performed better than guessing, but it still trails the bag-of-words method significantly. The effect of setting the SO-PMI value to 1 as done in this research is equivalent to reducing the number of dimensions of the representation. The dimensional reduction to 9 dimensions suggests that lower dimensional representations might work as well as higher dimensional ones, though this claim needs further elaboration.

From these results and results from other researchers, the semantic orientation of documents appears to be largely dependent upon the semantic dependencies of words within a corpus, at least from a statistical natural language processing point of view. Embedding any additional knowledge about the semantic orientation of individual words in a clause does not appear to improve or degrade the performance of the sentiment classification. This result parallels findings in information retrieval which has shown that a purely statistical natural language processing approach such as latent semantic indexing (LSI) generally outperforms more knowledge-rich approaches. A sentiment classifier based on the bag-of-words approach, however, is very sensitive to the word list used in the training set and the co-occurrence patterns. This sensitivity is not found in LSI.

This is a rather pessimistic finding in terms of developing a general purpose semantic orientation classifier given that it is not readily obvious how to use existing tagged corpora to train a sentiment classifier and then to deploy the trained classifier onto another corpus. Further investigation

could alter the words (unigrams and bigrams) used in the training vector. Data from the British National Corpus of the most commonly used words might be an attractive target for this word list. It would be interesting to use an evolutionary optimization algorithm to select the best set of "general" words from this word list which results in the best sentiment classification over multiple corpora rather than a single corpus. This might allow the trained classifier to be deployed against various corpora.

The main conclusion from this study is that if one is interested in developing a sentiment classifier, then one must devote considerable time and cost towards training the classifier on the target text. The expense of producing the tagged training data should not be underestimated. The cost of hiring the research assistants to produce the training data for the design text exceeded tens of thousand Australian dollars. The training set that has now been produced might be valuable for further research in sentiment analysis of design text. For the time being, the bag-of-words approach coupled with support vector machines appears to be the optimal approach for sentiment classification.

Acknowledgements

This research was supported under Australian Research Council's Discovery Projects funding scheme (project number DP0557346). Xiong Wang is supported by an Australian Postgraduate Award scholarship.

References

1. Dong A (2005) The latent semantic approach to studying design team communication. Design Studies 26(5): 445-461
2. Dong A (2006) Concept formation as knowledge accumulation: a computational linguistics study. Artificial Intelligence for Engineering Design, Analysis and Manufacturing 20(1): 35-53
3. Dong A (2007) The enactment of design through language. Design Studies 28(1): 5-21
4. Dong A, Kleinsmann M, Valkenburg R (2007) Affect-in-cognition through the language of appraisals. In McDonnell J, Lloyd P (eds), Design Thinking Research Symposium 7, Central Saint Martins College of Art and Design, University of the Arts London, London, UK: 69-80
5. Kleinsmann M, Dong A (2007) Investigating the affective force on creating shared understanding. In 19th International Conference on Design Theory and Methodology (DTM), ASME, New York, DETC2007-34240

6. Leech G, Rayson P, Wilson A (2001) Word frequencies in written and spoken English based on the British National Corpus. Pearson Education Limited, Harlow, UK
7. Martin JR, White PRR (2005) The language of evaluation: appraisal in English. Palgrave Macmillan, New York
8. Pang B, Lee L, Vaithyanathan S (2002) Thumbs up? Sentiment classification using machine learning techniques. In 2002 Conference on Empirical Methods in Natural Language Processing (EMNLP), Association for Computational Linguistics, University of Pennsylvania, Philadelphia, PA: 79-86
9. Shaikh MAM, Prendinger H, Mitsuru I (2007) Assessing Sentiment of Text by Semantic Dependency and Contextual Valence Analysis. In Paiva A et al. (eds), Affective Computing and Intelligent Interaction, Springer-Verlag Berlin Heidelberg, Berlin, 191-202
10. Shannon CE (1948) A mathematical theory of communication. The Bell System Technical Journal 27: 379-423 and 623-656
11. Toutanova K, Manning CD (2000) Enriching the knowledge sources used in a maximum entropy part-of-speech tagger. In Schütze H, Su K-Y (eds), Proceedings of the 2000 Joint SIGDAT Conference on Empirical methods in natural language processing and very large corpora, Association for Computational Linguistics, Morristown, NJ: 63-70
12. Turney PD, Littman ML (2003) Measuring praise and criticism: Inference of semantic orientation from association. ACM Transactions on Information Systems 21(4): 315-346
13. Wang J, Dong A (2007) How am I doing 2: Computing the language of appraisal in design. In Design for Society: Knowledge, innovation and sustainability, 16th International Conference on Engineering Design (ICED'07), Ecole Centrale Paris, Paris, France, ICED'07/124
14. Whitelaw C, Garg N, Argamon S (2005) Using appraisal groups for sentiment analysis. In CIKM '05, Proceedings of the 14th ACM international conference on Information and knowledge management, ACM, NY: 625-631
15. Wiebe JM, Bruce RF, O'Hara TP (1999) Development and use of a gold-standard data set for subjectivity classifications. In Proceedings of the 37th annual meeting of the Association for Computational Linguistics on Computational Linguistics, Association for Computational Linguistics, Morristown, NJ: 246-253

TRENDS: A Content-Based Information Retrieval System for Designers

Carole Bouchard, Jean-francois Omhover, Celine Mougenot and Ameziane Aoussat
Arts et Métiers ParisTech, France

Stephen J. Westerman
University of Leeds, United Kingdom

Designers cognitive processes formalization and explicitation become a major topic for many scientific communities like design science, cognitive psychology, computer science and artificial intelligence. This growing interest is partly due to a certain pressure coming from the industrial context where the shortening of the development durations and the increasing variability of the offer expected by the consumer lead to a formalization and a digitization of the earliest phases of the design process. In this context, these three research areas tend to develop new models and tools that will help to progressively enable to digitize the early design process: (1) formalization of the cognitive design processes with the extraction of design knowledge, rules and skills (2) translation of design rules into design algorithms and (3) development of software tools to be used by the designers themselves and by other professionals involved in the early collaborative design process. This paper deals with the elaboration of an interactive software which enables to improve the design information process implemented by the designers. TRENDS system is positioned in the core of these evolutions and will be presented in this paper following three parts which are related to the aforementioned research areas.

Research Aims

Inspirational materials play an important role in the design process. The very specific activity of searching for inspirational material corresponds to

J.S. Gero and A.K. Goel (eds.), *Design Computing and Cognition '08*,
© Springer Science + Business Media B.V. 2008

a hybrid semantic search of text and images which was formalized through the Conjoint Trends Analysis method (Bouchard, 1999). This innovative method needs however some improvements, especially for the phase of information searching. The main research advances presented in this paper are the digitization of this method in order to improve the precision and efficiency with which designers can access inspirational materials and particularly images. These advances are being met through the integration of three innovative technologies: meta-search-engine, semantic multimedia search-engine, and automatic image analysis that will be embedded into the graphical user interface.

This research was structured according to three main phases:

(1) **Formalization of the cognitive design processes** with the extraction of design knowledge, rules and skills: a specific study was developed in 1997 which was a base for the Conjoint Trends Analysis method definition.

The Conjoint Trends Analysis method (CTA) has been moulded to the cognitive information gathering process that takes place during industrial design, taking into account the task-based requirements and the cognitive and affective processing of designers. What is most original in this approach is the identification and use of various domains of influence (nature, arts, industrial sectors, sociological end values) in order to enrich the design solution space. Finally it enables the identification of formal trends attributes (shape, colour, textures) linked to particular environments in order to use them in the early design of new products. It makes it possible to enrich and to inspire the designers and the design team when designing product. It is positioned in the earliest phases of the design process.

(2) More recently, design knowledge and informational processes have been partly modeled, especially the **categorization phase of information** in the design watch process of the designers.

A core activity of a designer when selecting inspirational materials is the use of semantic adjectives in order to link words with images and *vice-versa*. This activity is very specific and appears as a hybrid search based on both text and images. Designers recognize that their activity deals with emotional content, although the process is not necessarily explicit. Their expertise consists in providing emotional effects through design solutions characterized by their semantic expression. Even when they are searching for inspiration sources, pictures they select explicitly or mentally often have a high emotional impact. The implementation of specific algorithms based on ontologies for the textual data, and also on clustering for linking

the textual contents with images, constitute one of the major scientific advances in TRENDS project.

(3) **Development of a software**, TRENDS, which is a multimedia search engine dedicated to the designers, helping them in their informational process to gather information coming from the web and being filtered according to specific rules. This software corresponds to the digitization of the CTA method.

The TRENDS content-based information retrieval system aims at improving designers' access to web-based resources by helping them to find appropriate materials, structure these materials in way that supports their design activities and identify design trends. TRENDS system integrates flexible content-based image retrieval facilities based on ontological referencing and clustering components related to Conjoint Trends Analysis (CTA). The main functionalities of TRENDS system are the trends identification and the pallets generation.

Formalization of the cognitive design processes

The design process consists in reducing abstraction through the use of various successive levels of representation which integrate more and more constraints. It can be seen as an information processing activity that includes informative, generative, evaluative and deductive stages (Bouchard, 2003). The informative phase is crucial because design problems are by nature ill-defined and ill-structured (Simon, 1981) (Restrepo, 2004), and so refer to semantically impoverished tasks. In addition, the novelty of the design candidates during the generative phase depends mainly of this phase and of the manner to integrate the information.

Design Information Phase

Designers integrate many categories of information that will be gradually visually categorized and synthesized into design solutions. They get their inspiration in their personal life and through a more focused way in their professional life, in various sources like specialised magazines, material from exhibitions and the web, and in different sectors. They use a large variety of types of sources coming from different areas as comparable designs, other types of design, images of art, beings, objects and phenomena from nature and everyday life. Sources of inspiration are an essential base in design thinking, as definition of context, triggers for idea

generation (Eckert, 2000), and anchors for structuring designers' mental representations of designs. They help designers structuring mental representations of designs and also arguing the generation of design solutions. The designers also operate a more or less systematic watch which completes their natural inspirational process. The latter goes largely over their professional activity. All related information will be memorized and potentially further evocated in design contexts (Gero, 2002).

There is little understanding of the requirements for information retrieval in the context of a creative process such as industrial design. For creative tasks it is possible that, instead of highly focused searches being optimal, some diversity in retrieved material is useful (Bonnardel, 2005). This idea is supported by the results of (Ansburg, 2003) who found that creative thinkers tend to use more peripherical cues (data not directly linked to the problem) (Hocevar, 1980). Of relevance is the theory of Conceptual Blending (Fauconnier, 1998) which proposes that the process of thought involves 'moving' between mental spaces that organise our knowledge of the world. Creativity can be conceived as the combination (or conceptual blending) of two, or more, conceptual spaces. This process requires both divergent and convergent thinking (Perreira, 2002). The generative phase of design is highly based on analogical reasoning (Bonnardel, 2005, Blanchette; 2000, Kryssanov, 2001, Visser, 1996). The originality comes from the creative distance between the sector of influence from which analogies were extracted and the reference sector.

Sectors of Influence

Sectors of influence are any sectors of analogy related to the reference sector (arts, nature, industrial design, etc) in which the designers are used to pick relevant information, and which integrate high-middle or low-level information (semantic adjectives, consumer values, shape, colour or texture), being potentially transferred as new references in the reference sector. Sectors of influence play a major role of filtering the information which is useful for the designers.

We launched a first experiment in 1997 with car designers (Bouchard, 1997). This experiment aimed to make explicit the designer's watch process and their sectors of influence by studying the specialized literature/exhibitions and motor shows they are used to consider. It was also studied which elements they select in these types of sources (table 1). A more recent study achieved in 2006 enabled to verify that these sectors are long term indicators (Mougenot, 2006). Both studies were based on interviews and observations during sketching activities.

Table 1 Sectors of influence classified by frequency of quotation by designers

Year	1997	2006
Designers	40 (10 professional, 30 students)	30 professional
Nationality	French, English, German	Italian, German, British, French
Sectors	1 Car design & automotive	1Car design & automotive
	2 Aircrafts, aeronautics	2 Architecture
	3 Architecture	3 Interior design & furniture
	4 Interior design & furniture	4 Fashion
	5 Hi-Fi	5 Boat
	6 Product design	6 Aircraft
	7 Fashion	7 Sport goods
	8 Animals	8 Product design
	9 Plants	9 Cinema & commercials
	10 Science Fiction	10 Nature &urban ambiances
	11 Virtual reality	11 Transportation (moto, trucks)
	12 Fine arts	12 Music
	13 Cinema	13 Fine arts
	14 Music	14 Luxury brands
	15 Travels	15 Animals
	16 Food	16 Packaging & advertising

Trend Boards

To finalize the information phase, designers build trend boards in favourable contexts in order to structure their inspiration sources. Trend boards offer a visual and sensorial channel of inspiration and communication for design research and development, which could be considered to be more logical and empathic within a design context than only verb-centric approaches (McDonagh, 2005). They are usually a collection of images compiled with the intention of communicating or provoking a trend or ambience during the product design process. The matter used for the elaboration of trend boards is extracted from the sectors of influence.

Conjoint Trends Analysis method

CTA method was built after studying the cognitive designer's activity (Figure 1). This method enables the identification of design trends through the investigation of specific sectors of influence and the formalization of trend boards and pallets. These pallets put together specific attributes linked to particular datasets (e.g., common properties of images in a database) so that they can be used to inspire the early design of new products. Trend boards offer a good representation of the references used

by the designers before idea generation. They also constitute a powerful representation tool valuable to designers to identify, investigate and represent the link between semantic universes and styling elements, so as to understand their structure (Eckert, 2000) (McDonagh, 2005). CTA results in the production of trend boards that can represent sociological, chromatic, textural, formal, ergonomic and technological trends.

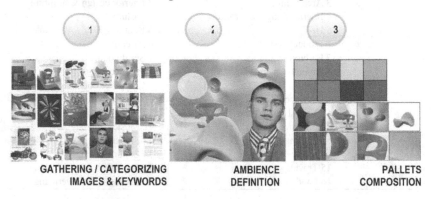

GATHERING / CATEGORIZING AMBIENCE PALLETS
IMAGES & KEYWORDS DEFINITION COMPOSITION

Fig. 1. 'Conjoint Trends Analysis' method.

The Trend boards convey identified homogeneity in terms of style and consumers' sociological values. Indeed kansei words including values words, high-level and low-level descriptors are used coherently with the pictorial information. They result from the frequent occurrence of certain properties within a dataset. From this analysis, images and relevant associated keywords are selected and formalized in the form of ambiences. Global and discrete design elements are then extracted from these ambiences under the form of pallets. These design elements are used for the generation of new design solutions.

Each new selected image is classified, categorized into various groups according to particular harmonies (colour harmony, but also texture and shape). In figure 1 we can recognize a common colour harmony in the different images, mainly characterized by the presence of very saturated purples, pinks, oranges. Shapes similarities can also be recognized (rounded forms, like distorted plastics...). Specific keywords come into our mind when watching these images: pop, inspired by seventies, plastics ... There are sometimes subcategories, in this case there is more chic and luxurious version of pop characterized with more shiny textures. A specific name and keywords are then given to each category by annotating sticky notes. Sometimes they come directly from a magazine. The passage from words to images and vice-versa is iterative and very dynamic. The

proposed names combine usually semantic adjectives, one or several object attributes, and sociological values. Only the strongest categories and elements (images and keywords) are kept. Strong means: a strong emotional impact, a high aesthetic level, a high coherence level of the elements together, a minimal number of represented sectors in the category and finally an obvious character.

Translation of design rules into design algorithms

The exploitation of the information process described in the CTA, and the results of both studies of the cognitive activity of the car designers led in 1997 and in 2006 enabled to extract essential data for the development of TRENDS system. The following elements were specified:

- *Designers sectors of influence (table 1),*
- *Domain specific knowledge (semantic adjectives, Kansei information)*

The way the designers search for information was investigated formalised and transferred into procedures. The latter gave birth to specific trends functionalities like the TRENDS search capabilities going from open, i.e. serendipitous, to focused search. The design cognitive structures and the domain specific knowledge were integrated into *Pertimmizers*. The categorization processes are investigated with specific clustering algorithms using similarities and also harmony rules.

Domain Specific Knowledge From CTA Case Studies

In order to link the images contained in the database with the relevant keywords by taking into account the expertise of the designers, it was first necessary to define the links between high-level and low-level vocabulary in a manner which reflects the cognitive structure used by the designers themselves. This part consisted in the extraction of the design knowledge from previous design processes based on the CTA method and also from specific tests of images annotation by the designers (figure 2).

The results of three previous CTA case studies in car and shoes design were used to build the design ontology. Design information search is based on a conjoint search of images and words. From the earliest stages designers use keywords which encompass mainly semantic adjectives. They cover a space going from high-level information (sociological values, abstract semantics), to middle level (style) and low-level features

(colour, shape, texture), through also object and metaphor names. The sociological values are sufficiently abstract information for highly stimulating creativity in the generation of new design solutions. They are of great interest for the designers in anchoring the consumer needs. Some specific supports like advertising pages are extremely rich because they are able to show all these levels on the same support at the same time (values and related attributes). In the perspective of digitizing the method, it seems interesting to use the advantages of the World Wide Web in order to gather relevant information about the evolution of sociological values on specialized websites. The identification of strong sociological values can further help in linking the three previous levels (low-level features, semantic adjectives and values words) according to the values-functions-solutions chain (Bouchard, 2007).

Fig. 2. Hand-made Kansei words extraction (Mougenot, 2006)

Structuring Knowledge Establishing Rules Through the Values Function Solutions Chain

In the framework of the Conjoint Trends Analysis method, it is proposed to structure the heterogeneous corpus of keywords used by the designers according to the cognitive chain, values-functions-solutions chain (Figure 3) established in the field of advertising (Valette-Florence, 1994). Indeed this cognitive chain is a quite realistic tool to formalize the link the designers intuitively do when they mentally link product attributes semantic adjectives and end values.

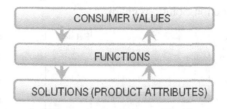

Fig. 3. Principle of Values-Functions-Solutions chain.

The method of cognitive chaining of means-ends scrutinizes the value-attribute relationship of the product through a train of hierarchical cognitive sequences graded into ascending abstraction levels. It lies on the hypothesis that high-level of abstraction attributes (semantic terms as "fresh", "light"...) and low-level attributes (colour, price, ...) are interdependent and bring about functional and psycho-sociological consequences for the consumers helping the latter to attain their end values. The semantic space can be determined by considering the frequency of appearance of individual items in the various types of chains, then by carrying out a multiple factor analysis dealing with the compatibility between individual items and types of chaining. A chaining is all the more coherent that the total number of links of which it is made up is limited. This method is fundamental for the translation of abstract values into tangible product attributes or vice-versa.

Trend panels including user's values, products and their attributes constitute a good representation of the values-functions-solutions chain. In order to do that the work team has to precise the retained semiotic products as well as the behavioural values to which they refer.

The value-function-attributes chain is an explicit formalization allowing to link marketing and design universes. This support integrates specifically the early marketing initial brief, with the brand values, and more generally the dominating sociological values.

Table 2 shows a representation where the value-function-solution chain appears at the top of the table, and the values are listed in the first column. The terminal values come from the Rokeach's list (Rokeach, 1973) which provides a finite number of values like comfort, pleasure, etc. Each of these values is defined into words following the values-functions-solutions chain. It uses semantic adjectives which are used by the designers when working with images and sketching new concepts of design. The highest level is that of values, the lowest level is that of products attributes.

Table 2 Values-Function-Solutions chain

Terminal Values of Rokeach	Behavioural Values of Rokeach	Other values	Trends	Semantic adjectives	Related semantic adjectives	Metaphors	Functional attributes	Visio-tactil attributes
A Comfortable Life								
				pleasant				
				delicate				
				softness				
				roomy				
							adaptation to the morphology of the driver	
				ergonomic				
							maintainability	
							assistance: the vehicle goes automatically to the garage	
							habitability	
							accessibility: comfort of	
							facility of driving, vocal control	

Building Trends Ontology in *Protege*

The introduction of ontological referencing in design science is quite recent. Some research was undertaken in this field, touching as well the earliest phases of design (Chi & al, 2007) (Ogawa & al, 2007) as the detailed design phase (Li & al, 2007). Expert design information is characterized by heterogeneous data insofar as they are more or less formal or informal, structured or unstructured, and abstract or concrete.

The interest of a formalization of knowledge in form of ontology is precisely that it constitutes a meta-model of expert knowledge in design as a whole (Yang & al, 2005). It is useful in early design for the formalization of Kansei data to establish a classification and a conceptualization of the knowledge of the designers on the basis of semantic links. Particularly ontologies allow the designers to insert and quantify semantic and emotional descriptors for evaluating design candidates directly by annotation. The advantage of this type of tool was shown to explain, formalize and share expert and subjective knowledge by taking into account inter-individual variability. Applications touch principally the indexation and research of unstructured information in large databases of pictures, digital libraries and multimedia archives (Reidsma & al, 2007). Most of the time approaches based on manual annotation proved to be more efficient for the time being than automatic approaches.

Protégé is an open-source platform that provides a suite of tools to construct domain models and knowledge-based applications with

ontologies. *Protégé* implements a rich set of knowledge-modeling structures and actions that support the creation, visualization, and manipulation of ontologies in various representation formats. Protégé can be customized to provide domain-friendly support for creating knowledge models and entering data. Furthermore, *Protégé* can be extended by way of a plug-in architecture and a Java-based Application Programming Interface (API) for building knowledge-based tools and applications[1]. Currently there are two ways provided by Protégé to model ontologies: by using *Protégé*-Frames editor, or by using Protégé-OWL editor. The former is frame-based, in accordance with open knowledge base connection protocol (OKBC)[2]; the later is based on the stand recommended by W3C's Web Ontology Language (OWL)[3]. The later is adopted in this paper because it is more suitable for building ontologies which will be later used on the Web and with Web Services.

The CTA ontology is developed by creating instances and linking them in terms of the abstraction, aggregation, and dependency-based semantically-rich relations using *Protégé*. As shown in figure 4, the top class "thing", as defined in OWL contains 5 subclasses. In the figure, the asterisk sign "*" indicates that there may be zero or many instances for the corresponding attribute value. "Value" class defines the three types of values in CTA, which are "behavioural", "terminal", and "other". These three types are defined as three mutually exclusive instances of class "Type". An instance of class "Value" is shown as "comfortableLifeValue" in figure 4. The class "Attribute" has two subclasses, "VisualTactileAttribute" and "Functional-Attribute", "colouredVis" is an instance of "VisualTactileAttribute" and "durabilityFunc" is an instance of "VisualTactileAttribute". The class "SemanticAdjective" is defined as a class, whose instances are attributes in class "Value". "Ergonomic" is an instance of the class "SemanticAdjective", which has several associated instances of "SemanticAdjective", such as "soft", "lightness", "easy" etc. In particular, there is an attribute "hasWordId", which will be later linked to a concept ontology "OntoRo" (Setchi, 2007) to enrich the CTA semantic adjectives. The instances of class "Metaphor" will also be used as attribute values of instances of "Value". Currently the CTA ontology contains 10 classes and 503 instances.

[1] Stanford Medical Informatics, The Protégé ontology editor and knowledge acquisition system, http://protege.stanford.edu/

[2] SRI International, OPBC working group, http://www.ai.sri.com/~okbc/

[3] W3C, OWL Web ontology language overview, February 2004, http://www.w3.org/TR/owl-features/

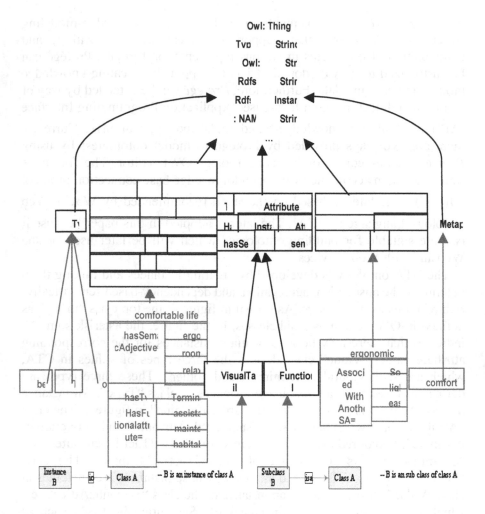

Fig. 4. Illustrative diagram to show the relations in the CTA ontology.

Integration into a Content Based Information Retrieval system

Trends Requirements

The main requirements towards the TRENDS system defined on the base of the designers' needs are the following:

- *TRENDS system shall correlate high-level dimensions like concepts, semantics and affective reactions with low-level image features.*
- *TRENDS system shall use semantic adjectives for retrieving images.*

- *The keywords used shall be structured according to a purpose built domain ontology dedicated to design expertise.*
- *The domain ontology shall be linked to the established sectors of influence following the Conjoint Trends Analysis (CTA) methodology.*
- *The mental categorization shall be supported by a clustering algorithm using harmony rules.*

Definition of a web-based design expert database from designer's sectors of influence

The preliminary analysis of the designer's natural cognitive processes enabled to define a list of designer's sectors of influence. From these sectors, specific websites were identified by the designers. Then the database was elaborated. This part falls within the competence of the data mining specialists. It consists of gathering the content of the database from the internet using a crawler. This software explores the list of websites that have been previously pre-selected by the designers. Then it makes a local copy of the sites: html pages and images are copied on the computer's hard drive. The first complete list of sites was harvested. The related overall and detailed procedure for identifying and extracting the design and sociological trends through the web was formalized and delivered. The database includes websites, images and words related to the sectors of influence. In the coming developments of the system, the major issues will be related to the huge quantity of data available in TRENDS, and the automatic exploitation of the database. The current version of this database gathers approximately 500.000 good-quality images that illustrate products in many sectors: automotive, architecture, aeronautics, fashion, sailing, sport, among others.

Translation of Needs Ranking into GUI Specifications

To develop the functional requirements for the GUI and the technology behind, field observations and analysis were performed at to study end-users needs. Another major output from the needs analysis was the list of ranked expected functions expressed by the professional designers (Figure 6) coming both from the current situation and their expectations for an ideal computational tool, for trends analysis, idea generations and design activities. Designers put emphasis on visualization, quality and freshness of information, mainly under the form of images in various sectors. The most important function they expect is storing. In fact they are limited by

Fig. 5. TRENDS database V2, sector of Urban Architecture (Nov. 2006, 14 Websites, 2,2 Go, 65 000 files, 500000 images)

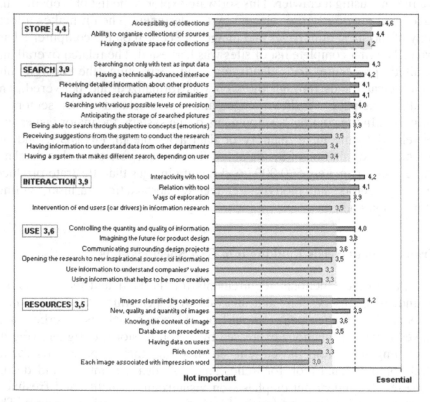

Fig. 6. List of functionalities wheighted by designers (10 subjects)

their own memory in their usual activity. The storing function could help them to find and retrieve adequate information. In addition, designers would like to store information everywhere and at every time. This function could be fulfilled by mobile devices. But then they want to visualize high quality images with high resolution, which is more appropriate on big screens.

Trends Interface

Creativity sessions enabled TRENDS end-users and project members to integrate their needs and opinions into the definition of the TRENDS-tool interface. Through these work sessions, the graphical interface and the functional sequences behind the latter were progressively defined. This result comes from a specific methodological approach including both a highly user centred approach and creative collaborative thinking.

Thus a list of around hundred functions coming from the needs analysis and from the Conjoint Trends Analysis was transferred into design solutions. This was done during a one-day creative session which involved all the work team. The proposed ideas were refined before the development of the initial version of the non-interactive GUI.

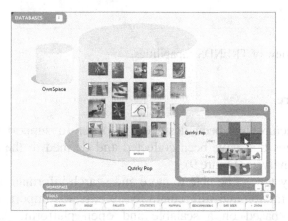

Fig. 7. TRENDS interface: Pallets generation from an images database.

The first of TRENDS GUI was used as support for the expression of the design and ergonomics specifications. After the first testing session by the end-users, the main improvements were the addition of personalisation capabilities, and the visual integration of the technologies of text and image retrieval on the GUI. Also the lightening of menus visualisation, the differentiation of spheres types by colour, and the integration and the

illustration of multiple functionalities in the search module. Finally, taking these improvements into account, the TRENDS system will be composed of the following main functions: SEARCH, STATISTICS, PALLETS. The workspace is an additional function enabling the transfer of images into writing mode.

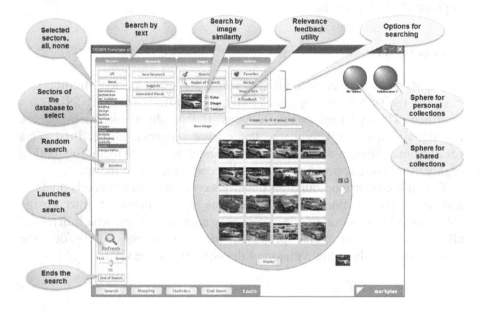

Fig. 8. Overview of TRENDS capabilities.

Architecture

The architecture has been designed in order to support the numerous functionalities that have been collected and defined in the user need and functional analysis (Figure 9).

For the system to be able to store and search information, with a good level of interaction and still remain feasible, it was important to design an architecture based on a scalable and open platform. As components develop, the system will require a high level of resources (memory, data storage, processing); we oriented the system architecture towards the collaboration between multiple specific servers supporting the various specific functions of the system: image and text retrieval, data storage, mappings, communications and exchange, etc. For the system integration to remain simple and cost efficient, we based our system architecture

design on standard communication protocols and request formatting languages.

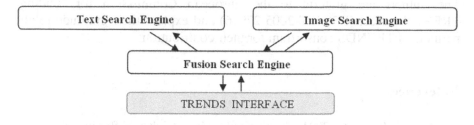

Fig. 9. TRENDS overall architecture of the system.

Conclusion

TRENDS system is a user interface enabling image retrieval through Kansei words. This paper outlines an approach for building the TRENDS GUI and the related outputs. Main outputs so far were the sectors of influence used by the designers for searching trends, and the semantically structured tables of words reflecting the expertise and knowledge of the designers. The later constitute the main input data for the elaboration of design domain ontology. Through the integration of the main functions of the CTA method, of the designers needs analysis, and of the expectations for an ideal computational tool, functional specifications were defined and translated into GUI design specifications. The next steps will be the whole integration of technology behind this GUI. In this way, specific tools like hierarchical clustering, ontological referencing and multidimensional scaling are being used.

The current prototype is the first interactive software which aims at demonstrating the feasibility of the technical architecture and assessing the first version of the interface and its functionalities: random search, search by image sample, search by relevance feedback, and search by text. It is currently improved with the integration of mixed text/image search. It is made of the GUI and two servers: the text search engine and the image search engine. The basis of the communications protocols and formats for the exchanges between the modules are defined to match the requirements of the functionalities implemented. Semantic developments such as ontology tags, *pertimmizers*, co-occurences are present in the text search engine but not visible from the user interface. In this prototype, the database index is built by steps integrating text indexation, images validation and ontology tags.

Acknowledgements

The authors are grateful to the European Commission for funding TRENDS project (FP6 IST 2005-27916) and express their gratitude to all partners of TRENDS consortium for their contribution.

References

1. Ansburg P, Hill K (2003) Creative and analytic thinkers differ in their use of attentional resources. Personality and Individual Differences 34 (7): 1141-1152
2. Blanchette I, Dunbar K (2000) How analogies are generated: the roles of structural and superficial similarity. Memory and Cognition 28 (1): 108-124
3. Bonnardel N, Marmèche E (2005) Towards supporting evocation processes in creative design: a cognitive approach. International Journal Human-Computer Studies 63: 422-435
4. Bouchard C (1997) Modélisation du processus de style automobile. Méthode de veille stylistique adaptée au design du composant d'aspect. PhD Thesis, ENSAM Arts & Metiers ParisTech
5. Bouchard C, Christofol H, Roussel B, Aoussat A (1999) Identification and integration of product design trends into industrial design. ICED'99, 12th International Conference on Engineering Design, Munich, August 24-26, 2: 1147-1151
6. Bouchard C, Lim D, Aoussat A (2003) Development of a Kansei engineering system for industrial design: identification of input data for Kansei engineering systems. Journal of the Asian Design International Conference 1
7. Bouchard C, Mantelet F, Ziakovic D, Setchi R, Tang Q, Aoussat A (2007) Building a design ontology based on the conjoint trends analysis. I*PROM'07, 3rd Virtual International Conference on Innovative Production Machines and Systems, Cardiff
8. Chi YL, Peng SY, Yang CC (2007) Creating Kansei engineering-based ontology for annotating and archiving photos database. HCI International 2007, 12th International Conference on Human Computer Interaction, Beijing
9. McDonagh D, Denton H (2005) Exploring the degree to which individual students share a common perception of specific trend boards: observations relating to teaching, learning and team-based design. Design Studies 26: 35-53
10. Eckert CM, Stacey MK (2000) Sources of inspiration: a language of design. Design Studies 21(5): 523-538.
11. Fauconnier G, Turner M (1998) Conceptual integration networks. Cognitive Science 22 (2): 133-187.
12. Gero JS (2002) Towards a theory of designing as situated acts. The Science of Design International Conference, Lyon

13. Hocevar D (1980) Intelligence, divergent thinking and creativity. Intelligence 4: 25-40.
14. Kryssanov VV, Tamaki H, Kitamura S (2001) Understanding design fundamentals: how synthesis and analysis drive creativity, resulting in emergence. Artificial Intelligence in Engineering,15(4): 329-342.
15. Li Z, Raskin V, Ramani K (2007) A methodology of engineering ontology development for information retrieval. ICED'07, 16th International Conference on Engineering Design, Paris
16. Mougenot C, Bouchard C, Aoussat A (2006) Fostering innovation in early design stage: a study of inspirational process in car-design companies. Wonderground – Design Research Society International Conference, Lisbon
17. Ogawa T, Nagai Y, Ikeda M (2007) An ontological engineering approach to externalize designers' communication style in support of artistic idea sharing IASDR 2007, Hon-Kong, Design Research Society
18. Pereira FC, Cardoso A (2002) Conceptual blending and the quest for the holy creative process. 2nd Workshop on Creative Systems: Approaches to Creativity in AI and Cognitive Science, ECAI 2002, Lyon
19. Reidsma D, Kuper J, Declerck T, Saggion H, Cunningham H (2003) Cross document ontology-based information extraction for multimedia retrieval. ICCS03, Desden
20. Restrepo J, Christiaans H, Green WS (2004) Give me an example: supporting the creative designer. Computers in Art and Design.
21. Rokeach M (1973) The nature of human values. The Free Press
22. Setchi R, Tang Q (2006) Concept indexing using ontology and supervised machine learning. Trans. on Engineering, Computing and Technology 19: 221 - 226
23. Simon HA (1981) The sciences of the artificial, 2nd edition. MIT Press, Cambridge, MA
24. Valette Florence P (1994) Introduction à l'analyse des chaînages cognitifs. Recherche et application en marketing 9 (1) : 93-118
25. Visser W (1996) Two functions of analogical reasoning in design: a cognitive-psychology approach. Design Studies 17: 417-434
26. Yang MC, Wood WH, Cutkosky MR (2005) Design information retrieval: a thesauri-based approach for reuse of informal design information. Engineering with Computers 21(2): 177-192

SPATIAL CONFIGURATION

Urban Identity Through Quantifiable Spatial Attributes
Anna Laskari, Sean Hanna and Christian Derix

Discursive and Non-Discursive Design Processes
Kinda Al-Sayed, Ruth Conroy Dalton and Christoph Hölscher

Using Shape Grammars for Master Planning
Jan Halatsch, Antje Kunze, Gerhard Schmitt

Urban Identity Through Quantifiable Spatial Attributes:

Coherence and dispersion of local identity through the automated comparative analysis of building block plans

Anna Laskari, Sean Hanna and Christian Derix
University College London and University of East London, UK

This analysis investigates whether and to what degree quantifiable spatial attributes, as expressed in plan representations, can capture elements related to the experience of spatial identity. By combining different methods of shape and spatial analysis it attempts to quantify spatial attributes, predominantly derived from plans, in order to illustrate patterns of interrelations between spaces through an objective automated process. The study focuses on the scale of the urban block as the basic modular unit for the formation of urban configurations and the issue of spatial identity is perceived through consistency and differentiation within and amongst urban neighbourhoods.

Hypothesis and aims

Analytical decomposition: the city through the urban block

Focusing on the scale of the urban block as the module of urban agglomerations, the analysis attempts to reveal the degree and nature of relation between quantifiable scalar, geometrical and topological spatial attributes, as they are expressed through plans, with the identity of the corresponding spaces, experienced from the point of view of the dweller and the passerby.

The building blocks that compose five distinct urban neighbourhoods, four in Athens and one in London, are analysed using a set of methods for

the measurement of plan features, which are then used for the classification of the neighbourhoods according to their experienced character.

The urban block is viewed as a configuration of built and open spaces whose geometrical shape and topological interrelations determine to a great extent the visual perception of urban environments, influencing spatial experience and defining local particularities related to spatial identity.

The notion of urban identity is examined by analysing patterns of relations amongst quantifiable spatial attributes as expressed in plan representations of the selected building blocks.

The main objective of the analysis is to investigate if and to what extent quantifiable attributes of spatial representations can provide information about spatial qualities that are *non-discursive* [1] but essential to the experience of spatial identity, in the sense that they are not easily described verbally or handled consciously, but intuitively and experientially perceived and manipulated during our daily existence in physical space.

The selection of neighbourhoods that are experientially recognisable as having particular, unlabelled qualities enables the examination of the hypothesis of correlation between our sense of spatial perception and the specific set of measurement methods.

Analytical recomposition: urban identity as a system of relations

"A city is a network of paths, which are topologically deformable" [2]. The city is viewed as a system whose identity constantly emerges from the rearrangement of interrelations between its elements. Focusing on the urban neighbourhood as a set of building blocks, this view on urban identity is tested through the automated identification of the structure of relations between discrete blocks of labelled neighbourhoods.

Attractions within urban locations, related to the consistency of the neighbourhood, are associated to spatial relations based on physical contiguity and continuity. Attractions amongst areas are related to *transpatial* relations [3] that act beyond spatial discontinuities.

The attempt to classify blocks according to a partial description of their attributes tests the possibility of discerning between sets of blocks that can, or cannot, coexist in the framework of a given neighbourhood. This would enable the illustration of an abstract synchronous view of the structure of relations from which urban identity emerges.

It is not the measured attributes per se that reveal elements of spatial identity, but the belief that they are governed by and reflect patterns in a structure of relations from which identity emerges, renders these attributes

partial indices of degrees of differentiation and identification between spatial units.

However, the efficiency of these indices is limited and their interpretation ambiguous, since major issues concerning the formation and perception of spatial identity are not spatial or describable in spatial terms.

In this framework, the analysis is based on a series of reductions and concessions regarding the relation between urban identity and quantifiable attributes of spatial representations. Despite these limitations, it is believed that such attributes do account for the way in which the city is perceived and its identity experienced, reproduced and propagated through space and time.

Context and significance

The relation between quantifiable spatial attributes, inherent in plan representations, with the experience of space and spatial identity, has been in the centre of focus of a wide range of theoretical and practical investigations. Although the plan excludes aspects of our experience of space, a variety of multi-modal analyses exist that can be inferred from it.

These can be generally distinguished into spatial investigations concerning the potential connection between patterns of human behaviour and patterns of spatial constants within plan configurations and researches regarding the categorisation of spaces based on comparisons between quantified features of the corresponding plans.

In the first direction, *space syntax* has developed several methods for the analysis and quantification of configurational attributes in relation to spatial experience. Other closely related studies investigate the way in which the structure of space and movement affect our exposure to the elements of shape [4], [5], [6], [7].

In the second direction, methods that aim at the quantification of qualitative, semantic features of shapes enable the classification of building plans within a relative system of comparisons [8], [9]. Qualitative shape representations have been used for the categorisation of plans, based on degrees of similarities between their codified features and defined shape categories [10]. Methods of classification of building plans according to the quantification of spatial features deriving from axial and boundary maps have been implemented by Hanna both in an analytic and in a generative framework [11], [12].

This analysis doesn't propose a new method for feature measurement but implements a combination of various, established and experimental

methods, developed in the context of different strategies of spatial investigation, in order to determine which are necessary or best suited to classify urban areas with different experienced character.

Variability of methods aims at multileveled spatial descriptions while the possible overlapping of measurements contributes to the validation of the different approaches. The automation of measurement and evaluation processes enables the unmediated representation of a system of relations based on the equivalent consideration of different methods.

At this stage, the main aim is to investigate the suitability of the specific set of methods for distinguishing between urban areas. The study case is being used as a test sample of known, labelled neighbourhoods, in order to enable the evaluation of the degree of conversion between the classification resulting from the methods under examination and the pre-existing knowledge about the given areas. This could contribute to the understanding of spatial perception by designating categories of spatial features that seem to be relevant to our experience of space. The combination of these measurements with information about the cultural history of places could contribute to the understanding of the relationship between the physical output of cultures and possibly to the development of methods for designing within particular cultural contexts.

Methodology

The study case

The city of Athens, Greece, was selected as the main study case and four central neighbourhoods were analysed. The dataset was complemented by a neighbourhood in London, in order to examine the scope of the analysis (Figure 1).

Mouseio, labelled as area A, is a very central and busy area, adjacent to Omonoia square, highly mixed in terms of national and social composition and characterised by predominantly modern constructions.

Kolonaki, registered as area B, is a neighbourhood on the banks of mount Lycabetus, also characterised by modern constructions. It is considered to be the traditional bourgeois area of central Athens.

Plaka, or area C, is part of the historical core of Athens, at the feet of the Acropolis. It is a protected area of cultural heritage, characterised by many archaeological sites and low rising buildings, prevailingly constructed before the beginnings of the twentieth century.

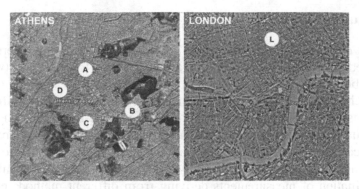

Fig. 1. The study case: five urban areas

The selected areas were Mouseio, Kolonaki, Plaka and Metaksourgeio in Athens and Bloomsbury-Fitzrovia in London (Figure 2).

Fig. 2. Characteristic snapshots of the selected areas. From left: Mouseio-Area A, Kolonaki-Area B, Plaka-Area C, Metaksourgeio-Area D, Bloomsbury-Area L

Metaksourgeio, labelled as area D, is an early-industrial area, situated along Peiraios avenue, the main connection between Athens and the port of Piraeus. It was developed in the nineteenth century in direct relation to the silk factory that was functioning in the area. The neighbourhood has been scarcely reconstructed.

Finally Bloomsbury, or area L, is a central neighbourhood of London, characterised by mixed land uses and variable construction phases.

The dataset consists of twenty-five building blocks from each area (Figure 3).

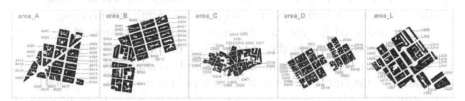

Fig. 3. The dataset: numbered building blocks

Measurement methods

A set of methods, used in distinct fields of spatial studies, were implemented in order to examine which are best suited to classify between the neighbourhoods.

Each of the methods produces measurements that capture different attributes of spatial configurations. According to the focus of each process, the quantities measured for the analysis of the blocks could be distinguished into scalar, geometrical and topological. This distinction shows that each method can only partially describe the plans. The comparative combination of measurements deriving from different methods enables a more complete, multiple consideration of the dataset and at the same time allows the examination of the suitability of the selected methods.

Scalar measures: Established measurements of Urbanism

Quantities involved in established urban analysis, such as footprints, floor area factors and number of buildings or voids per block, can be considered as scalar, since they don't describe geometrical or topological characteristics of the plans, but relations between quantities.

Geometrical measures: Fractal dimension through box-counting

Fractal dimension is a measure of dimensionality of fractal structures but in the case of architectural structures it refers to self-similarity and therefore to metric proportions of the parts in relation to the whole, reflecting geometrical attributes of space. The measurement of fractal dimension has been widely implemented by Bovill [13] in the context of various architectural analyses.

In this study, fractal dimension was used as an index of complexity and self similarity of the contours of open and built spaces. It was considered relevant to the perception of the blocks, since the amount and scale of meandering of the spaces constituting them affect the visual permeability of open spaces and the way they are perceived from the street or through the windows of adjacent buildings in terms of visual depth and layering.

The method used for the calculation of fractal dimension of the plans measures the box-counting dimension. This method, allowing the measurement of composite objects rather than single fractal curves, enabled the calculation of the fractal dimension of each plan as a whole.

Practically, the box-counting method is based on a repetitive process of laying a grid of constantly decreasing scale over the image under measurement (Figure 4). At each grid scale, the number of cells that contain

parts of the structure is counted and the fractal dimension is given by the comparison between scales.

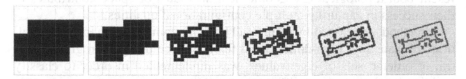

Fig. 4. Graphic calculation of box-counting dimension of a sample plan

Despite the drawbacks of this method, deriving from its sensitivity to issues of scale and its dependence upon the relation between the image under measurement and the grid, the appropriate graphic preparation of the plans can lead to rather consistent results.

Syntactic-topological measures: Spatial connectivity

Methods related to spatial connectivity [1], such as spectral analysis of axial graphs and convexity measurements of shape perimeters, focus on syntactic properties of the plans. Their results are affected both by the geometry and topology of the configurations under measurement, but what is measured is essentially the relation between locations of the plans, both at a local and at a global level. In this sense, these methods can be considered as prevailingly topological.

a. Classification by principal components analysis using axial graph spectra

Spatial representation and analysis through axial maps is used by space syntax in order to illustrate and quantify connectivity relations in continuous spaces, it terms of unobstructed sight lines (Figure 5).

B010　　　　　　　　　A003

Fig. 5. Axial maps of two sample plans

Properties of axial maps have been shown to relate to spatial perception and therefore to the experience of spatial identity [1]. Their ability to represent both topological and geometrical attributes of space contributes to their success in capturing multiple configurational qualities.

A method, developed by Hanna [11], for mapping axial map representations of plans into high-dimensional feature space using axial graph spectra, or ordered sets of eigenvalues, was implemented in order to classify building block plans from different areas (Figure 6).

As the comparison between high-dimensional data can be complicated, principal component analysis (PCA) was implemented in order to reduce dimensionality and highlight differentiations within the dataset. Principal component analysis is "an unsupervised approach to finding the "right" features from the data. (...) It projects d-dimensional data onto a lower dimensional subspace" [14]. The dimensions of this new feature space, or *Principal Components*, are strictly computational and do not represent specific dimensions of the original high-dimensional space.

The method of classification of axial graph spectra through PCA has been previously used for the description of different architectural styles through the definition of feature space archetypes as well as for the classification of plans of different building types [12].

It has been shown to be a method that enables the automated representation of plans within a uniform feature space in a way that depicts degrees of differentiation without requiring explicit description of the attributes compared [12].

Fig. 6. Plots of the sample's axial graph spectra in three-dimensional space. Blocks from Athens (left) and from both Athens and London (right)

b. Convexity through connectivity of shape perimeter

The experience of open spaces within the building blocks is directly re-
lated to the way they are gradually revealed to visual perception. A method
that measures shape convexity, introduced and developed by Psarra and
Grajewski [6] offers a combination of local and global, sequential and syn-
chronous approaches of visual experience, and is based on the description
of syntactic properties of shape perimeter, by quantifying their convexity
in terms of distribution of connectivity along the perimeter.

Fig. 7. Connectivity measurement

Approaching shape from its perimeter, this method was considered to be
suitable for the specific analysis, since the open spaces within the building
blocks are initially and often uniquely experienced through their perimeter,
either from the edges adjacent to streets or through the windows of the fa-
cades of the surrounding buildings.

In order to calculate connectivity, the perimeter of the shape is subdi-
vided into segments of equal length. From the subdivisions a complete
graph is derived, where all points are connected to each other (Figure 7,
top). The number of connections that lie completely within the perimeter is
calculated for each point and plotted on a graph (Figure 7, bottom left).
The average of these values gives the mean connectivity value (mcv) for
the shape whereas their standard deviation from mcv is defined as v-value.
The average distance between subsequent points of mean connectivity rep-

resents the mean horizontal value (mhv) and the standard deviation of all these distances gives the h-value for the shape.

These values correspond to global and local characteristics of shape, in terms of stability and change, rhythm and repetition [6], [7].

Scales of analysis

In order to arrive to conclusions about relations between plans, neighbour-hoods and possibly the two cities, but also about the suitability of the methods, the data was examined both at the level of individual building blocks and at the level of the local area, through the analysis of patterns occurring within each single measurement, by combinations of measurements in pairs and by the simultaneous consideration of the whole set of measurements.

Limitations of methodology

The main issue that this analysis attempts to approach is whether and to what degree quantifiable attributes of spatial representations, and specifically plans, can capture elements related to the experience of spatial identity. There are important limitations inherent in the question itself, as major issues concerning the formation and perception of spatial identity are not even spatial, let alone be captured in a plan. However, it has been proved that some aspects of spatial experience are indeed related to spatial layout, being influenced by it and reflected in it [1],[3],[4],[5],[6],[7]. The focus might thus be shifted to the validity of objective measurement of these aspects, since they are usually related to non-discursive spatial attributes.

A second level of limitations is imposed by the specificity and particularities of the selected dataset under analysis and by the nature of the measurement methods per se. Furthermore, the set of specific selected methods is not necessarily the most suitable for the description of the dataset. Nevertheless, the fact that it covers different categories of spatial attributes, and the observation of occasional information overlap between certain measurements, enforces its adequacy.

Results and possible interpretations

Single quantities

Individual plan scale

At the scale of individual blocks, looking at extreme values in each neighbourhood for each quantity, certain correspondences between measurements were revealed.

From the observation of the most intensively differentiated plans it was made clear that there is some conformity between the measurements deriving from the different methods. Their relative magnitudes are not related in a constant way, but extreme values repetitively converge towards the same plans (Figure 8).

Fig. 8. Comparison between mean connectivity and fractal dimension values in area A. Extreme values (numbered blocks) often coincide in variable relations

The PCA classification of the axial graph spectra was shown to distinguish as highly differentiated plans with high values in certain scalar quantities, related to the size and geometry of space rather than topological relations (Figure 9).

This might derive from the fact that larger plans, incorporating greater numbers of distinct elements, have the possibility of more diverse configurations than smaller ones [15], exhibiting thus a wider range of differentiation, or it might just mean that the spectra of the axial graphs are affected more by global metric transformation than local topological relations.

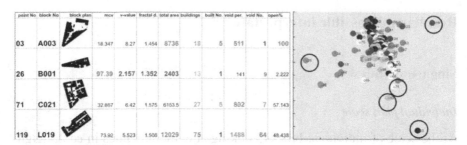

Fig. 9. Spectral analysis and scalar attributes. Outliers in the plot deriving from the PCA (circled, right) present repetitively extreme values in scalar attributes (left)

Neighbourhood scale

At the scale of the neighbourhood, comparisons were attempted according to the patterns of distribution of values for each quantity. In all cases the ranges of values corresponding to the various neighbourhoods overlapped. This showed that the distinct character of each area cannot be directly connected to single measurements. However, differences in the distribution and range of values do reflect some general characteristics. These were illustrated by sorting the values of each area from low to high and plotting them into graphs.

Although for single measurements differences were too fine to categorise the neighbourhoods, when considering different quantities the conversion towards persistent patterns of general ranking revealed some agreement of the ordered graphs with the experienced impression from the respective places.

For example, fractal dimension and mean connectivity exhibited very similar overall ranking in the case of Athens, ordering the different areas in terms of global complexity and fragmentation in a sequence that corresponds to the age and historical layering of each area (Figure 10).

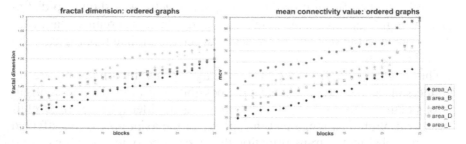

Fig. 10. Similar ranking deriving from fractal dimension and mean connectivity

Values concerning the characteristics of open spaces, such as the number, perimeter length and accessibility of open spaces in each block, reflect historical changes in the social role of open space, namely the shift from open space as a locus for social encounters, expressed through accessible, large courtyards in older areas, to open space as building infrastructure, reflected in the prevalence of fragmented, inaccessible light-wells in modern areas.

These and similar observations show that, although each single measurement is not sufficient for differentiating between the neighbourhoods or comparing blocks, the relative distribution of values seemed to have captured particularities of the areas that are usually not considered as directly related to spatial attributes, such as historical depth and certain social practices.

Pairs of quantities

Quantities corresponding to different categories of attributes (scalar, geometric, topological) were combined in pairs in order to illustrate complementary features inherent in the plans. Measures that in the previous level of analysis were shown to be related to each other were also paired up.

These pairs of quantities were plotted in scatter graphs, through which both the relation between the quantities themselves and general tendencies within different neighbourhoods were investigated. In most cases the overall impression was rather mixed, with groups of points corresponding to plans from different areas overlapping. However, when considering each area as a unity, differences in the slopes of the regression lines that best describe the points of each neighbourhood revealed differences in the overall behaviour of the distinct sets.

For example, by plotting mean connectivity against the other connectivity measurements, an interesting pattern emerged through positive correlation of values in all areas of Athens and negative for London, showing opposite trends for the two cities at a global scale (Figure 11).

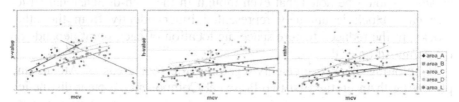

Fig. 11. Connectivity: Opposite tendencies between Athens and London

This fundamental difference might reflect the different processes that have prevailed in the formation of the two cities. Uncoordinated local actions in Athens led to differentiated, unequally distributed open spaces, whereas the equal distribution of open spaces in London is often the result of organised global processes of design and construction.

Such observations, deriving from the various measurements and their relational comparison, revealed that the combination of different quantities in pairs might again not be sufficient for the distinction between neighbourhoods or for the description of their particular character, but general trends that reflect specific relations between spatial attributes can be studied. These relations characterise each area as a heterogeneous but indiscernible whole and represent intrinsic tendencies associated with abstract expressions of spatial identity.

Set of quantities

This level of analysis, where each area is uniquely defined through the specific set of blocks constituting it, does not allow the classification of unlabelled examples. It reckons each area through a complete, finite set of given elements and attempts to reveal if and to what degree quantifiable attributes of specific blocks reflect the whole set of elements that constitute the neighbourhood.

In order to view this system of relations within a wider context, a more global structure was formed, within which the character of each element, as reflected in the values given by the measurements, and its location within the system would be uniquely related. In this system, unlabeled blocks would be identified according to their absolute location within the structure.

In this view, it was attempted to combine all measured attributes of the blocks in a high-dimensional structure, where each block would be represented as a uniquely defined point. The representation of such a structure was made possible through the implementation of principal component analysis. It should be noted that even though in the high-dimensional structure each block is uniquely represented independently from the other blocks, in the reduced feature space the location of each point depends on the composition of the set.

By plotting all measurements regarding the four areas of Athens and projecting them on the first two Principal Components, a clear distinction between areas was observed. Apart from some exceptions, there was a division between older and modern areas (Figure 12).

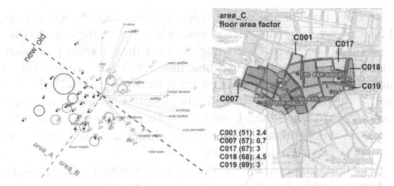

Fig. 12. PCA classification for the areas of Athens. Differentiation of old and modern neighbourhoods (left) and misclassified blocks in area C (right, numbered)

In the case of misclassified blocks from area C, it was noted that these are subject to building regulations standing for modern areas (Figure 12, right). This might signify that the PCA classified correctly blocks that were erroneously considered as belonging to a specific neighbourhood.

However, the introduction of the data regarding the area of London altered the interrelations within the system, resulting to a redistribution of the points representing the blocks (Figure 13).

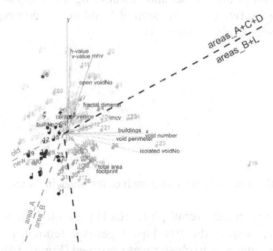

Fig. 13. PCA classification of the whole dataset

When plotting the system against the first three Principal Components, this redistribution led to the formation of two composite clusters with some overlap between them. The new distribution indicates that, on one hand, differences between areas A, C and D were weaker than the overall differ-

entiation from London and on the other hand similarities between area B and London were more intense than similarities within the city of Athens.

The formation of two clusters might reflect the different processes that generated the areas in each. Of course these processes are specific to the unique circumstances characterising each locus, but they could be very generally distinguished into prevailingly global or mainly local. The cluster consisting of areas B and L could thus be claimed to be characterised by global forces of formation whereas the cluster including the rest of the areas could be related to local actions.

It is true that neighbourhood B is the most thoroughly designed area of the Athenian sample, having been a privileged bourgeois location since the nineteenth century. This top-down process of formation might abstractly relate area B to London, where global decisions seem to have prevailed over local actions of spatial administration and control.

On the contrary, the other three areas were grown out of local actions and initiatives, through the conflict and equilibration of personal interests and small scale revendications. Even in the case of area A, which was massively rebuilt during the construction boom of the fifties and sixties, the forces of schematisation were largely localised, with the main driving force of construction being private investment [16],[17].

Because of the alteration of interrelations between the blocks according to the composition of the dataset and considering the unequal proportion of data concerning the two cities, the area of London was compared with each area of Athens separately (Figure 14).

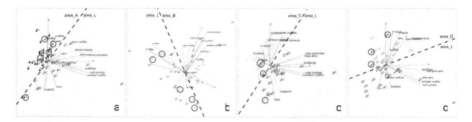

Fig. 14. PCA of the area in London and each of the areas in Athens

In accordance with the overall plot, area B presented the least differentiation. However, despite the overlap, a general tendency of the blocks belonging to the same area to cluster was observed (Figure 14b). The distinction between clusters was clearer in the plots of the rest of the Athenian neighbourhoods against the London sample and consistency was noticed in the misclassified blocks from London (Figure 14a, c, d).

Based on these observations, it could be claimed that, given wide enough amounts and variance of information on quantifiable spatial attrib-

utes, it is possible to distinguish between neighbourhoods based on their degrees of identification and differentiation. The relative distances between points representing blocks reflect the degree of variability, with similar blocks naturally falling closer together and highly differentiated cases being plotted far apart.

From the quantitative description of disconnected block plans, patterns of attraction and repulsion emerged that reflect both the unity and continuity of local identity, as it is formed through locally contiguous heterogeneous particularities, and the translocal relations between spatially discontinuous elements.

Discussion

Through the combination of different methods of shape and spatial analysis it was attempted to examine patterns of distribution and interrelation between various quantifiable attributes inherent in spatial representations, in order to illustrate complex relations of identification and differentiation between urban areas.

These methods were selected based on their different approaches to processes of spatial experience and were shown to complement each other in the description of spatial configurations and their interrelations, since they reflect related but distinct aspects of layouts, regarding scalar, geometrical and topological attributes. However, constant high correlation between specific quantities might reflect some redundancy in the measurements.

The examination of each quantity individually, led to the conclusion that even though a single measurement might be insufficient for the description of space and spatial interrelations, when applied to a labelled population, the range and distribution of values can reveal general relations between sets of building blocks. It also revealed relations and correspondences between the quantities themselves, indicating the convergence of results deriving from different methods.

These interrelations were examined in more detail through the scatter graphs of pairs of quantities. The overall degree of correlation between the quantities represented by the two axes indicated the general character of their association. The examination of patterns produced by the clustering or dispersal of points corresponding to block plans belonging to the same neighbourhood and of differences in the slopes of the regression lines best describing these points, revealed comparable general tendencies within each neighbourhood, illustrating degrees of differentiation or accordance.

The overall structure of these convergences and divergences between different areas, based on degrees of identification and differentiation between individual blocks along all measured quantities, was approached through the three-dimensional representation of the high-dimensional plotting of all measurements.

All three different scales of analysis have shown that the measurement of quantifiable spatial attributes might lead to the detection of degrees of differentiation between neighbourhoods that correspond to local particularities not directly related to the specific quantity. As inferred from the analysis of the results, such particularities regard the historical layering of construction periods coexisting in each area, elements connected to social practices such as the role of private open space as a locus for social interaction, the particular social, historical and political circumstances that formulated processes of construction, leading to the prevalence of global or local forces or the local and translocal propagation of spatial models related to social identity.

It could thus be claimed that configurational features manifest in plan representations, that by their own only partially reflect elements relevant to spatial identity, when used for the quantification and comparison between a population of plans, can be used as indices of relations that expand over the confined significance of the feature per se. It is not the measured attributes that reveal elements of spatial identity, but the way in which this identity has shaped and is reflected in the specific spatial configurations exhibiting the features under measurement.

However, the comparison between plans according to quantifiable spatial attributes can only express relative degrees of differentiation in an abstract, quantitative manner and further interpretation of these relations requires specific domain knowledge.

According to this observation, the analysis of a population of plans would result to an abstract illustration of the structure of attractive and repulsive forces between individual plans, in terms of degrees of identification and differentiation rather than to explicit information about the nature or causes of these relations.

At the first two levels of analysis, where quantities were examined individually or in pairs, the plans were labelled. In this case, general tendencies within the neighbourhoods were viewed as resultants of the internal forces within predefined sets of plans and relations between these resultants illustrated the relations amongst the corresponding neighbourhoods. At this level, local forces prevailed over translocal relations as each area was defined as a discrete unity and as such compared to other unities.

At the third level of analysis, where all quantities were considered simultaneously, the blocks were unlabelled and the structure of the field of forces emerged from the innate relations of every plan with every other. The fact that plans corresponding to the same areas naturally clustered together indicated that, as a general trend, local forces of identification indeed prevailed over transpatial attractions. However, the effect of transpatial relations was also manifest through the tendency of individual plans to cluster with blocks from different physical locations. The presence of transpatial relations was intensified with the introduction of the plans from London in the system that shifted the whole relational structure in an unpredictable way, changing the axes of projection and fortifying simultaneously the expression of local attractions within three areas of Athens and of transpatial attractions between the fourth area of Athens and London.

This reveals the relative nature of the system and the possibility of its application as an index of perceptual degrees of differentiation between a specific set of plans rather than an objective general measure.

Conclusion

The combination between different methods of shape and spatial analysis enabled the quantification of a range of spatial attributes regarding scalar, geometrical and topological features inherent in plans of urban blocks. The analysis of the resulting values at different levels of observation led to the gradual structuration of a system of forces reflecting spatial and transpatial relations according to degrees of identification and differentiation between neighbourhoods.

This system, representing the distribution of non-discursive spatial characteristics related to the perception of space, could be viewed as an abstract map of intensities through which spatial identity is experienced. Therefore, although spatial identity cannot be explicitly described through quantifiable spatial attributes as represented in plans, its continuity, indivisibility and heterogeneity can be abstractly perceived through the field of forces constantly rearranging the elements from which it emerges.

The investigation of the correspondence between closely related groups of plans and the relevant values and distributions in specific measures could possibly lead to the extraction of general rules that could inform design processes in the direction of reproducing elements of spatial identity independently from the repetition of specific morphological, configurational and technical characteristics.

References

1. Hillier B (1996) Space is the machine. Press Syndicate of the University of Cambridge, Cambridge
2. Salingaros N (1998) Theory of the urban web. Journal of Urban Design 3: 53-71
3. Hillier B, Hanson J (1984) The social logic of space. Cambridge University Press, Cambridge
4. Peponis J, Wineman J, Rashid M, Hong Kim,S, Bafna S (1997) On the description of shape and spatial configuration inside buildings: convex partitions and their local properties. Environment and Planning B: Planning and Design 24: 761-781
5. Peponis J (1997) Geometries of architectural description: shape and spatial configuration. First International Space Syntax Symposium, London
6. Psarra S, Grajewski T (2001) Describing shape and shape complexity using local properties. Third International Space Syntax Symposium, Atlanta
7. Psarra S (2003) Top-down and bottom-up characterisations of shape and space. Fourth International Space Syntax Symposium, London
8. Gero J, Park SH (1997) Computable feature-based qualitative modelling of shape and space. In Junge, R (ed), CAADFutures 1997, Kluwer, Dordrecht: 821-830
9. Gero J, Jupp J (2003) Feature-based qualitative representations of plans. In A Choutgrajank, E Charoenslip, K Keatruangkamala and W Nakapan (eds), CAADRIA03, Rangsit University, Bangkok: 117-128
10. Park SH, Gero J (2000) Categorisation of shapes using shape features. In Gero, J (ed), Artificial Intelligence in Design'00, Kluwer, Dordrecht: 203-223
11. Hanna S (2007b) Defining implicit objective functions for design problems. Generative and Evolutionary Computation Conference, GECCO-2007
12. Hanna S (2007c) Automated representation of style by feature space archetypes: distinguishing spatial styles from generative rules. International Journal of Architectural Computing 5
13. Bovill C (1996) Fractal geometry in architecture and design. Birkhauser, Boston
14. Duda R, Hart P, Stork D (2001) Pattern classification. Wiley-Interscience Publication, second edition, New York/ Chichester/ Weinheim: 568
15. Steadman P (1998) Sketch for an archetypal building. Environment and Planning B: Planning and Design, Anniversary Issue: 92-105
16. Philippidis D (1990) Για την Ελληνική Πόλη: Μεταπολεμική Πορεία και μελλοντικές Προοπτικές (About the Greek City, Post-War Course and Future Perspectives). Themelio, Athens
17. Karydis D (2006) Τα Επτά Βιβλία της Πολεοδομίας (The Seven Books of Urbanism). Papasotiriou, Athens

Discursive and Non-Discursive Design Processes

Kinda Al-Sayed and Ruth Conroy Dalton
University College London, UK

Christoph Hölscher
University of Freiburg, Germany

This paper investigates the hypothesis that the explicit knowledge of spatial configurations may aid intuitive design process. The study will scrutinize the performance of architects solving intuitively a well-defined problem. One group of architects will have experience with spatial configurations rules (Space Syntax) and the other will not have such experience. The design processes will be analysed in terms of cognitive activity, whereas the design outcomes will be evaluated qualitatively in terms of social organization and quantitatively in terms of spatial configurations. The analysis will show that the knowledge of Space Syntax may partially enhance the permeability of design solutions.

Aims

The aim of this paper is to explore the efficiency of employing Space Syntax knowledge into intuitive design processing and reasoning. It will attempt to provide evidence that the discursive form of design process, which the knowledge of Space Syntax may partially support can prove to be more efficient than the non-discursive one in creating permeable spaces

J.S. Gero and A.K. Goel (eds.), *Design Computing and Cognition '08,*
© Springer Science + Business Media B.V. 2008

(Hillier [7], p. 59 and p. 65-108)[1]. The non-discursive form of design process in this study may be attributed to the architects with no previous Space Syntax knowledge particularly in terms of knowledge of generic spatial configurations and methods of maximizing and minimizing depth in space. Space Syntax is an architectural theory which implements network theory in analysing spaces considering certain spatial elements as nodes in a network. The spatial configurations which result from the spatial elements connections in the network can be computed through a set of mathematical operations. These mathematical operations are normally calculated using computer technics and are hard to be predicted intuitively. However, this study suggests that the basic ideas of space syntax can support intuitive design processes by enhancing the permeability in the resulting design solutions. Whether this is a true or false statement will be investigated in this study. The capacity of Space Syntax evaluative tools aiding the computer-based design process might be observed in the computer processed design solutions as in Bentley [2], which will be investigated in further studies. The study is part of a main approach to investigate the capacity of Space Syntax as an effective evaluative tool for thinking architectural design.

Space Syntax as a quantitative architectural language has invested much in the study of spatial configurations of existing artificial environments rather than in generating future ones. Therefore it might be important to investigate the possibility of implementing such language in generating designs, but first it is important to inspect the influence of space syntax on architectural design. In general it will be interesting to observe the variety of routes that designers take when exposed to the same design situation. Therefore the study will compare between designers with different architectural backgrounds and investigate their design performances. The study will investigate the influence of certain knowledge such as Space Syntax on the design processes and products of architects with and without this knowledge. The study will record the commonalities between the

1 "an architectural theory is an attempt to render one or other of the non-discursive aspects of architecture discursive, by describing non-discursivity in concepts, words and numbers. We may say that an architectural theory seeks to create a 'non-discursive technique', that is, a technique for handling those matters of pattern and configuration of form and space that we find it hard to talk about. In research terms we could say that an architectural theory, at least in the 'narrow' aspects through which it describes and prescribes design decisions, is an attempt to control the architectural variable."(Hillier [7], p. 59)

design routes using cognitive methods and measure the productivity of their design outputs using Duffy's methods [3, 4, and 5] of qualitative spatial analysis and Space Syntax method for quantitative spatial analysis.

Significance

Many empirical studies have been made in the last three decades within the frame of Space Syntax theory following Hillier and Hanson's first publication [6]. Their research aimed to make explicit the social logic of space. Space Syntax theory is a spatial evaluation method which represents the synchronous view of space. The theory translates the topological and metric configurations of space to a morphic language[2] which may predict to some extent the social potentials of space. Much research have been made to demonstrate the correspondence between Space Syntax theory and human behaviour in space[3], but less frequently attempts have been made to investigate the initial connection between Space Syntax as an architectural theory and the practice of architectural design. Space Syntax theory; as Hillier [7] argues, can achieve a better understanding of the real built environment. This understanding may enhance the design process by establishing designs on a reasonable ground of scientific research and by making the logic of design thinking more explicit. Therefore it will be important to investigate the capacity of Space Syntax language as an effective evaluative tool for thinking architectural design and generating enhanced spatial configurations.

The syntactic measures may contribute to the feedback part of the design process, thus assisting design decisions with a spatial logic that can predict the subject's behaviour within artefacts. Therefore, it might be suggested that the knowledge of Space Syntax can enhance design processes depending on the models of partitioning and adjacency graphs.

2 Kanekar has interpreted the expression of morphic language in Hillier and Hanson [6] as the following; "Morphic language differ from both natural and mathematical language, in natural language there is a large lexicon which is combined through a simple syntax that is meaningful in a semantic referential sense while in mathematical language there is a smaller lexicon that undergoes complex permutations and combinations of syntax to create syntactic meaning. In contrast, morphic language is situated in between these two extremes". [8]

3 http://www.spacesyntax.net/symposia/index.htm

This might be relevant to the particular 'generic function' studies which Hillier explains as the first filter in design, [7], p. 258. The 'generic function' represents the simple logic of occupation and permeability in space. Its true state can turn the probable design solutions into possible ones and work together with the second cultural filter in specifying the possible generic structure of space. The third filter works successively on shaping the individual properties of the building. These filters play an important role during a design process by optimizing the field of possibilities in order to reach an adequate solution for the design problem.

The knowledge of generic function of space is embedded in every design process implicitly. Space Syntax has made this knowledge explicit through uncovering the spatial configurations of space. In this study we will investigate how the explicit knowledge of generic function can influence architects in their design practice and how this might be rendered in their design outcomes. It will implement cognitive and spatial analysis in detecting differences between the design performances of two groups of architects. The first group will have implicit or non-discursive knowledge of spatial configurations, and the other group will have an explicit or discursive knowledge of spatial configurations.

Method

The research is supported by design tasks solved intuitively by two groups of architects. The first group has academic or practical experience with Space Syntax methodology and the other has general architectural education and no knowledge of Space Syntax theory. A comparative analysis of the performance of both groups will go in parallel with investigating the different representations of their design processes and proposals. The study will start investigating the influence of Space Syntax theory on the cognitive actions of the design processes through analysing the design protocol embedded in the semantic transcripts. In the following step the design solutions will be evaluated in terms of qualities regarding social organization, and in terms of quantities depending on their spatial configurations.

In order to investigate the influence of Space Syntax knowledge on designers in practice, a set of interviews was organised with 12 architects. Six architects had either academic or practical experience in Space Syntax in addition to there architectural background. They are referred to as the SSX group. The remaining six architects had different architectural design backgrounds, and had no knowledge of Space Syntax theory. They are

referred to as the NSSX group. The first part of the interview started with a set of questions about the architect's experience and general design process strategy particularly in terms of locating occupational spaces and defining circulation routes (see table 2). In the second part of the interview each architect was asked to perform a design task for an architect's office floor plan. The second phase was supposed to last about 15 minutes, yet most architects were found to override the specific time required for the experiment. Each architect was asked to concentrate on the permeability of there design proposals taking into consideration the circulation and occupancy spaces; distributing them in the empty plan provided[4] according to a certain brief (see table 1). The brief was targeted to be for an architect's office because every architect is supposed to have had experience working in an architectural practice at some point in their career and therefore have an idea about the functionality of such a space. The brief is supposed to be applied on an existing layout. Both the brief and the layout constitute the first set of constrains which may help to narrow the range of possible design solutions. The architect was to interpret his/her ideas on a tracing paper, placing it over the original layout and had no access to computers. A video camera recorded the drawing process and a microphone recorded the architect's voice while describing his/ her thoughts during the design process. The verbal comments were later transcribed in order to subject them to a protocol analysis. The protocol analysis took into consideration all the semantic expressions. An example of a sketch is illustrated in table 5. Only the final design outcomes were considered for a syntactic evaluation of the spatial and visual configuration of space as the study will show later. Four females and eight males have participated in these experiments with different architectural experiences ranging between 10 years and 21 years. The time taken to solve the design tasks ranged between 11 and 50 minutes.

Design processes analysis

Previous research approaches to decode the design process have concentrated either on the strategy of design performance or on design contents. The methods of analysis which will be implemented in this

4 The layout is cited in Shpuza ([9], p.164, p.315-316) and it is an existing one and belongs to Weyerhaeuser Company SOM - Sidney Rodgers & Associates Tacoma, WA, USA.

research are the content-based methods proposed by Suwa, Purcell & Gero [10]. The content-based analysis provides a microscopic view of the design process. The design process is segmented using protocol analysis of physical actions and semantic expressions. The semantic part will be considered in this research rather than the physical, since the latter is less related to the research interests at hand. However unlike Suwa *et. al.*'s experiment, the semantic expressions will be recorded during the design process, given that the final design does not always represent the entire process of thinking. The visualization of the cognitive levels in the design processes will make it possible to extract the differences between them.

Table 1 Design task including a brief for an architect's office and an existing layout

The design brief	Design task layout.
Head office with its private secretary space Waiting area with small exhibition Two meeting rooms Management offices; (number: 3-4). Telecommunication offices (number: 2). Three spaces for consultants Spaces for five project directors, each with two associates, and design team. Two IT offices Two technical studies units One construction expertise unit Two service areas with small kitchen, toilets, and lounge.	

The detailed model of categorizations by Suwa *et. al.* [10] is documented clear in Table 3 and provides in detail the categorization's nature and criteria. Their description separates physical, perceptual, functional, and conceptual cognitive actions, and they provide detailed subcategories which belong to the former actions. It must be emphasized that their model of categorization was implied only partially in the research study due to the different scope of the research which deals with discursive thinking in architecture. Their scope was more concerned with proposing a very fine-grained level of labelling into design process analysis to depict the different cognitive actions within, and their regularities. The only physical action which is taken into consideration is (L- action) which represents the state when designers look at previous depictions and referring to them semantically. The perceptual, functional and conceptual actions will be

fully considered as long as they are expressed in the architect's utterances. Perceptual actions (P-Action) will be recorded whenever the architect refers to visual features or spatial relations. Functional actions (F-action) happen when the architect considers interactions between artefacts and people/nature, and think about the psychological reactions of people. Conceptual actions may occur during the process of knowledge retrieval (K-action), or whenever the architect makes preferential and aesthetical evaluations (E-action), or when the architect defines a goal (G-action).

Table 2 Participants experiences and interests

	Arch itects	Exper- ience	task period	word counts	How do architects think about spatial permeability during the design process?
NSSX group	AH	17	18m	1685	I always try to optimize circulation in relation to occupation.
	LC	20	49m	5426	Thinking about the logic of circulation, and occupation. This spatial structure is hierarchical reflecting the organization.
	AB	13	38m	3132	Depending on the scale, scope of the project, client demands, and how functions determine circulation.
	KS	11	32m	1189	Connecting main spaces visually. Circulation is a secondary issue.
	OO	21	38m	2673	On the basis of client requirements, the context and the environment.
	JG	11	11m	651	Depending on the design program
SSX group	BC	11	15m	1191	Circulation is a result of making connections between static spaces.
	PE	11	27m	2305	Setting the organizational structure and grouping functions.
	AN	11	18m 30s	1118	Thinking about the client, the users and functional organization.
	CE	10	30m 30s	1374	Space, connections, circulation are basic layers of design process; the top layer is an ideal one.
	LM	13	16m 30s	770	Depending on the functions.
	CR	19	15m	1819	–

Table 3 Cognitive actions categorization model adapted from Suwa *et. al.* [10], pp.460

Category	Names	Description	Examples
Physical	D-action	Make depictions	Lines, circles, arrows, words
	L-action	Look at previous depictions	
	M-action	Other physical actions	Move a pen, move elements
Perceptual	P-action	Attend to visual features of elements	Shapes, sizes, textures
		Attend to spatial relations among elements	Proximity, alignment, intersection
		Organize or compare elements	Grouping, similarity, contrast
Functional	F-action	Explore the issues of interactions between artifacts and people/nature	Functions, circulation of people, views, lighting conditions
		Consider psychological reactions of people	Fascination, motivation, cheerfulness
Conceptual	E-action	Make preferential and aesthetic evaluations	Like-dislike, good-bad, beautiful-ugly
	G-action	Set up goals	–
	K-action	Retrieve knowledge	–

The segmentation model regards every segment according to a corresponding reference. For instance, talking about cores defines one segment, whilst talking about design teams defines another segment. Further detailed segmentations then refer to the different cognitive actions whether physical, perceptual, functional or conceptual. It was possible to obtain another model from the resulting string data representing the number of different design acts in 30 seconds units of time. An example of the cognitive actions segmentation is represented in figure 1.

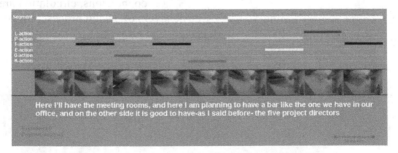

Fig. 1. A model of segmenting cognitive actions from semantic expressions

Design Outcomes analysis

This section will concentrate on evaluating the design outcomes. The evaluation will consider first the quality of the designs in terms of social organization using Duffy's model [4]. The second evaluation will consider the quantitative values of spatial and visual configurations of the proposals using Space Syntax tools. According to Duffy the structure of organizations is a determinant factor in explaining physical differences within a layout. Duffy identifies two basic concepts in describing organizations: bureaucracy and interaction. In the particular case of design offices, the model proposed by Duffy [4] is based on the hypothesis that spatial configurations promote less bureaucracy and interactions regarding the organization, and less subdivisions and differentiation regarding spatial configurations. His view considering design offices represents intensely project-based groups in loose touch with each other, serviced by normal support functions. Most spaces are accessible by visitors, and partners are well-connected. The work stations are concentrated with occasional confidentiality.

The quantitative analysis will use Space Syntax measures in order to calculate the adjacency and permeability of the spaces, as well as their visual configurations. Space Syntax measures are useful in evaluating the potentials of social encounters (Hillier [7], p. 200). According to Space Syntax the social organization is embedded in the spatial structure of space. Normally the tree-like structure of space reflects a controlled deep spatial structure and a hierarchy in the social organization. Conversely more rings of movement provide choices for movement routes; hence this reduces the depth of space. The spatial relations in a layout can be represented using the descriptive methods of justified graphs in Space Syntax (Hillier [7], p. 71). The technique starts with representing each convex space with a circle and each permeable link with a line as in figures 2. The depth might be shallow or deep and takes the behaviour of branching trees or looping rings. The relation between spaces might be 'symmetrical' if for example: A connects to B = B connects to A. Otherwise the relation is 'asymmetrical'. The total amount of asymmetry in a plan from any point relates to its mean depth from that point, measured by its 'relative asymmetry' (RA). Spaces that are, in sum, spatially closest to all spaces (low RA) are the most integrated. They characteristically have dense traffic through them. Those that are deepest (high RA) are the most segregated. Integration and segregation are global properties which relate one space to all the others. The convex integration map exemplifies five bands of integrated spaces identifying the warmest colours as the most integrated. Convex integration correlates with the

inhabitant's behaviour in the building, whereas the axial integration visualizes the permeability of space. Convex spaces are spaces where one is visible from everywhere. Axial lines are lines of sight interpreting the local phenomena of being able to see and reach one point from another point. The axial map optimizes the fewest and longest axial lines. The convex map identifies the fewest and fattest convex spaces; the fewest to be prevailed. Similar to spatial integration visual integration is calculated considering the grid fragments as interconnected convex spaces. It was first introduced by Turner, Doxa, O'Sullivan, and Penn [11]. In the visibility graph analysis, higher values are represented in warmer colours. Within the network of convex spaces there are different types of spaces; some are occupational, others contain dense movement, and others may contain both movement and occupational functions. Figure 2 shows a justified graph. In this graph Hillier differentiates between four types of spaces: a-types are dead-end spaces, whereas the omission of b-type leaves one or more spaces without connection to the graph. The c-type is positioned on one ring. D-type of spaces must be in a joint between two or more rings. The positioning of these types of spaces within the local and global configurations of the whole network can determine the depth maximizing and minimizing of the complex. The increase of a-type locally and d-type globally minimises depth creating an integrated system, while the increase of b-type globally and c-type locally maximises depth resulting with a segregated system.

Fig. 2. Types of spatial relations in a justified graph cited in Hillier [7], p. 249

Results

The verbal and visual data collected throughout the design experiments has revealed some differences and similarities between the two groups in addition to some individual differences between the participants. The

cognitive and spatial analysis has also indicated to some commonalities and distinguished some differences between the two groups.

The verbal transcripts of the design process highlighted some similarities between the different design approaches. The design processes similarities appeared in the reactions of designers when faced with the design problem; most of them stressed their own vision for an open plan layout against the normative brief demands for individual spaces. Most of them have started their design process calculating the number of space users, and were concerned about the spaces areas, the scale, and the structural system. The issue of visibility was raised very often by both groups. Most of them were designing circulation from the point of view of space users and their spatial experiences. They often started defining public and private access points, followed by allocating spaces accordingly. Apart from KS who was more interested in satisfying lighting requirements, all the participants started their designs by understanding the organizational structure, sometimes emphasizing and sometimes avoiding the hierarchical structure of the organization, and this was rendered in their spatial solutions. All the participants were occupied with the idea of open plan layout, although most of the NSSX participants have ended up limiting the visual qualities of their solutions by proposing opaque partitions. The knowledge of Space Syntax emerged in the verbal comments of the SSX group, especially in PE's proposal who avoided creating large enclosed spaces in order not to 'block potential movement'. CE and LM talked about the directors being usually segregated in the spatial structure. Similar comments were more implicit in the NSSX verbal transcripts, such as the segregation of directors in boxes that OO stressed in his design, or the visual experience of space that LC and AB have repeatedly referred to in their designs.

The segmentation of cognitive actions has resulted with the diagrams shown in table 4. The diagrams represent the frequencies of different (L, P, F, K, E, G) actions throughout the timeline of each design process. The number of occurrences of each cognitive action was counted within 30 seconds. The aggregate information formed trends. The total cognitive actions in each design process are represented in figure 3. The analysis reveals a number of differences between the two groups of architects, considering the circumstances in which the experiments were conducted. In the detailed model of protocol analysis, the design processes had mainly fluctuating but balanced trends between the functional and perceptual cognitive actions. Compared to them the conceptual and physical actions were less apparent. However, strategically conceptual and physical actions are more critical in terms of their connective nature with previous

experiences and following conjectures. Yet the diachronic models of design processes in table 4 do not really indicate remarkable regularities between the participants. The short time needed by SSX group for the design tasks may speak for the idea that this group was more confident in solving the design problem than the NSSX group. The latter generally suffered from rather erratic trends in terms of cognitive actions frequency. KS and LM showed lower trends of cognitive actions during their design performances and achieved the least intelligible[5] solutions. By the end of most design tasks in the NSSX group the value of functional actions dropped lower than the value of perceptual actions, whereas in the SSX group the value of functional actions was often above the perceptual ones. An exception was CR's case whose trend changed repeatedly in terms of perceptual and functional actions. CR who also has the longest experience using Space Syntax methodology has produced the most intelligible layout. This may suggest that CR was involved in a process of continuous evaluation in parallel with her design actions which turned out to be very successful. The results in general do indicate that the SSX group was more confident in decision making, although it is not unequivocally clear if both groups were expressing their initial thoughts discursively; however the method used in semantic recording during the design tasks is still probably the best method in making these thoughts explicit during design actions.

Table 4 The Cognitive analysis of design processes plotting cognitive actions frequencies against timeline of design process

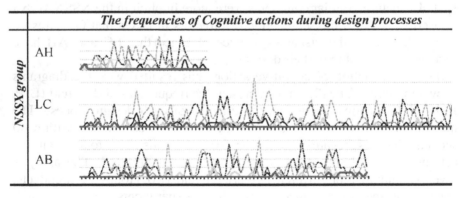

5 Intelligibility is the correlation between Global axial integration and connectivity; the later is the number of connections for each space.

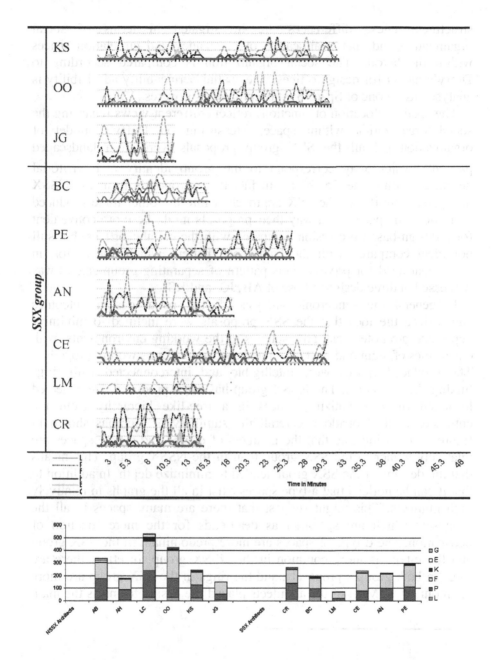

Fig. 3. Total cognitive actions in the different design tasks

Although the design task is the same for both groups, the design outcomes were significantly different in terms of organizational and spatial

structures. These differences are investigated in terms of social organization and spatial allocation of occupancy and circulation spaces within the layout. The social organization is compared according to Duffy's model for design offices. The spatial permeability ad visibility is analysed using one of Space Syntax computer softwares [12].

The spatial allocation of functions reflects different views regarding the social organization within space. Measuring on Duffy's model of organization [4] all the SSX group proposals were in a landscaped pattern[6], which may correspond to the group identity and territorial definition with some flexibility. In fact three proposals from the NSSX group were similar to the SSX approach, while the other three produced more defined spaces. In a way their proposals might be more convenient for a design-based profession compared with the cellular offices, but still not ideal compared with the landscaped pattern which allows for an occasional need for privacy. This pattern of separating group spaces was witnessed in three designs; those of AB, JG, and KS.

In general the synchronic analysis of the spatial design outcomes emphasized the idea that the SSX proposals were inclined to minimize depth and promote social atmospheres in the working environments, with equal lines of sight and well integrated spaces for teams working together. The produced spaces were intelligible and interconnected with rings linking the two cores. The NSSX group has often produced disconnected localized rings, organizing spaces in a tree-like hierarchy from the entrances to the corridors. Overall the summary of J-graphs shown in figure 4 and 5 indicate that the numbers of d-type and a-type spaces are relatively higher in the SSX group than in the NSSX group. This means that the designs of the SSX group tended to minimize depth. In addition to that it can be noticed that a-type spaces exist in all the graphs in relatively high numbers. This might suggest that there are many spaces in all the proposals which are specified as dead-ends for the mere function of occupation. The d-type of spaces are more predominant in the SSX group and the c-type is more common in the NSSX group. In effect there are rings in both group's proposals, and the rings in the SSX group are more interconnected. Most of the architects placed the design teams as the main

[6] The landscaped office is based on an open layout where the large space contains concentric rings of lines of communication between groups of clerical workers. The managers are accommodated in private enclosed offices. Space standards are centralized and uniform across the open plan space.

function within the most integrated areas as shown in table 5. However, the NSSX group produced different patterns where the corridors are the most integrated spaces within the layout. It can be noticed from the justified graphs examples in figure 5 that the design teams were shallower to the main entrance; between one or two steps away, in the SSX group. In contrast the majority of NSSX proposals had the design teams deeper in the organization in relation to the main entrance. In all the proposals the design teams were of c or d-types, located on one or two rings, although they were in a shallower position in the SSX group than in the NSSX group in relation to the main entrance. The design proposals made by the SSX group segregated the head office so that it was between two and five steps deep from the public access and was usually an a-type space. This was less noticeable in the NSSX proposals. In general; it can be observed from table 5 that the SSX group was able to integrate a larger area in the layout than the NSSX group.

The average convex and intelligibility values in figure 6 imply that there is little difference between the two groups; however the total average of the SSX group in that regard is more than the total average of the NSSX group. It might be important to note that these values (in addition to the mean axial integration) are the highest in the design outcome of CR, who has the longest experience among the participants in Space Syntax methodology. The axial integration value has differed between the two groups locally and globally in terms of homogeneity. Nevertheless the measures are not very reliant in such a small network. Both globally and locally integrated axial lines connected both cores, and generally passed through the most integrated convex spaces. The globally integrated axial lines in table 5 are the ones which connect the two cores together, passing by the design team's spaces in most of the cases. On the local scale which is determined by the two steps away formula, the integrated axial lines in table 5 connect both cores as well. It can be observed on both local and global scales, that the SSX group were more successful in creating integrated rings of axial lines between the two cores than in the NSSX group, *i.e.* the SSX group were able to provide more choices for movement. In terms of intelligibility, there seems to be little difference between the two groups. The SSX group did seem to generate more intelligible spaces than the other group, particularly in the case of CR where the intelligibility value is very close to 1 (reaching 0.95). The least intelligible solutions were made by KS and LM, whose values were 0.55 and 0.65 respectively. Overall the average values of convex, axial integration, and intelligibility shown in table 6 were higher in the SSX group than in the NSSX group. There was little variance within each group

in terms of convex integration and intelligibility. By contrast the local and axial integration values captured many differences within each group. On the one hand there seems to be a remarkable variance between the SSX members regarding the global scale of axial integration and more homogeneity in this regard in the NSSX group. On the other hand the NSSX participants produced heterogeneous results in terms of local axial integration (the SSX group had more similar results). In terms of visual properties of space, it can be seen that the SSX group was more successful in creating visually integrated spaces than the NSSX group. The latter created more fragmented designs and more clustered spaces which have potentials to be merely occupational spaces. Some examples of the spatial and visual analysis are represented in table 5. The analysis may suggest that the large integrated spaces proposed by SSX group are more likely to encourage dynamic movement than the other occupational-like proposals of the NSSX group.

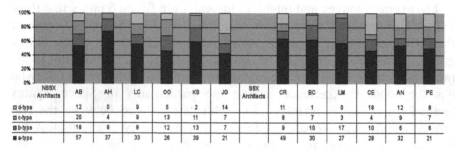

	NSSX Architects	AB	AH	LC	OO	KS	JG	SSX Architects	CR	BC	LM	CE	AN	PE
d-type		12	0	9	5	2	14		11	1	0	18	12	8
c-type		20	4	9	13	11	7		8	7	3	4	9	7
b-type		18	9	8	12	13	7		9	10	17	10	6	6
a-type		57	37	33	26	39	21		49	30	27	28	32	21

Fig. 4. Percentages and numbers of the four types of spaces in the J-graphs

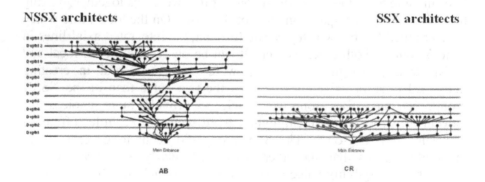

NSSX architects **SSX architects**

AB CR

Fig. 5. J-graphs of design proposals. All J-graphs start from the public entrance

Table 5 Spatial analysis of the design proposals using Space Syntax tools [12]

	AB - NSSX architects	CR - SSX architects
Sketches made by the participants during the design process.		
Convex integration analysis.		
Global axial integration analysis		
Local axial integration analysis		
Visual integration analysis.		

0 10 m 30 m

↑ Higher integration

Conclusion

The analysis of cognitive design processes, as well as the evaluations of spatial and visual qualities and quantities presented here, support Hillier's

hypothesis [7], p. 59. In other words, Space Syntax does seem to influence positively architects during their intuitive design processes producing relatively better design outcomes through rendering the non-discursive aspects of architecture to become more discursive.

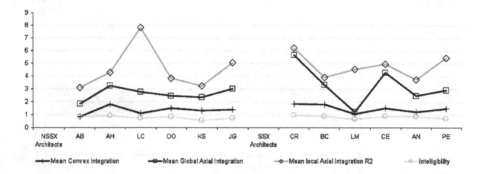

Fig. 6. Diagram showing integration and intelligibility values for the different proposals

Table 6 The homogeneity of integration and intelligibility values within the population

	NSSX Architects			SSX Architects		
	Mean	**Standard Deviation**	**Variance**	**Mean**	**Standard Deviation**	**Variance**
Mean Convex Integration	1.34	0.32	0.108	1.49	0.31	0.096
Mean Global Axial Integration	2.62	0.5	0.25	3.32	1.53	2.35
Mean Local Axial Integration R2	4.56	1.73	3.02	4.80	0.94	0.89
Intelligibility	0.78	0.132	0.017	0.82	0.116	0.013

Such a result was made possible through careful consideration of the circumstances of the design task situation, and the method in which the intuitive design processes were modelled. In general it can be observed from the analysis that the SSX architects were more able to express there

thoughts explicitly rather than the NSSX group. The explicit knowledge of the SSX group about the permeability of space and its spatial configurations might have helped them in being more confident in their design processes, and allowed them to provide more efficient solutions. This is most obvious in the performances of CR, BC, and CE. Both groups considered the same issues of making spaces accessible and visually connected. Therefore their outcomes reflect the optimization process they have gone through in order to approach an efficient solution. However, in the NSSX group there were more worries about privacy issues and confidentiality, resulting in clustered-like designs. There are regularities in the designer's considerations in general, as all of them seemed to concentrate mostly about permeability issues. Nevertheless the design solutions reflect more integrated spatial structures and better qualities of space in the SSX proposals than in the NSSX designs. This result is very interesting because it supports the idea that by exposing the spatial configurations of space to an explicit model of description it could be possible to enhance the design processes and design outcomes of architects. This knowledge of Space Syntax, if employed in the evaluative process of reasoning during design, can leave a positive impact on the design solutions and reduce the time required for problem solving. It is important to emphasize that this result is only viable in terms of spatial permeability considerations. Other methods of evaluation could be accommodated by extending the current study to include an integrated model of evaluation, and the development of computer-aided applications to enhance design qualities and productivity.

The present study has concentrated on evaluating the quality of the design product (the resulting layouts) rather than the relative cognitive efficiency of the design process itself. Cognitive efficiency can be seen as the number and complexity of mental operations required to achieve a design outcome, including how many and how varied design alternatives are considered. We are currently starting on further analyses and additional data collection to understand whether differences between SSX and NSSX designers might also be present on such a more fine-grained level of cognitive analysis, e.g. whether SSX knowledge may help designers to chunk information such that more short-term memory capacity is available for creative variation or whether more efficient sequences of design steps can be observed, avoiding backtracking to irrelevant design steps. It may be also important to present some variations of the design brief and expand the population of participants in the upcoming studies in order to obtain more consistent results which can be generalized to other architectural design problems.

Acknowledgements

We are grateful to the architects who participated in this experiment for the valuable time and insights they have provided for our research.

References

1. Al Sayed K (2007) Discursive and non-discursive design processes, MSc Dissertation in Advanced Architectural Studies, University College, London
2. Bentley PJ (ed) (1999) Evolutionary design by computers. Morgan Kauffman Publishers
3. Duffy F (1974a) Office design and organizations: 1. theoretical basis Environment and Planning B 1: 105-118
4. Duffy F (1974b) Office design and organizations: 2. the testing of a hypothetical model. Environment and Planning B 1: 217-235
5. Duffy F (1974c) Office interiors and organizations: a comparative study of the relation between organizational structure and the use of interior space in sixteen organizations. PhD thesis, Princeton University, Princeton NJ
6. Hillier B, Hanson J (1984) The social logic of space. Cambridge University Press, Cambridge.
7. Hillier B (1996) Space is the machine. Cambridge University Press, Cambridge
8. Kanekar A (2001) Metaphor in morphic language. Proceedings, 3rd International Space Syntax Symposium Atlanta
9. Shpuza E (2006) Floorplate shapes and office layouts: a model of the effect of floorplate shape on circulation integration. Doctorate dissertation in Architecture, Georgia Institute of Technology
10. Suwa M, Purcell T and Gero J (1998) Macroscopic analysis of design processes based on a scheme for coding designer's cognitive actions. Design Studies 19(4): 455-483
11. Turner A, Doxa M, O'Sullivan D, Penn A (2001) From isovists to visibility graphs: a methodology for the analysis of architectural space. Environment and Planning B: Planning and Design 28(1): 103–121
12. Turner A (2006) UCL Depthmap: spatial network analysis software, version 6.0818b. University College London, VR Centre of the Built Environment

Using Shape Grammars for Master Planning

Jan Halatsch, Antje Kunze, Gerhard Schmitt
Chair for Information Architecture, Switzerland

This paper describes the application of procedural modeling methods to automatically derive 3D models of high visual quality for a highly detailed and quick visualization of complex city models. We discuss the applicability of a procedural modeling pipeline of shape grammars in urban planning to derive meaningful 3D city models. Therefore we analyze CGA shape, a novel shape grammar for the procedural modeling of CG architecture, for its usage in architectural planning processes. Our system gives rise to three exciting applications in the field of city modeling and city visualization enabling a quick decision making and iterative design workflow: modeling of master plans, evaluation of built environments and planning of urban open spaces. It is capable to produce building shells with high visual quality and geometric detail. Context sensitive shape rules allow the user to specify interactions between the entities of the hierarchical shape descriptions. Selected examples demonstrate solutions to previously noted challenges.

Introduction

A shape grammar for master planning will be important for a) the quick and detailed visualization of urban designs including buildings, roads, locations and associated vegetation, b) the visualization of planning laws, c) the use of natural energy resources (solar and wind) and its effects on the visual appearance of cities. Grammar-based 3D modelers applied to an urban scale could be of great help for planning of future cities with an extremely reduced energy consumption due to its semantic system. One main advantage of recent shape grammar systems is the increase of possible design variations, which would result in time-consuming tasks if done with common planning methods. Manual tasks are difficult to handle in large-scale landscape and urban planning projects especially when a large portion of interdisciplinary expert knowledge is involved. To ensure the reliability and the quality of plans it takes a lot of human resources to manually

J.S. Gero and A.K. Goel (eds.), *Design Computing and Cognition '08,*
© Springer Science + Business Media B.V. 2008

model detailed 3D land- and cityscapes. In other industries beyond the field of architecture next generation applications are already used in that manner. If integrated in the architects' processes they could also dramatically raise design quality through (1) the added predictability of the aimed urban design, (2) the possibility to simulate certain key measures for the city's planning, like enhanced airflow through skillfully placed city layouts along with flow optimized building facades, and (3) the opportunity to re-design large drafted urban models within seconds of what before could have required months of work. Additionally, more sustainable designs can be achieved if associated attributes would be included into the semantics of such a system.

This paper explores how shape grammars can be integrated into the urban design process. We introduce a recently published system that can be used to visualize master planning scenarios in high polygonal resolution. We contributed to this system the ability to describe urban design patterns in the form of hierarchical patterns. This system can be applied (1) to the curriculum in education as a systematic learning tool to understand and encode architecture, (2) to the field of architectural theory e.g. for the analysis and synthetic construction of unbuilt city utopias, (3) to the field of architectural history and archeology for the reconstruction of building designs and cities [1, 2], (4) to the field of urban planning as well as to project development for the pre-visualization of large urban areas - especially in cases where common building regulations exist (see Figure 1) and (5) to evaluate simulation criteria on an urban scale e. g. in order to achieve lower CO_2 emissions within cities. This system had been introduced by Parish and Müller [3] for the production of city-like structures and computer generated architecture by Müller et al. [2]. We introduce this system as a novel framework for a grammar-based planning of urban environments. We extended CGA Shape to an urban visualization framework for architects. Further we show how this shape grammar approach can be integrated into a common design workflow.

Related Work

A landmark in the formal theory of architecture was the introduction of shape grammars by Stiny and Gips [4]. These shape grammars have been used to analyze and describe designs as in the following examples, such as Palladian villas [5], Mughul gardens [6], Frank Lloyd Wright's prairie houses [7], or Alvaro Siza's houses at Malagueira [8]. However, the applicability of Stinys' original shape grammars as a practical modeling tool is unclear, because it is hardly amenable for computer implementation. May-

all [9] presented an interesting implementation of a shape grammar specified for landscape design. The system produces urban scenes by generating parcels with simple 3D buildings and by distributing vegetation objects. Müller et al. [2] presented a more recent approach. They introduced a novel attributed shape grammar called *CGA Shape*, which is suited for applications in computer graphics. Important contributions for the use of shape grammars in urban design had been made by Brown and Johnson [10] simulating mediaeval city blocks in London as well as by Beirão and Duarte [11], they produced flexible urban plans with shape grammars. Ulmer et al. [12] introduced an approach to extend *CGA Shape* in order to produce large-scale vegetation scenarios for urban environments. Shape grammar rules of certain architectural configurations have been collected within libraries. One such library exists in literary form and is described as a collection of patterns. The use of patterns in architecture is founded on Alexander et al. [13].

Fig. 1. Left: Stochastically with CGA Shape placed building masses on a given urban field. Right: Automatic adjustments within the layout following regulations concerning shape masses [3].

Crowe and Mitchell [14] practically applied Alexander's patterns to describe specific landscape designs. The corresponding key components of patterns in landscape design have been specified and illustrated in detail by Bell [15]. Condensed as illustrated patterns, Turner [16] gives a comprehensive overview of landscape attributes in an urban context. Alexander [17] describes the formal relationship between landscape design and urban planning. Concerning the computational design curriculum there are only a few examples for the use of shape grammars: Flemming [18], Knight [19, 20], Beirão and Duarte [11] and Colakoglu [21].

Overview

This paper is organized as follows: Section 2 starts with an overview of the CGA Shape grammar, and afterwards we introduces our novel extensions needed for the encoding of urban open spaces. Section 3 deals with the design of vegetation patterns and their implementation by using our grammar. In section 4, we describe three design studies as examples. Our examples show that by using this framework users can easily generate and visualize large urban scenarios containing high-resolution building and vegetation geometry. Finally we give conclusions and future work in Section 5.

A Shape Grammar for Master Planning

CGA Shape

In the following, we briefly introduce the main concepts of CGA Shape but refer the reader to [2] for a more comprehensive description. CGA shape stands for a novel shape grammar for the procedural modeling of computer graphics (CG) architecture. CGA Shape is an extension of set grammars, introduced by Wonka et al. [22]. The notation of the grammar and general rules to add, scale, translate, and rotate shapes are inspired by L-systems [23], but are extended for the modeling of architecture. While parallel grammars like L-systems are suited to capture growth over time, a sequential application of rules allows for the characterization of structure i.e. the spatial distribution of features and components [24]. Therefore, CGA Shape is a sequential grammar (similar to Chomsky grammars). The CGA Shape framework consists of the shape definition, the production process, the rule notation with shape operations, and an element repository.

Shape definition: A shape A consists of geometry, a symbol, and attributes. The most important attributes are the position P, three orthogonal vectors x, y, and z, describing a local coordinate system, and a size vector s.

Production process: The production process can start with an arbitrary configuration of shapes, called the initial shapes, and proceeds as follows: (1) Select an active shape with symbol A in the set, (2) choose a rule with A on the left hand side to compute a successor for A resulting in a new set of shapes B, (3) mark the shape A as inactive and add the shapes B to the configuration and continue with step (1).

Rules: The CGA Shape production rules are defined in the following form:

```
    id:   predecessor: condition
                → successor: prob
```

where id is a unique identifier for the rule, predecessor is a symbol identifying a shape that is to be replaced with successor, and condition is an optional guard (logical expression) that has to evaluate to true in order for the rule to be applied.

Conditional behavior: For example, it can be secured via condition that the rule is only applied if the predecessor shape is not occluded by another shape. To make designs stochastic, the rule is selected with probability prob (optional).

2D shape operations: The subdivision split can subdivide objects along an axis. For example Subdiv(y,7,2,5){ A | B | A } splits the current scope along the Y-axis in three parts with sizes 7, 2, and 5 and adds three shapes A, B, and A accordingly. To enable size-independent rules, we also include the letter r to denote relative values, e.g. Subdiv(y,1r,2,4r) creates three parts: the middle part has absolute size 2 and the remaining two parts split the remaining space in a 1:4 proportion. We also employ a repeat split, e.g. Repeat(x,2){ A } places as many A shapes of approximate size 2 as possible along the X-axis of the current shape. The component split can divide a shape into its geometric components like 2D faces or 1D edges, e.g. Comp(e){ B } splits the predecessor shape into edge shapes with symbol B.

3D shape operations: Several different types of shape operations can be applied to modify the successor shape, e.g. transformations like translating or scaling.

Object placement: The insert command I(objId) adds, according to the size of the current shape or according to the featured goal a) object distribution along lines or curves, b) stochastic distribution on surfaces, c) combination of a) and b), an instance of a geometry object with identifier objId (from the element repository).

Hierarchy: Conditional behavior, shape operations and object placement are nested hierarchically due to the rules processing. This enables different ordering schemes like the following: city, street-network, block, lot and footprint.

Design patterns: A typical pattern described by Alexander [13] can be interpreted as relational function of confirmed geometrical and spatial configurations. In the case of CGA shape patterns can represent a facade design of an epoch or a given style, which can result in interchangeable terminal symbols. Otherwise patterns can describe relational proportions of an object on a defined scope. The combination of hierarchical organization and relative values for geometric configurations enables the introduction of

design patterns. For example, street types like avenues consisting of street and edging vegetation can be easily set up as well as parks or other geometric configurations consisting of nested rules or geometry objects [25].

Element repository: The library of 3D models consists mainly of basic primitives, elementary architectural objects (e.g. ionic capitals) and plant models. The elements are hierarchically organized in categories and types and each element has a unique identifier, shader attributes and metadata.

While CGA Shape was presented by Müller et al. [2] the placement of urban vegetation with shape rules was presented by Ulmer et al. [12]. The hierarchical linkage of shape rules, the introduction of urban patterns and the application of the grammar to master planning had been our contribution.

The CityEngine had been previously developed for the production of city-like structures [3]. With Müller et al. [2] the CityEngine evolved into a framework, which enables users to reconstruct architectural designs and archaeological scenarios with shape grammar rules as given inputs. Within this paper we explore the application of this evolved framework on urban design.

The City Engine System

The CGA shape grammar had been implemented in C++ and integrated in the CityEngine framework ([3] and continued by [2]). It can process urban environments of any size i.e. ranging from a single lot up to a whole city. The input data is represented in a GIS format and consists of different regions like streets, parcels, building footprints, patios etc and is supported by importing bitmap data or geographic vector data like Google Earth's KML format, which can be used for building mass models. Furthermore, these regions contain metadata information specified by the user in the GUI of the CityEngine.

Since the CityEngine represents a 3D modeling application the user relies on many different views of the model: (1) A top view shows an overview on building lots, streets, blocks and building footprints. (2) Within a three-dimensional view the partial derivation of the grammar can be analyzed on a mass model level. (3) A high detailed geometry visualization shows the final geometry. (4) A text based editor serves as an input for the shape grammar. Depending on the metadata attributes, the regions trigger the selection and application of corresponding shape grammar rules. Therefore, the region itself (usually a polygon) is fed as initial shape into the grammar engine, which derives it into an elaborate design by applying the selected rules. The resulting model can then be previewed in the

OpenGL viewer of the CityEngine or photo-realistically visualized in a 3D application like Autodesk's Maya.

Workflow for Master Planning using Shape Grammars

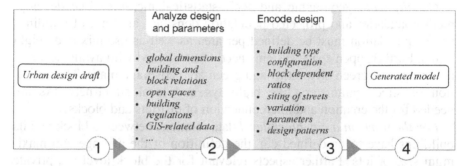

Fig. 2. Modeling urban designs with CGA Shape demands for prerequisites of available data, which have to be refined for processing with the grammar interpreter.

Enhancing traditional design cycles with shape grammars

Since CGA Shape was originally designed for digital content creation purposes such as needed in archeology and entertainment, the system itself provides many capabilities of a GIS-like application. The production processes can be constrained on different planning scales like districts, parks, blocks, lots and the building itself. The placement of buildings, the use mix and the type of buildings can be defined and controlled by bitmaps, which can be layered and combined. In order to produce a grammar-based synthesized city model, given urban designs have to be analyzed first and preprocessed including all necessary design features and regulations (see Figure 2). The preprocessing of design starts with the manual subdivision of a given design into its functional geometric parts. This input can be for example a simple sketch, drawing or a photography. In the next step relational or fixed geometric parts can be identified and written down in CGA shape syntax. Depending on the aimed level of detail to be described with the syntax the user is able to construct repeating elements like windows, plants, and street signals with a standard 3D modeling application. These elements represent the terminal symbols of the grammar derivation. Finally the model can be further redefined.

Preparation steps - Analyzing given designs

Several manual preprocessing steps are needed before our system can start with the generation of synthetic urban models. As stated above the system interprets different planning scales. Therefore the inputs have to be prepared:

On city-scale geographic and socio-statistical measures like development boundaries and projected population densities, age mix of buildings and/or population must be defined per area as well as use-mix and height ratios. Further, open space systems need to be aligned with available vegetation objects, green area ratios and green area coverage maps. The definition of street parameters like highways and local street-networks are needed for the creation and interconnection of districts and blocks.

For the work on a city block-level data relations between a block and its buildings have to be defined e.g. the definition of the average and maximum size of lots. Further aspects relevant for the block-level are private and open green spaces as well as mass-model dimensions, standard shape type descriptions and use descriptions like dwellings, office buildings and commercials.

Building designs must be analyzed for their spatial relationships of their elements such as dimensions, facade rulings like floor heights and facade elements like setbacks, and window geometry.

Encoding design into grammar

Master planning of urban environments operates on distinct major scales. In order to give planners access to a manageable view in our grammar approach, we use the following region definitions: district zones, block zones, lot zones, patio zones, and also vegetation regions (Figure 3).

District zones are created on both side of streets. They span over several blocks if necessary and can be split by ordinating street crossings. They are defined manually within the preprocessing steps, automatically generated with given defaults or can be equally imported from other projects. Within the generation process they do not take part in the creation of buildings nor do they interact with their footprints.

Block zones are CE block polygons enclosed by streets. They can be outfitted with vegetation objects, parks, or buildings only or as a combination of buildings and vegetation. Flanking streets can be defined by a manually drawn street-graph or by an automatic creation process [3].

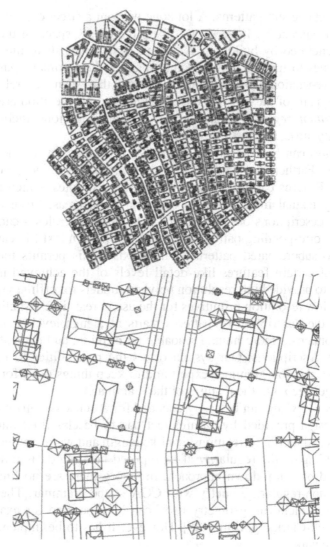

Fig. 3. Above: Layout of a typical urban environment produced with CGA Shape. Below: Close-up on detailed urban scene showing block, lot and vegetation zones [25].

Lot zones come into play when a combination of buildings and vegetation is desired. They are allocated to the regions list after the generation of buildings and thus hold information about their footprints, providing means to interact with its housing environment. Lot zones additionally get building type attributes from the CityEngine framework. Attributes like commercial, industrial and residential can be used later for a further selec-

tion of suitable sub-patterns. A lot zone without a street edge is character-
ized as a *patio zone*. It serves to fill up the empty space in the center of
blocks, enclosed by buildings. Although patio zones share the possibility
of lot zones to include footprint information, their primary purpose is to
contain vegetation without housing. Areas that span several blocks or
cover big parts of the city and contain elements of vegetation are classified
as *vegetation regions*. Examples of vegetation regions include forests
within city areas, big parks or fields.

All zones can be controlled, arranged and designed with the 2D shape
operators. Further, the configurations can be saved as geometric design
patterns. Patterns can be divided into sets of attributes, which contain all
necessary textual information to describe urban areas. From a system's
view the descriptions of each pattern – the grammar rules – can be stored
within a corresponding pattern text file. Each pattern text file can give ref-
erence to subordinated patterns if they exist. This permits the easy ex-
change of certain features like detail levels of the achieved models for
example to provide high resolution polygon models for offline visualization
needs or low resolution primitives for the use in real-time visualization.

Since the description of patterns starts at a high-level major pattern,
which contains a more human readable description, and ends at low-level
grammar descriptions. Our system offers the possibilities to keep things
simple for the non-grammar-expert and to keep things open for users that
want to get deep into the features of the grammar.

Building designs can be easily encoded for a quick visualization. There-
fore a design provided by an architect has to be classified into its main
elements and their interrelationships like length and width among them.

Depending on the regularity of a proposed building design, its parts are
developed on a top-down approach. In theory there are no limitations to
produce non-regular geometry with CGA shape grammar. The computa-
tion of non-euclidean geometry itself can be processed for example with
the Catmull-Clark algorithm [26]. However it has to be implemented into
our framework.

In this shorthand example we would like to show how easy a design can
be refined into a more detailed model by using the above named tools. The
"Cruciform Skyscraper" (see Figure 4) comprises of regular vertical and
horizontal layouts. The horizontal section reveals four wings (see Figure
5), which can be interpreted as a trice rotation around the building center
done in multiple 90 degrees steps (see Figure 6).

Fig. 4. Drawing from Le Corbusier's "Contemporary City".

Fig. 5. The analysis of the "Cruciform Skyscraper" by Le Corbusier.

The three-dimensional "body" of the building itself can be broken apart into seven key measures (see Figures 7 and 8). The building's mass design can be easily varied by changing values. It is possible to embed conditional measures such as building regulations or further artist constrains as design thresholds. Vertical elements for example the different facade types have been divided into functional geometric groups, which are nested hierarchically.

Similar to the urban and landscape design - facades are described by 2D and 3D shape operation tools. Geometric patterns are available as well. Within the resulting design itself many of its features can be controlled and distributed by using simple stochastic variations and conditions controlling for example the look of the different openings on Le Cruiser's facade of the "Cruciform Skyscraper", which can hardly be simulated effectively with manual methods (see Figure 9).

Fig. 6. Design can be easily modeled top-down.

Fig. 7. The programmed "Cruciform Skyscraper" visualized as a mass model.

BUILDING_H = 220

BUILDING_W = 100

GROUNDFLOOR_H = 6

WING_W = 16

SPINE_W = 50

TEETH_PROJ = 10

Fig. 8. Key measures for the appearance of the high-rise building.

Fig. 9. Detail of the modeled facade using the component split and stochastic variation for the placement of the curtains.

Examples

Singapore, Pungol

The district of Pungol in Singapore consists of a large high density housing area (see Figure 10). This area is aimed to answer the rising demands of housing and the fast growing population. The district's layout and the building shapes consist of regulated forms. The repetitive geometrical appearance of the facades is an ideal example that can be interpreted by our grammar (see Figure 11).

Fig. 10. Typical street view of Pungol.

The rules set for this example starts with an occlusion rule, which assures that the open spaces of avenue zones do not get filled with items of the following productions, e.g. buildings placed onto lots. Next, the district is subsequently split into sub-regions, each containing a center avenue and left and right building zones. Within the building zones courtyards can be

filled with parks if the available width and length permit the placement of vegetation (see Figures 12 and 13).

Fig. 11. Synthetic reconstruction of Pungol.

Fig. 12. The synthetic urban environment of Pungol produced by our system.

Fig. 13. Detailed view onto housing blocks with courtyards.

Avenue parameters like street width, tree density and tree types are adjusted automatically to the importance of the avenues. The buildings consist of length-dependent facade types. The associated facade rules react on different sizes: For example a building length up to 20 meters features the

facade types A (Edges), B (standard element), C (balcony). Above 20 meters a type D (middle balcony) is introduced.

Student work

The following two examples feature student works produced within a student course at our Chair for Information Architecture fall 2007.

The first example shows the application and variation of one and the same facade rule. The students started to analyze a facade design developed by themselves (see Figure 14). After encoding the design into the shape grammar, the students had been able to apply the rule and its variation as a design pattern onto an urban environment (see Figure 15).

Fig. 14. An original facade designed by students.

Fig. 15. Rendering of a large-scale urban environment with different facade variations based on the original facade.

The second example poses an artistic approach of creating a futuristic looking city (see Figures 16 and 17). The students focused on the recursive production calls of their skyscraper.

Fig. 16. The top view onto the "distorted city".

Fig. 17. A detail view onto the model.

They used a Manhattan-like layout where they placed their "recursive tower" with heights starting at 200 meters resulting in a "distorted city" model. Colors had been applied to interpret and analyze the resulting distribution of stochastic rules done by the system.

Conclusion and Future Work

Automatic and semi-automatic approaches can drastically reduce and ease complex and time consuming design and modeling tasks in the planning of urban designs. Therefore we presented a stochastic shape grammar for master planning as a novel approach for the automatic creation of large urban scenarios in real or virtual 3D cities. We extended CGA Shape to an urban visualization framework for architects. Our examples show that by using this framework users can easily generate and visualize large urban scenarios containing high-resolution building and vegetation geometry.

We showed that it is possible to implement this approach as a visualization method for design into existing design pipelines. The rule-based distribution and placement of objects like vegetation, buildings and the re-use of design patterns in urban environments enables the planner to explore further variations. The used procedural modeling methods are able to automatically derive 3D models of high visual quality for a highly detailed and quick visualization of complex city models. The system is also open for iterative (re-) design purposes. Successful design findings of suitable configurations can be stored within pattern collections. Also the complexity of procedural modeling became manageable with the help of reusable patterns, which are not limited to landscapes and landscape objects. CGA shape descriptions can be saved to a versioning database to encode and to store design for easy application on virtual city models that had been generated by the system. Beside this, stored design data sets can contain geometry attributes, which feature sustainable design criteria. In upcoming work we would like to explore how feedback (airflow, shading, movement of people) from simulation can be integrated to a modeled design. We see a strong potential in adding simulation based city layout optimization to our framework. The reusability of design patterns for sustainable urban design is another important research field. We will evaluate the inheritance of design components and design patterns with the help of standard methods from computer science like UML - unified modeling language - and test the applicability of object oriented design to shape grammars. Future work also includes the generation of non-regular geometry.

We have created a promising shape grammar and applied it to the existing one of Müller et al. [2]. Our approach can be used for pre-visualization, master planning, guided design variation and for digital content creation purposes of the entertainment industries. Ongoing projects deal with the pattern-based procedural design of the Science City ETH's open spaces in Zurich, Switzerland, and also with the challenging planning of High Density Housing in Singapore.

Acknowledgments

We would like to thank Andreas Ulmer, Pascal Müller, Remo Burkhard, and Martina Sehmi-Luck for their continuing support and for many helpful discussions as well as the review team and our students Jonas Epper, Pascal Hendrickx, Lukas Treyer and Nicolas Zimmermann.

References

1. Guidi G, Frischer B, et al. (2005) Virtualizing ancient Rome: 3D acquisition and modeling of a large plaster-of-paris model of imperial Rome. Videometrics VIII, JA Beraldin, SF El-Hakim, A Gruen, JS Walton (eds), SPIE 5665: 119-133
2. Müller P, Wonka P, Haegler S, Ulmer A, Van Gool L (2006) Procedural modeling of buildings. ACM Transactions on Graphics (TOG) 25(3): 614–623
3. Parish Y, Müller P (2001) Procedural modeling of cities. In E Fiume (ed), Proceedings of ACM SIGGRAPH 2001, ACM Press: 301–308.
4. Stiny G, Gips J (1972) Shape grammars and the generative specification of painting and sculpture. Information Processing 71: 1460-1465
5. Stiny G, Mitchell WJ (1978) Counting Palladian plans. Environmental and Planning B 7: 189–198
6. Stiny G, Mitchell WJ (1980) The grammar of paradise: on the generation of Mughal gardens. Environmental and Planning B 7: 209–226
7. Koning H, Eizenberg J (1981) The language of the prairie: Frank Lloyd Wrights prairie houses. Environment and Planning B 8: 295–323
8. Duarte J (2001) Customizing mass housing: a discursive grammar for Siza's Malagueria houses. Ph.D. Dissertation, Massachusetts Institute of Technology, Cambridge
9. Mayall K, Endhall GB (2005) Landscape grammar 1: spatial grammar theory and landscape planning. Environmental and Planning B 32: 895–920
10. Brown FE, Johnson JH (1984) An interactive computer model of urban development: the rules governing the morphology of mediaeval London. Environment and Planning B 12: 377–400
11. Beirão J, Duarte J (2005) Urban grammars: towards flexible urban design. In Proceedings of eCAADe Conference 2005: 491–500
12. Ulmer A, Halatsch J, Kunze A, Müller P, Van Gool L (2007) Procedural design of urban open spaces. In Proceedings of eCAADe Conference 2007: 351–358
13. Alexander C, Ishi Kawa S, Silverstein M (1977) A pattern language: towns, buildings, construction. Oxford University Press, New York
14. Crowe S, Mitchell M (1988) The pattern of landscape. Packard. Chichester
15. Bell S (1999) Landscape: pattern, perception, and process. E & FN Spon, London

16. Turner T (1996) City as landscape. A post-postmodern view of design and planning. E & FN Spon, London
17. Alexander C (2002) The nature of order: an essay on the art of building and the nature of the universe. Center for Environmental Structure, Berkeley, CA
18. Flemming U (1986) The role of shape grammars in the analysis and creation of designs. John Wiley & Sons: 213–244
19. Knight TW (1991) Designing with grammars. In GN Schmitt (ed), Proceedings of CAADFutures 1991, Vieweg: 33–48
20. Knight T (1999) Shape grammars in education and practice: history and prospects. International Journal of Design Computing 2
21. Colakoglu B (2006) Explorations in teaching design students to think and produce computationally In Proceedings of eCAADe Conference 2006: 826–831
22. Wonka P, Wimmer M, Sillion F, Ribarsky W (2003) Instant architecture. ACM Transactions on Graphics 22(3): 669–677
23. Prusinkiewicz P, Lindenmayer A (1991) The algorithmic beauty of plants. Springer Verlag
24. Prusinkiewicz P, Mündermann P, Karwowski R, Lane B (2001) The use of positional information in the modeling of plants. In E Fiume (ed), Proceedings of ACM SIGGRAPH 2001, ACM Press: 289–300
25. Ulmer A (2005) Modeling and rendering of plants in urban environments. Master Thesis, Computer Vision Laboratory, ETH Zurich
26. Catmull E, Clark J (1978) Recursively generated B-spline surfaces on arbitrary topological surfaces. Computer-Aided Design 10(6): 350-355

THE VIRTUAL AND THE PHYSICAL

Interacting with Virtual Prototypes Coherently with Design Intent
Maura Mengoni and Michele Germani

*Conceptualizing Tangible Augmented Reality Systems
for Design Learning*
Rui Chen and Xiangyu Wang

Generative Fabrication
Daniel Cardoso and Lawrence Sass

Interacting with Virtual Prototypes Coherently with Design Intent

Maura Mengoni and Michele Germani
Polytechnic University of Marche, Italy

This paper argues that the design intent can be preserved along the product design cycle only if the whole process is supported by proper methods and advanced digital technologies to model virtual prototypes managing the styling product coherence. In this context, the most critical phase is the transformation from the design concept represented by sketches and physical prototypes and the engineered CAD models necessary for testing and manufacturing. We aim at facilitating the design intent preservation identifying the better digital technology usable to convert designers' conceptual models in digital ones. The proposed classification is based on the analysis of creative strategies adopted by the designer and on their correlation with the modeling features in the computational systems. This goal requires the definition of design intent transmitters that we define freeform aesthetic features, and the determination of a benchmarking method to map computational systems with the creative strategies. Experimental work through protocol studies has been performed to validate the mapping method.

Introduction

Some artifacts are more appealing than others as the visual and tactile perceived attributes of the product appearance stimulate aesthetic impression, symbolic association and semantic interpretation in the consumers [1]. In particular, we state that the so-called aesthetic features that are tangible expressions of the designer intentions stimulate perception.

The design intent can be defined as the set of semiotic contents expressed by the product shape that allow the discrimination among products with the same functionality by inducing instinctive feelings and emotions in the customer. The set of aesthetic features characterizing the design intent must remain unchanged throughout the product development process.

J.S. Gero and A.K. Goel (eds.), *Design Computing and Cognition '08,*
© Springer Science + Business Media B.V. 2008

In fact, the success of a product depends on the capacity of product shapes to transmit emotions through aesthetic features [2].

Nowadays, freeform aesthetic features characterize many successful products. They are complex topological shapes whose character is determined by the spatial curvature of the styling curves or of the enveloping surfaces. Examples can be found both in industrial design (e.g. the car body) and in architectural design (e.g. the Gehry's envelopes). The preservation of the shape character (design intent) along the design cycle is even more difficult in the case of freeform shapes.

The lack of design intent preservation is generally affected by the different viewpoints that contribute to the final design solution. According to Mono [3], the aesthetic features are modified along the design process in order to satisfy the engineering and manufacturing constraints. This can influence the way in which products are perceived; therefore design modifications must be monitored to be coherent with the original design intent. A further cause of design errors is due to the heterogeneity of the representational means used along the design process. The product evolves from its original vague concept, represented in the form of sketches and physical prototypes, toward a more detailed design represented by a virtual prototype developed in Computer Aided Design (CAD) systems [4]. In the transformation of the initial concept into a 3D CAD model, information (e.g. size, dimensions, shape, materials, structure, etc.) increases contributing to the development of the final design solution. It progressively becomes from incomplete and approximated to accurate and detailed. During the design modeling loop, the design intent is often lost as its preservation depends heavily from the subjective capacity of individuals to perceive it, understand it and represent it with the different means of design representation. As a consequence several design iterations are needed to achieve the design solution validation and to avoid the aesthetic errors deriving from freeform features modeling misunderstandings. Computational tools are yet far away from supporting the whole design process development. Therefore we highlight the need of structured methodologies to improve the interaction with virtual prototypes coherently with the design intent preservation.

Considering the vast amount of available digital technologies it is important to find the most performing tool able to robustly represent conceptual freeform objects resulted from different creative strategies, facilitating the transformation from the designers' intentions into a digital model. The research focus, hence, is how to correlate and map the most effective digital technologies to model freeform aesthetic features with the creative strategies. This also involves the definition of proper modeling strategies

for each specified computational system and of a way to modify freeform aesthetic features in accord with the engineering and manufacturing requirements while preserving the design intent.

The research objective can be achieved by:

- formalizing the design intent in the different means of the conceptual design outcomes representation in terms of styling lines, aesthetic parameters, topological shape characteristics, etc.;
- identifying the main creative strategies to obtain freeform shapes and correlating them with proper 3D modeling operations that can be performed in different computational systems;
- mapping the specified strategies with the digital technologies that can be used to develop the final design solution without loosing meaningful information.

In order to achieve the above mentioned goals, we assume a cognitive standpoint to analyse the design process and the main creative strategies adopted by designer to conceive freeform shapes. The semiotic analysis of the evolutionary process of sketches and the role of physical prototypes in the design outcomes representation allow the recognition of the meaningful freeform shape characteristics that reflect the design intent.

A benchmarking approach based on suitable metrics is adopted to experimentally verify the correspondence *design technology* vs *creative strategy* using several digital systems and different styling products. After an extensive treatment of the proposed approach the paper describes the achieved preliminary results.

Research context

According to semiotics, the product can be seen as a sign whose expression form carries out the semiotic content that the designer wishes to communicate to the consumer. In this context, design ideation can be conceived as an act of signifying, a unique and original construction of the frame of reference that draws relationships among codes often belonging to different domains. Codes provide a framework within which signs make sense, and the meaning of a sign depends on the code where it is situated [5], [6]. The semiotic standpoint highlights the communicative nature of the design process as a process of design intent transmission from the designer to all persons that come in contact with the different representations of semiotic contents, till the final consumer. Furthermore it points out the main criticality for product success: as different viewpoints contribute to

product design definition, the design intent can be lost across the design cycle and the product fails in the market.

Jakobson [7] outlines that the coherence of the communication act can be achieved when the encoding and decoding processes are regulated by the same, or at least compatible, codes. As the spoken language, the design language also consists of sets of signs and symbols that allow the transmission of the designer intentions to the users: the success of a product is determined by the ability of the product shape and of its aesthetic characteristics to transmit the designer message (design intent). The main problem is related to the different codes and conventions that each actor of the design process adopts to perceive, interpret and represent the design intent.

The design process is highly influenced by the technologies used to support the creation and the representation of the design outcomes [8].

Representational technologies aim at representing the design models in order to develop, design and visualize the alternative solutions, to share the different viewpoints, to predict the impact of design changes on the product shape, etc. Different design models are realized to perform the specified tasks.

It is possible to distinguish between physical and mathematical models. The firsts reproduce existing shapes in a full-scale or reduction scale while the seconds are 3D representations of the design solution via specialized software such as Computer Aided Design (CAD), Computer Aided Styling/Industrial Design (CAS/CAID) systems, etc., that allow different models representations.

In the first stages, design models, from sketches to physical prototypes, generally called simplified models, are abstract, elementary, and intentionally incomplete with regard to the existing object. The different levels of abstraction stimulate interpretation and the emergence of meaningful features. In accord with the degree of abstraction the design model can be used for representing the designed object, communicate the design intent to the users and for creating new emerging relationships. [9]. Designers prefer traditional representation means instead of CAD tools as they evoke a common imagery of grid snaps, tight tolerances, and exactitude, inhibiting the abstraction necessary for exploratory design [10].

As product design moves forward, design models detail in order to allow the construction of the final product. They progressively move from simplified to nominal and expanded according to the amount of information and to the complexity of the design knowledge that the different actors, involved in the process, have. Nominal and expanded models are represented only via advanced digital technologies, especially CAD-based.

In the case of physical prototyping, models are usually 3D digitised with the help of measuring systems (reverse design) and then processed with specific software packages for surface reconstruction so that CAD models are available at the end. Surface reconstruction is not a trivial task as the recognition of freeform features on dense clouds of points requires a high degree of specialization to avoid misunderstandings of the designers' intentions [11].

In the field of direct design, several efforts have been made to create computational tools to support designers in the conceptual stages. CAS/CAID systems allow the conversion of digital sketches into three-dimensional solid or surface models or both. They contain features both to support the earlier phases of the design process and to model complex freeform shapes. Otherwise, the created 3D models are not usually precise and need to be redefined by specialists. They are hard to learn and require a high degree of experience. The modelling strategies they adopt, are far from the design practice to freely sculpture clay [12]. Dynamic CAD modelling software packages and virtual reality-based systems are more similar to the way in which freeform shapes are conceived. The first allows shape modelling by transforming a primitive form by stretching its control vertices, by applying a forces matrix to a skeleton or to a metaball system, by producing dynamic effects on the position of particles located in space, by morphing an original form into a target one, etc. Unfortunately, the output of the transformations does not contain any semiotic information useful for the following engineering shape development and they are not integrated in commercial CAD software tools [13]. The seconds try to involve the sense of touch for virtual clay modelling and immerse the users in the virtual scene to reproduce very natural conditions. Haptic devices are used to explore and create freeform shapes in the virtual environment giving touch feedback relating to the "surface" users are sculpting or creating. The main problems concern with the coordination of the user movements in a way that are similar to those he/she traditionally has and the difficulty to reproduce devices really used in the industrial design to create physical prototypes [14]. Attracting the research attention, hand gestures capture interfaces represent new way of virtually sculpturing clay. While designers conceive the product shape the system captures the hands motion and translates it in terms of 3D surfaces. The main problem deals with the difficulty to define a grammar of hand motion language and nowadays researches are far from a real application in the design practice [15].

In summary, it is worth to notice that in the industrial practice designers prefer to adopt traditional means of representation, while CAD operators are generally employed to translate the design concepts (as simplified

models) into detailed CAD models (solid, surface, voxel-based in accord with the particular used system) for the following phases.

Design errors and iterations derive from the communication problems along the transformation from simplified into nominal ones. The question is how to manage such transformation by available digital technologies without loosing meaningful aesthetic information that is represented by aesthetic freeform features. From an operational point of view, we define a freeform aesthetic feature as a parametric description of a shape, containing the styling curves, the set of parameters and attributes that define them, and the aesthetic constraints that allow the modeling of the shape according to the creative process the designer adopts to generate the design concepts. Such features and their use in surface modeling can enable users to coherently and easily modify the 3D virtual prototypes in the product development stages.

We believe it is important to recognise the aesthetic freeform features on freehand sketches realized in the first ideation phase and using them for 3D modelling into a computational tool able to represent the design model in the same way it is generated in the designer's mind. This assumption needs a practical solution correlating the designers' creative strategies with the more suitable design computational tool and a coherent a 3D modelling method to preserve the design intent.

The problem formalization is reported in figure 1.

Fig. 1. The problem formalization

Approach to map creative strategies and digital design technologies

The proposed approach is based on the following steps:
- classification of the creative strategies for freeform objects conceptualization and related means to transmit design intent;
- classification of freeform object modeling methods and technologies;
- definition of metrics to evaluate the technology in relation to the creative strategy;

- experimentation on test cases to determine the metrics value for different combinations (technology and strategy);
- determination of mapping matrix *design technology* vs *creative strategy*.

For each combination of creative strategy and computational design technology it is necessary to define also a proper method for virtual prototype creation. In this section we resume the first two classifications while in the next section we describe the metrics and their practical experimentation. In conclusion we report the preliminary benchmarking matrix.

The creative strategies classification

Designers rely on visual representations to generate and explore design ideas. Prats and Earl [16] demonstrate the reciprocal relationships between designers thinking and their representation: representations are consequence of thinking and thinking is stimulated by perception of representation. It is assumed here that there is also a relationship between concepts representation and the creative strategy adopted by designers to conceive the product shape. In particular freehand sketches serve as a tool to assist analogical and metaphorical thinking while physical prototypes, obtained by sculpturing malleable clay and foam, mainly support mutation strategy application.

Cross [17] identified four main strategies that can be adopted to generate design concepts: combination, mutation, analogy, emergence and first principles.

A freeform shape is the result of the deformation of global shape and it is generally characterized by a usually flowing asymmetrical shape or outline. We mainly focus on analogy and mutation as they are the creative strategies to obtain freeform shapes because:
- the first is based on the similarity relation between existing shapes often belonging to nature where forms are generally smoothed, no rational, and irregular;
- the second is based on the variation of an original shape due to specified strengths.

Freehand sketches and physical prototypes are central elements as concept means of representation respectively for analogy and mutation strategies.

Analogy

Among creative strategies, 'similarity-based' or "analogy-based" creativity attracts the most research interest that recognizes the key role of the

analogical reasoning in creative design [18], [19] (figure 2). Analogy involves accessing and transferring elements from familiar categories to use it in constructing a novel idea.

The mechanisms of similarity-based creativity, analogical and metaphorical, can be referred to as either 'juxtaposition of the dissimilar' or 'deconceptualization' [20]. The underlying idea is to put dissimilar concepts or objects so as to find new perspectives and create new meanings through their synthesis, moving away from similarity. Opposing, the "deconceptualization" mechanism preserves the associations but requires estrangement from the existing conceptualization and describing the object as if it is seen for the first time. New, spontaneous associations can then be originated either without any systematic guidance from outside or by creating by analogy and metaphor.

J. Laarman, Bonas chair V. Panton, Panton chair, by Vitra I. Maurer, Birds

Fig. 2. Example of analogical reasoning strategy application in industrial design case studies

The understanding of the similarity-based mechanisms clarifies the importance of associations for creative thinking. Creativity intensively makes use of concepts kept in memory and bound by associative relations.

Freehand sketching on paper stimulates analogy transfer, formal arrangements, structure mapping, and knowledge acquisition. [21], [22].

Mutation

Mutation seems to play an important role in determining the sensorial and emotional properties of the shapes (figure 3).

Advances in design and manufacturing digital technology have changed both designers and users imaginary: un-forms, blobjects, and free forms resulting from the adoption of mutation strategies in design, are the more intuitive outcomes of the post-information age, and at the same time, they look like primitive shapes as they draw several similarities with the or-

ganic and anthropomorphic forms found in nature. Motion may be considered as a perceived property of a shape in the same way of colors, textures, contours, etc. By mutation strategies designers imprint motion to shapes that visually reflect the creative way of idea generation. Complex transformations such as melting, expansion, stretch or compression, contribute to generate freeform shapes from primitive ones (e.g. sphere, cube, cylinder, etc.). Freeform shapes can be realized by sculpturing physical clay or foam. Perception is crucial in design and prototypes provide designers with a basis to stimulate perception. In mutation strategy application, physical prototyping seems to be a preferred mode of design representation to stimulate reinterpretation and emergence as sketches in analogy-based strategy. Foam modeling and woodcarving give designers new expressive freedom: they allow exploring material expression in the conceptual phase of the design process in a natural manner.

Fig. 3. Example of the use of mutation based strategy application in product and architectural design.

Freeform objects modeling methods

The definition of freeform aesthetic features is strictly linked to the CAD environment as they can be regarded as the key elements of shape modeling: they can be obtained by enveloping surfaces starting from some essential curves, called styling curves, that bound the overall shape, or by applying ing a sequence of deformations to a primitive shape.

A freeform virtual prototype can be generated [23], [24] by:

- editing a shape by deforming a primitive object (e.g. cube, sphere, plane, etc.) moving its control vertices;
- interpolating a 3D network of freeform curves that consist both of styling curves and characteristics curves such as boundary edges or internal edges;

- modeling by projecting planar sketches on different reference planes in the 3D environment.

While in the first case deformations are managed by the variation of the global shape control vertices, in the second case by the modification of enveloping curves parameters or of the control points of the generated surfaces.

Shape manipulations are often inaccurate and time consuming. They can be improved only if the semiotic contents are made explicit and CAD experts are able to identify which modeling methods allow the representation of the adopted creative strategy's outcomes and which elements should be modified.

The design technologies used for applying such modeling methodologies can be resumed as follows:

- surface-based CAD modeling systems that represent objects by NURBS mathematical surfaces;
- dynamic and physically-based CAD modeling systems that represent objects both as mathematical surfaces and voxel-based models.

A further main differentiation is relative to the available CAD systems that are characterized by different user interaction approaches as cited in section two, i.e. haptic systems, direct modeling etc.

Benchmarking method for design technology evaluation in relation to the creative strategy

In order to identify which digital technology better supports virtual prototyping, we define a benchmarking matrix that correlates available computational systems with the different creative strategies and the corresponding modes of representation. For each combination we analyze also a proper procedure for shape modeling.

Benchmarking is an accepted technique used to identify the strengths and weaknesses of a wide range of processes, products and technologies. It can be performed by defining a set of metrics as quantitative e qualitative estimates of the evaluation subjects.

Metrics for computational design systems evaluation

Metrics are defined to assess the performance of the computational systems for supporting the transformation of simplified models in nominal ones, for modeling freeform features and for interacting with virtual prototypes coherently with the design intent. We distinguish between design

system metrics and design process metrics. They are chosen because the firsts characterize the intrinsic features of the modeling system while the seconds highlight how the process is influenced by the specific system.

The main identified Design System Metrics (DSM) are:

DSM 1: 2D sketches usability in the modeling system

Assuming that sketching activity is generally performed in the ideation phase, both in mutation and analogy, the procedure for virtual prototyping starts from the recognition and extraction of the design intent from free-hand sketches in terms of styling curves and meaningful attributes.

Previous research works deeply faced the problem of design intent formalization by analyzing the evolutionary process of sketches and by adopting image processing techniques for extracting the styling curves in the different reference planes [25] (figure 4).

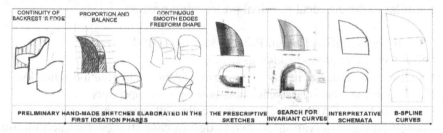

Fig. 4. Example of invariant curves searching by similarity measurement methods

The result of the design observation is that the styling lines look like the invariant elements in the evolution of the free-hand sketches. The design intent formalization is based on the research of these invariant lines in the same reference planes by measuring the similarity between the early sketches and the final ones. The matching result consists in the interpretative schemata that once extracted, are transformed into 2D B_Spline curves and projected in the 3D CAD modeling environment. Textual notes and graphic symbols play a crucial role in right scaling and positioning both free-hand sketches in order to extract invariant curves and interpretative schemata in the 3D CAD modelling environment. As they contain annotations about the overall dimensions of the product, they allow the dimensioning of all sketches in accordance with the 3D datasets measure, as they give information about the reference view to which they are related, they allow the comparison of early and detailed sketches and the recognition of the reference planes in the 3D CAD environment.

DSM 2: ease of setting both geometric and non-geometric constraints

CAD models need to be constrained in terms of continuity, curvature and tangency. Furthermore it is necessary to prescribe both qualitative attributes (fluency, sharpness, softness, etc.) and quantitative (dimensions).

DSM 3: ease and intuitiveness of freeform features modifications

The freeform features, generally, need to be modified according to the manufacturability but such modifications have to be realized through intuitive 3D modeling functionalities maintaining the initial intent.

DSM 4: user interface usability

The modeling commands and the resulting entities should semantically represent the designer's intentions; the user interaction modalities should be similar to the classical physical prototyping process.

The main identified Design Process Metrics (DPM) are:
DSP 1: time for freeform features modeling
DSP 2: number of design iterations necessary to achieve the solution validation
DSP 3: global number of aesthetic errors done by CAD operators
DSP 4: number of CAD models realized to collect all necessary information
Based on the observation of several design case studies, for each metric we assign a value from 1 to 5 in benchmarking matrix, and the total amount is used to qualify different technologies for the two analyzed creative strategies.

Experimental tests to metrics value determination

There are different methods of investigating the design process and the weakness and strengthens of the adopted technologies. For example "think-aloud" protocol is widely used in cognitive science, where participants are asked to talk during their work. In this experimental work we adopt a more informal method based on interviews and post-hoc questionnaire. We state that these methods are less intrusive than e.g. "think-aloud" and allow users to develop the specified task in their normal working spaces without the pressure to be videotaped.

Participants are engineering and industrial design students with different levels of product design expertise. Each of them has a good practice both of CAD-based tools and of haptic systems as they had attended specific courses. In particular tests are performed by students that have just at-

tended a course in Mechanical Design and by students that are at the end of a more advanced course of Industrial Design supported by CAD systems. Students belonging to each course are divided into small groups consisting of 4-5 members.

They were asked to develop a product design based on a specified brief and to represent the achieved solution by the different modeling technologies cited below. The work lasted two weeks and at the end they had to present a detail 3D model of the designed solution. They had at disposal all technologies for design outcomes representation (3D scanners, physical prototypes equipments, virtual reality lab, haptic devices, etc.) They were encouraged to produce both hand-made sketches and physical prototypes.

The focus is on four different computational systems for representing mutation and analogy strategy outcomes: CATIA by Dassault Systems that provide parametric surface modeling, Free Dimension based on n-sided surfaces (NSS) instead of non-uniform rational B_Spline surfaces (NURBS), Freeform by Sensable coupled with an haptic device and Rhinoceros software by Mc Neel that allows the NURBS modeling. The method is not limited to the considered elements. We choose them only for exemplifying the methodology. The four selected systems are usually used in real design processes.

Four different meaningful test cases are described in the following sub-paragraphs while the results are discussed in the next sub-section.

Case studies to represent mutation outcomes

Two different test cases have been studied: an armchair and a mini-car.

The first case study (CASE 1) is related to the re-styling of the armchair "Intervista designed in 1982 by Lella and Massimo Vignelli and produced by PoltronaFrau. Students were asked to modify the initial shape in order to meet new ergonomic requirements and make the chair more appealing while preserving the initial design intent.

As the designers used sketches to represent their ideas, students first analysed the evolutionary process of sketches and the textual notes and applied the method for design intent formalization in order to identify the creative strategy adopted by designers to conceive the initial shape. They observed that the freeform shape was obtained by enveloping a three-dimensional profile along a curve that defines the backrest. Aesthetic features communicate concepts such as continuity and proportion.

Some students preferred to realize a physical prototype of the armchair and deformed it by stretching the main functional elements until the backrest was divided in two main elements. This allowed the increasing of the

sitting dimensions. As they adopted a metallic net for physically model-
ling, reverse engineering techniques cannot be used to scan the prototype.

As more extensively reported in the next sub-section, the more perform-
ing solution has been identified in Catia. In fact, the group who used the
Imagine&Shape package of CATIA (figure 5) has achieved a good result
in a short time and without relevant process iterations. An initial sphere
containing the "Intervista" chair has been set and progressively stretched
by pulling the control vertices of the global shape. Interpretative schemata
have been projected on it in order to drive geometrical variations. The re-
sulting shape has been then exported into the parametric surface modeling
module for engineering developments.

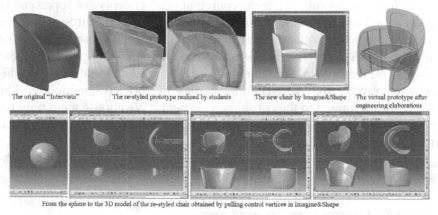

The original "Intervista" The re-styled prototype realized by students The new chair by Imagine&Shape The virtual prototype after engineering elaborations

From the sphere to the 3D model of the re-styled chair obtained by pulling control vertices in Imagine&Shape

Fig. 5. The re-styling process of "Intervista" chair by Imagine&Shape

The second case study (CASE 2) is related to the design of a mini-car
body. Some students preferred to directly realize a physical prototype by
sculpturing malleable clay and they simultaneously made freehand
sketches on paper to communicate the design outcomes. The resulting pro-
duct model has been then digitised by a 3D scanner in order to obtain a
cloud of points of prototype that can be used as reference for virtual proto-
typing. Sketches realized in the ideation phase have been compared and
similarity measures have been adopted to extract styling curves. These
styling curves have been then replicated as B_Spline curves in the corres-
ponding planes in the chosen 3D environment in order to manipulate the
digitised model coherently with the design intent.

As the shape has been conceived by deforming clay, the most effective
system resulted to be the haptic system.

The digitised model has been imported in Freeform software (figure 6);
it has been deformed and smoothed by a haptic device. The device lets
them to feel the surfaces continuity, touch them, and modify the model by

pushing, pulling and dragging its surfaces in a natural manner. Instead of working on construction curves, with the haptic device students can deform the model guaranteeing the continuity of surfaces. The styling curves have been used to drive deformation. In particular they have been used to subdivide the model into regions whose curvature can be modified. The consequent global deformation is coherent with the design intent as the styling curves remain the same while the surroundings areas are deformed.

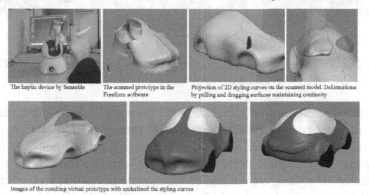

The haptic device by Sensable | The scanned prototype in the Freeform software | Projection of 2D styling curves on the scanned model. Deformations by pulling and dragging surfaces maintaining continuity

Images of the resulting virtual prototype with underlined the styling curves

Fig. 6. The design process of a mini-car by using FreeForm and the haptic device

Case studies to represent analogy outcomes

The mini-car design has been also used as third case study (CASE 3) since visual analogy has been also adopted to conceive the product shape.

Catia and FreeDimension have demonstrated the better applicability. Sketches realized at the end of the ideation phase have been compared with the thinking sketches and similarity measures have been adopted to extract 2D styling curves on the different reference planes. These curves have been then projected on the digitised shape using the Catia surface modeling environment in order to obtain a network of curves (both styling curves and characteristics curves helpful for surface reconstruction) to model the virtual prototype (figure 7).

Model modifications to achieve the final solution have been performed by the variation of characteristic and cross-sectioning curves parameters and by imposing constraints such as tangent and curvature continuity.

As analogical thinking was a prevalent strategy in one case of the mini-car design and only sketches have been used to represent design outcomes, the students successfully adopted an intuitive system that let them to reproduce the virtual prototype of the conceived shape in a manner that reflect the way the "fish" shape lashed-up in their mind.

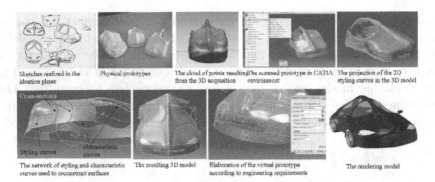

Sketches realized in the ideation phase | Physical prototypes | The cloud of points resulting from the 3D acquisition | The scanned prototype in CATIA environment | The projection of the 2D styling curves in the 3D model

Cross-sections

Styling curves | characteristic curves

The network of styling and characteristic curves used to reconstruct surfaces | The resulting 3D model | Elaboration of the virtual prototype according to engineering requirements | The rendering model

Fig. 7. The design process of a mini-car by using a parametric surface (NURBS) modeler (CATIA by Dassault Systems)

Extracted interpretative schemata have been replicated in the reference planes of a cylinder in FreeDimension software (figure 8). The boundary edges of the cylinder have been deformed until they had matched the 2D styling curves. The final shape is obtained by moving the control vertices of obtained 3D styling curves and of additional curves that were created to support freeform modeling and by imposing different vales of tangency to the network curves. At the end curvature analysis has been performed to check the quality of the achieved surfaces and improve it.

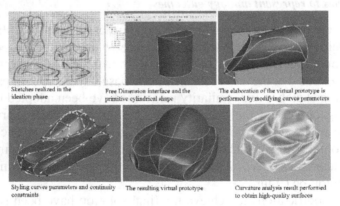

Sketches realized in the ideation phase | Free Dimension interface and the primitive cylindrical shape | The elaboration of the virtual prototype is performed by modifying curves parameters

Styling curves parameters and continuity constraints | The resulting virtual prototype | Curvature analysis result performed to obtain high-quality surfaces

Fig 8. The design process of a mini-car by using a parametric surface (NSS) modeler (FreeDimension by FreeDesign)

The final test case (CASE 4) consists in the design of a hairdryer. The creative process started from sketching on paper several hypotheses until a satisfying shape had answered to all design requirements in terms of size, dimensions, ergonomics, aesthetics, etc. A trajectory curves is used to sweep a rail along it in order to conceptually generate the hairdryer body.

The resulting shape visually recalls a strange animal's snout. Sketches have been compared and interpretative schemata have been extracted. The models have been successfully realised by Catia and Rhinoceros (figure 9). we report only the last case.

Sketches realized in the ideation phase

Interpretative schemata are projected in the corresponding reference planes in Rhinoceros

Planar B_Spline curves are projected in the 3D space to obtain the 3D model

The virtual prototype of the hairdryer after engineering developments

Rendering images of the resulting product design

The physical prototype obtained by RP techniques

Fig. 9. The design process of a hairdryer by using the NURBS modeler Rhinoceros by Mc Neel

Sketches have been imported into Rhinoceros in the corresponding views and replicated as planar B_Spline curves Each curve has been successively projected in the 3D space in order to obtain the 3D model.

Results discussion

On the basis of the experimental work and, hence, of interviews and post-hoc questionnaires analyses it has been possible to compile the following benchmarking matrix (table 2). The Design Systems Metrics values, from 1 to 5, are weighted (w_i), from 0 to 1, in relation of the importance of metric typology for the specific creative strategy (i.e. DSM 1, that is *2D sketches usability*, assumes a weight 0 for mutation, instead assume a weight 1 for analogy). In table 1 are reported the weights values.

Mutation strategy requires a software system able to deform shape in a very natural manner by looking at the styling curves for driving modifications. Both Imagine&Shape Catia module and FreeForm allow users to set the styling curves in the corresponding planes and elaborate the forms they work with as in physical sculpturing. The difference is that while in the first modifications are managed by the position of the control vertices of the global shape whose dimension can be set, in the second deformations are very similar to those performed on clay but dimensional control is not

allowed. The haptic system results highly usable and, definitely, the most effective for modeling of objects created by mutation strategies.

Table 1 Weights (w_i) relative to the different Design System Metrics for the mutation and the analogy.

	MUTATION	ANALOGY
DSM 1	0	1
DSM 2	0,7	1
DSM 3	1	0,7
DSM 4	1	1

Table 2 Benchmarking matrix between the considered available digital technologies and the creative strategies.

Systems / metrics values	MUTATION (CASE 1, CASE 2)				ANALOGY (CASE 3, CASE 4)			
	CATIA	RHINO3D	FREEDIM.	FREEFORM	CATIA	RHINO3D	FREEDIM.	FREEFORM
DSM 1	0	0	0	0	3	2	0	0
DSM 2	2,8	0	0,7	1,4	4	2	4	2
DSM 3	3	1	4	5	1,4	0,7	3,5	2,8
DSM 4	3	2	4	5	3	2	2	1
DPM 1	3	1	1	4	3	4	3	2
DPM 2	4	1	3	4	4	2	2	1
DPM 3	3	1	4	4	3	2	4	1
DPM 4	4	2	1	2	4	2	1	2
METRIC SUM	22,8	8	17,7	25,4	25,4	16,7	19,5	11,8

Regarding objects based on the analogy strategies, FreeDimension represents a software system able to model freeform surfaces with a minimal toolset instead of more complex parametric software packages (e.g. CATIA) where modifications need a high degree of specialization.

Advantages consist in the usability of the modeling tools to obtain freeform aesthetic features from the deformation of the styling curves and in the ease of modifications by controlling curves parameters and constraints. Otherwise, it lacks of real dimensional control and evaluation tools, getting closed to conceptual tools. It is difficulty usable for realizing a detailed virtual model, as it is not integrated within existing software packages for engineering developments. On the other side, CATIA modeler allows the surface reconstruction of the objects by interpolating the styling curves network and imposing constraints (e.g. tangency continuity, control points position, etc) to guarantee the preservation of the design intent. Modifications can be performed only if proper parameters and constraints are set. Time spent for shape modifications is longer then with FreeDimension, but at the end it is possible to develop the detail design without using additional tools.

Students' interviews highlight the ease of use of Rhinoceros and that the way of surface modeling is very similar to the creative strategy (analogy

and sweep-like technique) they adopted. The main difficulty consists in the modifications of the shape according to engineering requirements as it is not possible to manage and control styling curves parameters and impose aesthetic constraints.

Conclusions

The method proposed in this paper allows the identification of the more suitable 3D modeling computational system coherently with the creative strategy adopted during product ideation. Through this approach it is possible to improve the effective preservation of the designers' intent represented by sketches and physical prototypes along the 3D virtual prototype realization. The study is based on a benchmarking matrix where metrics values characterize the different design technologies in relation to the mutation and analogy taken as meaningful examples of creative strategies. The experimental case studies allowed a preliminary classification of technologies that has to be extended and improved. In particular, we verified that surface-based CAD systems can be successfully used to model shapes conceived by analogical reasoning strategies as they allow the definition of the styling curves starting from sketches analysis, while the haptic systems easily support the mutation principles by modelling shapes obtained by sculpturing physical clay.

The future work will be focused on the refinement of metrics in terms of weights used in table 1, on the analysis of further design software systems, and, finally, on the definition of a more extensive number of case studies to achieve a more robust and accurate characterization.

References

1. Crilly N, Moultrie J, Clarkson PJ (2004) Seeing things: consumer response to the visual domain in product design Design Studies 25: 547-577
2. Chan CS (2000) Can style be measured? Design Studies 21: 277-291
3. Mono R (1997) Design for product understanding Liber. Stockholm
4. Stevenson DA, Guan X, MacCallun KJ, Duffy A (1996) Sketching on the back of the computational envelope...and then posting it? AID'96 Workshop on Visual Presentation, Reasoning and Interaction in Design, Stanford University, USA
5. Jakobson R (1971) Language in relation to other communication systems. In Roman Jakobson (ed), Selected Writings 2: 570-579
6. Eco U (1976) A theory of semiotics. Indiana University Press, London

7. Jakobson R (1960) Closing statement: linguistics and poetics. In Sebeok (ed): 350-377
8. Oxman R (2006) Theory and design in the first digital age. Design Studies 27: 229-265
9. Lindsey B (2001,) Digital Gehry, the IT revolution in architecture. Birkhauser, Switzerland
10. Do EYL, Gross MD (1995) Drawing analogies: finding visual references by sketching. Proc. of ACADIA, Seattle WA: 35-52
11. Mengoni M, Mandorli F, Germani M (2006) Surface reconstruction method for reverse engineering based on aesthetic knowledge. Proc. of TMCE 2006: 251-262
12. Fontana M, Giannini F, Meirana M (2000) Free form features for aesthetic design. Int. J. of Shape Modeling 6(2): 273-302
13. Liu Y, Lim C (2006) New tectonics: a preliminary framework involving classic and digital thinking. Design Studies 27: 267-307
14. Bordegoni M, Cugini U (2006) Haptic modeling in the conceptual phases of product design. Virtual Reality Journal 9(1): 192-202
15. Horvath I, Tromp N (2003) Comprehending emotion language in shape conceptualization. Proc. of ASME/DETC 2003, Chicago
16. Prats M, Earl CF (2006) Exploration through drawings in the conceptual stage of product design. In JS Gero (ed), Design Computing and Cognition'06, Springer: 83-102
17. Cross N (1997) Descriptive models of creative design: application to an example. Design Studies 18: 427-455.
18. Vosniadou S, Ortony A (1989) Similarity and analogical reasoning. Cambridge University Press, Cambridge, UK
19. Goel V (1995) Sketches of thought. MIT Press, Cambridge, Massachusetts
20. Indurkhya B (1997) Computational modeling of mechanisms of creativity. In T Veale (ed), Computational Models of Creative Cognition, John Benjamins Publishing Co
21. Do EYL (2002) Drawing marks, acts, and reacts, toward a computational sketching interface for architectural design. AIEDAM 16(3): 149-171
22. Rodríguez A (2004) Cognitive analysis of relationships between analogies and sketches during idea generation in industrial design. Proc. of DCC'04, MIT, USA
23. Fontana M, Giannini F, Meirana M (1999) A free form feature taxonomy. Proc. of Eurographics'99 18 (3)
24. Langerak TR, Vergeest JSM (2007) A new framework for the definition and recognition of freeform features. J. of Engineering Design 18(5): 525-540
25. Mengoni M, Germani M, Mandorli F (2007) Reverse engineering of aesthetic products: use of hand-made sketches for the design intent formalization. J. of Engineering Design 18(5): 413-435

Conceptualizing Tangible Augmented Reality Systems for Design Learning

Rui Chen and Xiangyu Wang
The University of Sydney, Australia

New forms of combining tangible interfaces and Augmented Reality (AR) systems are the supporting technologies which can be devised to leverage the way learners develop skills/knowledge in the design process. The paper presents a theoretical framework which conceptualizes how tangible AR spatial interactive systems can be utilized to support cognitive development of design learning. The framework can be applied not only to evaluate existing tangible AR interfaces, but to conceptualize new prototypes for design learning activities.

Aims

Early research on tangible user interfaces focuses on the design of new systems. More recently, there has been a shift towards research based on theoretical and conceptual understandings of tangible interactions [1]. For instance, Ishii and Ullmer [2] developed a classic research framework that explores possible types of coupling between material and virtual representations through interactions from a data-centric view. The typical tangible user interface can be illustrated as in Fig. 1 from an example by the actuated workbench [3]. The traditional interactive tangible user interface provides feedback through video projection alone. The actuated workbench adds an additional feedback loop using physical movements of the tracked objects. Therefore, it provides an additional feedback loop for computer output, and helping to resolve inconsistencies. Users can observe each other's actions, and users can reach out and physically change the shared layout without having to grab a mouse or other pointing device.

Augmented Reality (AR) has attracted investigations as an alternative vehicle to facilitate learning. Doswell and Blake [4] built a Mobile Augmented Reality (MARS) e-learning tool with capabilities of adapting to

J.S. Gero and A.K. Goel (eds.), *Design Computing and Cognition '08,*
© Springer Science + Business Media B.V. 2008

various learning environments with considerations of cultural, geographical and other contexts about learners. AR training/learning systems have been developed in the area of military combat [5], training in industrial maintenance [6], and school education [7]. However, an existing gap between the lab and practical use for Augmented Reality was identified. The concept of Augmented Instructions that mixes AR and traditional printed materials therefore emerged. For instance, Wagner and Barakonyi [8] developed educational software that uses collaborative AR to teach learners the meaning of kanji symbols. Certain study [9] has been carried out to explore the potential strengths and limits of AR as a means of engaging and educating students who traditionally perform poorly in school.

Fig. 1. The Actuated Workbench based on tangible user interface [3]

Combining the tangible user interface and AR systems into tangible AR-based learning environments can present objects with natural affordances for supporting interactions. Tangible AR can enable learners to acquire concrete learning experiences through active experimentation. Students can actually 'experience' theory in a more familiar form, since the practical experiment enables the students to "observe and reflect on" the results of learning tasks and assignments. This theoretical process provides potentially beneficial categorizations of design learning activities with tangible AR interfaces. High integration of representations from visual and haptic stimulus is unique feature of tangible AR systems which exposes learners

to multi-channels from the concreteness and sensory directness. For example, a common discussion context consisting of same set of physical objects and public screen can then be created to physically bind everyone for more effective communication and discussion. Everyone has equal access to the tangible AR interface. They can easily do comparative work with concurrent interaction which leads to effectiveness of collaborative learning activities compared to the typical desktop setup with mouse and keyboard.

This paper developed an analytical framework of conceptualizing and integrating tangible Augmented Reality into design learning. This framework, which intends to inform tangible AR system design, is developed by considering notions from both cognitive development and educational theory. The relevance of the design of computational artifacts to the above two areas are identified and integrated into the framework, more specifically into the aspects of tangible and spatial interactions. A tangible AR prototype is also conceptually specified in the paper. The proposed prototype mainly focuses on supporting the design learning activity based on experiential and collaborative learning theories. From the practical perspective, tangible AR systems developed based on this framework, can be integrated into design education curriculum as a supplementary teaching aid.

Significance

Like a constructivist view on learning, meaning is created through interactions. Broader characterizations of tangible interfaces have been instantiated in design frameworks which concentrate on the design of the interaction itself [10]. Design frameworks which focus on spatial aspects were also considered [11].

A design framework should be developed to consider learners' physical, social and spatial interactions. To tackle this issue, integrating tangible interfaces and AR could be one promising technology option. The framework presented in this paper is the first attempt to address this gap, which can inspire and inform the design of interactive technologies for learning. The significance of the presented work is a focus on the theoretical framework for guiding the design of tangible AR systems, rather than merely on system development. This theoretical framework establishes design principles and produces methodological guidelines for creating effective tangible AR systems by integrating knowledge from various fields that address the human factors (perceptual, cognitive, and characteristics of real and virtual learning in design discipline), information visualization, information tech-

nology (hardware, software, communications), human-machine interaction, and learning theories. This theoretical framework also provides potentially beneficial categorizations of design learning activities with tangible AR interfaces.

Framework

The theoretical framework depicted in Fig. 2 addresses four knowledge domains from cognitive science, design process, tangible AR technology and learning theory.

Fig. 2. Theoretical process for applying tangible AR concept and technology into design learning

A response to behaviorism [12], people are not "programmed animals" that merely respond to environmental stimuli, since people are rational beings that require active participation in order to learn, and whose actions are a consequence of thinking. The term "cognitive science" is used for any kind of mental operation or structure that can be studied in precise terms [13]. Changes in behavior are observed, but only as an indication of what is occurring in the learner's head. Cognitivism [14] uses the metaphor of the mind as computer: information comes in, is being processed after the stimulus. There is an essential argument from cognitivist paradigm [14] that the "black box" of the mind should be opened and understood.

The learner is viewed as an information processor (like a computer). Opening the "black box" of the human mind is valuable and necessary for understanding how people learn. Mental processes such as thinking, memory, knowing, and problem-solving need to be explored. The framework in Fig. 2 shows that tangible AR systems are the stimulus to the learners, the brain is like the processing continuum (see Fig. 2) which includes the reflective observation through watching and the hapic feedback from feeling. These give concrete experience based on the perception which gives abstract computation. After the active experimentation, this can lead to certain response which can benefit some possible learning activities from playful, reflective, situated and interactive aspects (shown in Fig. 2). Knowing a person's (and your own) learning style enables learning to be orientated according to the preferred method. That said, everyone responds to and needs the stimulus of all types of learning styles to one extent or another - it's a matter of using emphasis that fits best with the given situation and a person's learning style preferences.

The framework focuses on supporting learning practice based on experiential and collaborative learning theories. Tangible AR learning space offers a richer form of experiential learning not available previously. Tangible interfaces can provide tactile sensational feedback and Augmented Reality visual interface can enhance human's perception of digitalized feedback from such interaction. This combination directly provides concrete experience. Learners receive the stimulus through the processing continuum which contains the broad diversity of learning styles ranging from constructive to analytical learning.

Learning Styles

Specific learning styles which are identified from Kolb's four-stage learning cycle (shown in Fig. 3) [15] is mapped onto the sequence of the processing continuum as shown in Fig. 2. Various factors influence a person's preferred style: notably in his experiential learning theory model, Kolb defined three stages of a person's development, and suggested that our propensity to reconcile and successfully integrate the four different learning styles improves as we mature through our development stages. The theory establishes a cyclical model of learning which consists of four stages as outlined in the Fig. 3. One may begin at any stage, but must follow each other in the sequence.

Kolb's four-stage learning cycle [15] represents how experience can be translated through reflection into concepts, which in turn are used as guides for active experimentation and the choice of new experiences. The

major four learning styles are abstract, concrete, active and reflective learning. The model is an iterative learning cycle within which the learner tests and modifies new ideas and concepts as a result of reflection and conceptualisation. One of the critical issues in educational methods is that the teaching style offered does not always significantly addresses the learning style preferred by learners. It is therefore useful to combine different teaching methods/techniques to cover different aspects of what needs to be learned.

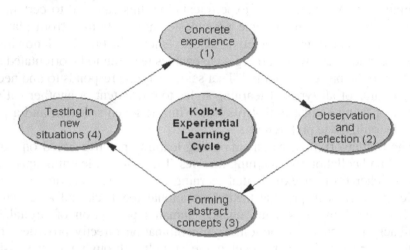

Fig. 3. Kolb's Experiential Learning Cycle [15]

The first stage, concrete experience, is where the learner gains active experiences through an activity such as a lab session or practical work. A learning process begins with a concrete experience, which is then followed by the second stage; reflective observation is when the learner consciously reflects back on that experience. The reflection can then be assimilated into a theory by the process of abstract conceptualisation The third stage, abstract conceptualization is where the learner attempts to conceptualize a theory or model of what is observed. The last stage, active experimentation is where the learner is trying to plan how to test a model or theory or plan for a forthcoming experience. New or reformulated hypotheses are tested in new situations.

Four learning styles have been identified by Kolb [15] which correspond to these stages. The styles give a highlight of conditions under which learners learn better. These can be categorized to the styles as below: Assimilators are the people who learn better when presented with sound logical theories to consider. The assimilating learning preference is for a

concise, logical approach. People with an assimilating learning style are less focused on people and more interested in ideas and abstract concepts. People with this style prefer readings, lectures, exploring analytical models, and prefer to have time to think things through. Convergers are those who learn better when provided with practical applications of concepts and theories. They mostly prefer to technical tasks, and are less concerned with people and interpersonal aspects. People with a converging learning style pay more attention to technical tasks and problems than social or interpersonal issues. Another style comes up with accommodators. These people learn better when provided with "hands-on" experiences [15]. The accommodating learning style relies on intuition rather than logic. These people desire to conduct a practical, experiential approach based on previous people's analysis. People with an accommodating learning style prefer to work in teams to complete tasks. They set targets and actively work in the field trying different ways to achieve an objective. Last category is divergers. They learn better when allowed to observe and collect a wide range of information. Particularly, they usually prefer to watch rather than do, tending to collect information and use imagination to solve problems. People with a diverging learning style have broad cultural interests and enjoy gathering information. People with the diverging style prefer to work in team, to listen with an open mind and to receive personal feedback.

Design Development

Design learning inherits certain features of design development. The typical design process was also analyzed and featured as a spiral process as shown in Fig. 4 to model how the various design elements fit together [16]. It can be extended to model how the various elements involved in design learning and development fit together. For tangible Augmented Reality systems, the initial mental image/model is perceived and constructed visually from reflective observation (Augmented Reality) and tactilely from tangible feedback (tangible interface). For each cycle along the spiral design process, designers proceed through by presenting, testing, and re-imaging responses to a set of related problems. Abstract concepts are then reinforced by this continuous combined feedback from visual and tactile channels. Designers then converge the current abstract concept to the active experimentation. Following the above immediate action, they return to problems that have already been studied to revisit earlier decisions throughout this design activity. The output is the knowledge gained from the expressive, playful, reflective, situated and interactive learning activities from tangible AR systems.

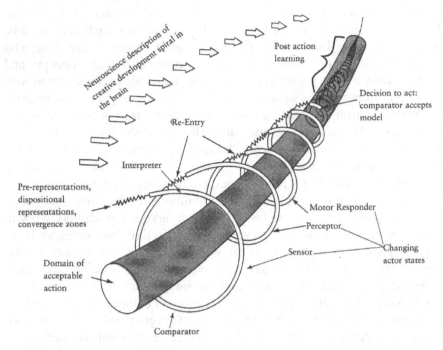

Fig. 4. Design Development Spiral [16]

Physicality

This section brings together a multi-disciplinary group of knowledge towards the central physicality [17]. It is necessary to dig more deeply into the nature of physicality itself. Physical objects impress people mentally. There are two issues which have been raised that how physicality plays a role in traditional computer-aided design and the other way round. Three properties of 'ordinary' physical things – that is inanimate, non-mechanical, 'natural' things. There are three aspects extended from the properties: directness of effort, locality of effort and visibility of state [17]. These aspects can explain the reason why the visual and tactile feedback can give the concrete experience provided by the tangible AR system, impact either explicitly or implicitly. The way designers design requires an understanding of how learners apply principles of cause and effect from the physicality. The design of tangible AR systems which do not conform to these principles may trigger confusion, disinterest or reflection. These properties lead to identification of centre-movement-expression (see Fig. 5). For example, when we press the door bell, we expect to hear the ring tone and

later hopefully some responses from the inside or somebody opens the door, but if we won't get any feedback, people usually will try to press the door bell again. From this simple case, we see the physicality has direct and central influences on the movements related to the locality change from outdoor to indoor and even the aural spatiality. Spatiality is another property of tangible AR systems, which provides space for actions where they affect computation. It is unlike traditional desktop systems which utilize an indirect-mapped controller, typically mouse and/or keyboard for input, tangible AR systems afford opportunities to capitalize on human's developing repertoire of physical actions and spatial abilities for direct system input and control. For example, theme parks and interactive exhibitions in museums, art galleries and science centers have created a rich tradition of creating environments which respond to human's actions and movement.

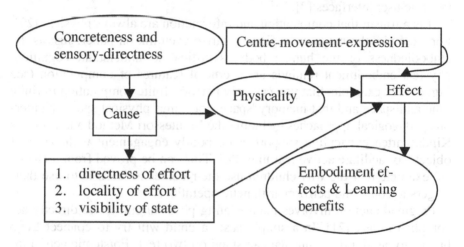

Fig. 5. The physicality between cause and effect

However, little is known about how to design these augmented reality environments specifically to support cognitive development of learning. Design requires an understanding of how and why people's actions in space are related to cognitive developmental change.

Embodied Cognition

The embodiment from cognitive science suggests that there are some stronger linkers between physical activity and cognition [18]. Tangible AR

systems are envisaged to offer more opportunities for learners to increase the physical activities which prove to influence and constrain cognitive process [19]. While learners perceive visual representations from AR systems and tacitly feel physical materials from tangible interfaces, perceptual and motor responses are complemented to offer a more accurate assessment of the current learning outcome. Such alignment/matching in turn tightly inter-leave the perceptual and cognitive processes together. Materializing knowledge into physical forms can also help learners to further advance the understanding of those purely gained from written media. Several informal evaluations of tangible AR systems [2] [7] for learning have been highlighted the integration of physical and digital representations as an important distinction between representations. Spatial and temporal relationships between representations are defined as the integration. The integration of representation has also been outlined as one of features for tangible user interfaces [2].

It is a truism that computation and information are always physical [20]. For example, the magnetic regions polarize even ink on paper. Just as the embodiedness of the human body is critical to understand cognition, physical embodiment reminds us of crucial features of computation (see Fig. 6). For example, that you can only perform finite computation in finite time and space and that memory 'space' consumes physical space. Numerous pedagogical approaches including the Montessori Method and Frobel's Kindergarten curriculum support using bodily engagement with physical objects to facilitate active learning [20]. This can be proved from a classical example that the way children use their bodies to learn is to use their fingers to count and perform arithmetic operations.

Pragmatic action involves manipulating physical entities to directly accomplish a task [21]. In a simple case, a child will try to connect Lego blocks to build a dinosaur that can stand on two feet. Epistemic action involves manipulating physical entities in order to change the nature of the cognitive operations necessary to complete a task. For example, a child may consider spending the amount of time to connect and disconnect Lego blocks to better understand how different configurations relate to the stability of their creation.

Conceptualizing Tangible AR Systems

This section presents the conceptualization of a tangible AR prototype based on the framework. It is highlighted that tangible manipulation is bodily interaction with physical objects. These objects are coupled with

computational resources [22], allowing users to control computation by fusing familiar desktop utensils, two-dimensional computer desktop applications, and three-dimensional models, we provide a seamless transition from the traditional 2D computer desktop to a 3D augmented working environment. Two hexahedral objects are attached together to create the new tangible AR interface. The shape of the new tangible AR interface removes the restriction of user's motions in existing tangible AR interfaces. Users can move and rotate the new interface freely to manipulate virtual objects in AR environment. This improvement is useful for applications that require unrestricted rotation motions of virtual objects. A user navigating the virtual environment using the two hexahedral objects interface, a virtual block is added or removed from the corresponding position of the destroyed building in the virtual environment can easily get the affection from the other view. This mode ends when users complete putting all the blocks in the right place on the broad.

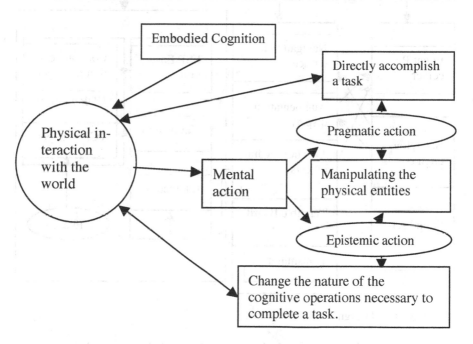

Fig. 6. The relation between the physical worlds to the embodied cognition

System Architecture

Fig. 7 shows the overall architecture of the tangible AR system that displays the event and messages flow among the sub-components of the system. It consists of the context server for managing the main logic, the virtual environment and the tangible interfaces for user navigation and interaction. The context server includes the communication manager for the event and message handling among the sub-systems. The augmented reality environment shows the reconstructed urban area (such as buildings, parking spots, trees and roads) with vivid sounds. It also contains user interaction and event processing modules for state update by the context server and the tangible interfaces.

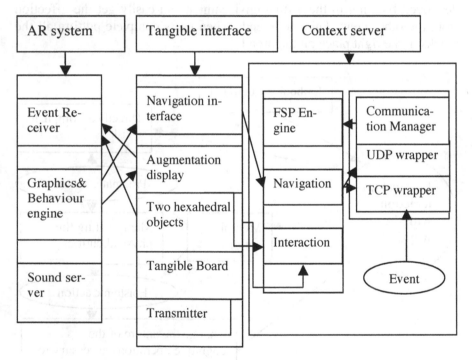

Fig. 7. System Design

The tangible interfaces include the augmented display and the navigation interface for navigation and the broad interface for user interaction in the augmented reality environment. Navigation interface allows learners to walk through the pre-designed area along with the virtual urban area. The augmentation display shows the overview of the open area and the user's current location in the virtual environment. It allows user to draw a path on

the map with their hands to navigate in augmented reality environment. The advantage of using this system design is to emphasize the physical interaction with the world as mentioned in the section of embodied cognition. When the learner performs the physical activities in the virtual urban area, their hands directly interact with the physical objects which improve the influence to cognitive process. In another word, the physical and digitalized learning material has been integrated into the representation. The board interface adopts the Teris puzzle game metaphor. It allows users to modify the structure of the buildings using various tangible blocks. Each block position is detected by 10*10 PIC micro-controller driven switch unit. Each micro-controller cell unit controls LEDs and switches. The board interface is connected to the communication manager by TCP.

System Setup

Fig. 8 is the sketch for the setup of the tangible AR system and it illustrates the practical system configuration. Underneath the table is a projector for a table display and a camera for tracking the hexahedral objects. It considers one aspect of interface principles, which is seamless interaction with an AR system. That is created by aligning two hexahedral objects as shown in Fig. 8 with markers. Eighteen distinguishable markers are attached to the block, so it can be viewable from the camera of the AR system at any orientation as long as the block is located inside the viewing area of the camera. The camera views the block, and the AR system detects markers on the block and estimates pose of the block using the detected markers. The block provides natural interactions with users. Users can hold the block and move or rotate it freely to manipulate the corresponding virtual objects. At least one side of the block is always visible to the camera as long as the interface is viewed by the camera. Learners can also hold the block with one or two hands not occluding all markers on the block. This helps to increase the physicality described in the previous framework. It directly effects on the concreteness and sensory-directness. As stated before, the way designers design requires an understanding of how learners apply principles of cause and effect from the physicality. Physical objects can impress people mentally so when the learners play around with the blocks meanwhile they also receive visibility from different broad. These helps them learn fast and understand better in space which is related to cognitive developmental change.

The camera under the table is only used to track object's position and orientation. Under the table, a mirror is equipped to extend the line of sight of the projector and the camera. Beside the table, the augmentation display

shows virtual graphical models augmented on the scene of the real table captured from the camera above the table. The upper camera is also used to track the 3D position and orientation of tangible interface. This more naturally engages learners to the learning activities since three aspects from the directness of effort (manipulating the physical objects), locality of effort (recognizing the orientation from the Augmentation display) and visibility of state (overview from the navigation display) are supported to some extent.

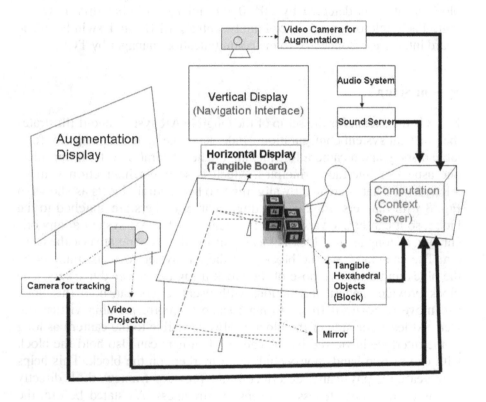

Fig. 8. Setup sketch for tangible AR system

Summary

This paper presented a theoretical framework which investigates how tangible Augmented Reality systems can be utilized to support cognitive development of design learning. The framework was developed by considering

different learning styles, design development theory, physicality and embodied cognition. The framework can be applied to conceptualize new tangible AR prototypes for design learning activities. It can also be used to evaluate existing tangible AR interfaces. The paper also presented a proposed tangible AR system, based on the framework. In order to verify its applicability, future work will apply this framework to a wider variety of cases in design learning.

References

1. Holmquist L, Schmidt A, Ullmer B (2004) Tangible interfaces in perspective: guest editors' introduction. Personal and Ubiquitous Computing 8(5): 291-293
2. Ishii H, Ullmer B (1997) Tangible bits: towards seamless interfaces between people, bits and atoms. Proceedings of CHI 1997, ACM Press, pp. 234-241
3. Pangaro G, Maynes-Aminzade D, Ishii H (2003) The actuated workbench: computer-controlled actuation in tabletop tangible interfaces, Proceedings of the 15th annual ACM symposium on user interface software and technology, October 27-30, Paris, France
4. Doswell JT, Blake MB (2006) Mobile Augmented Reality system architecture for ubiquitous e-Learning. Fourth IEEE International Workshop on Wireless, Mobile and Ubiquitous Technology in Education - (WMTE'06)
5. Department of Defense (2002) Augmented reality for ship survivability, live fire test and training program. url: https://www2.afams.af.mil/programs /projects/lftt/projects/aug_shi.htm, last update April 2005
6. Schwald B, Laval B (2003) An augmented reality system for training and assistance to maintenance in the industrial context. Journal of WSCG
7. Kaufmann H, Schmalstieg D, Wagner M (2000) Construct3D: a virtual reality application for mathematics and geometry education. Education and Information Technologies 5(4): 263-276
8. Wagner D, Barakonyi I (2003) Augmented reality Kanji learning. Proceedings of the Second IEEE and ACM International Symposium on Mixed and Augmented Reality, Tokyo, Japan
9. Asai K, Kobayashi H, Kondo T (2005) Advanced learning technologies. Proceedings of ICALT: 213–215
10. Hornecker E, Burr J (2006) Getting a grip on tangible interaction. Proceedings of CHI 2006, ACM Press:437-446
11. Bongers B (2002) Interactivating spaces. Proceedings of 14th Annual Conference on Systems Research, Informatics, and Cybernetics, Baden, Germany
12. Pavlov IP (1927) Conditioned reflexes: an investigation of the physiological activity of the cerebral cortex
13. Lakoff G, Johnson M (1999) Philosophy in the flesh. Basic Books, NY
14. Luger G (1994) Cognitive science: the science of intelligent systems. Academic Press, San Diego

15. Kolb DA (1984) Experiential learning: experience as the source of learning and development. Prentice Hall, New Jersey
16. Zeisel J (2006) Inquiry by design: environment/behaviours/neuroscience for architecture, interiors, landscape and planning, second edition. WW Norton, New York
17. Kamaruddin A, Dix A (2006) Understanding physicality on desktop: preliminary results. First International Workshop for Physicality, Lancaster
18. Barsalou LW, Wiemer-Hastings K (2005) Situating abstract concepts. In Pecher, D and Zwaan, R (eds), Grounding Cognition: The Role of Perception and Action in Memory, Language, and Though,: Cambridge University Press, Cambridge
19. Barsalou LW, Niedenthal, PM, Barbey, A, Ruppert, JA (2003) Social embodiment. The Psychology of Learning and Motivation 43: 43-92
20. Antle AN (2007) Child-based personas: need, ability and experience. Cognition, Technology and Work, Special Issue on Child Computer Interaction: Methodological Research, Springer, London
21. Klemmer S, Hartmann B, Takayama L (2006) How bodies matter: five themes for interaction design. In Proc. DIS 2006, ACM Press: 140-148
22. Ullmer B (2002) Tangible interfaces for manipulating aggregates of digital information. PhD thesis, MIT Media Lab

Generative Fabrication

Daniel Cardoso and Lawrence Sass
Massachusetts Institute of Technology, USA

This paper puts forward the concept of Generative Fabrication as a framework for exploring the potential of material and device-specific design grammars to act both as machine-readable information and as platforms for creative design exploration. A series of experiments and prototypes are presented and discussed.

Aims

The main aim of this research is to put forward the concept of generative fabrication as an integrated computational framework for both generative design exploration *and* prototype fabrication. The role of bottom-up design generation is thus considered in addition to, and as an alternative to, top-down design methodologies where computer programs or manual labor are used to subdivide an initial shape into a set of distinct building components. Furthermore, a formalization of the trade-offs inherent to a generative grammar where design and construction logic overlap is attempted.

Significance

Encoding design and construction information in a single digital entity has been object of many efforts in the field of design and computation [2,7]. Rather than having to create separate descriptions for different fabricators or contractors, the collapse of design and construction data into a single information package promises to achieve greater simplicity and to add control in construction processes [11].

Much of the research around such integrated descriptions, however, relates to the way such data structures can store the vast amount of information required to design complex projects, but few of them deal with the

implications of this emerging type of description for design exploration and reasoning. This paper present a series of experiments and prototypes that explore ways for both design and construction logics to overlap and dialogue. Their potentials and limitations are discussed, and a series of conclusions are extracted as steps towards the definition of the Generative Fabrication framework.

Methods

Single Material Assemblies

Single-material assemblies for digital fabrication (SMAs) have been a topic of exploration in recent years [1, 3 and 8]. The logic behind SMAs in these works is to avoid juncture-only elements. This is achieved by creating notches and slots along the pieces that constitute the design language in order to produce a friction-based system of assemblies comparable to a LEGO kit, or a 3D puzzle. By relying solely on friction joints other materials like glue or nails are deemed unnecessary, and therefore the complexity of the fabrication and assembly processes is significantly reduced. The relevance of SMAs draws also on the assumption that in the close future digital fabrication devices will be cheaper and more accessible, having effects on the building industry of developed countries, enabling communities to engage in cheaper and quicker design-to-construction processes. Under the light of these premises defining computational methods and procedures, as well as a solid theoretical framework, that enable creative design exploration using SMAs becomes a worthy arena of research. The following sections describe the computational methods used to develop a generative grammar for SMA fabrication under these ideas.

Using SMAs are used to reduce the conceptual complexity of the digital models and because of the possibility of fabricating them in the lab using a single machine. This simplicity grants us the ability to focus on the design reasoning afforded by the design language, and on formalizing the trade-offs inherent to it.

Digital Fabrication

The work presented in this paper builds on the knowledge gained in the projects mentioned above, and specifically on the wood frame grammar project [10] where the prototypes were constrained to 2D cutting tech-

niques including water-jet cutting, plasma cutting, CNC cutting, and laser-cutting. All the prototypes in this paper were fabricated using a Universal Laser Systems X-660 laser cutter (50 watt), which employs a laser of adjustable power and speed to cut planar sheet materials. This machine is capable of cutting sheets with a maximum size of 32x17in, and of variable thickness depending on the material employed; the machine is typically used to cut materials such as chipboard, plywood, balsa wood, masonite, acrylic, and Plexiglas. The prototypes presented in this document were built using 1/8" thick plywood and 1/16" thick cardboard.

A defining characteristic of this machine is that it is "two-axis", which means that the arm that carries the cutting device (the laser) can only move in the X and Y axis. This characteristic constrains the laser cutter to make orthogonal cuts on the sheet of material. Machines of 3, 4 and 5 axis that can vary the angle of the cut are available in the market at greater expense. The machine is physically connected to a computer equipped with a CAD software system (ACAD 2004), that sends instructions to the laser cutter to perform the cuts as specified in a loaded drawing file. The process is similar to printing a document in an inkjet printer.

When cutting, the laser beam burns part of the material. This burned section needs to be considered in the preparation of the file, as the amount of material that gets burned by the laser depends on the type of material, and on the power and speed of the head, as well as the age of the lens and other contingencies. For detailed descriptions of different digital fabrication technologies refer to [12].

Computer Aided Design Systems

There are several computer aided design systems in the market. For the purposes of this document we will separate them into two categories, even though the line that divides them is not entirely clear.

Solid Modeling and Drafting Systems

Exemplified by software packages like AutoCAD and Micro Station, these packages are often regarded as "traditional" CAD systems because they can be seen as evolved, automated versions of the traditional drafting table of the architect or engineer. The notion of computer aided design as an automation of hand drawing and drafting methods was the guiding idea in the early development of these tools, which evolved from the practical necessity of managing large amounts of information on designs in a faster

and more efficient way than paper allows[1]. In contrast with parametric modeling packages (the second category, described in the next section), solid modeling and drafting packages are primarily non-hierarchical and non-relational. This favors a type of design moves based on design transformations and operations such as copy, array, mirror, rotate, etc., and prevents almost completely the relational propagation of changes. The solid modeling and drafting package used for the first set of experiments is AutoDesk AutoCAD 2007.

Parametric Modeling Systems

The second category of CAD systems is parametric modeling systems, also can be described as relational modeling systems; these allow users to define geometrical entities by establishing relationships of geometrical or mathematical dependency between different elements of the design. Two examples of CAD systems often referred to as parametric are CATIA, developed by Dassault Systemes for the airplane industry[2], and Generative Components, developed by Robert Aish at Bentley as a parametric plug-in for the solid modeling and drafting package Micro Station.

Parametric modeling is highly hierarchical, partly due to a distinction between a driving geometry, generally a small set of geometric elements and parameters that govern the behavior of the whole model, and a driven geometry, a set of elements that responds and changes in accordance to the dictates of the driving geometry, within the global and local constraints defined in the model.

This hierarchy favors a top-down design manipulation (the changes in the general shape are *propagated* to the parts) over a bottom-up (the changes on the overall shape are given by the *addition*, *subtraction* or *interaction* of elements).

The power of a good parametric model is that once the constraints and chains of dependency are defined by the designer, the driving geometry can be changed in order to produce design variations that retain the logic

[1] Ivan Sutherland's Ph.D. thesis at the Massachusetts Institute of Technology, the Sketchpad, is the ancestor of modern CAD systems [15], consisted of a screen where the user could draw on using an optical pen. From that point on, and until very recently, the evolution of the interaction between the user and the machine as CAD systems developed can be described as a constant strive to mimic the interaction between the designer and his/her physical drafting table and drawing tools.

[2] CATIA was later adapted to aid in the architectural practice Gehry and Partners through a partnership between Dassault Systemes and what later became Gehry Technologies headed by Dennis Shelden

of the constraints. To the eyes of many professionals, the flexibility afforded by parametric modeling makes these systems "the future of architecture". This enthusiasm is notable since only very few firms in the world actually use parametric modeling packages due to their high prices and to the very high level of training required from both the designer and the fabricator: only expensive specialists can take full advantage of them [16].

The parametric modeling system used for exploring the possibilities of the grammar was the student version of CATIA V17 by Dassault Systemes.

Results

Pre-Rational logic

The term "pre-rational" makes reference to a design strategy in which the components for the construction are defined beforehand. In contrast, in a post-rational process a global shape is approximated by geometric strategies to infer the set of components needed for its construction. For a discussion on the origins and meanings of these two terms see [5]. Shape Grammars [13 and 14] provide a framework suitable for the formalization of design languages.

Lexicon

A morphological subdivision of an abstract box in corners, walls and end-walls returns a set of three basic lexical elements. A grammar composed of these elements can be used intuitively to compose spaces, like a LEGO kit.

The lexicon of the grammar is composed of a set of three compound types, which in turn are composed of a total of 9 different basic types or *morphemes*. The sequences of assembly are studied so that there is only one assembly vector in each assembly move. These sequences are meant to be deterministic derivations of grammar rules. The compositions of a design with this set of building blocks can be, however, open to many choices.

The elements of the vocabulary are defined geometrically with the tools provided by the software; the geometric definition of these objects is stored.

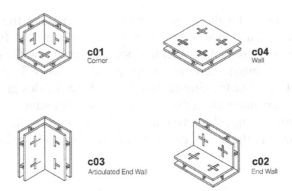

Fig. 1. Lexicon

Morphemes

It is important to note that the strategy explained above carries a great deal of implications for the designs, and is a design decision in *itself*. Other abstract strategies will result in a different "universe" of designs that can be generated by using the grammar rules. Some interesting alternatives were explored by the participants of the Special Problems in Digital Fabrication Workshop at the Massachusetts Institute of Technology in the spring of 2007.

The morphemes of the grammar were inferred from the abstract box morphology of the previous section, and defined to respond flexibly to many conditions.

Transformation rules

In a generative process such as speech the application of transformation rules on the elements of a grammar is non-deterministic, and therefore can produce an infinite number of outcomes. In a grammar-based generative design process, rules of transformation provide the framework for generative design, yielding a potentially infinite number of objects through opera-

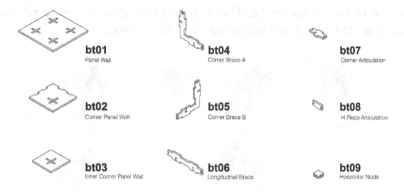

Fig. 2. Morphemes

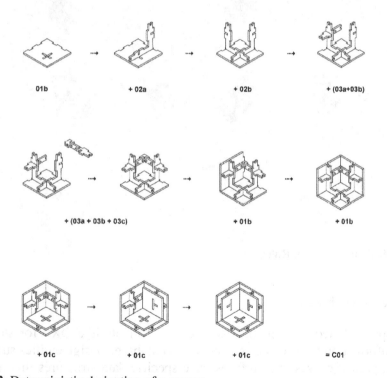

Fig. 3. Deterministic derivation of a corner

tions such as addition and subtraction on the elements. Furthermore, relationships of dependency between different values in the grammar can propagate changes parametrically, providing the framework for affording

variation of the global shape. This will be evidenced through a relational model built in CATIA and described in a later section.

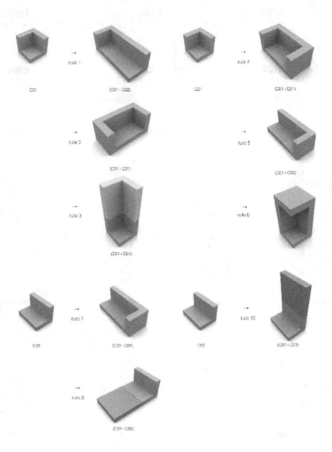

Fig. 4. Transformation Rules

Material Digitization

Computer Aided Design software uses file formats like DXF for storing the information for each design entity in a database. Design entities such as lines, points, curves and surfaces have specific data structures that allow the geometry to be constructed and reconstructed mathematically in the modeling environment. This section shows how the understanding of material behavior affects the digital representations of the morphemes and the lexicon. In order to make the elements of the vocabulary flexible to global changes, these data must be defined in terms of mathematical relationships

between different data fields, or as a function of a global parameter that stores information about the material and structural issues, or about the particular fabrication method of the element.

The generality of the description will afford the versatility of the system to operate at different scales and materials (for example 1/32" chipboard, 1/8" Plexiglas, or 1 inch plywood). The parameters taken into account in the grammar are a) Tolerance b) Thickness of material c) Size of the slot d) Distance between slot and end of the piece e) Depth of the slot f) Distance between slots. Material properties, however, do not scale linearly, and the basic behavior of the material used needs to be understood, as is shown in the following sections.

Dealing with Friction

The objective was to study the relationship between the length of the connecting piece (and therefore the friction area of the joint), and the strength of the connection. A key component of the grammar is the H-joint. In order to find an adequate dimension a series of tests was conducted on several instances of the joint in different sizes.

This study took into account vertical loads only. It was done using the Instron machine at the Lab. This machine measures accurately the strength required to pull apart the joints. The goal is to find a joint size that a) is not loose but still b) can be assembled manually. The Coulomb experiment yielded the friction coefficient of plywood. The experiment consists in finding the angle at which a surface is, when an object placed on it starts sliding. Although the friction force is not a function of the area, it is a function of the weight understood as normal force. u = angle, which in the model is determined by the pressure exerted by the braces caused by the tolerance of the joint.

The measurements and experiments resulted in an adequate value of 1/8 in for the H-joint piece, and a tolerance of 0.01 in.

For the load measurements, we chose a constant value for h (0.25 in), and a variable d, in 1/8 in, 1/16 in, 1/4 in and 3/4 in sizes.

As a result of these measurements and inquiries we were able to determine that a) H-Joints over 1/8 in behave almost the same, and b) Confirm that the strength of the joints is to be determined by the tolerance, and not by the area.

Fig. 6. Strength vs. displacement charts of two different joints

Dealing with tolerance and non-perpendicularities

The correct tolerance value needs to be assigned to the joints, as this is the critical value that will provide rigidity to the assemblies. The tolerance value should be such that it a) provides firmness and b) can be assembled manually. The assessment of the tolerance is to a large extent a result of a trial and error process. As a result of this process taking into account the varying condition of the slot relative to the angles, we were able to determine that the right tolerance for the prototypes built with plywood under stable room temperature was 0.254 mm (0.01"). A related problem is the assessment of the variation in the size of the slot relative to the angle of the crossing elements. And that the variation of the slot size is given by the formula (1):

$$W = \frac{d-2tol}{\tan(o)} + \frac{L-tol}{\sin(o)}$$

Where w is the width, d is the width of the vertical part, L the width of the horizontal part, and tol the value of the tolerance. Alpha (o) is the angle between the vertical and the horizontal elements. Finding this value is a precision aide in the modeling process, and it was to play an important role in the goal creating a flexible parametric model.

Fig. 7. Varying condition at the slot relative to the angle

Fig. 8. Finding the right tolerance in different materials

Dealing with structural optimization concerns

It is worth noticing that material properties do not scale linearly. The structural behavior changes between scales even in objects of the same material. The optimal structural solution for a 1/8" thick plywood box at 1" = 1' is not the same to that for a 1" thick plywood at full-scale. An informed use of the strategies in this chapter can provide non-linear scalability to the system.

(a) Modulation of the structure: By changing the distances between different structural elements, between the end of a structural element and the intersection with another element, and between the intersection of two structural elements and an end. The height of the structural element is also a defining factor of the structural performance of the object.

(b) Parameters of the joint: The size and depth of the slots, which will affect specifically the resistance to certain lateral loads.

(c) Substitution rules: A set of rules of substitution specific for certain elements is defined. These substitutions provide increased structural rigidity by breaking continuity of joint nodes along the structure (rule 1) or by conflating sheathing panels (rule 2).

Any design generated by the sequential application of the grammar rules is constructible as the parameters for tolerance, thickness of materials, structural modulation, etc. are built in the members of the vocabulary.

The structural performance of the objects that result of this sequential process of addition and subtraction is not, however, optimal. The "building blocks" of the grammar result in an inconvenient continuity of the connection nodes that increase the bending moments transversally to the continuity lines.

Fig. 9. Examples of Substitution Rules

Actual examples of structural adjustments for specific designs made with the grammar are outside the scope of this paper. In this section we defined three strategies for structural adjustments to take place in an object derived with the grammar.

Growth and Flexibility

In this chapter it will be shown how the grammar can be used generatively to derive a specific design (a simple box), and to modify this design flexibly by adjusting the global geometry of the object.

Growth

It is the ability of having open-ended design processes what makes this particular grammar generative. As rules of transformation are applied non-deterministically to the components, designs can change, grow, holes can be opened, and new sections may appear. The image shows the derivation of a very simple object, a closed box. It is worthy of noting that a pre-

rational process with clear rules can be described computationally very easily by the sequence of rules that was used to derive the design.

There is an infinite number of different sequences of rules that can generate the exact same closed box, and there is an infinite number of design variations that can be performed on the object.

Fig. 10. Using the grammar to derive a box

Flexibility

The generality of the description will afford the system versatility of the to operate at different scales and materials (for example 1/32" chipboard, 1/8" Plexiglas, or 1 inch plywood). The parameters taken into account in the grammar are a) Tolerance b) Thickness of material c) Size of the slot d) Distance between slot and end of the piece e) Depth of the slot f) Distance between slots. CATIA software provides a framework to encode the dynamic relationships of dependency between the parameters described in section X. A model was built of the closed box derived with the generative grammar. In the model all the faces except the floor can be changed and moved.

Fig. 11. Using the parametric model to flexibly modify materials, size and shape of the object derived with the grammar

Due to its very hierarchical nature (everything gets created as a branch of a large data tree and is either "children" or "father" of its neighbors) there is no simple way to use go back to the "generative level" and operate changes in the topology of the object. The model can, however, adapt easily to different materials and shapes.

Fig. 12. Image of the CATIA model on screen

Conclusions

Design Trade-Offs

One of the many ways in which design can be seen is as a continuous bargain between the designer and the constraints, some of which are imposed by the problem given, others are found along the process of design exploration. We've focused in discussing the role that material constraints play in computational design environments, keeping in mind that these constraints are a narrow subset of a much larger universe of issues to consider in any –even a very simple- design process.

There is room for future development in computational design systems towards finding active ways to involve such constraints in design environments and dynamically explore material trade-offs.

Growth vs. Flexibility

Making small changes in the global shape of the design in a closed box is extremely time consuming using a solid modeling and drafting system. In contrast, using a relational, the same changes can take a tenth of the time (See Table 1).

Table 1 Model comparison table

		Box 3	Param Box
Independent Variables	Shape	Cube w/angled roof and walls	Cube w/angled roof and walls
	Number of non-ortogonal edges	6	6
	Design Time (hr)	58	2
	Preparation for Fabrication Time (hr)	20	4
	Construction Time (hr)	15	3
	Total Time	93	9
Controlled Variables	Design Platform	AutoCAD 2007	CATIA V17
	Fabrication Device	Universal Lasercutter Bedsize: 32" x 18"	Universal Lasercutter Bedsize: 32" x 18"
	Material	Plywood 10 sheets of 24"x12"x1/8"	Plywood 10 sheets of 24"x12"x1/8"
	Designer	DC	DC

The trade-off lies in that the highly hierarchical and constrained nature of a parametric model makes it virtually impossible to organically "add" or "subtract" elements to the composition (a characteristic of a generative process): a box remains a box, even if we can change its angles or the

properties of its elements. Architects who are familiar with parametric modeling often refer to this condition saying that the design ideas must be completely clear before starting to model. In a way "there's no way back"; this is the price of a certain amount of global to local design flexibility.

In contrast, the non-hierarchical nature of solid modeling allows for addition and subtraction of elements (a typically generative or constructive approach), but the trade off lies in that there are no ways to propagate changes across the composition.

Ease of Manufacturing vs. Solution Space

The prototypes show how a material and device dependent physical grammar can provide 1) a certain amount of design flexibility and 2) an optimal connection to fabrication technologies.

The parametric boxes show how this flexibility can be increased by defining mathematical relationships between the different dimensions of the elements and global parameters that relate the elements to specificities of the materials and other dimensions. As mentioned in the previous section, they also show how the inherent geometrical and physical properties of the design language affect and characterize the language by limiting it.

It is clear that the boundaries of the language define a constrained world of shapes and variation. These boundaries can change substantially by manipulating the global parameters that control the structural and physical properties of the grammar. We were able to determine that for the material most used in the prototypes (1/8" thick plywood), the universe of "safe" designs is defined by the set of volumes that comply with the following two conditions: (a) The angles described by the walls and the horizontal plane are greater than 80° and smaller than 120°, and (b) The height of the box is at least 300mm.

This is the inherent trade-off of facing a design problem with a design language fixed beforehand. This problem is usually described by the opposition between two mutually exclusive processes: post-rational and pre-rational. A post-rational process typically starts with a shape devoid of material considerations and then infers methods for its construction; often a post-rational process involves rational subdivision of the "fluid" shape into components.

Fig. 13. Two similar structures built from different materials using the same file

A pre-rational process, in contrast, is a process where the construction technique is defined early in the design process, becoming a major constraint in the form-finding[3]. How flexible can building blocks be? How generative can fluid shapes be? We hope that the experiments presented in the technical sections of in this paper provided useful insights into this question in the light of the current landscape of digital design and fabrication technologies.

A pre-rational process, in contrast, is a process where the construction technique is defined early in the design process, becoming a major constraint in the form-finding[4] process. How flexible can building blocks be? How generative can fluid shapes be? We hope that the experiments presented in the technical sections of in this paper provided useful insights into this question in the light of the current landscape of digital design and fabrication technologies.

Problems

Warping

Sheet materials distort from their original plane in a phenomenon known as warping. These distortions are caused by different factors such as humidity, temperature, and therefore are very impossible to fully predict in a digital model. Warping falls perfectly in the category of "sticky and inconvenient contingencies of dealing with physical matter".

[3] See [5:33]

[4] See (Loukissas 2003:33)

Fig. 14. Two corners where the components are generated automatically by the model when the shape and/or material of the box changes

Although the prototypes show that the structural elements of the objects derived with the grammar are able to self-correct the errors produced by the warping of the plywood sheets, this is not the case for the paneling, and warping has a negative impact on the sheathing that needs to be addressed in order to advance the system (in an extreme case of warping the panels pop-out from their positions in the structure).

Fig. 15. Warping

Possible solutions can be
- Additional joints that connect perpendicularly between panels
- A system where the panels instead of being fixed by friction can be "slide-in". Instead of fighting the warping with more material, acknowledging it and providing a margin of movement to the panels.

Towards Generative Fabrication

This paper exposes the lack of an integrated software platform that simultaneously supports both growth and flexibility as design operations, and easy to implement material constraints.

A novel kind of design tool can be outlined on the basis of this observation, a tool that is able to involve material knowledge in the early conceptual stages of design and keeps the design process constrained to the requirements of specific material and device concerns. The explorations conducted in this research suggest that in order to achieve this, the design tool needs to a) allow a designer to switch between different levels of representation (considering fabrication-ready information as one of these levels), b) allow for both local and global dynamic design variation c) have a detailed and extensible construction knowledge-base.

Contributions

A generative grammar for manufacturing 3D objects from sheet materials that:
- Is based solely on friction.
- Can be scaled in a non-linear manner
- Can be used with different materials.
- Can grow, and can be flexibly changed within a constrained design space.

An alternative to post-rational views and strategies in digital design and fabrication.

The outline of a Generative Fabrication tool.

Acknowledgements

This work was made possible by the generous support of the Center for Bits and Atoms at the MIT Media Lab under the direction of Neil Gershenfeld. The author is indebted to Terry Knight and Bill Mitchell for their very valuable insights and George Popescu for his help in understanding the –sometimes obscure- inner workings of the machinery.

References

1. Botha M (2006) Customized digital manufacturing: concept to construction methods across varying product scales. MS Thesis. Department of Architecture. Massachusetts Institute of Technology
2. Eastman C (1999) Building product models: computer environments supporting design and construction, CRC Press, Boca Raton FL
3. Griffith K (2006) Design computing of complex-curved geometry using digital fabrication methods. MS Thesis, Department of Architecture, Massachusetts Institute of Technology
4. Knight T (2000) Shape grammar in education and practice: history and prospect. The International Journal of Design Computing 2
5. Loukissas Y (2003) Rulebuilding: exploring design worlds through end-user programming. MS Thesis, Department of Architecture, Massachusetts Institute of Technology
6. Oxman R (1997) Design by re-representation: a model of visual reasoning in design. Design Studies 18: 329-347
7. Sacks R, Eastman C, Lee G (2004) Parametric 3D modeling in building construction with examples of precast concrete. Automation in Construction 13: 291-312
8. Sass L, Shea K, Powell M (2005) Design production: constructing free form designs with rapid prototyping. Paper presented at the ECAADE conference, Portugal
9. Sass L (2007) A physical design grammar: a production system for layered manufacturing machines. Unpublished
10. Sass L (2005) A wood frame grammar: a generative system for digital fabrication. International Journal of Architectural Computing 4(1): 51-67
11. Sass L, Oxman R (2006) Materializing design: the implications of rapid prototyping in digital design. Design Studies 27: 325-355
12. Seely J (2004) Digital fabrication in the architectural design process. Architecture, MS Thesis, Department of Architecture Massachusetts Institute of Technology
13. Stiny G, Gips J (1978) Algorithmic aesthetics: computer models for criticism and design in arts. University of California Press, Berkeley and Los Angeles, CA
14. Stiny G (1980) Kindergarten grammars: designing with Froebel's building gifts. Environment and Planning B 7(4): 409-462
15. Sutherland I (1963), Sketchpad: a man-machine graphical communication system. PhD dissertation, School of Electrical Engineering and Computer Science, Massachusetts Institute of Technology
16. Wodzicki CP (2004) Thesis (MEng) Massachusetts Institute of Technology, Dept. of Civil and Environmental Engineering

First Author Email Address

Al_Sayed, Kinda k.sayed@ucl.ac.uk
Athavankar, Ameya ameya.athavankar@gmail.com
Athavankar, Uday uaa@iitb.ac.in
Bandini, Stefania bandini@disco.unimib.it
Banerjee, Amit metsforever@gmail.com
Bilda, Zafer zafer.bilda@gmail.com
Bouchard, Carole bouchard@paris.ensam.fr
Burge, Janet burgeje@muohio.edu
Caldwell, Benjamin bwcaldw@clemson.edu
Cardoso, Daniel dcardoso@mit.edu
Chen, Rui rche0750@mail.usyd.edu.au
Dabbeeru, Madan Mohan mmadan@iitk.ac.in
Darses, Françoise francoise.darses@cnam.fr
Economou, Athanassios economou@coa.gatech.edu
Gómez de Silva Garza, Andrés agomez@itam.mx
Grobler, Francois Francois.Grobler@erdc.usace.army.mil
Halatsch, Jan halatsch@arch.ethz.ch
Helms, Michael mhelms3@gatech.edu
Hölscher, Christoph hoelsch@cognition.uni-freiburg.de
Jin, Yan yjin@usc.edu
Kozhevnikov, Maria mkozhevn@gmu.edu
Krstic, Djordje gkrstic@signalife.com
Kurtoglu, Tolga tolga.kurtoglu@nasa.gov
Laskari, Anna laskaran@yahoo.gr
Lim, Sungwoo sungwoo.lim@strath.ac.u
Maier, Franz franz.maier@cs.unisa.edu.au
Mengoni, Maura m.mengoni@univpm.it
Mou, Tsai-Yun tsaiyunm@gmail.com
Nickerson, Jeffrey jnickerson@stevens.edu
Orsborn, Seth orsborns@mst.edu
Somwrita Sarkar ssar3264@mail.usyd.edu.au
Still, Jeremiah jeremiah@iastate.edu
Tang, Hsien-Hui drhhtang@gmail.com

Uflacker, Matthias	uflacker@hpi.uni-potsdam.de
Vattam, Swaroop	svattam@gmail.com
Wang, Xiong	xiong.w@ieee.org
Yue, Kui	kyue@andrew.cmu.edu

Author Index

Aksamija, A	23	Goel, A	341, 377
Al_Sayed, K	635	Gómez de Silva Garza, A	417
Aoussat, A	593	Grasl, T	361
Athavankar, A	123	Grobler, F	23
Athavankar, U	321	Halatsch, J	655
Bandini, S	181	Hanna, S	615
Banerjee, A	397	Helms, M	341, 377
Bilda, Z	303	Hickerson, C	23
Boatwright, P	3	Ho, C	473
Bokil, P	321	Hölscher, C	159, 635
Bonomi, A	181	Jin, Y	491
Bouchard, C	593	Kim, H	23
Burge, J	221	Kiper, J	221
Cagan, J	3	Kozhevnikov, M	143
Caldwell, B	261	Krishnamurti, R	23, 61
Campbell, M	553	Krstic, D	81
Cardoso, D	713	Kunze, A	655
Chase , S	41	Kurtoglu, T	553
Chen, R	697	Laskari, A	615
Corter, J	103	Leclercq, P	283
Dabbeeru, M M	201	Lee, Y	439
Dalton, R C	159, 635	Lim, S	41
Dark, V	457	Lores, A Z	417
Darses, F	283	Louis, S	397
Derix, C	615	Maier, F	513
Dong, A	533, 573	Mayer, W	513
Economou, A	361	Mayeur, A	283
Elsen, C	283	Mengoni, M	677
Fadel, G	261	Mocko, G	261
Garner, S	41	Mou, T	473
Germani, M	677	Mougenot, C	593
Gero, J	303, 533	Muehlenfeld, A	513
Geslin, M	491	Mukerjee, A	201

Nickerson, J	103	Sharma, S	321
Omhover, J	593	Still, J	457
Orsborn, S	3	Stumptner, M	513
Patsute, R	321	Summers, J	261
Prats, M	41	Swantner, A	553
Quiroz, J	397	Tang, H	439
Rao, G K	321	Tversky, B	103
Rho, Y J	103	Uflacker, M	241
Royan, J	143	Vattam, S	377
Sarkar, S	533	Wang, X	573, 697
Sartori, F	181	Westerman, S	593
Sass, L	713	Yue, K	23, 61
Schmitt, G	655	Zahner, D	103
Sen, C	261	Zeier, A	241